FLEMISH AND DUTCH PAINTING

FROM VAN GOGH, ENSOR MAGRITTE AND MONDRIAN TO CONTEMPORARY ARTISTS

edited by Rudi Fuchs and Jan Hoet

RIZZOLI
NEW YORK

First published in the United States of America in 1997 by
RIZZOLI INTERNATIONAL PUBLICATIONS, INC.
300 Park Avenue South, New York, NY 10010

First published in Italy in 1997 by
RCS Libri & Grandi Opere S.p.A., Milan

ISBN 0-8478-2055-6
LC 97-65835

Printed and bound in Italy

This exhibition devoted to modern Flemish and Dutch painting is intended to pay tribute to a culture that, besides playing a vital role in contemporary art, has also had many contacts with Italy. In addition to the close relationship between the respective artistic outputs, these have been of both an intellectual and an economic nature.

From the end of the Gothic period onwards, when artists such as Jan van Eyck and Antonello da Messina, and various stylistic developments, indicated the Flemish influence in Italian art – and, at the same time, the Italian influence in Flanders – themes, discoveries and borrowings were constantly interwoven. And there was, in reality, but one theme: the fundamental role of light and the way it animates objects, whether they be human faces or different aspects of the natural world.

In fact, this attention to light and the way it reveals the inner nature of thoughts and visions has, over the centuries, characterized the whole of Flemish painting. And it constitutes the basis of the individual contemplation that has produced the representations of domestic interiors – and those of public buildings and churches – as scenes of everyday life rather than views of specific places.

This approach, reflecting the spirit of the Flemish people, has never ceased to exist, nor has it succumbed to the styles and fashions of other cultures; and it has always been an interpretation of modernity that is both individualized and fascinating.

This exhibition demonstrates this very clearly: linked to the painting of the Italian Renaissance and Mannerism through the works of Joachim Patinir and Jan van Scorel, the great masterpieces of Vincent van Gogh and James Ensor manifest, despite their contrasting styles, the attention these artists paid to a world that – to the point of becoming abstract – is dominated by a light belonging to the soul rather than nature. Thus, from Expressionism to Surrealism, abstraction and the revolution of the Cobra group, right up to the experiments of Pop Art and Minimal Art, no aspect of Flemish art – whether it regards the Netherlands or Belgium – is lacking.

But this exhibition also highlights the way in which political entities cannot oppress cultural entities; on the contrary, they are nurtured by those relationships of the spirit that characterize the essential elements – in a diversity that is, at the same time, unity – of the identities of the two nations.

Naturally, thanks are due to those who conceived the exhibition, organized it, and lent their works of art; but we are also grateful to this concurrence of two nations with regard to their unity. This is, indeed, based on art, but it is also the product of a great culture, and is an example and a gift for us, and all the other cultures of today.

Feliciano Benvenuti

Under the patronage of
Her Majesty Queen Beatrix of the Netherlands
His Majesty King Albert II of the Belgians
the President of the Italian Republic Oscar Luigi Scalfaro

This book was published on the occasion of the exhibition
*Art of the 20th Century. Flemish and Dutch Painting
from Van Gogh, Ensor, Magritte, Mondrian
to Contemporary Artists*, Palazzo Grassi, Venice
March 16th - July 13th 1997

Exhibition by
Rudi Fuchs, Stedelijk Museum, Amsterdam
Jan Hoet, Museum van Hedendaagse Kunst, Ghent

Working Committee
Geurt Imanse, Stedelijk Museum, Amsterdam
Herwig Todts, Museum voor Schone Kunsten, Antwerp
Esther Hemmes, Stedelijk Museum, Amsterdam
Norbert De Dauw, Museum van Hedendaagse Kunst, Ghent
with
Raoul Boer, Stedelijk Museum, Amsterdam
Maarten Bertheux, Stedelijk Museum, Amsterdam
and members of the staff of Museum van Hedendaagse Kunst, Ghent
and Stedelijk Museum, Amsterdam

Catalogue edited by
Geurt Imanse

Working Committee
Geurt Imanse
Esther Hemmes
Norbert De Dauw

Assistants
Wil Njio, Stedelijk Museum, Amsterdam
Patrick Van Rossem, Museum van Hedendaagse Kunst, Ghent

Biographies of the Artists
Paul Kempers, Stedelijk Museum, Amsterdam
Anne Parez

Critical Anthologies
Margreeth Soeting, Stedelijk Museum, Amsterdam
Robert Hoozee, Museum voor Schone Kunsten, Ghent

The Low Countries, more precisely Belgium and the Netherlands, have been a focus of interest for art lovers for centuries, and a source of inspiration for artists. Their golden ages, that of Flanders in the fifteenth and sixteenth centuries and that of the Netherlands in the seventeenth century, have attracted a great deal of attention. The Netherlands and Flanders, one of the three language communities in the Kingdom of Belgium, have close ties. In addition to being neighbours and having been part at various periods in European history of the same political entity, they share a common language, Dutch. With twenty million Dutch-speaking inhabitants, they form the sixth largest language area in the European Union. Co-operation between them in the field of the Dutch language is institutionalised in the Nederlandse Taal Unie (Dutch Language Union), an intergovernmental organisation whose activities include the promotion of the Dutch language and literature in other countries, as well as at major events, such as the presentation of Dutch literature at the international book fairs such as the Frankfurter Buchmesse in 1993, "Liber" in Barcelona in 1995, and the Gotenborg Book Fair this year.

Sharing a common language has also led to frequent exchanges in the field of theatre: a great many Flemish productions have been seen in the Netherlands and vice versa. For some years a theatre festival has been held at the same time in Amsterdam and Brussels in September, in which the main productions of the previous season have been restaged. There is also a busy cross-border traffic in art forms such as dance, music and the visual arts, in which the Dutch language is not the principal medium.

Whenever possible, both governments would like to promote joint action in other countries based on the awareness that in this way our language and culture may attract greater interest. In 1995 this common view was laid down in a cultural treaty. There is now a tradition of joint action in the visual arts, as we can see in Venice where the exhibition "Art of the 20th Century. Flemish and Dutch Painting from Van Gogh, Ensor, Magritte, Mondrian to Contemporary Artists" is being held. For the Venice Biennale in 1993 and 1995 Flemish and Dutch curators organised a joint, extramural exhibition. This collaboration between the two countries proved to be a fascinating experience, not least for the curators themselves. Bart De Baere and Lex ter Braak discovered during their tour of the Netherlands and Flanders for the exhibition "Among others... Onder anderen" (1995) that if the mental distance were the same as the geographical distance "the journey would suddenly be much too short because it would dissolve into unfinished discussions of surprising proximities and correspondences".

The exhibition which this catalogue accompanies has another dimension, that of art history. The director of Palazzo Grassi, Paolo Viti, the director of the Museum van Hedendaagse Kunst in Ghent, Jan Hoet, and the director of the Stedelijk Museum in Amsterdam, Rudi Fuchs, have put together an overview of the modern art of the twentieth century in both countries. We would like to take this opportunity to express our gratitude to both the organisers and the many lenders. It has been a great pleasure to assist in making this event possible.

The exhibition takes the form of dialogues between works from the Netherlands and Belgium. In choosing this original arrangement the organisers have undoubtedly heightened the tension felt by the viewer and provided new insights into the development of modern art in the Low Countries. It also seems to us to be a good metaphor, probably unintentionally, for the close cultural cooperation between the Netherlands and Flanders. We hope that the dialogue at this exhibition will enrich international discourse in the field of art. The future will show whether the twentieth century will turn out to have been a new Golden Age for our two countries.

Aad Nuis
The Netherlands State Secretary for the Ministry of Education, Culture and Sciences

Luc Martens
The Flemish Minister of Culture, Family and Welfare

Lenders

Amsterdam, Private Collection
Amsterdam, Rijksmuseum
Amsterdam, Stedelijk Museum
Amsterdam, Van Gogh Museum
 Vincent van Gogh Foundation
Antwerp, Koninklijk Museum voor Schone Kunsten
Antwerp, Ronny Van de Velde
Arnhem, Museum voor Moderne Kunst
Brussels, Collection Crédit Communal
Brussels, Galerie Jan De Maere
Brussels, Johan A.H. van Rossum
Brussels, Ministerie van de Vlaamse Gemeenschap
Brussels, Musée des Beaux-Arts, Ixelles
Brussels, Musées royaux des Beaux-Arts de Belgique
Brussels, Private Collection - Courtesy Galerie
 Maurice Keitelman
Eindhoven, Stedelijk Van Abbemuseum
Ghent, Dan van Severen
Ghent, Museum van Hedendaagse Kunst
Ghent, Museum voor Schone Kunsten
Ghent, Vereniging voor het Museum
 van Hedendaagse Kunst
Groningen, Groninger Museum
Groningen, H. de Groot Family Collection
K.C.M. Fauser Collection
Kruishoutem, Fondation Veranneman
Leeuwarden, Keramiekmuseum Het Princessehof
Łodz, Muzeum Sztuki
Mendrisio, Private Collection, Courtesy
 Massimo Martino S.A.
Naarden, Becht Collection
Ostend, Museum voor Schone Kunsten
Ostend, PMMK - Provinciaal Museum
 voor Moderne Kunst
Otterlo, Kröller-Müller Museum
Paris, Musée National d'Art Moderne Centre
 Georges Pompidou
Paris, Galerie Daniel Lelong
Rotterdam, Museum Boijmans Van Beuningen
The Hague, Haags Gemeentemuseum
The Hague, Rijksdienst Beeldende Kunst
 the Netherlands Office for Fine Arts
The Hague, Rijksdienst Beeldende Kunst
 on loan to the Museum voor Moderne Kunst, Arnhem
Turin, Ezio Gribaudo Collection
Zumikon, Angela Thomas Bill Collection

and all those who have wished
to remain anonymous

Installations

Catalogue

Project and Coordination
Gae Aulenti
with
Francesca Fenaroli

Graphic Design
Pierluigi Cerri

Lighting
Piero Castiglioni

Press Relations
Vladimiro Dan

Editorial Director
Mario Andreose

Graphic Design
Pierluigi Cerri
with
Carla Parodi

Coordinating Editor
Simonetta Rasponi

Editor Staff
Gianna Lonza
Maria Cristina Maiocchi
Giuliana Sassone

Translators
from the Dutch
Gregory Ball
Alexander Brown
Peter Flynn
Ruth Koenig
John Rudge
from the Italian
David Stanton

Iconographic Research
Carla Viazzoli

Coordination
Milena Bongi

Production Staff
Fulvio Bassani
Italo Cisilino
Sergio Daniotti
Rino Pasta
Carla Regonesi
Enrico Vida

Secretary
Enza Barbieri
Luisa Gandolfi

Contents

17 L'antica storia dell'arte moderna
Rudi Fuchs

27 A Yardstick or a Step
Jan Hoet

30 Controlled Dissensions and Shared Prosperity
The Netherlands and the Dutch, 1880-1996
Dirk Jan Wolffram

63 Belgium, 1880-1996
Sophie de Schaepdrijver

99 There and Back. A Confession To Rudi Fuchs
Henk van Os

102 Reality and Light in the Art of the Low Countries
Maurizio Calvesi

107 The Works

304 Critical Anthology - The Netherlands
edited by Margreeth Soeting

312 Critical Anthology - Belgium
edited by Robert Hoozee

321 Biographies of the Artists

341 Bibliography

348 Index of Names

355 Index of the Artists and Works

L'antica storia dell'arte moderna

Rudi Fuchs

Before entering the twentieth century, not by the direct route but via the pictorial unrest initiated in the previous century, we have to define a few specific perspectives. The art of Flanders and the Netherlands, when the two still formed a single monarchy, issues from the same sources. It was based on an intent, accurate contemplation of the visible world. Artists were not given to great flights of fancy. Paintings were painstakingly detailed and their colouring was for the most part restrained. By about the middle of the fifteenth century it was clear that two major schools of painting had developed in Europe, one of them Italian, the other Netherlandish, each with its own distinctive character. Italian art was more graceful, the construction of its refined compositions more flexible, albeit at the cost of detail – all those little moments of intense observation which in Netherlandish art impeded construction and made the paintings look slightly stiffer than the Italian ones. The seductive grace for which the Italians seemed to have an innate aptitude, and for which Raphael is so famous, did not come naturally to the Netherlandish painters, whose subtly luxuriant realism was nonetheless beguiling.

The writer Bartolomeo Fazio, who worked at the court of Naples, admired the refined, decorative elegance of Gentile da Fabriano's paintings; at the same time he observed how different he was from Jan van Eyck, praising a scene by that Flemish artist in which the bodies of bathing women were miraculously reflected in the motionless water. Every style or painterly method has its own developmental potential, and that development will reflect the expectations of a specific culture. To this day the Italians are more extrovert than the Flemings or the Dutch. Their paintings have always been livelier and more mobile than ours. Even when the subject-matter is as intrinsically dramatic as a Deposition (by an artist like Rogier van der Weyden, for instance), in Northern paintings the figures stand there calmly and silently, frozen in their pose, more like precisely drawn full-length portraits than of people actively involved in an event.

In Italy the term *inventio* had become current in Renaissance art theory. It referred to a painter's talent and intelligence to devise a convincing, lively composition for a complex group of actions as enacted in a Deposition. Painters of the Netherlandish school, Jan van Scorel for example, excelled in intent observation. To illustrate that quality so fundamental to the Northern notion of art, this exhibition begins with Van Scorel's little portrait of a boy. The painter's eye is fixed firmly on his sitter in an observation so motionless that it is hard to imagine how such an exact, descriptive method could ever achieve mobility. Recalling Raphael's narrative compositions thronged with figures, like those in the Stanze del Vaticano, I am struck by his constant search for lively, energetic variants of movement in his compositional structure. In order to show off that talent to its best advantage he had to renounce minute detail. Attention to detail while painting would have inhibited the flourish that gives Italian paintings their marvellous vivacity. This is borne out by panels by Flemish masters with several figures, panels in which everything, even the movement, seems to be frozen under a dome of bright light, but in which the tiniest details become sparkling jewels of painterly finesse.

All Northern painting approaches the condition of a still life. That is its most typical condition, even the capricious landscape by the Antwerp painter Joachim Patinir which accompanies the Van Scorel portrait of a boy in the exhibition. Despite the curious rock formations, the angular mountains, the ominous light emanating from the burning cities of Sodom and Gomorrah, this painting, however mysterious it may be, is pervaded by the strange, silent concentration that is so characteristic of still lifes. We (the compilers of the exhibition) selected Patinir because we feel that at the beginning of the sixteenth century certain differences between the North Netherlands and Flanders were becoming apparent, notwithstanding the basic similarity of the two traditions and their shared differences from the Italian tradition. I am reluctant to stress such differences, but I must. After all, I am trying to localize certain artistic identities here, certain aesthetic visions and dreams. In this exhibition a landscape, with its somewhat capricious form and odd lighting, is compared with a cool, lucid portrait.

Even in that slightly overstated comparison it is still quite clear that the landscape, like the portrait, shows accurately observed and executed details; indeed, it is quite literally an 'accumulation' of details. What the two painters have in common is the precise, patient realism that constitutes the Northern tradition. Patinir, though, brings a different emotion to bear on that traditional, Northern method; he is haunted by other, dark visions. I am unable to say exactly how typical that is of the South Netherlands. But there is no denying the fact that such strange,

fantastical pictures were painted in the South (don't forget Hieronymus Bosch), and scarcely at all in the North. Another, and fairly typical, difference between Patinir and Van Scorel is that in a subtle way the landscape is more decorative than the portrait. Despite its realistic finesse it is capable of abandoning reality in order, quite literally, to 'fantasize' with it. Perhaps this is a Flemish form of *inventio*. Be that as it may, Patinir's landscape assumes a strange charm and beauty, while tranquil sobriety and a clear vision pervade Van Scorel's portrait.

That selfsame sobriety can be observed in figure paintings by Van Scorel and other sixteenth-century masters who came after him in the Northern provinces. As a matter of fact, such differences had been manifest even earlier.

Whereas in the South painters like Jan van Eyck and others tended to embellish their paintings with a profusion of dazzlingly colourful details, the Haarlem masters invariably treated their surfaces more frugally, more unyieldingly. In those days the South was richer than the North, and that wealth is reflected in the architecture of the two regions: lavish decoration in the South, sobriety in the North. Recalling that the sober architecture of De Stijl (under the influence of Mondrian and Van Doesburg) came from the North, while Belgian architecture was decisively affected by a strong Art Nouveau tradition, we observe a concrete difference between the aesthetic identities of the two regions.

I see additional confirmation of these differences in the way sixteenth-century South and North Netherlandish artists handled the Italian influence. By this time the mobility, the spatial clarity and the smooth narrative flow which had developed in the Italian Renaissance were irresistible. As I said, close attention to detail, a fundamental trait of Northern painting, inhibited mobility. Came the time when Northern patrons – now familiar with Italian art thanks to the lively contacts between the Netherlands and Italy – favoured this kind of narrative representation, it was time for artists to sit at the feet of their Italian colleagues. Jan van Scorel, one of the first to go to Rome, justly deserves the title of "torch-bearer and pioneer of Netherlandish art" conferred on him by the Dutch Vasari, Carel van Mander, in his lives of the Northern painters (1604). Even so, Netherlandish painters rarely or never achieved the imaginative vivacity of Italian compositional design. Artists from the South Netherlands had a greater talent for this than their Northern colleagues, though. The tendency to decorative formulation, to the ability to let go of reality and be led by the imagination, a tendency I observe in Patinir's landscape, made the South more amenable to Italian flourish; and it was in that same South that the process of assimilation peaked in the Baroque, in Rubens.

Inevitably, though, almost all sixteenth-century painters found it hard to master the Italian model, the Northern painters finding it harder than their Southern neighbours. Ambition notwithstanding, many of the figures retained a certain rigidity, unable to disavow their sober ancestry. It is interesting to see painters who produced mediocre figures suddenly beginning to paint much better, much more purely, when they tackled portraits or landscapes. Breeding will tell, and the realistic tradition – their true native tradition – was always stronger, particularly in the North where the great painters of the seventeenth century (Vermeer, Rembrandt, Ruysdael, Hals, Saenredam) disavowed Italy.

They no longer went there, but exploited their time-hallowed, Northern talent for realistic observation to formulate an entirely individual art. Rubens (and this is also true of his great pupil Antonie van Dyck) might even be said to be better in his portraits and landscapes than in his other work. But then the portraits and landscapes possess a brilliant, dashing breadth; they are generously endowed with pictorial and decorative inventivity. That characteristic difference survives centuries later in the paintings of James Ensor and Vincent van Gogh, the two artists with whom we broach the twentieth century.

I have dwelt at such length on the history of Flemish and Netherlandish art in order to explain how processes of influence work, how outside influences, like those from Italy, are admitted and assimilated in what is regarded as native style. When sixteenth-century Northern painters set off in search of impulses from Italy, they did so of necessity. After all, the Italians were the uncontested masters of broadly conceived, narrative compositions. Earlier, around the middle of the fifteenth century, things had been the other way round. As the Italians gradually mastered the construction of expressive figures with supple movements, they logically felt a need to depict the 'place' of the action – a landscape, say – in a more convincing, realistic fashion. They began to observe how the Northerners painted trees, flowers, grass and clear skies. Ital-

ian portraiture, too, was influenced by the Flemings. However, in all such cases the great artists remained loyal to the unmistakably distinctive character of their style, their typical idiom. They did not allow themselves to be overwhelmed or carried away by an influence. Their attitude towards foreign examples was cautious. In the sixteenth century Northern painters let themselves be guided by Italian examples in order to give fresh direction to their own painting (towards greater flexibility); but in the final analysis the result is just as Flemish or Dutch in character as the work they had done before. A painter works on his home ground, in his own idiom. From that vantage point he can, if he wants to, see what is being done elsewhere and, if so inclined, make use of it. He may go somewhere else, just as Jan van Scorel and so many others went to Rome. But the idiom dogs him like a shadow, acting as a constant, sensitive filter through which other things are observed and comprehended.

What makes the sixteenth century so interesting is the fact that an 'international' idea of art began to take shape then. In large areas of Europe Italy, and more particularly Rome, came to be regarded more and more as the fecund womb of advanced art, and what emerged from that womb was considered the best. Not to drink from that fountain entailed the risk of remaining old-fashioned and provincial. Painters took their luggage along with them to Rome from home – their native idiom or dialect. In Rome they met Italian painters and (other) foreigners – Germans, Spaniards, Frenchmen; in Rome the various dialects began to mingle. They then returned to their native countries, nourished by Italy, their heads ringing with memories of the other foreigners they had met there. Back home, these experiences and memories continued to fuel their artistic imagination – but always within the framework of their own idiom. The Dürer who came home to Nuremberg from Venice was still a German painter; Van Scorel and Rubens did not become Italians either.

However, the various regional schools of European painting, each with its distinctive identity, were invaded by a 'collective' consciousness of the Italian style. Wherever they were in Europe, that consciousness reminded them that somewhere there was a manner of painting which they regarded as superior and glorious and which would serve them in achieving their own ambitions. (Conversely, all those foreigners left traces of their various dialects in Italian art.) This always happens when a particular style is generally regarded as exceptionally good, exceptionally effective, exceptionally attractive. Such a style gradually becomes more prevalent, because its quality and potency become irresistible when compared with more primitive styles elsewhere – in places where its beauty is already being dreamed of. In the Middle Ages that was how Gothic architecture, which attained its purest form in France, gradually came to dominate Europe. But during the course of that development the process of transformation and stylistic differentiation had already begun.

This was because all over Europe the Gothic idiom was being assimilated into the idiom of existing architecture and building. By the same token, allowing oneself to be influenced by great exemplars meant adapting to the local idiom. Later on in the sixteenth century a wide range of local variants of Italian Mannerism developed in this fashion. All these variants were different, however. Each of them (whether in Paris or Fontainebleau, Prague, Haarlem or Antwerp) was permeated by the local idiom and by local criteria of beauty and style. In the end not a single variant resembled the Italian model, which had been absorbed into the alien, local idiomatic energy and artistic inventivity. It is important to understand this mechanism of assimilation and transformation properly. There is no reason whatsoever for evaluating Haarlem or Antwerp Mannerism as a puny sub-school, dependent on Rome. It possesses far too much individuality for that, too much confidence in the local idiom, which ultimately defines the character and quality of the paintings to a greater extent than the Italian model.

A model is never more than a model: it is a starting point, but not a finished painting by a long chalk. Remember, the Flemings do not speak Dutch in the same way as their Northern neighbours; they have discovered a different, more baroque melody in the language, and the proximity of France is reflected in Flemish syntax. The language is thus almost two languages, each with its native emotion and expression. By the same token, artistic models have to be first translated into and then expressed in an idiom before they really come to life.

Pour besoin de la cause, I shall approach the twentieth century in the same way as I have been considering the sixteenth. At the turn of the twentieth century, artists were preoccupied by a number of extraordinary, highly influential stylistic developments, like Mannerism in its day.

Again, such models (taken from Cubism, Fauvism, Expressionism, Surrealism) were always and everywhere translated and transformed into the idiom of whoever was exposed to them. The central postulate of this exhibition, after all, is that in the twentieth century, the century of Modern Art, Dutch and Flemish art passed through an entirely individual development, inspired and motivated by specific, idiomatic notions formed in the course of history. At the same time artists in Flanders and the Netherlands, often in a highly individual fashion and always in accordance with their own ideas, repeatedly made use of impulses and models from elsewhere. It is also claimed that there is difference in character and ambition between Flemish and Dutch art – the same kind of difference I have already described: between Patinir and Jan van Scorel, or Rubens and Vermeer, or James Ensor and Vincent van Gogh. That is how the exhibition – the selection of artists and works and the actual arrangement of the rooms – is constructed: not as a precise historical or chronological résumé but as a network of comparisons and contrasts by means of which we wanted to assign a certain emblematic meaning to a number of artists (Ensor, Van Gogh, Mondrian, Magritte).

I do not believe that there is any such thing as Modern Art. At most we can conceive of it as a hypothesis, as a fairly loose context of notions which most of this century's artists seem to have in common – such as the notion that every modern artwork is supposed to be new and individual and that there can consequently no longer be any great tradition to determine the direction of the development.

Actually, Modern Art consists solely of variants, each of which is still determined by a regional idiom, as of old, with premises and ambitions which are often similar and which are prompted by certain artistic methods (Cubism, for example) which have become international 'in their use'. (In the sixteenth century and in exactly the same way, Italian Mannerism became international in its use.) That is why we originally planned to give the exhibition the intriguing but perhaps abstruse subtitle of *L'antica storia dell'arte moderna* (The Age-old history of modern art). We intended it to express the concept that the historical structure of Modern Art is not all that different from that of, say, the sixteenth century: certain models and exemplars which came to be used on a general and international scale but whose regional assimilation was conditioned by idiomatic preferences and notions of local character.

There is another reason why the comparison with the sixteenth century is instructive, and that is why I keep coming back to it: it is notably in the sixteenth century that we frequently encounter an idea put forward by those who 'wrote' about art (a relatively new activity in those days), an idea expressed in a more pronounced fashion than before: that a particular school (or style or method) was by far the best and that other artists simply had to follow its shining example. It was a normative aesthetic. Giorgio Vasari, for instance, regarded the Tuscan school as the true fount of art, while his Dutch counterpart Carel van Mander (*Schilderboeck*, 1604), although a dedicated chronicler of the history of Netherlandish art (both North and South), repeatedly asserted that painting should really be studied in Italy, in Rome. The problematic thing about this approach, which is based on an exemplary model and its followers and variants (in the way Vasari writes about Michelangelo's consummate artistry), is that artists who work on the fringe of the grand tradition tend to be soon forgotten. Aesthetic dogma can involuntarily assume the guise of censorship.

As far as the twentieth century is concerned, the hypothesis of a central tradition (which critics and art historians, especially Americans, have come to call mainstream Modernism) is particularly laborious due to the lack of a tradition in the classical sense. Modern Art, at least to my mind, consists in a series of parallel developments: Cubism, Expressionism, Abstract Art, Dada and so forth. The majority of them were first formulated 'more or less' at roughly the beginning of the century. Although they proceed 'more or less' from the various transformations undergone by Impressionism (Cézanne, Van Gogh, Seurat, Gauguin, the late Monet), they did appear relatively fast, more as inspired 'discoveries' than as the result of prolonged experiment – and in most cases thanks to the genius of great, intractable artists like Picasso and Braque, Matisse, Mondrian, Kirchner, Duchamp and a few others. In the further course of their lives these 'styles' mingled and interbred with each other, with other impulses and new inventions ("nouveaux trucs, nouvelles combines", as Marcel Broodthaers said), over and over again on the basis of individual artists' very personal decisions.

Of course a few vague lines can be discerned here and there, and also in the complex of this

exhibition. An artist's inspiration can come from an Abstract, an Expressionist or a Surrealist cast of mind. Such kinships are definitely manifest. Inside, though, the different formulations are so personal (and are meant to be) that it is hard to speak of a coherent style. If there are any norms and models at all, the typical twentieth-century artist's strongest desire is to 'depart' from them. Then something else happened, something which was to make twentieth-century art look completely different from the way it had looked in the foregoing centuries. I am referring to a unique invention: Abstract Art. Other early influential forms like Cubism, Fauvism and Expressionism were still based on the old, figurative model – even though their protagonists radically manipulated forms in terms of structure, drawing or colouring. Of course that position gave direction to their ideas about art and to their search for innovation: by manipulating what already existed.

The invention of Abstract Art (roughly simultaneously, around 1915, and of its various versions, by Mondrian, Malevich and Kandinsky) was a totally new departure. In Matisse's paintings the radiant colours are combined with figurative elements – a flower, or a tree, or a dancing girl; the structure of a Cubist composition by Picasso resulted from the analytical deconstruction and manipulation of, say, a violin or a face. In Mondrian's abstract images, though, the concrete elements of painting, form and colour, began to move freely, seeking a place in the light, transparent space of the painting. Relieved of the weight of figuration, forms and colours could be placed by the painter in the abstract arrangement he sought; in abstraction, art became pure *verbeelding* (representation).

The appearance of Abstract Art fundamentally changed art. The artist now had a real 'alternative' to figuration, manipulated or not. Because of this, figurative art, for centuries the great model which, with greater 'verisimilitude' as the goal, had stimulated the invention of Italian perspective and Flemish realism, became just as 'abnormal' as Abstract Art is according to some. And when Marcel Duchamp appeared on the scene about the same time, there was actually a 'third' alternative. The artist no longer needed to make a painting: an *objet trouvé* or intellectual concepts sufficed.

Mondrian came across the first signs of abstract painting when he went to Paris and improved his acquaintance with Cubism. His first exercises with the method were traditional, directed towards the construction of flexible forms. Picasso tackled Cubism in the same way, juggling with forms and formal connections. However, Mondrian came from a taut, symbolistic style which was related to the brand of Art Nouveau practised in the Netherlands by Jan Toorop, stately and graceful. He wanted to retain that stateliness. In Cubism he discovered the transparent network of lines. By applying that network in the manner of a system to the (figurative) theme of intrinsically lucid and rectangular facades of houses, he saw, almost automatically (but of course by dint of great concentration), the appearance of an abstract art – more or less by omitting that architectural theme from the network. His idiomatic predilection for tranquil, stately images played a part in that discovery.

In terms of history, then, there is a direct link (in Malevich's development too) between Cubism and Abstract Art – and it was due to that connection that the basic hypothesis of mainstream Modernism began to emerge. One of the great ideas which came to play a decisive role here was the so-called pure use of the concrete elements. It was in Mondrian's lucid abstraction that those elements were used in the purest fashion. That aesthetic predilection for purity can be discerned in the further progress of Cubism, and of course in Matisse's graceful simplicity as well. That is how it came to pass that in the amazing pluriformity of modern art (for the Expressionists were active in Germany, the Futurists in Italy, the Sezession painters in Vienna) a kind of centre began to form – a nucleus of purity of style and means formed by the Cubism-Fauvism-Abstract Art trinity. The hub of this mainstream Modernism was the Ecole de Paris at first; later, after World War Two, it was the New York School.

Of course this is merely a very brief and general account of what happened, but it doesn't matter, because what I want to say is that the modernistic description of developments in the twentieth century is too limited, too exclusive. I cannot deny that a kind of mainstream Modernism did exist, nor that its effect is still felt and that it brought forth art of the highest quality. But the authority imputed to Modernism in most literature on the history of modern art is out of all proportion. Our view of noteworthy developments on the fringe and further away from the centre is sometimes impeded.

That is when Modernism as a style and a theory unintentionally becomes censorship, for there is no reason whatsoever for decreeing that the visual means should be used in a pure fashion. It is only an opinion and a claim – to which, as it happens, many artists did not subscribe. George Hamilton's standard work on the period 1880-1940 in the *Pelican History of Art* (1967) understandably presents a lengthy and detailed account of the rise and growth of Cubism, Fauvism and Abstract Art, but devotes only a few pages to developments in Belgium (with the exception of Magritte's Surrealism) and the Netherlands (with the exception of the abstraction of Mondrian and De Stijl). A great painter like Jean Brusselmans merits only three sentences and not one illustration. In the article on the same period in *Propyläen Kunstgeschichte*, compiled by Carlo Giulio Argan, I found no reference to Brusselmans at all; another great Expressionist, Gustave De Smet, is only mentioned in passing. Argan does grant Constant Permeke an illustration. Dutch painters Herman Kruyder and Charley Toorop are missing, although both works deal at length with German Expressionism.

I share the opinion that the German Expressionists may have played a more significant and dramatic role in modern German art than their colleagues in Flanders. Their art was more urban, more worldly, whereas the Flemings were more pastoral, seeking their themes on their own patch. Looking at modern art through the lens of Modernism, we cannot help arriving at such considerations. Nevertheless, we must try to face up to all our prejudices. As the century draws to a close it is time to adjust and broaden our outlook and, as we have done in this exhibition, to establish that every cultural region brought forth its own version of modern art in which every aspect and impulse of 'international' modern art, assimilated into the local idiom, is represented. By no means did the Flemings and the Dutch meekly succumb to international temptation; they created their own distance and relationship to foreign influences, based on their own sensibilities and aesthetic natures – echoing their sixteenth-century predecessors' attitude towards the (international) Italian model. In the final analysis, this exhibition is a record of that independent, distinctive orientation.

After the initial comparison of the two paintings by Joachim Patinir and Jan van Scorel, which in our opinion confirm certain differences between the South and North Netherlands, and after the foregoing peroration on historical style, we come to a second atmospheric comparison, this time of James Ensor and Vincent van Gogh. Although Ensor, born in 1860, was Vincent's junior by seven years, he embarked on his career earlier. Van Gogh did not paint his first, clumsy oils until 1882. Ensor displayed the same precocious talent for stylish painting as Rubens and Van Dyck.

Prior to *Le Rameur* (The Rower, 1883, cat. 4), an early, mysterious masterpiece, he had painted interiors and still lifes in dark, vibrant colours, keeping a remarkable distance from Impressionism which, I think, was too bright for him, too light for the melancholy mood expressed in *The Rower* and to which he was so partial. Van Gogh's *Weaver* (cat. 6) of 1884 is a laboriously painted work in which we actually see the artist toiling away. In *The Rower* we detect a tremendous verve and talent for painting, although Ensor was only twenty-three years old at the time. While he was already abandoning himself to his painterly fantasy in *The Rower*, and to an even greater extent in a few later works in this exhibition such as the splendid, large *Sunset* of 1885, Van Gogh was tackling his subject-matter with dogged tenacity. In a short space of time he painted a number of versions of the Weaver theme – always preoccupied with the precise placing of the loom and with its characteristic, firm angularity. His difficulties were not due to ineptness. It was important to Van Gogh for a painting to be 'true', imbued with real emotion. Depicting things as he saw them, imposing his vision on the painting: this was paramount.

Ensor often allows reality to ebb away until all that remains of a painting is a mysterious, sensual, chromatic fantasy. A comparison of Van Gogh's and Ensor's flower pieces is instructive. The latter saw flowers as graceful ornaments of elegant painting; he displayed a similar interest in decoration in his other work, in the curious masquerades in which the decorative element is combined with a strange, occasionally droll or absurd fancy. Ensor's treatment of colour is uncommonly lively and mobile; sometimes we are regaled with a motley procession of figures in bizarre attire. His work exhibits a tendency to a spectacular, compellingly dashing style which was completely alien to Van Gogh.

After the Dutch painter's discovery of Impressionism in Paris, his style exhibited greater flex-

ibility. He always remained close to his subject, however. He abhorred painterly fluency, regarding it as frivolous. His flowers are extraordinarily firm, like flesh. Even in his *Road with Cypress and Star* (cat. 29), in which colours and shapes are lashed up into a frenzy of expression, he still clings to realism. His style is direct, devoid of decorative embellishment and completely lacking the stylistic refinement at which Ensor excelled; Van Gogh is concentrated, he shuns hasty excursions into fantasy. His paintings are compact in a literal sense; he achieved that compactness by applying paint thickly.

This gave his subjects more weight; the colours became more intense. The painting became more serious. In this connection it is interesting to examine Van Gogh's relationship to Impressionism – also because the manner in which the Impressionists freed themselves from carefully composed classical art gave rise to an artistic attitude which was of fundamental significance for the course of modern art. Briefly, the Impressionists wanted to paint nature as they saw it: individually, at the moment of painting. Because weather is changeable and because light slips away as the day progresses, they had to paint 'fast'.

The picture had to be finished before the sun went down. That accounts for their hasty technique, for those rapid dabs of loosely juxtaposed colour. There was no time to mix your colours carefully like the old masters in their studios when you were sitting outside, on the Seine, battling with the clock to capture your motif on canvas; nor was there time to ponder on the composition. The Impressionists' *prima vista* technique consequently led to paintings with a remarkably fragmentary appearance, like snapshots, the surface not homogeneously closed but open, mobile, grainy. It was as if the colours scarcely adhered to the canvas at all. The impression of volatility, of a rapid invention stemming from an artist's personal vision and personal imagination, seemingly without very much consideration, appealed strongly to a host of later modern artists, up to and including Karel Appel and Rob Birza.

This has nothing to do with style, but it does concern attitude. The Impressionists showed artists that they could paint fast and impulsively if they wanted. Paintings executed in that flowing manner, suggestively, the forms not wholly defined, could assume an extremely stately form and even inspire a painter like James Ensor to flights of mysterious, graceful fantasy. Other painters who learned from the Impressionists' mobility, albeit from a greater distance, were Symbolists like Leon Spilliaert and Jan Toorop. They had little in common with the Impressionists, but they did follow their example of loosely constructed paintings. This volatility inspired new fantasies which were no longer volatile but elegant and stately. Van Gogh was opposed to this, because in his serious view of art paintings were supposed to be more than beautiful representation. The other great painter who constantly sought to consolidate the image, who eschewed fast, compelling representation (like Picasso's), was Mondrian of course. Was their Dutchness coincidental? I have already pointed out that an important difference between Flanders and the Netherlands was the contrast between attractive gracefulness and serious sobriety. Furthermore, as in the case of Mondrian and Van Gogh, that sobriety is linked with a strongly idealistic, even moralistic view of art – art is not really supposed to beguile. This had posed a problem to Rembrandt, but not to Rubens with all his exuberance and panache. Rembrandt sacrificed pictorial bravura to dignified gravity.

I am not imputing a lack of gravity to Flemish artists; of course they are serious, but their seriousness is less devout, less of an encumbrance. The visionary idea of art, which ultimately led Mondrian to abstraction, called for the utmost control and devout concentration. It prevented him from indulging in elegant inventivity or decorative beauty. To Van Gogh, the unyielding firmness of his paintings was his life's work. Charley Toorop's bold realism is implacable in its sharpness. Opting for such constraints is perhaps a Dutch trait, as is demonstrated by postwar artists like Schoonhoven, Stanley Brouwn, Jan Dibbets and Marien Schouten, to name but a few of those who have pursued that path with conviction.

When Flemish artists chose to work with such constraints, for instance Servranckx or Van Severen, their approach was less severe; even Georges Vantongerloo, one of Mondrian's comrades in De Stijl movement, produced a much more colourful, mobile and decorative version of Abstract Art than his Dutch colleague, a version relieved by playful touches. Vantongerloo was less rigorous. Occasionally his playful lightness, which of course has its own seriousness, reminds me of Marcel Broodthaers' wonderfully inventive 'trucs et combines'. On the other side, like Mondrian versus Vantongerloo, we have Stanley Brouwn or Jan Dibbets. They, too,

are inventive, but in a different, restrained manner. They are more interested in constructing principles, in imposing strict limits within which their work develops step by step, consistently. Unlike Broodthaers, they seem to mistrust sudden brainwaves which might cause confusion. Broodthaers was fond of confusion, of mystification, of strange masquerades, as were Ensor and of course Magritte; he let his imagination lead him in every direction, he combined and fantasized because he liked surprises so much.

To Vantongerloo the method of geometric abstraction was precisely that: not a principle but a method which could develop further and reveal its own surprising variants to which the painter could react. Mondrian's abstract art was a 'creed': he believed that it was the task of new, modern man to create a new art without a single trace of the old art which was over and done with. Such a creed brooks no frivolity. It entails a seriousness which, albeit less stringent than the prodigious Mondrian's, plays a role in a lot of Dutch art. It manifests itself in a certain economy of colour and line.

Even an Expressionist like Herman Kruyder, notably in the drawing of his paintings, is far more frugal and stern than his Flemish colleagues. At a time when a flamboyant Baroque was flourishing practically all over Europe (in a slightly compacter form in Paris, admittedly, than in Vienna or Rome), the Dutch were content to paint simple still lifes and cool landscapes. It seems a long stride from an almost monochrome still life to an abstract composition by Piet Mondrian, or from a sober church interior to one of Jan Dibbets' perspectives, but it isn't really all that far. The idiom is the same. It is expressed in a different style and with other means, but it is just as controlled and just as devoid of decoration, and has the same reservations about extravagance. Reality is always very near – even to Mondrian, who eventually painted yellow and red and blue with the same, slow circumspection as Pieter Claesz' still lifes. Conversely (I cannot stop comparing), landscapes by Jean Brusselmans or Gustave De Smet seem to be inspired by a different kind of representation – a representation with a different idiomatic history. We are in a different period: in the construction of a composition by De Smet we can see that he was acquainted with Cubism and came to love its arrangements.

The angular structure of Brusselmans' landscape surely bears witness to an awareness of abstract art, as do the colours, which are much brighter than De Smet's. Even so, neither of the two tends towards frugality. De Smet's subtly modulated, soft colours generate a magical light, while Brusselmans celebrates a veritable feast of carefree decorative painting with the clouds above the lush landscape. These Flemish painters' inspiration comes from the opulent Flemish Baroque, from Rubens' generously undulating landscapes and from even further back, from Pieter Bruegel's frolicsome scenes. The decorative instinct seen in Brusselmans' clouds belongs to the same idiom that caused Patinir to paint his capricious mountain landscapes. Dutch art is characterized by a need for sober severity; Flemish art is undeniably more baroque. Apart from that, the Flemish have a more practical approach to imagination. They let themselves go more readily.

Words are often inadequate when it comes to describing art. The differences and similarities they attempt to define are more manifest in the exhibition, where the paintings and sculptures keep each other company. Many of the artists represented in the exhibition have not been mentioned in this article. All I wanted to do was point the reader (and the viewer) in a certain direction. In the course of doing so, I remembered things which Jan Hoet and I said to each other during our intensive two-year collaboration on this project, groping our way through a labyrinth which we gradually came to know better. Sometimes we were stimulated by conversations we conducted in the presence of our interlocutor in Venice, Paolo Viti. Having written this text, I realize that the different characters of Flemish and Dutch art have been defined only partially. But something else has just occurred to me. The Dutch, I said, like to keep close to concrete reality, which gives them something to hold on to. They grope for that reality in order to fathom its essence, in Mondrian's case until the only reality was the concrete and at the same time spiritual reality of the painting. In a manner of speaking it enabled him to express an entire universe. Stanley Brouwn compares measurements and footsteps; Jan Dibbets sees a variety of realities as optical illusions; Karel Appel regards a painting's surface as a wonderful stage for matter and colour; unlike Ensor, Van Gogh fails to see an ornament in a flower; Jan Schoonhoven gives form and rhythm to 'real' light.

Dutch artists curb their imagination and then 'steep themselves' in what they have found.

Things are a little different with the Flemings; instead of keeping close to reality, 'they keep close to their home ground'. There, at home, on their own patch, in the country and in the city, they encounter marvellous adventures – melancholy, absurd, lyrical, wistful, surrealist adventures. Talking to the artist Jan Fabre once about his fabulations, I remarked that Flanders and Belgium are the home of so many comic strips.

'That' is what just occurred to me. Many of those comic strips are brimming with imagination and adventure, and yet they are always set in their native town, their native region and, let us not forget, their native language. It is in that light that I see Roger Raveel, telling us about his father and mother, his friends, his backyard, the village, the clouds up in the sky – stories which stimulate his paintings. Everything Paul Delvaux saw, all those pale women and strange figures, he saw in the streets and squares of Brussels.

Brusselmans painted the world of Dilbeek. Jan Vercruysse recalls Flemish drawing-rooms on a Sunday afternoon. In his Antwerp dialect, Panamarenko dreams of journeys to far-off places, of castles in the air. In his Brussels parlour Magritte conjures up fantastical anecdotes and apparitions. The windows in his paintings are the windows of the house he lives in, and the hat is his own hat.

A Yardstick or a Step

Jan Hoet

Bruce Nauman, *Green Light Corridor*
1970, Varese, Panza of Biumo
Collection

James Ensor, *Warmth-seeking
Skeletons*, 1889, oil on canvas
Fort Worth, Texas
Robert F. Winfohr Collection

As I write, the beauty and commotion of the last few days and nights flow through my body like an intoxication. For, although most of it is still in the preliminary stages of construction, I declared the new Museum van Hedendaagse Kunst (Museum of Contemporary Art) in Ghent open for the first time for an exhibition of forty artists and a retrospective of Marina Abramović. Perhaps it might sound unusual – opening the back door when the front door isn't even ready yet. But it gives me a nice feeling knowing that the museum never really has to be finished, as it were. In other words, that it should never be dead, never be a tomb for art or a nicely paved passageway only for the elite connoisseurs and collectors of art.

This museum must continue to grow, to grow along with the times and with people, with art and with artists. Only in this way can it escape the all too well-known white chill and the enforced serenity of the museum shrine. The art of our times does not tolerate mummification, no strategies of measured virginal certitude. The museum should be a laboratory where ideas can be a trial run and dare to clash, surprise, annoy, and give hope – where ideas are not allowed to rust.

That is why I've opened the backdoor. And also because I've turned sixty perhaps. I don't want to rust either. Some will ask why particularly this rust-free lad is now covering the walls of an old Venetian palace with old art – a handful of important contemporary Flemish artists, but mainly the work of Expressionists, paintings of the late nineteenth century and even some of the sixteenth century. No, this has nothing to do with nostalgia. A large part of this exhibition casts a glance back on my youth – a concentrated glance because the thing should be effective both for me and for the viewer.

I have to be able to look backwards – on how the past dealt with quality, materials, colours, and contradictions. In this way, I can teach myself and others how to look at the context – and also at the sensibilities of art developing at a local level. In the same way, gaining a better understanding of Andy Warhol requires some knowledge of the local American context at the time and of the phenomena that occurred in that context at the time. So, by following this path, one can try to discover how and to what extent the "local" – even the very close – can invoke a longing for the universal. It is then that one discovers art.

That backward glance has always been part of me. It is no false display of sentiment, no nostalgia. It is merely a necessity. And also because it works so fruitfully, in both directions. Because conversely too, I have learned, through my sometimes reckless life in the world of contemporary art, to see the things of the past better and more clearly. Without the art of Bruce Nauman, for example, I would never have been able to read the surgical precision, the persistence, and the inner rage in the work of James Ensor so clearly. Great art never rests. It forever weaves as it goes.

I was born in the climate of African art and Flemish Expressionism. There were masks and paintings on the walls, Constant Permeke and many others seated in my father's sofa or at my mother's table. I saw them at it, heard them speaking and laughing, drinking and telling tales. I breathed in Flemish Expressionism in all the rooms of my childhood. On the walls, among my parent's circle of friends, in the workshops of artists. And only later have I understood how indescribably valuable this experience was for my life and my ideals. It is so much deeper and more active than all I learned about art and artists at school or have gleaned from books. Deeper and more active. Not only for purely informative, technical or documentary reasons, but mainly because those times have taught me that the decision to become an artist is entirely different to choosing any other activity or beginning any profession, that the artist adopts a totally separate and incomparably visionary point of view in his or her exploration of the world.

It was there, in that atmosphere and in that knowledge, that I have found the breeding ground of how I look at art.

The exhibition at Palazzo Grassi is in the first place historical in its conception: twentieth century art from the Low Countries. But at the same time, while caught between doubts and suspicions, we, Rudi Fuchs and I, tried to see how far we could go by extending this historical aspect up to today: to living art and to artists who are now in full development. We know, too, that we have to be careful with such things, that someone staring at something in the face will only be able to perceive and analyse it as a person with impaired sight. History will be the judge of the work of Jan Fabre, Luc Tuymans, Panamarenko, Marien Schouten, Marlene Dumas, Thierry de Cordier. But that history begins now.

When she was eighty-five years old, my mother bought a painting by Luc Tuymans. She was one of the first to buy a Tuymans on her own initiative, without asking me or anyone from the art

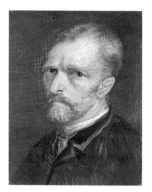

Vincent van Gogh, *Self-portrait*
1886, oil on canvas, The Hague
Haags Gemeentemuseum

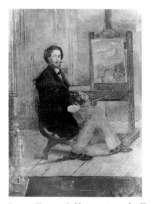

James Ensor, *Self-portrait at the Ease*
1890, oil on canvas, Antwerp
Koninklijk Museum

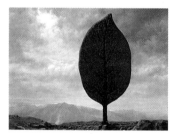

René Magritte, *La Plaine de l'air*
1941, oil on canvas, private collection

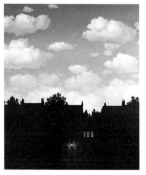

René Magritte, *L'Empire des Lumières*
1948-62, oil on canvas, Brussels
private collection

world for advice. She did so by using her own often infallible intuition. In the same way, she had spontaneously and intuitively bought a Georges Minne, a Jean Brusselmans in the past and Miró, David Hockney, Karel Appel, Joseph Beuys, Roger Raveel, and Panamarenko. She just felt what was happening because that was how she experienced art in life, at home, and among artists.

When mother bought a Tuymans, I knew that she had understood – even if her understanding was only feeling. And I also knew that there had to be a relationship with the past, for she was far from being a speculator. She only bought what she felt as being a decisive step following the previous one, as a step that had to come. And she too probably often doubted in the same way as I shall always doubt. But she acted. As we too act here, and next to and with Permeke, Broodthaers, and Alechinsky, also show Fabre, Panamarenko, and Thierry de Cordier; in the same way we show Dutch artists such as Mondrian and Schoonhoven next to Marien Schouten and Jan Dibbets.

Another interesting dimension of this exhibition is that it brings together Flanders and the Netherlands for the first time in a relatively concise and clear way, and often in the same room, too. Flanders and the Netherlands: we speak the same language and yet we have remained separated from each other communicatively for so long.

Where did my parents go with their children on art expeditions? To Paris. Not to the north. The Flemings went southwards. It was only in the 1950s that things slowly began to change, except of course for the sun lovers. Only then did the Flemings (and many French-speaking Belgians) discover the Netherlands. And when we looked further we discovered other sensibilities – we first among them and then they later among us.

Moreover the Netherlands served as a bridge to the Anglo-Saxon world, to a new type of freedom and tolerance. To the Beatles. To art. We experienced many heroic situations in the heart of Amsterdam – where the discussion took place in the café of the Stedelijk Museum, where Appel painted the walls, where art and life embraced warmly and turbulently.

And yet, despite our common language, despite the delightful contacts, the lasting vows that we pledged and the plans that we made together, the borders have remained in many ways. Each of us lives in his own house and sows his own garden. Not here though, not at Palazzo Grassi. For, even though you will not find a single Van Gogh in a Belgian museum, here in Venice one is hanging next to a James Ensor.

And it is exactly this that makes the exhibition unique for our two countries, that all historical, artificial, and tribally sensitive barriers between Flanders and the Netherlands are opened up here through art. In no other way than through art do we have so much to say to each other and so much to learn from each other. And nowhere else does art stand so visually tangible, so fruitful, and so confrontational as here. (By the way, Federal Belgium has about ten million inhabitants, of whom six million are Flemish. They speak the same language as about fifteen million Dutch people, whereas the Walloons – in the south of Belgium – speak the language of Voltaire and those in the smaller East Cantons speak the language of Goethe.)

René Magritte was a Walloon. But he lived and worked in Brussels, the capital of Europe – but also that of Flanders and Wallony for much longer – and his paintings were in many ways Flemish: ironic and morbid, which is why we thought he belonged to this exhibition. Flemish art and its influence do not stop at the language boundaries. (Eugène Leroy is an Artesian and here we see his work next to that of the Flemings.)

We have also included a couple of references to centuries long past, to artists such as Joachim Patinir and Jacob Jsaacksz van Ruysdael: they uncover the golden thread for us, the continuity in the Flemish way of looking, in the expression of feeling, in the handling of light.

By showing this old art we are trying, no matter how subtly or how sparingly, to awaken and uncover traces in our memory. A person like Ruysdael gives us that silence and that refinement. Art can never be seen outside the continuity of history. But why no Rubens then? Why no names that are easy to remember? Because we were afraid that, in this context, such great world-famous names would put the spectator on the wrong foot. That we would wander off from the refinement and silence which are ideal for dealing with our memory and thereby challenge us to look deeper and in the best of cases to arrive at discovery.

This exhibition is one of nuances, of subtle unity, of completion, and contradiction. On the Flemish side (and by extension on the Belgian side) undoubtedly more 'solitaire' than on the Dutch side. Flemish artists are far more difficult to categorise in groups or schools than their Dutch colleagues.

Even Magritte: where else does Surrealism distance itself so much from the Surrealists? The Flemings often possess a kind of obscurity – "darkness" would be a better word in so far as it can be rendered in Italian – a kind of darkness that is an individualistic stance against a bourgeois ideology. Take Permeke, for example: his sombreness and darkness are no final effects, but are there precisely with the intention of breaking away, out of the depths of earth and soul. And yet on the other hand, the final works of Vincent van Gogh have become ones of the purest light, whilst he himself was locked in the deepest darkness.

I find that the remarkable, often refined, mutually tuned contradiction between the undeniably pictorial sensuality of Flemish artists and the explosive lucidity in light and line of the Dutch is fascinating. And it is for this reason that we have put the emphasis on painting in this exhibition. And also because – as far as the Flemings are concerned – painting can serve as a metaphor for art in general.

I find it wonderful that the North is visiting the South. Italy has always drawn us to it like a magnet and more so because of its creative diversity and originality than because of the sun. The mutual artistic influences between Flanders and Italy are innumerable, both in name and in art. But there has always been an important difference, I believe – a difference at the heart of the matter. I will attempt to make this clear by means of a small example: the difference between a yardstick and a step. Ask an Italian how long a metre is and he'll go off in search of a ruler. Ask a Flemish person how long a metre is and he'll take a step. You don't have to take this literally; it's just a way of talking – of talking about art.

Compare Italian and Flemish art from the time of Jan van Eyck, for example. What strikes me about this period is the way Italian artists relate ordinary, everyday experiences and observations with a ruler in their hands, while Flemish artists make use of their sense of the step to show the same thing. Even a great master of drawing and compositional efficiency like Van Eyck. With him, too, you will find, behind all his rationality and calculation, something which is characteristically Flemish and which I would dare call, in the broadest sense of the term, intuition.

This particular element makes Flemish art very complex. It allows local, earth-bound experiences behind the mathematical structures and is exceptionally charged with emotion and not purely based on trained logic, as is the case with Italian art. For this reason you will often find figures that resemble each other in many ways in Italian art. This is never so in Bruegel. And also because of this, I think, Flemish art finds itself on the edge of orthodox art history. It is hard, as the saying goes, to make head or tail of it. The yardstick is there of course but it has been relegated to the background by emotional, intuitive changes that belong to the "local". And because of this specific tone, its complexity, and layered emotion, Flemish art is in a certain sense harder to grasp. I'm convinced that Flemish art forms part of the basis of the modern way of dealing with local space. Local space: the space of tangible intuitive sensibilities – the space my mother was part of.

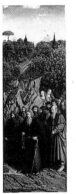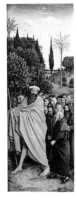

Jan van Eyck, *Hermits and Pilgrims*
right panel of the polypthic
Adoration of the Holy Lamb, 1432
oil on wood panel
Ghent, Saint-Bavon's Church

Controlled Dissensions and Shared Prosperity
The Netherlands and the Dutch, 1880-1996

Dirk Jan Wolffram

The Netherlands is an exceptional country, not only because of the highly gifted painters it has brought forth. It is a land which only a few foreigners really understand, even though historians, particularly British and American, are producing a growing body of evidence of their fascination in the rich past of the Netherlands. The language, with its strange combinations of harsh and rolling sounds, is an obstacle at first. Once the foreigner has taken this linguistic hurdle and embarked on a study of the characteristics of Dutch society, he or she encounters one surprise after another.

The resulting picture shows a society in which, from 1880 on and apparently without any major upheavals, a growing number of people shared a high degree of prosperity, while from the last quarter of the nineteenth until well into the twentieth century, that same modern society was sharply divided into different religious groups. A nation whose wise statesmen and political leaders repeatedly succeeded in channelling sharp religious and social differences. A highly developed but low-lying country whose existence was constantly threatened by the forces of nature, a threat which has reared its head with dramatic results throughout the twentieth century.

It is my intention to reveal the main lines of Dutch history from 1880 to the present. Presenting a few important themes from the history of the modern Netherlands, I shall endeavour to give the reader an idea of the distinctive traits of Dutch society. One of them lies in the firm continuity in the country's political, cultural, and social unity. For a proper understanding of the Netherlands in the nineteenth and twentieth centuries, a look back at the sixteenth is unavoidable.

Prelude: growing towards a middle-class society

From 1568 on, under the inspired leadership of the royal House of Orange, the North Netherlands had fought to shake off the Spanish-Hapsburg yoke. The struggle for independence (which lasted until 1648 and duly came to be known as the Eighty Years' War in the Netherlands) had also the character of a religious war. The Dutch rebels were fighting for the right to practise their Protestant, Calvinist faith. Unfortunately their ruler, Philip II of Spain, had set himself up as the defender of Roman Catholicism, and was out to stem the advance of Protestant heresy.

In 1581 the States General, the national assembly in which representatives of the seven provinces of North Netherlands had seats, abjured Philip as their ruler. The Netherlands became a Republic with a prominent role as commander of the army for the prince of Orange, who was, however, not entitled to the position of head of State. The Republic of the Seven United Netherlands had no head of State. It rapidly developed into a small but highly assertive nation which took the fullest advantage of its key position in international trade and European power politics. By 1600 the Republic was one of the most powerful nations in this part of the world, with a trade network covering a large part of the globe. Amsterdam became a metropolis.

The city of Amsterdam mirrored the character of the Netherlands as a nation, perhaps just as much in what was not there as what actually was. It boasted no examples of the sublime architecture to be found in the north Italian City-States or in the late Renaissance cities of Flanders such as Brussels, Bruges, and Ghent. It did not possess the metropolitan glamour of, say, Paris or London. Along the canals of Amsterdam rose solid mansions, sparsely decorated, and sober warehouses. But nor was it beset by the typical drawbacks to life in the big city: the percentage of paupers was low, lower than in most large cities in the seventeenth century, and certainly lower than in nineteenth-century Amsterdam. This is because seventeenth-century Amsterdam was above all a city of sensible merchants who prudently but with determination defended and expanded their own interests. A city without opulence but enjoying a solid prosperity that was shared by broad sections of the population.

This prudence was characteristic of the Republic, which was basically nothing more than a federation of autonomous provinces. Without the consent of each of the seven provinces, the Republic could not go to war. War was seldom in the interests of the rich mercantile cities in the provinces of Holland and Zeeland. Commercial interests shaped foreign policy under the aspect of English and French competition. When the Netherlands did act as an aggressor, as in its naval wars with England, it was to ensure undisturbed trading. It was with reluctance that the Republic joined in the War of the Spanish Succession in 1701, subsequently taking no part in the dynastic jockeying for position that ensued at the end of this protracted conflict.

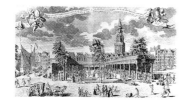

Jan Schenk, *The Corn Exchange built in 1617 in Amsterdam the centre of the grain trade*
18th-century engraving, Amsterdam
Amsterdams Historisch Museum

The position of the Orange dynasty in the Republic began to weaken in 1651 for the simple reason that the Orange stadholders Willem II and Willem III died without suitable successors. Between 1651 and 1672 and again between 1702 and 1747, the deputies of the cities of Holland (the richest and most powerful province) ruled the roost in the States General.

However, the regents of Holland did not always get their own way in matters of foreign policy. In 1672 the aloofness they favoured in combination with an aggressive mercantile policy backfired on the Republic. The English and French embarked on a unique alliance, supported by two German diocesan States. This alliance aimed at toppling the Republic from its dominant position in international trade. When large areas of the country were overrun by the French and by the troops of the bishops of Münster and Cologne, the people rebelled against the Holland regents and lynched the Grand Pensionary of the province (the highest-ranking official and in the absence of an Orange stadholder the mightiest man in the Republic). The States General were forced to appoint a member of the House of Orange (Willem III) as stadholder of the entire Republic. Since Willem III was married to a daughter of the king of England, the balance of power in Europe swung back in favour of the Republic. This reversal was strengthened when Willem III became king of England after that country's "Glorious Revolution" in 1689. However, his early death in 1702 marked the end of the Republic's strong position in Europe. His marriage to Mary Stuart was childless. The Republic, by this time involved in the War of the Spanish Succession against France, drifted back into isolation.

R. Roghman, *The horribly mutilated corpses of Pensionary Johan de Witt and his brother*, engraving, Dordrecht Museum Mr. Simon van Gijn

Something of an economic recession in the eighteenth century encouraged this tendency. England outstripped the Republic. Moreover, the population was suffering from the consequences of rinderpest. In 1747, during the War of the Austrian Succession, the history of 1672 repeated itself. The French threatened the south border of the Republic, which did its best not to get involved in hostilities. The Dutch rebelled again, demanded that strong action be taken against the French and once more compelled the regents to appoint a member of the Orange dynasty as stadholder. Stadholder Willem IV, likewise married to an English princess, assumed his duties and endeavoured to strengthen his position. The office of stadholder was declared hereditary, which marked the first step towards the establishment of the monarchy in 1813. In practice there was little change though, partly because Willem IV died quite soon, in 1751, leaving a son who was only four years old at the time. This enabled the regents to assume control again, even though the Oranges maintained a high public profile due to the "Orange party" which rallied to the stadholder's widow and heir. Willem V succeeded as stadholder in 1766.

Around 1780 the ideas of the Enlightenment appeared to be catching on in the Republic too. "Patriots" opposed the Oranges' aspiration to the monarchy and advocated forms of civil liberty. They found support among the regents of many cities, not only in the west of the country, but especially in the east. As a matter of fact, the majority of the Holland regents had little affinity with the 'democratic' ideals of the patriots, but their shared antipathy towards the Orangists tipped the scales in the patriots' favour.

The Republic now slid into a phantom state of civil war. The towns of Holland refused to accept Orange authority any longer, and in a few towns in the middle and east of the country the patriots formed militia groups and volunteer corps which seized power. People with Orangist sympathies were hounded until Orange struck back, restoring order by force of arms. In 1787 Willem V provoked a conflict, in the course of which his wife Wilhelmina, a sister of the Elector of Prussia (a loyal ally of England), was physically threatened by a volunteer corps of patriots. With Prussian support Orange managed to seize power. Many patriots fled to France, and the regents of Holland reconciled themselves to the new situation.

J. Cats, *French soldiers entering Amsterdam on January 19 1795* drawing, Amsterdam Gemeentearchief

In 1795 the expansionism of the French Revolution put an end to the Orange regime. When French forces crossed the country's south border, Willem V fled to England. Between 1795 and 1810, when it was annexed by the French Empire, the Republic experienced a politically turbulent and occasionally chaotic period, during which moderate elements, often former Holland regents, and revolutionary reformers challenged each other's claim to power. The people observed all this with growing indifference. In 1806, when Napoleon put an end to the squabbling (and to the Republic) by crowning his brother Louis king of the Netherlands, the overriding feeling was one of relief. The French Empire's annexation of the Republic, which lasted from 1810 to 1813, was borne with equanimity, although people groaned under the hardships caused by the war with England and the concomitant economic blockade.

The revolutionary events which took place between 1795 and 1813 did not put an end to the strained political and administrative set-up designed for the sixteenth and seventeenth centuries. Deputies of the province of Holland continued to determine the content and course of national government until the middle of the nineteenth century. Home and foreign policy was still focused on the commercial interests of the cities of Holland. The House of Orange did, however, procure a lasting and central position in the machinery of the State: the Netherlands became a monarchy.

The period from 1815 to 1830 was marked by a noteworthy episode: the South Netherlands, which had hitherto been part of the Spanish or Austrian Hapsburg Empire, was incorporated into the brand-new kingdom. The Kingdom of the Netherlands, and in particular its king, Willem I (son of the stadholder who had fled to England in 1795), was of the opinion that the country could play a significant role as a medium-sized power in Europe.

However, the South Netherlanders, i.e. the Belgians, had other ideas; in a confused concurrence of circumstances and events in the summer of 1830 they broke away and, supported by the European 'superpowers', formed their own kingdom. For many years the Netherlands refused to recognize its new neighbour in the south. Not until the end of 1838, by which time it was obvious that reunification would never happen and the Dutch were seriously worried about the deplorable state of the country's economy and finances, did Willem I face the facts. A disappointed man, he abdicated in 1840. Being the king of a small country did not appeal to him. He was succeeded by his son. He himself remarried, this time a Roman Catholic Belgian lady-in-waiting of his late wife, and moved to Berlin, where he died in 1843.

The Oranges continued to play a prominent role in the Netherlands. In 1848, the year of Marx's and Engels' *Communist Manifesto* and the end of the July monarchy in France, the new king (Willem II) personally engineered the introduction of a liberal constitution, doing so at a time when the turbulent European situation of 1848 had little effect on the Netherlands. The Liberal statesman J.R. Thorbecke (1798-1872), who for years had been advocating a constitutional monarchy with limited powers and recommending the introduction of liberal freedom, took full advantage of the nation's fear of social unrest and of Willem II's caprices.

The Netherlands became a parliamentary democracy. Parliament (the States General) was the centre of governmental power. It consisted of the Second Chamber, whose members were elected directly by their constituencies, and the First Chamber, whose members were elected by the Provincial States, the representative bodies in the provinces. The government was no longer answerable to the king but to the States General. Suffrage, incidentally, was limited to men who paid a certain amount of poll tax (census) each year. In 1848 this meant that 5% of all males were entitled to vote. In the course of the nineteenth century the lowering of the census and the granting of suffrage on the basis of educational and professional qualifications gradually increased the male electorate. In 1848, along with the introduction of parliamentary democracy, a number of civil rights became anchored in the Constitution, including freedom of the press and the right of association and assembly.

Jan Rudolf Thorbecke, Rotterdam Stichting Atlas van Stolk

The radical swing to Liberalism in 1848 ushered in a period during which the Netherlands had to adjust to various changes: political changes, economic reforms, the formulation of new social and political issues. Soon after the nigh-revolutionary events of 1848, two socio-political groups emerged which by about 1880 constituted a serious threat to the position of Liberals and Conservatives, who had been running the country in turn since 1848. These two groups were the Catholics and the Calvinists.

In one sense the Netherlands was not all that small a nation around 1880. From its glorious period of power and prosperity in the seventeenth century it had retained one of the richest colonies: Dutch East Indies, now Indonesia. The archipelago was a seemingly inexhaustible source of natural resources and products. In the seventeenth century the East Indian spice trade had made the Netherlands rich. In the nineteenth century tea brought even greater profits, and the new European industries needed East Indian rubber and oil. The Royal Dutch Oil Company was to grow into the Shell concern, one of the world's biggest oil-processing industries.

The Netherlands had not acquired these riches by dint of ruthless colonial conquest. The colonial empire was built slowly, trading posts gradually developing into an administrative system in the course of the nineteenth century. By acting prudently, leaving indigenous administrative structures intact and installing local administrators, the Netherlands had established its authority

*Fighting in Aceh: the battle
of Salamangan, 26-8-1877*
Amsterdam, Rijksmuseum

throughout the Indonesian archipelago. The use of force was avoided, but countenanced. When, in 1873, it transpired that the Achinese people on the island of Sumatra baulked at Dutch rule, the Dutch government had no compunction about waging a colonial war that was to go on for thirty years

In the first half of the twentieth century the colonial government steered a calmer course. Nevertheless, the native population continued to regard Dutch rule as foreign domination. The 1920s saw the development of a sense of national identity which in due course manifested itself in movements opposed to colonial rule.

Designing new social relationships

From 1848 to 1888 the Netherlands was governed alternately by Liberals and Conservatives. It was a solid, respectable nation, its prosperity based on agriculture and trade. Under the surface, though, tension was mounting. The gulf between social groups was widening. The period prior to 1888 was characterized by the crystallization of religious differences in society. The Catholics found themselves siding with their traditional religious enemies, the Protestant Calvinists, against the Liberals and (later) the Socialists.

Catholics in the Netherlands
Formally, catholic worship no longer had any place in a Republic freed of the Spanish yoke. The Dutch Revolt was aimed at shaking off Spanish-Hapsburg domination, and was partly inspired by the new Protestantism and especially by the dour Calvinist variant which only in Scotland acquired a following of any significance outside the Netherlands. In practice, however, quite a large proportion of the population remained loyal to the Roman Catholic Church. There were also Baptist and Jewish minorities. The situation actually generated a strong degree of tolerance, certainly in comparison with the rest of Europe. Worship other than that practised in the Reformed Church (Gereformeerde Kerk) was tacitly accepted, as long as it did not take place too openly. All over the country there were conventicles, some hidden away in mansions (like Onze Lieve Heer op zolder, Our Lord in the Attic, in Amsterdam), others barely concealed behind existing buildings. Catholic and Baptist schools were tolerated and recognized by the secular authorities. Civil marriages had become just as legal as those solemnized in church, freeing Catholics from the obligation of having their marriages confirmed in a Protestant church. Although the State regarded mixed marriages as undesirable, they were not forbidden. In short, the Republic was formally a Calvinist nation, but in practice religious pluriformity prevailed.

Frans Brun, *Building a moderate
Protestant conventicle behind
merchants' houses on Keizersgracht
Amsterdam, in 1630*, engraving
Amsterdam, Rijksmuseum

The Catholics' formally subordinate status ended in 1795: the French revolutionary cry for "freedom, equality, and fraternity" led to freedom of worship. But that was only the beginning for the Catholics. For a fully-fledged religious life they needed an episcopal institution. Whereas spiritual guidance had previously been in the hands of regulars, members of a monastic order, Rome urgently called for the establishment of an episcopal hierarchy. Negotiations had been conducted between the Vatican and the Dutch government prior to 1848, but the introduction (or "restoration", as the Catholics saw it) of their organized Church gathered momentum when people were granted the right of assembly in 1848.

The Liberals, who had come to power in 1848 with Willem II's support and won, with the help of Catholic votes, the first elections held that year under the terms of the new Constitution, gave the Catholics free rein. The Vatican took the fullest advantage of this situation and in 1853 installed an organizational body in the Dutch church province. This provoked a storm of protest, particularly when it became known that the city of Utrecht, a stronghold of Conservative Protestantism, had been chosen as the seat of the archbishop. The Liberal cabinet fell when a section of the Protestant Liberal electorate proved susceptible to anti-papism and defected from Thorbecke.

After 1853 the Liberals lost the political support of the Catholics, even more so after the pope's condemnation of Liberalism in the *Syllabus errorum* in 1864. As a result, the Catholic leaders drifted slowly but inevitably towards the Calvinists, their erstwhile enemies in the Eighty Years' War. Largely responsible for their defection was the conflict sparked off by endeavours to define the identity of primary education and obtain financial aid for parochial schools (the schoolstrijd or school-funding controversy).

Anti-Revolutionaries

1848 saw the crystallization of a social and political movement based on Calvinist ideals and opposing the democratic principles of the French Revolution. These 'Anti-Revolutionaries', although numerically insignificant at first, were extremely determined and tenacious in stating their political wishes. They called for a re-assessment of the Church's role in society, notably with regard to its responsibility towards the poor and in educational matters. They also demanded strict observance of Calvinist doctrine in the Dutch Reformed Church (Nederlandse Hervormde Kerk) which Willem I had established in 1816. In many eyes this Church was an unworthy, watered-down successor of the more strictly orthodox Reformed Church of the Republican period. The man instrumental in drawing up the Anti-Revolutionary programme was the lawyer and historian Guillaume Groen van Prinsterer (1801-1876), archivist of the Royal House. In 1849 he was elected to Parliament.

Groen gave direction to the Calvinist movement in society and politics. His disgust at the loss of the Calvinistic Church's dominant position was combined with his Romantic-Conservative politics and his views about the role of the State. Firmly opposed to the democratic achievements of the French Revolution, he maintained that the State's primary task was to reinforce Christian values instead of placing itself at the service of the people.

Obviously, these tenets were inappropriate in the modern political system created by the Liberal Constitution of 1848, as soon became apparent in the matter of primary education and its character. Formally, State primary schools could only have a vague, generally Christian identity, so that neither the Catholics nor the Protestants would be offended. Groen's efforts to bolster the Christian character of primary education was incompatible with the neutrality the State was obliged to observe in matters of religion. Frustrated by the impossibility of achieving his aims through Parliament, he resigned from the Second Chamber.

Groen realized that parents who wanted a proper Christian education for their children would have to set up their own schools. He began to support such schools as there were, and to stimulate the founding of new ones. A young pastor called Abraham Kuyper soon rallied to his cause. Kuyper (1837-1920) was already a pastor at the time of his 'conversion' to orthodox Calvinism. Like many proselytes, he invested tremendous enthusiasm and all his persuasiveness in his new ideal. As an organizer, he possessed boundless energy and immense ambition. He fought his fight to restore Calvinism to the Church and society on several fronts.

H.J. Haverman, *Abraham Kuyper in 1897*, drawing, Amsterdam Historisch Documentatiecentrum voor het Nederlandse Protestantisme

First and foremost, he and Groen were behind a number of organizations which represented the interests of Christian education. He also founded a daily newspaper (*De Standaard*) in 1872, whose editor-in-chief he remained until his death.

The formation in 1879 of the first modern political party in the Netherlands, the Anti-Revolutionary Party (ARP), was largely due to his efforts. That same year, Kuyper put into effect an even bolder plan. He founded a university where students could train for the Calvinist ministry and where, more importantly, science was taught on a Calvinist basis. Law and medicine could also be studied at the Free University.

The founding of the Free University may be seen as a challenge to the Liberal establishment. It was tantamount to a motion of no-confidence in the scholarship of the day with its positivist character. Kuyper countered the Liberals' infinite faith in reason and progress by promoting scholarship based on Christian values, on man's humility in the face of God, on the futility of human action. Gradually, the Free University gained recognition alongside the existing State universities of Leiden, Utrecht and Groningen and the Gemeentelijke (municipal) University of Amsterdam. It was Kuyper himself who as prime minister in 1902 granted the Free University the *Ius promovendi*.

In 1886 Kuyper forced a split in the Dutch Reformed Church, the church adhered to by more than half the Dutch nation. The breaking point was its organizational form, which in the eyes of Kuyper and his party had turned the Calvinist Church into a false Church. According to them, free-thinking, modern pastors held sway in the Dutch Reformed Church, impeding the practice of the true, Calvinist faith.

The Free University on Keizersgracht Amsterdam, 1900 circa, Amsterdam Historisch Documentatiecentrum voor het Nederlandse Protestantisme

A number of quarrels between local congregations and the national Church bodies forced the issue, Kuyper intervening personally in the most important of these from Amsterdam, where he had worked as a pastor since 1877. In late 1886 Kuyper and his group declared the Dutch Reformed (Hervormde) Church illegal and founded the Reformed (Gereformeerde) Churches in the

Netherlands, based on the seventeenth-century rules of the old Calvinist Church. The Anti-Revolutionary movement now had its own schools and a university, a newspaper, a political party, a workers' organization (founded in 1879) and its own Church. It should, however, be pointed out that some Anti-Revolutionaries did not wish to secede from the Dutch Reformed Church. To make things even more confusing, there were also orthodox Calvinist groups in the Dutch Reformed Church who wanted nothing to do with the Anti-Revolutionaries.

Subsidized religious dissension

Kuyper's ambitions were not yet satisfied, though. His goal was still to emancipate the orthodox Calvinist section of the population, an emancipation which would manifest itself in the predominance of Christian education. In this, Kuyper was less amenable to compromise than his followers. The idea he really favoured was for all parents to pay for their children's schooling (unless they lacked the financial wherewithal to do so), for all schools to be run by the pupils' parents, and for the State to confine its task to monitoring the quality of the tuition. In that way parents would determine a school's identity. Kuyper's aspirations were, however, at odds with the 1848 Constitution, according to which the State was responsible for providing primary education. What is more, his ideas met with opposition in his own ranks.

Most Calvinists belonged to the lower middle classes. They were ordinary folk: farmers, shopkeepers, trained workers. Put into daily practice, the operation of Christian schools had to cope with the great problem of providing tuition of the same quality as that offered in State-subsidized schools, and with the fact that Christian tuition had to be paid for by parents with low incomes. A new Liberal education act of 1878 stipulating that State education have a neutral character and requiring teachers, educational tools and buildings to meet high standards, added to the financial burden of the Christian schools. The practical consequences of the new act fanned the flames of agitation (in the form of a petition against it, for which signatures were collected on a wide scale). Kuyper and his supporters were encouraged in their opposition to the new act by the Catholics, who themselves petitioned the king not to sign it. Willem III received the organizers of the petitions in audience, but signed the act all the same. His only constitutional alternative would have been to abdicate.

Anti-Revolutionaries and Catholics gradually realized that government subsidies were essential for parochial schools. In 1888 the two parties won a resounding election victory. The Netherlands now had its first confessional government. Catholic and Protestant politicians reached out their hands to one another above the religious gulf that separated them. It took all the powers of persuasion of the priest H.J.A.M. Schaepman (1844-1903), the great leader of organized Catholicism, to bring this about and induce his suspicious fellow-Catholics to cooperate with the heretics. The realization that the achievement of Catholic educational ideals could only be expedited by interconfessional cooperation with the Protestants and opposition to the Liberals clinched the matter. The Catholics remained split by serious differences of opinion on such issues as the introduction of military service and the desirability of promoting the material interests of the Catholic working class.

Kuyper had other things on his mind in 1888. Almost entirely preoccupied with launching the Reformed Churches and the Free University, he had no ministerial ambitions at that moment. Other, more pragmatically-minded Anti-Revolutionary politicians pressed for compromises. In 1889 they succeeded in getting a new education act passed under the terms of which parochial schools were entitled to a State subsidy covering 30% of their costs.

Actually, the significance of the passing of this act lay less in the financial advantages for Christian education. More important was the fact that in 1889 the State of the Netherlands became responsible for social activities developed by groups which held certain ideologies. The freedom to set up organizations established constitutionally in 1848 now included the additional right to an education partly funded by the government, an education on whose character the State had no influence (although that selfsame State was responsible for the quality of tuition). Not until 1917 did parochial schools become constitutionally entitled, like non-denominational ones, to total government funding. This led to a rapid increase in the number of Protestant and Catholic schools at the cost of (State) education.

By 1917 the Liberal nation of 1848 had been transformed into a State where religious dissension prevailed. This dissension never led to really sharp or violent social clashes. The bourgeois-liberal free-

Herman Schaepman, Amsterdam Internationaal Instituut voor Sociale Geschiedenis

dom of the press and right of association and assembly dating from 1848 now proved to be a suitable instrument for the Anti-Revolutionaries and Catholics to realize their aspirations with, notably in the field of education. The strength of their social movement also gave strength to the confessional arm (Calvinists and Catholics together) from 1888 on, even if it took them until 1918 to obtain a stable majority among the electorate. This accounts for the various Liberal Dutch cabinets, even after 1888.

A proud and modest nation

The Dutch take the unity of their country for granted, regarding it as closely interwoven with their virtually uninterrupted history of independence. Since the sixteenth century, apart from its annexation by Napoleon between 1810 and 1813 and the German occupation from 1940 to 1945, the Netherlands has been an independent State. The names of the central political bodies have not altered since the sixteenth century (except for a brief interval in the revolutionary Franco-Batavian period from 1795 to 1813), even if their functions have changed with the passing of time. The heart of government is the States General, or national assembly. The government's most important advisory body is the Council of State (presided over by the head of State).

Dirck van Delen, *The Great Hall of the Binnenhof at The Hague during the Assembly of the States General in 1651*, painting Amsterdam, Rijksmuseum

In the Republic (i.e. up to 1795) the States General was the assembly of representatives of the provinces. Today it is the representative body of the people, of which the legislative Second Chamber is the most important constituent. Since 1918 the members of the Second Chamber have been elected according to a system of proportional representation. The location of the States General symbolizes the government's historical continuity. From as far back as the sixteenth century the representatives of the provinces, and later of the people, have gathered in the stately buildings on the Binnenhof (Inner Courtyard) at The Hague. Central among them is the Ridderzaal (Knights' Hall), a mediaeval building used on ceremonial occasions. Incidentally, the capital of the Netherlands is not The Hague but Amsterdam.

There never were any marked cultural differences between the various regions of the Netherlands. All Dutch people speak the same language, though local idioms are also spoken in a few parts of the country. Culture has been regarded as a national phenomenon since the seventeenth century, albeit that the province of Holland was the cultural centre. Aspects of daily life such as clothing and eating habits have always displayed great homogeneity, and still do.

It is paradoxical that in a nation which can look back on such a long history of political unity and possesses such a pronounced cultural identity, there is no rampant nationalism. After successfully fighting for independence in the sixteenth and seventeenth centuries and attaining the position of a major power in conflicts with England and France, the Netherlands sank into a state of indifference as to the nation's status in the eighteenth century, just when a sense of nationhood and nationalism were awakening in Europe. Only at the end of the nineteenth century did something resembling national feeling emerge, with the royal House of Orange as its crystallization point.

The paradox of Dutch nationalism lies first and foremost in the lack of a need to emphasize national identity. The necessity did exist in countries formed in the nineteenth century by the amalgamation of regions with their own political history and their own cultural and socio-economical development. Nationalism was a necessary ideology in Germany and Italy, countries which needed to buttress their artificial unity. But the proud nationalism of countries like England and France, both of which had been united for centuries, was an equally alien concept to the Dutch. England and France (until 1789) were kingdoms with their own monarchic traditions which reached far back into the Middle Ages. The monarch was the State; State institutions were subordinate to the royal house. The Netherlands was a Republic until 1806, without a royal house as the embodiment of national identity.

The Republic, still a world power in the seventeenth century, adopted a policy of non-involvement in the eighteenth. Commercial interests were paramount. It was vital to the Dutch economy to do nothing that might impede the free transport of merchandise and people. Involvement in international conflicts was undesirable because, as seventeenth-century experience had shown, they almost inevitably led to attempts on the part of the opponent to hit the Netherlands where it hurt most: its dependency on unobstructed trading. Conflicts led to sea blockades and to confiscated cargoes. And at the end of the seventeenth century the Netherlands had lost its marine supremacy because of conflicts with England.

Bernard Picart, *Synagogue in Amsterdam during a service* 1725, engraving, Amsterdam Joods Historisch Museum

Albert Verwey on Frederik van Eeden 1935 circa

To me, words were elements of living speech and as such subject to the vagaries of mood, ear and imagination. To Van Eeden they were conventional signs whose use we learned and through which each of us tried to convey his meaning. We could reconcile these two notions. I could acknowledge that I was after all using an existing language. Van Eeden could acknowledge that a poem did not consist solely of meanings. But the difference lay in our points of departure: his was the definite phrase which made of the word a sign, mine was emotion and imagination, expressed in words. The latter was not only mine: the entire movement of the '80s sought to renew language through emotion and imagination, Van Eeden being the only one to accept language as an established aid to expression, an aid, however, which had to be used in the best possible way.

A. Verwey, *Frederik van Eeden* Santpoort, 1939

Jan Veth, *Portrait of Albert Verwey* 1885, Amsterdam, Stedelijk Museum

A sanctuary or an enclave of narrow-mindedness

Another significant factor in the development of the Netherlands was its openness to external influences. The country had a strong tradition of tolerance, notably towards minority cultures. The Jewish minority, in other countries often the butt and crystallization point of nationalist sentiments, was accepted in the Netherlands, albeit not respected. Not even the national minority *par excellence*, the Catholics, were pestered in any way. Catholics, too, left their mark on Dutch culture. Our greatest seventeenth-century poet, Joost van den Vondel, was a Catholic. The most splendid examples of his oeuvre bear the traces of his Catholicism – indeed, it even inspired their subject-matter.

The Netherlands offered a safe haven to the persecuted, from the Huguenots who fled from France in the sixteenth century to the poor Ashkenazi Jews from East Europe in the eighteenth and nineteenth. Voltaire sought refuge and published his books here, although his ideas did not excite much response. Books forbidden in other countries were printed in the Netherlands, and revolutionaries like the Communists led by Marx and Engels held meetings here.

Our borders were not only open to the persecuted. The Netherlands welcomed cultural innovation too. Amsterdam's Concertgebouw Orchestra pioneered performances of Bruckner's music and in the early twentieth century played those monuments of musical innovation, the symphonies of Gustav Mahler, many of them in the presence of the composer himself. Mahler was (rightly) ranked higher in the Netherlands than his Dutch contemporary Alphons Diepenbrock (1862-1921). In the twentieth century even an avant-garde movement like Dada gained a foothold in the Netherlands. Kurt Schwitters was fond of coming here. In Drachten, a village in a remote part of the country, local inhabitants formed a circle whose poems and artistic productions gave an entirely original voice to Dada's anarchic ideas. After World War Two, Dutch open-mindedness towards cultural innovation took the form of an interest in new tendencies in classical music, jazz, and pop. Representatives of the avant-garde found a platform and a public in the Netherlands.

This open Dutch culture was easily influenced by foreign ideas. French naturalism gave an impulse to literary movements like *Tachtig* (Eighty), which favoured a highly individual form of literature in verse and prose alike. The sonnets of Willem Kloos (1859-1939) and the abstract poetry of Albert Verwey (1865-1937) are the most successful examples. In the 1880s the group rallied round its periodical *De Nieuwe Gids* (The New Guide), which attacked the prevailing traditions in literature and literary criticism.

Not only was Dutch culture open to influences from other countries, but many of the greatest Dutch artists and writers had outgrown their native soil and sought refuge abroad. Our most eminent literary figures simply found the Netherlands too small for their stature, complaining from their chosen exile of the scant interest in, or poor reception of their work back home. The greatest Dutch writer of the nineteenth century, Eduard Douwes Dekker (pseudonym Multatuli, 1820-1887), bitterly disappointed in his countrymen, decamped to Germany; two of our most important postwar writers, Willem Frederik Hermans (1921-1995) and Geerard Kornelis van het Reve (b. 1923) sought salvation in France, from where they would occasionally express their contempt of Dutch society. None of them were read in their new surroundings, incidentally. Even in voluntary exile they continued to write for a Dutch readership.

Vincent van Gogh (1853-1890) was not appreciated in the Netherlands and in 1886 went off to France in search of a more favourable cultural climate. Piet Mondrian (1872-1944) painted his most famous works in Paris and New York.

After World War Two, Dutch avant-garde painters like Karel Appel (b. 1921) and Constant Nieuwenhuijs (b. 1920) were members of Cobra from its first hour. The home of this brief but intense international movement in painting was Paris. Cobra's exhibition at the Stedelijk Museum in Amsterdam in 1949 sparked off a violent public debate as to whether these "bungled daubs" (some of the works had actually been painted in the museum during the exhibition) belonged in a museum at all.

The Fifties, a group of experimental poets, met with a similar fate. Their unconventional style inflamed the wrath of the critics and was greeted by the public with total incomprehension. Subsequently they, too, achieved wider recognition and have become part of the Netherlands' cultural heritage. Paul Rodenko (1920-1976), the greatest of the Fifties, died misunderstood and destitute in a country known abroad for its liberal outlook and welfare.

August Allebé, *Eduard Douwes Dekker (pseudonym Multatuli)*, 1874 lithograph, Leiden, Prentenkabinet der Rijksuniversiteit

Nation and Orange

The Dutch took their nation for granted; it was not venerated, it was not the focal point of an ideology. Although the national anthem (the *Wilhelmus*) sings the praise of the Father of the Fatherland, Willem of Orange, who in 1568 had headed the revolt against Spain, it also calls for the humility that is God's due.

The nineteenth-century Dutchman's modest attitude towards his fatherland can be partly explained by the traumatic end of the amalgamation of the Kingdom of the Netherlands, the former Republic, with the previously Austrian Southern Netherlands (Belgium today). The union had been orchestrated by England and Austria, Russia and Prussia to counterbalance France's continental ascendancy. Willem I's policy of perseverance came to naught; it damaged his country's prestige and, partly due to the high cost of maintaining an army to intervene with force if necessary (which actually happened in 1831, but to no avail), the Netherlands suffered a serious financial crisis. After the political loss of face in the matter of Belgian independence, modesty was the only appropriate attitude.

Despite occasional displays of undivided loyalty to the House of Orange (for example in reaction to Socialist agitation), royalty's prestige declined during the reign of the unpopular Willem III (1817-1890, acceded to the throne in 1849). Celebrations marking the monarchy's fiftieth anniversary in 1863 were chiefly an aristocratic affair which was ignored by the majority of the population. The celebrations held in 1872 to commemorate the liberation of territory from Spanish domination, an operation which began in 1572, met with more response. Even so, these national remembrance celebrations were again largely an affair for the wealthy middle classes.

In the meantime the future of the Orange dynasty was unsure, due to the premature deaths of Willem III's sons. When the king himself died in 1890 his only surviving child was an underage daughter, Wilhelmina (1880-1962), born of his second marriage. Her mother, Emma van Waldeck-Pyrmont (1858-1934), acted as regent until Wilhelmina's eighteenth birthday in 1898. Emma carefully stage-managed a highly successful campaign aimed at strengthening the bond between the people and the young House of Orange. By the time Wilhelmina mounted the throne in 1898 she was the undisputed symbol of a new nationalism with a broad public appeal, not only to the wealthy bourgeoisie but to the masses too.

Nationalism in a divided nation

A less visible but no less significant phenomenon was that leading intellectual and ideological thought in the Netherlands associated itself more closely with the 'nation' as the nineteenth century drew to a close. The Calvinists had in any case always regarded themselves as unconditionally linked with the Netherlands and Orange. They upheld the myth of Orange's bond with the absolutely Calvinist identity of the Netherlands in the seventeenth and eighteenth centuries.

The pre-1880 Liberal leaders, in a certain sense the descendants of the Republic's regents, held the nationalistic ideas of the Anti-Revolutionaries in contempt. The values they themselves held dear were universal ones – "reason", "freedom", "citizenship". After 1880, though, Liberal thinkers did associate these traditional notions with the nation. Had not the nation's past shown how well liberal values could thrive in the Netherlands? Had not tolerance and moderation been the principal virtues in the Republic? Could bourgeois values have been more fittingly depicted than in the peerless paintings of Rembrandt, Hals, and Vermeer? Had not the Dutch philosopher Erasmus laid the foundations for humanism and the liberals' belief in reason? In short: at the end of the nineteenth century many Liberals held the Dutch nation and the Dutch national character to be the most reasonable and decent in the world.

After the Catholic Church's freedom and rights were reinstated and confirmed in 1853, Dutch Catholics had to get used to the idea of being fully integrated citizens in a State whose roots lay in the fight against Catholicism. Even many non-Catholics found it hard to accept the fact that they now had to share their glorious Calvinist past with their Catholic compatriots.

In 1853 the tension exploded into fierce Protestant protests at the advent of Catholic bishops. In 1872 the Netherlands ebulliently celebrated the fact that three centuries earlier the struggle against Spanish domination had taken a decisive turn with the unexpected capture of the town of Den Briel by rebel forces. The merrymakers took revenge on their erstwhile enemy of 1572, smashing windows of houses belonging to Catholics and forcing priests to fly the Dutch tricolor from Catholic churches.

Willem Frederik Hermans
on Catholics, 1951

'The Catholics are the plague of the
Dutch nation', said Lodewijk, 'after
the Treaty of Münster we should have
deported them. The Catholic parts
of our country should always have
remained under special supervision,
as they were three hundred years ago,
when they were *généralité* areas
without a government of their own.
They should never have been
emancipated as Provinces. The decline
of the Dutch nation began when the
Catholics were given political power.
The Netherlands emerged from the
Eighty Years' War, a war of liberation.
Giving the Catholics power meant that
the Eighty Years' War had been fought
in vain. I've no objection to their
practising their faith at home and in
church. They're entitled to that
freedom. That freedom is Dutch.
But not the freedom to hamper other
people's freedom.'

W.F. Hermans, *Ik heb altijd gelijk*
Amsterdam, 1951

Calvinist resentment gradually gave way to a kind of fellow-feeling between Catholics and Anti-Revolutionaries in their fight against the powerful Liberals to obtain funding for parochial schools. From 1878 on, Catholics and Protestants, albeit divided in strictly Church matters, joined forces in opposing the much-reviled Liberal education act which was passed that year and which stood in the way of Christian educational equality. The Catholics had been identifying more closely with the Dutch nation since the 1870s. It was as if their religious orientation towards Rome had acquired a secular counterpart in their loyalty to the Dutch nation and indeed to the House of Orange, which had epitomized Protestant independence ever since the sixteenth century.

In 1918, in the latter days of Dutch nationalism, Catholics actually took the lead in demonstrating their allegiance to the Oranges. At the end of World War One (in which the Netherlands were neutral) the Dutch Socialists attempted to seize power. The rest of the nation rallied enthusiastically around the royal family. A few days after the abortive Socialist coup, a mass demonstration of loyalty to the Oranges and against Socialism was held in The Hague, and it was the Catholics who gave unmistakable voice to their allegiance to the Netherlands and to Orange.

Despite the Catholic community's unalloyed patriotism, and despite the continuous presence of Catholics in government from 1918 on, many non-Catholics still distrusted Catholic nationalism. The writer W.F. Hermans expressed these misgivings in his novel *Ik heb altijd gelijk* (I Am Always Right) of 1951, in which the principal character lashes out against the rapidly increasing numbers of Catholics in Dutch society, accusing them of trying to hand the country over to Rome. The Catholic press promptly launched a fierce attack on Hermans for what was seen as anti-papism.

The suspicion with which many Dutch people regarded Catholic patriotism, and which Hermans had put into words in his novel, became painfully apparent in 1964. Princess Irene (b. 1939), second in line for the throne, announced her intention to marry the Spanish prince (and pretender to the throne of Spain) Carlos de Bourbon Parma and to be received into the Catholic Church. This gave rise to a terrific commotion in the non-Catholic press and in Parliament. As a potential successor to the throne, Irene needed the Second Chamber's permission to marry. This was refused, whereupon Irene renounced her right of succession. The marriage was solemnized by the Dutch cardinal Alfrink (1900-1987) in Rome, but was not attended by the bride's immediate family, who watched the ceremony on television.

Popular nationalism
The affection in which a large section of the Dutch population had held the House of Orange since 1890 began to subside in 1920. Nevertheless, the Dutch cannot be said to have been unaware of their national identity. During the interbellum, however, nationalism was not expressed in adherence to an abstract theory or a dignified royal family, but in a certain pride in Dutch achievements.

A nice example is provided by the feelings of national pride in Dutch achievements in the skies. In 1924, Royal Dutch Airlines (KLM, Koninklijke Luchtvaart Maatschappij), founded in 1919, made the first direct flight to Batavia, the capital of the Dutch East Indies. Ten years later, the whole country was glued to the radio in order to follow the progress of the Uiver, a KLM cargo plane, in a race from London to Australia.

Sports achievements could also trigger outbursts of national pride. Reactions to the 1928 Olympics, held in Amsterdam, were relatively restrained, but it was the performance of the Dutch football team in 1934 that first gave rise to national euphoria. For weeks everybody was singing *Wij gaan naar Rome* (We're off to Rome), where the world cup final was to be played. Unfortunately the Dutch team was knocked out in the first round. Nevertheless, the link between sport and nationalism had been forged. As in the case of the Uiver's flight, radio reporting played an important part. Major sports events attracted millions of listeners. In the depression of the 1930s, the achievements of Dutch footballers, cyclists, boxers, swimmers, and athletes certainly brightened many a gloomy existence. This kind of passive nationalism predominated in the years between the two world wars. It was symbolized by the monarchy (which even the Socialists accepted as a constitutional form) and was usually manifested in the form of enthusiasm at sporting successes. More aggressive forms of nationalism (like the Flemish Movement in Belgium or National Socialism in Germany) did not really catch on in the Netherlands. Even so, attempts to form nationalistic movements certainly did take place.

The most successful of them was the Nationaal-Socialistische Beweging (NSB), which to some ex-

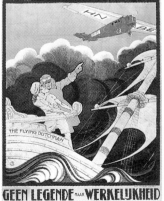

Not a legend but reality, 1924
Royal Dutch Airlines, poster
Amsterdam, Stedelijk Museum

Bitter rural poverty: turf hut in Drenthe
1930s, Haarlem
Spaarnestad Fotoarchief

tent benefited from the need for powerful leadership that had arisen in the 1930s in reaction to the economic crisis, political dissension and the presumed impotence of the political parties. The NSB did not grow into a mass movement, however. In the 1935 election it polled 8% of the votes, mainly among farmers and shopkeepers, to whom the recession had dealt a severe blow. The NSB's following dwindled when the economy began to recover in 1936. Furthermore, the NSB had been steering an increasingly National-Socialist course in which the party (its name notwithstanding) propagated an ideology akin to Italian Fascism until 1935. Germany's brand of National Socialism was seen by many in the Netherlands who had voted for the NSB up to 1935 as an aggressive movement which constituted a threat to Dutch independence. There was no strong antisemitic feeling in the Netherlands either.

In the 1930s, nationalistic sentiments were reinforced by the actions of movements opposed to totalitarian ideologies like National Socialism and Communism. The Dutch Movement for Unity through Democracy united prominent names from practically every walk of life. In its writings against National Socialism and Communism, Unity through Democracy called loudly for allegiance to the House of Orange and the glorious history of the Netherlands.

The nation crushed, the Indies lost

The German occupation, which lasted from 1940 to 1945, inflicted deep wounds on Dutch society. The murder of more than 100,000 Dutch Jews in the German extermination camps overshadowed all the miseries of war. Anne Frank's world-famous diary paints a poignant picture of the Jews' tragic fate and of how those who had gone into hiding had few illusions of any future. Most of the Dutch came through the war by doing what no Jew could: they carried on with pre-war life as best they could. The German occupation was a period in which frightened Dutch men and women switched on their carefully concealed clandestine wirelesses to hear Radio Orange broadcasting on the BBC.

The German invasion of May 1940 revived Dutch feelings of allegiance to the House of Orange. The royal family became the symbol of steadfast resistance to the German oppressors during World War Two. This was quite remarkable in view of the fact that the royals and the government had fled to England immediately after the beginning of the war in May 1940. An extremely wise decision, partly because the Kingdom of the Netherlands also had colonial possessions in East Asia and the Caribbean.

The Germans prohibited and quelled every sign of adherence to the House of Orange. Nonetheless the first year of the occupation saw the formation of the Netherlands Union, a powerful national movement which was intended as a patriotic alternative to the NSB and which called for dignity and for the preservation of Dutch identity. Many saw in the Union an expression of resistance to the German occupation, but others (including many Anti-Revolutionaries) found its actions too moderate and cooperative. In 1941 the NSB became the only legal political movement. The Germans had a stranglehold on Dutch society and disbanded the other political parties, the trade unions, and the Netherlands Union.

The Liberation in May 1945 briefly heightened nationalist feeling and royalist sympathies. There was, however, little cause for national pride. The country was faced with the almost insuperable task of repairing war damage. The decolonization of Indonesia was also at hand. Postwar reconstruction drove home the hard fact that the Netherlands could not survive without foreign aid. The decolonization of Indonesia was inevitable, that much was clear to many. During the war the government had already announced from London that it would recognize a certain degree of colonial autonomy. In spite of this pledge an armed conflict ensued, partly because the Dutch were not prepared to listen to the demands of the Indonesian nationalists headed by Sukarno, who had sought, and obtained, the help of the Japanese forces who occupied the Dutch East Indies from 1942 to 1945. Another factor, of course, was the Dutch government's desire to defend Dutch economic interests in South-East Asia to the best of its ability.

It turned out that both reconstruction and decolonization depended on the foreign policy of the United States. Without economic and financial aid from America the Dutch economy would have been in dire straits in 1948. At the same time the United States was exerting heavy pressure on the Dutch government to give up its forcible resistance to Indonesia's desire for independence and to hand over power to Sukarno, in whom America saw a trustworthy ally against advancing Communism. Dependency on a major power is never conducive to feelings of national pride.

In 1949 the Netherlands granted sovereignty to the Republic of Indonesia. Thousands of Indonesian Dutch nationals who had lived in the archipelago (the "Emerald Girdle") practically all their lives now returned to their small, chilly fatherland. So, in their thousands, did the inhabitants of an Indonesian group of islands called the Moluccas, whose attempts to obtain independence for their own tiny island State had been in vain. The Moluccans' desire for independence remained latent in the Netherlands, flaring up in the 1970s when young Moluccans refocused attention on the issue with a number of violent hijackings, including two trains and a class of school-children, during which hostages were taken.

After World War Two Europe was less interested in nationalism than in the prospect of international cooperation. A paramount example was of course military cooperation in NATO from 1949 on. The policy of neutrality that had collapsed in May 1940 had been abandoned. Equally important was the Netherlands' vanguard position in economic collaboration, first of all with Belgium and Luxemburg (Benelux) and as early as 1951 in the European Coal and Steel Community. The European Economic Community followed in 1957, paving the way towards the far-reaching integration of the 1990s. Summing up: nationalism in the postwar Netherlands deferred to an internationalism based on the Atlantic alliance and European cooperation.

Tea-planter on West Java, 1907
Amsterdam, Koninklijk Instituut
voor de Tropen

The House of Orange and the other Orange

The House of Orange was still the crystallization point for the national sense of identity. The royal family, however, was no longer above controversy. In 1956 the whole world could read of tensions at court. Their cause was a faith-healer engaged by Queen Juliana (b. 1909), who had succeeded Wilhelmina in 1948, to cure her youngest daughter's (congenital) eye complaint. It was the German press that trumpeted the news abroad; at first Dutch papers refused to carry reports on the affair. In the 1960s the marriages of Juliana's eldest daughters caused a greater stir. First came the aforementioned controversial marriage of Princess Irene. The engagement and marriage (in 1966) of the heir to the throne, Princess Beatrix (b. 1938), sparked off a great commotion. Her fiancé was a German diplomat called Claus von Amsberg (b. 1926). The simple fact that Beatrix had chosen a German was enough to unleash a storm of protest.

It was not only among former resistance fighters and Jewish organizations that feeling ran high. Many people who had been too young to actually experience the horrors of the war were violently opposed to the marriage. Antagonism mounted when it became known that the government was firmly resolved for the wedding to take place in Amsterdam. The fiercest protests against the marriage were held in the capital, where since 1965 an anarchic movement called Provo had been defying the authorities by staging humorous forms of protest against the consumer society.

On the eve of the wedding, which was solemnized on March 10 1966, there were rumours that Provo planned to disrupt the ceremony. With the exception of a well-aimed smoke bomb which exploded in the middle of the royal procession without causing any harm, nothing happened. There was, however, some rioting elsewhere in Amsterdam. The storm soon subsided. Claus turned out to be an exemplary Dutchman who mastered the language surprisingly quickly. The royal family could return to the tranquillity so ardently desired by Queen Juliana. Every year, on April 30th, the nation celebrated her birthday, and at regular intervals the birth of yet another member of the House of Orange prompted a small surge of royalist sympathy. At the end of the 1960s, however, what really held the country together was not the royal family, but King Football. Apart from athlete Fanny Blankers-Koen (b. 1918), winner of four gold medals at the 1948 Olympic Games in London, the nation had had little cause for euphoria in the field of sport during the first two postwar decades. Soccer did have a vast army of fans, but not until 1969 could the Netherlands boast any impressive results on the international football pitch. Highlights were matches between the national teams of the Dutch (Orange) and the Belgians (Red Devils). Only one exception, and a very Dutch one at that, relieved the general mediocrity: 400-metre speed ice-skating, a sport long dominated by the Norwegians, Russians, and Dutch. During the two-day European or world championships, the whole nation was glued to its television sets.

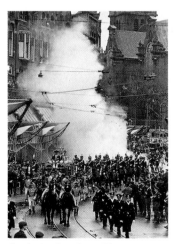

Smoke bomb in the wedding procession of Beatrix and Claus, March 10 1966
(Photo ANP)

In 1969, when Amsterdam's soccer eleven, Ajax, became the first Dutch team to reach the final of Europe's top football tournament (only to be trounced by AC Milan), it seemed that the Netherlands now belonged to the cream of European soccer. In 1970 Feyenoord of Rotterdam won the European cup in Milan against Celtic of Scotland. This success was followed by a long series of Ajax victories. Football euphoria transcended club loyalty in 1974, when the Nether-

lands played in the world competition for the first time. The national team was captained by Johan Cruijff (b. 1947), universally hailed as one of the most brilliant footballers of all time. Orange's defeat in the 1974 final in Munich to the West-German national eleven marked the birth of a growing mass cult of the Dutch team. National enthusiasm for football, known as the "Orange feeling", intensified Dutch-German rivalry. Again, the war played a part in this. In the mid-1960s attention refocused on World War Two. Partly responsible for this revived interest was the Vietnam war, compounded by the fact that many victims of the German occupation (people who had been forced into hiding and former prisoners-of-war) were suffering from serious psychic problems during this period, the legacy of their terrible wartime experiences. In 1988 the Dutch got their revenge on the Germans for the 'Munich trauma' of 1947. Orange became European champion under the inspiring captaincy of yet another wonderful player: Ruud Gullit. With his dark skin and curly locks he became a symbol of the new multi-cultural Netherlands. Beating West Germany in the semi-final, crowned by victory in the final (in Munich), triggered unprecedented manifestations of Orange hysteria. More than a million people cheered the Orange team during its coach tour of the country and a boat trip along the canals of Amsterdam.

Artificial landscape

The Netherlands has always been a densely populated country with an intricate infrastructure. Naturally scenic areas are rare, and often maintained by artificial means. Woodland is the result of afforestation, most of which took place at the end of the nineteenth century on the sandy soil of the central and eastern regions of the country. The narrow strip of coastline with its superb beaches and peaceful dunelands offers the most unspoilt scenery. It is there that the most important artists' colonies were formed in the nineteenth and twentieth centuries: in Domburg in the province of Zeeland, where painters like Mondrian were fascinated by the special effect of the light where land and water meet, and in Bergen, in the province of Noord-Holland.
Much of the Netherlands was formed by and from water. In the west it consists of the common delta of the Rhine, Maas and Scheldt. These rivers, with their numerous branchings, have formed a flat, fertile landscape kept dry by an ingenious drainage system. This facilitated the development of a rich and varied agriculture in the region. Here, too, the main shipping routes of North-West Europe met. It was almost inevitable that this should become one of the richest and most densely populated areas of Europe.

Peacefully conquered territory
Although water brought great wealth to the Netherlands throughout the ages, it was a constant worry to the people who lived there. Although the Dutch learned to control the water to a great extent, from time to time they were plagued by serious floods. The need to control the water, and an increasing need for more agricultural land, led in the seventeenth and nineteenth centuries to land reclamation projects which involved draining a number of lakes.
Around 1880 serious plans were devised to enclose and partly drain the Zuyder Zee, a North Sea inlet penetrating to the heart of the Netherlands. Until 1826 the Zuyder Zee had been the sole means of access to Amsterdam by water, and was thus part of one of the most important trading routes in Europe. In the nineteenth century, however, two new canals linking Amsterdam directly with the North Sea were built, reducing the Zuyder Zee's importance as a shipping route.
Hydraulic engineers and young Liberal politicians formed a united front in lobbying for the enclosure and partial draining of the Zuyder Zee by the State. Cornelis Lely (1854-1929) was the spiritual father of the Zuyder Zee Project, which involved the aforesaid two operations and the reclamation of land to form new polders (flat land dyked against the sea). Between 1886 and 1891 Lely, a hydraulic engineer employed by the Zuyder Zee Association (a propaganda organization set up by Liberal politicians), devised a scheme for enclosing the lake and building the polders. He subsequently held ministerial posts in three Liberal cabinets, which gave him an opportunity to enact his plans by law. However, by no means everybody in the Netherlands was convinced of the usefulness and necessity of such large investments on the part of the State for the land reclamation project. Consequently, it was 1918 before Lely's bill was passed. When the Zuyder Zee flooded large areas of land in January 1916, a substantial parliamentary majority was per-

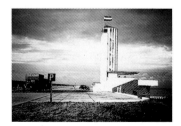

W.M. Dudok, *Monument on the Enclosing Dyke on the spot where the dyke was closed in 1932*, october 1938
Rijksarchief in Flevoland

suaded that the operation was in fact both useful and necessary. During World War One minister Lely had also played enthusiastically on national sentiments. He painted the Zuyder Zee project in glowing colours as an enterprise which would gain the Netherlands international prestige. While the belligerent parties waged war, the neutral Netherlands kept out of the hostilities, being capable of enlarging its territory by peaceful means.

Due to stringent restrictions on government spending in the first half of the 1920s, it was 1932 before the more than 30 kilometre-long Afsluitdijk (Enclosing Dyke) was completed, turning the Zuyder Zee into a freshwater lake henceforth called the IJsselmeer. The smallest of the four planned polders had also been built by then. Two more followed in the course of the century (the last gap being closed in 1967). The fourth polder did not materialize; in 1990 it was decided not to go ahead with the operation. The politicians were unwilling to invest the billions of guilders it would cost to drain the land without the guarantee of its being a viable proposition.

Defeat in the battle against the water
In the night of January 31 to February 1 1953 the combination of a spring tide and a severe north-westerly gale caused catastrophic floods in the South-West Netherlands, a region consisting of islands and peninsulas separated by estuaries, inlets, and canals. The dykes were not high enough to cope with the water that poured from the North Sea into the Rhine, Maas and Scheldt estuaries. Tragically, experts had been aware of the danger of the too-low dykes for some years prior to the disaster. Work had actually begun on some parts of the sea wall. However, nobody had foreseen that the water would attack with such a tremendous force. The dykes burst, the water tearing gaps of several hundred metres in some places. Farms, villages, and towns were inundated, and more than eighteen hundred people drowned.

The extent of the tragedy made it perfectly clear that this was no time for half measures. As a matter of fact, things could have been much worse. The lowest-lying part of the Netherlands, the polders north of Rotterdam, only narrowly escaped flooding. It was decided to close the sea gates in the south-west of the country, with the exception of the Scheldt estuary, which provides access to the Belgian port of Antwerp. Known as the Delta Plan, the operation was designed to protect the Netherlands for thousands of years to come. Activities were not confined to the south-west, though. The plan was to heighten all the Dutch sea dykes.

After the breaches in the dykes had been repaired, a system of hydraulic engineering projects of hitherto unprecedented dimensions was embarked on in 1956 and completed in 1988. Estuaries were dammed and huge flood barriers erected in the rivers. The Delta Plan reached its climax in 1988 with the completion of an advanced and immensely expensive piered dam with sliding gates in one of the widest stretches of water in Zeeland, the East Scheldt. Usually, the gates are kept open so as to admit fresh seawater into the East Scheldt, and are only closed when storm floods are expected. Not only did this operation enable a unique tidal region to be preserved, it also ensured the survival of the mussel farms, an important source of income. The preservation of nature and mussel farming had its price though, the estimated costs were greatly exceeded.

After 1988 the Netherlands could feel safe. There was nothing more to be feared from the sea. Unexpectedly, though, a different kind of water later menaced the Dutch delta. In the winters of 1994 and 1995 enormous amounts of rainwater from the Rhine and Maas catchment areas threatened to flood large areas of the south and middle of the country. In January 1995 the situation became so critical that several hundred-thousand people were evacuated from the endangered areas. Yet again, the water had the country in its power. Serious breaches in the dykes were prevented, but only just. The narrowly averted disaster led to immediate major dyke reinforcement in the heart of the Netherlands, an operation resulting in considerable changes to this characteristic part of the Dutch river landscape.

February 1953. Destroyed bridge in the flooded Zuid-Beveland
Haarlem, Spaarnestad Fotoarchief

Economic development and social struggle

In the twentieth century many Dutch people see Van Gogh primarily as a painter who was moved by the bitter struggle for survival in the impoverished rural areas. In many homes hangs a reproduction of *The Potato Eaters*, painted in 1885, a sombre, poignant portrait of a poor Brabant family eating its daily warm meal of boiled potatoes.

In 1885 Van Gogh's harsh, dismal picture of the plight of the poor was not appreciated by his contemporaries. Perhaps not only his unorthodox technique was ahead of his time. When he painted his *Potato Eaters*, the art-loving public was only marginally interested in such things as poverty, child labour and degrading working conditions. The Liberal and Conservative elites saw the "social question" (poverty and stark social contrasts) as a potential source of unrest, a threat to public order.

Like every country in West Europe, the Netherlands had to cope with the consequences of changing economic circumstances. Until well into the twentieth century it was a largely agricultural nation; this, however, was one of the causes of the problems facing the country in the final decades of the nineteenth century. The world-wide agricultural crisis brought great suffering to Dutch farmers. Many of their sons moved to the cities in the west of the country, where quite a thriving industry was beginning to develop, notably in the ports of Amsterdam and Rotterdam. Smaller towns in the east and south also saw a large influx of young families in search of a bearable existence. While the textile industry in Twenthe, in the east, grew rapidly, and down south in Limburg the potteries and (from the beginning of the twentieth century) mining flourished, many people could not make a decent living.

In the Netherlands, as in other countries, there was virtually no social legislation. In 1874 Sam van Houten (1837-1930), a progressive Liberal member of the Second Chamber, had great difficulty in getting Parliament to impose a modest law prohibiting child labour. Henceforth it was illegal for children to work in factories.

However, cottage industry and agriculture, two important sources of income, were not covered by the terms of the law, nor was any form of control introduced. The practical effect of Van Houten's law therefore did not amount to much. The important fact of having got the act through Parliament did, however, demonstrate that there was scope for social legislation. Care for the welfare of the poor and workers had hitherto been regarded as a matter for private initiative: charity dispensed by the Church or benevolent citizens. The State kept out of such matters.

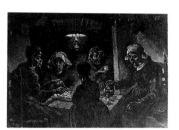

Vincent van Gogh, *The Potato Eaters*
1885, oil on canvas
Amsterdam, Van Gogh Museum

Organization of workers

The organization of workers and their interests was still in its infancy in 1880. In 1871 a small number of Liberal and well-educated workers had taken the initiative of founding the ANWV (Algemeen Nederlandsch Werklieden Verbond, or General Dutch Union of Workers), a labour union which held moderate views and sought to improve workers' position by negotiating with employers. The ANWV remained a marginal organization and did not achieve very much.

Typical of the Dutch situation, which in the last quarter of the nineteenth century was dominated by religious differences, were the fierce discussions held in the ANWV in 1879 about what stance the organization should adopt in the school-funding dispute. A few prominent Anti-Revolutionary members of the ANWV, headed by an Amsterdam beer-brewer, refused to side with the ANWV majority which supported the Liberal Education Act of 1878, and set up an organization of their own: Patrimonium. Guided by the Word of God, they held forth on the necessity for negotiations between employers and employees. Patrimonium rejected strikes and sackings as means of settling labour conflicts. It saw itself not only as a defender of the people against godless Liberalism, but also wanted to erect a dam against encroaching Socialism.

As a matter of fact, Socialism was not encroaching all that much in 1880. As stated above, the Netherlands was an agricultural nation with a relatively high standard of living. Although by twentieth-century standards many people lived in wretched circumstances, Dutch industrial cities suffered far less from pauperization than was the case in England and Belgium. The government generously tolerated the presence of international Socialist leaders on Dutch territory, a policy in marked contrast with the tiny following that Marx's and Engels' ideas attracted in the Netherlands.

Even so, since 1869 there had been a revolutionary vanguard in the Netherlands in the form of a section of the Second International. From this developed the Social-Democratic Union (SDB) in 1881, which vociferously preached its cause in the 1880s, chiefly in Amsterdam.

The SDB was borne along by the unflagging energy and less impressive fortune of Ferdinand Domela Nieuwenhuis (1846-1919). This flamboyant apparition was a Lutheran minister who had left the Church in 1879 in order to dedicate himself entirely to the revolution. The revolutionary movement lived mainly on the fruits of Domela Nieuwenhuis' inflammatory pen. His newspaper

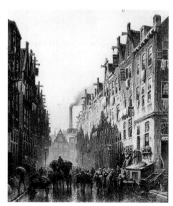

Eduard Alexander Hilverdink
Amsterdam's poor Jewish district in 1889, painting, Amsterdam
Amsterdams Historisch Museum

Ferdinand Domela Nieuwenhuis
Amsterdam, Internationaal Instituut
voor Sociale Geschiedenis

Recht voor Allen (Justice for all) became the mouthpiece of the downtrodden and of those without rights. At the height of Socialist agitation, dozens of colporteurs, many of them jobless, were peddling the paper in Amsterdam's city centre.

Domela had little influence on the masses, however. The greatest demonstration of social unrest in the 1880s was a spontaneous action. In 1886, at the nadir of the economic crisis, tough police action against eel-heading led to riots. Eel-heading was a cruel working-class pastime which enjoyed sporadic popularity.

A live eel was tied to a rope stretched above the water of one of the canals in the Jordaan, a working-class Amsterdam district. The idea was to pull the slithery, squirming creature off the rope from a rowing-boat. The authorities were wary of such spontaneous outbursts of merrymaking, which offended the rules of bourgeois decency. The crowds gathered along the canal might easily be incited to rioting and looting. The clumsy intervention of the badly paid and poorly trained policemen on that warm summer's day in 1886 had the effect of a spark in a powder-keg. Within a few hours what had started off as an eel-heading fracas developed into a fully-fledged battle which spread all over town and resulted in fatalities. The government had to send in troops to restore order.

Domela's SDB was unable to take advantage of the fray. Indeed, not for a single moment did it obtain a grip on the situation. The only effect was to drive the movement into a defensive position: as a reaction to the vociferous SDB propaganda, a late nineteenth-century variant of an age-old phenomenon arose in Amsterdam after the eel riots. The citizenry asserted itself in a mass display of Orangist loyalty. The gesture was no longer directed against the regents, as in the seventeenth and eighteenth centuries, but against the Socialists. *Recht voor Allen* had distinguished itself with a ceaseless battery of attacks on the unpopular Willem III. But no matter how unpopular "King Gorilla" (the nickname bestowed on him by *Recht voor Allen*) was, as a symbol of the monarchy he was inviolate. The fury of the working classes was unleashed in noisy demonstrations and the storming of a few Socialist bastions. But not even Domela escaped: he was sentenced to a year in jail for *lèse-majesté*.

Around 1880 there was a marked polarization in people's situations. Things were still very bad in rural areas. Farming showed no signs of recovery, and industrialization had ground to a halt. In the extensive areas of peatland in the north and east of the country, people suffered terrible privations. They were ripe for social agitation, which was rampant. It affected the poorest of the poor, who saw in Domela a messianic redeemer, an image that appealed to the former preacher. But not only the powerless, oppressed people who had no vote were easy converts to Socialism. Many teachers, small businessmen, farmers, and trained workers lent a willing ear to the new Socialist gospel. This enabled Domela to win a seat in the Second Chamber in the election of 1888, helped by a considerable increase in the number of people entitled to vote. Many of those who elected Domela that year were voting for the first time. The decisive factor in his election, however, was probably the Anti-Revolutionaries' advice not to vote Liberal because of the school-funding dispute. Domela's opponent in the Friesland constituency of Schoterhand was a Liberal. Many voters stayed at home, and were thus indirectly responsible for Domela's victory.

Domela was completely on his own in the Second Chamber. This was no place for his rhetoric. The Liberals booed him, the Catholics and orthodox Protestants, who due to the increased electorate now had a parliamentary majority, ignored or attacked him. An embittered Domela turned his back on the parliamentary fray and became an anarchist. This brought him into violent collision with International Socialism in the 1890s, which were dominated by the German Socialists led by Karl Kautsky. His irreconcilable hatred of parliamentary work isolated him in the Netherlands too. In 1894 Dutch Socialism was divided as never before, just when universal male suffrage seemed within reach under a Liberal government (in the event, it was not granted until 1917). Disillusioned in Domela, a dozen Socialists founded a party based on a German model. It took some time for the Social Democratic Workers' Party (SDAP) to gain a footing. In 1897, after another increase in the electorate, the party won three seats in Parliament. The lawyer Pieter Jelles Troelstra (1860-1930), initiator of the SDAP and fiercely opposed to Domela Nieuwenhuis' views, took his seat in the Second Chamber.

In 1909 a number of radical Marxists connected with the periodical *De Tribune* left the SDAP because of its 'revisionist' course. They constituted the basis of the later Dutch Communist Party, which was formed after the Russian Revolution. The defectors boasted a number of dis-

Herman Gorter, The Hague
Nederlands Letterkundig Museum
en Documentatie Centrum

Pieter Jelles Troelstra on his attempt
at revolution, 1918-1929 circa

I ran riot for a while, but as soon as I
realized that this would not lead to
the desired results, I pulled out. It is
certainly fortunate that we went no
further. We could have gained power
temporarily, but we would not have
been able to use it, nor to retain it,
because the circumstances were not
yet ripe [...] My real mistake in those
days, the same one whose influence
is apparent in my brochure "The
revolution and the S.D.A.P.", was this:
I expected the end of the war to bring
about the collapse of the capitalist
system; I believed that the rise, gradual
of course, of Socialism had dawned.

P.J. Troelstra, *Gedenkschriften. Vierde
deel. Storm*, Amsterdam, 1931

Sam van Houten on the limits of State
interference, 1874-1908

To increase direct State involvement
in workers' lives was not what I had in
mind; only a better promotion of the
government's traditional and necessary
duty to protect children against abuse
of the power legally invested in parents
and guardians, an abuse to which
employers – the inhumane among
them out of greed, the humane driven
by competition – are party.
As I see it, such State involvement
ceases when children are of an age
to speak for themselves, which is fairly
early in the working classes.

S. van Houten, *Vijfentwintig jaar in de
Kamer* (1869-1894). *Tweede periode*
Haarlem, 1908

tinguished names in their ranks. Members of the SDAP's intellectual vanguard were keen to play a vanguard role in the Socialist Revolution too. The best-known revolutionary Marxists were the poetess Henriëtte Roland Holst (1869-1952) and the poet Herman Gorter (1864-1927).

The social question

In the meantime – since the 1880s – the realization that social injustice could no longer be tolerated had spread beyond the Socialist group. Left and right recognized that the social question (poverty, unemployment, and deplorable industrial conditions) should not be left to the effects of market mechanisms and private charity, but that the excrescences should be combated. This awareness sprang from a blend of sincere social commiseration and the fear of advancing Socialism.

The question as to who should be ultimately responsible for solving the social question was answered differently by the various movements. The young generation of Liberals who had come strongly to the fore from 1880 saw State intervention as the best option. They called for legislation to combat the evils. The confessional parties favoured negotiations between employers and employees. It was the opinion of the Anti-Revolutionaries and the Catholics that the State's role should be kept to a minimum.

According to the Anti-Revolutionaries, all social problems ought to be solved in their own ranks. "Sovereignty in our own circle" was Abraham Kuyper's credo for all social action. Catholics, buttressed in the social question by the papal encyclical *Rerum novarum* of 1891, held similar views. They thought that social matters should be tackled at as basic a level as possible (i.e. in factories, schools, and other institutions). On the issue of whether to set up organizations under direct episcopal control or assign responsibility to the organizations themselves, opinion was divided. The few Catholics who favoured a vigorous representation (by priests and chaplains as well) of workers' interests foresaw little benefit in a far-reaching episcopal intervention. Their prime concern was to improve the wretched circumstances under which many of their co-religionists laboured. The bishops, however, were afraid that the lures of Socialism would tempt the faithful to stray from the fold.

The outcome of this pluriform concern for the workers' interests was, after all, that legal measures were taken. As in the school question, Anti-Revolutionaries and Catholics, despite their firmly held ideological positions, came to the conclusion that their aims in the social question would be best served by legislation. First of all, under a government of Catholics and orthodox Protestants, and preceded by a large-scale parliamentary investigation into working conditions in various branches of industry, a Factory Act was passed in 1889. It imposed limits on working hours; not only child labour but also night shifts for women were now unlawful. More important was the introduction of factory inspections to ensure that the law was obeyed.

Twelve years later, there was more important legislation, this time under a cabinet dominated by progressive Liberals. An Industrial Accident Act was passed. Strictly speaking, the Compulsory Education Act (under whose terms parents were obliged to send their children to school until the age of twelve) did not fall under social legislation, but in practice it eliminated child labour, except for a certain amount of seasonal farm work. Moreover, it gave all children the opportunity to learn to read, write and do arithmetic, thereby increasing their chances of escaping from poverty. Strange to say, in the Netherlands – a country with a reputation for a well-implemented system of social security – legislation advanced at a slow pace after the Industrial Accident Act of 1901. Indeed, the terms of a new Poor Law of 1912 moved the fight against poverty back into the private initiative corner. Churches now provided support for care of the elderly, trade unions dispensed unemployment benefits, albeit only to their own members. This situation remained unchanged until the economic crisis of the 1930s.

The workers' organizations

Up to the turn of the century there had been frequent signs of industrial unrest; by dint of persistent strike action workers occasionally succeeded in obtaining some improvement in their position. Nevertheless, they were a long way off from the well-organized labour movement of modern times. Workers were divided along ideological lines. They were members of organizations which were run on Calvinist, Anarchist, Liberal or Catholic lines and held each other for heretics. The first modern trade union was the Socialist General Union of Dutch Diamond-Workers with a membership consisting largely of trained Jewish diamond-cutters. A strike fund and various

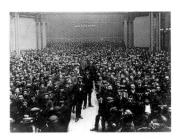

ANDB meeting during a strike in 1900
Amsterdam, Internationaal Instituut
voor Sociale Geschiedenis

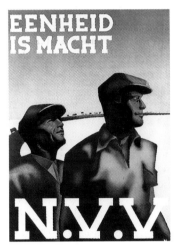

Eenheid is Macht (Strength in Unity)
poster, Amsterdam
Stedelijk Museum

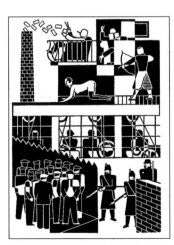

Gerd Arntz, *Unemployed people*
1931, Woodcut, Amsterdam
Stedelijk Museum

other resources enabled the union to work for the well-being of its members. One result of these efforts was the Zonnestraal sanatorium, built by the diamond-workers' union for its members to the superb design (1926) of architect Johannes Duiker (1890-1935).

The impotence of the labour movement had been demonstrated during the outbreak of strikes staged by railway workers in 1903. At first the strikers' actions met with success, but when Abraham Kuyper's confessional government banned railway workers' strikes, the existing Socialist and Anarchist labour organizations failed to take a hard line and quarrelled among themselves. The failure of 1903 did, however, encourage the formation of a modern Socialist trade union, the Dutch Association of Trade Unions (NVV), founded in 1905. Its initiator, great stimulator, and first chairman was Henri Polak (1868-1943), chairman of the diamond-workers' union. The Socialists' example was followed by the Catholic and Calvinist workers' organizations, which likewise developed into trade unions.

Little by little, the modern unions gained more ground. Their most important achievement in the 1920s was to obtain employer and State recognition for collective labour agreements, so that workers in larger industries no longer had to negotiate wages and conditions individually. The unions acted on their behalf, the result of their negotiations being binding for all workers in the company in question.

Crisis and war

Like all countries with a modern economy, the Netherlands was dragged into the grave economic crisis into which the world was plunged after the Wall Street crash in October 1929. Dutch agriculture, still the largest sector of the Dutch economy, was threatened with ruin due to the steep fall in prices of agrarian products on the world market. If the government had not stepped in with radical support measures, the Dutch farming industry would not have survived. The crisis was coupled with personnel cuts, closures and bankruptcies. Mass unemployment was the result.

Under prime minister H. Colijn (1869-1944) the Dutch cabinet stuck obstinately to a policy aimed at reducing the government deficit and keeping the guilder linked with its value in gold (the Gold Standard). This policy seriously hampered Dutch exports to countries which had gone off the Gold Standard at the beginning of the 1930s. Consequently, the crisis lasted until the guilder was finally devalued in 1936, whereas for most European countries recovery had started five years earlier.

Day after day, the unemployed formed long queues in front of the dole office where they had to register in order to get a government allowance which just sufficed to keep a family alive, but no more than that. Households on the dole for any length of time lived in wretched circumstances. Many bore their fate stoically, but were scarred for life by the privations they suffered. Now and then, a spark, of resistance flared up. When the government announced plans to cut the dole, tumult broke out in the Jordaan. As had happened during the eel-heading riots of 1886, locals and police engaged in fierce street-fighting. And although the Dutch Communists did their best to fan the flames of revolt in the Jordaan and inspire the rioters with the revolutionary spirit, the Jordaan disturbances, like the eel-heading fray, were an expression of popular resistance, of people's impotent rage at their plight and at the government's high-handed attitude.

Although the economy began to make a hesitant recovery in 1936, there was no prospect of ending mass unemployment until war broke out in September 1939 and thousands were mobilized. In World War Two, which the Netherlands entered on May 10 1940 (when Germany invaded the country), the Dutch economy was annihilated. The Germans plundered the Netherlands' industries and destroyed a substantial part of the infrastructure, including the ports of Amsterdam and Rotterdam. Thousands of acres of building land were inundated in the course of wartime activities, and as the result of mindless German destruction in the final days of the war. Furthermore, people in the west of the country were exhausted due to a ruthless blockade which cut them off from food supplies in the last winter of the war. Tens of thousands died as a result of these deprivations.

Recovery and reconstruction

After the Liberation, on May 5 1945 (a mere three days before Germany's total capitulation), the Netherlands was in a sorry state. For fifteen years large sections of the population had been leading wretched lives. The years of economic crisis between 1929 and 1939 had inflicted deep

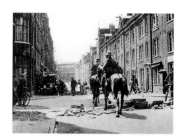

Rioting in the Jordaan, 1934
Amsterdam, Gemeentearchief

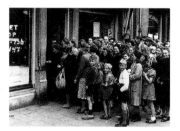

Food shortage in 1945: queuing for vegetables (Photo ANEFO)
Haarlem, Spaarnestad Fotoarchief

wounds, and not only on wage-earners. Large numbers of businesses had gone bankrupt, causing the national economy to totter. That was the big difference to the crisis of the 1880s, when there was also a great deal of unemployment and impoverishment but business life and the budding industries came through relatively unscathed.

Just as the country was getting back on its feet, it had to suffer the shock of German occupation and was plunged into chaos. Although the worst infrastructural damage was repaired fairly quickly after the Liberation, curing the entire economy turned out to be an insuperable task. On top of all this, the Dutch East Indies were still groaning under the rigours of the Japanese occupation, and when that came to an end in August 1945, the struggle for independence began. The Dutch government had to divide its attention, energy, and resources between reconstruction at home and restoration of its authority overseas.

It was all too much. The Netherlands was staring ruin in the face due to trade and budget deficits, when the United States, worried by the advance of Communism in impoverished Europe, came to the rescue. The Dutch government eagerly grasped American Marshall aid and in 1949 embarked on an ambitious industrialization programme.

The country's labour force had to become less dependent on agriculture and the service industries, and compensation had to be found for the loss of the Dutch East Indies. Industrialization was the magic word. The State began to build industrial zones on the outskirts of major cities. A big petrochemical industry rose outside Rotterdam. The infrastructure underwent rapid improvement, notably for air traffic and for transport by road and water. Railway development had stagnated back in the early 1930s, since then the network had not been significantly expanded. Indeed, a number of local lines had been shut down. The 1950s, however, saw large-scale modern improvements, brought about by diesel traction and the electrification of direct routes.

Sobriety, prosperity and recession

After World War Two social services underwent structural changes. Mass unemployment was a thing of the past. The elderly, traditionally the largest group of needy people, no longer depended on the Church or private charity or family support. Many of them had private pensions. In 1947, moreover, the State introduced pensions for people who had made no provision for their old age. Despite the rapid economic growth of the 1950s, there were few or no benefits for millions of Dutch people. Wages were deliberately kept low. This was due to the "controlled income policy" devised by the government, in which, led by the Social Democrat Willem Drees (1886-1988), Catholics and Social Democrats held sway until 1958. Under the terms of an agreement they made with the Socialist and confessional trade unions, and employers' organizations, pay could only be increased by a small percentage, enough to compensate for the slowly rising prices. The aim was to protect the Dutch economy by curbing the growth of incomes, thereby preventing surplus imports and inflation.

The scheme worked excellently until the end of the 1950s. No wonder there was no serious industrial unrest in the 1950s – after all, the major unions did not make any pay claims. The smaller Communist union did stage strikes here and there (in the Amsterdam docks, for instance), in places where they had a large following. These actions had no effect on income policy, though. The Dutch Communists were totally isolated in their own country, especially after the Communists seized power in Prague in 1948. The Netherlands was dominated by the Cold War, and the Social Democratic Labour Party (founded in 1946 as the successor of the SDAP) set an example in anti-Communism. Only a small group of intellectuals, including the writer and criminologist W.H. Nagel (1910-1983, who wrote under the pseudonym of J.B. Charles, the name he adopted in the Resistance during the war), tried to take up an independent stance. This immediately labelled them as fellow-travellers in the eyes of the anti-Communists.

Controlled income policy derived from the pursuit of economic organization dating from the interbellum. Despite strong differences in premises and aims, the concepts developed in confessional and Socialist circles turned out in practice to have a lot in common after World War Two. Driven by the dreadful economic circumstances of the 1930s and by doubts as to what the future held in store after the Liberation, Catholics and Socialists discovered common ground in their need for a centrally controlled economy. This took the form of powerful government stimulation of industrialization, and also the setting up of bodies in which employers and employees could discuss terms of employment and other matters. In this manner the Catholic, Socialist and Calvin-

ist trade unions were made to shoulder some of the responsibility for economic development. In the 1950s and 1960s the social security system was expanded. This involved statutory benefits in cases of illness, unemployment, and disablement, and also for widows and orphans. Under the terms of the 1965 Social Security Act, unemployed people who did not qualify for benefits under existing schemes were nonetheless entitled to a minimum income. Designed primarily with unmarried mothers in mind originally, during the economic recession that began in the late 1970s the scheme was extended to cover hundreds of thousands of young people who had never worked.

By 1958 the economy had made such a good recovery that restraints were no longer deemed necessary. The government abandoned the policies of controlled incomes and limited spending. The end of the controlled incomes policy increased industrial unrest. The workers' eagerness to make up for the lean years led to a sharp increase in wages. Tensions were particularly apparent in the building industry, partly because the three major trade unions (Socialist, Catholic and Calvinist) were not all that keen to allow non-organized workers to share the fruits of their endeavours. In the summer of 1966 this tension erupted among building workers in Amsterdam. Anger at cutbacks in the holiday pay of non-organized builders led to demonstrations during which a worker died – of a heart attack, as was quickly established. In the ensuing outbreak of violence attacks were launched on the building and a number of trucks belonging to the right-wing daily *De Telegraaf*.

The rapid growth in national welfare was stemmed towards the end of the 1960s. Dutch economic recession was accelerated by the international oil crisis of 1973, when oil prices soared as a consequence of a war between Israel and its neighbours. The Dutch pro-Israel stance was punished by an Arab boycott which for a time completely cut off the Netherlands from supplies of Arab oil. In 1979 the economic crisis worsened and unemployment mounted in the Netherlands, especially in the big cities. Hundreds of thousands, including many school-leavers (young people who had never been in work), depended on social security. Many families who had to subsist on social security for a long time gradually sank into poverty, particularly as rents were increasing rapidly.

From 1982 on, the unions rated work higher than income. As in the 1950s, they recommended great restraint in wage movements. In exchange, they demanded measures which would generate work, such as shorter hours. Nothing much came of this, but restraint in pay rises slowly but surely strengthened the position of Dutch industry. By the end of the 1980s unemployment was gradually decreasing and economic growth accelerating.

In the 1980s, partly due to the enormous strain on social security funds, the government budget deficit increased by leaps and bounds. Government finances threatened to get out of hand, giving rise to discussions about the social security system that had been built up in the course of the twentieth century. Although unemployment had been subsiding since the late 1980s, the government (consisting of Christian Democrats and Socialists since 1989) decided to clip the wings of the Welfare State. The Socialist-Liberal coalition which came into power in 1994 (the first government since 1918 without confessional party representatives) has continued this policy.

Housing shortage

Although most Dutch people had enjoyed a goodly share of the country's increasing prosperity since the late 1950s, there was still one major limiting factor. The nation suffered from a severe housing shortage. This situation actually dated from the 1880s, when there were not enough good, affordable dwellings for the wage-dependent section of the population. The situation was often deplorable in the big cities, where many house-owners shamelessly exploited the scarcity of dwellings by demanding high rents for poor accommodation. To counter this, the Housing Act of 1901 imposed quality standards on new housing construction and made funds available for council housing.

All over the country in the course of the twentieth century, and as a consequence of the Housing Act, housing corporations were set up. They administered thousands of good, cheap dwellings. In many cases the initiative for these corporations was taken by workers' organizations. However, the slump of the 1930s had checked the growth of council housing. Government subsidies dwindled and in some cases even had to be given back, which landed many housing corporations in difficulties. To make things worse, a large number of houses were damaged or destroyed in the war,

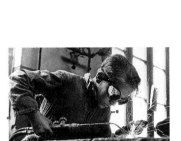
Technical school in the 1940s
Haarlem, Spaarnestad Fotoarchief

notably at the beginning (the bombardment of Rotterdam on May 13 1940) and the end (fierce fighting in towns like Arnhem and Nijmegen in September 1944 and Groningen in April 1945). Bombs dropped by the allies likewise took their toll on towns like Middelburg and The Hague. Although a lot of building went on in the 1950s, the demand for new dwellings still by far exceeded the supply. The explosive population growth after World War Two was partly responsible for this situation. Another reason for the continuing housing shortage was the inadequacy of many old dwellings. Too small, they sometimes lacked such facilities as indoor toilets (certainly no luxury in the Netherlands' long, chilly winters), and were often quite ramshackle. More and more houses were built.

Urban development thrived in this situation. Planners and architects were inundated with commissions and given plenty of freedom to execute their ideas. In the 1950s, traditional builders like M.J. Granpré Molière (1883-1972), a Catholic, gave distinctive form to the reconstruction of Groningen's inner city and to ten of eleven new villages in the North-East Polder, which had been drained during the war. The eleventh village (Nagele) was designed by an innovative collective inspired by pre-war architects such as Hendrik Petrus Berlage (1856-1934) and Duiker.

Modern urban planners like Johannes Hendrik van der Broek (1898-1978) and Jakob Bakema (1914-1981) shaped the reconstruction of Rotterdam's ruined centre. The idea of recreating the old street-plan and buildings was rejected. New shopping streets with modern buildings appeared, echoing pre-war initiatives like the handsome, functionally designed Van Nelle factory built between 1928 and 1930 to the design of Johannes Andreas Brinkman (1902-1949) and L.C. van der Vlugt (1894-1936). Brinkman and Van der Broek also designed the splendid De Kuip football stadium in 1934. In the 1980s and 1990s the 'un-Dutch' expansive scale of Rotterdam building received a fresh impulse in the form of imposing high-rise construction in the heart of the city and a striking waterfront.

Generally speaking, though, Dutch urban construction was not very spectacular. Planners were chiefly concerned with creating an optimum living environment for the average Dutch family. Most dwellings built in the 1950s and early 1960s were in new housing estates on the outskirts of villages and towns. Terraced one-family houses and apartment blocks with no more than four storeys arose, often around small parks or along long, green avenues. In the 1960s the pace increased. Buildings became higher, too: ten floors, twelve, fourteen.

In 1968 the construction began of Bijlmermeer, an enormous Amsterdam suburb consisting of vast blocks of high (by Dutch standards) buildings situated in a huge park with an ingenious system of separate roads for fast and slow traffic. Whereas housing was often cramped in the 1950s, the Bijlmermeer dwellings had plenty of space for families with children to raise, and were designed with people's increased affluence in mind. Things which had not existed at the beginning of the 1950s, or had only been available to the happy few, were now within everyone's reach. Not only was space required for the wall-unit and television set, but also for the refrigerator and washing machine. Bijlmermeer did not have much of an appeal to the Dutch. In the 1970s, though, it became the home of thousands of new Dutch citizens who had come over from Suriname, the South-American Dutch colony which gained independence in 1975. The arrival of the Surinamese, who settled in cities all over the Netherlands, made a major contribution to the Netherlands' transformation into a multi-cultural society.

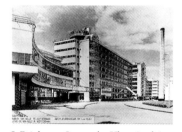

J. Brinkman, L. van der Vlugt (arch.)
Van Nelle Factory, Rotterdam
Nederlands Architectuurinstituut

Dormitory towns and polder towns

But housing programmes were still unable to cope with the growing population. Moreover, living conditions in the big cities in the west of the country threatened to become intolerable due to the fact that too many people were living in old and inadequate houses. The government devised an ambitious physical planning policy intended to relieve the burden of the Randstad (Ring City) – the circle formed by Utrecht, Rotterdam, The Hague, Leiden, Haarlem, Amsterdam, and smaller towns in between. Sleepy commuter villages outside the Ring City were designated as "overspill" communities with housing programmes for the construction of thousands of additional dwellings. At the same time the government stimulated the renovation of old housing in the cities. Of major significance in the 1960s and 1970s was the decision to house part of Amsterdam's growing population in two new towns to be built in Flevoland, the largest polder (built in two stages) in the IJsselmeer. In 1967 the first inhabitants moved into their homes in Lelystad; nine years later, the first Amsterdammers settled in Almere.

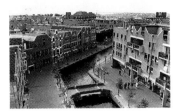

Almere-Haven: housing and shops along the main canal, 1983
Rijksarchief in Flevoland

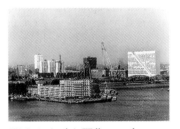

W. Quist (arch.), *Willemswerf office building on the right in 1991*
(Photo Ger van der Vlugt)
Rotterdam, 1991, Nederlands
Architectuurinstituut

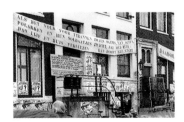

De Groote Keyser, in 1980 an important squatters' stronghold in Amsterdam. The building was purchased by the city council in October for conversion into accomodation for young people
Amsterdam, Gemeentarchief

The original plan for Lelystad was the work of the celebrated architect Cornelis van Eesteren (1897-1988). He designed a city for 100,000 people, a magnificent gesture to crown the imposing land reclamation operation. Lelystad was envisaged along the lines of Amsterdam's Bijlmermeer suburb, with high-rise buildings, separate traffic systems, intersected by highways and a railway line, and presenting a distinctive silhouette. It was also supposed to become a city with a bustling centre, a hive of activity.

Things didn't turn out that way. The government department in charge of the operation did not fancy the plans. Strongly influenced by the traditionalism of the aforesaid Granpré Molière, they favoured a far more conservative approach. Lelystad became a collection of suburbs with a lot of low-rise buildings but lacking a distinctive city centre. Although its planners were inspired by the "New Towns" built in England in the course of the twentieth century, Lelystad cannot hold a candle to Milton Keynes or Stevenage. Many of the inhabitants did not feel at home in Lelystad, which gradually emptied in the 1980s.

The second polder city, Almere, is more of a success. Designed in the 1970s by a team of young planners and social scientists, it has several nuclei and buildings which catered to the requirements of the new population. The first nucleus, Almere-Haven, was meant for people from Amsterdam who were forced to move because of the radical renovation of their neighbourhoods. The design of Almere-Haven's centre is based on the layout of a seventeenth-century port ("Haven" is the Dutch word for port): winding canals lined by narrow roads and buildings which hark back to the famous seventeenth-century houses along the canals of Amsterdam.

The residential neighbourhoods and public buildings which rose in the 1980s and 1990s in Almere-Stad, the city's largest district, exemplify modern construction in the Netherlands. Competitions, ambitious exhibitions, and forward-looking government commissions have produced dwellings and other buildings whose designs and colour schemes make a change from run-of-the-mill Dutch architecture.

Almere is the trend-setter in a development which has yielded attractive – albeit controversial – results elsewhere. The impressive new construction in Rotterdam's city centre and on its waterfront reflect people's confidence in the vigorous Dutch economy, a confidence which has been growing since the latter half of the 1980s. Another striking example is the new Groningen Museum building designed by Italian architect Alessandro Mendini and financed by a donation from the national company which exploits the vast natural gas fields under the North Netherlands. Like Rotterdam's skyline, the Groningen Museum symbolizes the thriving Dutch economy, which runs partly on cheap natural gas. Natural gas is also the source of energy for the country's extensive glasshouse horticulture, a major contributor to Dutch exports.

Squatters

To many people the process of house-improvement and increased housing production was not fast enough. Young people, in particular, were upset at the growing number of buildings left empty when offices and government departments relocated to new, modern premises. In the early 1970s hundreds of squatters, later thousands, occupied these vacant buildings. Loopholes in the law (notably pertaining to tenant protection) prevented the government from dealing effectively with squatters. Nor was there much point in taking action in view of the government's inability to provide adequate housing for the increasingly younger people who were leaving home to live on their own. This resulted in a tolerated subculture of alternative forms of habitation which went hand in hand with a growing political awareness among young people in the 1970s. Amsterdam was a hotbed of resistance to what many saw as the government's overly lax approach to the housing shortage. This was painfully demonstrated in 1975 when construction started on the Amsterdam metro. The plans necessitated the demolition of a large part of one of the city's oldest neighbourhoods. The beginning of the operation was the signal for street battles which the demonstrators vainly waged against the police for several days.

As the 1970s drew to a close the continuing incidence of unoccupied premises sparked off ever more confrontations between the authorities and squatters. The authorities showed signs of wanting to do something about empty buildings, and also about squatters. This more active policy, initiated at the end of the 1970s, was combined with an intensive construction project aimed at housing young people.

The government also purchased many of the buildings occupied by squatters, with whom nego-

tiations were conducted with a view to earmarking the premises for residential purposes. On the other hand, new squatters' actions were treated less leniently. However, many squatters had no intention of giving up the buildings they occupied. Squatting had become a way of life, a counter-movement inspired by British punk culture and imbued with radical political protest. Among those indebted to this subculture is artist Rob Scholte (b. 1958).

Mounting radicalism led to fierce resistance when squatters were forcibly evicted. Under the slogan *Geen woning, geen kroning* (No home, no coronation) demonstrators broke into dozens of vacant premises all over the country on April 30 1980, the day on which Princess Beatrix was installed as the new queen. In Amsterdam, squatters and police engaged in battle almost immediately. Fierce fighting ensued when squatters and other radical demonstrators advanced on the city centre, where the coronation was taking place. As at the wedding of Beatrix and Claus in 1966, a smoke-bomb exploded near the royal procession, but the ceremony itself passed off without a hitch. Growing dissension as to the use of force in evictions, and also against racists, led in the 1980s to the collapse of the squatters' movement, which retired to a few bastions in the big cities.

Unity in division

The Netherlands has always been a country of religious minorities, and still is. From the end of the nineteenth century onwards, large areas of Dutch society were affected by these different outlooks. As a consequence of the efforts to achieve equality of denominational education (anchored in the Constitution in 1917) as described earlier, it became common practice in other sectors for government funds to be shared among the various persuasions. A striking example is the division of broadcasting time on radio (and television).

In the course of the 1920s the possibilities of conveying sound by radiography were explored. The new medium of radio caught on fast in the Netherlands. In 1925 a few pioneers took the initiative of making broadcasts. The electrical concern Philips built a transmitter in the centre of the country. It seemed that the foundations had been laid for a private radio corporation operating on a broad basis. It was not long before the leaders of confessional and political blocs (Catholic bishops, Calvinist pastors, the Socialist party and union leaders) realized that the new medium gave them a great opportunity to disseminate their own particular message. They also realized that they had no control over whether their own followers were receiving the message of other blocs too. Not much could be done about the latter problem, for anyone who owned a radio set could receive everything that was broadcast. It was therefore all the more urgent to claim broadcasting time and make sure that the message reached everyone of the same persuasion.

Towards the end of the 1920s the Calvinists, Catholics, Socialists and Liberal Protestants set up their own broadcasting corporations in rapid succession. The pioneers of the first hour had little choice but to found their own organization on a broad basis and share the ether with everyone else. The government (consisting of Catholics and Calvinists since 1918) anchored this distribution in a Broadcasting Act under the terms of which broadcasting time was shared among the corporations, each of which broadcast its programmes on a fixed evening.

Prime Minister Colijn speaking on the radio, Haarlem Spaarnestad Fotoarchief

Compartmentalization

The proportional division of meagre public funds (the basis of equality in public and denominational education) became the yardstick that was applied to all controversies as to the allotment of public means. In the 1950s, television time was apportioned in exactly the same way as radio time. The distribution of broadcasting time among the different blocs was, besides denominational education, the most striking example of a phenomenon which became universally known in the 1950s as "verzuiling" or compartmentalization. *Verzuiling*, derived from zuil (pillar), is a metaphor for the structure of important elements of Dutch society since 1920. According to this imagery, Dutch society is built on four pillars erected side by side (Catholic, Calvinist, Socialist and Liberal) on which rests the roof – the State and its institutions. In the 1950s and 1960s sociologists and political scientists elaborated on the metaphor in shrewd analyses of power relations in the Netherlands. Notably the political scientists H. Daalder and A. Lijphart each sought an explanation for the stability of Dutch society in the twentieth century, a society which at a first glance seems deeply divided along confessional and political lines.

The very basis of that stability was in fact the nation's consciousness of this division. Spiritual and secular leaders were constantly aware of the need for compromise to prevent the nation from becoming ungovernable. The new elites of radical Liberals, Anti-Revolutionaries and Catholics who held sway around 1880 realized, like their moderate Liberal and Conservative predecessors, that they had to reconcile the stark differences in Dutch society, even if it meant taking no for an answer at times. Their political culture may well have been new in its manifestations (political parties and networks of organizations) and its rhetoric (with its distinctly shrill ideological overtone), but not in its actions and aims. It was an attitude rooted in the seventeenth-century regentesque desire for tolerance and moderation and abhorrence of conflict.

But even a theoretically revolutionary movement like Socialism, which only after 1900 developed into a movement of any significance in the Netherlands, had relatively little trouble in appropriating this attitude. The Socialists demonstrated their willingness to compromise as early as 1902, when the SDAP, albeit after hot internal debate, recognized the right of the confessionals to fund parochial schools. The Socialists' readiness to join the system of 'pillars' was underlined shortly after the outbreak of World War One, when their leader Troelstra told the Second Chamber that his party would set aside current political issues (universal suffrage and social legislation) in order to strengthen national unity.

In making compromises, two related conditions always had to be satisfied. The leaders, the bloc elite, needed the confidence of their supporters. This could only be obtained by satisfying those supporters. Every compromise had to contain elements with which, according to the composition of the government, three of the four (Catholics, Calvinists, Socialists or Liberals) could identify. This was obviously impossible in a number of issues, and this sometimes led to the postponement of decisions until an issue was no longer topical or a new distribution of seats in the government could enable a compromise to be made. The second condition to be met was secrecy. A party's supporters were not supposed to know how far their leadership (usually closely linked with the leadership of the 'pillar') was prepared to go in the matter of compromise. Such obfuscation was (and still is) manifest during the formation of a new government. In the twentieth century elections for the Second Chamber were inevitably followed by a lengthy cabinet formation involving negotiations so secret that not even the members of the Second Chamber were allowed to read reports of discussions. Only the leaders of the major political parties and a highly select group of confidants were involved in negotiations. The requisite official support (in complex legal and financial matters) was stage-managed by the various ministries, which clamped shut like oysters. The best-kept secret is the queen's role in a cabinet formation. Formally she has no influence whatsoever, but in practice she certainly pulls a few strings. The head of State encharges someone to form the new government, formally on the recommendation of the political leaders. In practice, though, especially when there is no outright election winner (as is almost always the case in a land of minorities like the Netherlands), she has a certain amount of discretion to influence the formation of a cabinet. On two occasions the monarch's role was probably of decisive significance. During the formation of a new government at the end of World War Two, Queen Wilhelmina managed to ensure that the new cabinet would be led by politicians who favoured political reforms (in the event, little came of such reforms). And in 1973, Queen Juliana was partly instrumental in getting the charismatic Social Democrat Joop den Uyl appointed prime minister; during the formation of the new cabinet the confessional parties (which had not held a majority in the Second Chamber since 1967) were played off against each other.

In the twentieth century not only cabinet formations but also day-to-day practical politics and important areas of social intercourse have been characterized by obscure decision-making in committees and informal negotiation. The private rooms of clubs where many a nineteenth-century deal was made between Liberal and Conservative gentlemen, have been replaced by the conference rooms of government buildings and the boardrooms of private institutions representing the various blocs. In this way governmental practice was and is kept as untransparent as possible. Interestingly, the press has never shed much of a light on this governmental culture. This was largely due to the fact that the press, too, was compartmentalized up and into the 1960s. The major dailies, often controlled directly by the 'pillar' elite, joined in the game of obfuscation. But even papers without links to a 'pillar', for instance a few independent news weeklies, failed to lift the veil that conceals political and governmental behaviour.

It was the aforementioned political scientist Lijphart who pointed out that the success of com-

partmentalized society depended on the strict conditions to be met not only by the elite but also by its supporters, who likewise had to fit perfectly into the compartmentalized pattern. Among other things this called for a great willingness among supporters to trust what the elite was doing. Solving problems and conflicts had to be left to the pillar elite. There could be no question of direct confrontations with supporters of other 'pillars'. And even in their own compartment, supporters had to adopt a passive attitude and trust the actions of its elite (clergy, politicians, trade union leaders).

Another characteristic of adherents to a particular 'pillar' was their loyalty to it. This automatically meant that the average Dutch person was expected to associate only with those of the same religious persuasion and was definitely not supposed to marry anyone of a different faith. The Catholic and Protestant clergy, mindful of its responsibility, passionately opposed mixed marriages until far into the 1950s. Contacts between young people of different religions were prevented as far as possible. Denominational education played an important role here, especially denominational secondary schools. Leisure activities were also compartmentalized – sports, for example, partly because of the Calvinists' refusal to participate on Sundays (the day of the Lord). Also compartmentalized were a wide range of boys' and girls' clubs and student associations.

Since the 1920s there had been an explosion of associations for a motley array of social activities segregated according to the various political or confessional blocs. It was important to belong to one's own trade union, employers' organization or farming union. People were also expected to be members of their own broadcasting corporation (and not listen to the programmes of another), and to read their own newspaper.

Sports enjoyed the sustained attention of the 'pillar' leadership until well into the 1950s. A Calvinist did not indulge in sports on a Sunday. In predominantly Calvinist communities the local authority forbade and opposed any form of sabbath activity. In such towns latitudinarians and agnostics were prevented from, or had great difficulty in, organizing activities on Sundays, for many people their only day off. Catholics were less stringent in their observance of the Sabbath-day commandment, but did keep a sharp eye on the separation of the sexes. In the case of Catholic gymnastics this even led to the devising of special exercises to be performed in a kind of uniform which completely covered the gymnast's body and limbs.

Religious adherence dominated class distinctions. This was particularly the case with the Catholic bloc, where class distinctions were most in evidence. Most workers were Catholics or Socialists, most big businessmen were Catholics or Liberals. The middle classes tended to consist largely of Calvinists. By dint of compartmentalization the Catholics endeavoured to complete their emancipation and become fully integrated Dutch citizens; on the other hand, the Catholic clergy endeavoured to keep the Catholic workers in the Church, also by dint of compartmentalization. They were extremely successful in achieving this. The Socialists had great difficulty in reaching Catholic workers. Indeed, Socialism was signally unsuccessful in making any headway in the predominantly Catholic industrialized areas in the east and south of the country.

The limits of compartmentalization

'Pillar' is a nice metaphor and as such a simplification of reality. It is a bold image well suited to characterizing the political relations as described above, although to put things in their proper perspective it should immediately be pointed out that cooperation between the 'pillar' elites on a governmental level was restricted to the Catholics and Calvinists between 1918 and 1933. The Liberals (who had suffered heavy losses in the first elections to be held after universal suffrage had been introduced) did not enter government until 1933, when the economic crisis was at its worst. Not until August 1939, on the eve of World War Two, did two Socialists have seats in the government, much later than in neighbouring countries like Belgium and England.

An important limiting factor to the 'pillar' metaphor was furthermore the virtual impossibility of compartmentalizing the Dutch arts, although it was not for want of trying on the part of the various elites. Of course there were writers and painters who were inspired by their religious or Socialist convictions, but this rarely produced an art that was entirely at the service of such ideologies. Even so, many artists did derive their subject-matter from their inner convictions. But the work of artists inspired by their religion or their politics, for example the Catholic painter Jan Toorop (1858-1928) or the Socialist poet Herman Gorter (whose best work, incidentally, was

Meeting of the socialist Workers' Youth Headquarters (SDAP), *dancing round the maypole,* Haarlem Spaarnestad Fotoarchief

Henriëtte Roland Holst on social commitment among non-Socialist poets, 1929

Among non-Socialist poets sympathy tends to be infinitely more limited than among Socialist ones [...] Feelings of sympathy arouse the poetic mood of non-Socialist poets; those feelings are released in that idea and then it is over and done with. In Socialist poets, every surge of sympathy is spontaneously associated with an entity, a system of emotions, notions, and ideas which together form the Socialist view of life and the world. It is absorbed into that system. It is nurtured by all the juices, all the forces, enriching the system in turn with its own juice, its own life-force.

H.R. Holst, *Tijdsignalen. Bloemlezing uit moderne revolutionaire poëzie* Amsterdam, 1929

written before he became a Socialist), refused to be compartmentalized. A writer such as Frederik van Eeden (1860-1932), despite his social conscience, was too much of an individualist to assume the mantle of Socialism. As a Dutch exponent of the Romanticism that emerged at the turn of the century, he took refuge in a hyper-individual, mystical form of Christianity.

The group of artists known as De Stijl banded together in 1917, the year in which compartmentalization became anchored in the Constitution. De Stijl's reputation spread far beyond the Dutch frontiers. The abstract work of its members, Piet Mondrian and Theo van Doesburg (the pseudonym of C.E.M. Küpper, 1883-1931), and the architecture of Gerrit Thomas Rietveld (1888-1964), and Jacobus Johannes Oud (1890-1963), whose work reflected the idiom of Neue Sachlichkeit (New Objectivity), were not amenable to compartmentalization.

Nevertheless, to a certain extent architects and planners certainly were inspired by ideological principles. This was suggestively apparent in the work of Granpré Molière, the planner referred to above who after his conversion to Catholicism advocated a return to traditional architectural styles. Granpré Molière gave form to the landscape and settlements in two large areas of land reclaimed in the 1930s and 1940s. It was in designing agricultural polderland that he and his fellow-members of the Delft School could give full rein to their traditionalistic views.

The socially committed architect Berlage, famous for his magnificent Stock Exchange (ironically a stronghold of capitalism, built between 1898 and 1903) in the heart of Amsterdam, expressed that commitment mainly in his plans for dwellings and residential estates where Amsterdam workers could enjoy every amenity. The Catholic architect Petrus Josephus Hubertus Cuypers (1827-1921) designed many a church and made no secret of his source of inspiration, expressed in a penchant for neo-Gothic elements. He also designed two of Amsterdam's most famous profane buildings: the Rijksmuseum (1876-85) and the central station (1881-89).

Remarkably, the critic and essayist Menno ter Braak (1902-1940), one of the most important Dutch literary figures of the interbellum, took up the cudgels against society's compartmentalized character. In the review *Forum*, which he co-edited, he censured the petty-minded parochialism that held the country in its grip. By no means did this mean that Ter Braak was averse to pronounced political opinions. On the contrary, he reproached such intellectuals as the historian Johan Huizinga (1872-1945) for a lack of commitment, and defended the work of the left-wing historian Jan Romein (1893-1962), whose Marxist sympathies, however, he did not share.

Ter Braak demonstrated his commitment in the stance he adopted against Fascism in the 1930s. At his side, incidentally, he found the leading Catholic poet of the period, Anton van Duinkerken (the pseudonym of W.J.M.A. Asselbergs, 1903-1968). Generally speaking, literary figures, whether grouped around the non-denominational review *Forum*, the Catholic *De Gemeenschap* or the Protestant *Opwaartsche Wegen*, were against what they called "narrow-minded bad taste". By this they meant commercial cinema with its mass audiences, and popular, non-literary reading matter. Basically they despised the masses who so meekly succumbed to compartmentalization. After the German invasion Ter Braak took the ultimate consequence of his literary and political engagement. Refusing to bow to Fascism, he committed suicide on May 10 1940.

In 1947 the young writer Van het Reve joined the fight against the stuffy narrow-mindedness of the times. In his novel *De avonden* (The Evenings) he attacked the Netherlands' bourgeois climate with a penetrating and devastating account of the lack of understanding and inability to communicate in a postwar Dutch family. Writers J.M.A. Biesheuvel (b. 1939), Maarten 't Hart (b. 1944) and Jan Wolkers (b. 1925) settled scores with the smothering Calvinist atmosphere in which they grew up. Their work goes into many printings, evidence of the subject-matter's appeal to a broad public.

Compartmentalization - decompartmentalization

The 'pillars' survived the German occupation. In the first postwar decade they were more than just a metaphor. Social scientists studied them as a genuinely existing social phenomenon. More explicitly than between the wars, compartmentalization was the basis on which government subsidies were distributed and according to which the limits of government policy were defined. Even so, the 1950s saw the beginning of the end of compartmentalization. Its dismantling was a somewhat diffuse process which cannot really be linked with a marked turning point or attributed to a few determining factors. Combined factors in that process were rapidly growing prosperity and the dwindling need for Churches to impress their stamp on so-

Paul Citroen, *Menno ter Braak*
oil on canvas, The Hague
Nederlands Letterkundig Museum
en Documentatiecentrum

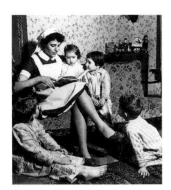

Family welfare in the 1950s
Haarlem, Spaarnestad Fotoarchief

Secretary of State Cals opening the first evening of television broadcasting in 1951, Haarlem Spaarnestad Fotoarchief

ciety. A look at changes in social welfare, traditionally the most important social area in which the Churches were involved, illustrates the complexity of the decompartmentalization process. After 1945, when unemployment disappeared and the social security system was soon installed, private (mainly church) organizations no longer bore the responsibility for the material welfare of the poor and the jobless and sought fresh pastures for their charitable activities. Post-1945 social welfare turned to solving individual problems of a non-material nature (marital and child-raising difficulties, alcoholism) and to combating socially undesirable behaviour. This resulted in a ramified network of facilities ranging from maternity and family care to ambulant mental health care and aid for drug addicts. This work was done by private, State-subsidized institutions.

The emphasis on non-material welfare led to the introduction of new methods based partly on the American example. Social welfare no longer centred on religious-ideological notions as the most desirable form of aid. Social workers examined the problem and personality of the person seeking help. This led to the rapid professionalization of social assistance in the 1950s. Provision was quickly made for vocational training institutions, which became breeding grounds for modern methods and techniques. Professional codes replaced religious creeds, while clients were helped regardless of their ideological persuasion.

Welfare organizations were, however, compartmentalized (Protestant, Catholic or neutral). Representatives of Churches and other 'pillared' organizations dominated the executive boards of aid bodies. This was typical of the 'pillar' system. The 1950s saw the formation of ramified networks consisting of the executive bodies of 'pillared' organizations. Union leaders also ran housing associations and broadcasting corporations; politicians came from, for instance, educational and agricultural organizations.

These networks survived for a long time, in social welfare too. The traditional executives continued to watch over a confessional or political identity which had long since vanished in daily practice. Although the institutions themselves were still neatly separated, in practice they were often already collaborating in health centres, family welfare offices, marriage counselling, district nursing, facilities which were appearing in all the big cities and in rural areas too.

State-imposed integration sealed the process of professionalization and collaboration that had begun in the 1950s. In the 1960s the government became disinclined to grant subsidies to maintain the 'pillar' system, since in practice the activities of welfare institutions no longer had anything to do with ideological principles. The State demanded that the various institutions cooperate, even if this entailed the loss of confessional or political identity. Far-reaching forms of cooperation, on an executive level too, were the consequence. This inevitably led to the fusion of institutions of different 'colour', so that by the early 1980s few signs of 'pillarization' still survived in welfare.

Television

When, from 1958 on, wage-earners became able to share in the Netherlands' prosperity, there was a run on durable consumer goods such as cars, washing machines and television sets. The latter brought the world into hundreds of thousands of living rooms.

In the 1930s, 1940s and 1950s the radio had strengthened rather than weakened compartmentalization. The broadcasting 'pillars' had their hundreds of thousands of members who were tethered to their 'pillars' not only by their radios but also by their programme guides and major events. Many of them listened only to broadcasts of their own 'colour'. Many radios were only switched on for certain popular programmes. The whole family would listen to a play or a speech, at the end of which the radio was switched off. In the meantime the members of the family could perform some domestic task or play a game.

The advent of television had a different effect. To start with, seeing programmes was quite different from listening to them. Television, a highly expensive purchase in its early years, led to a special kind of viewing behaviour. The owner of a set viewed all the programmes on offer, and it was not uncommon for neighbours who did not have television to come over and watch too. Added to this was the fact that television is a much more direct medium than radio. No longer did the Dutch people need to be told what was going on in the world by a preacher from the pulpit, by the newspaper or by the radio. He could see for himself. German television programmes could also be received in much of the country. The Dutchman's view of the world was no longer determined by his country's 'pillared' television programmes; he could now see the more outspoken German version of world news if he chose. The Germans also showed forms of television

amusement deemed too daring in the Netherlands. The result of all this was that the Dutch came to apply different criteria to their programmes. Dutch television developed by leaps and bounds in the 1960s. Critical current affairs programmes were unawed by established reputations. Shocking images belied the reassuring words of American politicians about Vietnam. The Dutch could no longer shut their eyes to world hunger when proof of it was delivered into their very homes. Satirical programmes became harsher, partly due to the British influence.

The 'pillars' were crumbling. Notably the Catholic Church lost its hold on large areas of society. This was partly due to cultural change within the Catholic Church itself. The Dutch bishops felt it less and less incumbent upon themselves to control people's social activities. Conversely, the average believer felt less and less inclined to listen to the weekly message from the pulpit. Church attendance dwindled in the 1960s, a development illustrated by the fewer churches built in new residential suburbs and in new population centres like the villages in the reclaimed IJsselmeer polders. In any case, new churches were often shared by different congregations. Of the other major denominations, the Dutch Reformed Church had been suffering from diminishing membership and attendance since the turn of the century. On the other hand, the Calvinist Reformed Churches maintained their position well into the 1980s.

In leisure activities and sports, the relationship between a person's religion or politics and his social activities began to disappear in the early 1960s. Oddly enough, Saturday was still the day for sporting activities, although only some of those who indulged in Saturday sports were principally opposed to sporting activities on Sundays. Increasing leisure time meant that many people preferred to keep Sunday for family activities. In the 1960s, then, the Dutch climbed into their new cars *en masse* to drive somewhere or other. Traffic jams and roadside picnicking were the result. Many people preferred to schedule their sporting activities on the free Saturday they had obtained when the forty-hour week was introduced in 1960.

The postwar generation as the carrier of decompartmentalization
"The hand that rocks the cradle rules the world", to paraphrase a Dutch proverb. As outlined above, an essential factor of compartmentalization was a ramified network of youth associations oriented towards their own particular confessional-political blocs. They maintained close links with the Church, or in the case of Socialist youth organizations, the party. The majority of young Christians also attended Catholic or Calvinist schools, thus obtaining their education entirely within their own 'pillar'. Compounded with the Christian sports clubs and a rigid morality in sexual matters, this conjures up an oppressive atmosphere of religious meddling. This climate was probably taken for granted up to World War Two. Many youngsters seldom or never came into contact with people who held views different to their own. And even when they did, they saw that the rules of behaviour were not all that different. In Socialist circles, too, sexual morality was strict and youngsters were supposed to join Socialist clubs wherever possible.

Slackening standards during the war and the jubilation occasioned by the Liberation triggered something during those first summer months after the German occupation. Dutch girls succumbed to the charms of bold American and Canadian soldiers. Many marriages of longer standing proved unable to withstand the strain of war. The result was a surge of divorces, weddings and births in the first postwar years.

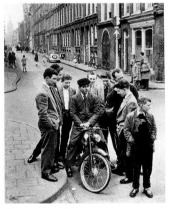

Young Amsterdammers in 1956
Photo Louis van Paridon, Haarlem
Spaarnestad Fotoarchief

The liberators brought their culture along with them, a culture which appealed to many young people but had no place in their 'pillared' activities. Dutch youngsters were hearing new sounds on the radio. Jazz was more exciting than before the war. A Lionel Hampton concert in Amsterdam in September 1954 provoked unprecedented reactions: the audience got up and danced, urged on by the charismatic bandleader. The advent of rock 'n roll led to even wilder scenes, and in some places the film *Rock Around the Clock* sparked off rowdyism.

Worried politicians and clergymen expressed their concern about the moral decay of young people. Behavioural scientists published fat reports. It was patently clear that many youngsters no longer felt bound by the values and standards with which their parents had grown up. The generation born shortly before, during or soon after World War Two seemed to have slipped out of the 'pillars' grasp. This was particularly true of young people in the big cities, and even in rural areas there were signs of impending change.

Greater prosperity meant that youth culture was becoming a material culture. Before the war, youngsters had been condemned to activities which cost nothing or very little, such as staying at

home or joining Church-run clubs. During the economic recession of the 1930s they had been unable to afford the cinema or trendy clothes. This situation soon changed when the war ended, due less to the rapid growth in prosperity for most people (which did not become apparent until the late 1950s) than to the fact that many youngsters started working after only a few years of secondary education. There were plenty of jobs to be had in the Netherlands, where thanks to Marshall Aid from America war damage was being repaired at a brisk pace, and where the government was supporting industrial development. Young people had money and were eager to spend it, preferably on enjoying themselves after a hard week's work. To get away from the tame programmes of the Dutch broadcasting corporations they bought their own radios and tuned in to more exciting stations like Radio Luxemburg, which played the latest American music. They went to the movies and identified with the characters played by James Dean and Marlon Brando – good-looking, nihilistic anti-heroes eternally at odds with their elders. Traditional activities had lost their appeal to the young. The writing on the wall was plain for all to see when the Socialist Workers' Youth Centre, one of the country's largest youth organizations before the war, disbanded in 1958. Young workers had lost their interest in traditional Socialism. A multitude of youngsters eagerly snapped up music magazines which carried reports on the stars of the day and focused increasingly on the rock 'n roll culture. Magazine publishers realized that there was a growing market for their products, and a few enterprising young people were given the chance to produce their own magazine. The younger generation now had its own mouthpiece which addressed such matters as sex and new music seriously at last. Magazines for the young generation acted as a crystallization point for culture in the 1960s. The effect of this new openness on Dutch mass culture was demonstrated by the changed face of women's magazines, traditionally decent, stodgy publications with a huge readership of housewives. In the 1960s subjects such as marital problems and sex found their way in to the columns of women's magazines to the horror of some readers but, judging by the undiminished number of subscribers, perfectly satisfactory to the vast majority.

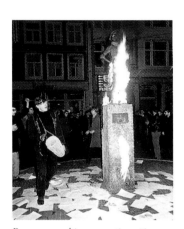

Provo engaged in provocative action on Spui Square, Amsterdam, in March 1966 (Photo ANP)

Countercurrents

1965 saw the appearance of Provo in Amsterdam. With its amusing actions and inflammatory pamphlets the movement was soon on a collision course with the authorities. Provo's activities were aimed at ridiculing the modern consumer society. The movement favoured alternative habitation forms and propagated free love and drug-taking. Reactions from the media were mixed. The police usually maintained a low profile, taking action only when public order threatened to become seriously disrupted. The driving forces behind Provo were the artist Robert Jasper Grootveld and the student drop-out Roel van Duijn. It was Van Duijn who gave Provo a political charge by coupling its derision of consumerism with attacks on American imperialism in South-East Asia. Most Provos, though, were chiefly opposed to the TV-watching middle classes, thus assuming the legacy of the interbellum writers who (albeit not in the streets but in their distinguished reviews) had once attacked bourgeois compartmentalization.

Provo was the prelude to the politicized movements whose voices began to be heard towards the end of the 1960s. Their prime aim was the democratization of the universities. Mounting worry about the endangered environment, concern for the plight of the Third World, and opposition to continuing arms programmes (and until 1975 to the war in Vietnam) led to a motley array of action groups and political movements. Social discontent also took root in the fast-growing number of university students, many of whom in the 1970s showed themselves to be susceptible to criticism of society, occasionally couched in ponderous Marxist rhetoric. Not only, the younger generation was concerned about the environment, issues of war and peace and the world food problem. The Church, too, showed signs of political awareness, particularly in its concern for the Third World. Instead of its traditional task of caring for its own poor (a task which had been taken over entirely by the State and professional welfare organizations), the Church now turned its attention to the oppressed and starving in Africa and Asia and took a firm stand against apartheid in South Africa. The nineteenth-century urge to spread Calvinist or Catholic Christianity among the primitive pagans in deepest Africa was replaced by a pragmatic need to give the Third World a share in modern welfare and health care.

Feminism, too, which had burgeoned at the beginning of the twentieth century in the fight for female suffrage (introduced in 1922), reappeared. Since 1967 women had been making it clear that they would no longer put up with their subordinate position in Dutch society. Since the

Gerard Kornelis van het Reve on social criticism, 1971

As an artist the best you can do is make your work as exciting as possible and not give a shit about anything else. And take sides with the powers-that-be, if you want to be left reasonably in peace. I'm all in favour of the establishment because I know what I get out of it: not too much trouble and virtually complete freedom. What the opposition wants sounds rather horrible to me. Especially that strange primeval urge to bring people to art is something I totally fail to comprehend. In practice it means bringing art to the people, because the people are certainly not going to take one step towards art in order to understand it. I must say that I'm more for regimes which refrain from this kind of dangerous interference. Let's hope I'm never given a chance to do 'useful' work or 'help build a better world'. Odd, too, that resistance to 'the established order', a term buzzing around all over the place these days. Order *is* established, isn't it? It is the very nature of order to be established. The expression wrongly suggests that a different order is possible. Another curious thing is this unhealthy respect for all things young: 'young readers', 'young artists', and, in general, 'the young'. Why should they be more entitled to speak than the rest? It is just as absurd as believing that 'workers and peasants' should be given power. Why? Where does it say so in any scripture inspired by the Holy Ghost? To me they are a category of people to whom I would gladly grant full civil rights, but the very last who should be deemed worthy – to the exclusion of all others, to boot! – of governing!

G.K. van het Reve, *De taal der liefde* Amsterdam, 1971. Letter to the Dutch writer/columnist Simon Carmiggelt from Les Chauvins (France) October 27 1971

1920s women's status had been unchallenged. A married woman was supposed to stay at home and take care of the household. If she did have a job (which was rarely the case), she had less pay and fewer legal rights than her male colleagues. Despite the introduction, in the 1970s, of legislation against unequal treatment for women, little was done about equal pay for men and women. Even so, the percentage of working wives grew, and schemes and provisions such as maternity leave and crèches were introduced.

But other reasons prompted women to creep out of their shells in the late 1960s. Feminists demanded legalized abortion and demonstrated for the right to terminate a pregnancy if they saw fit. This was a highly sensitive issue in a country still dominated by Christian values. As long as Catholics and Calvinists held key positions in national politics, legalized abortion seemed out of the question. Even though the confessional parties no longer held a parliamentary majority after 1967, no government could be formed without them because of the fierce antagonism that existed between Socialists and Liberals (a situation which lasted until 1994). The abortion issue was therefore shelved. In 1976 a solution seemed to be in the offing when Socialists and Liberals reconciled their viewpoints in the Second Chamber. The First Chamber torpedoed the bill however, abetted by the intervention of the chairwoman of the Liberal party.

Politics were, however, more intransigent than practice. For years women had been able to have pregnancies which had not progressed beyond eighteen weeks terminated under proper medical supervision and at a low cost in abortion clinics up and down the country. The government did nothing about this situation. However, the illegal but tolerated practice was a thorn in the side of confessional politicians, which is why in 1980, with support from the Christian Democrats (the Catholics and Calvinists had merged into a single party in 1977), abortion was finally legalized. Pregnancies could now be terminated on condition that a woman let five days elapse between two medical consultations and could convince the doctor that her decision was well-founded. There also had to be confirmation that continuance of a pregnancy would cause physical or mental distress. The cost of abortion was to be borne by the State. Although the limiting clauses suggest differently, the law does not impede current abortion practice. It should, however, be pointed out that the abortion percentage in the Netherlands is extremely low, partly due to the vast number of women who have been taking the anti-conception pill since the early 1960s.

People concerned about the environment and nuclear armament took to the streets at the end of the 1970s. In 1979 and again in 1980 thousands of demonstrators blocked the gates to one of the country's two nuclear power-stations in a fruitless attempt to get it shut down. More impressive was the broad opposition to nuclear armament and in particular to NATO's plans (supported by the Dutch Christian Democrat and Liberal government) to deploy new nuclear missiles in Europe, ready to be fired at Eastern Europe. Church peace groups were behind the protests. In November 1981 a wave of similar demonstrations in West-European cities climaxed in a 400,000-strong march through the streets of Amsterdam. Two years later more than half-a-million demonstrated in The Hague. According to opinion polls the marchers represented a large majority of Dutch people opposed to the deployment of new nuclear weapons. This did not affect Dutch government policy, which upheld NATO decisions. It was only thanks to the relaxation of East-West tension when Mikhail Gorbachev assumed power in the Soviet Union that no new missiles were placed in the Netherlands.

Mass national protests abated in the latter half of the 1980s. The thaw in East-West relationships and the collapse of Communism in East Europe, followed by substantial disarmament in East and West, made the broad peace movement superfluous. Furthermore, apartheid in South Africa was dismantled. Most of the young generation of students and unemployed people who had enthusiastically rallied to the protest movement now turned their attention to more individual activities. Many of them sought and found work, and started families.

The Netherlands and the Dutch: steady and safe

A new era of Dutch history dawned around 1880. The traditional power relationships of the Republic had been replaced by an open, democratic political system. It was a climate conducive to the development of new powers in society, such as Catholicism and the Anti-Revolutionary movement, before Socialism got a chance to make an impression on social relationships. Economic crises in the nineteenth and twentieth centuries did not generate violent social conflicts, despite

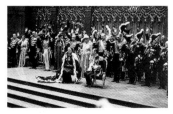

Queen Juliana during the coronation with Prince Bernhard at her side September 6 1948 (Photo ANP)

the misery they caused. Religious division prevailed, and determined the face of the modern, twentieth-century Netherlands. Of decisive importance here was that the different movements were able to realize their aims through the State. National institutions and government schemes designed to protect the underprivileged and distribute the meagre public funds were the binding factors in the Dutch nation.

Even after 1880 the Netherlands retained distinctive traits which had been formed in the period of the Republic. Dutch society remained open and tolerant, even if a number of leading Dutch artists and writers did feel unappreciated by their countrymen. The social fabric was pervaded by a willingness to compromise and to accept pragmatic solutions. This explains how, in a nation whose political arena was dominated by Christian parties, a liberal abortion practice could thrive. Above all, the Netherlands is characterized by an extremely restrained form of nationalism, expressed largely in calm pride at exceptional achievements (notably in sport, but also in the field of hydraulic engineering), and in an equally steadfast adherence to the House of Orange. The troubled period of neutrality during World War One generated a remarkable sense of solidarity. During these years the Socialists temporarily abandoned their struggle, and it was unanimously decided to end the school-funding controversy, introduce universal suffrage and reclaim the Zuyder Zee, a project whose cost could scarcely be envisaged in 1918. Although in many aspects World War Two signified a breach with the past (neutrality was abandoned, and the ravages of war entailed a restructuring of the economy), political and social relationships were unchanged in 1945. Nor did the apparently violent social disturbances in the 1960s, 1970s and early 1980s really jolt existing relationships. On the contrary, the government's flexible attitude to the squatters' movement (except for the odd excess) and its pragmatic solution to the abortion issue are an indication of how shock-proof the State of the Netherlands really is.

One might say that the country's physical geography compels its citizens to have faith in the government. The Netherlands and the Dutch need permanent protection from the menacing water, a menace which can only be averted, as the disastrous floods of 1953 showed, by dint of immense exertions on the part of the State and the investment of millions of guilders. This is what constitutes the nature of the relationship between the Dutch and the State of the Netherlands: an individual willingness to make sacrifices for the benefit of many and ultimately of oneself. In return for passive self-sacrifice in times of economic crisis, war, reconstruction, and renewed economic crisis, the Dutch are quite confident that the State will supply a high-quality infrastructure, protect the country from water, insure the individual citizen against loss of income, support him in times of social or psychic need and provide a roof over his head.

Almere, August 26 1996

Bibliographical Note

Algemene Geschiedenis der Nederlanden, 1-15, Haarlem, 1977-83; *Biografisch Woordenboek van Nederland*, I-IV, 's-Gravenhage, 1979-94; *De dagboeken van Anne Frank*, 's-Gravenhage-Amsterdam, 1986; *Het spoor. 150 jaar spoorwegen in Nederland*, Utrecht-Amsterdam, 1989; BANK, J.; VOS, C., *Hendrikus Colijn. Antirevolutionair*, Houten, 1987; BAX, E.H., *Modernization and cleavage in Dutch society. A study of long term economic and social change*, Groningen, 1988; BLOEMGARTEN, S., *Henri Polak sociaal democraat 1868-1943*, Amsterdam, 1993; BLOM, J.C.H., *Crisis, bezetting en herstel. Tien studies over Nederland 1930-1950*, 's-Gravenhage, 1989; BLOM, J.C.H. et al. (red.), *Geschiedenis van de joden in Nederland*, Amsterdam, 1995; BOOGMAN, J.C., *Rondom 1848. De politieke ontwikkeling van Nederland 1840-1858*, Bussum, 1978; BOSMA, K., *Ruimte voor een nieuwe tijd. Vormgeving van de Nederlandse regio 1900-1945*, Rotterdam, 1993; BOSMA, K.; ANDELA, G., "Het landschap van de IJsselmeerpolders", in *Het nieuwe bouwen. Amsterdam 1920-1960*, cat. Stedelijk Museum, Amsterdam, 1983, 142-74; BOSMA, K.; WAGENAAR, C. (red.), *Een geruisloze doorbraak. De geschiedenis van architectuur en stedebouw tijdens de bezetting en de wederopbouw van Nederland*, Rotterdam, 1995; DAALDER, H., *Ancient and modern pluralism in the Netherlands*, Cambridge, 1989; DAALDER, H., "Consociationalism, center and periphery in the Netherlands", in P. TORSVIK (ed.), *Mobilization, center-periphery structures and nation-building. A volume in commemoration of Stein Rokkan*, Bergen, 1981; DAALDER, H., "The Netherlands: opposition in a segmented society", in R.A. DAHL (ed.), *Political oppositions in western democracies*, New Haven, 1966; DAALDER, H., *Van oude en nieuwe regenten. Politiek in Nederland*, Amsterdam, 1995; DE HAAN, H.; HAAGSMA, I., *De Deltawerken. Techniek, politiek, achtergronden*, Delft, 1984; DE JONG, L., *Het Koninkrijk der Nederlanden in de Tweede Wereldoorlog*, 1-14,

's-Gravenhage, 1969-91; DE KWAASTENIET, M., *Denomination and primary education in the Netherlands (1870-1984). A spatial diffusion perspective*, Amsterdam-Firenze, 1990; DE LIAGRE BÖHL, H.; NEKKERS, J.; SLOT, L. (red.), *Nederland industrialiseert! Politieke en ideologiese stijd rondom het naoorlogse industrialisatiebeleid 1945-1955*, Nijmegen, 1981; DEN HOLLANDER, A.N.J. et al. (red.), *Drift en koers. Een halve eeuw sociale verandering in Nederland*, Assen, 1962; DERCKSEN, A.A.M.; VERPLANKE, L.H.J., *Geschiedenis van de onmaatschappelijkheidsbestrijding in Nederland, 1914-1970*, Utrecht, 1987; DE ROOY, P., *Crisis in Nederland. Beelden en interviews uit de jaren dertig*, Rijswijk, 1981; DE ROOY, P., *Werklozenzorg en werkloosheidsbestrijding 1917-1940. Landelijk en Amsterdams beleid*, Amsterdam, 1979; DE WIT, C.H.E., *De strijd tussen aristocratie en democratie in Nederland 1780-1848. Kritisch onderzoek van een historisch beeld en herwaardering van een periode*, Heerlen, 1965; DRUKKER, J.W., *Waarom de crisis hier langer duurde. Over de Nederlandse economische ontwikkeling in de jaren dertig*, Amsterdam, 1990; DUFFHUES, T.; FELLING, A.; ROES, J., *Bewegende patronen. Een analyse van het landelijk netwerk van katholieke organisaties en bestuurders 1945-1980*, Nijmegen, 1985; ELLEMERS, J.E., "Pillarization as a process of modernization", *Acta Politica*, 19, 1984, 129-44; GRIFFITHS, R.T. (ed.), *The Netherlands and the integration of Europe 1945-1957*, Amsterdam, 1990; GROENVELD, S., *Huisgenoten des geloofs. Was de samenleving in de Republiek der verenigde Nederlanden verzuild?*, Hilversum, 1995; GROENVELD, J., *Veranderend Nederland. Een halve eeuw ontwikkelingen op het platteland*, Maastricht-Bruxelles, 1985; HARMSEN, G.; REINALDA, B., *Voor de bevrijding van de arbeid. Beknopte geschiedenis van de Nederlandse vakbeweging*, Nijmegen, 1975; HENDRIKS, J., *De emancipatie van de gereformeerden. Sociologische bijdrage tot de verklaring van enige kenmerken van het huidige gereformeerde volksdeel*, Alphen, 1971; ISRAËL, J.I., *The Dutch Republic. Its rise, greatness, and fall. 1477-1806*, Oxford, 1995; JACOB, M.C.; MIJNHARDT, W.W. (ed.), *The Dutch Republic in the eighteenth century. Decline, enlightenment and revolution*, Ithaca, 1992; JANSEN VAN GALEN, J.; SCHREURS, H., *Het huis van nu, waar de toekomst is. Een kleine historie van het Stedelijk Museum Amsterdam, 1895-1995*, Amsterdam, 1995; KNIPPENBERG, H., *De religieuze kaart van Nederland. Omvang en geografische spreiding van de godsdienstige gezindten vanaf de Reformatie tot heden*, Assen, 1992; KNIPPENBERG, H.; DE PATER, B., *De eenwording van Nederland. Schaalvergroting en integratie sinds 1800*, Nijmegen, 1988; KOSSMANN, E.H., *De lage landen 1780-1980. Twee eeuwen Nederland en België*, 2 delen, Amsterdam-Bruxelles, 1986; KUIPER, J.A., *Visueel & dynamisch. De stedebouw van Granpré Molière & Verhagen 1915-1950*, Delft, 1991; LEEB, I.L., *The ideological origins of the Batavian revolution. History and politics in the Dutch Republic 1747-1800*, The Hague, 1973; LIJPHART, A., *The politics of accommodation. Pluralism and democracy in the Netherlands*, Berkeley, 1968; NEY, R., *De organisatie van het maatschappelijk werk*, Zutphen, 1989; RASKER, A.J., *De Nederlandse Hervormde Kerk vanaf 1795. Geschiedenis, theologische ontwikkeling en de verhouding tot haar zusterkerken in de negentiende eeuw*, Kampen, 1986; RIGHART, H., *De eindeloze jaren zestig. Geschiedenis van een generatieconflict*, Amsterdam, 1995; RIGHART, H., *De katholieke zuil in Europa. Een vergelijkend onderzoek naar het ontstaan van verzuiling onder katholieken in Oostenrijk, Zwitserland, België en Nederland*, Meppel, 1986; ROGIER, L.J.; DE ROOY, N., *In vrijheid herboren. Katholiek Nederland 1853-1953*, 's-Gravenhage, 1953; RÜTER, A.J.C., *De spoorwegstakingen van 1903. Een spiegel der arbeidersbeweging in Nederland*, Nijmegen, 1978; SCHAMA, S., *Patriots and liberators. Revolution in the Netherlands, 1780-1813*, New York, 1977; SCHAMA, S., *The embarrassment of riches. An interpretation of Dutch culture in the Golden Age*, New York, 1987; STEININGER, R., *Politisierung und Integration. Eine vergleichende Untersuchung der strukturellen Versäulung in den Niederländen und in Österreich*, Meisenheim am Glan, 1975; STUURMAN, S., *Verzuiling, kapitalisme en patriarchaat. Aspecten van de ontwikkeling van de moderne staat in Nederland*, Nijmegen, 1983; STUURMAN, S., *Wacht op onze daden. Het liberalisme en de vernieuwing van de Nederlandse staat*, Amsterdam, 1992; TEN NAPEL, H.M.T.D., *"Een eigen weg". De totstandkoming van het CDA (1952-1980)*, Leiden, 1992; TE VELDE, H., *Gemeenschapszin en plichtsbesef. Liberalisme en nationalisme in Nederland, 1870-1918*, 's-Gravenhage, 1992; VAN DER VEN, G.P. (red.), *Leefbaar laagland. Geschiedenis van de waterbeheersing en landaanwinning in Nederland*, Utrecht, 1993; VAN DISSEL, A.M.C., *59 jaar eigengereide doeners in Flevoland, Noordoostpolder en Wieringermeer. Rijksdienst voor de IJsselmeerpolders 1930-1989*, Zutphen, 1991; VAN DOORN, J.A.A., "Verzuiling: een eigentijds systeem van sociale controle", *Sociologische Gids. Tijdschrift voor sociologie en sociaal onderzoek*, 3, 1956, 41-49; VAN RAALTE, E., *Staatshoofd en ministers. Nederlands constitutionele monarchie historisch-staatsrechtelijk bericht*, Zwolle, 1971; VAN SAS, N.C.F. (ed.), *De kracht van Nederland. Internationale positie en buitenlands beleid*, Haarlem, 1991; VAN SCHENDELEN, M.C.P.M., "The views of Arend Lijphart and collected criticism", in *Acta Politica*, 19, 1984, 19-55; VAN ZANDEN, J.L.; GRIFFITHS, R.T., *Economische geschiedenis van Nederland in de twintigste eeuw*, Utrecht, 1989; VON DER DUNK, H.W., "Tussen welvaart en onrust. Nederland van 1955 tot 1973", in *Bijdragen en mededelingen betreffende de geschiedenis der Nederlanden*, 101, 1986, 2-20; WOLFFRAM, D.J. (red.), *Om het christelijk karakter der natie. Confessionelen en de modernisering van de maatschappij*, Amsterdam, 1994; WOLTJER, J.J., *Recent verleden. De geschiedenis van Nederland in de twintigste eeuw*, Amsterdam, 1992.

Sophie de Schaepdrijver

Fin-de-siècle and *belle époque* (1880-1914)

On 11 March 1882 the philosopher Ernest Renan delivered a speech at the Sorbonne in which he addressed the question *Qu'est-ce qu'une nation?* (What is a nation?). A question that was being asked with increasing urgency in both Western and Eastern Europe in Renan's day, and one that for the first time evoked fashionable criteria such as race and language. Renan vehemently rejected these criteria. In his view modern nations were the result of history and were maintained by the *human will* – irrespective of whether their unity stemmed from an "uprising against feudalism", as in Italy, or from a royal dynasty, as in France, or from "the direct will of the provinces, as is the case in the Netherlands, Switzerland and Belgium". In each case "a profound *raison d'être* has presided these formations".

This article will not explore the question of whether Renan rightly regarded the Belgian uprising of 1830 (which led to Belgium's independence) as an expression of "direct will". Of more importance is the fact that the tiny kingdom apparently qualified as a 'nation' in French eyes to such an extent as to be cited as an example in an essay on the subject. A far cry from forty years earlier when a *Dictionnaire politique* considered it necessary to make the following remark under the headword 'Nation': "Is there not something faintly ridiculous about calling Belgium a nation?".

In the half century since it was formed, Belgium had therefore increasingly made its presence felt in Europe. In the thirty years that followed, the country became an increasingly important player on the international scene. After the turn of the century the French sociologist Gabriel Tarde even described Belgium as "the most densely populated [country] in the world" and the Belgians as "the richest and most industrious people on earth". On the eve of the First World War Belgium had a population of over 7.6 million, making it the world's most densely populated country. It was also the fourth commercial power in the world. Antwerp was Europe's most important port, ranking immediately after New York on a world scale. The Belgian capital, which had increased enormously in size, was a growing presence abroad: Belgian companies were building railways in France, Germany, Austria, Italy, Spain, Russia, and China. Tramway systems also carried the 'Made in Belgium' stamp. All of the major tram companies in Russia were Belgian, while the Belgian holding company Empain laid the Cairo tram line and also built the fashionable suburb of Heliopolis (the Empain family was thereupon granted the right to be buried in the crypt of the cathedral there). Belgian capital and Belgian labour helped build the Paris metro. And in 1908 the Belgian State made it to colonial power when it accepted dominion over the Congo, a vast realm in Black Africa (over eighty times the size of Belgium), which until then had been the private enterprise of the "crowned businessman" Leopold II. Colonialism, which came about more as a result of the excessive ambition of one man than because of any rampant imperial aspirations on the part of the Belgian middle classes, loomed less longingly in the Belgian imagination than, for example, in the Dutch. It was not reflected in the literature and did not attract large numbers of colonials. The possession, which had been so reluctantly accepted, did, however, gradually start bringing in more and more revenue for the 'mother country'. This revenue was no longer extorted in blood through the use of forced labour, as was the case in the days of Leopold's Congo Free State; nevertheless the relationship between 'Brussels' and the overseas territory was one of exploitation.

Construction of a new railway Elisabethville, 1910
from *Union Minière du Haut Katanga 1906-1956*, Bruxelles, 1956

Within Belgium itself the new wealth was also unequally distributed. Though the standard of living of the Belgian middle classes was lower than in the neighbouring countries – the luxury enjoyed by well-to-do Belgians in the *belle époque* was mainly culinary – even this was beyond the reach of the bulk of the working classes. The Marxist Hendrik de Man described Belgium in 1911 as a country of low wages and long hours, where the proletariat, more so than elsewhere, was weakened and exhausted by systematic exploitation. Real wages had in fact increased by almost a fifth compared with twenty years earlier (at least in the section of heavy industry). As a result workers were able to spend more on housing and medical care than ever before. Nevertheless most Belgian workers continued to work very long hours for a very modest wage. Bakeries operated a 13-hour day on average, while railway conductors and engine drivers kept going for up to eighteen hours at a time, and yarn spinners in the Ghent textile industry worked a 66-hour week for an hourly rate that enabled them to buy exactly ten grams of pork. Poverty bit particularly deep in rural Flanders, where huge numbers of young children were employed in the declining cottage industries-making rope, lace or matchboxes. (The rate of illiteracy was therefore

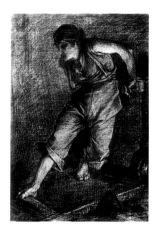

Cecile Douard, *Hiercheuse poussant son wagonnet: Cuesmes*, 1897, Brussels Institut Royal du Patrimoine Artistique

highest in Flanders. Out of 1,000 men, women and children, 288 could neither read nor write in 1910; the corresponding figure in French-speaking Wallonia was 224, and in Brabant 230.) Amidst rampant capitalism and poignant differences, the face of Belgium was not that of an utterly transformed urban-industrial landscape. In the Walloon mining area a semi-industrial, semi-agricultural landscape had been created with factories set against a rural backdrop of fields and cows; a landscape that was admittedly cluttered and unsightly, but whose village ambiance had little in common with the traditional, dark, large-scale industrial world of the nineteenth century, with its manufacturing towns and barrack-type housing.

Despite the sharp increase in population density, Belgium was still a country of small communities rather than gigantic cities: six out of ten people lived in villages or small towns with fewer than 10,000 inhabitants. These small places steadily grew without there being a massive rural exodus to the cities. Instead people commuted in huge numbers. Day labourers walked to work – often covering very long distances – and an increasing number of people went to work in the factories and the mines by train using their State-subsidised season tickets. (The railway network was the densest in the world.) The Catholic party which had virtually ran the country since 1884 (see below) in fact aimed its policies at preserving rural life. In the meantime, however, the farming community did dwindle from one half of the working population in 1850 to one fifth in 1910, some 800,000 farmers. (In France the figure was 40%, while in the Netherlands it was 28% around the same time.) Peasant families usually owned very little land so that the men also had to go and work in the mines or factories, or do seasonal work in France. Some moved away altogether and went to live in Roubaix or Tourcoing, manufacturing towns over the French border where they even formed the bulk of the population. Only a few exchanged their hard life against a new life far away; of the tens of millions of Europeans who emigrated to America between 1900 and 1910, only a very small proportion was Belgian.

Since the rural exodus in Belgium remained limited in scale, no huge cities sprang up. Even the largest city, Brussels, had only three quarters of a million inhabitants, including the suburbs. Even though one in ten Belgians lived in the Brussels area, the capital did not have the same kind of dominance over 'the provinces' that London, Vienna, Budapest, and especially Paris enjoyed. Belgian cities formed more of a network, particularly Flemish cities like Ghent and Antwerp. Each of those had its own elite for whom moving to Brussels was not necessarily the height of ambition. (Moving to Paris of course was another matter.) While the provinces were not 'peripheral', the capital retained a certain provinciality. In the 1860s Brussels had acquired modern boulevards modelled on those of Paris; but small industries (furniture makers, brewers, etc.) continued to flourish in the side streets. Many apartments on these boulevards remained vacant: people preferred the suburbs where they could live in a whole house, built on several floors and with a garden. In short, Brussels bore only a superficial resemblance to Paris.

Since modernisation had not come with huge shocks, the Belgian elite had long been able to completely ignore the bulk of the population as far as political policy was concerned. Until 1893 political participation was limited, as a result of suffrage based on ownership of property/tax assessment, to 130,000 voters: less than four per cent of adult males. In this 'legal land' Catholics and Liberals, the two major political powers, had long shared the conviction that 'social issues' simply did not exist, and that the free market would solve all problems. In 1878 a law restricting the use of underground child labour in coal mining was condemned in Parliament as "statism"! The political discussions between Liberals and Catholics were mainly restricted to denominational issues: a very bitter school funding controversy raged in the 1870s around the question of the 'soul of the child' in education. This battle was 'won' by the Catholics in 1884, marking the start of thirty years of dominance. In the meantime the concentration on the competition between the education systems had drawn attention away from the simple fact that Belgian education was inadequate: in 1900, 101 out of every thousand Belgian recruits were illiterate, compared with 47 among the French, 23 among the Dutch, and 5 among the Germans.

In more general terms, the denominational conflict had drawn attention away from the country's social problems. Yet the deep depression experienced by Belgium around 1875 had only made the social problems more acute than ever before. A massive revolt broke out in the Walloon industrial areas and spread throughout the country. The mansions of the 'bosses' went up in flames, factory buildings were torn apart: the rage could no longer be contained. The existing employees' associations united to form one Belgian Workers' Party. However many union leaders the au-

Pupils of the school for boys 8 Kapucinessenstraat, 30 July 1873 from H.van Daele, *150 jaar stadelijk onderwijs te Antwerpen 1819-1969* Antwerpen, 1969

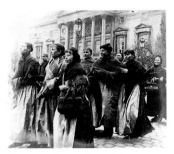

Factory workers in front of the court-house in Ghent express their support for the big strike for universal singular (male) suffrage, 1893 Ghent, Museum voor Volkskunde

thorities arrested, the problem could no longer be denied: an official investigation uncovered abuses that shocked Parliament. The workers were demanding political rights. Clandestine 'black meetings' were held in the Borinage mining area. The Workers' Party swore an oath not to rest until universal suffrage had been introduced. Major strikes broke out in Liège and elsewhere. Parliament played for time as long as possible, but eventually gave in. In 1893 all adult males were given the right to vote. However, the principle of 'one man, one vote' had still not been introduced. While it is true that men over the age of twenty-five had one vote, anyone with a family, or who was in possession of a house, capital, a good job or a university degree, and who was thereby involved in preserving the social order, was entitled to extra votes. This conservative 'plural franchise' applied to the majority of the electorate. The arrangement obviously could not satisfy the Socialists indefinitely. Nevertheless it remained incontrovertible for the time being. During the major industrial disputes in April 1902 hundreds of thousands of workers downed tools and the gendarmerie used live ammunition. Despite the fatalities, the voting system remained unchanged. Following the elections of 1912, when the Catholics again made substantial gains, insurgency flamed up once more. Riots broke out in the Walloon industrial region, and more demonstrators lost their lives. On 14 April 1913 almost half a million workers went on strike. The government then let it be known that a review of the voting system was not out of the question. A consensus was in fact in the offing on this very subject in business circles and even at the royal court. The war would get in the way of this development.

The 'plural franchise' of 1893 may have been a bizarrely 'qualified' franchise, but in the meantime it made politics in Belgium a matter for the masses. The Liberal party, which was traditionally the party of the urban middle classes, lost a great deal of ground during this transition to the 'politics of the masses', becoming a minority party, albeit one that was well represented among the 'people with influence'.

The Catholic party, which dominated Belgian politics continuously between 1884 and 1914, developed into a party that appealed to the masses. More than just a party, the Catholic power formed a 'social middle ground', unequalled in the useful work it undertook within associations: guilds, by way of convents, all kinds of parochial organisations, benevolent societies, insurance companies, mortgage banks and other credit institutions, student associations, women's associations (women were thought to be more religious than men), and the rapidly expanding Farmers' Union (which was particularly strong in Flanders). Catholicism had a complete hold on provincial public life. For instance, around 1910 one town in the province of Hainaut with 9,000 inhabitants had some fifteen Catholic institutions: a primary school, a Cercle Léon XIII (Pope Leo XIII Circle), a labour exchange, a domestic science school, a Jeune Garde Catholique (Catholic Youth Guard), trade unions, an association of electors, a health insurance and pension scheme, youth groups and various *sociétés* (clubs), and an organisation for the distribution of the 'right' newspapers. Belgium by no means was not a theocracy, but the Catholic party, the Church and the Catholic beliefs of society were certainly dominant. In other Catholic countries in Europe the Church and the State had clashed and secularisation was on the increase, for instance in places such as Catalonia, the Po Valley, and the French Limousin region. There were also pockets of secularisation in Belgium – in Brussels, Ghent, and the heavy industrial areas in Liège and Hainaut. By and large, however, Belgium remained a Catholic country. In 1910 over 80% of Belgian children between the ages of six and fourteen attended Catholic schools. Following Pope Leo XIII's encyclical *Rerum novarum* in 1891, social issues became the focus of a great deal of attention within Catholicism; this led to the development of a powerful Christian Democratic movement. The most powerful 'counterforce' was Socialism. Like the Catholics, the Belgian Socialists were more than a political party; they were a huge social presence. In 1905 the German economist Werner Sombart described Belgian Socialism as the best organised in Europe. It did not engender brilliant theorists, so much as pragmatic politicians and an astonishing organisation. This Belgian form of 'tamed socialism' – reviled by consistent Marxist thinkers for its embourgeoisement – found expression in cooperatives, health insurance schemes, workers' banks, and in the Volkshuizen in the various cities and municipalities, which kept the Socialist 'world' together with their meeting halls, banquet halls, libraries, cooperative bakeries, breweries, and pharmacies, and with their printers, musical bands, parks, children's holiday camps, and sometimes even health centres. The Belgian Workers' Party as a result encompassed a large proportion of the Belgian population. In 1911 the BWP had 276,000 members (the French Socialists were only 80,000

People's House, Brussels
Brussels, Institut Royale
du Patrimoine Artistique

around the same time). The greatest Belgian artists and writers – led by the world-famous poet Emile Verhaeren (see below) – joined in the workers' struggle, which to their mind lent contemporary Belgian history that touch of heroism which it had lacked before. Although the BWP failed to end the socially distorted 'qualification' of the right to vote before 1914, it did nevertheless achieve some success: a start was made on social and labour legislation, child labour was restricted and working hours in heavy industry were regulated. Success was limited as yet-compulsory schooling for instance was not introduced until after the war. Nevertheless indifference to social issues was now a thing of the past.

The incomplete 'democratisation' of 1893 also marked the end of official indifference to another reality in Belgian society: the language question, more specifically the Flemish question.

Although Flemish was the language spoken by most of the population (according to the census of 1910, 54% of Belgians spoke 'Flemish' as their first language), French was still more or less the official language of Belgium. French was the language of the judiciary, the administration, the army, and the major newspapers. It is true that since the 1870s public life in the Flemish provinces was very slowly 'Flemishised': the administrative system used the vernacular, as did the judicial system and primary schools (and also secondary schools, albeit to a very limited extent). It was clear, however, that 'Flemish' was the inferior language. In practice it was spoken by most people in the form of very different dialects. Only for a minority of the Flemish middle and lower middle classes was it also regarded as a standard language (in the guise of Dutch). French, a language unknown by 46.5% of Belgians, was still the language of social ambition, the language of 'social advancement', of modern culture, of learning, and prestige. The existing language laws were therefore primarily intended as 'facilities' for the lower classes who did not speak French, and not as a means of putting the national languages on an equal footing.

After 1893, however, when the electorate was extended and both the lower middle classes and the lower classes in Flanders also had a right to vote, the question of bilinguality could no longer be ignored. Pro-Flemish opinion gained ground within the Catholic party in Flanders. Increasingly it became a question of elevating Flemish, as it was spoken in Belgium, from a collection of local dialects spoken by the uneducated majority of Flemings, to an education medium, an official language on a par with French. A tough battle was fought about this issue. The *Gelijkheidswet* (Equality Act) bill, which would give the Dutch spoken in Belgium the same official status as French, was adopted in Parliament by a majority vote at the end of 1896. This gave rise to a violent reaction against the principle of two official languages, a reaction that was particularly heated among public servants in Brussels, among the upper middle classes, and broadly speaking among the French speakers in Flanders and Brussels, who failed to realise that they had enjoyed preferential treatment for generations at the expense of half of their fellow citizens. The idea that knowledge of 'peasant' Flemish would be imposed just as strictly as knowledge of the world language, French, was intolerable to many. Following protests in the (upper-class and aristocratic) Senate, the government opted for a very much toned-down version of the original bill.

This time, however, for the very first time in Belgian history, Flemish public opinion was completely up in arms about the language question. The simple yet powerful principle of equality for both national languages touched on respect for one's own language, a language that for so many years had been dismissed as inferior; it had to do with the fact that if a Flemish speaker wanted to get on in life, he had to forget his own language and speak a foreign one fluently. The growing revolt against this state of affairs coincided with the general pursuit of advancement and dignity that characterised this period. Tens of thousands of Flemings – farmers, shopkeepers, professors, politicians – organised marches and rallies. It was obvious that this was an issue that really touched the Flemings very deeply and that the government had to deal with it. In 1898 the official equality of both national languages in Belgium finally became law.

After the triumph of the Equality Act, however, mobilisation of public support for the language question died down again and became focused within what was known as the Vlaamse Beweging (Flemish Movement; this was not an independent party, but rather a collection of associations spread over the various parties: cultural associations, student groups and the like). Thus, for instance, it did turn out to be impossible to make all primary schools in Flanders Flemish-speaking: anyone who wanted to send his children to a French-speaking school could continue to do so. After all, the "freedom of the head of the family in language matters" was part of the Belgian Constitution.

Petition for the use of the Dutch-
language at Ghent University
Ghent, Archive and Cultural Centre
of the Ghent University

Cyriel Buysse, *Het Gezin Van Paemel*
(The Paemel family), 1903, performed
by the Multatuli-circle
Ghent a Socialistic theatrical company
on 10 July 1905, poster
Ghent, Rijksarchief

In view of the superiority that French still enjoyed, however, this meant that anyone who wanted to get on in Flanders would choose French. It looked as if the elite in Flanders would continue to speak French and that a Flemish-speaking elite would never emerge. The absence of a Flemish-speaking elite was also due to the fact that higher education was not available in Flemish. The pro-Flemish campaigns therefore began to focus on making the University of Ghent Dutch-speaking: providing a university education in the local language would create an elite who would no longer be separated from the lower classes by the language barrier. The idea behind this was that the 'Flemish people' as a whole would have a lot to gain from this new harmony. From 1910 onwards the Flemish Movement (forming a front that embraced all three parties, the Catholics, the Liberals, and the Socialists), which had adopted the 'Ghent issue' as its own, began to wage a vigorous mobilisation campaign. Sunday after Sunday, pro-Flemish speakers went out into the countryside to convince people that a Flemish university was indispensable. This had begun to appear as the ultimate solution to all the social problems of Flanders. Public interest grew again, with over 100,000 signatures being collected for a petition to Parliament.

The Catholic government (the Catholic party, which had its staunchest base in Flanders, had always been more receptive to the Flemish question) quickly promised to make the University of Ghent Dutch-speaking. Such promises could not satisfy pro-Flemish opinion, however, since they were based on the premise of creating a bilingual university: education in Dutch would be offered alongside the existing lectures in French. The Flemish Movement feared that under this system the Flemish elite would continue to have its sons taught in French. The creation of a "Flemish-speaking" Flemish elite would thus be postponed indefinitely. The only solution was to abolish the French-speaking university in Ghent. The opposition of the French-speakers (not just the middle classes this time, but also the Socialist party) made it impossible to do away with the prestigious French-language education offered in Ghent, which attracted so many foreign students. Consequently no solution to the problem was found during this entire period, which was a source of great frustration to many supporters of the Flemish Movement.

But no matter how fiercely the debate raged, the Flemish question in Belgium at that time was never the 'community' battle (battle between language communities) that it would later become. Flemings and Walloons were not implacable enemies. When the Socialist Member of Parliament Destrée wrote in an open letter to the king in 1912: "Sire, there are no Belgians [...] there are Flemings and Walloons in Belgium, but no Belgians", this was generally thought to be an expression of frustration at the latest in a long line of Catholic election victories, which was chiefly due to the votes of the Flemish provinces. Certainly the spread of culture had made educated Flemings and Walloons more mindful of their own cultural heritage. But it did not necessarily follow that this should lead to separation. Quite the reverse in fact: the development of both cultures to maturity would, in the words of one pro-Flemish intellectual at the time, bring about "increased unity". This optimism was in keeping with the Belgian culture of the time, a culture that was flourishing exceptionally. This manifested itself in contemporary literature: the Flemish-language literature of Belgium reached a high point and was also for the first time much acclaimed in the Netherlands. The French-speaking Fleming Maeterlinck won the Nobel prize in 1911, and Emile Verhaeren (another French-speaking Fleming) was one of the most admired poets of his time. Among historians, Henri Pirenne, a Walloon who taught in Ghent, marked a European milestone with his *Histoire de Belgique* (History of Belgium), which interwove national history with a scientific but heroic tale of a cosmopolitan civilisation in a small, long since urbanised region that seemed destined to fulfil the role of 'intermediary' between the major cultures. The *Histoire* did not claim Belgian nation as a 'natural fact'; instead Pirenne, adopting a line of reasoning reminiscent of Renan and using a compelling cool and lyrical style, brought together the history of the Southern Netherlands into a cohesive whole and suggested its *raison d'être*: "To be Belgian was in a certain sense to be European".

This was a view that was more widespread among the literate elite of the time. The Viennese writer Stefan Zweig, in his biography of his friend Verhaeren, described Belgium as "a mirror with a thousand surfaces, offering a summary on a reduced scale, as it were, of the multiform universe". Generally speaking, there was growing foreign interest in this curious, heterogeneous country, which seemed to encompass the whole European experience on such a compact scale. "Belgium is the testing ground of Europe", asserted the French geographer and anarchist Elisée Reclus, who lived in Brussels. In an essay honoured by the Académie française in 1910, the sociologist

Henri Charriaut praised Belgium as an extremely condensed "social laboratory" for the new social ideas of the new century. Belgium was no longer the battlefield of Europe, as Napoleon had claimed. In Charriaut's view, the Belgians could now give the best of themselves, now that the struggle between nations was confined to economic matters, and now that the old "days of bloodthirsty fame" had come to an end once and for all...

The First World War and its immediate aftermath (1914-19)

During the *belle époque* the European superpowers were embroiled in a fierce competitive battle. The arms race grew more intense and the continent divided itself up into power blocks: the Hohenzollern and Hapsburg Empires together with Italy against the *entente cordiale* of France, Great Britain, and Russia. As a neutral State, Belgium kept aloof. In 1830 the Great Powers had thought it advisable that the new State should not take sides in any European conflicts. This 'imposed neutrality', for which the Great Powers also acted as guarantors (i.e. they committed themselves to war against any aggressor of Belgium), had, over a period of three-quarters of a century, become part of collective Belgian consciousness: the awareness of neutrality was as deeply rooted in the Belgians of the early twentieth century as it is today in the Swiss. Nevertheless, the Belgian elite noticed the tension between the two power blocks and feared that Belgium might be drawn into a Franco-German conflict. (This fear was justified given that the – secret – plans of attack of the German general staff had provided for an invasion of Belgium as early as 1906.)

An invasion of Belgium – by whichever side – would constitute a violation of international law, and many Belgians hoped that this would provide sufficient deterrent. In an effort to do even more to avert an invasion of Belgium, the fortresses were reinforced and the army was reformed. In 1909 Leopold II signed, on his deathbed, the law on individual military service. This law put an end to the socially inequitable system of drawing lots, where well-off young men systematically exchanged their 'bad' lot for a 'good' one in return for cash, with the result that in practice only the working classes were called up. In 1913 compulsory military service was applied to all young men (instead of one per family). This idea got a very cool reception, especially among the Catholic community: for Catholics the barracks had long been synonymous with ruin, a place where young men irrevocably lost their faith.

Broadly speaking, Belgium was a country with no martial ambitions, a country in which the army had a very low status; few young bourgeois opted for the career of a professional soldier. Foreign observers therefore considered even a reformed Belgian army to be of no great consequence in the event of a conflict: the Belgians lacked a spirit of national sacrifice, in the opinion of the French military attaché. German diplomats expressed their private view that if the country was invaded the worthless Belgian forces would be unable to do more than stand at the side of the road and stare at the German army. In London Winston Churchill predicted that in the event of a war in Europe Belgium, in its impotence, would choose the strongest side without offering too much resistance – an opinion that was shared by many.

Belgian public opinion tended to rely on the power of neutrality. The assassination in Sarajevo on 28 June 1914 (which heralded the start of the escalation of hostilities) created less interest on the streets than the winning of a leg in the Tour de France by fellow countryman Philippe Thijs (who would become the first triple Tour champion). There could be no doubt, however, that Europe was on the brink of war. In vain did the Belgian government try to obtain a non-aggression promise from Germany (France did give this assurance). On 31 July the Belgian army was mobilised. There was still hope. "Your neighbour's roof may be on fire, but *your* house will be spared", said the German envoy in an interview on 2 August. That same evening, however, he handed over an ultimatum from Berlin to the Belgian government.

The German ultimatum stated that the imperial government had decided to march against France through Belgium. If the Belgians allowed this, nothing would happen to them. Otherwise, they too would be treated as enemies. In the tense nocturnal meeting that followed – Brussels was only given twelve hours to respond – the government ministers decided that Belgium would violate international law if it gave in, and agreed unanimously to reject the ultimatum. Early the next morning the Belgian refusal was handed over to the German embassy. On the 3rd of August the news spread throughout the country. Only the evening before had the war still seemed a remote possibility. Everywhere there

was an atmosphere of bewilderment and outrage at "Germany and its false oaths". In just a few days twenty thousand men joined up; most came from the cities, where people were more open to the fierce 'patriotic spirit' that was rapidly spreading. This violent patriotism also spread to Socialist circles, and even among pro-Flemish Catholic youths. The extraordinary session of Parliament on 4 August was, as it were, the high mass of this new national feeling; in just a few short hours the thirty-nine-year-old King Albert became the mythical personification of Belgian heroism. In a rousing speech, he called on citizens to put up "tough resistance", evoking the legendary *Guldensporenslag* (Battle of the Spurs) of 1302 for the Flemings, and reminding the Walloons of their glorious medieval past.

Parliament voted unanimously for war loans; if there was any opposition to the government's decision, it was not articulated. In the midst of the discussions news came that the German army had invaded the country near Liège. The war had begun.

The German army had invaded near Liège because 'fortress Liège' was the strongest fortification in Europe and therefore had to be rendered harmless before the French army went into action: it was a *Blitzkrieg* operation *avant-la-lettre*. But despite clumsiness the resistance offered by the Belgian army near Liège was more tenacious than expected. Kaiser Wilhelm and the general staff were horrified and on 6 August the Brussels press was talking about a great Belgian victory – even though at that moment resistance at Liège was more or less broken. Be that as it may, 'Liège' marked a delay in the German advance and was ecstatically celebrated in Paris and London.

In the meantime, however, the Belgian army suffered very heavy losses and had to withdraw to 'fortress Antwerp', allowing the German army to advance further west. Civilians witnessed at first-hand the most refined war machine of all time: the face of War itself, as the writer Suzanne Lilar was later to describe it. In some places it was a horrifying face. The German army took revenge for the delay it suffered in its advance by burning whole villages and deporting the inhabitants to Germany *en masse*. Among the German ranks it was thought that the Belgian civilian population, armed to the teeth, was waging a guerilla war. This myth about the Belgian *francs-tireurs* (snipers) was false (the population knew better than to offer armed resistance), but it was not contradicted by officers, which only served to increase the anxiety felt by the soldiers. Every German setback was promptly avenged: hundreds of people were shot dead, beaten to death or burned alive in places like Aarschot, Dinant, and Tamines. In Leuven on 25 August two German companies began shooting at one another as dusk fell, and a few soldiers were killed. In the ensuing confusion the townspeople were pointed out as the culprits and a huge reprisal operation began, in which over two hundred civilians were murdered. The city centre was burned to the ground and the famous medieval university library reduced to a smoking pile of rubble. It was this last action, in particular, that made a profound impression on international public opinion. By September Belgium was defeated and occupied and the "German Atrocities" – as they were called in the allied press – came to an end, having claimed the lives of 6,500 Belgians.

In the meantime the Belgian army had been forced to withdraw out of Antwerp, which was being constantly bombarded by German Krupp cannons. The city surrendered on October 10. The fall of this stronghold, which was thought to be impregnable, spread a feeling of deep despondency throughout the country. By and large people felt that Belgium's foreign 'protectors' had let them down. King Albert, commander-in-chief of the Belgian army (which in the meantime had withdrawn to the far west of Flanders in a very sorry state), was persuaded (though only with great difficulty) by the French army commanders to stand firm and do battle at the Yser River, side by side with the French and British front. The Ijzerslag (Battle of the Yser) began with heavy losses for the Belgians; around the 25th of October it looked as though the Belgian front would buckle. At the last minute the Belgians won the day by opening the sluice gates and flooding the Yser plain. At the beginning of November the German advance on the Yser, and all along the Western front, was halted, and trench warfare began, for the Belgians as for everyone else.

Belgium was now an occupied country and for the first few months of the war there was a feeling of complete desperation everywhere. Following the invasion, whole villages and towns had fled in panic before the advancing German army. Hundreds of thousands of people took refuge over the border. In the first couple of weeks of October there were one million Belgian refugees in the Netherlands alone – one seventh of the population. Many of these came back when the situation settled into some sort of normality; but until the end of the war almost 600,000 Belgians would remain abroad (325,000 in France, 160,000 in England, and some 100,000 in the Netherlands). This meant that there were 'two Belgiums' for the duration of the war: one under occu-

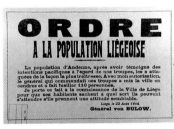

Ordre à la population Liégeoise
Général von Bulow, 22 August 1914
poster, Brussels, Musée Royal
de l'Armée et d'Histoire Militaire

*Fugitives on the beach of Ostend
waiting for the embark in fishing-boats*
between 10 and 13 October 1914
Brussels, Musée Royal de l'Armée
et d'Histoire Militaire

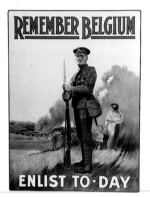

Remember Belgium Enlist To-day
August-September 1914, poster
Brussels, Musée Royal de l'Armée
et d'Histoire Militaire

Gabrielle Petit, Ghent
Archive and Museum
of the Socialistic Labour Movement
(Foto-archief AMSAB)

pation and one in exile. Relations between the two camps became more and more strained as a result of incomprehension and reproaches. The exiles, many of whom were dependent on charity for four years, reproached the others with their 'accommodation' of the occupying forces, while the Belgians who had stayed behind blamed the refugees for leaving their fellow countrymen in the lurch. This mutual resentment was intensified by the total lack of reliable information available, and by biased reports in the German-controlled press, which did everything possible to discredit the French-based government in the eyes of the occupied population.

In the meantime a *modus vivendi* between the German occupying forces and the conquered population needed to be found. The first problem was the provision of fresh supplies. Belgium was largely dependent on imports for its food supplies, and these had virtually come to a standstill by that time. There was no domestic agriculture as a result of the devastation and the mass exodus. Faced with an imminent famine, the Brussels business community came up with the initiative to provide food for the Belgian people by means of neutral intervention – more specifically with the help of the United States of America.

So after prolonged discussions within occupied Belgium, a National Committee for Aid and Food Supplies, led by the energetic Brussels businessman Emile Francqui, was created. This Committee worked closely with the foreign Commission for Relief in Belgium, chaired by the American engineer Herbert Hoover (who would later become President of the United States). Both committees would succeed in providing supplies for Belgium over the next four years, often in extremely difficult circumstances. The 'visibility' of "Brave Little Belgium" was also considerably boosted with a view to securing international solidarity. A series of charity events in aid of Belgium – bazaars, balls, exhibitions – were organised in New York, Buenos Aires, Paris, Madrid, The Hague, and London. The enormous efforts paid off: a total of one billion dollars was raised and five million tons of food shipped out.

Within occupied Belgium, 'America' gradually acquired the status of ultimate protector – after a ban on Belgian symbols was imposed the "Stars and Stripes" appeared everywhere. The National Committee, with its many sub-committees and sub-sections, became almost a 'State within a State', and was thus greatly distrusted by the occupation government. Apart from this, communications between occupied Belgium and the outside world were virtually non-existent. Along the Dutch border a high-voltage fence had been erected, and communications with the soldiers beyond the Yser River had broken down. It had become very difficult to move about within Belgium; passes were compulsory and non-military rail traffic had been reduced to a minimum. Millions of Belgians found themselves confined to their local community. The effects of the occupation weighed heavily on the population: the exorbitant war contributions, the countless prohibitions, the ubiquitous military police. As the American envoy remarked, Belgium had acquired "the institutional odour of a penitentiary".

Unlike during the Second World War, there was never any armed resistance. Other forms of resistance existed though: various organisations smuggled letters from and to the Yser front, intelligence sources provided London and Paris with military information, small units regularly sabotaged the vital rail link between Brussels and Aachen, and an 'escape route' helped young men who wanted to join the Belgian army to get across the Dutch border. This was a highly risky operation, which reinforced the Belgian army based at the Yser by a total of 32,000, but which also cost the lives of many resistance workers and potential recruits, shot dead at the border or electrocuted on the high-voltage fence.

Various 'patriotic figures' acquired great symbolic significance, such as the Brussels Mayor Adolphe Max, who was deported to Germany for opposing the war contributions, the Primate of Belgium, Cardinal Mercier, who in a pastoral letter issued at Christmas in 1914 (immediately circulating in many clandestine publications) made a spirited defence of patriotism, and the young Gabrielle Petit, a native of Doornik (Tournai), who was executed on 1 April 1916 at the National Shooting Range in Schaarbeek for her espionage activities. The legendary underground newspaper *La Libre Belgique* (Free Belgium) kept up the morale of the occupied population for four long years. Before long, the newspaper had a Dutch counterpart called *De Vlaamsche Leeuw* (The Flemish Lion), a patriotic and militant Flemish publication that set itself the task of joining battle with a new phenomenon, one that would cause a major rift in the united front of Belgian war patriotism: activism. The roots of this activism were just as much German as Flemish, given that it was largely a reaction to the divide-and-rule policy pursued by the German command in

Belgium. In the summer of 1914 Germany did not yet have any long-term plans for Belgium, but these were gradually developed. The idea grew that hostile Belgium should henceforth serve the interests of the Reich. Germany wanted to establish military bridgeheads in Belgium after the war and maintain a tight grip on the Belgian economy.

To this end an 'internal Belgian' policy was also outlined, aimed at prising a significant proportion of the Belgian population away from the patriotic front and bringing them round to the German way of thinking. Almost immediately the idea materialised of joining forces with the Flemings, who had suffered so much frustration within the Belgian State. "We may have to give up Belgium", said the head of the German command in Belgium, Baron Von Bissing, in December 1914 (when the German dream of 'Christmas in Paris' had been banished forever), "but we shall destroy it through the Flemings." The *Flamenpolitik* (Flemish Policy), as this policy came to be known, had the additional advantage of placing Germany's conduct of the war in a quite different light internationally: from the brutal aggressor of an innocent, neutral neighbouring country, the Reich would metamorphose into the benevolent liberator of its fettered Germanic brothers. Flamenpolitik therefore appealed to many German intellectuals both in Germany and among the senior ranks of the occupying forces in Belgium.

Initially this policy found no support in pro-Flemish circles: here, too, the occupying forces had bred hostility and opposition. The only exception was a very small group of young Ghent intellectuals, led by the Frisian Minister Domela Nieuwenhuis (a cousin of the renowned Dutch Socialist). The group, which called itself Jong-Vlaanderen (Young Flanders), had declared its loyalty to the German Reich right at the start of the occupation. However, it was precisely the extreme anti-Belgian and pro-German views of these young Flemings that compromised the Flamenpolitik in the eyes of the majority supporters of the Flemish Movement (and, all the more so, in the eyes of the Flemish population as a whole). The breakthrough that brought broader grass-roots support did not come until 1916, when the Von Bissing regime promised to make the University of Ghent Dutch-speaking. The fulfilment of this pro-Flemish key demand made a deep impression. What was more, in French-speaking circles, Flamenpolitik had led to nasty comments being directed towards all supporters of the Flemish Movement. As a result, some of these supporters had become alienated from Belgian patriotism. A new way of thinking emerged: the Flemings owed loyalty to the Belgian State only insofar as the State gave them rights in return. The new motto was: "If I have no rights, I have no country". The Flemish radicals who, with the help of the Germans, continued the language campaign during the occupation gave themselves the honorary title of "activists". (By extension, those Flemish nationalists who kept aloof were condemned as "passivists".)

Activism gained a few thousand supporters but was rejected by the majority of the pro-Flemish public. The new Ghent University – disapprovingly nicknamed the Von Bissing University – had trouble finding professors and students since its association with the repressive occupation regime was obvious, especially after the deportation of recalcitrant professors (including Pirenne).

Nevertheless, around the end of 1916 and the beginning of 1917 a movement of sympathy arose at the front among the militant Flemish soldiers in support of activism in general and that of Ghent in particular. Their indignation was rooted in a more general dissatisfaction with the way the war was dragging on.

The Belgian army had embarked on trench warfare in a deplorable state: of the 117,500 men in the field army at the beginning of the war, only 52,000 were left following the Battle of the Yser (as a result of casualties and prisoners). These were very poorly equipped and were physically and morally exhausted. Gradually, in the relative calm that reigned behind the flooded Yser plain, numbers were built up again (with new recruits from occupied Belgium and Belgians in exile). The first winter was the hardest as soldiers struggled to cope with the bleak, marshy terrain and the as yet shallow trenches. In the course of time a more solid defence system was constructed along the thirty-kilometre-long Yser front. On the whole, the Belgian army was spared the huge losses suffered by the British and especially the French armies. The Belgian high command would allow the army to do no more than stand its ground, and refused to participate in the major allied offensives. Between 1915 and 1917 the Belgian army had fewer casualties than during the 'movement war' of 1914. (The total number killed during the entire war was 26,000.) Nevertheless, the front misery was dreadful: Belgian soldiers were the only ones out of all the fighting troops (with the exception of the colonial troops) who could not return home once during four

Golden Sporen-Feesten. Juli 1918 Antwerpen, poster in D.Vanacker, *Het aktivistische avontuur*, Gent, 1991

years of fighting. A new 'trench culture' developed, substantially different from the traditional world in which so many soldiers had lived before the war. Churchgoing declined, foul language and heavy drinking increased, and more and more soldiers sought solace with prostitutes. This was a cause for particular concern to the militant Christians at the front; the pro-Flemish Catholic soldiers and non-commissioned officers, who even before the war had regarded the army as the cause for a decline in moral values , were the most alarmed. Besides, they had even more cause for complaint: the senior ranks of the Belgian army had remained almost exclusively French-speaking, while the Flemings made up 65% of the ordinary fighting troops at the Yser front. This Francophone dominance made it virtually impossible for soldiers who did not know French (and only Flemings from the middle classes spoke French) to get promotion: only half of the non-commissioned officers were Flemish.

The dismal situation of moral degeneracy and linguistic injustice brought to the creation of small militant groups ("prayer groups" and "study circles"), led by chaplains. The campaign for piety and Flemish consciousness was also waged in the hundreds of small newspapers that were produced at the front, and that were primarily directed – often in dialect – at particular areas or villages (like their Flemish counterparts, the Francophone front newspapers targeted a local audience and usually had a Catholic slant).

The suspicions harboured by the French-speaking officer class about the Catholic pro-Flemish action gradually brought more militant Flemish-nationalist elements into the campaign. These were strengthened by the aversion to official patriotic rhetoric that was spreading throughout the whole army. When the army command banned the "study circles" in the spring of 1917 (these were regarded as hotbeds of trouble within an army that, like all armies on the Western front around that time, was becoming increasingly restless), a more coherent, clandestine Front Movement emerged. This Movement made known the grievances of the pro-Flemish soldiers in the army in a bitter open letter to King Albert in July 1917. Punitive measures taken by the Military Security Service only served to strengthen its militant attitude. The leaders of the Front Movement were left alone (they were secretly in contact with the Catholic Flemish ministers in the Belgian government), but ordinary members were regularly sentenced to solitary confinement.

By the winter of 1916-17 the 'spirit of 1914' had been completely extinguished in all ranks of the Belgian army – among the Walloons as well. Despondency set in on all sides, and in 1917 there was a great deal of sympathy for the Russian revolutionaries, who had after all turned their back on the whole war. The sporadic news that reached the front about the dreadful shortage of food in occupied Belgium (see below) caused alarm: soldiers began to wonder out loud whether their place was not at home where they were really needed. The number of desertions rose, reaching a peak in December 1917, the coldest month in thirty years.

There was never a mass mutiny, however, as in the French army. Belgian soldiers were not condemned to fight in the same senseless, murderous offensives, and discipline in the Belgian army, which had essentially remained a 'civilian army', was less strict than elsewhere (for instance, there was no corporal punishment at the Yser front and deserters were not shot). King Albert, commander-in-chief of the army, was looked upon as the soldiers' protector; his close proximity, and the intense caring activities of Queen Elisabeth, played a very large part in preserving a kind of loyalty among the majority of the men. The fact that the 'morale' of the Belgian army still stood, despite much rude awakenings, was all too obvious in the liberation offensive that was launched at the end of September 1918.

Even though pro-Flemish discontent had spread, the Front Movement had only a limited influence on the mood of the army. At its peak the Movement attracted no more than five thousand Flemings (counting leaders, members, and sympathisers together). Just like official Belgian patriotism, Flemish nationalism mainly met with indifference within the Yser army.

Meanwhile the mood in occupied Belgium had grown steadily more gloomy. Restrictions on freedom of movement had been tightened even further and shortages had become much worse since the third winter of the war. For workers the minimum food requirements went down to the level of half a century before, and even the lower middle classes suffered greatly from the shortages. The population grew weaker, there was an outbreak of tuberculosis, children were anaemic, and the birth rate plunged. The German Reich was in the meantime becoming more and more of a military dictatorship. The military-industrial leaders decided to embark on a harsher policy of immediate exploitation of Belgium. In the autumn of 1916 Berlin decided to deport the hun-

dreds of thousands of unemployed Belgians that were out of work, to do forced labour in German factories and in the trenches at the Western front. There followed a flood of deportations and round-ups of unemployed Belgians. Thanks to the refusal of the local authorities to cooperate, only 120,000 men were tracked down (whereas Berlin had hoped to raise of 700,000). The ill-treatment these men received in the German camps and at the front took its toll: 2,600 died during deportation, many thousands more shortly after returning home, and an even larger number were permanently disabled. The *Arbeitseinsatz* (Labour Conscription) caused a huge public outcry internationally; neutral dignitaries, including the Pope, delivered protests to Berlin. The Germans were thus pressurized into stopping the deportations to Germany (although deportations to the front continued).

In the meantime, in an effort to escape from the increasing shortages and the brutal deportations, more and more Belgian workers were voluntarily going to Germany to work, despite appeals in the underground press. This gave rise to resentment between those who thought that the Belgians should stand firm above all else and those who were prepared to compromise in order to keep their family alive. This nasty atmosphere was maintained by German propaganda in Belgium. Distrust grew among Belgians: starving townspeople bitterly reproached farmers, Belgians who had fled and those who had stayed behind called each other names, workers and the bourgeoisie were deeply suspicious of each other. The large-scale preparations for the German spring offensive of 1918 contributed to the general feeling of dejection.

The failure of the spring offensive revealed, however, that the German soldiers, who had been tested to the limit, no longer believed they could win. Soldiers sold their boots and jackets for drink. The underground press reported a wave of suicides in the German garrisons.

Like the spring offensive, Flamenpolitik had also failed. After the Von Bissing University had been founded, the policy had taken a more extreme turn. Since the 'slow' approach had yielded very indifferent results, Flamenpolitik officials and their activist collaborators decided to switch to a 'policy from above': for administrative purposes Belgium would be divided into two. This would enhance the status of the activists since they would have a large number of positions in the new administration to divide up amongst themselves. The administrative division was presented as a long-standing demand of the Flemish Movement.

The result of the measure – whereby Brussels became the capital of Flanders and Namur the capital of Wallonia – was a mass exodus of the incumbent officials. In both Namur and Brussels they were replaced by collaborators, who often lacked the necessary skills. This made little difference since the actual administrative work was carried out by the Germans, whose numbers in Belgium swelled (an office job in Brussels being a more attractive prospect than a tour of duty at the front).

In an effort to present the split as an 'independent demand' of the Flemings (and also with an eye to the increasingly sceptical public opinion in Germany), the German command in occupied Belgium encouraged the formation of a kind of Flemish 'government' comprising fifty activists, which called itself the *Raad van Vlaanderen* (Council of Flanders) and declared in an appeal – albeit an anonymous one – that it would fight for Flemish "national liberation". The Council then travelled to Berlin to obtain clearer promises from the chancellor regarding Flemish self-government.

News of the trip to Berlin caused an outcry among the occupied population. The Council became increasingly isolated and steadily more extreme: at the end of December 1917 the activists, in an effort to boost the flagging support from Berlin, proclaimed a 'Flemish State'. The German command immediately imposed elections on the Council. The elections, which were held in January and February 1918, were a disaster for the activists, as a result of mass counter-demonstrations, and had to be stopped by the German authorities. Against the background of forced labour, activist politics had become extremely unpopular. When it became evident that Germany had lost the war, most of the activist ringleaders – some two hundred families – fled to Germany without waiting to see how things would develop.

In the first week of November 1918 the German Reich collapsed, and with it the German command in Brussels, where power was briefly assumed by a revolutionary Military Council. The German army withdrew from the occupied country *en masse* (stopping only to take with them objects of value from museums and private houses); German officials packed up the archives and left in great haste. At about this time a small delegation drove from Brussels to the king's headquarters near Bruges. A very small group came together there and decided to establish a new

government of 'national unity' with the Socialists and members of the National Committee: an 'age of competence' was to take the place of old party interests. The 'new Belgium' became a democratic State with universal suffrage based on 'one man, one vote'. (Almost by consensus this right was reserved for men; the new Belgium should not be too new.)

The problems facing the 'new Belgium' were immense, and were only briefly put aside in the ecstasy of liberation: the Belgians were "touchy in the midst of all their rejoicing", as one eye-witness observed. The country had suffered enormous damage. Human losses, however, were fewer than those suffered by other countries caught up in the fighting: France had lost one in six of its adult men, Belgium one in fifty. Nevertheless, the country recorded 50,000 war casualties and another 50,000 soldiers were maimed for life. There was an alarming housing shortage, the infrastructure had been systematically destroyed, at the front a whole area some sixty kilometres in length and twenty kilometres in wide had been completely devastated, and elsewhere cities lay in ruins. The country had 800,000 unemployed.

The 'economic postwar period' was long and hard. There seemed to be no end in sight to the "high cost of life", as inflation was called. To make matters worse, German reparations failed to materialise, and it was made clear at the peace conference that Belgium had lost the credit it had in 1914 – even the headquarters of the new League of Nations were set up in Geneva instead of Brussels. This loss of international prestige was partly due to extremist "Greater Belgium" claims on Dutch territory (which briefly raised the spectre of a military conflict with the Netherlands). To some extent the end of "Brave Little Belgium" also had to do with the complete disappearance of the allies' wartime enthusiasm, which had been seriously compromised after four years of carnage. Within Belgium itself the 'spirit of 1914' had also vanished.

The period between the wars (1920-40)

The subject of the reconstruction of Belgium, which had suffered such devastation in the Great War, gave rise to fundamental discussions among town planners. The debate concerned the question of whether reconstruction should be tackled in a traditional or a modern way. Should the towns and villages, blown to pieces by the cannon, be restored to the old and beloved state they had been in before the bleak industrial war? Or must large-scale destruction be seized as the ideal opportunity to embellish Belgium with the clear lines of modern town planning?

The proponents of reconstruction in the old, familiar vein won the day. Ruined towns were restored to their former glory, complete with medieval market squares, clothiers' halls, beguinages, bell-towers and alleyways. The tens of thousands of homeless families who lived in emergency housing outside the rebuilt city centres until well into the 1920s might perhaps have chosen different restoration priorities if asked. Still, the reconstruction of the devastated regions was generally considered to be a success and it satisfied the widespread emotional need to restore the familiar landscape.

But even the resurrection of the step-gabled mansions of Diksmuide did not alter the fact that the war meant the end of a world, an end that was very painful for many middle-class Belgians. Many thousands of small savers, civil servants, modest businessmen, rentiers and notables were reduced to poverty by the war and were very bitter about the status they had lost within a society that only seemed to recognise the power of large numbers. They found themselves, as it were, in a new country in which there was only room for big capital on the one hand, and organised labour on the other, the latter having found such a strong political voice and become so important socially; a country that increasingly sneered, or so it seemed, at the values that gave the lower and upper middle classes their self-respect-decency, the work ethic, respect for authority and religion. The signs of the times were disquieting. The dominance enjoyed by the Catholic party for the last thirty years was over. An eight-hour workday was introduced in the factories-people working for eight hours for the same wage as before: where would it all end? And "that pure universal suffrage for men aged twenty-one and over is another one of those idiotic inventions of our time, and with the best will in the world I can see no good in it", as the Flemish novelist Ernest Claes grumbled in December 1919. The Catholic elder statesman Charles Woeste complained bitterly in his memoirs about the shameless demands of the workers and the recent shortage of clean, hard-working servants. A great deal had been lost in the war, that much was clear. And with hind-

sight the whole war was also appearing increasingly senseless. In 1914 it had all been so simple: the war that broke out was a struggle between right and might. "Brave Little Belgium" embodied the side of right: a small country, fragile but firm of principle, which had placed itself right in the path of the brutal juggernaut from the East and had paid dearly for that brave decision. The liberation had been but a brief eruption of patriotism. Afterwards, the splendid image of a heroic Belgium involved in a gargantuan battle between good and evil quickly faded. Within the international community (and especially in Britain) the heroic interpretation of the war quickly became tarnished, and Belgium lost the special position it had held in the world's esteem. The view of Belgium was even to some extent coloured by increasing revulsion at the war propaganda of 1914.

Wartime heroic rhetoric also died down quickly. In Belgium itself, the avant-garde was the first to speak out and as most vehement in its condemnation. Almost immediately, avant-garde artists set about attacking patriotic pieties – the Mercier-Max liturgy, the valiant Yser army, the sacrosanct 'national unity' of the middle classes with the Socialists, who had become so revoltingly reliable. The anarchist, anti-militarist, bitingly scathing avant-garde newspaper *Haro*! published a cartoon in which champagne-drinking war profiteers were proposing a toast to the framed portrait of the "Soldier King" while singing "Dying for one's country/is the most glorious fate". The front page showed a corner of the desolate Yser landscape, with a bombed-out tree and a skeleton lying in the mud. The caption read: *La voie triomphale* (The Path of Glory). This constituted a very bitter criticism of the official commemoration efforts, which, in Belgium and elsewhere in Europe, were trying to give some sense of solemnity to the trenches by dint of substantial amounts of marble, allegorical images, municipal monuments and military cemeteries, all for the benefit of the grieving population.

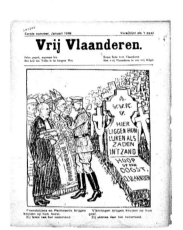

First issue of *Vrij Vlaanderen*
January 1919, Antwerp
Archief en Museum
voor het Vlaamse Cultuurleven

This was not the only crack in the solemn marble of Belgium's commemoration of its fallen. The first edition of the newspaper *Vrij Vlaanderen* (Free Flanders) appeared in January 1919. Its front page depicted the country's patriotic elite (officers, magistrates and the inevitable Cardinal Mercier) being decorated with medals. Beside the official group stood a hill studded with graves of dead Flemings. The caption read: "Pro-French Flemings and ultrapatriots get crosses on their chests [...] Flemings get crosses on their grave". *Vrij Vlaanderen* was the organ of the Flemish Front, a party that had evolved from the wartime Front Movement. This new Front party continued the struggle for remembrance begun in the trenches, demanding a memorial for the dead Flemish soldiers separate from the general Belgian commemorative liturgy, with the argument that the Flemings in the Yser army had not "died for their country", as the official inscriptions claimed, but that they had given "All for Flanders" including their lives.

For the time being the Front party found little support since in the first few years after the war many Flemish voters were rather ill-disposed towards those radical Flemish views they had been swamped with during four years of occupation. Still the significance of the party at that time was greater than its electorate. The general horror in Europe at the human losses suffered in the Great War had led critical groups in all the belligerent countries to condemn the flag-waving brand of patriotism and lend strong support to the pursuit of world peace, militant anti-militarism and international humanism. In Flanders at that time this rejection of war and official patriotic rhetoric had pro-Flemish elements, so that even the minority Communist Party did not fail to include a militant Flemish message in its criticism of the war in general and of the national and social 'reliability policy' of the Belgian Workers' Party in particular. During this time the 'Flemish idea' thus found more support on the left wing of the political spectrum than it ever had before – or ever has since. The new pro-Flemish anti-militarist commemoration of the dead found its own ritual in the annual 'pilgrimages' to the soldiers' graves at what had been the Yser front. With a view to erecting a Flemish national monument, the organising *Ijzerbedevaart* (Yser Pilgrimage) committee purchased a plot of land in Diksmuide, close to the site that had been the most dangerous spot on the Belgian front. Between 1928 and 1930 a concrete tower, some fifty metres high, was built there. Pilgrims reached the tower through a gate with the inscription PAX (peace); the tower bore the dedication: "All for Flanders". "All for Flanders" – with its companion motto "Flanders for Christ" – derived from the old motto of the Front Movement. There were in fact very clear religious overtones to the pro-Flemish commemoration of the dead, also revealed in the solemn masses that formed the climax of the annual pilgrimages. Generally the pro-Flemish movement remained predominantly Catholic, despite its left-wing avant-garde tendencies in the

postwar period. Grassroots support in the cities and among Liberals and Socialists had declined and the militant Flemish Movement's target area for recruitment became more provincial and Catholic than had been the case before the war. At the same time the rhetoric of the Front party was increasingly influenced by that of activism, more specifically by the uncompromising, anti-Belgian ideas of the Jong-Vlamingen (Young Flemings), partly circulated by activists who had fled to the Netherlands and who continued to be subsidised by Berlin. A way of thinking gradually developed in which the activists became martyrs to the Flemish question, on an equal footing with the Flemings who had died in battle: anti-Belgian feeling became the ultimate criterion for anyone claiming to have pro-Flemish views. From this unyielding perspective, any 'compromise' with the Belgian State was regarded as betrayal. Rampant resentment was made worse by the malicious remarks of French-speaking nationalist extremists, who conflated the Flemish Movement in its entirety with collaborationism. In both of these nationalist circles, Flemish and Belgian symbols were regularly and violently fought over.

In the wider Belgian society and among political decision-makers the atmosphere was appreciably more pragmatic and less polemical. The mainstream of pro-Flemish opinion had certainly 'cooled' in its attitude towards 'Brussels'. This was caused by some degree of Belgian nationalist malice, by the sometimes excessive punishments meted out to activists, and, above all, by the slowness with which Flemish legislative demands were put into effect – or even the existing language legislation observed. Nevertheless, the proponents of the so-called *minimum programme* (Flemish in Flanders) remained indefatigably active in political work and tried to pierce public and political indifference by slowly and surely building up (by now mainly Catholic) grassroots support. Generally speaking, the 1920s in Belgium were not a time of radical attitudes and vehement slogans, but rather of pragmatic effort. As far as international politics were concerned, the "Greater Belgium" hysteria was very quickly abandoned in favour of a more sober diplomacy. Once the disappointment about the fact that German reparations had failed to materialise had died down somewhat, Belgian businessmen helped to draw up the Dawes Plan regarding international war debts.

On a national level, the difficult programme of reconstruction took precedence during the seven years following the end of the war. By 1925 the losses had been made up for and most Belgians had returned to the level of prosperity they had enjoyed before the war. In 1926 the Belgian economy began to grow. The cabinet, with the ubiquitous Francqui working behind the scenes, levied two billion in new taxes and the franc, which had been heavily devalued, was once again linked to the Gold Standard. As part of a programme of public works, the long-neglected public housing problem was tackled under the motto "Down with the slums!". Unemployment was reduced to a minimum. The period between 1926 and 1930 was a time of economic euphoria, with a seemingly endless rise in prosperity.

This prosperity was more widespread than during the *belle époque*, which had certainly not been equally 'beautiful' for all Belgians. The purchasing power of large sections of the population increased – and there were a surprising number of nice things to buy and a surprising range of entertaining things to do. Like other European countries, Belgium was touched by the irreverent, ironic culture of the jazz age. Even in the farming villages in the Kempen region street organ grinders played the charleston. After years of occupation shortages, and heartbreaking tedium, young people in the towns and cities fell under the spell of the new culture of cinema, cigarettes and American *panache*. Close-cropped *garçonnes* in short dresses danced the foxtrot with clean-shaven young men to the sounds of *Why shouldn't I love you*, a Belgian hit at the time. Dance halls sprang up in even the sleepiest little towns, each with its own jazz orchestra. The palatial establishments in the major cities – for instance the Saint-Sauveur in Brussels, the Magic Palace in Antwerp and the Forum in Liège – also offered the public a tango orchestra during the interval. In 1924 during the Mechelen Fair the Dancing Scala offered, in addition to its usual waltz orchestra, a "JASS BAND (sic) with a very special line-up", as the poster proclaimed, adding: "A completely new experience for the public!". Many people were shocked to see that young women were no longer saving the money they earned in the flourishing retail trade for their trousseau but instead were spending it on their Saturday nights out, something that had been a male prerogative up until then. And they were even wearing lipstick, only seen on prostitutes before the war. In short, it seemed that, after the deep depression of the war, Belgium was entering a new era of prosperity, an era whose graceful, modern self-confidence was expressed in the elegant tricolour

Paul van Ostaijen, *Het Bordeel van Ika Loch* (The brothel of Ika Loch) frontispiece by René Magritte, Antwerpen

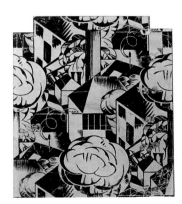

Victor Servranckx, *Wallpaper design for the Peters-Lacroix factory*, 1922 gouache, Brussels, Musées Royaux des Beaux-Arts de Belgique

feminine logo of Belga cigarettes and, for the happy few, in the sublime lines of the 'Made in Belgium' Minerva automobiles. The independence day celebrations in 1930 therefore took place amidst an atmosphere of optimism. (The festive mood was further enhanced by tax cuts.) This celebration of the country's centenary was also characterised by a carefully devised balance in 'symbolic visibility' between the two halves of the country. The centenary celebrations duly culminated in two national exhibitions, one in Liège and the other in Antwerp. The Walloon exhibition focused on industry while the Flemish exhibition had the arts as its theme, once again confirming the *clichés* pertaining to both regions. Nevertheless, these *clichés* were being perceptibly undermined, given the fact that the Flemish provinces had become increasingly more industrial over the last decade. A growing number of Flemings now worked in factories or mines, and various new industries had established themselves in the north of the country.

Be that as it may, the dual nature of the centenary celebrations indicated that Belgium was no longer regarded as a unified culture. This development was also evident two years later in a law introducing regional monolingualism. Henceforth, as far as public life, education and administration were concerned, only the Belgian capital was officially bilingual: Wallonia was completely French-speaking and Flanders, after centuries of Francophone upper classes, was 100% Dutch-speaking. The University of Ghent became a wholly Dutch-speaking establishment in 1930. This was a triumph for the pro-Flemings, who saw the realisation of their agenda – a Belgium in which there was genuine linguistic equality – getting closer.

Although 1930 considerably eased the tension on the language front, at the same time it was evident that polemical nationalism was still alive and well. On 24 August of the centenary year, Flemish nationalists celebrated the grand inauguration of their new Yser Tower during the eleventh Yser pilgrimage. At the climax of the solemn commemoration an aircraft flew over the scene of the celebrations, dropping tricolour flags and pamphlets on the pilgrims. The leaflets argued that the Flemings being commemorated in the Yser celebrations had indeed fought for King and Country. This constituted a frontal attack on the legitimacy of the Flemish nationalist war commemoration and caused a huge outcry among the Yser pilgrims, who then proceeded to set fire to the flags and pamphlets.

Mainstream politics had no answer to this nationalistic bitterness and the social resentment that fueled it (which still burned in sections of the Catholic lower middle classes) other than the optimistic message of the rising prosperity that everyone was enjoying. That prosperity would be shorter-lived than anyone had ever thought possible, however.

The world recession hit Belgium head-on in 1931. The economy, which was so dependent on foreign trade, got into severe difficulties as a result of the sharp drop in world prices. Stock exchange values collapsed, and industrial production sharply fell by 40%. Wave after wave of redundancies put thousands out of work. At the beginning of 1934 the country had 350,000 jobless, and hundreds of thousands more were on part-time working. Both men and women desperately combed the newspapers looking for jobs. Women were the first to be sent home *en masse*, given that bosses and unions were both of the opinion that at times when work is scarce, every working woman was usurping the place of a man – perhaps even of a *pater familias*. The proportion of women in the labour force fell from 31% in 1910 to 18% in 1939.

Politicians were powerless in the face of the disastrous sudden recession. Initially the government introduced an economic policy in accordance with the age-old formula of curbing inflation whatever the cost. A stringent deflationary policy was pursued from 1931 until 1935. This policy was unable to preserve the value of the franc; at the same time, however, the purchasing power and expectations of the bulk of the Belgian workers were hit hard. In 1935 economic policy changed course and the franc was devalued by 28%, which enabled the Belgian economy to take part in the world economic upswing. The economy slowly recovered from 1936 onwards. Until the Second World War, however, unemployment would remain much higher than in the 1920s.

The shock had been tremendous. Admittedly the crisis had not caused any starvation; real earnings remained above the level of the tough postwar years, and the hordes of unemployed were guaranteed a subsistence level through direct financial assistance. The 'hunger marches' on Brussels at that time rather symbolised the bitter experience of acute impoverishment and shortages, and the disintegration of many Belgians, hopes for a better future – workers in heavy industry, shop assistants, supply and office clerks, small businessmen, retired people, schoolteachers. Major strikes broke out in industry, very much against the wishes of the trade unions. In 1932 wage

Unemployed people are standing in the street while reading a newspaper in search for a job, Bruxelles 1935 circa, Brussels, Institut Royal du Patrimoine Artistique

cuts caused a social explosion in the Borinage mining region, which spread to other areas in the country. Riots broke out, the State police took a hard line, and the situation escalated near revolutionary proportions. Four years later a general strike brought the entire country to a standstill. Many Belgians' faith in government, in politics, and even in parliamentary democracy was severely dented. The idea spread that the old Liberal systems, which were a legacy of the nineteenth century, were no longer adequate and that the time had come for more systematic reforms – in the State, in the economy, in politics, in social life, and in people's mentality.

A more 'system-oriented' way of thinking invaded Belgian Socialism, which until then had chiefly been known for its pragmatism. In the vanguard of this development was the former orthodox Marxist Hendrik de Man, who had completely rejected Marxism in the 1920s and had gained international fame with his writings on the subject. He devised the 'Labour Plan', which the Workers' Party accepted towards the end of 1933 as its party manifesto and its own answer to the crisis. The 'De Man Plan', as it quickly became known, proposed a planned economy. It was mainly based on centralisation and nationalisation of banks and power companies. The idea was to supply the State with the tools to provide society with credit and energy where necessary, and to take action, for example with a programme of large-scale public works. The power of the executive within the State would also be increased and separated from Parliament and political parties.

Never before had the Belgian Socialists drawn up such a detailed and systematic plan for the future. In practice very little came of the whole concept of 'planned Socialism', but Socialist culture was very much influenced by it. The Plan was launched with a propaganda campaign in the like of which, in terms of scale and reach, had never before been seen in Belgium (the budget was five million francs, an enormous sum of money in those days). Both traditional and modern communication techniques were used in abundance: the campaign surrounding the Plan was conducted using flags, songs, radio speeches, miracle plays rhymed, 'thematic' bicycle trips, mass demonstrations, and propaganda films. De Man, who personified the whole Plan, became a cult figure, inspiring banner slogans like "Father of the Plan, we shall follow you!". The Plan was hailed ("The whole Plan and nothing but the Plan", as the slogans declared) as the radical, rousing, hopeful magic formula for a whole new world. The Catholic community in Belgium also responded to the contemporary crisis by conceiving grander visions. "Earthquake in Europe!" screamed a poster in 1936, presenting the Belgian Catholics with a complete collapse of the old world with the question: "What will be left standing?" and offering the answer: "The Church, the rock of twenty Centuries, is the Basis of the new age!". Since the encyclical *Rerum novarum*, whose message was echoed in *Quadragesimo anno* of 1931, the official social message of the Church had been one of preservation of the social order through a return to corporatism, the Catholic panacea for modern economic problems, the so-called 'third way', alongside that of unbridled individualistic greed and that of a destructive, godless class struggle. "Workers, your salvation comes from Rome!" proclaimed one banner at a *Rerum novarum* march in 1936.

At the same time the Katholieke Actie (Catholic Action) in Belgium, according to the watchword of Pope Pius XI, was systematically seeking to re-establish the dominance of the Church on the thoughts and behaviour of the population. Catholicism had to be a powerful force in society, now more than ever before. The challenge became all the greater as the culture became more of a mass culture. Whereas the Church in Belgium had simply ignored modern culture in the 1920s, in the early 1930s the feeling was that it was time for an all-out offensive aimed at the 'moralisation' of the Catholic masses. The Catholic establishment saw itself as a 'guide' to modern culture. Organisations like the Liga voor Publieke Moraal, Zedenadel, Offensief and the Scriptores Catholici took militant action against 'improper' books, films, radio programmes, and newspapers, and waged campaigns against the 'moral depravity' in dance halls and on the beaches. Undesirable private behaviour within the family also became the target of a Catholic offensive. The guild of the Katholieke Arbeidersvrouwen (Catholic Working-Class Women) sent female district inspectors into working-class homes and exercised control over every aspect of family life, ranging from the choice of clothes and interior furnishings to how the children should be brought up – indeed how numerous they should be. Families suspected of practising birth control suffered tremendous moral pressure. Ever since the encyclical *Casti connubii* of 1930 the Church had redoubled its vigilance in demographic matters. Catholic organisations in Belgium devoted themselves to obtaining a complete ban on the dissemination of contraceptive information and on married women's work outside the home, adopting the slogan: "A mother's place is in the home – a child is a blessing!".

It is not possible to ascertain whether the Catholic offensive was much of a success. Belgium was certainly still a predominantly Catholic country in the 1930s, and there was even some evidence of popular mysticism flaring up, with reports of Madonna visions in various villages throughout the country (a phenomenon on which the Church took a very aloof stance). The demographic choices of the Belgians were, however, unaffected by the Catholic pro-natal rhetoric and the number of births continued to decline, falling from 164,257 in 1920 to 126,257 in 1939. (The birth rate was higher in the more Catholic Flanders, though there too it dropped from 25 to 17 in a thousand; in Wallonia the rate fell from 19 to 10 in a thousand.) This decrease was wholly due to birth control, given that more people were getting married – and at a younger age – than before the war. Contraceptive techniques were still primitive: coitus interruptus and the rhythm method were the most common methods used. (Abortion was much less common than at the beginning of the century, when it was still regarded as a form of contraception.) The growing use of these methods indicates the determination of families to gain more control over their own future through family planning.

The pro-natal offensive was not restricted to the Church but was also conducted on a more limited scale by the State. The declining growth in the Belgian population caused official concern. In more general terms a certain 'regimented' way of thinking took hold in the public domain. The massive scale of modern society gave rise to a tendency towards the ideological regimentation of the 'masses'. As in other European countries, organised public life in Belgium in the 1930s was characterised by 'massism'. Huge numbers of people did gymnastics, went camping, and demonstrated; *en masse* people went to plays, 'song festivals', and outdoor religious services. The ongoing 'social education' of the masses was evident in the proliferation of youth movements, which, regardless of political persuasion, all manifested an unquenchable need for communal singing, fresh air, orderly marches, and military-style shirts.

The culture of both the Catholic and Socialist socio-political groups reflected an equivocal attitude towards modernism. On the one hand, rejection of the 'individualistic', the materialistic and (especially among the Catholics) the hedonistic elements in modern culture; on the other hand, appropriation of the 'mass' aspects of the new society. In both 'cultures' there was a strong sense that the 1930s were a time of sudden and traumatic changes. This was in effect a period of accelerated modernisation for Belgium. Old industries disappeared at a rapid rate and a growing proportion of the labour force worked in large companies where the 'boss' was invisible. Before the war 80% of Belgian workers were employed in small and medium-sized companies; in 1930 one worker in three worked in a factory with more than 500 employees, and this proportion continued to increase as industry steadily became more concentrated and more mergers took place. The result of this was that the 'tertiary sector' grew, and although the 'secondary sector' continued to dominate, more and more people earned a living typing and filing.

The farming community, on the other hand, got smaller with every passing year. A growing number of Belgians left their village every morning to go and work in the city. Neon lights and first-generation apartment buildings changed the appearance of the cities. The chilling austerity of the blueprints of modern urban development implied that this was only the start of a complete transformation of the old urban landscapes. In Brussels, for instance, despite the protests of the local authorities and under unrelenting pressure from De Man (by then Minister of Public Works), large parts of the old city centre disappeared to make way for a supposedly vital rail link between the North and South Stations. Commercial culture increasingly became an industry: local vaudeville theatres made way for cinemas, of which Belgium had the highest number per capita in Europe (without, however, developing an extensive film industry of its own, except in the documentary genre).

Building of the Nationaal Instituut voor Radio-Omroep (NIR)*, Flageyplein* Brussels, Institut Royal du Patrimoine Artistique

In Belgium and elsewhere in Europe the 1930s, with their painful succession of crises, saw the emergence of a new ideology, which demanded a radically different political culture, a political culture that would be capable of tackling the challenges of the new, while at the same time restoring an *order* thought to have been lost. This "New Order" way of thinking was an authoritarian body of ideas that placed emphasis on respect, authority, efficiency and mass discipline instead of on the liberal, 'nineteenth-century' values of political freedom, parliamentary control and rational criticism, which were now considered to be outdated. This way of thinking was to some extent diffusely disseminated throughout the whole of Belgian public life. It influenced Catholic as well as Socialist culture; the Belgian King Leopold III (who had succeeded to the throne in 1934

Fritz van den Berghe, *Political cartoon concerning the VNV-Rex agreement*, 1936, drawing, Ghent Foto-archief AMSAB

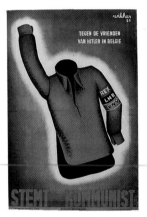

Tegen de vrienden van Hitler in België kommunist (Against the friends of Hitler in Belgium, vote Communist) 1936, election poster, Ghent Foto-archief AMSAB

after his father, Albert I, was killed in an accident) was very open to these new ideas. However, the New Order also came under attack from the existing parties, who continued to uphold the democratic principle. The 'new way of thinking' therefore gave rise to the creation of new parties outside the existing political groupings. The two most important New Order parties were Rex and the Vlaamsch Nationaal Verbond (VNV, Flemish National League), both of which mainly appealed to Catholic supporters, chiefly made up of malcontents from the lower middle classes.

The crisis and the rapid disappearance of small industries had aroused resentment among the lower and upper middle classes against both organised labour and the occult power of what had become known as "banksters" (a combination of "banks" and "gangsters"). This term of abuse of "banksters" studded the violent rhetoric of the young Walloon publisher Léon Degrelle, who became a successful political entrepreneur in the 1930s. In 1935 the ambitious and aggressive Degrelle launched an exceptionally fierce campaign against the Catholic party with the ostensible aim of cleaning up its 'corrupt practices' on behalf of a new and pure generation (he himself was only twenty-nine). Fulminating brilliantly, never at a loss for an accusation, regarded by a growing number of people as the personification of a new crusade for decency and order, *le beau Léon* (handsome Léon), as he was known, quickly made a name for himself – especially when the Catholic party broke with him in 1936.

His party Rex (named after the Brussels Catholic printing business Christus Rex ran by him) was phenomenally successful at the 1936 elections: coming from nowhere, the party won 21 seats out of 202. Following this triumph, Degrelle stepped up his efforts to spread his authoritarian, corporatist, anti-parliamentarian message further by arranging mass rallies in various sports stadiums (as in Germany and Italy the venues reserved for mass popular entertainment at that time were also used for political mobilisation). The total rejection by Catholic leaders (the episcopate forbade Catholics to vote for Rex) was fatal for Degrelle, however, as were the increasingly pronounced National-Socialist tendencies in the Rex ideology. Rex became altogether too extreme for the timid Belgian bourgeoisie. Despite generous support from Mussolini, the party also got into financial difficulties. Having reached a peak of 20,000 members, membership then declined rapidly. Rex suffered a crushing defeat at the 1939 elections, when it was reduced to just four seats. Degrelle's Fascism, a phenomenon of the times, had thereby become a marginal affair, which, without the war (seec chapter "The Second World War and the Royal Question, 1940-50"), would probably have vanished from public life of itself.

The VNV was of more abiding importance, and in 1939 still won 17 seats. In 1933 this party had grown out of the old Front party, which thereby moved lock, stock and barrel to the right-wing camp; the VNV embraced a rather anti-parliamentary ideology, hierarchical and corporative. The party's final aim in Flemish nationalist matters remained equivocal, covering as it did a wide spectrum from the transformation of Belgium into a federal State to the merger of an independent Flanders with the Netherlands to form a new *Dietsland* (the Netherlands showed little interest). It was in any case certain that the VNV wanted a 'more independent Flanders', and that this Flanders should be a corporatively organized society under authoritarian rule; furthermore, a Catholic society (although the Catholic Party rejected Rex unequivocally, its attitude to the VNV was considerably more ambiguous). This was a programme that appealed to those groups in Flanders who were most alarmed by the social and economic changes of the 1930s: farmers, small tradespeople, workers in the small towns and in the country, and low-level civil servants. The VNV also resorted to the reassuring cult of the 'leader', in the unlikely form of Staf de Clercq, a middle-aged teacher who had chiefly distinguished himself in the political agitation over the language border. The impact of the VNV on the Flemish electorate was not overwhelming; at its pre-war peak in 1939 it obtained no more than 13% of the votes in Flanders. But the entire Flemish political movement was gradually dominated by the VNV's reactionary interpretation, so that even critical intellectuals began to admit to the necessity for greater 'national commitment'. The annual pilgrimage to the monument on the Yser battleground became an increasingly militarily tinged mass demonstration, losing any link to the humanitarian pacifism of the 1920s; in 1933 Flemish nationalists were already rejecting Albert Einstein as a pacifist speaker at the Ijzerbedevaart, it being no place for a Jew. In short, the 1930s in Belgium brought with them the flowering of authoritarian movements which openly attacked liberal principles, just as elsewhere in Europe. However, on the whole Belgian parliamentary democracy was not really threatened from within. A coup by the New Order was not a genuine possibility. The Belgian democracy lurched on-

ward, pragmatic, prepared to compromise, not actually loved but neither massively condemned. But it was of course completely impotent in the face of international storms. With an almost bizarre determination it kept on pondering the familiar domestic questions, right up to the eve of catastrophe. On 26 April 1940, in fact, the Catholic / Liberal / Socialist government of Pierlot offered the king its resignation because it had reached an *impasse* regarding the language reforms in the Ministry of Education: which in other circumstances would undoubtedly have been a burning question. (The government's resignation was rejected.) Two weeks later the German armies invaded Belgium.

The Second World War and the Royal Question (1940-50)

In 1936, Belgium had opted for a neutral 'free hands' policy, severing its military ties with France. The Belgian population held the strong belief, which it shared with the French, that the country was never again to allow itself to be 'dragged along' in a war. But mere neutrality was not sufficient, as the experience of 1914 had taught. The build-up of a vast war potential in Nazi Germany contradicted all declarations of peacefulness from Berlin. In order to 'deter' the possible aggressor from invading, a policy of military effort had therefore been pursued. Military expenses grew to immense proportions and military service was lengthened to seventeen months.

After the Polish invasion and France and England's declaration of war on Germany, the Belgian government repeated its assurance of neutrality. It did, however, keep its troops, now 600,000 men, ready for war, under the supreme command of the king. All they could do was wait and see. Together with the whole of Western Europe, Belgium hoped that there might not be a war after all. At the end of March 1940, the German ambassador reported to Berlin that the Belgians, after a half a year of 'phony war', had come to believe, in spite of themselves, in the possibility of staying clear of the war.

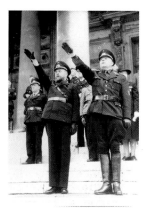

German soldiers in a Belgian city
Brussels, Centre de Recherches
et d'Etudes historiques
de la Seconde Guerre Mondiale

But this hope was shattered. Without an ultimatum or declaration of war, at the break of day on 10 May 1940, the Reich attacked Belgium. In a few hours, the great fortress Eben-Emael at the border was taken. The army was forced to retreat, just as in 1914, and was given French and British reinforcements (which arrived sooner than in 1914). But this time, the Ardennes no longer proved impenetrable to the German advance. The Belgians retreated even further so as not to be encircled. After a final battle, the Belgian army capitulated on the morning of 28 May. The 'Eighteen-Day Campaign' was over: 6,200 Belgians had been killed, 205,000 had been taken prisoner. The fact that the army had been enlarged to such a great extent had weakened it enormously, although it must be said that *all* continental armies were powerless against the *Blitzkrieg* and that the Belgian forces did all they could. In the years leading up to the war, VNV leader Staf de Clercq had received funds from Berlin for his 'Military Organisation', which was to propagate a 'spirit of defeatism' amongst the Flemings in the Belgian army. It is unclear whether this propaganda had any effect at all. Meanwhile in the occupied country, things looked as if '1914' was repeating itself. Nearly two million Belgians fled in a panic from the approaching troops, fearing a repetition of the atrocities. Thousands of civil servants abandoned their posts and left for France. In the first days of the occupation, the Belgian government itself had arrested various categories of 'suspects' and had them taken to French prisoner camps: Fascists, Flemish nationalists and Rexists, of whom it was feared that they would form a 'fifth column' for the attacking German army. Amongst these prisoners there were also Germans and Austrians suspected of 'espionage' for the Reich (although they had in fact fled from Nazism).

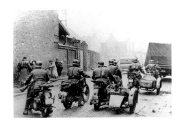

Staf de Clercq (VNV) in uniform brings the Hitler salute, Brussels
Centre de Recherches
et d'Etudes historiques
de la Seconde Guerre Mondiale

After Belgium's capitulation, the atmosphere in France became extremely anti-Belgian. The Belgian refugees were subjected to abuse in the streets and were unable to buy food anywhere. Cars with Belgian plates were pelted with stones. On the morning of the 28th, on the French radio, Prime Minister Reynaud used very strong words in an outburst against the 'sudden' capitulation of the Belgian army. His judgement of Leopold III was extremely harsh: the king was accused of having abandoned the allies and was scathingly contrasted to Albert I, the hero of 1914.

Leopold III had in fact been following a course of his own after the invasion. When it became clear that the Belgian army was going to lose the unequal battle with Germany, the government had recommended throwing in Belgium's lot with that of the allies and to continue the war, if necessary in exile. But Leopold was of the opinion that Belgium had done its international duty,

that the war was over for Belgium, and that everyone was to go back to work. He did not consider himself bound by the government. On the contrary, he judged his role in wartime to be much greater than the Constitution allowed for. The king possessed strongly authoritarian traits and was very sensitive to the general opinion that constitutional parliamentary democracies were 'over and done with'. Matters came to a head. After a bitter confrontation with the king during the night, the government left the country. In the autumn, the government and the king went their entirely separate ways. At the end of October, the government left for London to continue the war. On 19 November 1940, Leopold was received at Berchtesgaden for a meeting with Hitler. It was an unproductive meeting, as the Führer did not reply to Leopold's requests to alleviate the war contributions and to release the prisoners of war.

After the parting of ways between the king and the government, a great majority of the Belgians at first took Leopold's side. The departure of the ministers met with vehement disapproval, while the king's decision to 'share the fate of his soldiers' was generally applauded. The prevailing mood was that the war was over. The great majority of the refugees returned to their homes, sharing in the consensus that Belgium had to get back to work as usual. This consensus was reinforced by the behaviour of the German soldiers, who had followed their strict orders to refrain completely from anything that could recall the 'atrocities' of 1914. Furthermore, the German military authorities had been extremely efficient during the first weeks of the war in importing food and in providing immediate relief to the half a million unemployed, partly with the aim of winning over the Belgian people.

This initial half-dazed acceptance of the German occupation would, however, dissipate from July-August 1940 onwards, when the reality of the occupation became more apparent. The new powers imposed a ban on public meetings, demonstrations and strikes, introduced severe penalties for listening to British radio, subjected the press to censorship and 'purified' the public and university libraries of 'suspect' books. And quite soon, food became scarce again, while the population saw uniformed Germans everywhere with goods requisitioned from the shops.

All over the country, people initiated small acts of sabotage: telephone wires were cut, aircraft engines were put out of order. On 2 August, a German report described the escalating "hatred of Germany, which is manifesting itself both among the Flemish and the Walloons".

Germany did not hesitate to appropriate the riches of the occupied country – gold, labour force, coal – and use them for its own war economy. The requisitions and seizures of the first few weeks were soon followed by a systematic exploitation (a pillage in which, incidentally, quite a few Belgian 'middle men' lined their pockets considerably).

Hitler had not specified any long-term plans for Belgium, but there was no question of its natural annexation by the Reich. According to Nazi State doctrine, Belgium did not qualify as a 'Germanic' area, such as the Netherlands, which was to be treated as a *Schutzstaat* (protectorate) and given a civil government (*Zivilverwaltung*). Rather, Belgium was to become a kind of 'buffer State' against the British-French influence, and it was to be reduced to a satellite of German economy. In short, the main priority was economic exploitation. Furthermore, Berlin wanted to make sure that the German administrative machinery in Brussels would not grow to gigantic proportions as it had done in 1914-18, when there had been tens of thousands of military officials who were not connected to the Reich's actual war effort. The German authorities in the occupied country were therefore given the form of a Military Government (*Militärverwaltung*) which was to remain small, in keeping with the principle of 'government, not administration'. In December 1940, the German government consisted of less than 700 officials. The military governor of occupied Belgium was sixty-two-year-old Alexander von Falkenhausen, a Junker from a family of military men and civil servants, more of military than National-Socialist inclination. Leopold stayed at Laken Palace in Brussels as a kind of 'prisoner of war'.

In the meantime, an 'informal top' of the national elite, consisting of union leaders, magistrates, industrialists, financiers and high-level civil servants, had decided that the Belgians would do best to stay at their posts, as civil servants, mayors, judges, police officers, company directors, and so on. This 'policy of lesser evil' was inspired by the belief that staying at one's post could prevent 'worse', meaning unbridled exploitation and repression. But the Belgian leadership had very little room for manoeuvre. And although the Military Government at first aimed primarily to keep things going rather than to 'Nazify' Belgium immediately, the Belgian administration was nonetheless promptly purified of 'elements hostile to Germany', from top to bottom.

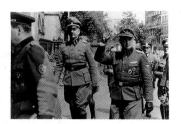

Léon Degrelle (Rex) in uniform brings the Hitler salute, Brussels Centre de Recherches et d'Etudes historiques de la Seconde Guerre Mondiale

This was the hour of the New Order movements, who had offered their services to the occupiers from the beginning of the war: Rex and VNV. Rex had possessed a virtual monopoly on pro-German feeling in French-speaking Belgium. Degrelle and his followers therefore hoped that their ideological affinity would provide them with a share of the power. But the golden days of Degrelle's reception by Hitler (in 1936) were over, although as late as 1943 the Führer still mentioned in passing that the Rex leader was 'the sole reliable Belgian' as far as he was concerned. The Military Government, however, despised Degrelle as a grovelling nitwit. The German authorities in Brussels knew how small the Rex following was. Degrelle's boisterous Führer worship had made him unacceptable to the Belgian public and even offended his supporters: "No-one negotiates on their knees", was an internal criticism in January 1941. (During the war, Rex never had more than about 15,000 members.) As the occupation went on, the Germans did start to employ Rexists to fill posts in the Belgian government, but to a much lesser degree than they employed VNV members.

The VNV took advantage of the new Flamenpolitik. For German authorities, this was the only concrete policy followed with regard to the occupied country. In July 1940, Hitler had announced that the future of the Belgian State was to remain 'open' for the time being, but that the Flemish were to be given preferential treatment as much as possible, to the detriment of the Walloons. The Führer therefore also decided to release Flemish POWs whilst keeping Walloon and Brussels POWs imprisoned (unless they could prove their 'Flemish origin'). After the massive repatriation of mainly Flemish POWs (October 1940 - February 1941), eighty thousand Walloons remained in German camps. A German report mentioned that "the people – and especially the women – who, in spite of everything, think in Belgian terms, simply do not [understand] why one man is allowed to return to his family, while the other remains captive here".

In the name of the "Flemish need for justice", as the saying went, the VNV made a grab for power in various sectors of public life – media, culture, professional associations and administration. Half of the mayors in occupied Flanders belonged to the VNV. The VNV was also given control of the Ministry of the Interior – and therefore of the police force.

The VNV's new position of power bore little relation to its number of supporters. The party had about 25,000 members at the time of the invasion. Afterwards, its membership among the Flemish grew to about seventy thousand (in 1943), but it never developed into a real 'popular movement', as its leadership admitted internally. A secret survey of Belgian public opinion in wartime stated that anti-French feeling among the Flemish had now become overshadowed by anti-German feeling, and that the VNV following, as before, continued to consist of "semi-intellectuals" and Flemings "eternally discontented".

Indeed, the population had quickly turned anti-German. As in the other occupied countries, only a minority of the Belgian people were involved in active resistance. After the war, about 200,000 Belgians were to be recognized officially as 'resistance fighters', that is, about 2.4% of the total population. (56,000 military, economic and ideological collaborators were sentenced by courts after the war.) Still, the 'divergence of minds' between the Belgian people and the German authorities with their collaborators started quite early on during the occupation. On 11 November 1940, the armistice of 1918 was celebrated as a national festival. The population held marches, though these were forbidden. In the streets of Brussels, Liège and Antwerp, civilians were arrested in the streets for shouting pro-English slogans. The news that the Germans had lost the Battle of Britain was spread underground. Many listened to the British radio. A resistance press sprang up, picking up where it had left off in 1914-18. No less than six different editions of the *Libre Belgique* were published in the first war year. It had a Dutch-language counterpart entitled *Vrij België*. As during the First War, the pro-Flemish resistance paper *De Vrijschutter* reopened its columns. The title of the paper explicitly referred to the first occupation (a *vrijschutter* or *franctireur* is a sniper). This was moreover the only paper that combined pro-Flemishness with the spirit of resistance, because, even more than in 1914-18, the radical pro-Flemish rhetoric had been appropriated by the collaborators. For that matter, of the 567 different clandestine papers which were published during the occupation, the majority (415) were in French.

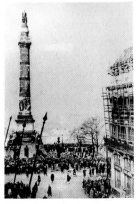

Silent demonstration of the inhabitants of Brussels before the Unknown Soldier Memorial, Brussels, Centre de Recherches et d'Etudes historiques de la Seconde Guerre Mondiale

In spite of this, the two parts of the country did not differ from each other significantly in their aversion to the occupying forces and their collaborators; Flamenpolitik or not, exploitation, impoverishment, and the checks and humiliations of a military occupation affected the majority of the people under it. As a result, the collaboration movements were forced to get on even closer

terms with the German powers. German support was paid for with more emphatic commitment to the Reich and the relinquishing of same State claims. From this point on, Rex stopped talking of its blueprints for a 'Burgundian State'. Degrelle grew more and more profuse in professing his unconditional love of Hitler. The VNV obeyed the summons of the Military Government to refrain from referring to an ideal 'Dietsland' in the party paper *Volk en Staat*.

The isolation of Rex and VNV was reinforced by the fact that the Belgian authorities were absolutely not co-operating 'sufficiently' with the occupying forces. The Military Government complained that the Belgian administration was impossible to work with and that it was increasingly forced to take on more cases itself, for which it made use of the collaboration movements.

It was clear quite soon that the Belgian police specifically were lacking in 'loyalty' when carrying out the tasks specific to the occupation: their duties regarding forced employment, fighting the resistance and tracking down RAF pilots. From 1941 onwards, the police and gendarmerie forces were systematically enlarged with pro-German elements. But this had an adverse effect: the 'old hands' distrusted the New Order elements (who remained a minority, preferring their own militias because of the better pay) and kept their 'co-operation' to the barest minimum, if they did not actively join the resistance. As a result the Military Government judged the gendarmerie to be only one-sixth 'reliable'.

In October 1942, the Germans introduced the measure of *Arbeitseinsatz* (Forced Labour) in Germany. As during the First World War, the Military Government met with much resistance from the Belgian administration. Mayors refused requests to inspect the population registers, Belgian employees of the German Werbestelle (Employment Agency) refused to co-operate, and the resistance gave all kinds of support to those who refused to work. After a while, four out of ten people who were ordered to report simply did not show up. The Belgian police made only half-hearted attempts to track down those who refused. That is why the Military Government was forced to set up its own Zivilfahndungsdienst. As expected, this corps of about one thousand drew many social failures – a feature typical for the 'troops' of the collaboration in general – most of whom belonged to Rex and to the Flemish collaboration movement De Vlag (Deutsch-Vlämische Arbeitsgemeinschaft). In collaboration, De Vlag was much closer to the SS than to the VNV. It openly advocated the *Anschluss* of Flanders to Nazi Germany, had its own armed militia of 1,500 men as early as the summer of 1940, and could boast of the special attention of Himmler. Moreover, in August 1940, an SS-Vlaanderen was founded. From 1943 onwards, Rex also started to take the side of the SS far more explicitly than it had done before. In January 1943, Degrelle proclaimed that the Walloons too were a Germanic people – thereby adopting the more 'ethnic' rhetoric of the SS. (The SS were in favour of Belgium's annexation.)

In fact, Himmler's SS (whose political power in the Reich was growing) was conducting a power struggle with the Military Government of Belgium and was to win the battle definitively at the very end of the occupation (in July 1944). During the first months of the occupation, the SS-dominated police forces, including the Gestapo, had already settled in Belgium, where they quickly overshadowed the police forces of the Military Government in repressing the resistance. From 1942 onwards, brutality became more widespread among the occupying forces. This reached a climax in the last year of the occupation, which was characterized by Sunday raids on football fields and cafés by the Zivilfahndungsdienst, to catch work refusers and deport them to SS prison camps in Germany.

The systematic persecution of the Jewish community in Belgium also started halfway through the occupation. It is estimated that this community consisted of 52,000 people at the end of 1940. Most of them were immigrants from Russia and Poland and refugees from the Reich. Nine out of ten did not have a Belgian passport. For the Military Government, anti-Jewish policy had not been a priority during the initial stages of the occupation. The reason for this was not humanitarian: necessarily the German occupation of Belgium was mainly military and aimed at economic exploitation (the primary aim was to make the country serve, rather than to 'purify' it to Nazi standards). Nevertheless, the basis for the eradication was laid already in 1940: the definition of the concept of 'Jew', the exclusion from professional life, and the registration of the Jewish people. The collaboration press gave its frank assent. "The curtain has fallen, gentlemen of the Old Testament," wrote the NVN paper *Volk en Staat*, "Room for our own people!"

These ordinances were issued by order of the Military Government. The Belgian administration

*Dossin-barracks in Mechelen
meeting-place for the deportations*
Brussels, Centre de Recherches
et d'Etudes historiques
de la Seconde Guerre Mondiale

refused to announce them, on the grounds that the Constitution rejected discrimination as to 'race' or religion. This was a fine point which probably did not do much to change the fate of the Jewish community, because the German order to establish municipal Registers of Jews was followed up anyway. By means of this register of Jews and the SS police's own files, the German authorities had collected a total of 56,186 names and addresses by the spring of 1942.

On 27 May 1942, Jews in Belgium were forced to wear the yellow star. The Brussels mayors unanimously refused to co-operate, so that the local Kommandantur had to distribute the stars itself. Two days later, this job was taken over by the Belgische Jodenvereniging (Belgian Association of Jews), established at the end of 1941, which thereby hoped to prevent anything worse from happening. The enormity of this miscalculation became evident when, in August of the same year, the first convoys of Jews were put on transport trains from the Dossin-barracks in Mechelen. In July, a group of Jewish partisans had broken into the offices of the Association of Jews to destroy the files. But the machine of destruction had been set in motion and would grind on mercilessly until July 1944. Between August 1942 and July 1944, the SS police transported 25,257 Jews from Mechelen to the extermination camps (45% of all the people registered by the Germans). About 1,500 of them returned.

Up until 1942, the Jewish persecution had provoked no reaction to speak of from the Belgian population. Although some individuals, here and there, wore a Belgian tricolour star in May 1942 (and Elisabeth, the Queen Mother, wore a brooch in the shape of a star of David), there was not yet any large-scale protest.

On the other hand, neither were there any 'native' anti-Semitic initiatives, except in Antwerp, where the anti-Semitic organisation Volksverwering organised a kind of 'Kristallnacht' in the Jewish neighbourhood in April 1941 with a few hundred Flemish SS members. As a rule, the occupied population, according to a complaint expressed in a German report in February 1942, had "no sympathy at all" for the 'Jewish problem'. In December 1942, the Belgians even showed an aversion to buying goods that had been requisitioned from the Jews.

The Belgian Association of Jews was intimidated into greater co-operation from September 1942, when it appeared that a great many Jews who had been ordered to report were not obeying this order. The Germans were still upholding the fiction that the Jews were called up for forced employment in Germany. (The summons, issued by the Military Government and distributed by the Association of Jews, was therefore called an *Arbeitseinsatzbefehl*). By November 1942, 15,000 men, women and children had already been placed on transport trains. Whereas the first groups had left without incident, this changed when people gradually became aware of the meaning of the deportation. The last transportations had to be enforced by raids of the SS police, as was communicated to Berlin by the person in charge on 11 November 1942. An example was the *Grossaktion* carried out by the German Devisenschutzkommando in September 1943, in which nine Antwerp Jews were crushed to death in the transport truck to Mechelen. The deportations continued, but the contingents got smaller and smaller. The head of the Sicherheitspolizei estimated, in July 1944, that eight out of ten remaining Jews in Belgium had by then been provided with forged papers by the resistance. Thousands found shelter with private families, in monasteries, convents and schools.

The clandestine *Joods Verdedigingscomité* (Jewish Defence Committee) was able to rescue two thousand children from deportation. In April 1943, a unit of the armed resistance succeeded in stopping the twentieth convoy of the deportation train from Mechelen.

This showed that the armed resistance in occupied Belgium had started to get more organised. There was a tightening of the bonds between the various departments of the armed resistance on the one hand – ranging from the Communist Partisans to the right-wing Geheim Leger (Secret Army) – and the government in London on the other hand. Acts of sabotage gradually grew more systematic. The most spectacular was probably *la grande coupure*, carried out by a sabotage group that had grown amongst anti-Fascist circles at the free-thinking Université Libre de Bruxelles (ULB. The membership of this Groupe Général de Sabotage during the war was estimated to be 4,000. The members came from very different political and social backgrounds: priests and free-thinkers, farmers, prominent citizens and workers.) In the night of 15 January 1944, the group succeeded in cutting the entire Belgian high-voltage network at one stroke. The defect was felt as far as the factories in the Rhine basin.

In contrast to the French, the Belgian resistance movements at first refrained from attacking col-

laborators. But in the summer and autumn of 1942 (when the Nazi regime started the Jewish deportations, the Arbeitseinsatz, and Communist witch-hunts in the occupied territory), more and more 'pro-Germans' became targets of attacks by the armed resistance. The Communist resistance in particular had set itself the task of systematically eliminating collaborators. The tortures (at the Gestapo headquarters on the fashionable Avenue Louise in Brussels and in the notorious Fort Breendonk near Antwerp) and the executions only hardened the Partisan resistance in its resolve. "Communists do not mourn their dead, they avenge them", was the motto (after the war, the Communist armed resistance was to claim responsibility for a total of 1,100 liquidations). The collaboration movements, which became more and more isolated from the people, felt not at all protected by the Belgian police, and insufficiently protected by the Military Government, although, on German orders, Belgian prisoners were executed in retaliation for each attack. After the resistance had also started to kill Germans in the winter of 1942-43, the Military Government started with more massive reprisals. SS forces increasingly urged the collaboration movements to take the law into their own hands. This was how both Flemish and Walloon retaliation commandos were created, which attacked prominent Belgians who were held to be 'morally responsible' for the resistance: freemasons, magistrates, bankers. But 'common Belgians' too were the victims of the commandos, often in operations which were used to settle personal scores. For instance, a ticket collector on a ferry across the Meuse was shot because he refused a free crossing to two members of the Rexist Walloon Guard. The retaliation commandos attacked Jewish citizens, as well as people who helped them in hiding. The violence of the commandos reached a climax in the summer of 1944. Himmler had openly given the go-ahead for extreme retaliations. A new wave of attacks by the resistance had killed a number of top collaborators (including Degrelle's brother). The Veiligheidscorps (Security Corps) of De Vlag carried out massive raids. At the beginning of August, practically the entire male population of a small East-Flemish village was deported to the concentration camps, never to return. One week later, 27 people were killed by a Rex retaliation group near Charleroi. Near the end of the occupation, this situation nearly turned into a civil war in several places, for instance, in the province of Limburg, where attacks, counter-attacks, raids and deportations followed one another in quick succession.

In the midst of this spiral of violence, the end of the war, and even the postwar period were being prepared. The government in London was now generally recognized as the true representative of the Belgian people (partly thanks to the abuse heaped on them by the collaboration press). The king had little credit left. Not only had he never openly taken a stand against the Arbeitseinsatz or against the persecution of the Jews, but it was known that he condemned the resistance. Any impression that Leopold III was "sharing the fate of his soldiers and his people", as the pious message from the Palace had it, had already been banished in the autumn of 1941 by his sudden marriage to his children's governess, the twenty-four-year-old beauty Liliane Baels. (Leopold had been a widower since 1935, when the adored Queen Astrid was killed in a car accident.) This second marriage in wartime was a serious mistake with regard to public opinion, a judgement which was shared by the king's close friends, such as Hendrik de Man. When the prisoners of war in the camps were sent photographs of the king (in uniform, with the caption "I am thinking of you"), they threw them out of the barracks windows in a rage. The occupied country, and especially Wallonia, bitterly condemned this 'treason'.

In the summer of 1944, the occupation neared its end. In August 1944, the Germans still made attempts to send the remaining Jews in Belgium to the camps, even including the staff of the Jewish Association. But it was too late. On 2 September, the allies invaded Belgium. The next evening, allied troops liberated Brussels, cheered by an overjoyed crowd.

The government returned to Brussels on 8 September. The Belgian king had left. Hitler had ordered that Leopold and his family were to be transferred to Germany. The next day, the government read Leopold's 'political testament', a kind of proclamation which he had drafted in January 1944 and in which he justified his wartime attitude. This document made it clear how little the king had departed from his authoritarian ideas. Leopold saw himself as the sole judge of the country's foreign policy and war policy. He also meddled in home affairs, with his summons to lose no time in tackling the 'problem of nationalities' in Belgium, which, in his opinion, had become even more acute under the occupation. Finally, the government was to solemnly ask for forgiveness for its 'misconduct' of May 1940.

The ministers were deeply shocked by the tone of this document and sent it back. On 21 Septem-

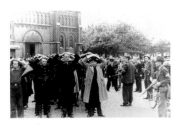

Round up collaborators in Peer (Antwerp), Brussels, Centre de Recherches et d'Etudes historiques de la Seconde Guerre Mondiale

ber, the restored Parliament appointed Leopold's brother Karel as regent, awaiting the king's return. This return, however, promised to be extremely problematic. The war was not over yet. In December and January 1944-45, the Belgian Ardennes was still to be the stage of a deadly German counter-offensive. But the process of 'settling moral scores with the war' had already started.

The violence of the last occupation year continued after the liberation, when collaborators ('blacks') were liquidated brutally. Several hundred were killed in the first weeks – often by last-minute 'resistance fighters' and frequently as a result of personal feuds. In the cities, jeering gangs threw the furniture of 'blacks' out of the windows. Women who had consorted with Germans were shorn bald. In Antwerp, the police had to lock up 'blacks' in the cages of the zoo to protect them from the people's fury.

When this uncontrollable violence had been brought to a halt, the collaborators were able to be taken to court. By February 1946, twenty-one military courts had been established and several thousand accused stood trial. Eventually, 56,000 people were sentenced for collaboration: 1,247 death penalties were pronounced, of which 242 were carried out. Degrelle fled to Spain, where he was to die at a ripe old age in the early 1990s, the last surviving leader of the collaboration of the Nazi era. The leader of SS Flanders, Lagrou, also found refuge under the Franco regime. Other collaborators escaped to Austria. The VNV leader Elias (who had taken the place of the deceased De Clercq in 1942) was first sentenced to death, which was later commuted to life imprisonment. He was released in 1959 (after which he published a gigantic erudite history of the Flemish Movement).

The purges were to remain controversial and continue to be so even today. They were certainly not done in a perfectly balanced way. As had happened after the First World War, though literally on a scale that was two hundred times as large, the heaviest punishments fell at the beginning of the purges (when the anger over the occupation and the horror at the gruesome finds in the extermination camps were at their height). This created a disproportion in the penalties and gave rise, in certain circles, to the idea that the whole postwar administration of justice had been an orgy of vindictive injustice. The notion gained ground, especially in Flemish collaboration circles, that the purges – significantly renamed the "repression" – had been a campaign of revenge against the pro-Flemish. This notion is not supported by a careful analysis of the trials. In postwar Belgium, there certainly was enmity towards Flemish nationalism, which had become rather compromised under the occupation (when the Flemish collaboration press had triumphantly propagated its message, "justice for Flanders at last"). Moreover, at the time of the purges, French-speaking circles suggested that the heroics of the resistance was to benefit the French-speaking Belgium, while the shame of the collaboration was to be borne mainly by Flanders. This kind of crude *cliché* about the two parts of the country also surfaced in the Royal Question.

In the meantime, the era of postwar economy set in. The period of scarcity ended more quickly than it had after the First World War. Belgium was soon able to buy foodstuffs on foreign markets on a large scale (using the foreign currency earned from the sale of Congolese uranium to the allies).

Rationing was discontinued in December 1947. In other fields too, an economic and social normalization was reached quite quickly. The 'Social Pact', which had already been concluded before the end of the occupation, laid the foundations for what was later to be called Social Security. In a much more structural way than ever before, labour entailed rights: the right to an old age pension, health insurance, unemployment benefit, and child benefit. The economic reconstruction was carried out in a relatively short time. After the First World War, it had taken the country more than seven years to get back to its pre-war level; after the Second World War, it took only three years. By 1948-49, most Belgians were doing relatively well again. But the political, and, in a way, the moral recovery from the havoc wreaked by the war was to take much longer. The national drama of Leopold III, which only really unfolded in May 1945, involved much more than just the role of the king. In a sense, it was the trial of the whole occupation period: of the collaboration, the purges, the ambiguity of the accommodations made, and the resentment all this had caused. The king's war record was bitterly discussed from May 1945 onwards. Word got out that Leopold had met Hitler (although the details of the meeting were not known). Many of the supporters of the king's conduct did not know about his incriminating 'political testament' and praised the king's consistency and concern for his country. Pro-Leopold posters announced: "The King stayed, the rest is slander!". For his opponents, especially left-wing politicians, and particularly in the Wal-

loon industrial areas, negotiations on the return of the seriously compromised king were out of the question, just as much as was discussion on the whole principle of the purges itself. The case was to continue for five years, prolonged by the king's obstinacy, by the shaky political situation (between September 1944 and August 1950, Belgium had nine governments), and because the political elites themselves had made it into a major case. Finally, in 1949, a Catholic-Liberal government arranged to have the matter decided by a referendum. Royalist circles hoped that this direct plebiscite would show overwhelmingly that the people stood behind the king.

But on 12 March 1950, only 57.7% of the Belgian voters declared the wish for Leopold to return to the throne. 42.3% voted against it. The proponents of the king's return were most numerous in Flanders (72% of the votes). In Brussels and Wallonia, a majority (of respectively 52% and 58%) did not want the king back. The resistance was strongest in leftist Wallonia. (The Catholic Walloon province of Luxembourg was royalist, but too sparsely populated to make a difference.) An outcome thus divided was no basis for allowing the king to return, as his position had to rest on at least some degree of consensus. But the Catholics, who gained a great deal electorally from the extremely heated debates (as did the Socialists, who rallied around the 'no' vote), imposed the king's return and ended the regency. On 27 July 1950, Leopold returned to the palace in Laken, after more than six years absence.

Three days later, the country was on fire. Four demonstrators were killed in Liège in a confrontation with the gendarmerie. There were riots in the port of Antwerp and in all the industrial areas in Wallonia. In Liège, meetings called for Walloon secession. An anti-Leopold "march on Brussels" with hundreds of thousands of participants was in the make. Civil war loomed. On the night of 31 July the government made the king face the fact that, under these circumstances, his return was impossible. At six o'clock in the morning, Leopold III abdicated.

Ten days later, Leopold's eldest son, twenty-year-old Baudouin I, swore allegiance to the Constitution in the Belgian Parliament. The ceremony was disrupted by a cry of *Vive la République!* by the chairman of the Communist party, Julien Lahaut. He was killed a week later in front of his house. (The murder has not been solved up to the present day.) A fitting end to a terrible question, it would cast a dark shadow over the history of Belgium for years to come.

Modern Belgium (1951-1995)

The Royal Question was a traumatic event in the collective consciousness of Belgium. The country was divided and both parties felt cheated. The question of the collaboration had begun to smart anew. During his long reign, Baudouin I was to succeed in making the monarchy acceptable to the Belgians again, even in making it appear self-evident. But at the moment itself, the end of the postwar period was full of grief, sorrow and bitterness.

Horror swept the country in 1956 at the mining disaster in Marcinelle near Charleroi, in which 262 miners suffocated to death in a collapsed mine-shaft. It was the worst mining accident in Belgian history. Against a background of solemn piano music, the radio reported on the crowd waiting near the pit. The papers published heart-rending details about the shoes found in the collapsed tunnels, which the men had taken off in their futile escape attempts. The funeral was a national manifestation of mourning and dismay, yet another sorrow to add to these grey years.

It was the beginning of the end for Walloon heavy industry. Although the 'coal battle' of the immediate postwar years had been won, it was clear now that the whole 'war' had been lost. Belgian coal could no longer compete with oil products. In 1959, eight million tons of coal remained unsold and stayed in the mine yards. This was the start of the irreversible decline of Walloon coal. This decline disrupted the whole economy of the old heart of the smoke-stack industry, the axis of Sambre and Meuse, where the steel industry was deteriorating too.

The workers fought to the bitter end. The Unity Law of 1960, which cut back heavily in social provisions, aroused angry reactions, especially from Socialists and especially in the Walloon industrial areas. The strike broke loose on 20 December 1960; 300,000 Walloon workers downed their tools. In Liège, the Guillemins railway station was half demolished. On 23 January 1961, union leaders stopped the action, which had already reached the status of *la grève du siècle* (the strike of the century). The enraged reactions were moreover not limited to Wallonia. In Ghent and Antwerp too there were strikes in the winter of 1960-61 (five years later, the planned closure

of a Limburg mine encountered a similar bitter protest. This time, two demonstrators were killed in a clash with the gendarmerie). It was also the end of Belgium as a colonial power. At the end of the 1950s, it still looked as in its rapid economic expansion the Congo had concluded an eternal unity with Belgium. (In 1956, a manifesto in the periodical *Conscience africaine* demanded full political rights, but not yet independence.) But from 1958 onwards, the call for independence from Belgium began to be heard clearly.

After bloody conflicts between rebels and the police in Léopoldville (the capital of the Congo, in the province of Kinshasa) in January 1959, things went very quickly. In that same month, Brussels decided that the Congo would be granted independence, and one and a half years later, on 30 June 1960, the independence of the Congo was officially declared in Léopoldville in the presence of Baudouin I (eleven years later, the Congo was renamed Zaire).

So the metropolis and the colony were separated, without the violent repression of independence that occurred in the Dutch East Indies, and certainly in Algeria. No Belgian troops were sent to the Congo. Public opinion in Belgium was very much opposed to any kind of 'Algerian' policy. But the separation was not entirely peaceful. Belgian economic interests were defended with some degree of concealed violence. For instance, there was Belgian support for the secessionist mercenary republic in the province of Katanga (which is rich in minerals). In the summer of 1960, there was mutiny in the Congolese army, which hastened the exodus of several thousand Belgians – high-ranking officials, officers, technicians and their families. For all its smoothness, the separation proceeded amidst much bitterness. In the Congo, there was bitterness about an era of exploitation and discrimination, a resentment which was expressed to the shocked king of Belgium by the new Prime Minister, Patrice Lumumba, at the ceremony of independence. On the Belgian side, the separation meant failure, in spite of everything. The 'Belgian civilizing mission' that had been held up for the admiration of so many generations turned out to have been at best a mistake, at worst perhaps a crime.

This being said, there had never been very many Belgians in Africa. Although the ex-colonials did establish clubs where they commemorated their 'heroic' time in the tropics and were much given to sulking amidst their collections of ivory kitsch, they never formed a permanently discontented group as did the returned French *pieds-noirs*. They found their place in Belgium, as did the workers of the shut-down mines and steel factories, who found new jobs in other industries or in the expanding universe of State officialdom.

It all dissolved into a 'social peace' which was concluded against a backdrop of growing affluence. From 1960 to 1973, the Belgian economy experienced an unprecedented boom, which was later remembered with acute nostalgia as the "Golden Sixties". These were years with an average economic growth of 5%, in which the number of unemployed fell to a negligible fifty thousand (in 1964). The booming economy was also kept up by a massive import of foreign 'guest workers'. No more Italians arrived after Marcinelle. The site for systematic recruitment of workers had now moved to North Africa and Turkey. In 1964, the brochure *Vivre et travailler en Belgique* was distributed in Morocco, Tunisia and Algeria. Belgium pursued a policy of family immigration, in order to be more attractive to potential employees than other European countries, which at first accepted only single male workers. Between 1961 and 1968, the North African population in Belgium multiplied tenfold, reaching nearly 16,000 (out of a total population of more than 9 million), after which this increase accelerated even more. In 1977, there were just over 95,000 North Africans in Belgium, the great majority of them from Morocco. The Turks, who came mainly from rural Anatolia, formed a smaller contingent; a little over 7,000 in 1970.

The newcomers from the Maghreb and Turkey, most of whom were low-skilled and came from the country, formed the new unskilled industrial proletariat in Belgium, working in the mines, the metal factories and the building trade. The less numerous women worked in sweatshops and canneries or cleaned office buildings. These 'guest workers' did the work that Belgians no longer had to do. The time when Belgians had rented out their unskilled labour to the highest bidder was long past. The very last Belgians to do seasonal work on the chicory fields of Northern France quit in the middle of the 1970s. The new times were good to the Belgians, and the Belgians were suitably grateful. "Keeping up with the times" became the formula of these years. Symbols of the new era rose all over the country. The best-known symbol was the Atomium in the Heysel park in Brussels, a building representing a gigantically enlarged iron molecule, hosting a restaurant in the top 'atom'. The Atomium was built for the World Exhibition (Expo) in 1958, the first of its

An abandoned classroom Bandaloengwa (Léopoldville) 4 January 1959, Tervuren Geschiedenis van de Belgische Aanwezigheid Overzee

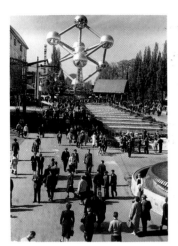

Atomium, World Fair Brussels, 1958
Brussels, Institut Royal du Patrimoine
Artistique

kind since the Second World War, which drew forty million people, including practically the entire population of Belgium (four out of five Belgians, to be precise). *Happiness Will Come Tomorrow*, the title of a film set against the backdrop of Expo '58, might have served as the catchphrase of Belgium's Golden Sixties.

The standard of living of most Belgians shot up. In the space of twelve years, the purchasing power of the average family doubled. More and more families bought a television, and even a car (between 1960 and 1973, the percentage of car owners in Belgium went from 9% to 21%). A record number of families were living in a house of their own. Even the ultimate luxury, a holiday abroad, came within reach. From the early 1960s onwards, a steadily lengthening train of caravans edged its way south to the Spanish Costas (in 1951, paid holiday was one week. This was extended to a minimum of twenty working days by 1975).

But this happiness came at a price. The landscape of this small and densely populated State needed to be ruthlessly mobilized for modernity. The government pursued a lavish policy of public works. The obligatory destination of many a school trip became the 'inclined plane' of Ronquières in the Hainaut province, a kind of high-tech river lock, hardly more useful than the Atomium, prestigious as a symbol of progress. In a very short time, Belgium found itself criss-crossed with spacious and extravagantly lit motorways. Belgium became the only country in the world to be fully illuminated all night long by street lighting, to the delight of the truck drivers who were passing through the country in ever greater numbers. The cities too increasingly turned into transit zones. Fly-over motorways went straight across residential areas. The first of these was the steel viaduct over the Avenue Leopold II in Brussels, which was built in 1958 to lead the millions of visitors efficiently to the Expo. In a short time, it reduced this middle-class area to a run-down ghetto. Great chunks of the Brussels inner city disappeared to make way for an express motorway, fifty metres wide. All this met the needs of commuter traffic, which was becoming more and more prevalent. More than ever, the capital became a bureaucratic working city of ministries, political parties, insurance companies and banks. Hundreds of thousands of Belgians left Wallonia and Flanders every day to go to their offices, counters or warehouses.

These commuters were willing to spend a large part of their day travelling. The great majority did not consider it an option to move to the big city. In contrast to the French, most Belgians did not live in blocks of flats in the suburbs of the large cities. As of old, the Belgians tended to stay in the smaller towns and villages; no rural exodus took place.

Under the surface however, a tremendous change was taking place in the country's human geography. The villages might not have been losing their inhabitants to the cities, but they did undergo a transformation which is practically unparalleled in Western Europe. A full urbanization came about surreptitiously, which made Belgium, as one architect wrote, beyond dispute into the ugliest country in the world. The whole country was covered with a practically uninterrupted urban 'quilt', especially Flanders, where houses followed one another monotonously along the major roads. This landscape of continuous building was not created by unchecked urban spreading so much as by the growth of the village populations.

The Belgians commuted, and did not move. They stayed in the village; the village was where they made merry and married. Many saved to build a house in their home town, their ultimate ambition. The percentage of Belgians who lived in a house of their own (most of these were single family homes, rather than apartments) was higher than anywhere else in Europe. Furthermore, the Belgians did not *buy* a house, but had one *built* (on the plot of land that was the traditional wedding gift). And very often they helped to build it themselves. Half of the Belgians did not go on holiday in the summer, but stayed at home to work on their house. (To this day, the Belgians are the least travel-minded people of Europe.) As regards the type of house, the rustic *fermette* (farmhouse style) became the absolute favourite from the 1970s onwards, a clear indicator of the bucolic priorities of the commuting office workers.

This traditional-seeming pattern shows that Belgium, in all its modernity, kept things 'nice'. It developed a kind of uncomplicated hybrid culture in which mini skirts could be seen at communion celebrations and village fairs were shown on television. 'Traditional' values remained especially important in Flanders, because the Catholic Church still had a great power over the culture, though this was increasingly contested. The *schoolstrijd* (school conflict) of the 1950s shows how keen the denominational differences still were. Because of the growing number of pupils (caused both by the baby boom and the growing percentage of teenagers who went to secondary

school), the problem of Catholic versus State schools arose again. In 1955, the State made an arrangement which greatly displeased the Catholics. The well-organised Christian public reacted with mass demonstrations and petitions signed by millions. The new battle over the 'soul of the child' – basically a battle for subsidies – ended in 1958 in a very Belgian compromise. The Catholic network was from now on to be funded by the State, while the State offered a public school as an alternative to every Catholic ('free') school. This was expensive, but a full laicization of education in Belgium was absolutely out of the question, and a complete take-over of education by the Catholic Church was of course unimaginable.

The increasing welfare of the 1960s resulted in more education: secondary education became an obvious choice, even for girls. Higher technical education drew more students (Flanders especially made up a lot of ground in this respect). And the universities made their first steps in the direction of mass education. In 1959, Ghent University had three thousand students; in 1970, it had over ten thousand.

With all this, popular culture in Belgium still remained amazingly parochial. 'Kermesse' cycling races and mussel festivals were still the preferred stops during election tours. Flemish television scored with popular traditional comedies, of which some were in dialect. Rural television epics were great favourites, while the percentage of farmers fell from 7.7% of the population in 1960 to 3% in 1980. The Italian-Belgian Salvatore Adamo, a miner's son from the Borinage, was extremely popular with delightful, reassuring songs such as *Vous permettez, monsieur* (of an innocent mischievousness that reminds one more of the *belle époque* than of the naughty 1960s) and the monster hit *Dolce Paola*, dedicated to Paola Ruffo di Calabria, the most recent and most glamorous member of the Belgian royal family (Nella Sua Maestà / ho vista in verità / Una colomba fragile / La la, la la, la la).

The wonders of modern consumption were introduced with the greatest ease. Cosy television quizzes like "10.000 or nothing" provided evenings full of excitement, with weeping winners receiving television sets, fridges or even cars from the hands of the quizmasters.

Christian culture did not lag behind. The Catholic Boerenbond (Farmer's League), which kept a firm grip on its dwindling number of families for as long as it lasted, kept an eye on the consumption of durable goods. The local representative drew up monthly reports on every family. Did family X already have a mixer? A refrigerator? Why had family Y not been seen at Sunday mass for two weeks? The consumption pattern was guarded as strictly as mass attendance. Materialism was no longer evil.

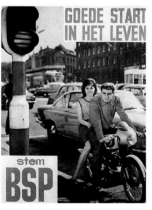

Goede start in het leven stem BSP
election poster of the BSP
1966 circa, Ghent, Foto-archief AMSAB

The Socialists too embraced modern consumption. Their election posters showed a young couple on a Vespa, an object of ardent desire, in front of the new head office. This new building embodied the party's wish to exchange its working-class past for a more technocratic image. The party was now called the Belgische Socialistische Partij (Belgian Socialist Party), a self-confident title, more 'in keeping with the times' than its old name of Werkliedenpartij (Workers' Party). The word 'Socialist' had long lost its sulphurous odour. The new office tower built in 1965, for which the Art Nouveau People's House built in 1895 had to be demolished, was no gathering place, no 'people's house' with a café and a meeting room, but an expression in stone of bureaucratic power. In short, of the future (between 1961 and 1980, employment in the services sector grew from 46% to 63% of total employment).

In the year of the Expo, Brussels had become the capital of the European institutions. In 1967, the European Commission moved into another colossal office building, the enormous Berlaymont building, in the middle of an area which was becoming completely dedicated to the new super-bureaucracy.

Brussels became the 'Capital of Europe', but at the same time it was losing some of its status as the capital of Belgium, so to speak. Belgium as a unitary State was becoming more and more disputed. In the 1950s, the conflict between the Flemish and Walloon communities had not dominated political life, although the Royal Question had injected the Belgian language problem with a degree of mutual resentment. The school conflict (see above) had also its 'community' elements. Support for the public schools was to be found mainly in the industrial area of Wallonia, while the supporters of the Catholic network were situated in Flanders (where black flags hung from the church towers after the 1955 measures in favour of State education). Nevertheless, in the Royal Question, and much more so in the school conflict, the denominational conflict had been more decisive than the difference between the two communities.

Then again, both conflicts were entirely separate. Traditionally, the Walloon industrial cities had been bulwarks of Socialism, and Flanders, especially outside the big cities, was mainly Catholic. (In 1972, 67% of Flemish children went to a Catholic secondary school, as against only 42% of the Walloons.) The denominational pacification, which was reached with the 'school pact' of 1958, would in fact pave the way for what gradually became known as the Community Question. The new affluence actually showed up more and new differences between the two large communities of Belgium. Whereas Walloon wages had still been higher in the 1950s, with more Flemish unemployed, this situation reversed itself in the beginning of the 1960s. Walloon heavy industry died a slow death.

The multinationals (Philips, Siemens, Ford, Bayer) and the new industries (the petrochemical industry, electronics, the pharmaceutical industry, car assembly) preferred to establish their new plants in the triangle Ghent-Antwerp-Brussels. Flanders was less affected by the disadvantages of a relative headstart, had a 'social climate' that was more attractive to entrepreneurs than that of the red industrial belt in the south of the country, and had a young, skilled population whose wage expectations were nearly one-third lower than those in Wallonia. The economy therefore started to grow more rapidly in Flanders than it did in Wallonia. By 1966, the Flemish GNP per capita was higher than the Walloon figure, for the first time in Belgian history.

The contours of a differential demographic pattern also became more clearly defined. In spite of greater immigration to Wallonia, the Walloons constituted a diminishing percentage of the Belgian population: 34.5 % in 1955, 33% in 1961. Wallonia had a very old population and one of the lowest birth rates in the world, which led the demographer Sauvy to exclaim that "Wallonia is committing suicide!" Brussels remained static at one-sixth of the population, which was due to immigration, since the birth rate was low here too. Not so in Flanders, which was extremely fertile at that time, with a formidable baby boom and a respectable number of big families. The Flemish comprised 50.2% of the Belgian population in 1955, 51.2% in 1961.

The Walloons became anxious at this situation and at the prospect of becoming a 'minority' in their own country. The awareness of industrial obsolescence added to this feeling of insecurity. There was much indignation on the Walloon side at what was seen as economic 'favouritism' for more tractable Flanders as regards the location of new companies. In reaction, plans were developed to obtain greater autonomy. At the time of the 'strike of the century' in 1960-61 (see above), calls were already being made for federalism. There was an appeal to separate Socialist Wallonia from the Belgian State, perceived to be dominated by the Catholic and conservative Flemish community (and soon renamed "The Belgian-Flemish State"). Leftist Walloon nationalism found its hardest core in the militant metal industry of Liège. It claimed that making Belgium into a federal State would halt the decline of Walloon economy, by pursuing an autonomous policy of anti-capitalist structural reform.

While the demands of Walloon nationalism were concentrated on economic problems, Flemish nationalism was mainly cultural. Although language equality had made enormous progress, many French-speaking circles still maintained their old contempt for Dutch as a 'peasant' language', an attitude that infuriated many Flemings. In pro-Flemish and Catholic circles, the 'defeat' of the Royal Question had moreover not been entirely forgotten. And finally, the hard core of Flemish nationalism had completely redefined the postwar purges as a conscious anti-Flemish pogrom (see chapter "The Second World War and the Royal Question, 1940-50"). In these circles, anti-Belgicism had remained alive.

Anti-Belgicism, however, was not part of the mainstream of Flemish nationalism as it developed within the Christene Volkspartij (Christian People's Party) or CVP, the party of Flemish Christian-Democrats. It was obvious that the Flemish were gaining numerical superiority. In 1971, they already comprised 56% of the population. This allowed the CVP (who were, up to the 1980s, consistently able to count on half the Flemish votes) to pursue a so-called "majority strategy", dominating the Belgian State machinery by their sheer weight of numbers. (Nearly all Belgian prime ministers between 1955 and 1996 were Christian-Democrat Flemings.) This numerical majority was then 'fixed', in the sense that pro-Flemish politicians put a stop to the language censuses, because these showed that the French language was advancing in Brussels and in the boroughs around the capital. In 1962, the language border was established definitively. It ran, and still runs, to the south of Brussels. The area of the capital is a 'bilingual area', the only one in Belgium, language homogeneity being laid down by law in the rest of the country.

Language homogeneity in higher education became the latest demand. From 1962, Flemish-nationalist students at the Catholic University of Leuven started to protest the presence of French-speaking professors and students. The logic of the language border required that French was to disappear from Leuven, as this city was situated in the Flemish half of the country. The battle of Leuven Flemish was long and bitter and even gradually took on some elements of the May 1968 rebellion. The resistance of the Belgian episcopate against breaking the unity of the *alma mater* conferred an exciting anti-authoritarian undertone to the battle. Demonstrating students carried banners with death's heads and the slogan "Walloons go home" (inspired by the "Yankee go home" of the anti-NATO resistance of the time). The Flemish nationalists of Leuven won the battle and from 1969, the French-speaking professors and students were forced to leave the university. A brand new campus was built in the countryside in Walloon Brabant, under the name Louvain-la-Neuve. The university library was divided in half (more specifically, it was split according even and uneven numbers, to circumvent any problems of principle).

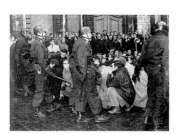

Flemish students protesting
Leuven, January 1968
in M.-T. Bitsch, *Histoire de la Belgique*
Paris, 1992 (Photo Belga)

In short, the struggle between the communities had intensified. The elections of 1968 showed progress for the parties who had made it their main issue. The Brussels Front démocratique des Francophones (FDF), who followed the old francophone habit of emphasizing the principle of 'language freedom', got 2.5% of the votes. The Rassemblement Wallon (RW), a Walloon-federalist party which was the first to unite Socialists and non-Socialists, got 3.4%. The greatest progress was made by the Flemish Volksunie (VU), a party which had been created in 1954 as an offshoot of the CVP, but had become gradually more 'Flemish' than Catholic and offered an exciting alternative to the old Catholic loyalty in these somewhat 'wilder' years. The VU obtained 9.8% of the votes, that is, one fifth of the Flemish votes. This was the highest figure ever obtained by a Flemish-nationalist party in Flanders.

The new 'community priorities' found their way into policy. The constitutional reform of December 1970 changed unitary Belgium into a State 'of communities and regions' with three culturally autonomous communities: the Dutch-speaking one, the French-speaking one, and the small German-speaking one. But the communities and the territory (the 'regions') did not seamlessly coincide (for instance, the location of bilingual Brussels in Flanders made a full division of the country into two impossible). The new Constitution identified three 'regions': the Flemish, the Brussels, and the Walloon regions.

This cultural autonomy was given an extremely politicized form. Within the communities, education, scientific research, art policy and social work became completely dominated by party politics, which determined appointments and even agendas. At a national level the Flemish and Walloon politicians were competing for government money, with every piece of expenditure for the benefit of one part of the country having to be immediately balanced by compensations to the other part. This federalization hereby perpetuated a trend towards the compartmentalization of the public domain, a chronic disease in Belgian political culture. Still the end of the "Belgique à papa", as the saying went, seemed to herald a new era of possibilities. Flemish nationalism was in that period at the height of its self-awareness: modern, successful, dynamic. Its traditional following, the intellectual lower middle class, had also increased a lot with the growth of the 'service sector'. A Flemish elite pushed its way through to the top of the Belgian establishment. A picture arose of Flemish dynamism versus Walloon stagnation.

The blooming Flemish middle class fancied itself to be working harder, to be more productive and to have earned its prosperity more than the grumbling Walloons, who held on firmly to State safeguarding of their industries, which had long ceased to be viable, and who saw in every adaptation a capitulation – a lack of flexibility of which their blunt unwillingness to learn Dutch was only one expression.

This rather triumphalist Flemish thinking was soon attacked by critical Flemings who pointed out its self-satisfaction and narrow-mindedness. The critics included painters, performing artists and writers, like the playwright, novelist and poet Hugo Claus, probably the most important postwar writer in Flanders. (Claus was later to acquire international recognition with his great novel *The Sorrow of Belgium* [1985], which is set during the Second World War in the oppressive Catholic environment of Flemish collaboration. *The Sorrow of Belgium* is virtually the only attempt made in Belgium to give shape to the traumas of the war.)

Claus was the exponent of a generation which had already been attacking the typically Belgian, beatific middle-class mixture of modernity and tradition. It was, too, in this context that the bril-

liant Bohemianism of the international Cobra group was set (Copenhagen, Brussels, Amsterdam), which included the Belgian painter and graphic artist Pierre Alechinsky, the creator of keenly ironic epigrams such as *Parlement – Parle. Ment.* (Parliament: Speaks. Lies.). Jacques Brel of Brussels also became world famous, taking classic chanson to a final peak in the midst of the rock and roll revolution, with compelling compositions and radical-humanist lyrics (*Quand on n'a que l'amour*). Brel became a wellnigh mythical figure during his own lifetime, whose odes to the Flemish country – *Le plat pays (qui est le mien)* – moved hundreds of thousands of Belgians to tears, on both sides of the language border. Flanders had not been praised in such lyrical French since Emile Verhaeren (see first chapter "*Fin-de-siècle* and *belle époque, 1880-1914*"). Many supporters of the Flemish Movement consequently felt painfully hurt when in the mid-1970s Brel, shortly before his death, made a bizarre thrust at the Flemish in *Les Flamands* ("who force our children to learn to bark in Flemish"). A counter-chanson soon appeared on the market, entitled, rather pathetically, *Neen, Jacques, neen!* (No, Jacques, no!).

The 'spirit of '68', less radical than in the Netherlands, but at least as irrepressible, carved its way in the world. Protests against the Vietnam War and the presence of NATO gave the opportunity for the expression of increasing criticism of the 'Atlantic loyalty' of an earlier generation. Protests also arose against the working conditions under multinationals. In 1968 the strikes at the Ford car assembly plant in Genk were massively supported by university students.

This anti-establishment activity also took the form of a rebellion against Catholic morality, particularly in Flanders. The writer Louis-Paul Boon, previously a factory worker, an autodidact, nominated several times for the Nobel prize just like Claus, shocked conservative opinion with novels that portrayed the reality of life in working-class neighbourhoods. This was a break from 'official' literature, whose authors appeared to write more for the Christian Committees' list of school books than for a contemporary public.

All of this happened to the cheers of an increasingly non-churchgoing generation. Between 1967 and 1972 weekly church attendance in Flanders decreased by a quarter. Believers could no longer go to mass every morning, because there were simply no longer enough priests for an early mass every day. Vehement protest arose in Flanders at the introduction in the early 1970s of 'deontological chambers' for Catholic education. These were committees that checked whether the teachers at the Catholic schools were leading a suitably Christian life.

This ran counter to a public opinion for which the rigid sexual morals of the Church had less and less to do with their own lives. Knowledge of the latest contraceptive methods had already penetrated to the Belgian province by the end of the 1950s. The Belgian working women at the Southern Dutch company of Philips brought the first generation of birth-control pills to the attention of their Dutch colleagues, and in the succeeding years the use of the pill rapidly spread. Belgian feminism was characterized by a level-headed concentration on concrete goals such as access to the labour market and the right to contraception. However, in contrast with the Netherlands, abortion remained a criminal offence. In 1973 the right to termination of pregnancy was contested fiercely, in connection with the criminal case of the gynaecologist from Namur, Peers, who openly admitted to having carried out abortions. In practice, abortions did take place in many hospitals, but they were kept secret. However, the conservative reaction prevented abortion from being decriminalized, and so Brussels and Walloon hospitals kept on carrying out illegal terminations as before, and Flemish women travelled to Dutch clinics in chartered coaches.

A new generation asked itself more questions about the price to be paid for galloping prosperity – the Valium-addicted commuters from tidy home to office, the stomach ulcers, the heart attacks, the nylon, the traffic jams. This led to the start of ecological protest, and new parties such as the Flemish Agalev (*Anders Gaan Leven* – Live in a Different Way) and the French-speaking Ecolo. During the 1973 oil crisis it even seemed as if the Greens had won the argument: the traffic-free Sunday enabled a whole generation of Belgian children to familiarize themselves with something their parents took for granted – *playing in the street.*

A year later it became clear that the hefty increase in the price of oil also marked the end of an era of growth in prosperity. The worldwide recession hit an unsuspecting Belgium in 1974. For the first time in many years the Belgian economy showed a loss in its balance of trade. Production figures dropped, unemployment rose, the national debt grew and the frank kept on decreasing in value. By 1980, Belgium had 350,000 unemployed: one tenth of the active population. The government was at its wits' end. In the face of diminishing financial resources the communities

began to begrudge each other State support. Flemish politicians questioned the subsidizing of the bottomless pit of the Walloon steel industry. Walloons disputed the flow of cash to the dying Limburg mining area. In the absence of an answer to the problems of the recession it seemed, in short, that a continued division of the country was the only way of retaining the prosperity acquired.

The political world also continued its division along language lines. In 1978 the Belgian Socialist Party split in two and Flemish and French-speaking Socialists went their own way. The BSP was the last Belgian party to relinquish its unity, after the Liberals had taken final leave of their unitary position six years previously, and the Christian Democrats, who had split up first, in 1969, after the trauma of Leuven.

In itself the Community Question did not rouse Belgian feelings more than previously, probably less in fact. From 1977 the following of the Flemish and Walloon nationalist parties actually shrank. But the loose ends and contradictions in the State reform gave the Flemish-Walloon question a dynamic of its own which dominated politics beyond the actual concerns of the public. So, for instance, it was possible for an affair to erupt in 1986 which provided the Belgian State with the greatest ministerial crisis in its history. The cause of the conflict was the Voeren area in the east of the country, consisting of six agricultural villages, about four thousand inhabitants altogether, which in the 1960s were attached to the Dutch-speaking province of Limburg (from which they are physically separated by the southernmost point of the Netherlands) as a result of their Dutch speaking majority. One of the champions of the re-attachment of the Voeren area to the province of Liège was the Socialist Mayor José Happart. In order to give extra weight to his demand, he refused to take a Dutch-language exam, which led to his dismissal. This increased his popularity in Wallonia enormously. In the end it was this question of principles down to the last square millimetre that led to the downfall of the government, leaving the country without a government for five months in the first half of 1988.

A new government would, in that same year, carry through a new constitutional reform that made Brussels a completely independent region and gave the three regions (the Flemish, the Walloon and Brussels) and the two communities (the Flemish and the Walloon) new areas of authority – education and public works. The areas of authority of the Belgian government were from then on limited to foreign affairs, defence, justice, the mint and social security. From the 'community perspective' the status of the bilingual capital became more and more of a 'problem'.

All this hardly answered every Belgian's deepest wishes. The majority of the citizens were more concerned with the economic situation, which did not improve. The number of unemployed had risen to half a million. Women were hit especially hard by the lack of jobs. Tens of thousands of young people simply found no way into the labour market and clutched helplessly their worthless diplomas. Like elsewhere in Europe, the gap between the political class and the citizens became ever wider.

The political practice of patronage which had developed in the years of prosperity hindered a Parliament plagued by absenteeism from seriously applying itself to the country's problems. Politicians considered themselves responsible for their own following, not for the public domain, which was therefore excluded as much as possible. Ministers distrusted the civil service and worked mainly with their own retainers (called a *kabinet* – an office). The 1981-86 Christian Democratic-Liberal governments with 'special powers' regularly left Parliament on the sidelines, in order to carry out a neo-Liberal disinvestment policy which contrasted sharply with the interventionist policy carried out up to then.

The 1991 elections demonstrated just how great the distance between the citizen and politics had become. The traditional parties suffered a serious downturn, and a greater percentage than ever voted for the new parties. In Wallonia the Socialists lost heavily, to the benefit of Ecolo. There was a disturbing increase for racist parties, who sought to profit from the 'problem' of immigration in Belgium, and found their target in the Moslem newcomers (Turks and those from the Maghreb countries), the majority of whom belonged to the working class, often lived in impoverished areas in the inner cities, and to whom all Belgium's problems – criminality, unemployment, urban decay – were attributed (at the time of the elections this group consisted of about 232,000 people, or 2.3% of the total population of ten million). In Wallonia the virulently anti-immigrant Front National attracted 30,000 votes, 1.7% of the total: no far right party had had such success since 1939. Another racist party called Agir attracted a somewhat lower percentage. But even more alarming was the phenomenal rise of a party which, in its short life (it was found-

ed in 1979), had united extreme Flemish nationalism, powerful xenophobia and general anti-parliamentarianism into a potent cocktail (its rise gave the title of "Black Sunday" to this election day). This was the Vlaams Blok, which, with its anti-immigration slogan "Our own people first", won 10.3% of the Flemish votes (even though the Moslem immigrants in Flanders were relatively fewer than in Brussels and Wallonia), and in Antwerp even had more than a quarter of the electorate behind it.

With its demand for Flemish separatism and its mystical-racist Blut und Boden ideology (adapted to modern terminology by way of such expressions as "Flemish identity" and "colonization of Flanders by a foreign power"), the Vlaams Blok was, as it were, the fundamentalist face of Flemish nationalism. A great many supporters of the Flemish movement were extremely annoyed by its monopolization of the Flemish idea – with its excessive vindication of the Collaboration and New Order Flemish radicalism. Things were in the meantime not going so well for the 'mother party' of modern Flemish radicalism, the Volksunie: it lost supporters to the Vlaams Blok, and even more to the reformed Flemish Liberal party, which was a new amalgam of pro-Flemish feeling and laissez-faire economic Liberalism.

This was a successful amalgam, and not without reason: neo-Liberal thinking seemed to fit perfectly with pro-Flemish aims. The recession and the Belgian State's budget problems (by the early 1990s the national debt had risen to 135% of the GNP, probably the largest national debt in the Western world) had gradually created an increasingly strong neo-Liberal reflex in certain Flemish circles. Flanders was still doing relatively better than the Walloon part of the country, which, it had been concluded, was unproductive, and presented a better chance of recovery.

In the 1990s an effort was put into the 'development' of the identity of the communities. The economy remained the population's greatest concern: after a short-lived fall, the percentage of unemployed in 1991 once again stood at 10%. But, just like everywhere in the world, the government had only a limited control over the economy. This was revealed painfully in 1988, when Carlo De Benedetti undertook a daring raid on that venerable government holding, the Société Générale. Although he did not succeed, from that moment on Belgians only occupied a minority of the top posts in the Société. In the regions, neither the Flemish, nor, *a fortiori*, the Walloon authorities were capable of 'anchoring' economic activity.

A greater emphasis on identity as the *raison d'être* of the new political entities therefore imposed itself. In 1990 the Brussels Capital Region acquired a symbol of its own (a yellow iris with a white border against a blue background). A zealous search was made for a Walloon anthem, but this has as yet been unsuccessful. It is not at all clear whether this anthem should be in French, as an expression of the French-speaking "community", or in Walloon, as a song for the Walloon "region" (the latter also raises the question of which Walloon dialect, there being dozens of them). Nevertheless, a small army of civil servants is fully occupied in the continued 'development' of a Walloon identity. On the Flemish side, as far as identity is concerned, things are rather simpler, because the federalization of Belgium is in a certain sense the result of the long-term cultural and political efforts of the Flemish Movement. There is therefore a somewhat broader heroic tradition available. Even so some symbolic engineering is called for, such as, for example, is found in the popularizing writing that consistently rewrites the whole of Belgian history in terms of the communities. For instance, a recent 'radical democratic' Flemish manifesto suggested that the struggle for universal suffrage was fought a hundred years ago by the Flemish working class, hand in hand with the pro-Flemish middle classes, whereas in reality this struggle can only be understood in a Belgian perspective: without the deaths in the Walloon protest campaigns (see first chapter "*Fin-de-siècle* and *belle-époque*, 1880-1914"), the Flemish workers would have remained voteless for much longer.

The cultural distance between the language groups is also increasing in areas not influenced by official efforts. The majority of French-speaking Belgians have by tradition never spoken a word of Dutch. The borders between Wallonia and France and between Flanders and the Netherlands are gradually becoming more porous (both 'geographically' and in media terms) than that between Flanders and Wallonia. Walloons watch French TV *en masse*, and scarcely ever Flemish TV. A recent survey showed that 56% of Flemings travel to the Netherlands 'occasionally or often', which is 9% more than ever go to Wallonia or Brussels. Even in the capital social life is usually limited to the same language group. The media increasingly report on 'the other half of the country' as if it were foreign.

What was provisionally the last step in the reform of Belgium dates from 1993, when the country became a fully Federal State. It was the culmination of a twenty-three-year deconstruction of unitary Belgium. The national State has finally lost its predominance, and 40% of government money is now managed by autonomous regions and communities, which has acquired authority in an increasing number of areas. From then on, Belgium has been a State comprising eight 'sub-State entities', with their own executive bodies, councils, administrative services, and teams of specialists to instruct the population in the ins and outs of the new State system. It has been a complex, peaceable, civilized reform, but which did not lead to an explosion of popular joy.

There was another event in that same year which had a greater resonance. On 21st July King Baudouin I inspected the traditional military parade on the Paleizenplein in Brussels. Ten days later he died suddenly in his summer home in Motril in Spain. No one could foresee what was to come next. The country mourned the king – in a more open, emotional way than appeared possible in such an aloof culture as the Belgian. The day the news was made known more Belgian flags appeared in the streets of Brussels than at any time since liberation. In the following days there was an uncommon show of sorrow *and* of a will for unity.

More than half a million Belgians, with communities, regions and generations merging together, came to Brussels on the 5th and 6th of August to pay tribute to the body of the king. Interviews made amongst the patiently waiting crowd (some had awaited their turn in their sleeping bags for a whole night) recorded the general fear that with the death of Baudouin perhaps the end of Belgium was not so far off. Journalists were amazed to find how much loyalty this country, which had already been written off, was able to elicit.

It turned out that the hope expressed by some that a revival of Belgian political unitarianism might be built on this zeal was unfounded. As ever, it proved that a militant sort of Belgian nationalism was neither feasible nor desirable. The significance of the 'tricolour tears' of August 1993 was to be found elsewhere. They prove the continued existence of a loyalty to a communal Belgium: a minimal loyalty which is only expressed when it is under threat.

The rest of the 1990s in Belgium were years of scandal, in which the corruption of public life and the political culture accumulated since the war became increasingly visible. For the moment, the latest nadir reached in this woeful development is the discovery in the summer of 1996 of a murderous paedophile ring in Charleroi and Brussels, and the subsequent exposure of an almost systematic obstruction of judicial investigation. A wave of horror swept through the country. As a bitter and dignified protest, 325,000 Belgians, including the parents of the murdered and vanished children, held a silent "white march" through Brussels on the 20th of October 1996. This was the largest public demonstration in Belgian history and was directed partly at the rot in Belgian justice, and more generally in Belgian public life. 'Rot' did not seem too exaggerated a term. The pats on the back, the corruption, the political appointments in the magistrature, the obstruction of judicial investigations and even infiltration by organized crime turned out to have been able to assume excessive forms because only a minority of 'public servants', in a civil service, a magistrature and a political class shot through with partisanship and indifference, appeared to feel any responsibility towards the common good.

One small advantage does appear out of this disgrace: it is now openly acknowledged. In October 1996 the government and the royal household held out the prospect of a complete 'clean-up'. The public scandals and the danger of racism have stimulated debate in society. Committed and sophisticated commentators have directed their gaze at the Belgian here and now, as well as at the reality as found in Brussels, Flanders, and Wallonia. The 'public texts' are more interesting than ever. The Flemish linguists Jan Blommaert and Jef Verschueren keenly dissected the dubious principles of *The Belgian Debate on Immigrants*. The Brussels historian Anne Morelli headed the bilingual collective work entitled *Histoire des étrangers et de l'immigration en Belgique* [...], which showed that Belgian history is also the history of immigration. Another bilingual collective work by Professor Morelli, *Les grands mythes de l'histoire de Belgique, de Flandre et de Wallonie* was a great success among the public at large. It demolished various invented traditions in the imagined communities with ironic professionalism. The journalist and historian Marc Reynebeau also provided a superb survey of "the Flemish identity, from the 12th to the 21st century", in his book *Het klauwen van de leeuw* (The Lion's Clawing).

Works such as these make a contribution to major public debates that lead to 'communities of ideas', which do not conform to party disciplines, *clichés* of identity or even, in some cases, lan-

Emblems of Flanders and Wallonia
in A. Morelli, *De grote mythen*
uit de geschiednis van België
Vlaanderen en Wallonië, Berchem, 1996

guage borders: because even those Belgian intellectuals who least tend towards unitarianism are still obsessed by 'the other'. So for the time being Belgium still exists as a bridge between the communities, as an object of debate and, if one wishes, even as an 'identity'. According to a survey carried out at the end of September 1996, 70% of the Flemish people clearly and systematically opt for a 'Belgian identity'. (Although, when asked, this majority might not know what this identity signifies, and would rightly view a question like this as impertinent.)

The impressive "white march" on the 20th of October united Walloons, Flemings, the people of Brussels, and newcomers. In all its sorrow, this shows that Belgium still has a *raison d'être*. Probably the *raison d'être* the old French anarchist attributed to this country a century ago: "To be Europe's experiment".

Bibliographical Note

La Belgique, société et culture depuis 150 ans, Bruxelles, 1980; *Les grands événements du XXe siècle en Belgique*, Bruxelles, 1987; BARTIER, J. et al., *Histoire de la Belgique contemporaine 1914-1970*, Bruxelles, 1975; BIRON, M., *La modernité belge: littérature et société*, Bruxelles-Montreal, 1994; BITSCH, M.-T., *Histoire de la Belgique*, Paris, 1992; DUMONT, G.-H., *La Belgique*, Paris, 1991; GENICOT, L. (dir.), *Histoire de la Wallonie*, Toulouse, 1973; KOSSMANN, E.H., *The Low Countries*, Oxford, 1978; MABILLE, X., *Histoire politique de la Belgique*, Bruxelles, 1986; MORELLI, A. (ed.), *Les grands mythes de l'histoire de Belgique, de Flandre et de Wallonie*, Bruxelles, 1995; PIRENNE, H., *Histoire de Belgique des origines à nos jours*, Bruxelles, 1975; STENGERS, J. (dir.), *Bruxelles, croissance d'une capitale*, Antwerpen, 1979; STENGERS, J., *Congo, mythes et réalités: 100 ans d'histoire*, Paris, 1989; STENGERS, J., "La déconstruction de l'état-nation: le cas belge", *Vingtième Siècle*, 50, 1996, 36-54; WITTE, E. (dir.), *Histoire de Flandre des origines à nos jours*, Bruxelles, 1982; WITTE, E.; CRAEYBECKX, J., *La Belgique politique de 1830 à nos jours*, Bruxelles, 1987

1880-1914

ARON, P., *Les écrivains belges et le socialisme, 1880-1913: l'expérience de l'art social, d'Edmond Picard à Emile Verhaeren*, Bruxelles, 1985; BITSCH, M.-T., *La Belgique entre la France et l'Allemagne*, Paris, 1994; CHARRIAUT, H., *La Belgique moderne, terre d'expériences*, Paris, 1910; ELIAS, H., *Geschiedenis van de Vlaamse gedachte 1780-1914*, vierde deel: *Taalbeweging en cultuurflamingantisme. De groei van het Vlaamse bewustzjin 1883-1914* (Tweede druk), Antwerpen, 1971; GODDARD, S.H. (ed.), *Les XX and the Belgian Avant-garde. Prints, drawings and books circa 1890*, Kansas City, 1992; LEMONNIER, C., *La vie belge*, Paris, 1905; LIEBMAN, M., *Les socialistes belges, 1885-1914: la révolte et l'organisation*, Bruxelles, 1979; LILAR, S., *Une enfance gantoise*, Paris, 1976; PIRENNE, H., *Histoire de Belgique*, deel VII: *De la Révolution de 1830 à la guerre de 1914*, Bruxelles, 1948; ZOLBERG, A., "The Making of Flemings and Walloons: Belgium, 1830-1914", *Journal of Interdisciplinary History*, 5, 1974, 179-235; ZWEIG, S., *Emile Verhaeren, sa vie, son oeuvre*

1914-19

CHRISTENS, R.; DE CLERCQ, K., *Frontleven 14/18. Het dagelijks leven van de Belgische soldaat aan de Iijzer*, Tielt, 1987; DEFLO, F., *De literaire oorlog. De Vlaamse prozaliteratuur over de Eerste Wereldoorlog*, Aartrijke, 1991; PIRENNE, H., *La Belgique et la guerre mondiale*, Paris-New Haven, 1928; STENGERS, J., "Belgium", in Wilson, K. (ed.), *Decisions for War 1914*, New York, 1995, 151-74; VANACKER, D., *Het aktivistisch avontuur*, Gent, 1991; WHITLOCK, B., *Belgium: a personal narrative*, New York, 1919, 2 delen

1920-40

De dolle jaren in België 1920-1930, Bruxelles, 1981; *Les années trente en Belgique: la séduction des masses*, Bruxelles, 1994; HOOZEE, R. (red.), *Moderne kunst in België 1900-1945*, Antwerpen, 1992; STÉPHANY, P., *Les années 20-30: la Belgique entre les deux guerres*, Bruxelles, 1983, 2 delen; VAN KALKEN, F., *Entre deux guerres: esquisse de la vie politique en Belgique entre 1918 et 1940*, Bruxelles, 1945

1940-50

BERNARD, H., *La Résistance 1940-1945*, Bruxelles, 1968; CONWAY, M., *Collaboratie in België. Léon Degrelle en het Rexisme, 1940-1944*, Bruxelles, 1994; Yale University Press, Yale, 1993; DE WEVER, B., *Greep naar de macht. Vlaams-nationalisme en Nieuwe Orde: het VNV 1933-1945*, Tielt, 1994; GÉRARD-LIBOIS, J.; GOTOVITCH, J., *L'an 40: la Belgique occupée*, Bruxelles, 1971; HUYSE, L.; DHONDT, S., *Onverwerkt verleden. Collaboratie en repressie in België, 1942-1952*, Leuven, 1991; KLARSFELD, S., *Mémorial de la déportation des Juifs de Belgique*, Bruxelles-New York, 1982; STEINBERG, M., *L'étoile et le fusil, I. La question juive 1940-1942*, Bruxelles, 1983; *II. 1942. Les cent jours de la déportation des juifs de Belgique*, Bruxelles, 1984; *III. La traque des juifs 1942-1944*, Bruxelles, 1986, 2 delen; STRUYE, P., *L'évolution du sentiment public en Belgique sous l'occupation allemande*, Bruxelles, 1945; VERHOEYEN, E., *België bezet 1940-1944*, Bruxelles, 1993

1950-96

BLOMMAERT, J.; VERSCHUEREN, J., *Het Belgische migrantendebat: de pragmatiek van de abnormalisering*, Antwerpen, 1992; CEULEERS, J.; VANHAECKE, F., *De stoute jaren '58-'68*, Leuven, 1988; CLEMENT, J. et al., *Het Sint-Michielsakkoord en zijn achtergronden*, Antwerpen, 1993; COPPIETERS, M.; DE BATSELIER, N., *Het sienjaal. Radicaal-democratisch project*, Antwerpen, 1996; FOX, R.C., *In the Belgian Château: the spirit and culture of a European society in an age of change*, Chicago, 1994; MORELLI, A. (red.), *Histoire des étrangers et de l'immigration en Belgique de la préhistoire à nos jours*, Bruxelles, 1992; REYNEBEAU, M., *Het klauwen van de leeuw. De Vlaamse identiteit van de 12de tot de 21ste eeuw*, Leuven, 1995

There and Back
A Confession to Rudi Fuchs

Henk van Os

Jan Both, *Italian Landscape with Draughtsman*, oil on canvas Amsterdam, Rijksmuseum

Every now and then in the Rijksmuseum I muse in front of a masterpiece by the Dutch Italianate painter Jan Both. He depicts his journey from the Low Countries, across the Alps into the promised land: Italy. On the other side of the mountains he sees nature in a new guise. He paints himself with a sketchbook. Trees, flowers, and plants – he brings them within reach. As he pursues his path, the landscape gradually opens up and he surveys the plain. An endless prospect, bathed in golden light. Now the sketchbook stays in his knapsack, and Both paints himself once more. This time he is not working "from life", but gazing at a vision of another world. No other painter ever surpassed Jan Both in conveying the northerner's experience of Italy. Not even Claude Lorrain, whose Italy transcends Arcadia. Jan Both, who came from Utrecht, was able to render palpably visible the experience of the promised land.

Jan Both had been preceded in earlier centuries by pilgrims making their way to Italy from the north. On their way past holy places they offered up prayers to heaven. It was near Bergamo that Both discovered heaven on earth. Countless travellers were to follow him. However, many of those travellers learned that happiness found far from home was often dearly bought. Only an infinitely shallow nature can experience the happiness that lies abroad without forfeiting her native roots. Perhaps, then, it is better to deny those roots – to stay in the land of your dreams, if only to escape the centrifugal pull once you are back at home. Or to avoid reproaches from the stay-at-homes, which are bound to be your portion sooner or later. In Both's case it was two centuries before he was branded a cultural traitor on the authority of Thoré-Bürger. Like Nicolaas Berchem, he was decried as "un maître falsifié par un mélange étranger".

In the early years of my art-historical work in Italy I found that looking back from the land of true art to the world one comes from is inevitably accompanied by a certain disdain. One immediately recalls the descriptions by Dutch writers in Italy of the burghers who lived north of the Alps, their lives devoid of glamour or beauty, rarely looking further than their own backyard. By that token, Dutch painters would have done better to paint directly on biscuit tins instead of canvas. Among authoritative art connoisseurs I found support for that attitude. In the autumn of 1958 I was granted audience with the aged Bernard Berenson. I sat at his couch. He mustered the young Dutchman who was so eager to study the Sienese paintings. Whatever was someone from Rembrandt's country thinking of, he asked. Wouldn't I have to make a choice between the stylized refinement of Sienese painters like Sassetta and the less uplifting directness of Dutch artists? "There's nothing I'd like better", I thought at the time.

Back at my university in the Netherlands, it was tempting to cultivate a patronizing attitude towards Dutch art. At that time scholarly specialization was vigorously stimulated in my field. In the long run, there was nothing for it but to peer over the art-historical fences at the art on the other side, not on yours, where you were definitely meant to remain. It can't have been easy for my friend Rudi Fuchs, who wanted to write about, say, Manet, or Rembrandt, or Olitsky. Although permitted, these were essays, not scholarly articles. In those days serious art historians were not supposed simply to enjoy art. Only in private was it all right to confess to being an "art lover" rather than a scholarly specialist. Fortunately, everybody knew me for the early Italian art man, a reputation I was able to confirm by distancing myself from the bourgeois art that preoccupied my Dutch colleagues.

At the 1964 Documenta I met Horst Gerson. It was the beginning of a long collaboration. Although Horst's speciality was Dutch painting, he was not so much a scholar as a *connoisseur* and an *amateur*. He simply had a great love for art, which is why he lacked the parochialism of scholarly specialists. Wherever he went he felt at home, because there was always a museum somewhere. The two of us travelled all over the place, trekking from museum to museum and especially from store-room to store-room. He would take me round the Dutch paintings and I would take him round the "golden background paintings". Then we would look at the rest of the art wherever we happened to be, attributing and dating it. Hundreds of paintings were his province, no more than a few dozen mine. He could sort an entire store-room in a day, whereas my day was made if I managed to identify a Droogsloot or a Pieter Codde.

In those days Dutch painting was like a vast postage stamp collection in need of sorting. My carefully cultivated disdain disappeared.

An opportunity for a trained outsider to administer the national treasury is nothing short of miraculous. My first task was to prepare a big Rembrandt exhibition scheduled for the winter of 1992. A more violent confrontation with my own country's art was scarcely imaginable. Rem-

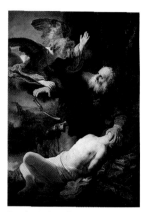

Rembrandt, *Abraham's Sacrifice*
1635, oil on canvas
St. Petersburg, Staatliche Ermitage

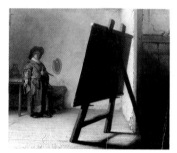

Rembrandt, *Artist in His Studio*
1628, oil on canvas
Boston, Museum of Fine Arts

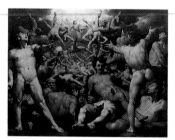

Cornelis van Haarlem, *Titans*
oil on canvas, Copenhagen
Statens Museum for Kunst

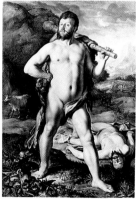

Hendrick Goltzius, *Hercules
and Cacus*, oil on canvas
Haarlem, Frans Halsmuseum

brandt's work had prompted not only disdain but downright hatred among Italianate-minded critics. Ruskin, Burckhardt – they loathed Rembrandt. Only the very greatest artists merit hatred. Ruskin wrote: "Vulgarity, dullness, or impiety, will indeed always express themselves through art in brown and grey as in Rembrandt [...] He is a sullen and sombre painter in whose system the colours are all wrong from beginning to end [...] not one colour is absolutely true. In front of such a dark painting by Rembrandt one realises that vile things are dark and noble ones fair". What Burckhardt detested most about Rembrandt was his vulgarity. He regarded him as totally unworthy to paint holy subjects.

In art, Ruskin sought enlightenment for his tortured soul, and Burckhardt yearned for an art that would transport him into a higher, purified world. It was through their hatred that I learned to see Rembrandt's genius. My conversion also had a time and a place. In winter 1990 I stood in front of *Abraham's Sacrifice* in the Hermitage. Rembrandt – the greatest European Baroque painter. The merciless light on the boy's throat. Abraham's clawed hand, baring Isaac's throat to the sacrificial knife. An angel plunging down to grasp the uplifted arm. The falling knife. Compared with this physical violence and confrontational directness, Italian Baroque portrayals of gruesome scenes are merely good acting. Of course Caravaggio was spectacular, and art was hotly discussed too. But here, in Rembrandt, the relation between art and life was completely different.

In the first room of the Rembrandt exhibition, with early works, hung his self-portrait in the studio from the Museum of Fine Arts in Boston. You see the back of a large canvas on an easel. Rembrandt is standing at the back of the room. At a distance. He is pondering. What shall I paint this time? None of that stuff about a patron or a professional context, that fills much of today's art history. Here we have the artist as a conceptualist. Tiny, insignificant, he stands there, facing that huge surface destined for art. Dutch artists from Rembrandt to Ger van Elk never took art for granted. Not that the Netherlands lacked a painting tradition. Indeed, Italy and the Netherlands are the only countries with a firmly rooted tradition of producing paintings. In the Netherlands, though, you always get those painters who take a step back and then discover something more exciting somewhere else: in Italy, for instance, in Flanders or in France. That curious ambition of not belonging as the source of creativity. I came to see Rembrandt as the greatest artist of all.

During preparations for "Dawn of the Golden Age", held in the winter of 1994, there was ample opportunity to see examples of "there and back". It was a time when Dutch art assumed Italian airs. Nudes tumbled down Cornelis van Haarlem's canvases as if he were a new Michelangelo. You gawp at those king-size paintings and realize that virtuoso variants of Mannerism are also part of Dutch art. What makes this painting so much merrier than a host of similar demonstrations of painterly skill from Italy or elsewhere in Europe? It is the remarkable lack of dignity. No cleverly posed Titans these, but naked men really crashing down! And the painter is good at nature details, too. It is to his skill that mankind owes the most exquisite butterfly to ever alight on a penis.

But the most disconcerting example of Italian airs in Dutch art at "Dawn of the Golden Age" was Goltzius' portrait of Kolterman in the role of Hercules. Flouting decorum, the well-fed belly of Haarlem's burgomaster bulges straight at you. That cheerful face is simply asking for a club. But how in heaven's name was it done? Did Kolterman just hang up his clothes on a hook in Goltzius' studio one afternoon at four o'clock and, posing in his birthday suit, imagine he was Hercules for an hour and a half? What did his wife and children think about it? Or the rest of the family? Italians must have seen this as a send-up of their art. Like Daumier, who in the nineteenth century scotched the myth of the great French art of his day, was Goltzius cocking a snook at the Italians? If only he had been! This was meant to be serious painting. Be that as it may, it is another example of a Dutch artist who did not take art for granted.

In the course of our store-room forays Horst and I occasionally ran into Jan Steen. Not hard to recognize, his paintings were often very ugly indeed. Heads which didn't fit their bodies, clumsy combinations of mobility and stiltedness. Leaving aside the quality, though, it was the vulgarity of what Steen painted that I found unpalatable. My "Rembrandt-haters" had not even taken the trouble to fulminate about Steen. He painted very well from life. That said it all, but it was not enough. Horst and Lyckle de Vries, my colleague at the Art Historical Institute in Groningen and a leading Jan Steen specialist, was kind enough to take my aversion to Jan Steen seriously. "You shouldn't look at Jan Steen in store-rooms", they told me. "Far too many paintings are attributed to him." "It's a poorly sorted oeuvre." "A lesser master is all right, but a second-rate Jan Steen is

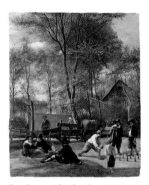

Jan Steen, *Skittle Players Outside an Inn*, 1663 circa, oil on canvas, London The Trustees of the National Gallery

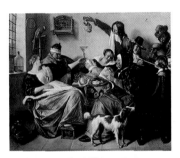

Jan Steen, *As the Old Sing, So Pipe the Young*, 1663-65 circa, oil on canvas The Hague, Koninklijk Kabinet van Schilderijen "Mauritshuis"

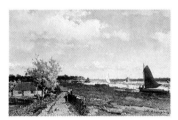

Jan Hendrick Weissenbruch *View at Geestbrug*, oil on canvas Amsterdam, Rijksmuseum

atrocious." None of this really helped. To make things worse, art historians with an iconological orientation were beginning to point out that Jan Steen had not merely painted lifelike drunken gatherings, but that there was also a meaning behind these scenes of dissipation. And what a meaning! Jan Steen was raising a moralizing finger. "Watch it! Thou shalt not indulge in debauchery!" Or "See what happens when thou dost". A moral both naïve and stodgy. It was straight to the biscuit tin with Jan Steen!

Then someone came up with the suggestion to stage a Jan Steen exhibition in the Rijksmuseum in 1996. My immediate reaction was: "Not if I can help it!". Whereupon the head of the department of paintings, Wouter Kloek, said that the exhibition would comprise no more than fifty of Steen's very best works. Might he show me the tentative selection? It was a confusing experience. Jan Steen turned out to be much more versatile than I had imagined. The inebriated little groups were offset by superb poetic paintings like the *Skittle Players* from London's National Gallery. Birmingham was to send a work which I knew, *Ahasuerus*, a drunken painting on a biblical theme, with the enraged monarch sweeping away the entire composition with one superb gesture. "The most beautiful painting of a falling still life", as Wouter Kloek put it. I'd never looked at the picture like that before, I must say. But it was Rudi Fuchs who brought about my final conversion. "Look at Jan Steen's red. You'll never see a red like that anywhere else" and "It's an incredible experience to see an artist apply the entire repertoire of respectable history painting to scenes of everyday life".

It took quite a time, but eventually I learned to see the exceptional quality of Jan Steen the artist. To me, *As the Old Sing, So Pipe the Young* in the Mauritshuis is one of the most stirring pictures ever painted in the seventeenth century. But it took a long time because you have to look at a picture like that with different eyes than you would most Italian paintings. Jan Steen's figures are completely integrated in the action. They are what they do. In Italian art, figures represent the action. They do what they are. A good Jan Steen painting has a tense, dynamic composition, but you have to read it carefully and at the same time enjoy the *peinture*, the material rendering, the lifelikeness, the cogency of expression, the anecdotes in the pictorial narration.

Over the past few years, then, Dutch art, up to and including Jan Steen, has acquired a different meaning to me. Back in Italy I realize that this has changed my attitude to art. I have not yet discovered the precise nature of that change, but I do know that "there and back" are now on the same level. To me, that icon of the Dutch landscape, Jan Hendrick Weissenbruch's *View at Geestbrug*, has become a *pendant* of equal standing to Jan Both's painting.

Siena, November 10 1996

Maurizio Calvesi

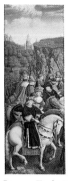
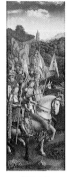

Jan van Eyck, *Judges and Knights*
left panel of the polypthic *Adoration of the Holy Lamb*,1432
oil on wood panel
Ghent, Saint-Bavon's Church

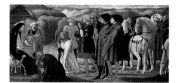

Masaccio, *Adoration of the Magi*, 1426
oil on wood panel
Berlin, Staatliche Museen
Preußischer Kulturbesitz

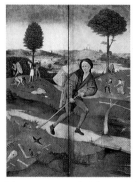

Hieronymus Bosch, *The Path of Life*
exterior panels of *The Haywain*
triptych, 1500 circa, oil on wood panel
Madrid, Prado

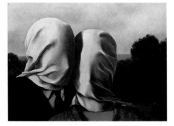

René Magritte, *Les amants*, 1928
oil on canvas, private collection

"In the past nobody had the vaguest notion of what good draftsmanship was, so art declined completely. But, not many years ago, this was revived and reinstated by the Italians and Flemings." This statement by Felipe de Guevara (in *Comentarios de la Pintura*, 1560 circa) is certainly imprecise; this also regards the references to time, which seem to exclude the previous century. Nonetheless, it reflects the concept of 'rebirth' (the term 'Renaissance' was only used at a later date) that Giorgio Vasari introduced into the language of criticism at the same time as Guevara, but only with reference to Italian art: in fact, it is commonly believed that Italian art was almost entirely responsible for promoting the Renaissance.

On the other hand, what was 'reborn' in the Renaissance? Art, to be sure: but, if it was reborn, this means that it had been born previously, and, in fact, it was born in antiquity. Thus the art of the ancients was reborn: that is, antiquity was reborn too, as was its legend – and its cult was also begotten – in addition to humanist studies.

In this more complex sense of 'rebirth of antiquity' it cannot be denied that, in effect, the Renaissance was Italian. If we limit ourselves, as Guevara did, to the rebirth of "good draftsmanship" – and what he meant by this was drawing capable of reproducing the forms of nature – there is no doubt that, in addition to the contribution of the Italians, there was the equally important one of the Flemish artists, who inaugurated a new chapter in art history when they detached themselves from the Gothic tradition. And, if we compare the dates of Van Eyck with those of Masaccio, the Flemish contribution may be considered to be the earlier one.

The difference between the two cultures also emerges from what has been briefly outlined above: aside from the texts, the Italians had the works and monuments of classical antiquity before their eyes, and they were able to use these as models and base their theories on them, while the model for the Flemish artists, in a land where remains of the past were much scarcer, was, above all, the natural world. Basically, the greater intellectualism of the new Italian art was a consequence of this, as was the more analytical and painstaking attention to reality that was typical of the Flemish artists, with their lenslike eyes intent on 'seeing' – and also in this respect they were more sensitive to the revealing medium of light. In twentieth-century Dutch art, too, there have been estimable 'realists', such as Charley Toorop and Co Westerik; and with Vincent van Gogh it has experienced the most radical exaltation of light of all time.

Forms of 'surrealism' (or heightened, immobile naturalism) may also be derived from realism, as they were in Flemish art, centuries earlier, in the output of Bruegel the Elder and, above all, Bosch. The need to transcend the natural world, to go beyond its assumptions, was satisfied in Italian art by the "cult of the number" – that is, the measurement and the abstraction of rhythms and proportions. In Flemish art it led to the stimulation of the fantasy, in a 'northern' landscape that was gloomier but, amidst the mists, richer in indistinct presences and potential apparitions. But this recourse to fantasy, although it broadened their horizons, did not betray the artists' faithfulness to nature. In fact, Felipe de Guevara wrote: "I can say one thing about Bosch: that is, never in his life did he paint an object that was not natural, with the exception of whatever regarded heaven and hell. His creations aimed at showing the rarest things, which were, however, always natural, and in such a way as to make natural laws of them".

This observation could equally well be applied to the leading exponent of Belgian Surrealism, René Magritte: in fact, his "cult of mystery" neither distanced him from reality nor urged him towards unreality; on the contrary, he stated that "mystery is what is absolutely necessary for reality to exist [...] For me, reality without mystery is incomplete [...] Mystery is the *sine qua non* of existence". And Magritte continued thus: "Since I am a painter, I believe I can only show the appearance of things, what they seem to be. But these visible things cannot exist without mystery. From my point of view, it is also a question of realism, in the sense that reality is what seems most important to me". He affirmed that he wanted to paint pictures "having the characteristics of apparitions, in which it is, however, possible to recognize people, objects, trees, stones, skies, etc.". Hence, Magritte's meticulously detailed, 'Flemish' rendering of landscapes, trees, leaves, skies and seascapes contrasts sharply with de Chirico's flat, quasi-abstract areas of color – although Magritte owed a great deal to the Metaphysical period of the Italian artist. However, by reversing, or altering, the typically Italian perspective constructions inherited from the Renaissance, de Chirico presented a vision of the world 'mediated' by the intellect, while the focus of Magritte's interest was the sphere of appearances. He continued, therefore, to remain in contact with this, but in order to strengthen its secret "sense" rather than to astonish us with its "non-sense" – its

102

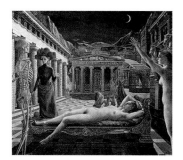

Paul Delvaux, *La Vénus endormie*
oil on canvas 1944, London
Tate Gallery

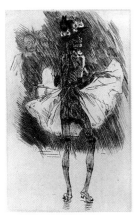

Félicien Rops, *La mort qui danse*
1865-75 circa, engraving, Brussels
Cabinet des Estampes
Bibliothèque Royale Albert I

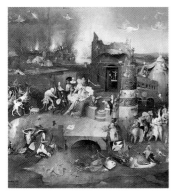

Hieronymus Bosch, *The Temptations
of St. Anthony*, 1520 circa
triptych, central panel, oil on wood
panel, Lisbon
Museu Nacional de Arte Antiga

absurdity, in other words – as de Chirico wished to do. In this respect, he declared: "I do not accept the idea that the world or the universe are incoherent and absurd". This attitude became more strikingly evident in the output of Delvaux, the less refined, but nonetheless fascinating, painter of eros. Paul Delvaux's mystery is the unattainable woman. He paints an imaginary, ethereal world that, however, contains tangible, carnal presences, shapely nymphs whose nudity is amphibiously united with the arboreal life of nature, the matrix of which is stressed and extolled. Thus, in Delvaux's Surrealism, although in very different forms, there is also an element of sensuality that characterized, for instance, the greatest painter in the Flemish tradition, Peter Paul Rubens. I have always thought that Rubens' female nudes are the only ones in painting that, although they form part of the transfigured reality of art, can arouse a feeling of concupiscence in the observer, so well does his brush manage to evoke the seductiveness of the flesh.

And was not the 'scandalous' Félicien Rops Belgian? His eroticism went as far as the provocative tribute to pornography with the famous painting (entitled *Pornokratès*) of a woman with a pig on a leash. This is what Rops wrote in January 1879 at Liesse: "I would like to show you this beautiful nude girl, wearing black shoes and gloves, silk, leather, and velvet, who is walking blindfold on a marble frieze, guided by a pig with a gilded tail through the clear blue sky. The dimensions are almost the same as those of the *Tentation*". The *Tentation* (The Temptation [of Saint Anthony Abbot]) represents the hermit who, while contemplating the crucifix, is dismayed to see it falling down after being pushed by the devil, while, in its place, a big-breasted girl is displayed on the cross under the inscription EROS, which has replaced INRI; here too a splendid piglet is present at the scene.

Although the essayist Mario Praz associated this picture with Flaubert's *La tentation de Saint-Antoine*, the theme is recurrent in the Flemish tradition, dating back to Bosch, who painted it eleven times, in some cases with the presence of female nudes. In his turn, Quentin Metsys, in collaboration with Joachim Patinir, produced his own version, now in the Prado, where the reluctant saint is surrounded by three alluring girls. In the case of Rops, the luxurious sensuality – which is simply one aspect of the complete correspondence of the Flemish and Belgian sentiment with the substance of reality – is closely linked to the subject.

But, eight years after Rops, Ensor also addressed the theme of the temptations (or rather 'tribulations') of Saint Anthony in a completely different manner in the splendid painting in the MOMA. The female nudes are the only recognizable figures – but only just so – amidst the forms dissolving in an atmosphere of anxiety, with a crumbling pictorial fabric of blots and gestures that turns Bosch's vision into malaise. What we see in Ensor's painting is the result of another current in Flemish art: the one that reverses and extends reality in the imagination, frequently colouring it – as if it were tragedy and happiness at the same time – with the grotesque tones that are also typical of the national tradition.

Although there were considerable aesthetic and stylistic differences, this current continued in the output of the members of the Cobra group, whose expressive abstraction (which, to a certain extent, was foreshadowed by Ensor) was nurtured by a vision verging on the grotesque.

In the Flemish and Dutch cultures, in fact, the grotesque is the manifestation of an *ethos*. On public holidays, in the streets of Antwerp or Ostend one can still see in the flesh, as if they had suddenly materialized, the disorderly fantasies of Bruegel and Bosch, as well as those of Van Ostade and Steen: the dance of the toothless old woman, and pranksters dressed up in the most improbable headgear, from socks to chamber-pots, these objects being decorated with bizarre anthropomorphous ornaments.

All this may be related to the symbolic value of the mask, an object that is the quintessence of disguise and grotesque. It was not by chance that this subject is treated so often by Ensor and is also discernible amongst the shattered forms of Appel and Alechinsky.

The anthropological dictionaries of symbols devote many pages to the theme of the mask, which, they say, externalizes demoniacal tendencies; and the infernal, satanic aspect is manifested with a view to its own expulsion. The mask is liberative and has a cathartic effect. Rather than concealing, it reveals the infernal tendencies, which must be put to flight. But the mask also puts death to flight because it represents the vital spirit. Masked ceremonies are cosmogonies in progress that regenerate time and space; they are cathartic performances during which man becomes aware of his place in the universe and sees his life and death as part of a collective drama that gives them a meaning.

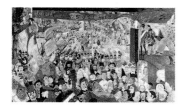

James Ensor, *The Entry of Christ into Brussels* 1888, oil on canvas
Zurich, Kunsthaus Zürich

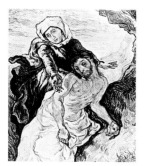

Vincent van Gogh, *Pietà (after Délacroix)*, 1889, oil on canvas
Amsterdam, Van Gogh Museum

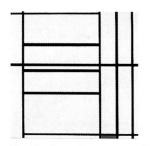

Piet Mondrian, *Composition with Red* 1938-39, oil on canvas, Venice
Peggy Guggenheim Collection

Ensor was fond of representing himself (as in the superb *Self-portrait* of 1899) unmasked amidst a crowd of masks, and it seems that he wants to contrast his purity with the hypocrisy and the depravity of the world – although, in fact, the masks also seem to be self-portraits. There is evident complicity between Ensor and these masks; this is betrayed by the bizarre decoration on the painter's hat consisting of flowers and feathers, which also adorn the brows of the carnival crowd. And it is suggested, in particular, by the cheerfulness – albeit harsh and acid – of the carefully matched colours. The red of Ensor's jacket and headgear is identical to the colour of the hair and mouths of his grotesque companions. His face sensitive and serene, the artist stands out against the repulsive rabble that is, however, closely related to, and emblematic of, the same passions and, above all, the same fears lurking in the depths of his unconscious. Here they are, surfacing around him, attracted by the bait of the collective imagination: the same that Bosch shared, it forms part of the Flemish tradition and the Flemish feast-day.

The strange jocundity is, in fact, the common exorcism of fear and death. The Flemish grotesque had always been – and was still in Ensor's work – the exorcism of death, which, significantly enough, often accompanies the masks in the form of a skull.

But once he had conjured up and unconsciously vivified his masks, the artist distanced himself from them: this was not achieved through the imagination, which was too similar to the id, but rather through an indignant moral judgement. Thus, as he gave them life, he repudiated and condemned the monstrous creatures. Companions of horror and exorcism confronted with death, twins of the phantoms dwelling in the memories of the country's museums and in the national imagination, mirror of the temptations that have crept into its very blood, these hideous faces represent not only an identity but also diversity: the alienated diversity of the obtuse critics of his painting, of the arrogant neighbour, the hateful know-alls, and of all the pettiness that plagued his life.

He thus became the victim, saviour and judge at the same time: the lamb, the fish and the Pantocrator – Christ, that is. Like Christ he is half man (half sharing in sinful, mortal human nature) and half God. And, in fact, on many occasions he represented himself as the Nazarene, from the *Christ Mocked* to the famous *Entry of Christ into Brussels*: he stands among the despicable crowd that derides him and is incapable of understanding him. This is a crowd that he must not only judge, but must also redeem, in one way or another, with his own sacrifice – that is, with his art. The "imitation of Christ," which is central to the thought of Erasmus, is, moreover, a theological theme that is deeply rooted in the Low Countries. The famous work entitled the *Imitation of Christ*, attributed to Thomas à Kempis, is believed to be of Flemish origin; it is the expression of the *devotio moderna* that was a fundamental canon of the religious brotherhood to which Bosch belonged. Indeed, critics have often associated Bosch's painting – an important source of inspiration for Ensor – with the brotherhood.

Turning to the other major figure of modern art in the Low Countries, Vincent van Gogh, it should not be forgotten that, the son of a Protestant pastor, he himself was a lay preacher. For Van Gogh, too, art has salvational value; in his heart, suffering attacks of insanity in the process, and much more dramatically than Ensor, he also chose Christ, the salvific victim, as his model.

And there is no equivalent to this in the whole of the history of Italian art (aside, perhaps, from Caravaggio), or French or German art either, which was dominated, if anything, by the figure and output of the demiurgic artist, from Dürer to Michelangelo and Pablo Picasso. However, in this respect, the "expressionism" of the Low Countries – with Van Gogh who participated in the torment and the tension of matter and nature, Ensor 'the exorcist', and also, to a certain extent, Permeke, who was so sympathetic to the suffering and anxiety of his fellow human beings – differs profoundly from German Expressionism, with its reactive projection of violence.

Van Gogh's hallucinatory vision of the world avails itself of the same medium utilized by the Impressionists, the light: a very intense light that destroys the shadows. But while, for the Impressionists, this light was a merely optical factor, for the great Dutch artist it was, above all, a spiritual, and potentially mystical, element. Its function was not that of simply interpreting and analysing reality, but was rather one of revelation. Over and above the external aspect of the phenomenon being investigated, it sought its essence, even though this was unattainable. In Van Gogh's work there is a thrilling union of the brightness of the Mediterranean world – which he was seeking as a pilgrim, just as one seeks the light – and the impelling inner voice that projected, like a mirage, the expectation of revelation and salvation.

Thus, together with realism, or the capacity to extend reality, without distancing oneself from it, into the imagination – together with a visionary capacity, therefore – a mystical element, identical in substance to art and its redemptive values, seems to have left an indelible mark on the art of the Low Countries. In Rembrandt's painting, light – this extrovert 'Flemish' quality serving to analyze and investigate nature – had already begun to return towards mankind. In Ensor's painting, too, light has a mystic echo with its mirages reflected in the seascapes, and it seems almost to be linked to the surging waves and the storms that Christ manages 'to calm'.

After Van Gogh, the absolute truth of Mondrian, fleeing from the 'daily tragedy', is an objective that has finally been reached and overcome by the mystic impetus. In a way, Piet Mondrian is the reverse of Vincent van Gogh, with his theosophy of equilibrium. He too contemplates the light, with those milky, curdled whites that only seem to be abstractions to those who do not know the light of the Netherlands. In his work, the light is a sign of the persistence of nature, despite its despoliation; it is reality that has been purified (just as in Magritte's paintings it has been rendered more transparent by mystery) and dominated by the spirit.

From Van Gogh, Ensor
Magritte, Mondrian
to Contemporary Artists

The Works

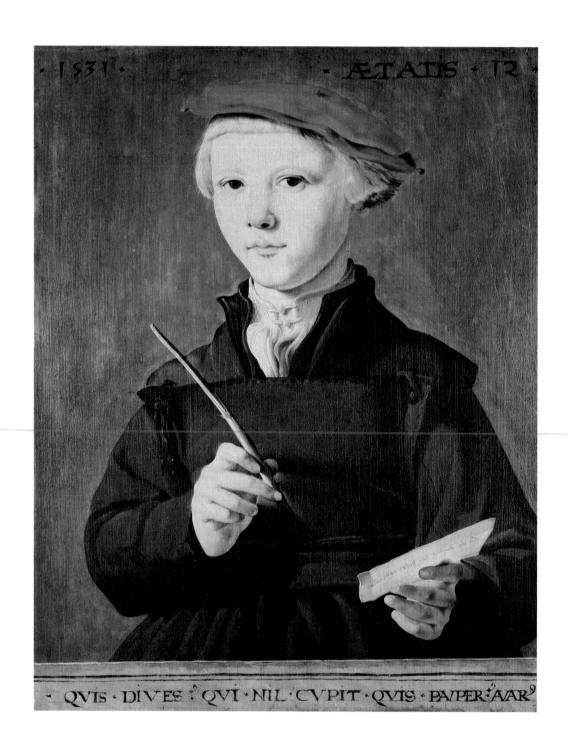

Jan van Scorel
Portrait of a Young Scholar, 1531
oil on panel, 46,5x35 cm
Rotterdam
Museum Boijmans Van Beuningen
cat. 1

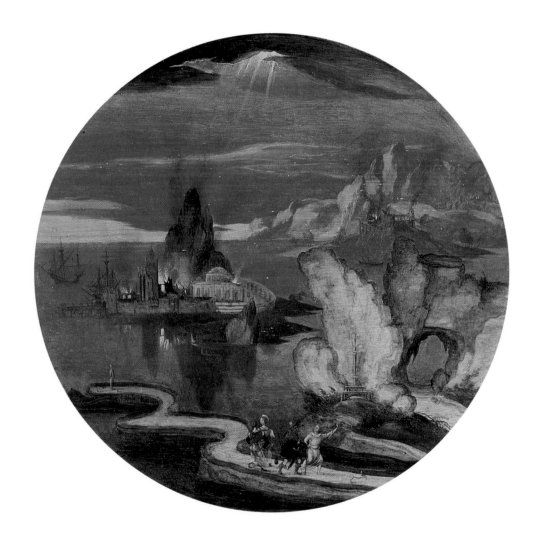

Joachim Patinir
Sodoma and Gomora on Fire, undated
oil on panel, diam. 25 cm
Antwerp, Koninklijk Museum
voor Schone Kunsten
cat. 2

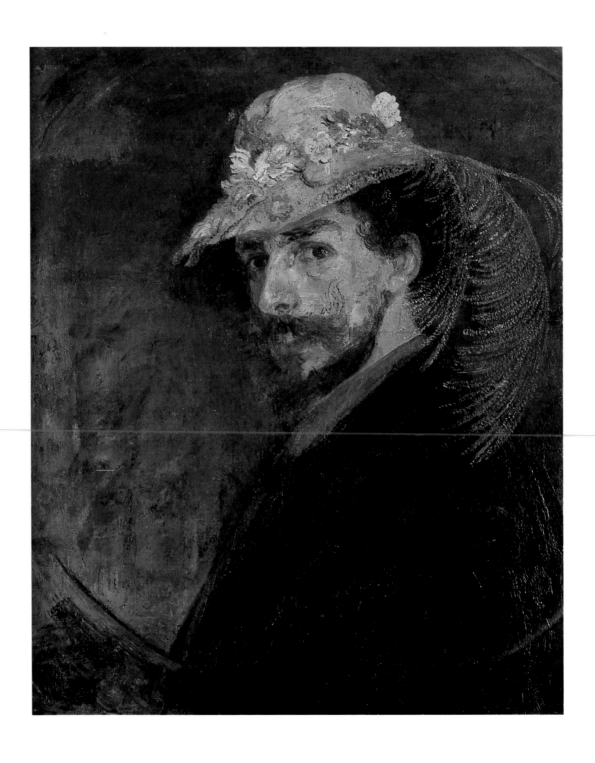

James Ensor
Self-portrait with Flower Hat, 1893
oil on canvas, 76,5x61,5 cm
Ostend, Museum
voor Schone Kunsten
cat. 3

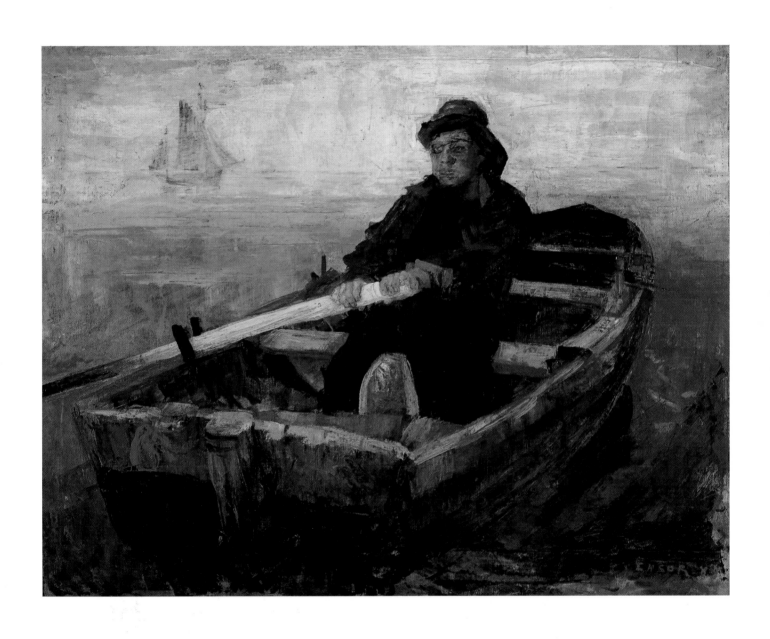

James Ensor
The Rower, 1883
oil on canvas, 79x99 cm
Antwerp, Koninklijk
Museum voor Schone Kunsten
cat. 4

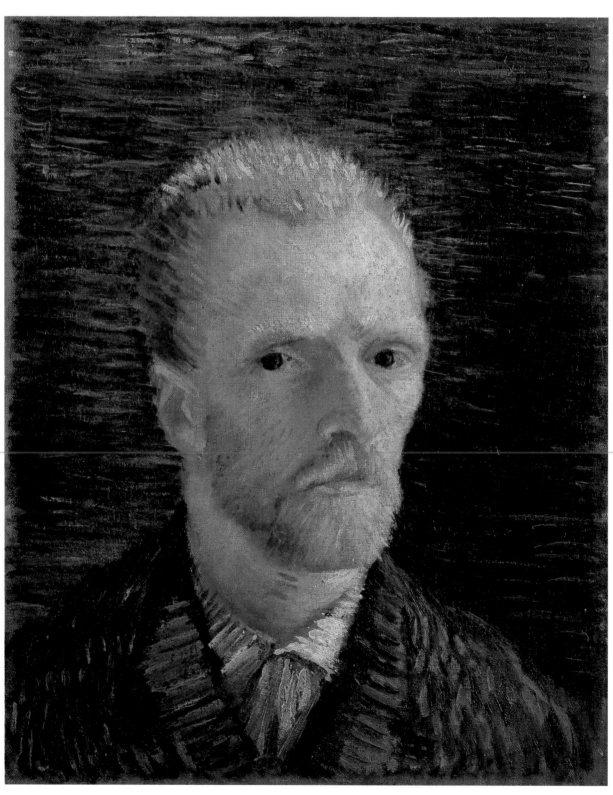

Vincent van Gogh
Self-portrait, 1887
oil on canvas, 42x34 cm
Amsterdam
Van Gogh Museum
Vincent van Gogh Foundation
cat. 5

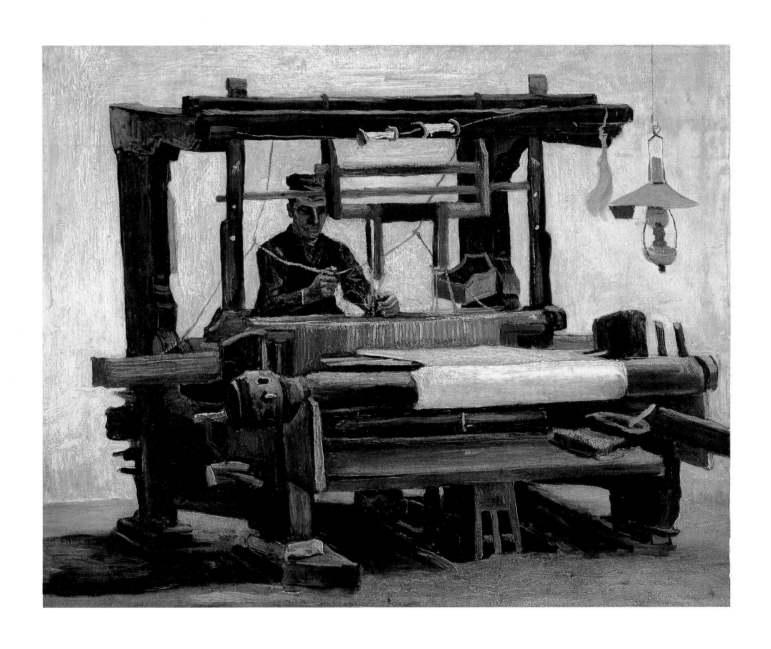

Vincent van Gogh
The Weaver: the Whole Loom
Facing Front, 1884
oil on canvas, 70x85 cm
Otterlo
Kröller-Müller Museum
cat. 6

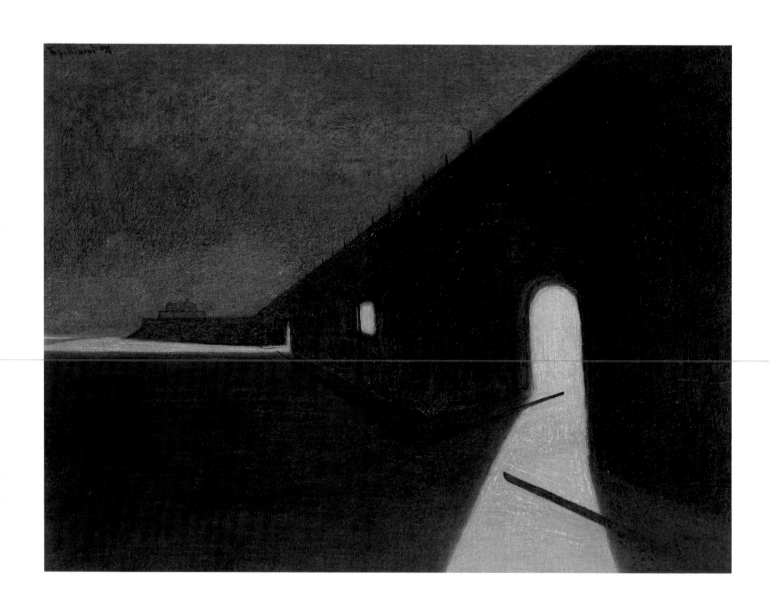

Leon Spilliaert
Kursaal and Dike at Ostend, 1908
coloured pencil, Indian ink
50x65 cm
Brussels, Johan A.H. van Rossum
cat. 7

Félicien Rops
Quarrel, 1877 circa
oil and watercolour on paperboard
62x43 cm
Brussels, Private Collection
Courtesy Galerie Maurice Keitelman
cat. 8

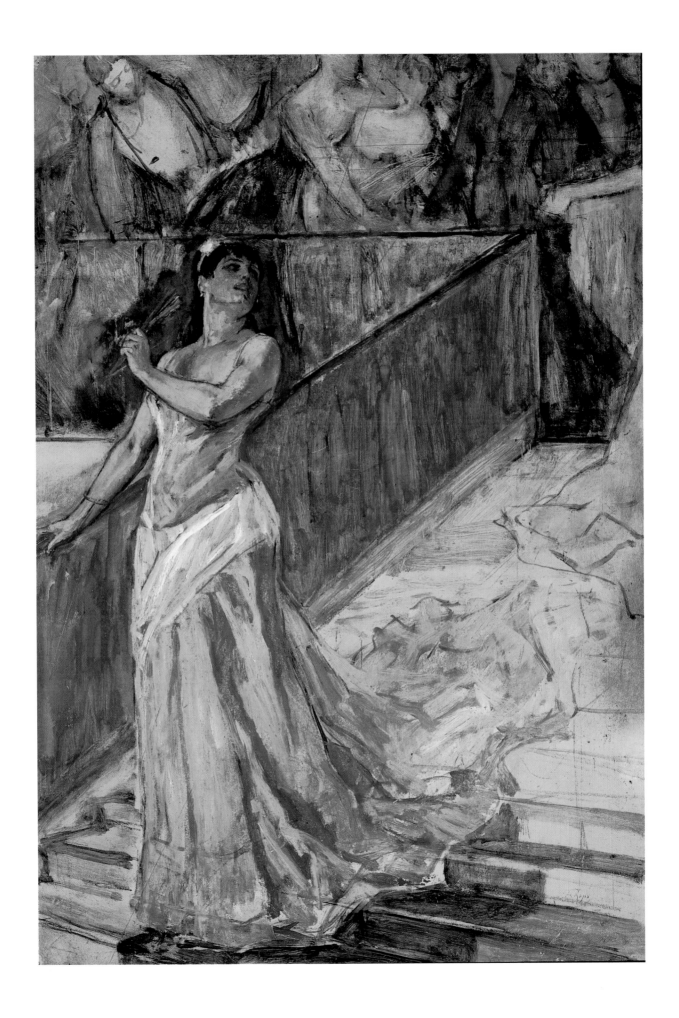

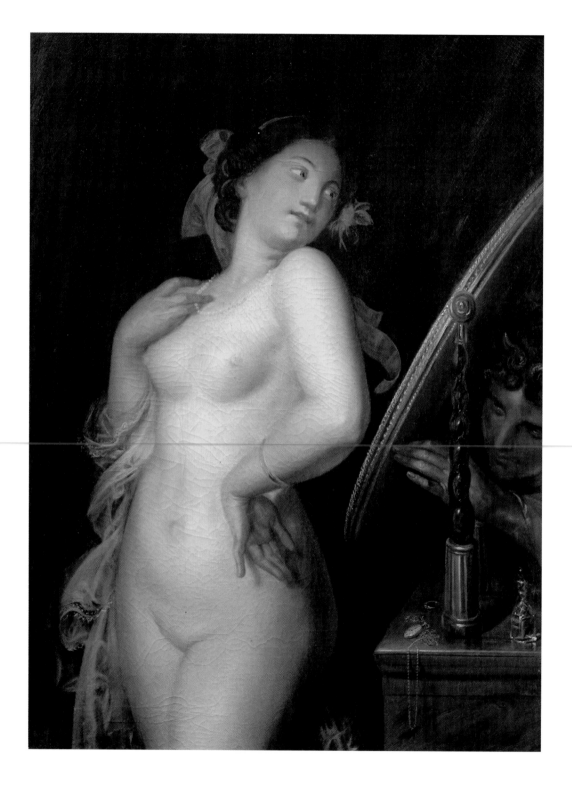

Antoine Wiertz
A Coquettish Woman Undressed, 1856
oil on canvas, 97x72 cm
Brussels
Musées royaux des Beaux-Arts
de Belgique
cat. 9

116

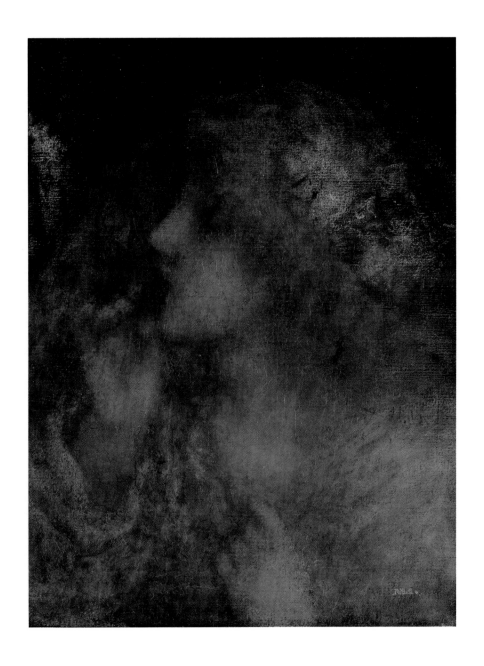

Matthijs Maris
Young Bride, undated
oil on canvas, 54x39 cm
Amsterdam, Stedelijk Museum
gift of the VVHK (Association
for the Formation of a Public
Collection of Contemporary Art)
cat. 10

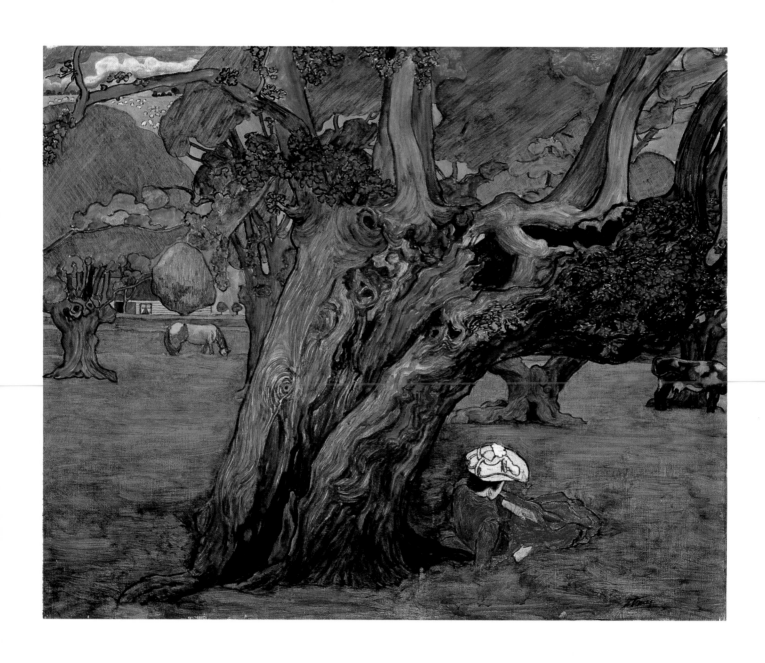

Jan Toorop
Old Oaks in Surrey, 1890-91
oil on canvas, 63x76 cm
Amsterdam, Stedelijk Museum
gift VVHK (Association
for the Formation of a Public
Collection of Contemporary Art)
cat. 11

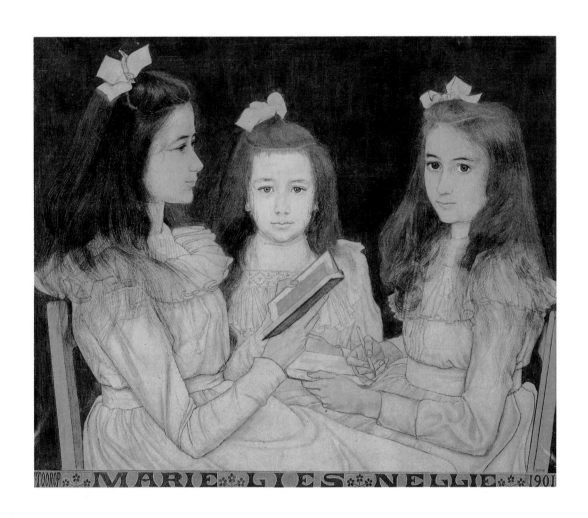

Jan Toorop
*The Three Girls of Volker
van Waverveen*, 1901
grease pencil on paper
89x103 cm
Amsterdam, Stedelijk Museum
cat. 12

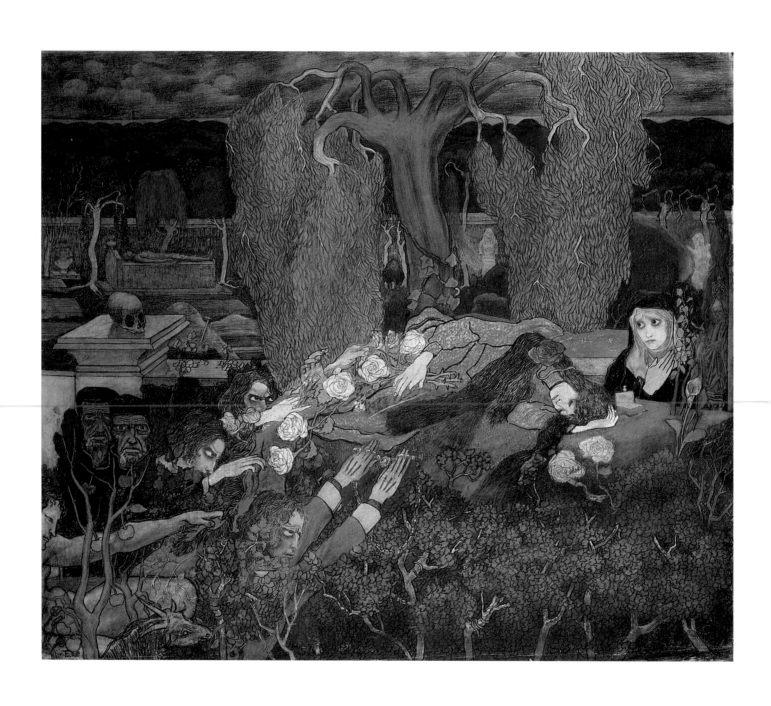

Jan Toorop
Tramps, 1891
black charcoal, wax crayon
ink on paper, 65x76 cm
Otterlo, Kröller-Müller Museum
cat. 13

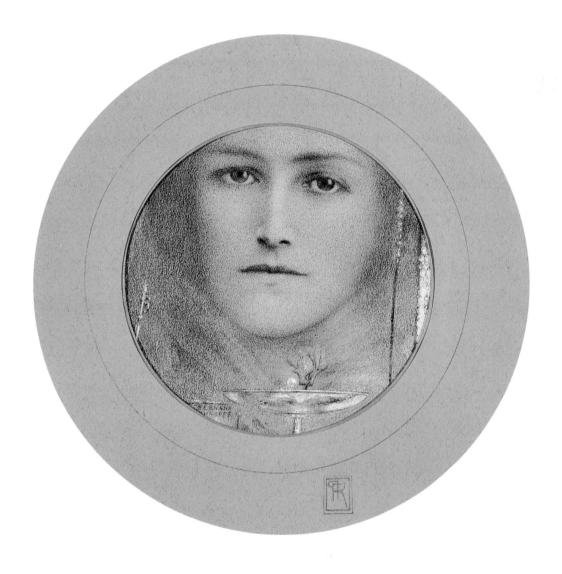

Fernand Khnopff
Brown Eyes and a Blue Flower, 1905
pastel, diam. 16 cm
Ghent
Museum voor Schone Kunsten
cat. 14

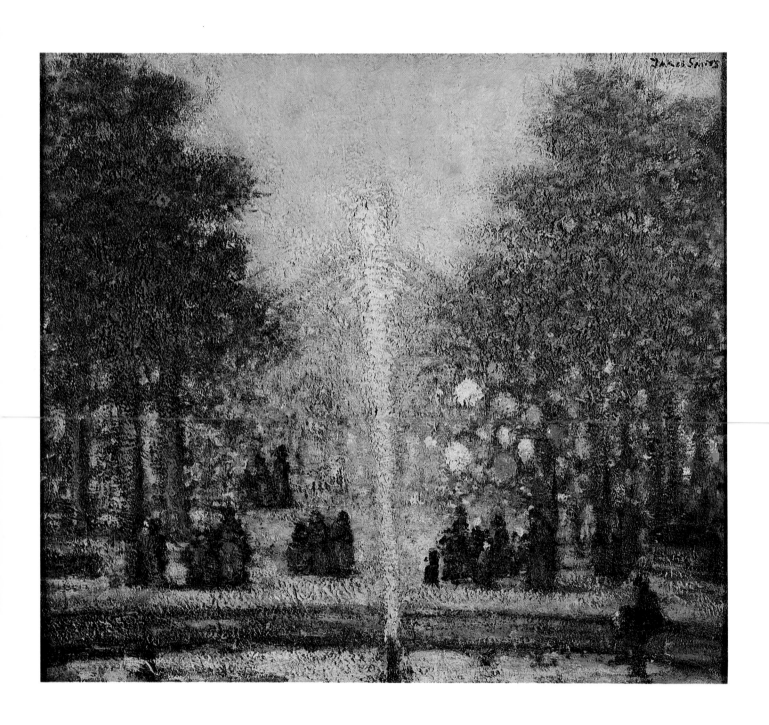

Jacob Smits
Pond in a Park at Brussels, 1919-25
oil on canvas, 100x110 cm
Groningen, Groninger Museum
cat. 15

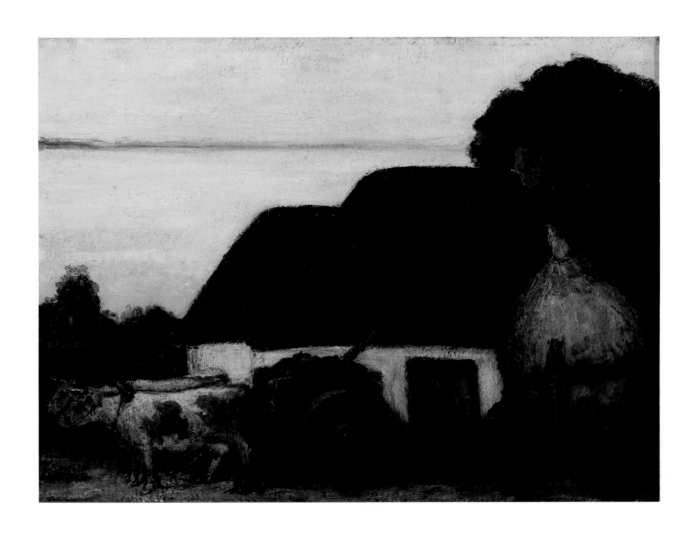

Jacob Smits
Sunrise in the Kemp - Brabant
oil on canvas, 67x91 cm
Amsterdam, private collection
cat. 16

Georges Minne
Man Crying over his Dead Deer, 1896
bronze, 25x62x45 cm
Ghent, Museum voor Schone Kunsten
cat. 18

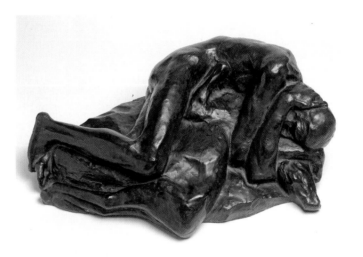

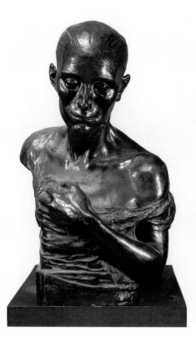

Constantin Meunier
Working-class Woman, 1890 circa
bronze, 72x46x33 cm
Antwerp, Koninklijk Museum
voor Schone Kunsten
cat. 17

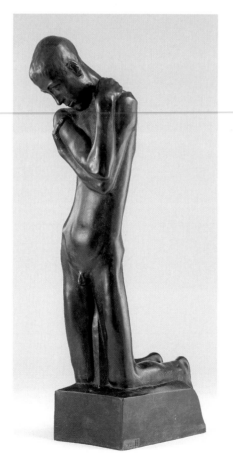

Georges Minne
Little Boy Kneeled, 1898
bronze, 79x19x45 cm
Ghent, Museum voor Schone Kunsten
cat. 19

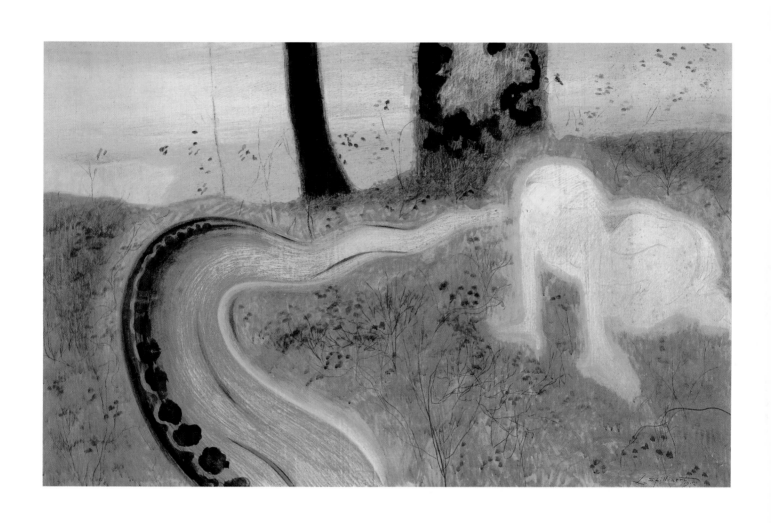

Leon Spilliaert
Eve and the Serpent, 1913
watercolour, gouache, pastel
100x150 cm
Wuustwezel, private collection
cat. 20

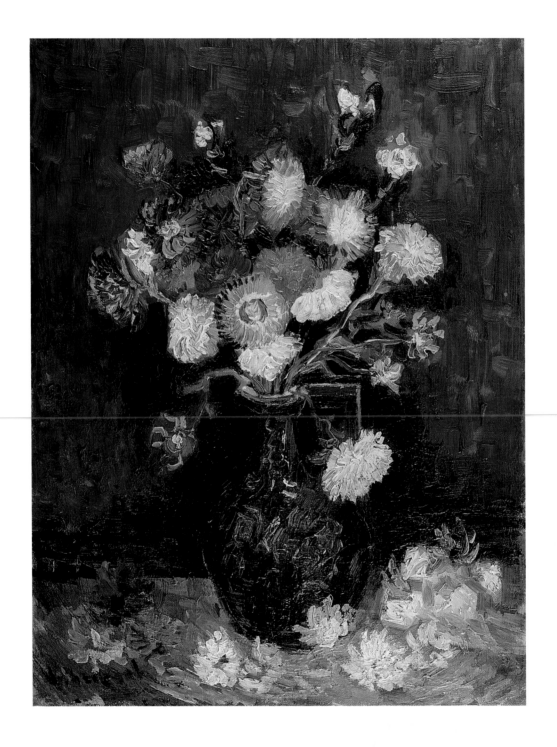

Vincent van Gogh
*Still Life: One-eared Vase
with Asters and Phlox*
1886
oil on canvas, 61x46 cm
Amsterdam
Van Gogh Museum
Vincent van Gogh Foundation
cat. 21

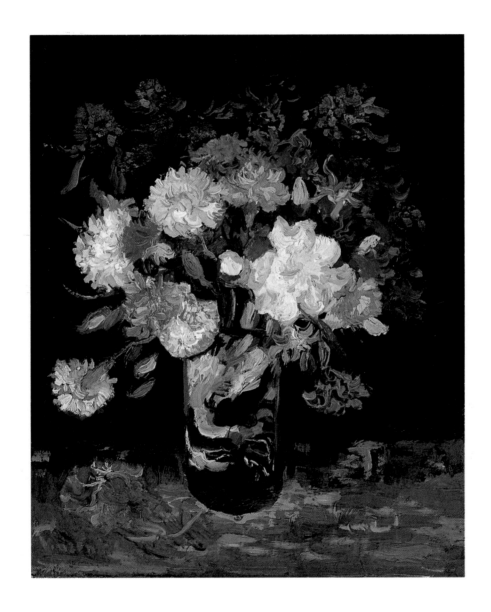

Vincent van Gogh
Still Life: Vase with Carnations
1886-88
oil on canvas, 46x37,5 cm
Amsterdam, Stedelijk Museum
gift VVHK (Association
for the Formation of a Public
Collection of Contemporary Art)
cat. 22

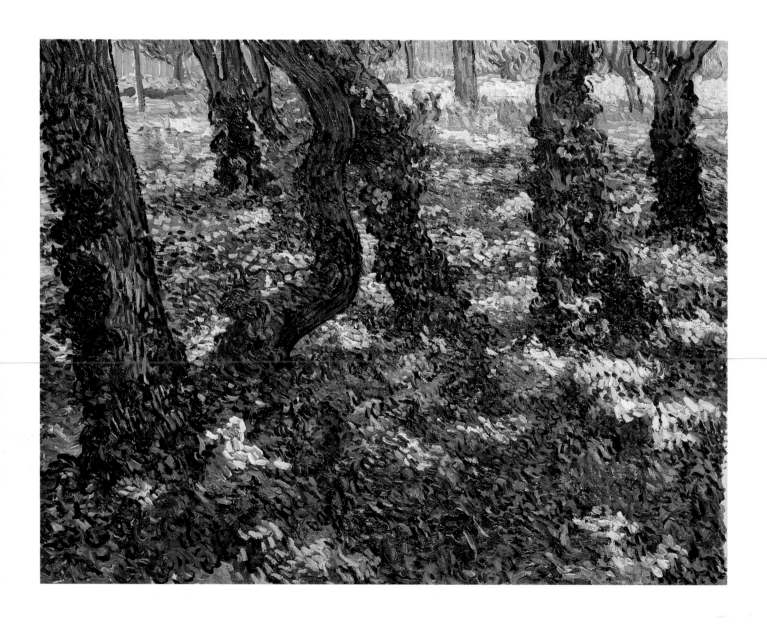

Vincent van Gogh
Undergrowth, 1889
oil on canvas, 73x92,5 cm
Amsterdam, Van Gogh Museum
Vincent van Gogh Foundation
cat. 23

Vincent van Gogh
Ears of Wheat, 1890
oil on canvas, 64,5x48,5 cm
Amsterdam, Van Gogh Museum
Vincent van Gogh Foundation
cat. 24

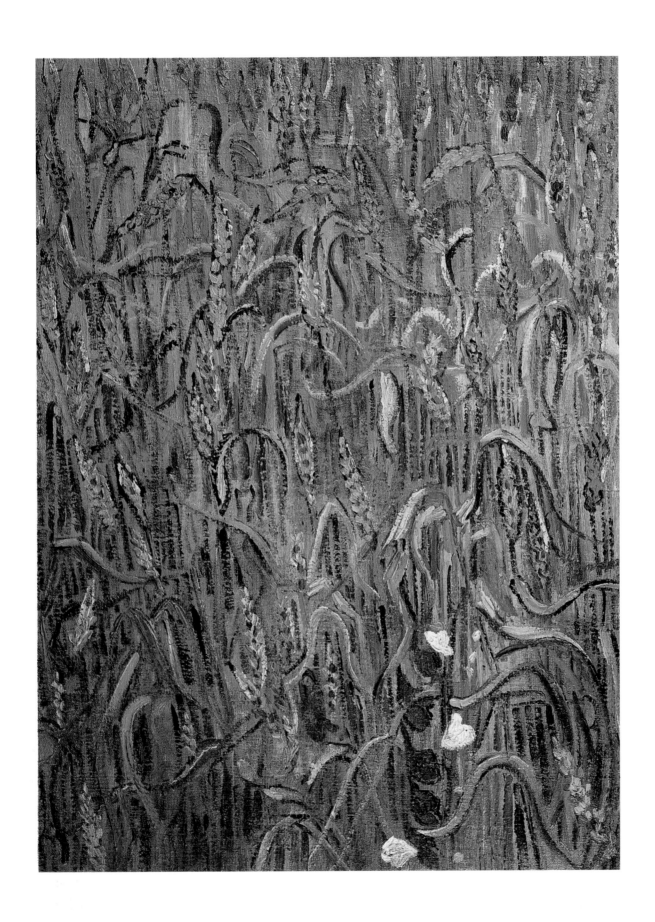

129

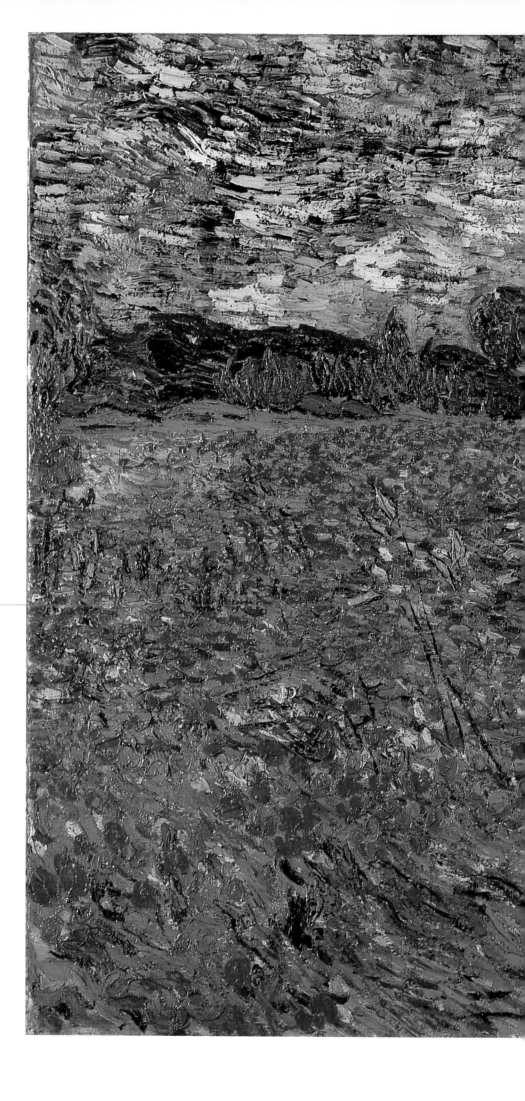

Vincent van Gogh
Field with Poppies, 1890
oil on canvas, 73x91,6 cm
The Hague
Rijksdienst Beeldende Kunst
cat. 25

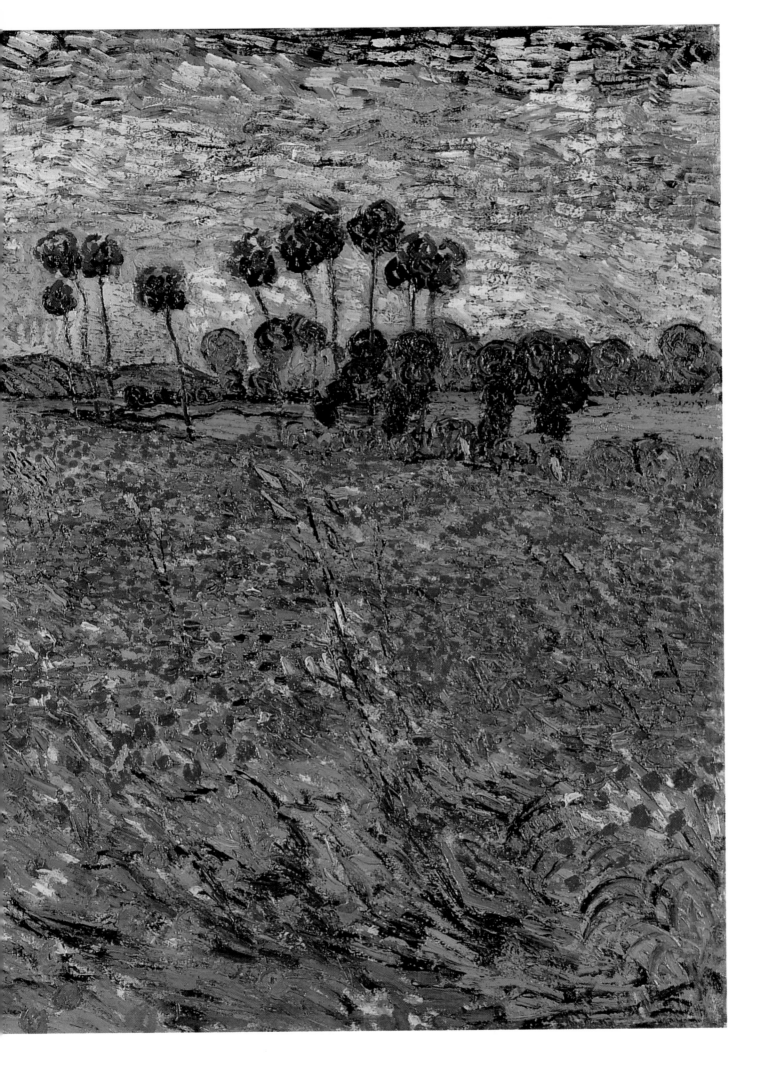

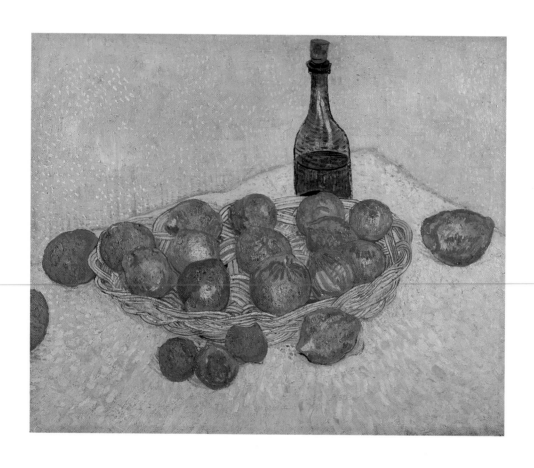

Vincent van Gogh
Still Life with Lemons and Bottle, 1888
oil on canvas, 53x63 cm
Otterlo, Kröller-Müller Museum
cat. 26

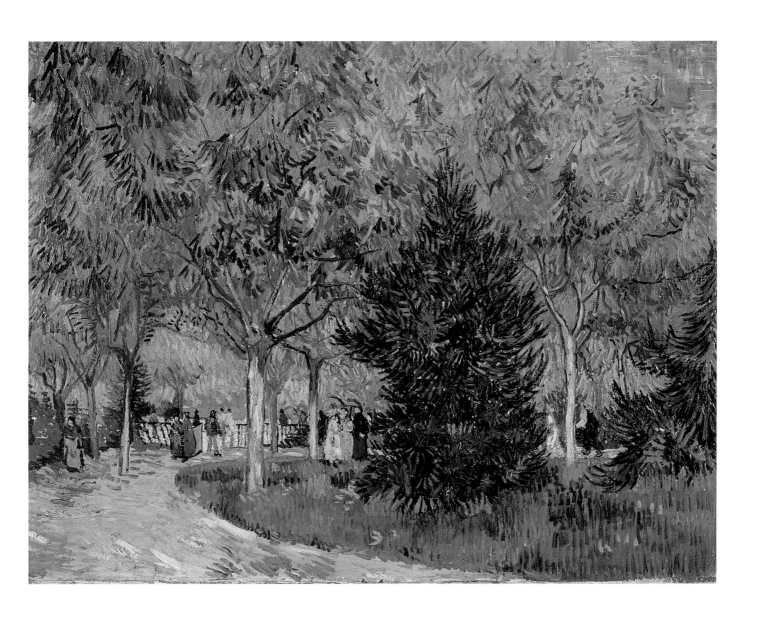

Vincent van Gogh
Cedar Walk with Figure, 1888
oil on canvas, 73x92 cm
Otterlo, Kröller-Müller Museum
cat. 27

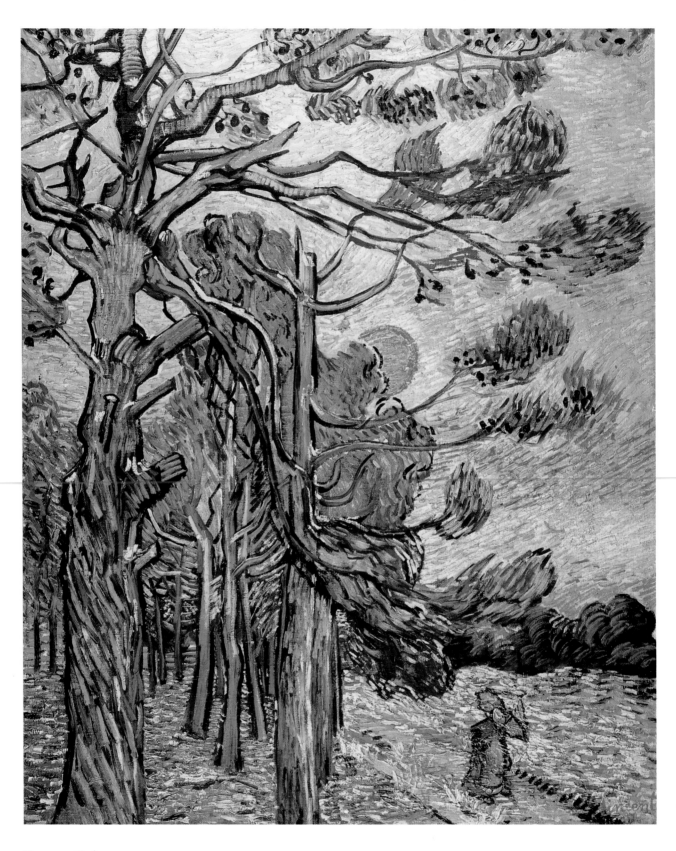

Vincent van Gogh
Fir Trees at Sunset, 1889
oil on canvas, 92x73 cm
Otterlo, Kröller-Müller Museum
cat. 28

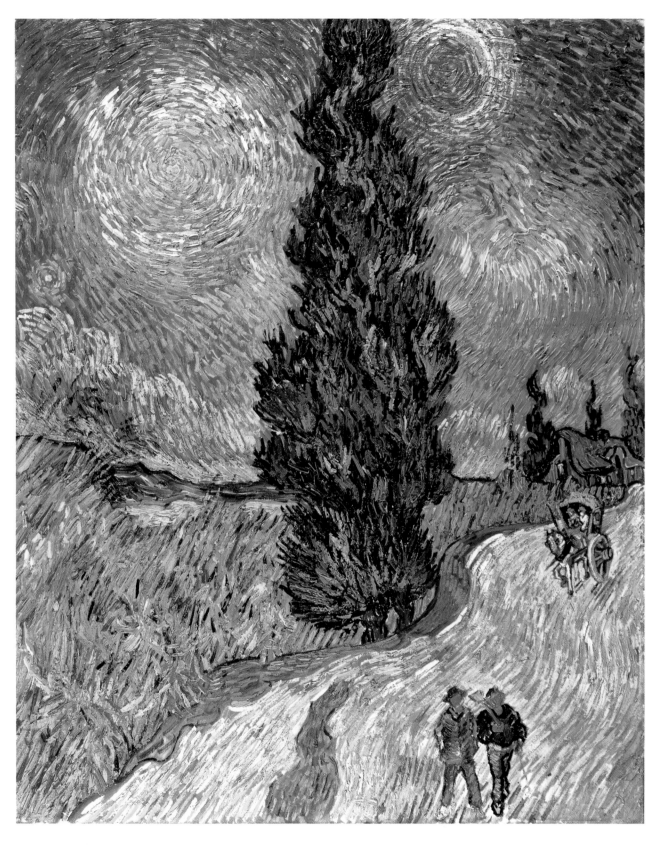

Vincent van Gogh
Road with Cypress and Star, 1890
oil on canvas, 92x73 cm
Otterlo, Kröller-Müller Museum
cat. 29

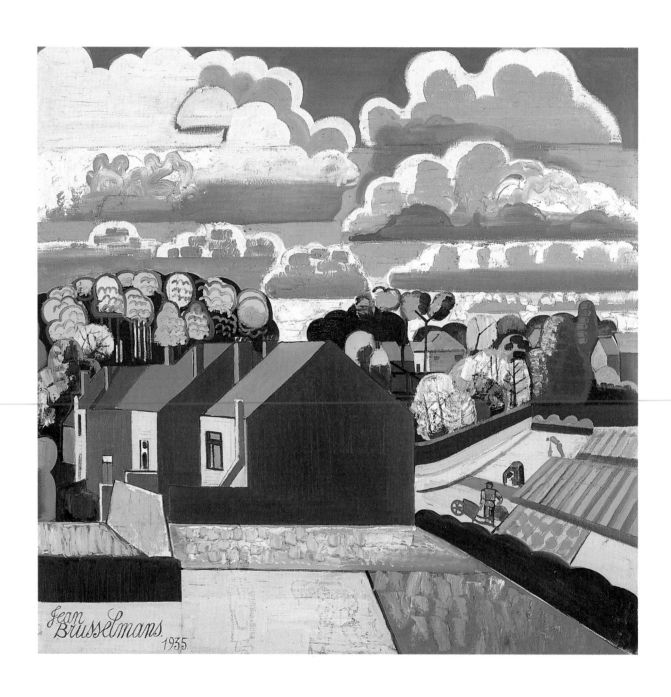

Jean Brusselmans
Spring, View of Dilbeek, 1935
oil on canvas, 151x151 cm
Antwerp, Koninklijk Museum
voor Schone Kunsten
cat. 30

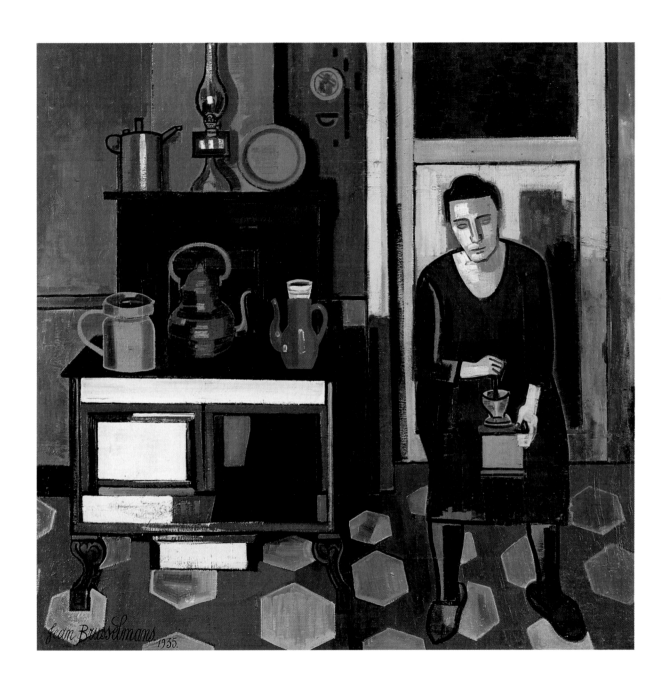

Jean Brusselmans
Woman in a Kitchen, 1935
oil on canvas, 150,7x153,3 cm
Brussels, Ministerie
van de Vlaamse Gemeenschap
cat. 31

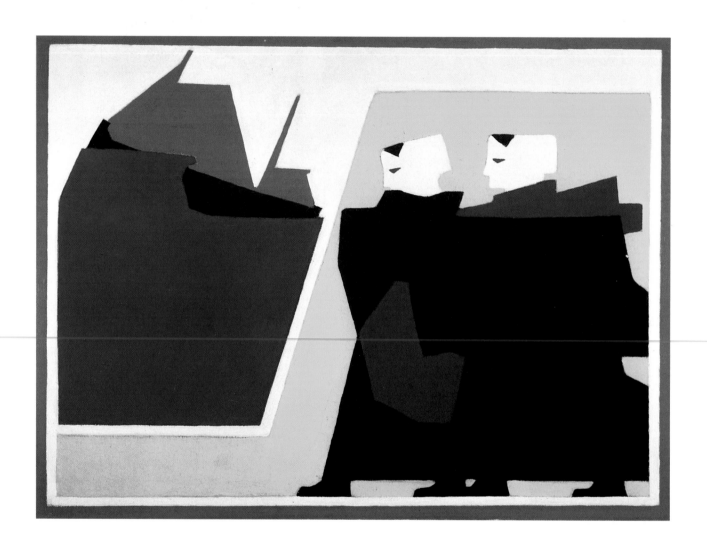

Bart van der Leck
The Storm, 1916
oil on canvas, 118x159 cm
Otterlo
Kröller-Müller Museum
cat. 32

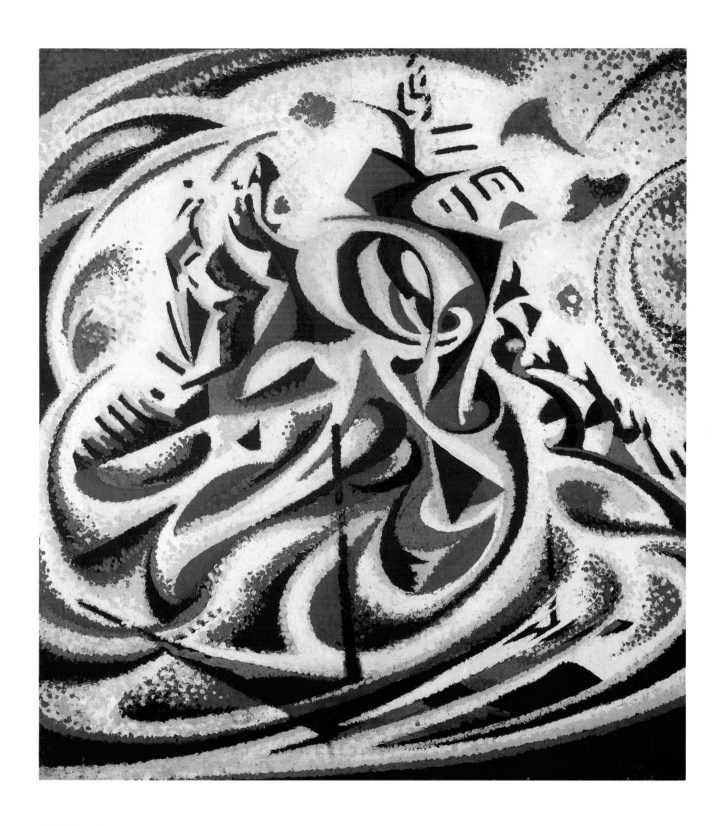

Jules Schmalzigaug
Space and Light (The Sun Moves through
the Church of the Salute - Venice), 1914
oil on canvas, 105x95 cm
Antwerp, Ronny Van de Velde
cat. 33

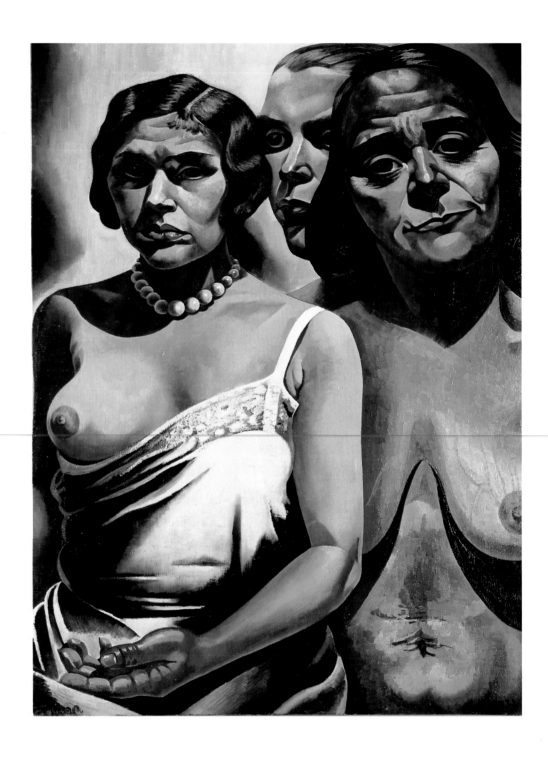

Charley Toorop
Women, 1931-32
oil on canvas
134x100 cm
Eindhoven, Stedelijk
Van Abbemuseum
cat. 34

Charley Toorop
Three Generations, 1941-50
oil on canvas, 200x120 cm
(with frame)
Rotterdam, Museum
Boijmans Van Beuningen
cat. 35

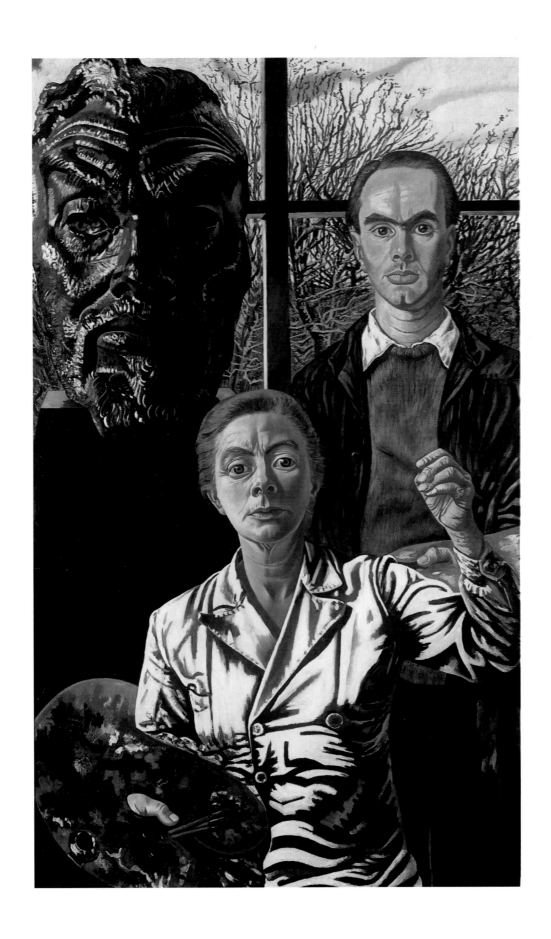

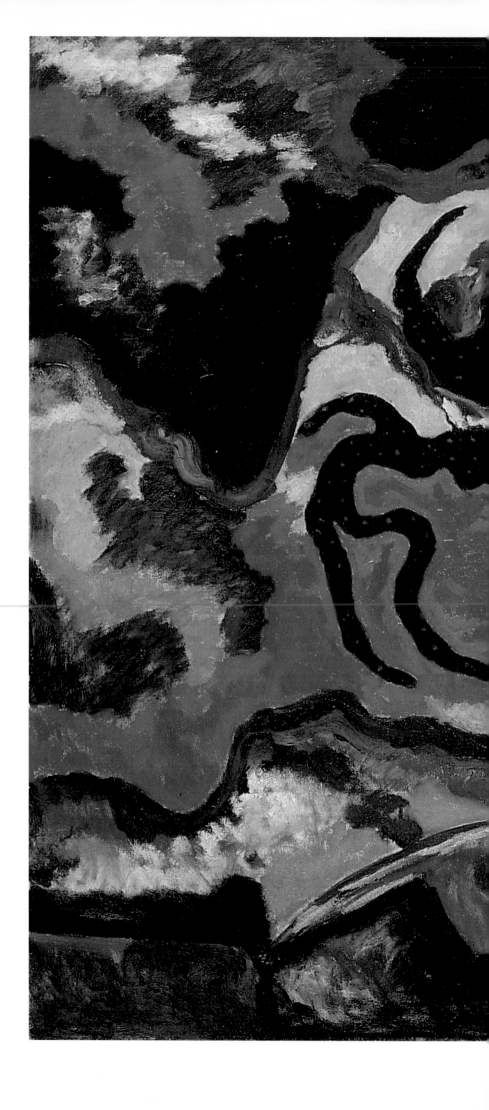

Jacoba van Heemskerck
Composition No. 93, 1918-19
oil on canvas, 100x120,5 cm
The Hague
The Haags Gemeentemuseum
cat. 36

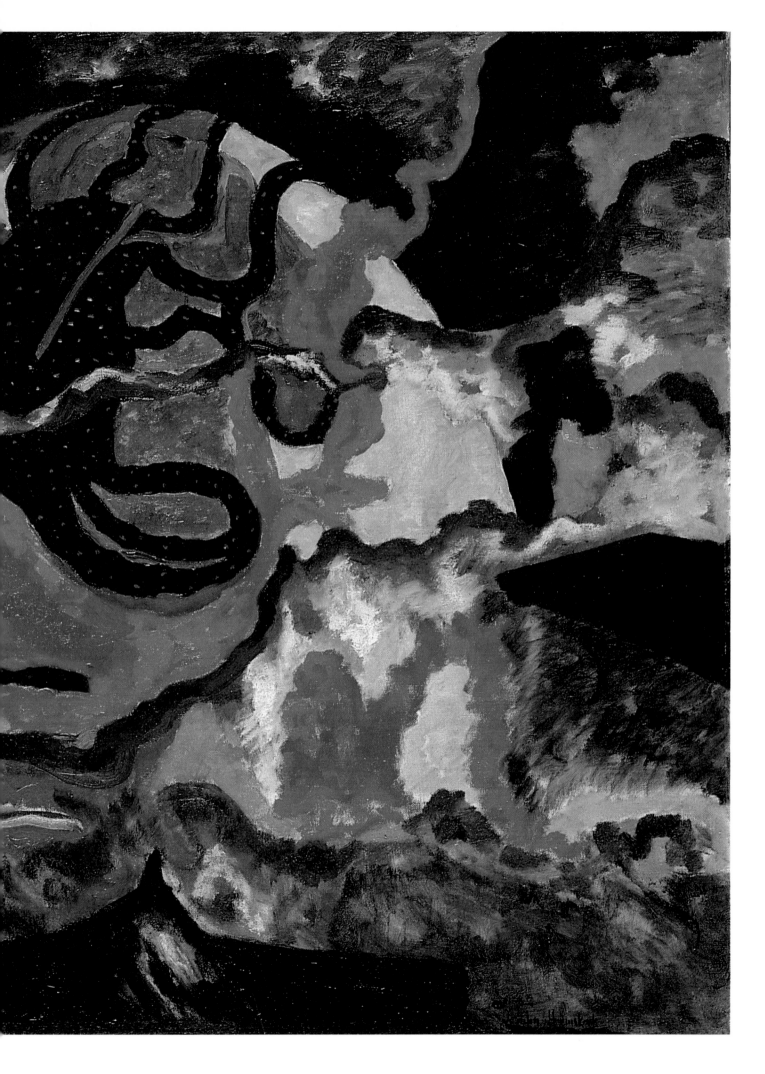

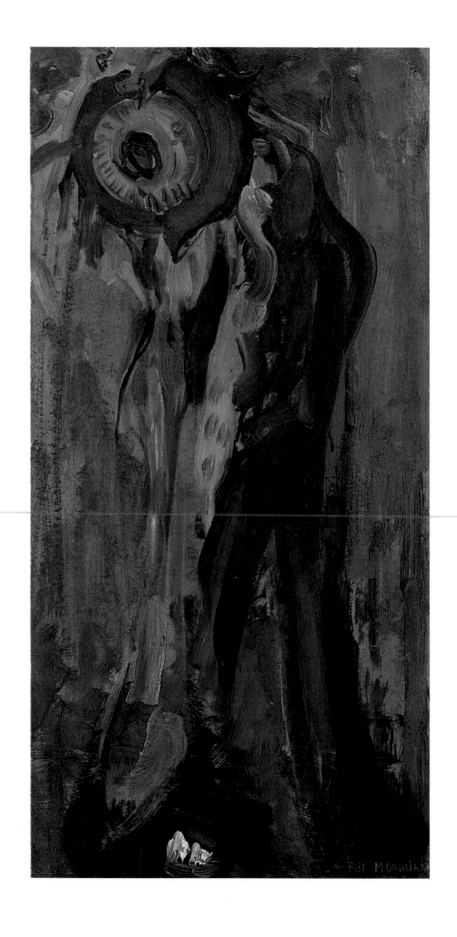

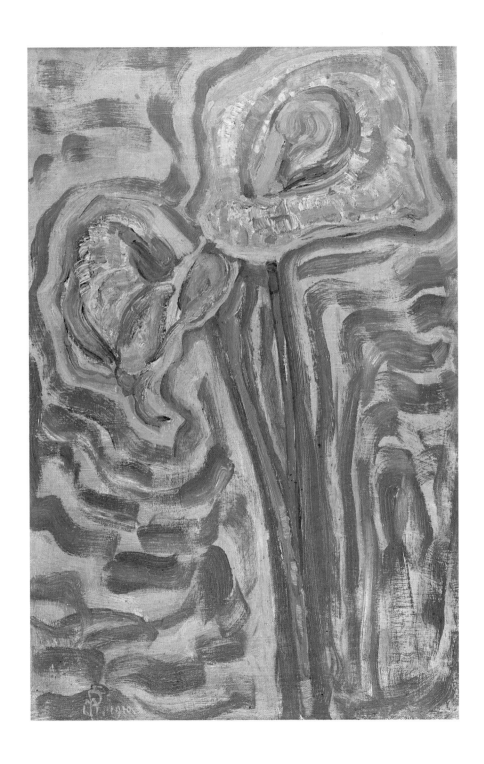

Piet Mondrian
Sunflower I, 1907-08
oil on cardboard, 68x31 cm
The Hague
The Haags Gemeentemuseum
cat. 37

Piet Mondrian
Arum Lilies, 1909-10
oil on canvas, 50x33,5 cm
The Hague
The Haags Gemeentemuseum
cat. 38

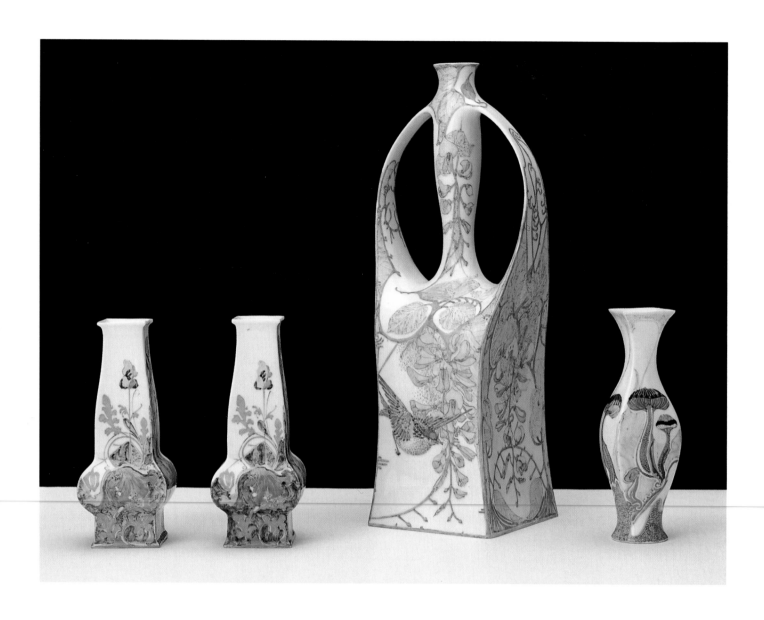

Koninklijke Haagsche Plateelfabriek
Rozenburg N.V. (Royal Rozenburg
Earthenware and Porcelain Factory
The Hague)
Vase, 1908
eggshell porcelain, 12,5x5 cm
design: Jurriaan Kok
decoration: J.W. van Rossum
Amsterdam, Stedelijk Museum
cat. 39a

Koninklijke Haagsche Plateelfabriek
Rozenburg N.V. (Royal Rozenburg
Earthenware and Porcelain Factory
The Hague)
Vase, 1908
eggshell porcelain, 12,5x5 cm
design: Jurriaan Kok
decoration: J.W. van Rossum
Amsterdam, Stedelijk Museum
cat. 39b

Koninklijke Haagsche Plateelfabriek
Rozenburg N.V. (Royal Rozenburg
Earthenware and Porcelain Factory
The Hague)
Vase, 1900
eggshell porcelain, 26,5x10 cm
design: Jurriaan Kok
decoration: Sam Schellink
Amsterdam, Stedelijk Museum
cat. 39c

Koninklijke Haagsche Plateelfabriek
Rozenburg N.V. (Royal Rozenburg
Earthenware and Porcelain Factory
The Hague)
Vase, 1903
eggshell porcelain, 12x4 cm
design: Jurriaan Kok
decoration: R. Sterken
Amsterdam, Stedelijk Museum
cat. 39d

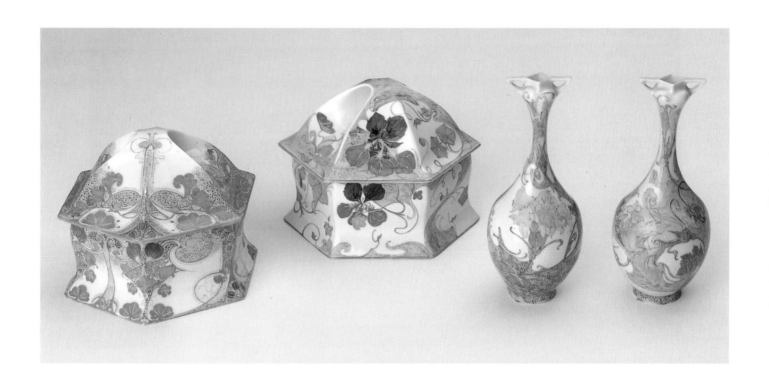

Koninklijke Haagsche Plateelfabriek
Rozenburg N.V. (Royal Rozenburg
Earthenware and Porcelain Factory
The Hague)
Bonbonnière, 1903
eggshell porcelain, 10x14 cm
design: Jurriaan Kok
decoration: J.W. van Rossum
Amsterdam, Stedelijk Museum
cat. 40a

Koninklijke Haagsche Plateelfabriek
Rozenburg N.V. (Royal Rozenburg
Earthenware and Porcelain Factory
The Hague)
Bonbonnière, 1903
eggshell porcelain, 10x14 cm
design: Jurriaan Kok
decoration: Sam Schellink
Amsterdam, Stedelijk Museum
cat. 40b

Koninklijke Haagsche Plateelfabriek
Rozenburg N.V. (Royal Rozenburg
Earthenware and Porcelain Factory
The Hague)
Vase, 1909-10
eggshell porcelain, 14,5x6 cm
design: Jurriaan Kok
decoration: Sam Schellink
Amsterdam, Stedelijk Museum
cat. 40c

Koninklijke Haagsche Plateelfabriek
Rozenburg N.V. (Royal Rozenburg
Earthenware and Porcelain Factory
The Hague)
Vase, 1909-10
eggshell porcelain
design: Jurriaan Kok
decoration: Sam Schellink
Amsterdam, Stedelijk Museum
cat. 40d

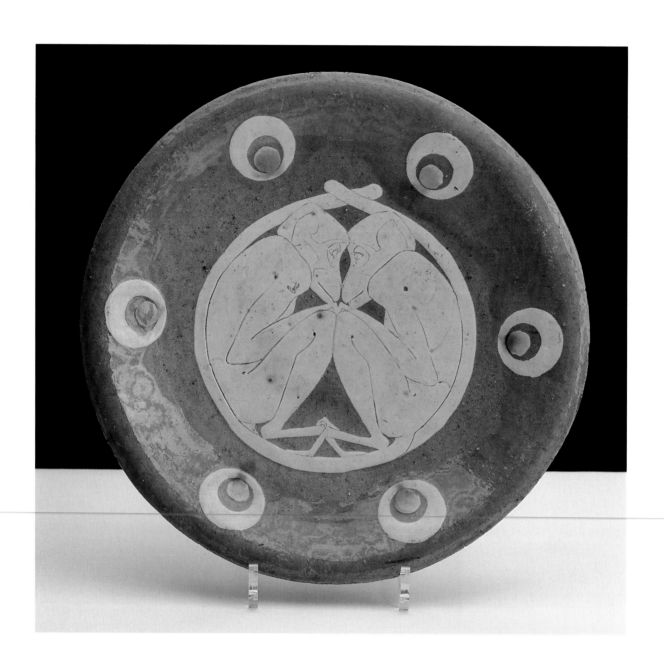

Joseph Mendes da Costa
Plate, 1897 circa
earthenware, diam. 34 cm
Amsterdam, Stedelijk Museum
cat. 41

Chris van der Hoef
for Amstelhoek, Fayencefabriek
Amsterdam
(Amstelhoek, Faience Factory
Amsterdam)
Dish, 1900 circa
4,5x25 cm
Amsterdam, Stedelijk Museum
cat. 42a

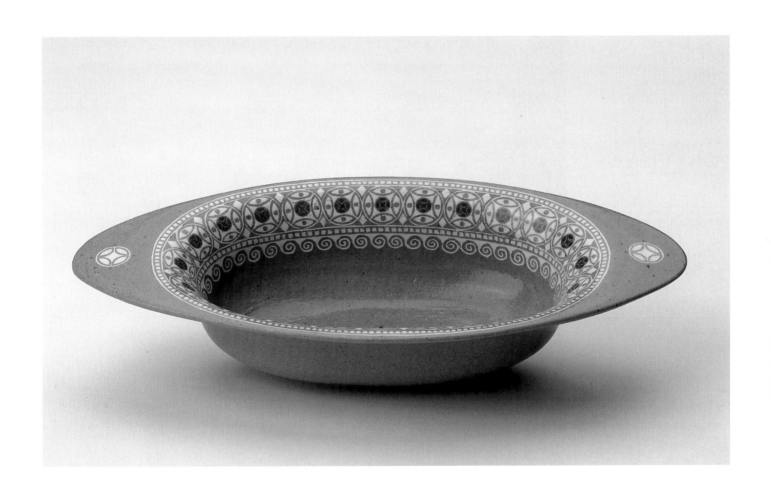

Chris van der Hoef
for Amstelhoek, Fayencefabriek
Amsterdam
(Amstelhoek, Faience Factory
Amsterdam)
Bowl, 1904
6,5x10,5 cm
Amsterdam, Stedelijk Museum
cat. 42b

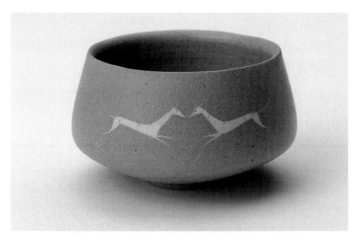

149

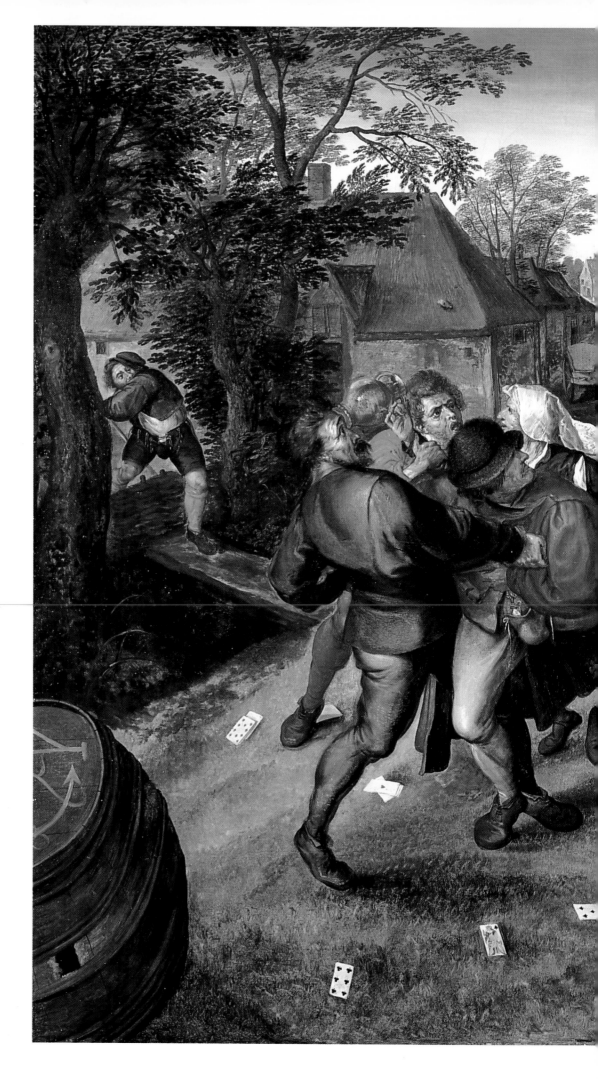

Jan Bruegel the Elder
Fighting Farmers, 1620 circa
wood panel, 94x124 cm
Courtesy Galerie Jan De Maere
cat. 43

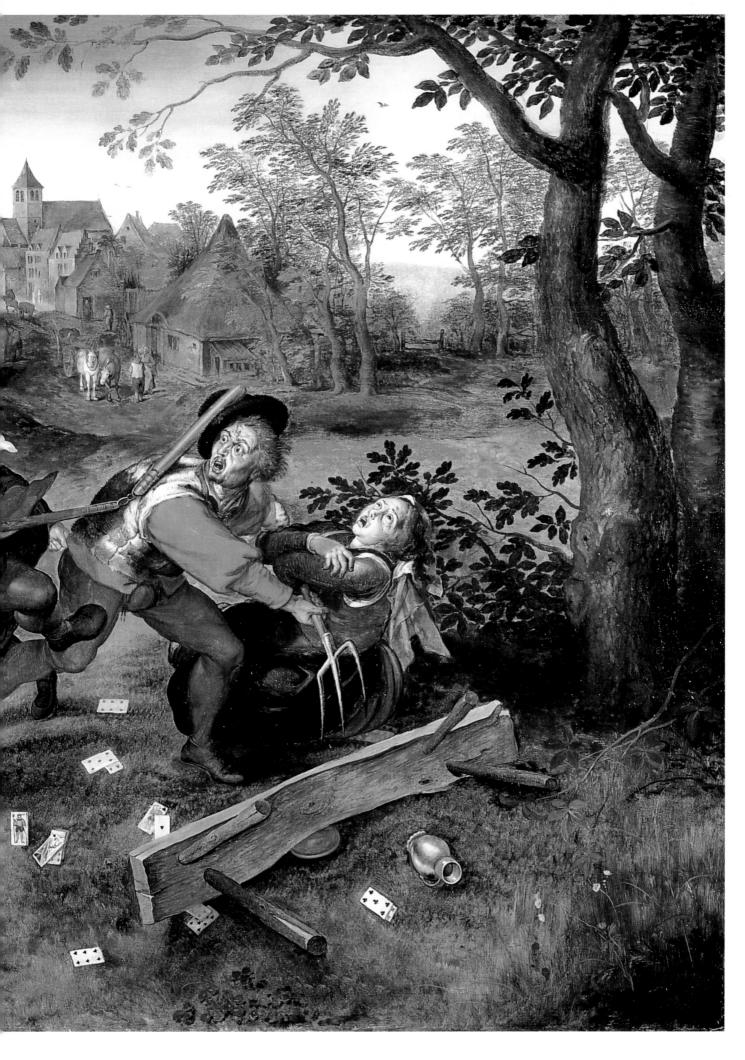

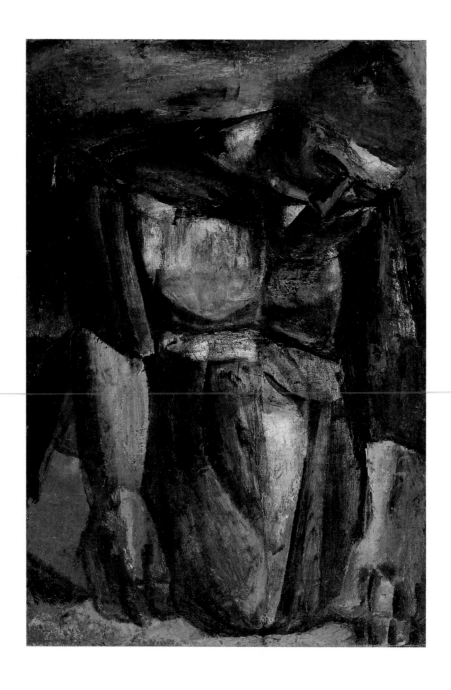

Constant Permeke
The Weeder, 1923
oil on canvas, 110,6x75,1 cm
Ghent, Museum
voor Schone Kunsten
cat. 44

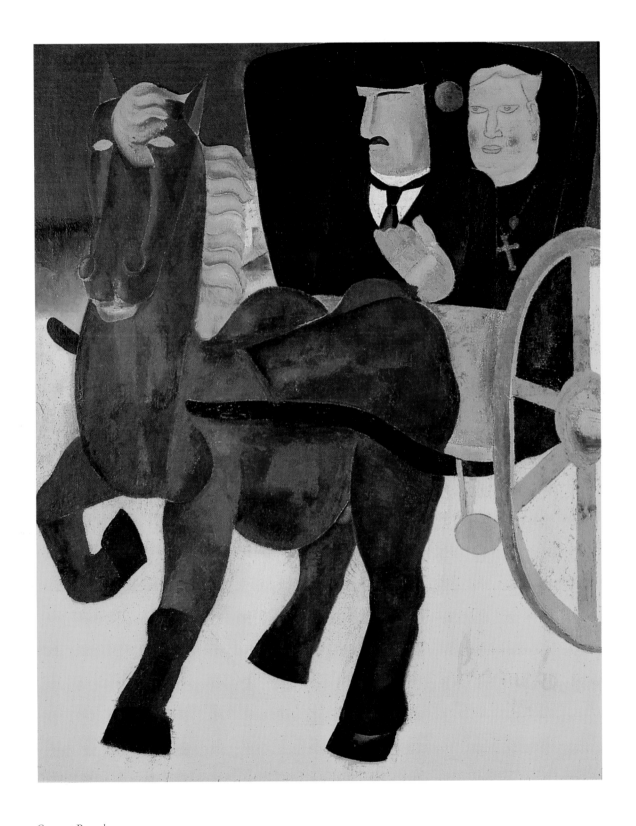

Constant Permeke
The Cabriolet, 1926
oil on canvas, 165x128 cm
Ostend
PMMK - Musée d'Art Moderne
cat. 45

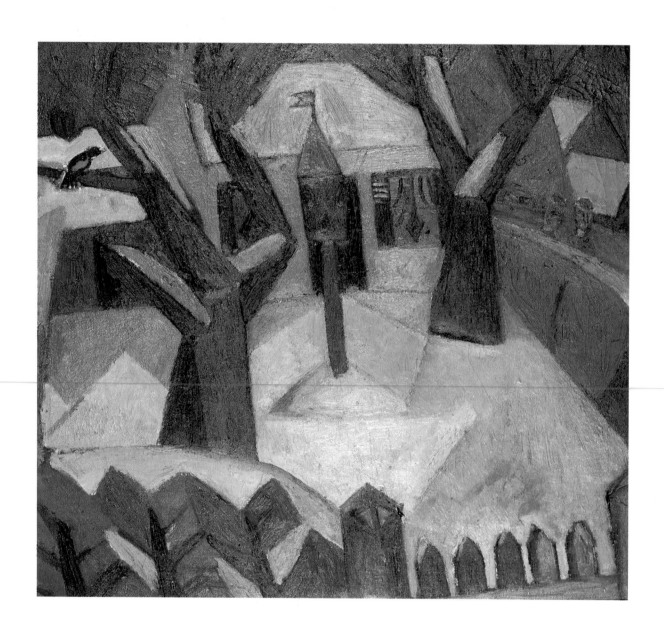

Gustave De Smet
The Pigeon House, 1920
oil on canvas, 70x75 cm
Brussels
Musée d'Ixelles
cat. 46

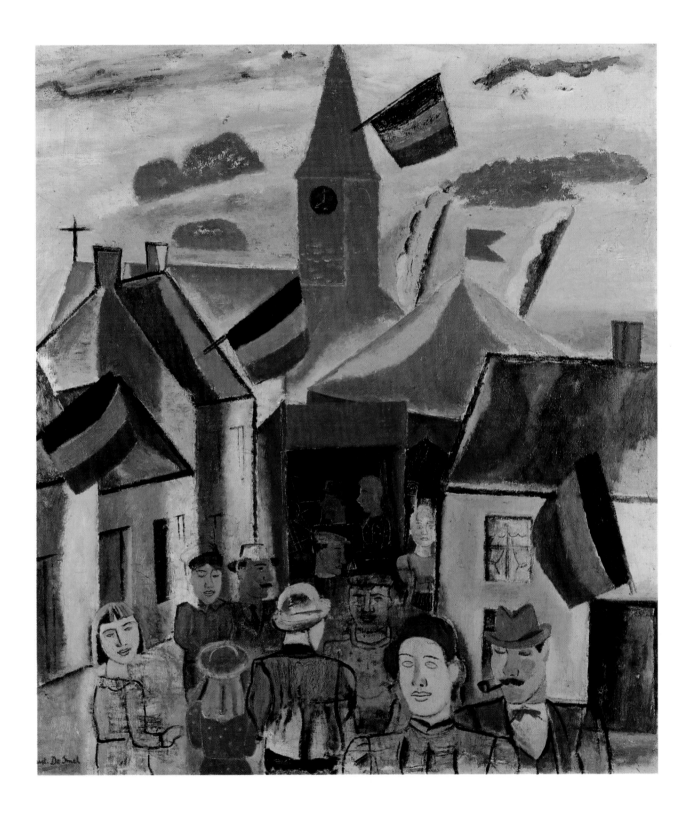

Gustave De Smet
Village Fair, 1933
oil on canvas, 132,4x115,6 cm
Brussels, Ministerie
van de Vlaamse Gemeenschap
cat. 47

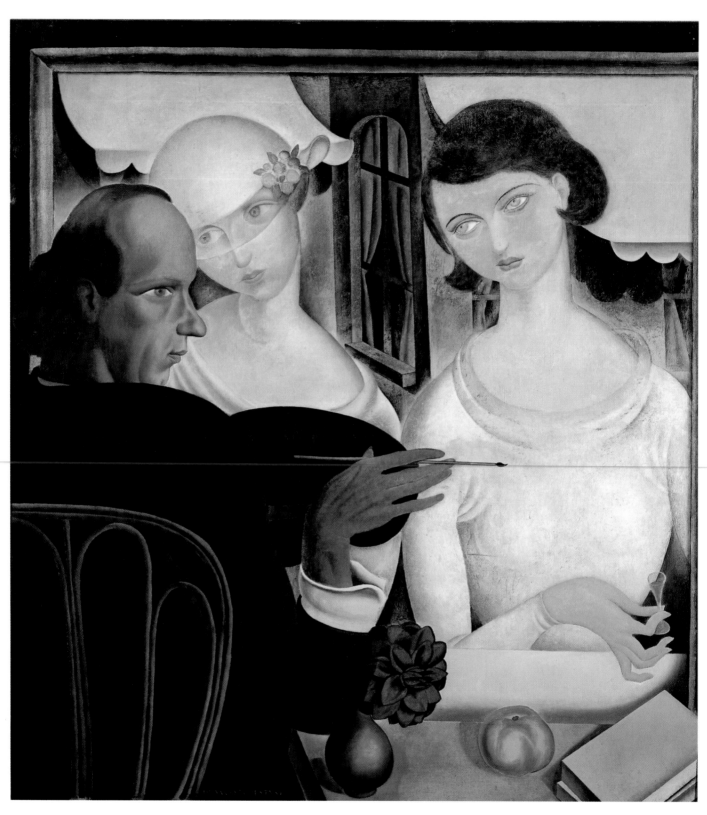

Gustave van de Woestijne
Liqueur Drinkers, 1922
oil on canvas, 109,5x99cm
Antwerp, Koninklijk Museum
voor Schone Kunsten
cat. 48

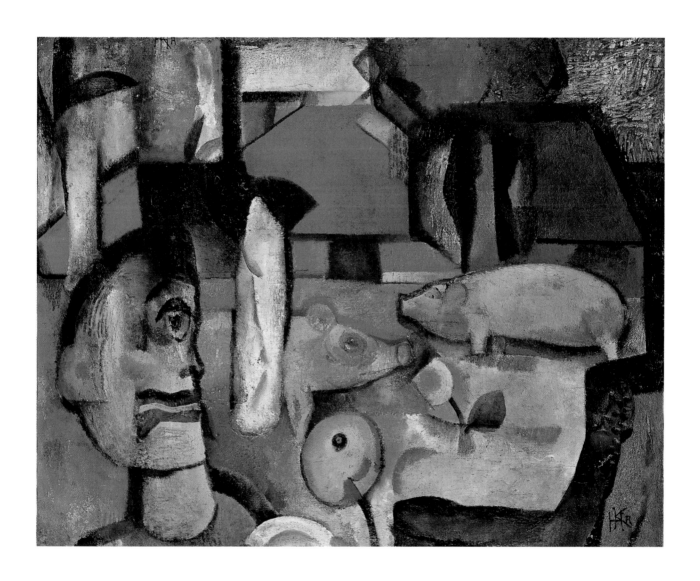

Herman Kruijder
Pig Killer, 1925
oil on canvas, 56x68,5 cm
Eindhoven, Stedelijk
Van Abbemuseum
cat. 49

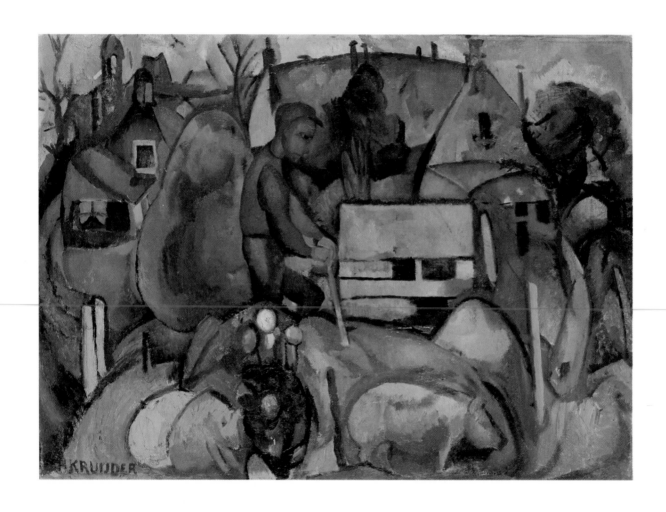

Herman Kruijder
Pig Farmer, 1925
oil on canvas, 54x72 cm
Amsterdam
Stedelijk Museum
cat. 50

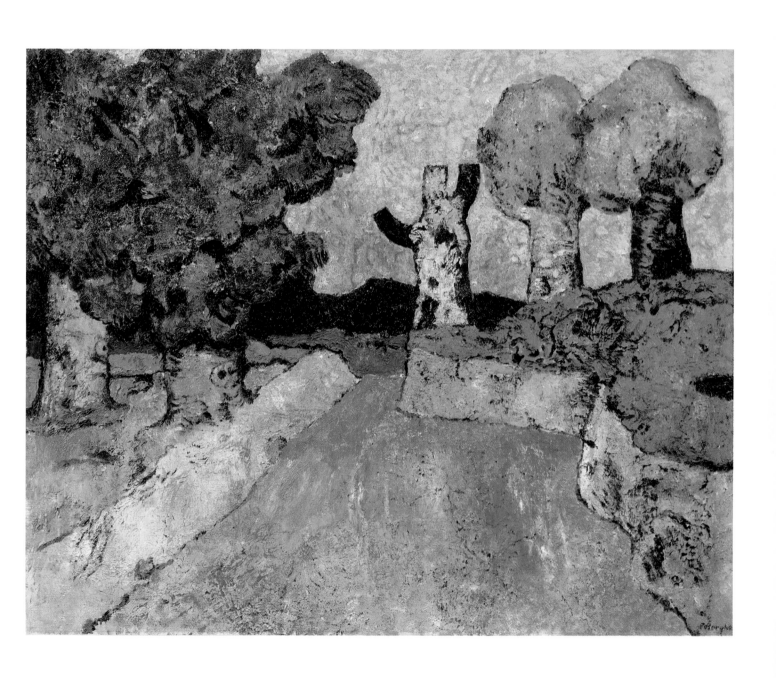

Frits van den Berghe
The Sunken Road, 1931
oil on canvas, 73x88 cm
Brussels, Musées royaux
des Beaux-Arts de Belgique
cat. 51

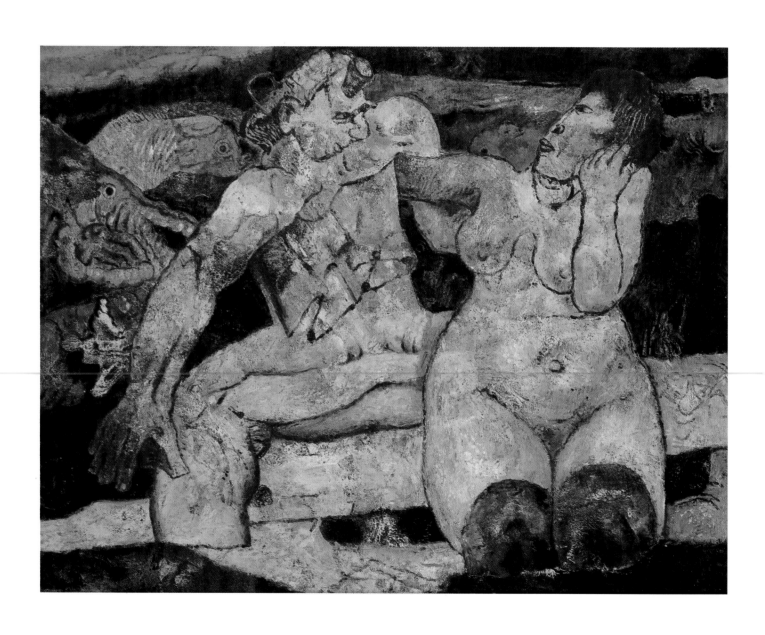

Frits van den Berghe
Neptune, 1932
oil on canvas, 90x114 cm
Amsterdam, Stedelijk Museum
on loan from the Netherlands
Office for Fine Arts
(Regnault Collection)
cat. 52

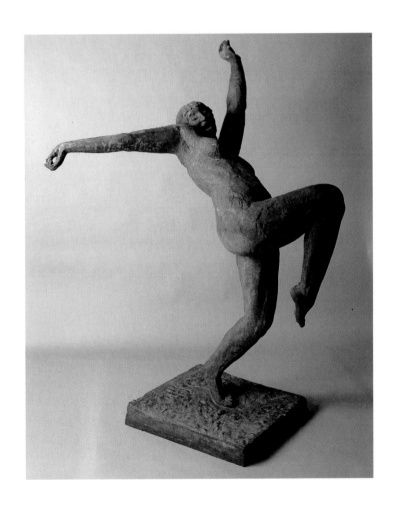

Rik Wouters
The Crazy Dancer, 1912
bronze, h. 200 cm
Brussels
Collection Crédit Communal
cat. 53

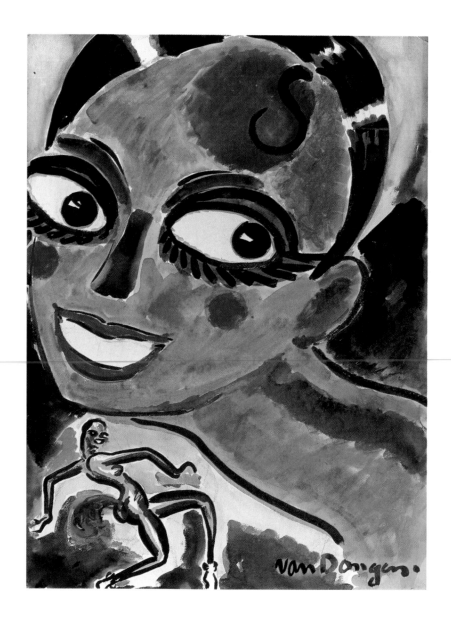

Kees van Dongen
Josephine Baker at a Blacks' Ball
1925
watercolour, 66x48 cm
Antwerp
Ronny Van de Velde
cat. 54

Jan Sluijters
Bal Tabarin, 1907
oil on canvas, 200x140 cm
Amsterdam
Stedelijk Museum
on loan from a private collection
cat. 55

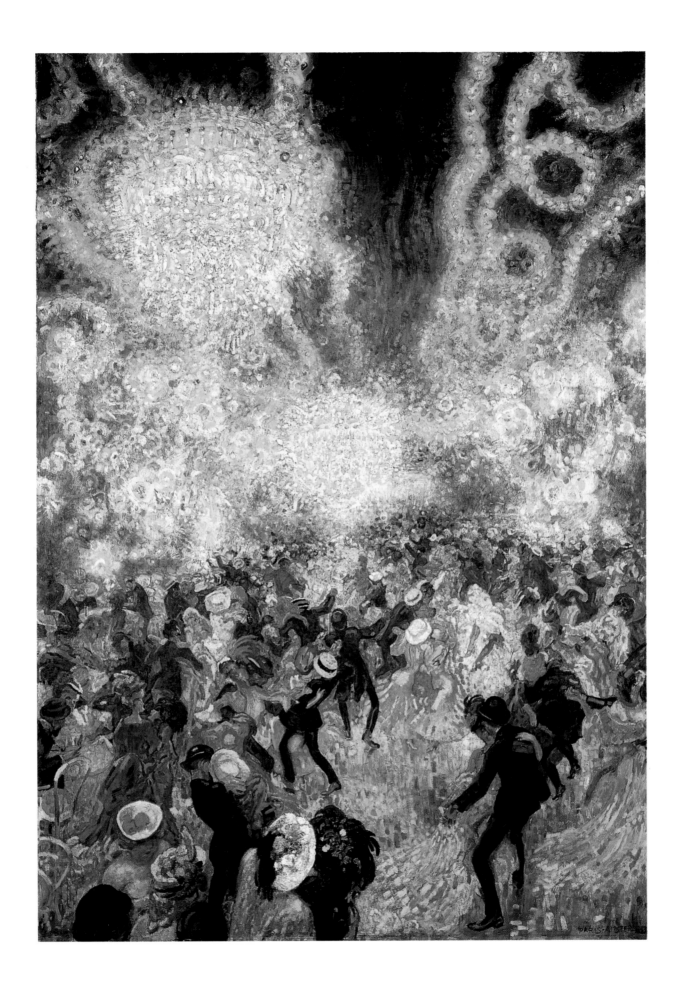

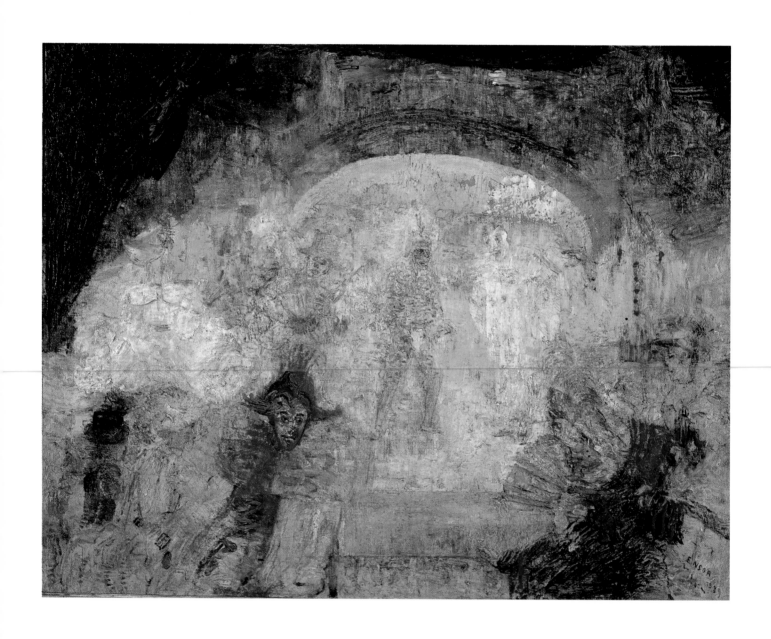

James Ensor
The Mask Theatre, 1889
oil on canvas, 59x72 cm
Antwerp, Koninklijk Museum
voor Schone Kunsten
cat. 56

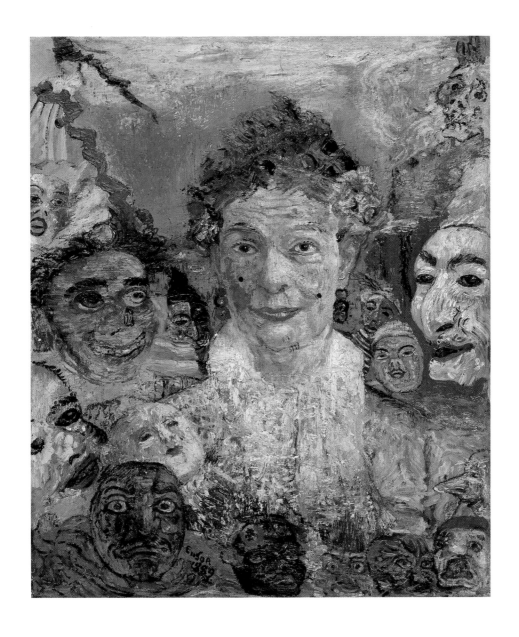

James Ensor
Old Lady with Masks, 1889
oil on canvas, 54,5x46,5 cm
Ghent
Museum voor Schone Kunsten
cat. 57

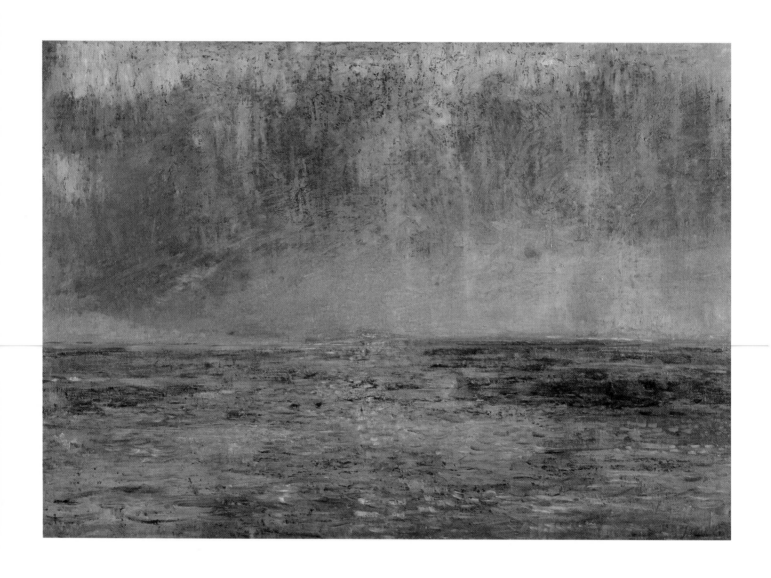

James Ensor
Large Marine: Sunset, 1885
oil on canvas, 114x161x4 cm circa
Ostend
Museum voor Schone Kunsten
cat. 58

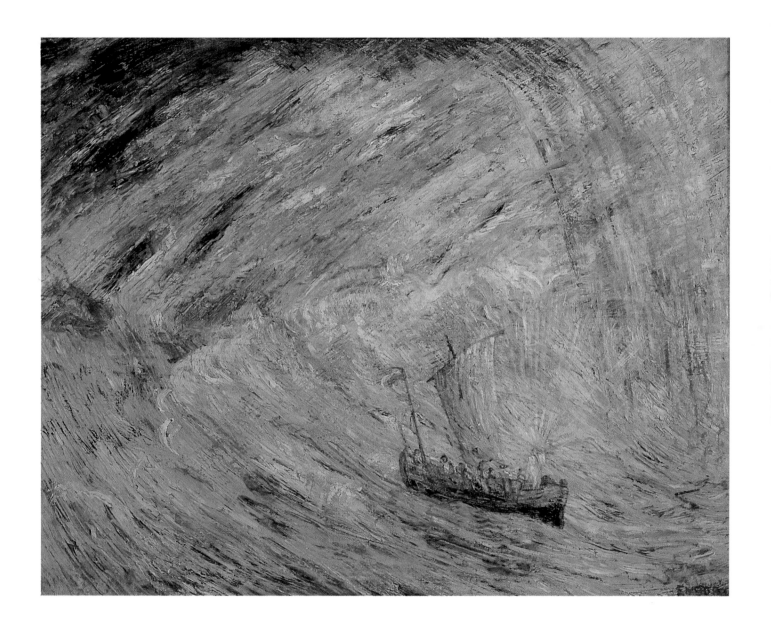

James Ensor
Christ Calms Down the Storm, 1891
oil on canvas, 80x100x4 cm circa
Ostend
Museum voor Schone Kunsten
cat. 59

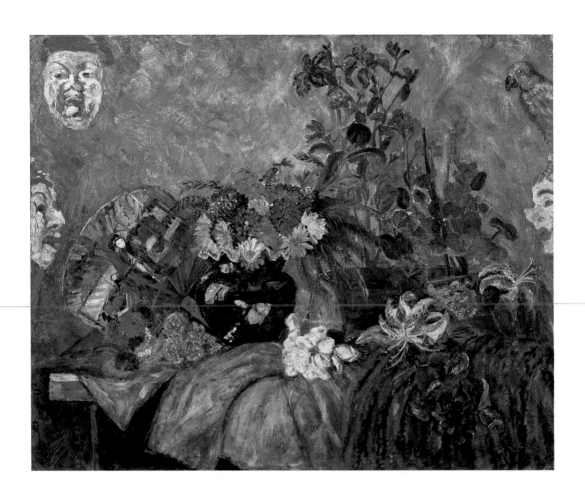

James Ensor
Still Life
oil on canvas, 54,5x66 cm
Amsterdam
Stedelijk Museum
cat. 60

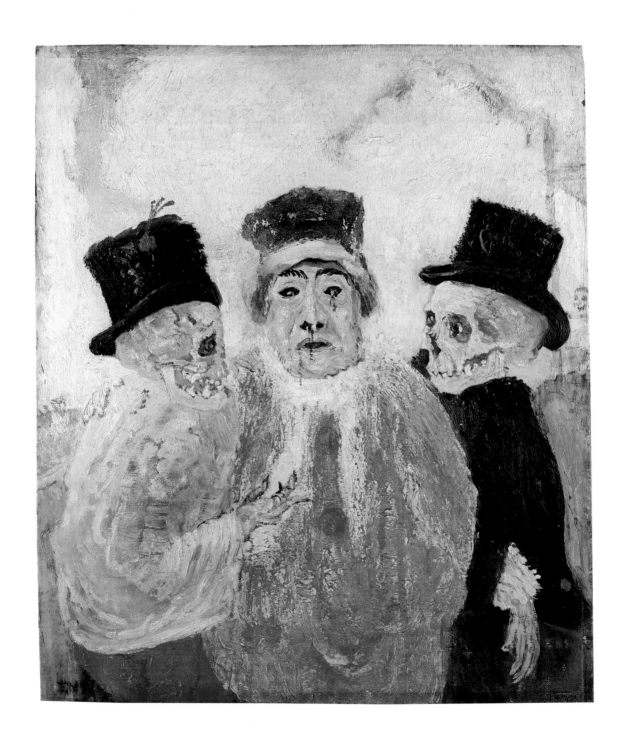

James Ensor
The Red Judge, 1890
oil on canvas, 46x39 cm
Mendrisio, Private Collection
Courtesy
Massimo Martino S.A.
cat. 61

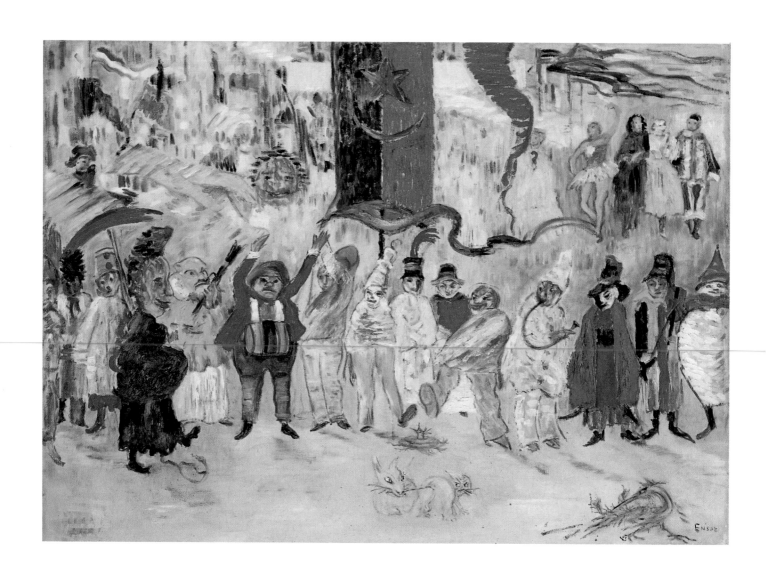

James Ensor
Carnival in Flanders
oil on canvas
54x73 cm
Amsterdam
Stedelijk Museum
cat. 62

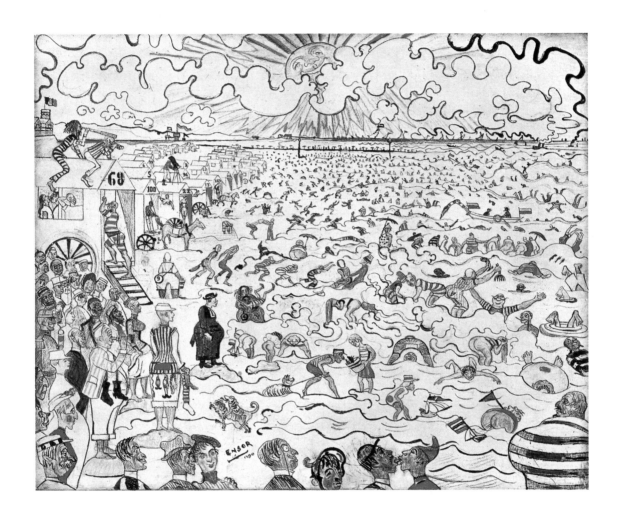

James Ensor
Baths at Ostend, 1890
mixed media on panel
37,5x45,5 cm
Antwerp
Ronny Van de Velde
cat. 63

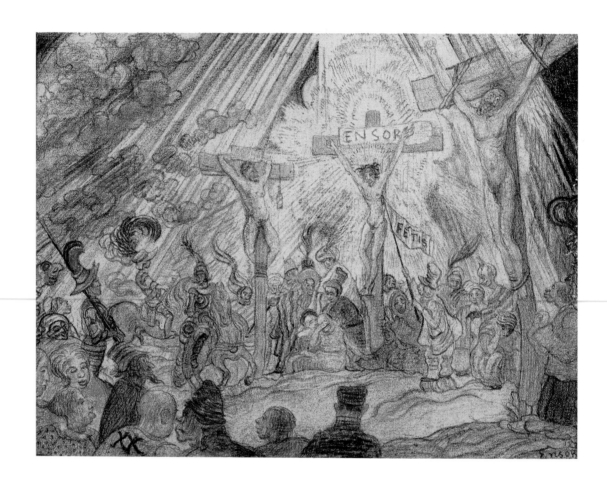

James Ensor
The Calvary, 1886
mixed media on panel, 17,2x22,2 cm
Antwerp
Ronny Van de Velde
cat. 64

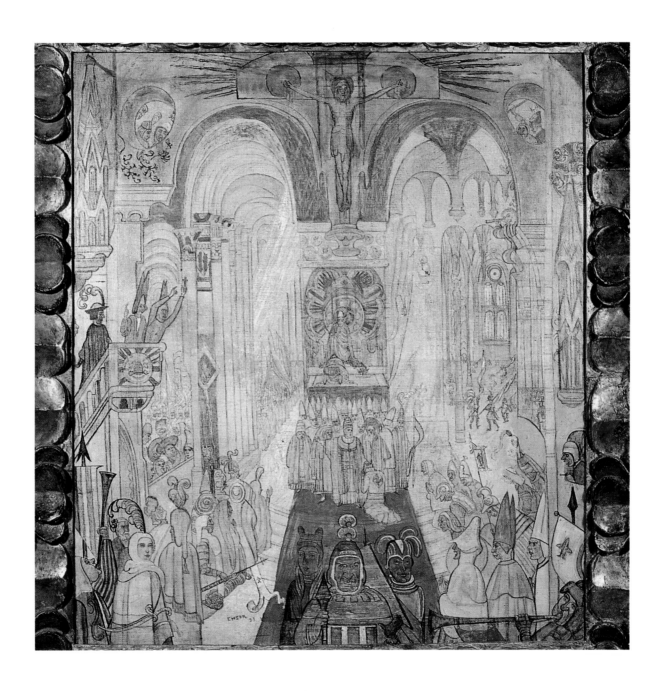

James Ensor
Penitent Mercenaries in a Cathedral
1893
oil and pencil on canvas, 120x105 cm
Turin, Ezio Gribaudo Collection
cat. 65

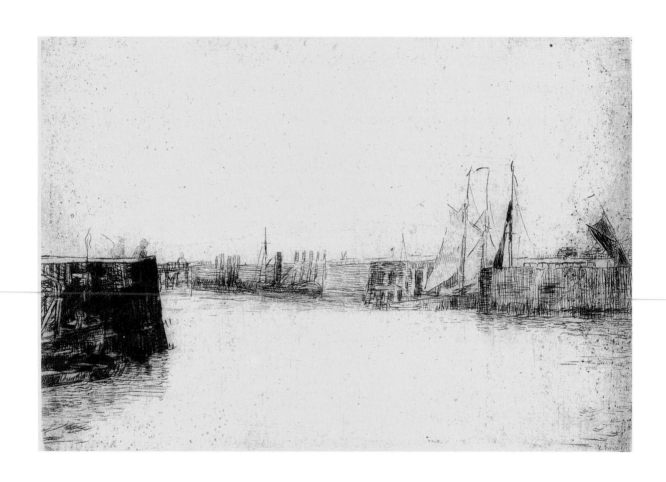

James Ensor
Breakwater
1887
etching, 89x128 mm
private collection
cat. 66

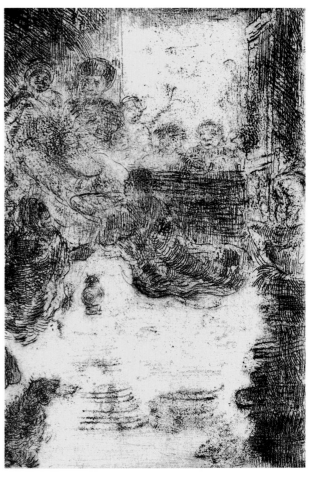

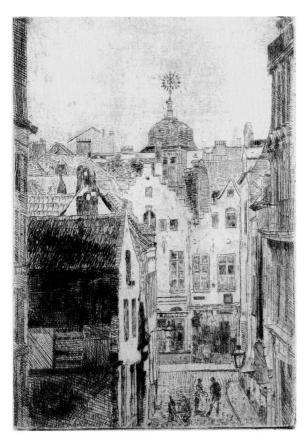

James Ensor
Rue du Bon Secours, Brussels
1887
etching, drypoint, 130x90 mm
private collection
cat. 67

James Ensor
Adoration of the Shepherds
1888
etching, 157x113 mm
private collection
cat. 68

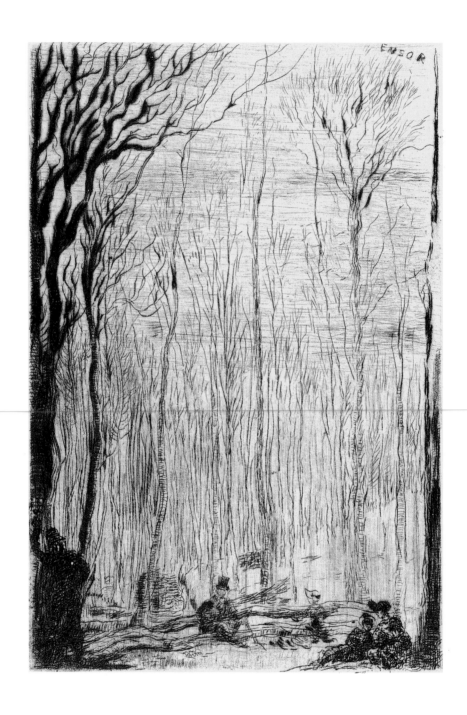

James Ensor
Forest at Groenendael
1888
drypoint, 113x75 mm
private collection
cat. 69

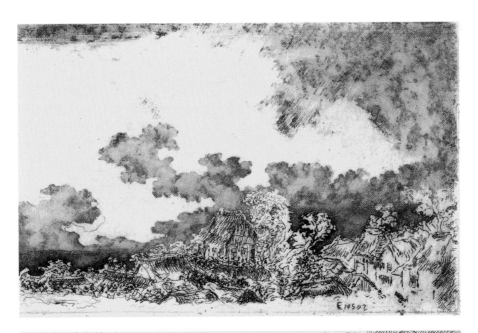

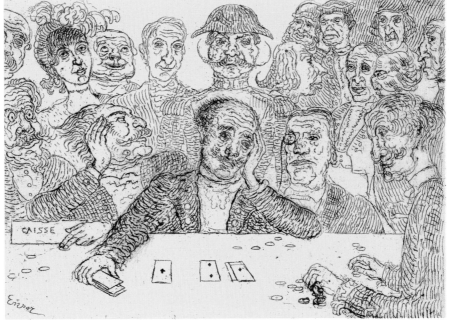

James Ensor
The Thunderstorm
1889
etching, 75x116 mm
private collection
cat. 70

James Ensor
The Gamblers
1895
etching, 114x155 mm
private collection
cat. 71

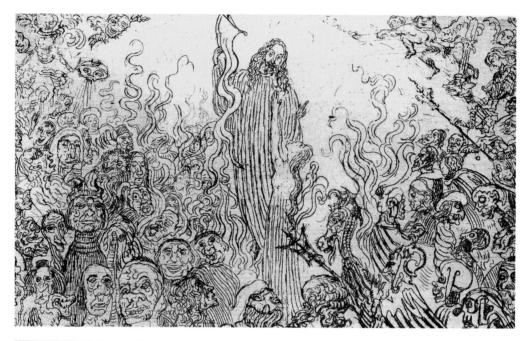

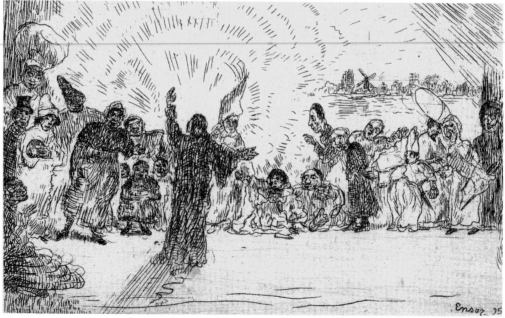

James Ensor
Christ Descending to Hell, 1895
etching, 84x136 mm
private collection
cat. 72

James Ensor
Christ and the Beggars
1895
etching, 88x131 mm
private collection
cat. 73

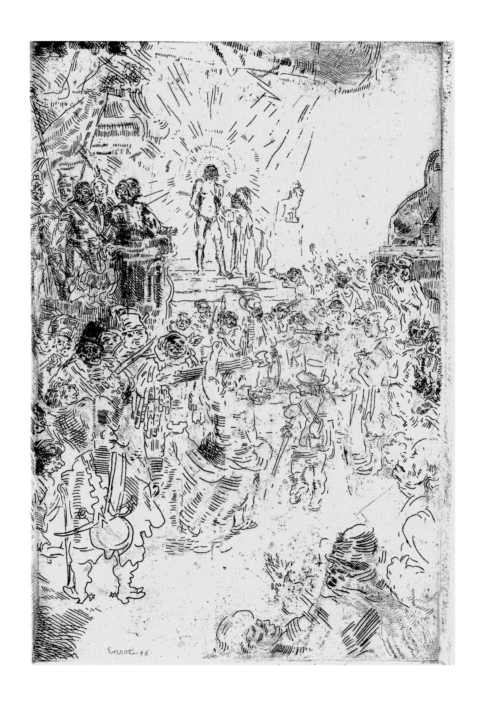

James Ensor
Christ Mocked
1886
etching, 230x150 mm
private collection
cat. 74

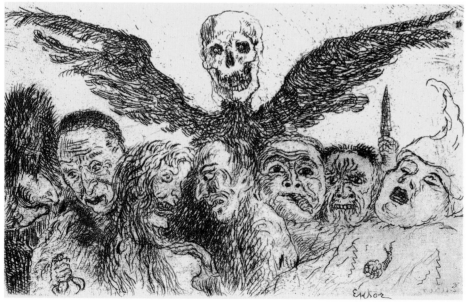

James Ensor
Menu for Charles Vos, 1896
etching, 157x109 mm
private collection
cat. 75

James Ensor
*The Deadly Sins Dominated
by Death*, 1904
etching, 84x134 mm
private collection
cat. 76

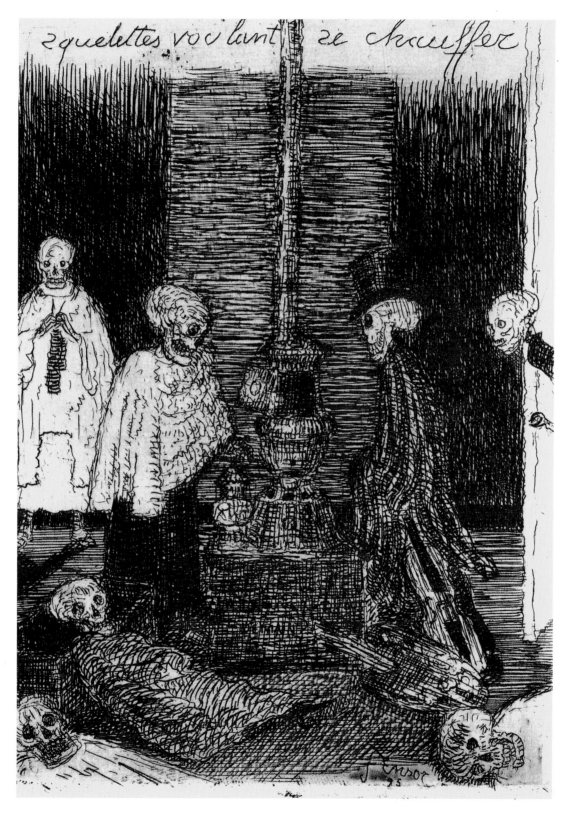

James Ensor
Warmth-Seeking Skeletons
1895
etching, 133x97 mm
private collection
cat. 77

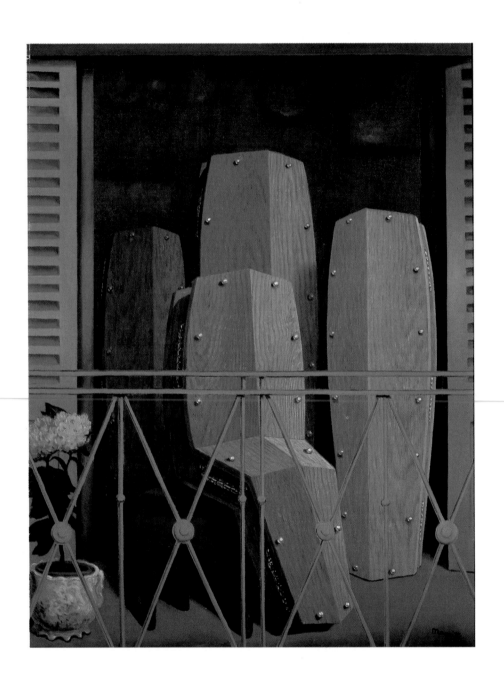

René Magritte
Perspective (Manet's Balcon) II, 1950
oil on canvas, 80x60 cm
Ghent
Museum van Hedendaagse Kunst
cat. 78

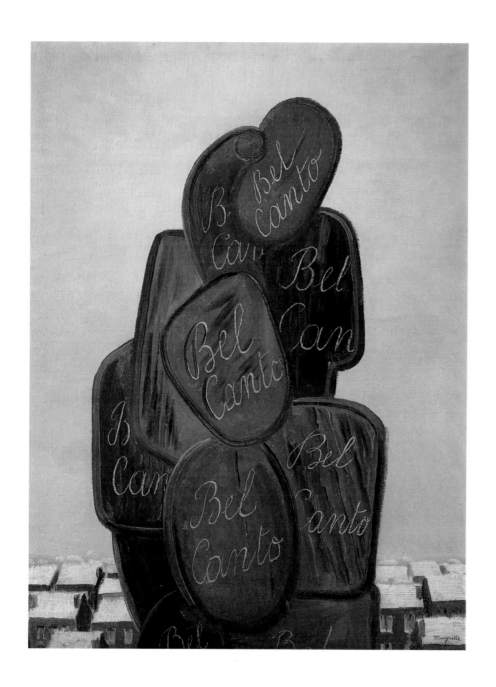

René Magritte
Bel Canto, 1938
oil on canvas, 75,3x54,7 cm
Brussels, Musées royaux
des Beaux-Arts de Belgique
cat. 79

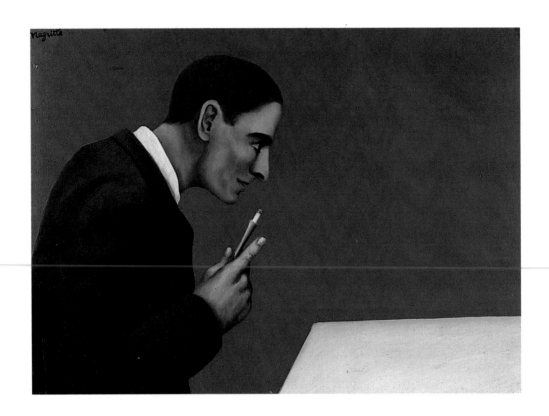

René Magritte
Person Meditating on Madness
1928
oil on canvas, 54x73 cm
Brussels, Musées royaux
des Beaux-Arts de Belgique
cat. 80

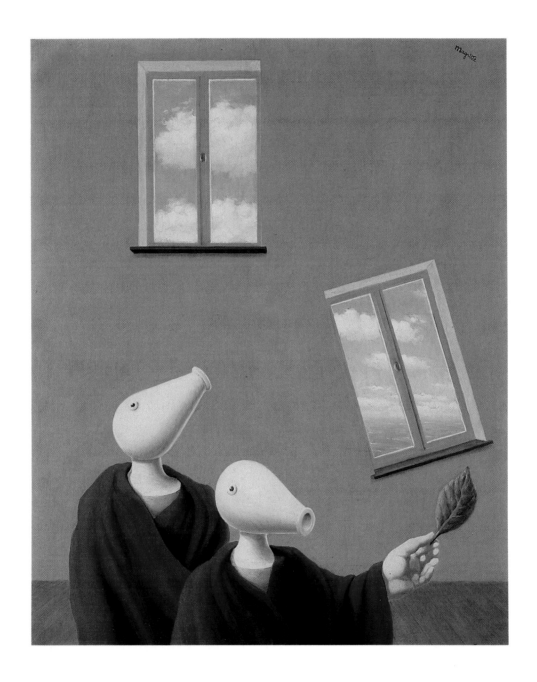

René Magritte
Natural Encounters
1945
oil on canvas, 81x65,3 cm
Brussels, Musées royaux
des Beaux-Arts de Belgique
cat. 81

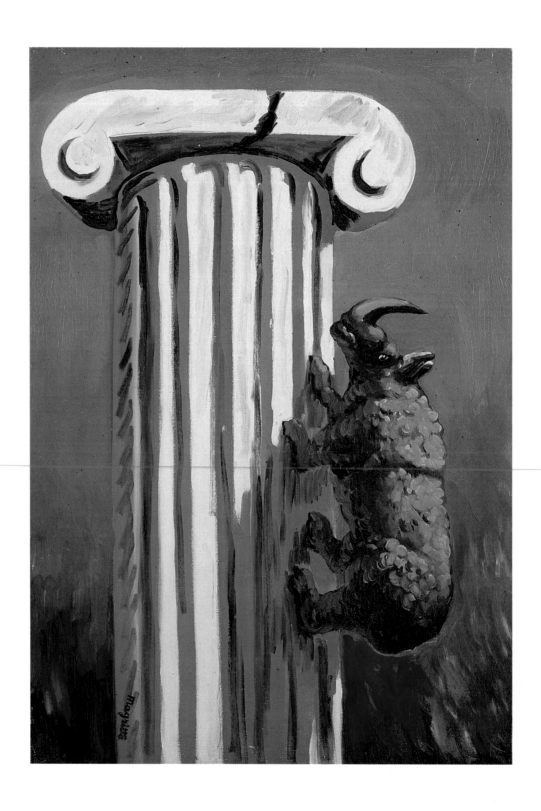

René Magritte
The Mountaineer, 1948
oil on canvas, 73x50 cm
Antwerp
Ronny Van de Velde
cat. 82

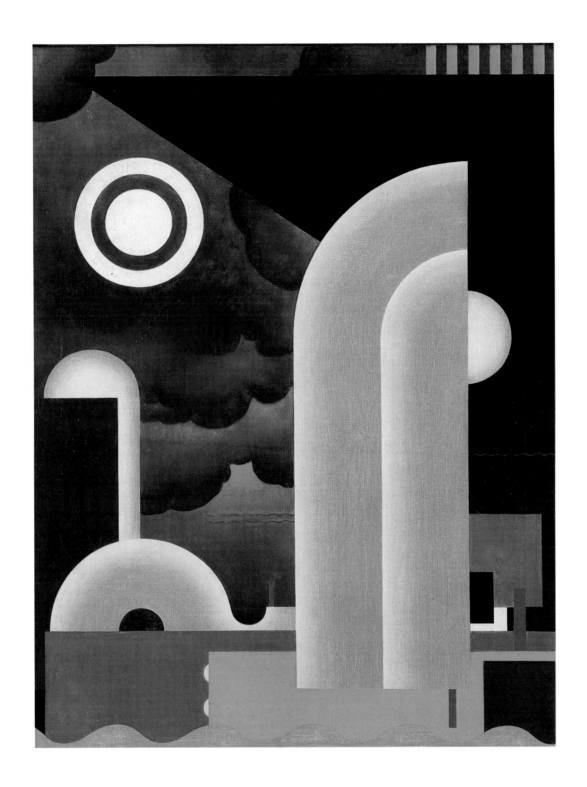

Victor Servranckx
Opus 2, Port, 1926
oil on canvas, 67x92,5 cm
Ghent, Museum
van Hedendaagse Kunst
cat. 83

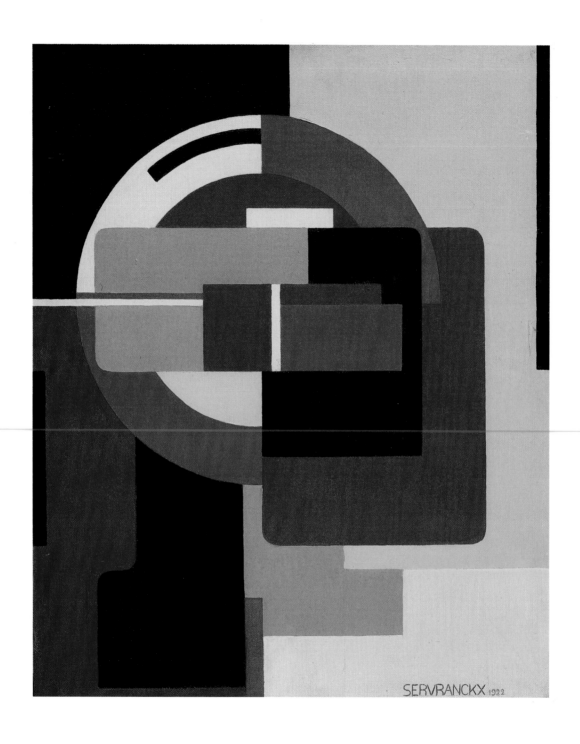

Victor Servranckx
Red Rotative, 1922
oil on canvas, 72,5x57,5 cm
Paris, Musée National d'Art Moderne
Centre Georges Pompidou
cat. 84

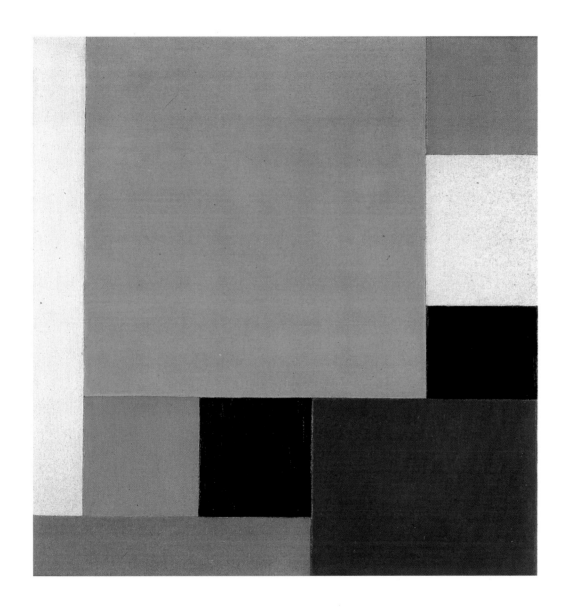

Theo van Doesburg
Composition XXII, 1920
oil on canvas, 50x50 cm
Eindhoven, Stedelijk
Van Abbemuseum
cat. 85

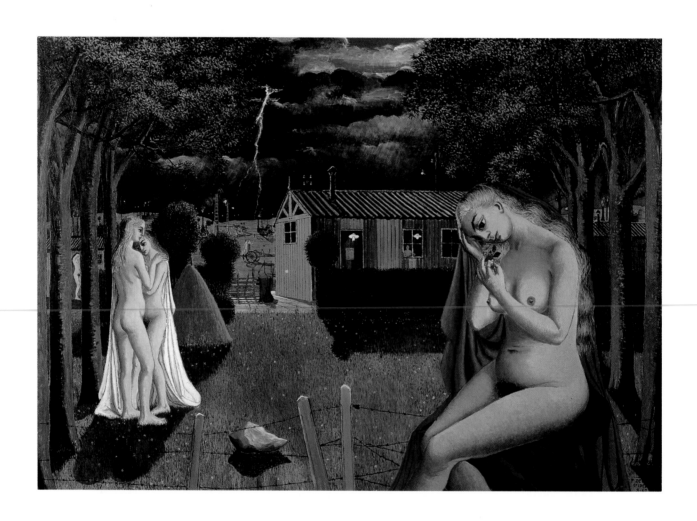

Paul Delvaux
The Storm, 1962
oil on canvas, 108x150 cm
Kruishoutem
Fondation Veranneman
cat. 86

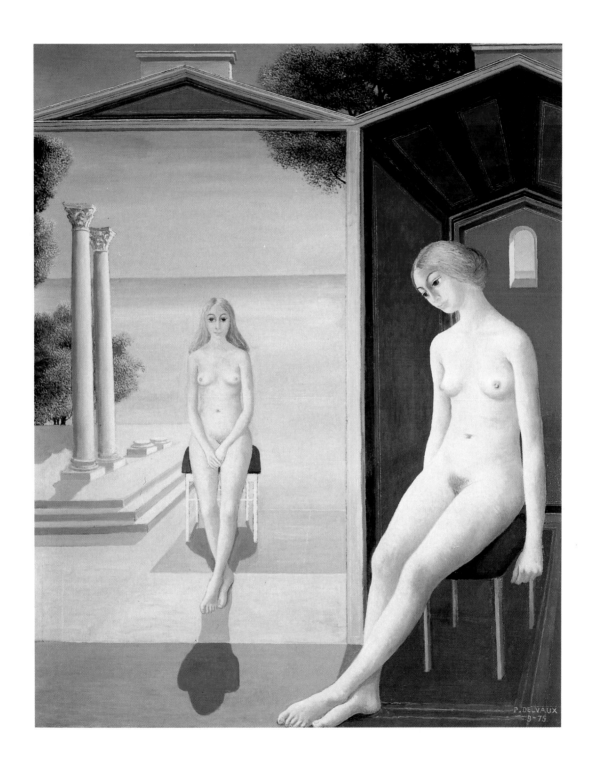

Paul Delvaux
Au bord de la mer (At the Seaside)
1975
oil on canvas, 150x120 cm
Liège, private collection
cat. 87

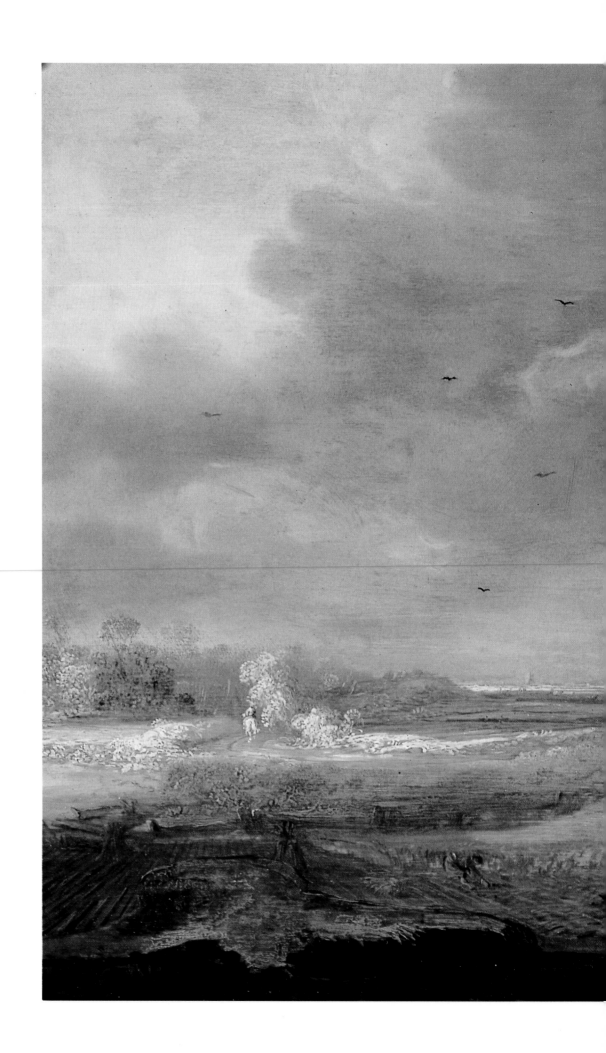

Jacob van Ruysdael
Cornfield, 1660 circa
oil on canvas, 61x71 cm
Rotterdam, Museum
Boijmans Van Beuningen
cat. 88

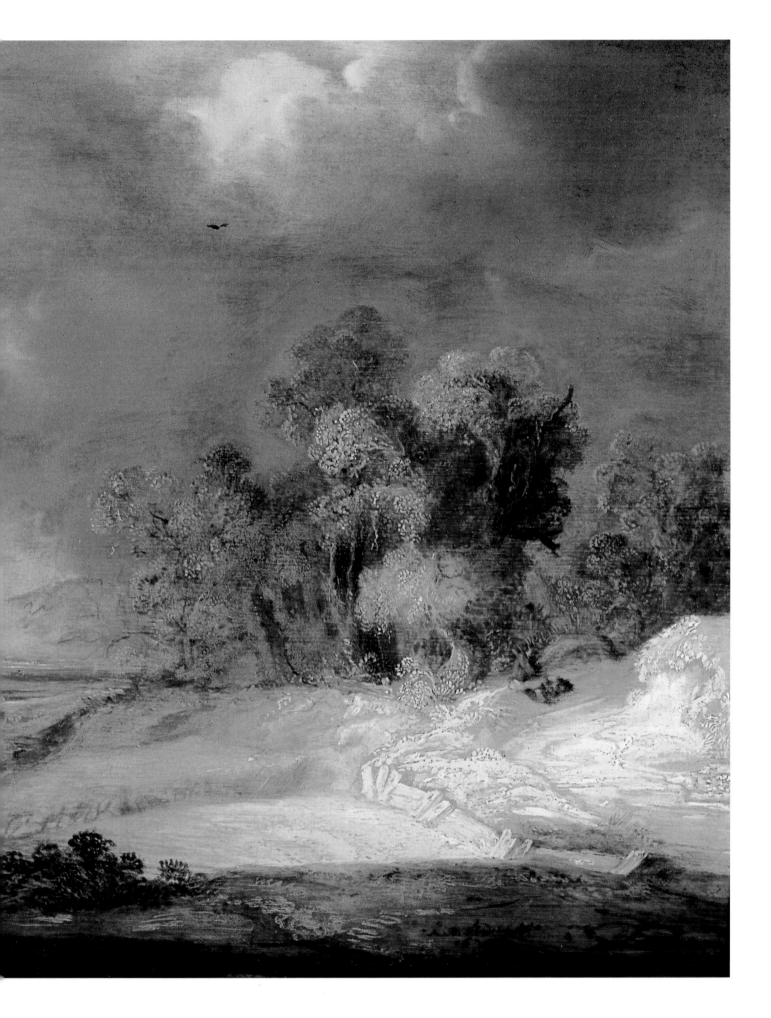

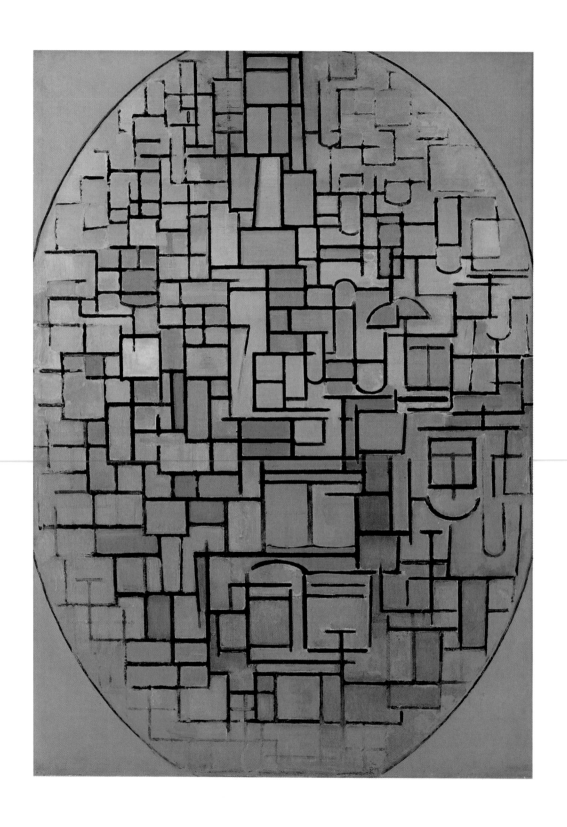

Piet Mondrian
Tableau III (Oval Composition)
1914
oil on canvas, 140x101 cm
Amsterdam, Stedelijk Museum
cat. 89

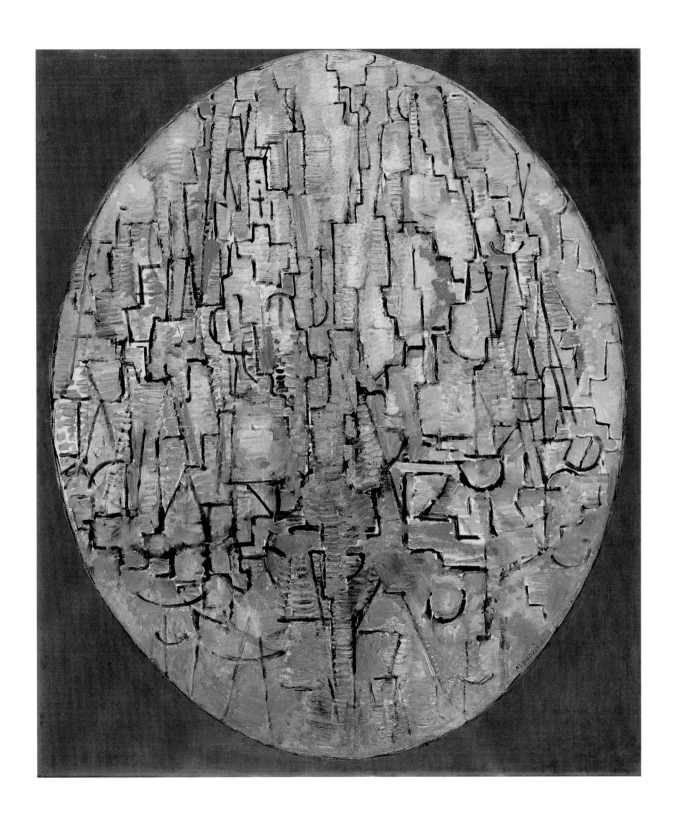

Piet Mondrian
Tableau No. 3 (Oval Compostion)
(Trees), 1913
oil on canvas, 94x78 cm
Amsterdam, Stedelijk Museum
cat. 90

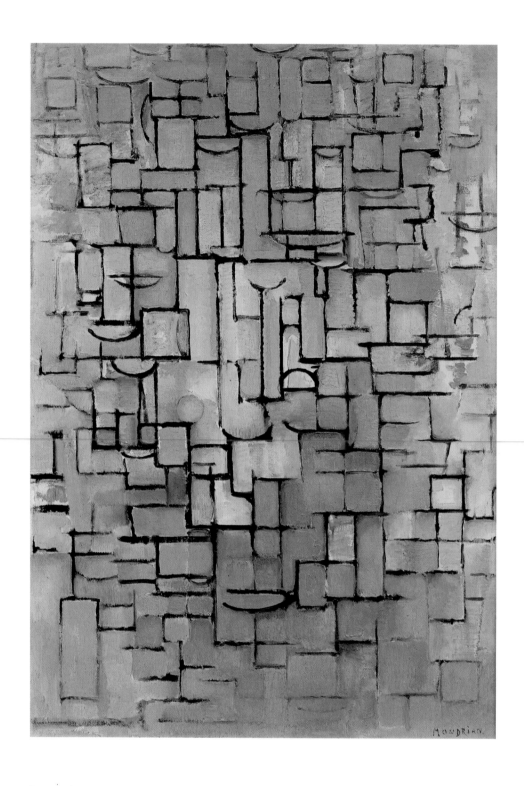

Piet Mondrian
Composition No. XIV, 1913
oil on canvas
93x64,5 cm
Eindhoven, Stedelijk
Van Abbemuseum
cat. 91

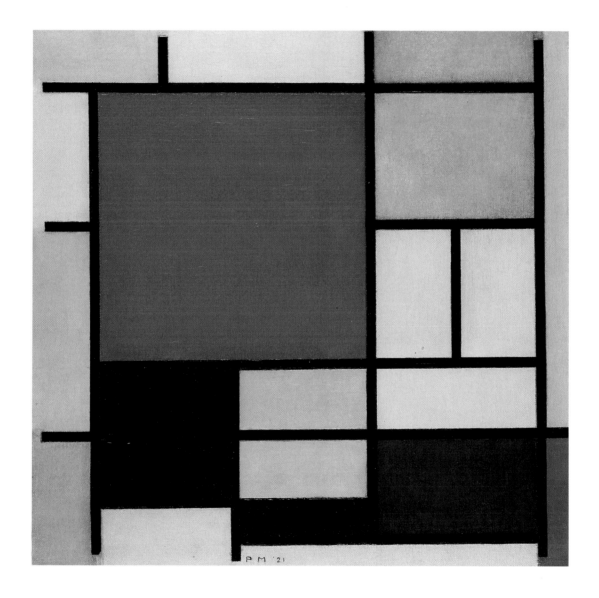

Piet Mondrian
*Composition with Red, Yellow
Blue and Black*, 1921
oil on canvas, 59,5x59,5 cm
The Hague
The Haags Gemeentemuseum
cat. 92

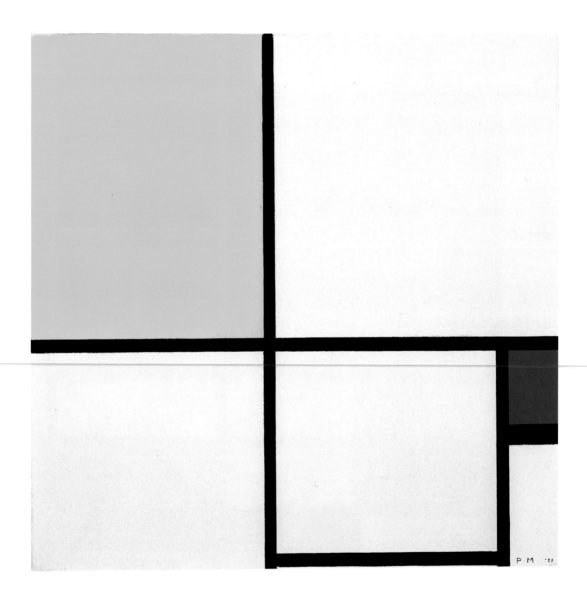

Piet Mondrian
Composition with Yellow and Blue
1929
oil on canvas, 52x52 cm
Rotterdam
Museum Boijmans Van Beuningen
cat. 93

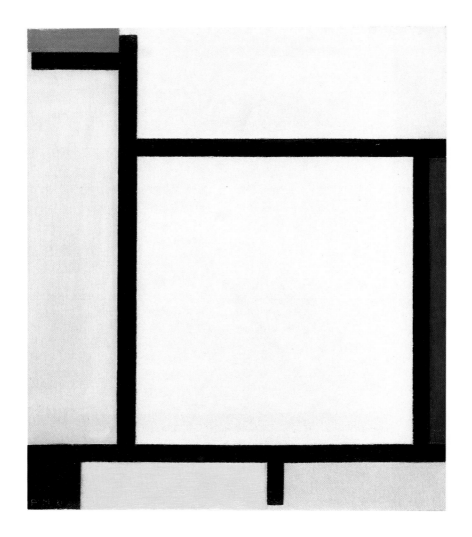

Piet Mondrian
*Composition with Red, Yellow
and Blue*, 1921
oil on canvas, 39,5x35 cm
The Hague
The Haags Gemeentemuseum
cat. 94

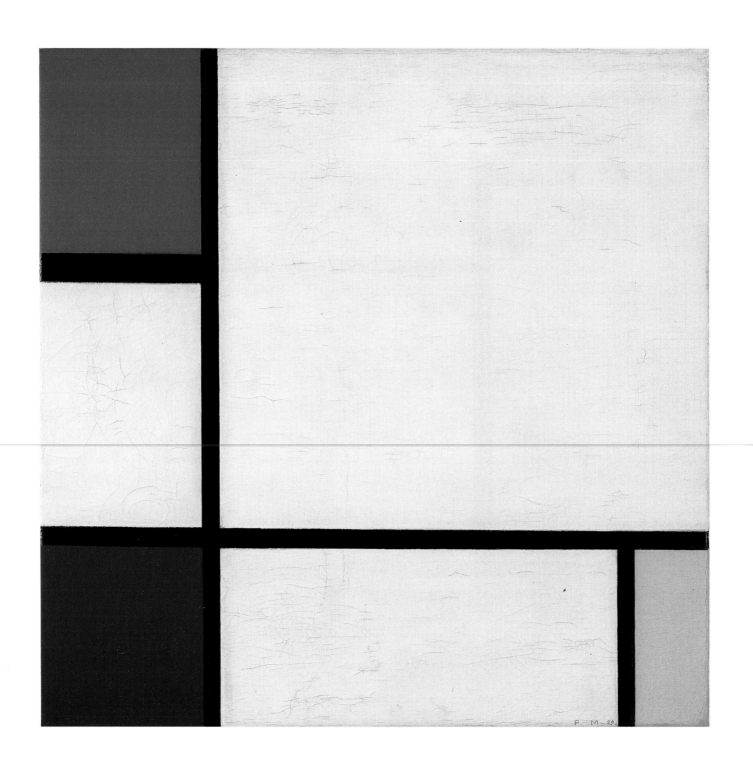

Piet Mondrian
*Composition I with Red, Yellow
and Blue*, 1921
oil on canvas, 103x100 cm
The Hague
The Haags Gemeentemuseum
cat. 95

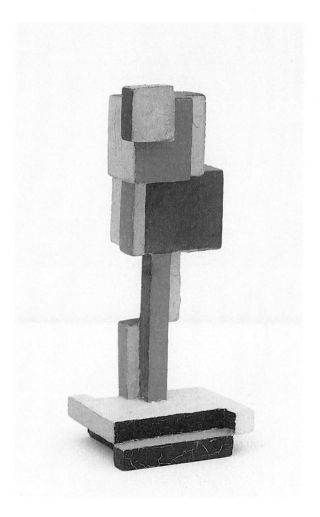

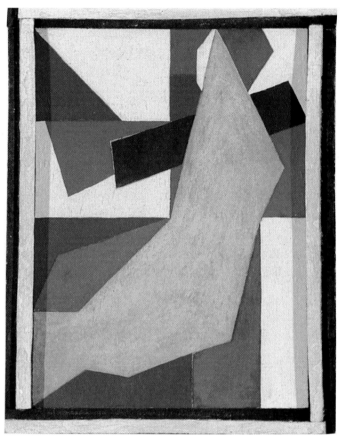

Georges Vantongerloo
Composition from the Ovoid, 1917
mahogany painted in 3 colours
16,6x6,5x6 cm
Zumikon, Angela Thomas Bill
Collection
cat. 96

Georges Vantongerloo
Study, 1918
oil on panel, 28,2x22 cm
Zumikon
Angela Thomas Bill Collection
cat. 97

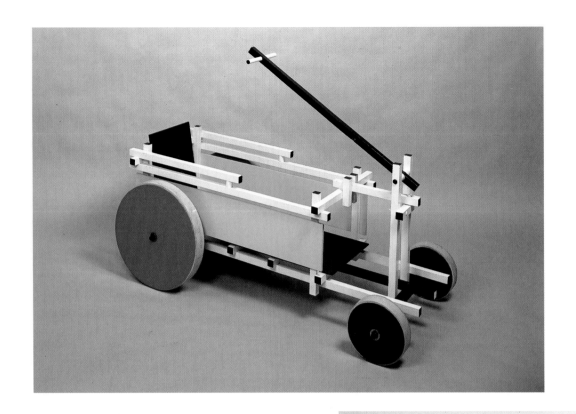

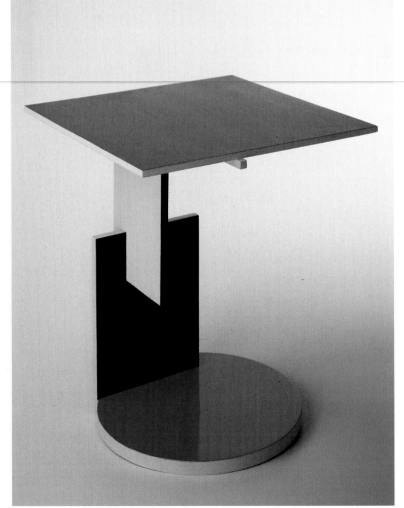

Gerrit Rietveld
Cart, 1918
painted, screwed, glued wood
58,5x63x119 cm
Amsterdam, Stedelijk Museum
cat. 98

Gerrit Rietveld
*Small Low Table, from the 'Military'
Series*, 1923
painted wood, 61,5x49x49 cm
Amsterdam, Stedelijk Museum
cat. 99

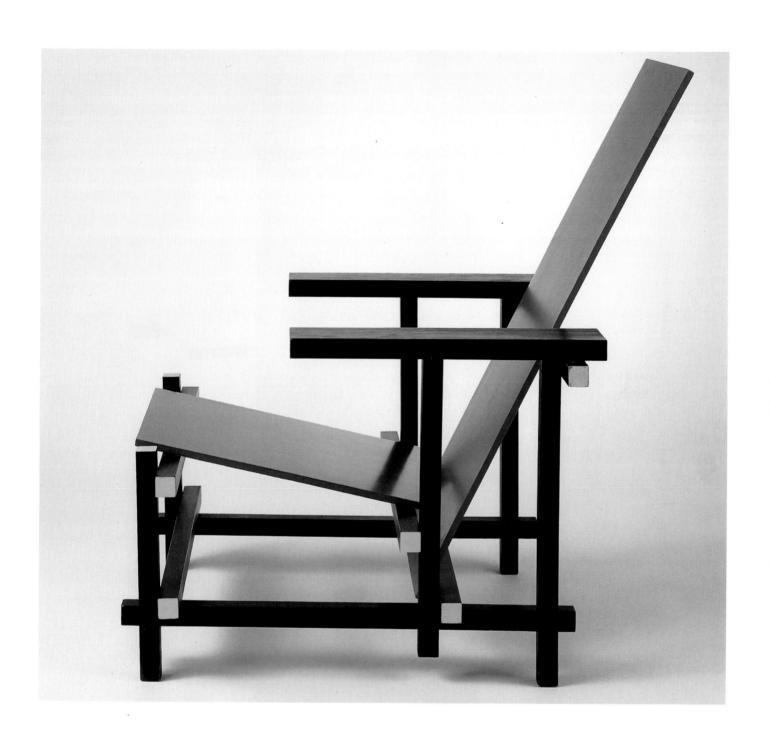

Gerrit Rietveld
Low Armchair, 1918
wood, construction pegged
and screwed, 86x64x68 cm
h. 32,5 cm
Amsterdam, Stedelijk Museum
cat. 100

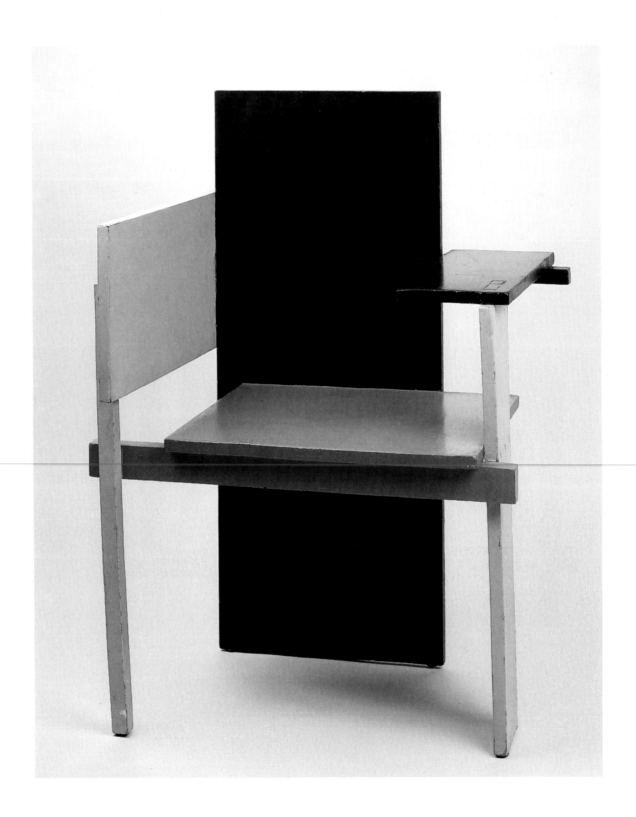

Gerrit Rietveld
Armchair (Berlin Chair), 1923
painted wood, 105x70x55 cm
Amsterdam
Stedelijk Museum
cat. 101

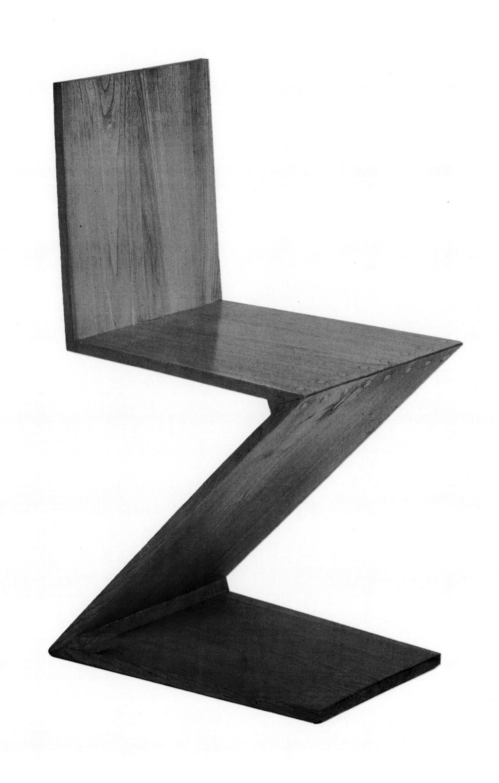

Gerrit Rietveld
Chair, 1934
painted wood, 78x38x38 cm
Amsterdam
Stedelijk Museum
cat. 102

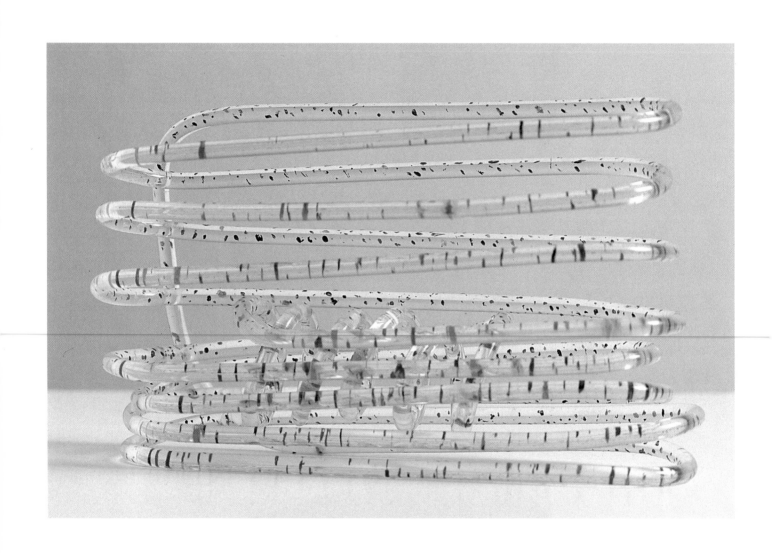

Georges Vantongerloo
Space Segment, 1953
transparent plastic with colours,
22x13x8 cm
Zumikon, Angela Thomas Bill
Collection
cat. 103

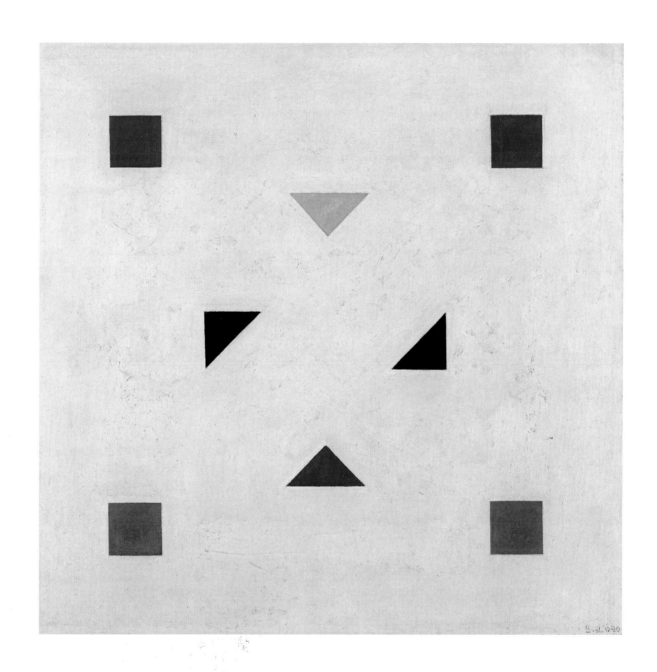

Bart van der Leck
Composition
1918-20
oil on canvas, 101x100 cm
Amsterdam
Stedelijk Museum
cat. 104

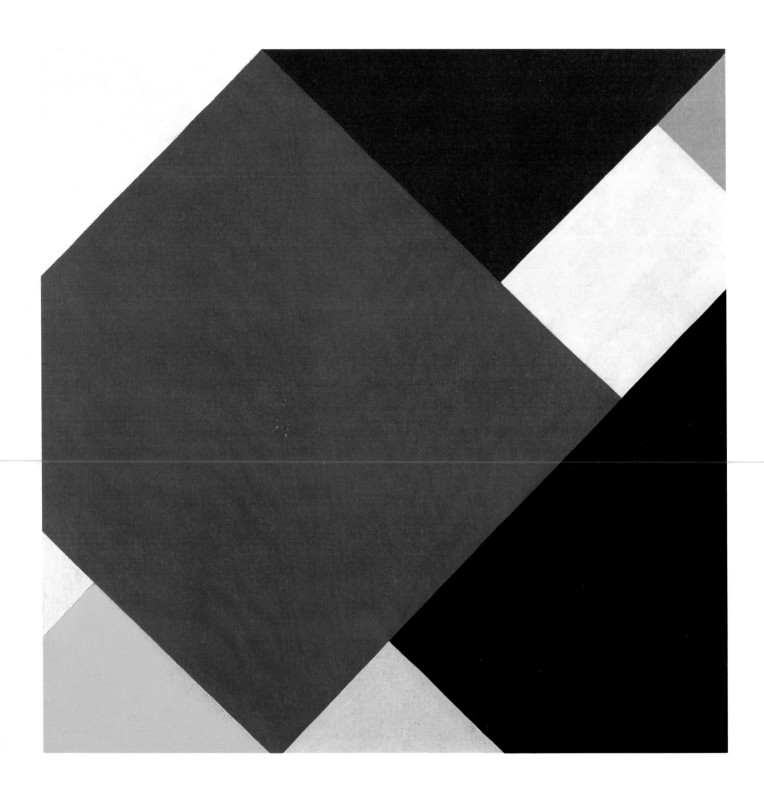

Theo van Doesburg
Contra-composition V
1924
oil on canvas, 100x100 cm
Amsterdam, Stedelijk Museum
cat. 105

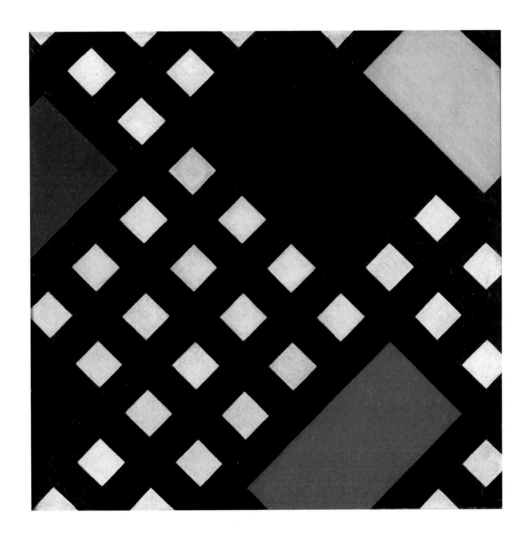

Theo van Doesburg
Contra-composition XV
1925
oil on canvas, 50x50 cm
Łodz, Muzeum Sztuki
cat. 106

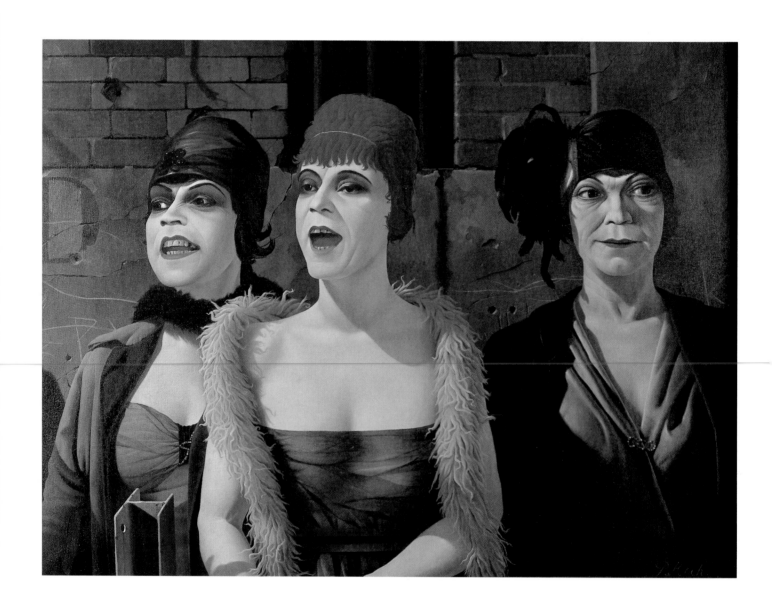

Pyke Koch
Women in a Street, 1962-64
oil on canvas, 114,5x150 cm
(with frame)
The Hague, The Netherlands
Office for Fine Arts
(Rijksdienst Beeldende Kunst)
on loan to the Arnhem Museum
of Modern Art
cat. 107

Pyke Koch
The Big Contorsionist
(*Cirque Parade*)
1957
oil on canvas, 168,5x120 cm
Amsterdam
Stedelijk Museum
cat. 108

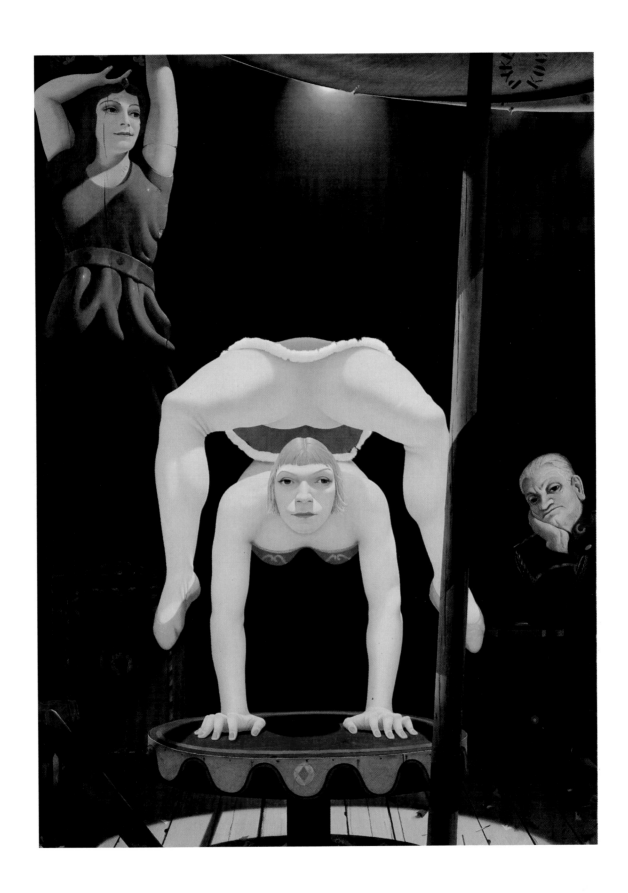

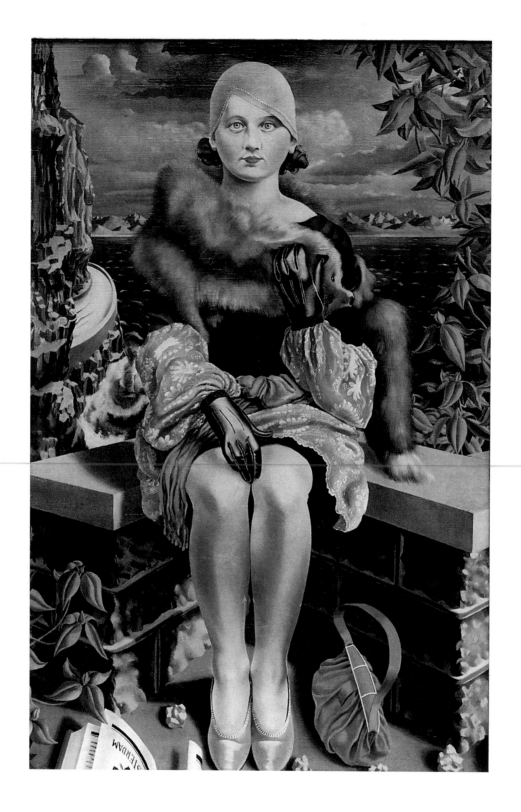

Carel Willink
Portrait of Miesje, 1928
oil on canvas, 133,8x85,5 cm
Leeuwarden
Keramiekmuseum het Princessehof
cat. 109

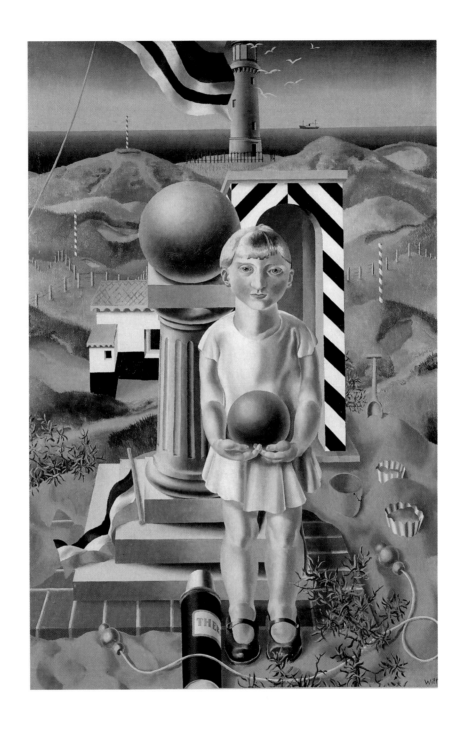

Carel Willink
Girl with a Ball, 1925
oil on canvas, 135x91 cm
Arnhem
Museum of Modern Art
cat. 110

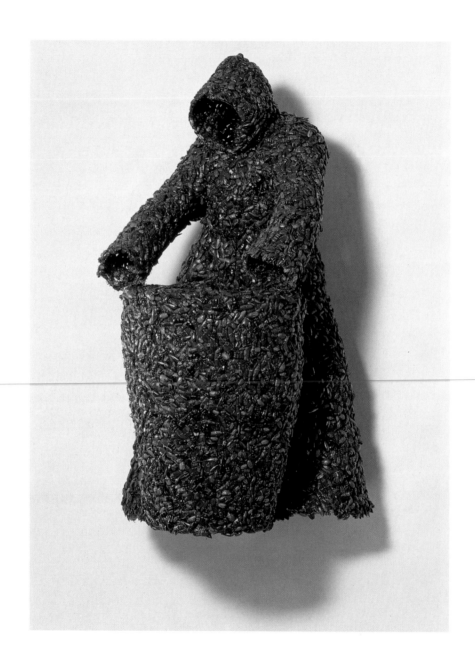

Jan Fabre
The Bee-keeper
1994
jewel beetles on iron wire gauze
145x84x88 cm circa
Amsterdam
Stedelijk Museum
cat. 111

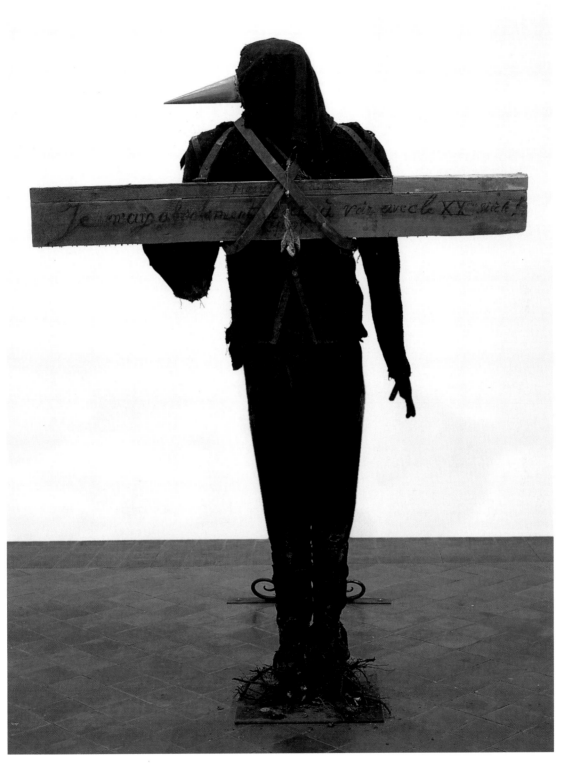

Thierry de Cordier
Je n'ai rien à voir avec le XXème siècle
(I have nothing to do with the 20th
century), Schorisse, 1988-89
mixed media, 230x170x40 cm
Ghent, Vereniging voor het Museum
van Hedendaagse Kunst
cat. 112

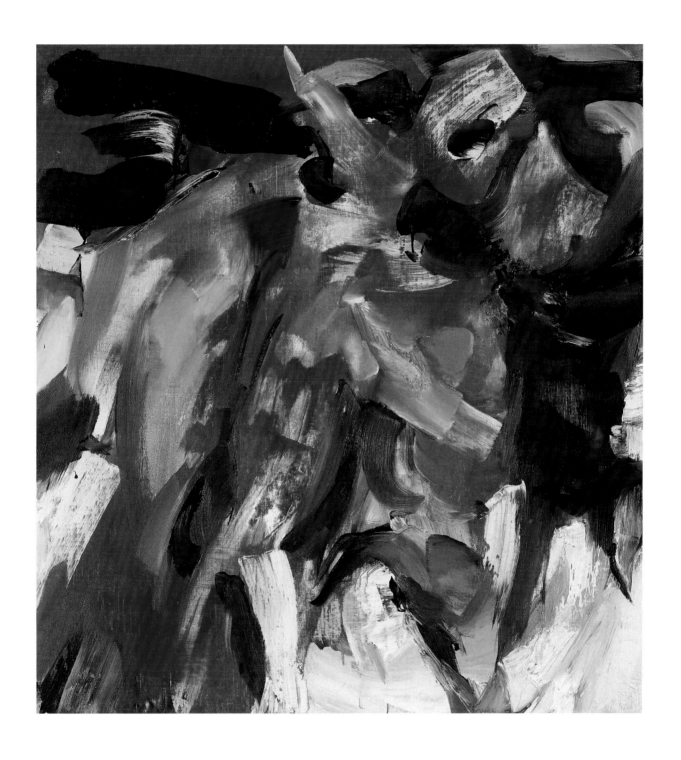

Englebert van Anderlecht
Composition No 3, 1959
oil on canvas, 168x155 cm
private collection
cat. 113

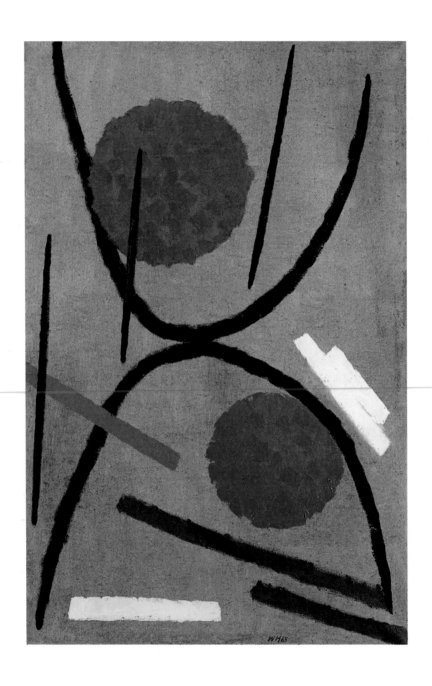

Willem Hussem
Untitled, 1962-65
oil on canvas, 195x125 cm
Amsterdam, Stedelijk Museum
cat. 114

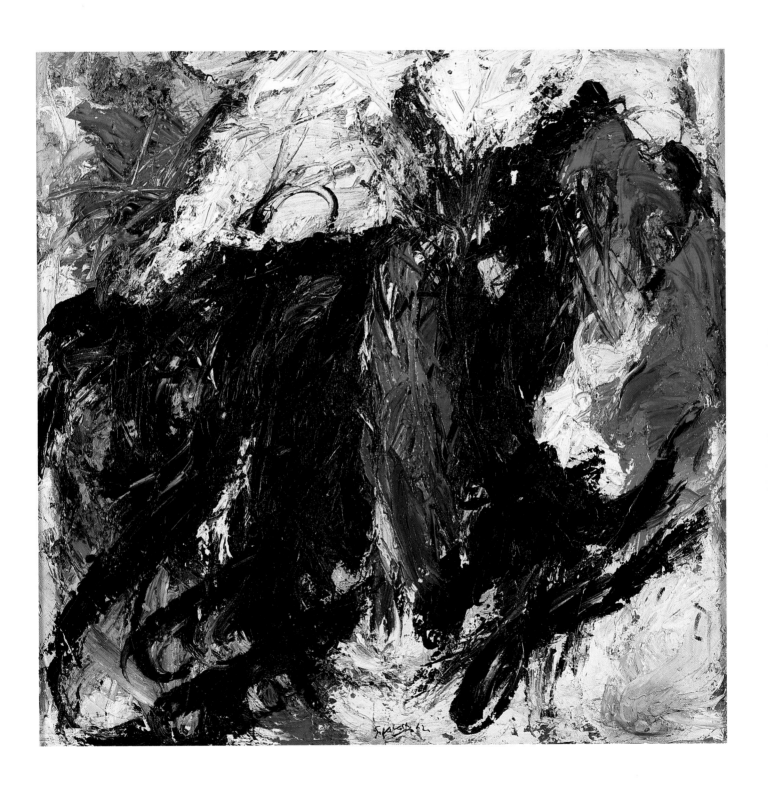

Ger Lataster
Spain, 1962
oil on canvas, 200x200 cm
Amsterdam, Stedelijk Museum
cat. 115

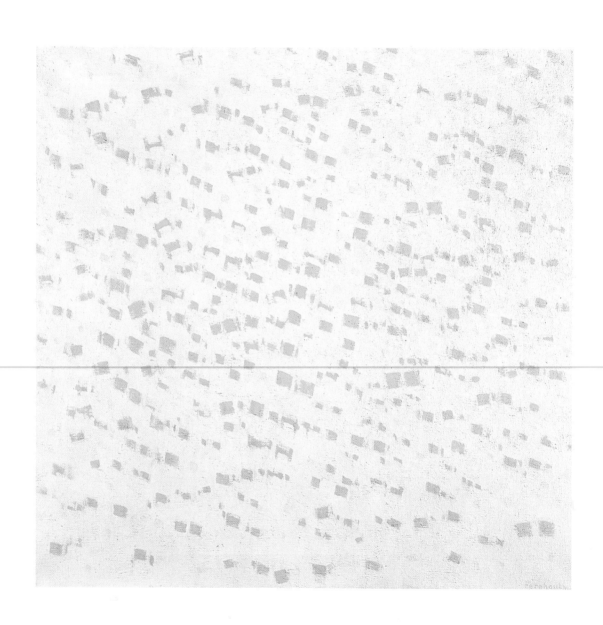

Edgar Fernhout
In Autumn, 1971
oil on canvas, 96,5x97,5 cm
(with frame)
Eindhoven, Stedelijk Van Abbemuseum
cat. 116

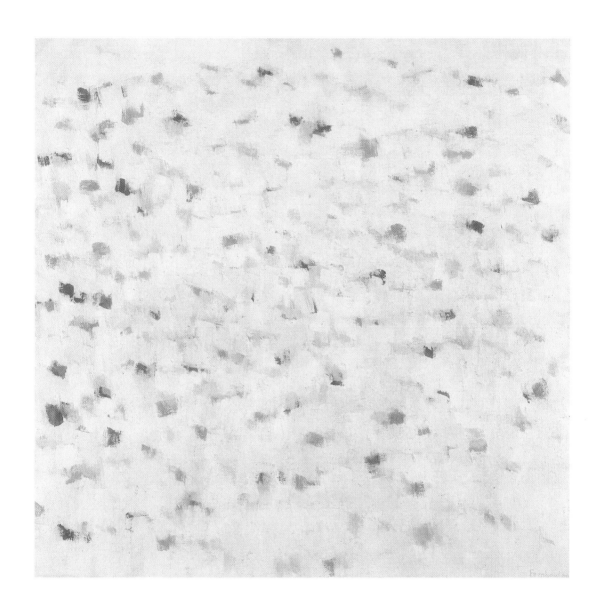

Edgar Fernhout
By the Sea, 1969
oil on canvas, 100x100 cm
Amsterdam
private collection
cat. 117

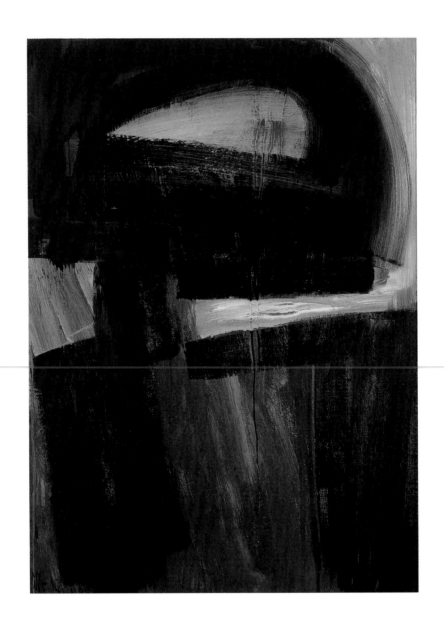

Antoine Mortier
Reminiscence
1961
oil on canvas, 162x114 cm
Waregem, private collection
cat. 118

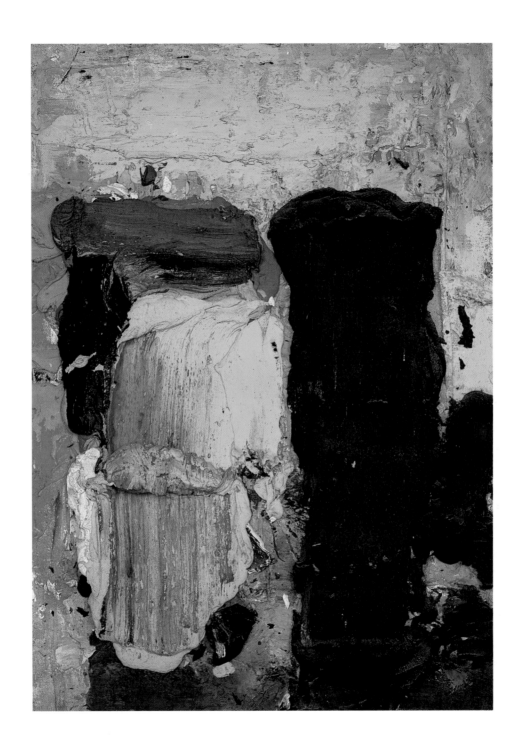

Bram Bogart
Urge, 1963
plaster and pigment on panel
174x122x10 cm
private collection
cat. 119

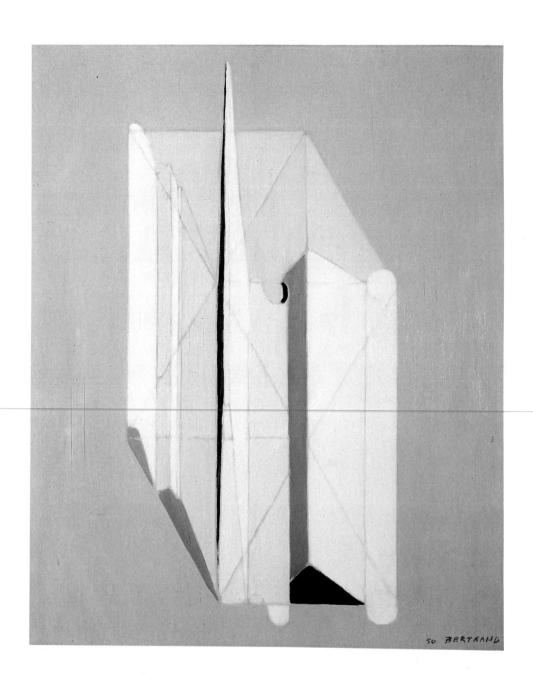

Gaston Bertrand
Cathedral, 1950
oil on canvas, 81x65 cm
Ghent, Museum
van Hedendaagse Kunst
cat. 120

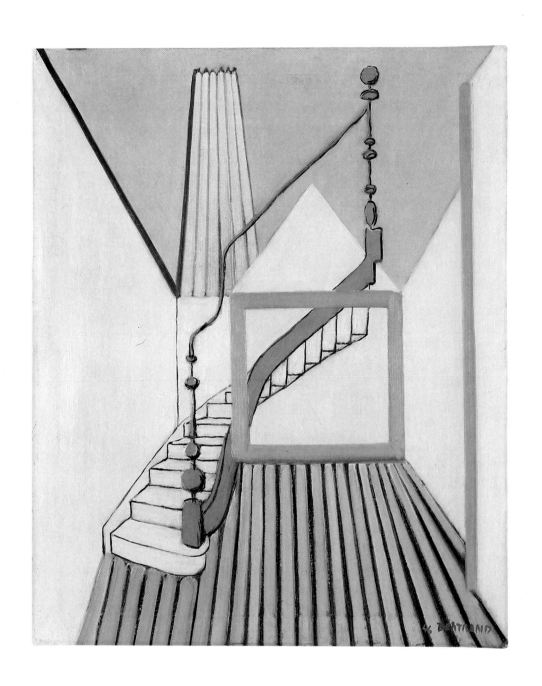

Gaston Bertrand
Composition, 1946
oil on canvas, 81x65 cm
Ghent, Museum
van Hedendaagse Kunst
cat. 121

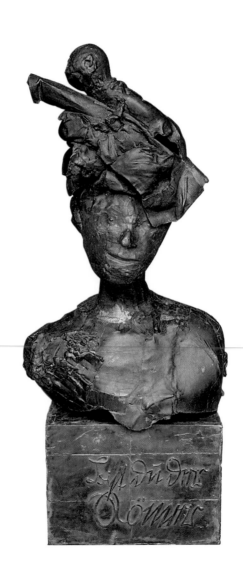

Roel D'Haese
Bist du der Römer?, 1989
bronze, 70x40x40 cm
Ghent, Museum
van Hedendaagse Kunst
cat. 122

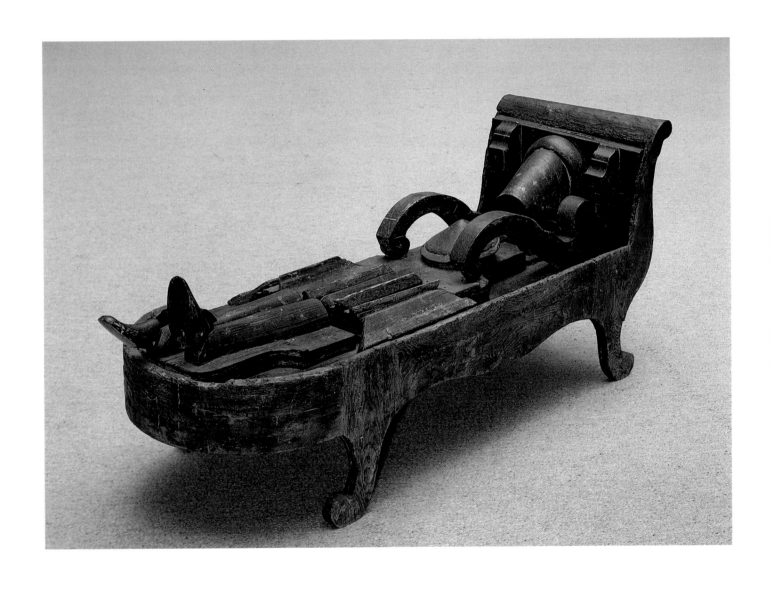

Vic Gentils
Hommage à Permeke, 1964
mixed media, 75x1,75x61 cm
Brussels, Ministerie
van de Vlaamse Gemeenschap
cat. 123

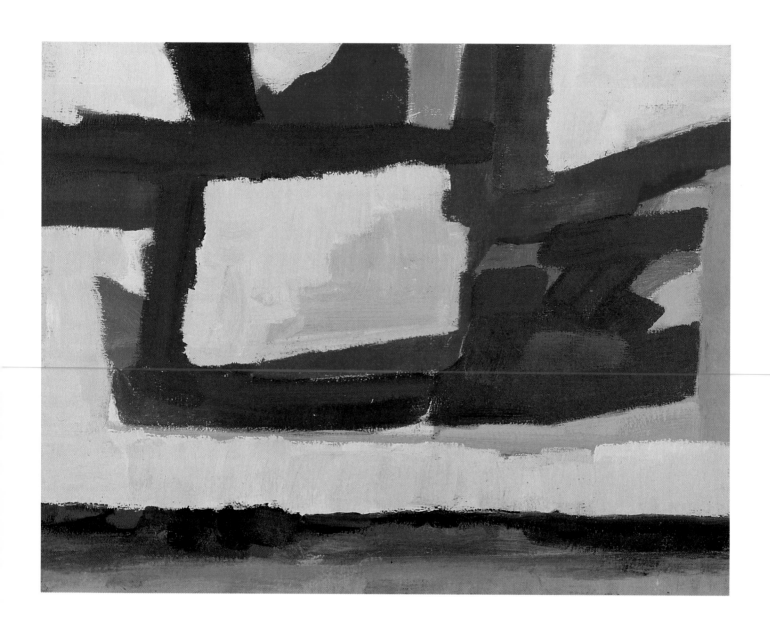

Gerrit Benner
Frisian Landscape, 1970
oil on canvas, 80x100x1,5 cm
Groningen, Groninger Museum
cat. 124

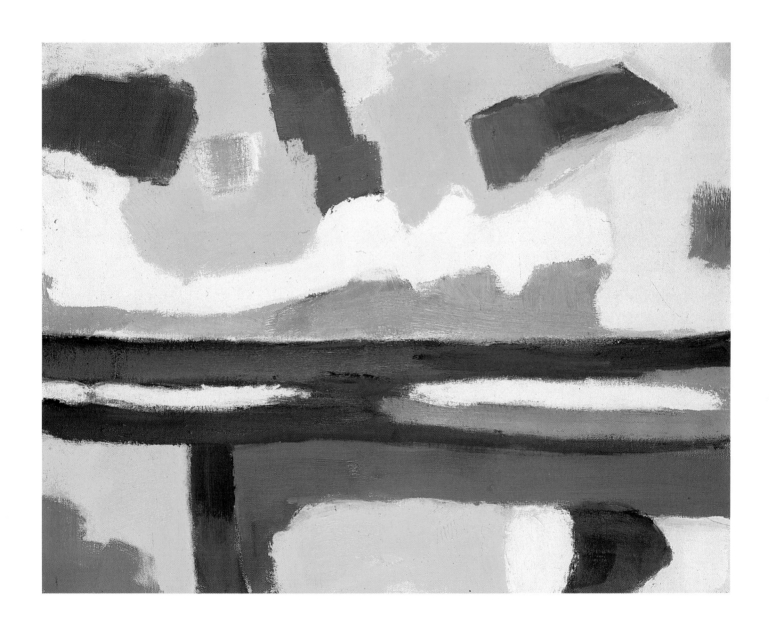

Gerrit Benner
Spring, 1971
oil on canvas, 80x99,5 cm
Amsterdam, Stedelijk Museum
cat. 125

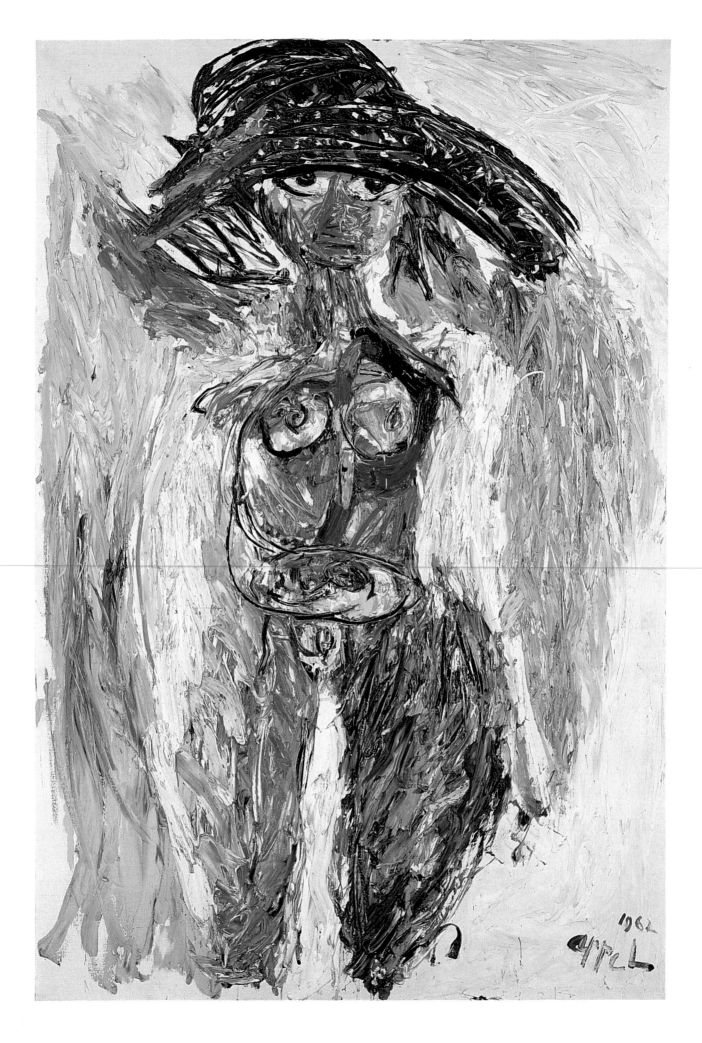

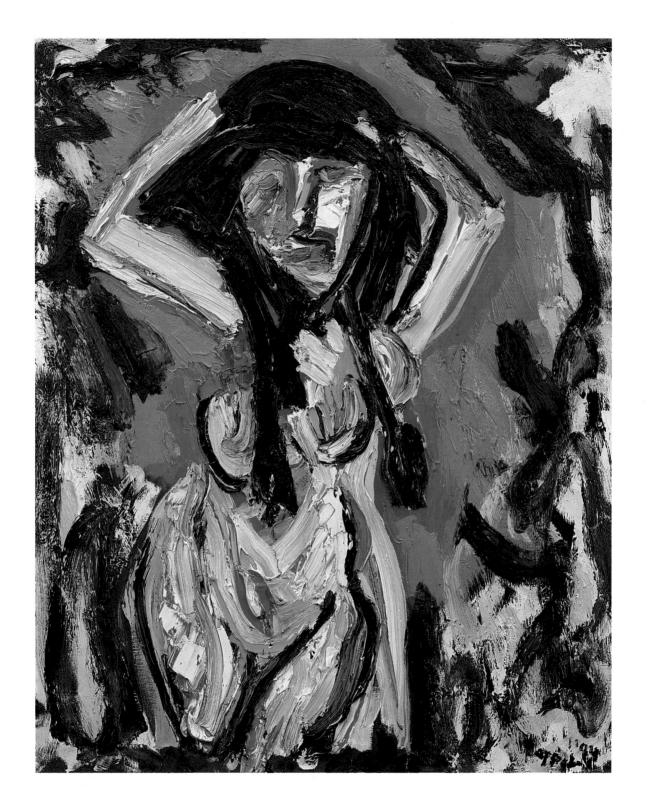

Karel Appel
Machteld, 1962
oil on canvas, 195x130 cm
Amsterdam, Stedelijk Museum
on loan from the artist
cat. 126

Karel Appel
Nude No. 1, 1994
oil on canvas, 153x122 cm
(with frame)
Amsterdam, Stedelijk Museum
cat. 127

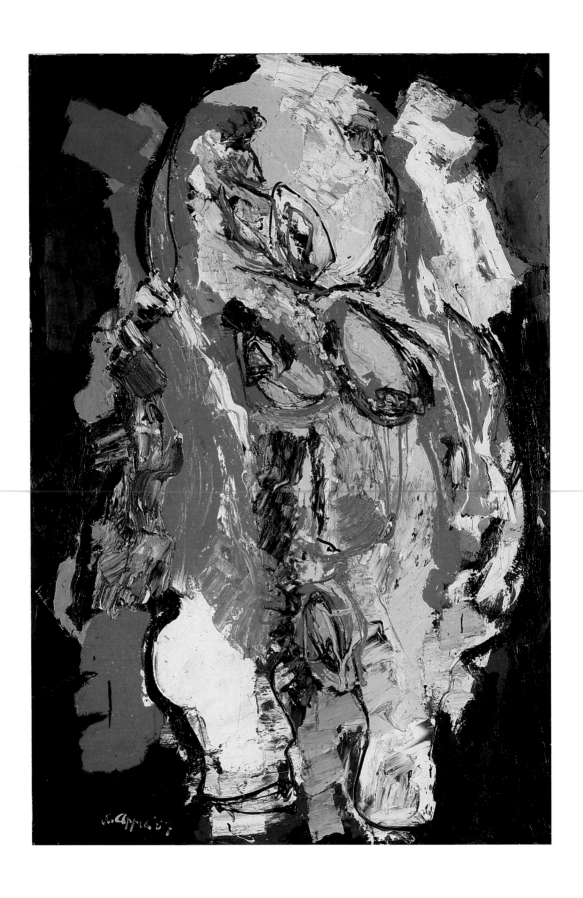

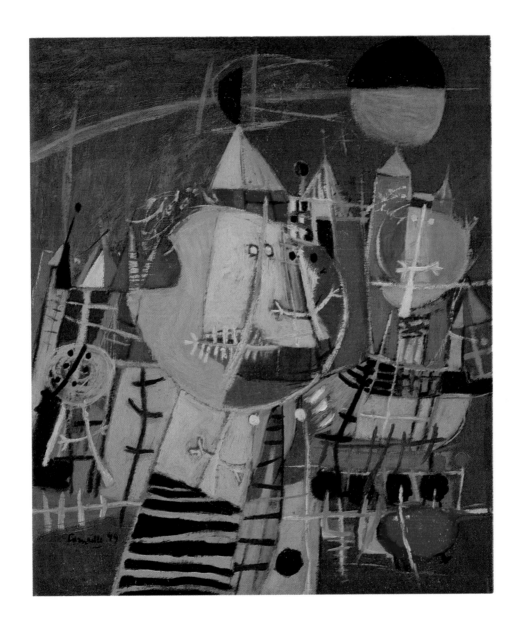

Karel Appel
Savage Nude, 1957
oil on canvas, 195x130 cm
Ghent, Museum
van Hedendaagse Kunst
cat. 128

Corneille
The Gay Rythm of the City
1949
oil on canvas, 58,5x49 cm
Amsterdam, Stedelijk Museum
cat. 129

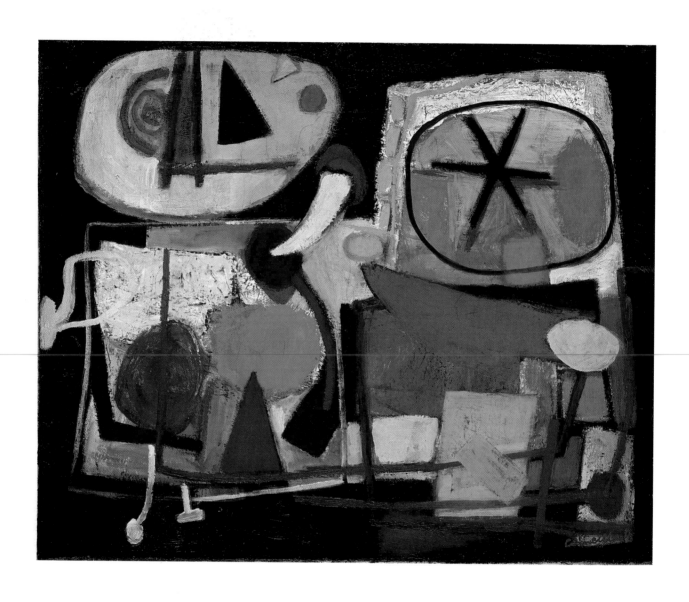

Corneille
Man looking for Mushrooms
1950
oil on canvas, 50x60 cm
Amsterdam, Stedelijk Museum
cat. 130

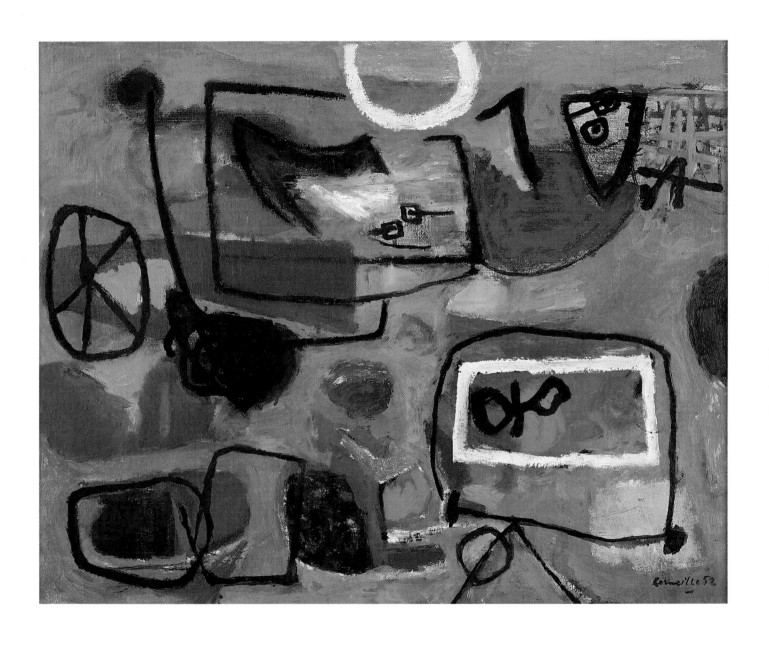

Corneille
Summer-day, 1952
oil on canvas, 60x73 cm
Amsterdam
Stedelijk Museum
cat. 131

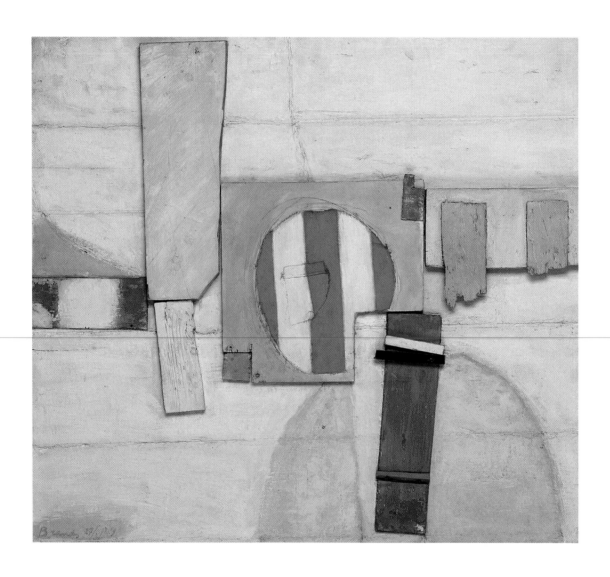

Eugène Brands
Summer, 1949
oil on canvas, wood, 76x83 cm
Amsterdam, Stedelijk Museum
cat. 132

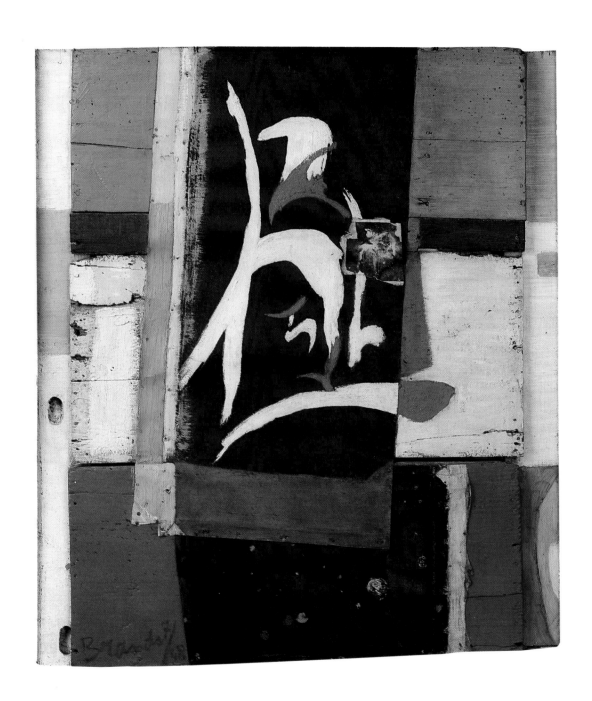

Eugène Brands
Sign in Orion, 1948
oil on canvas, wood, paper, 80x68 cm
Amsterdam, Stedelijk Museum
cat. 133

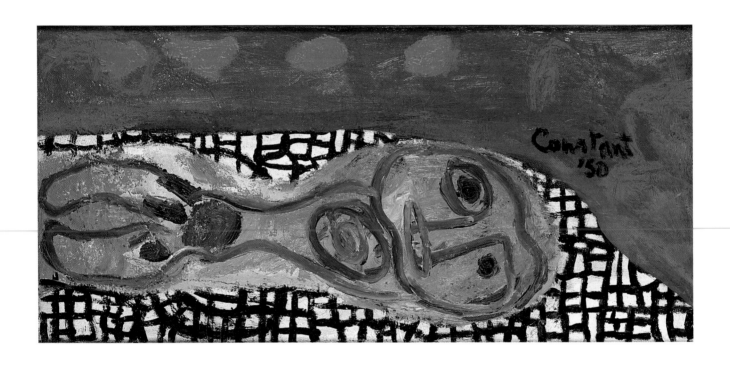

Constant
Reclining Figure, 1950
oil on canvas, 45x95 cm
Amsterdam
Stedelijk Museum
cat. 134

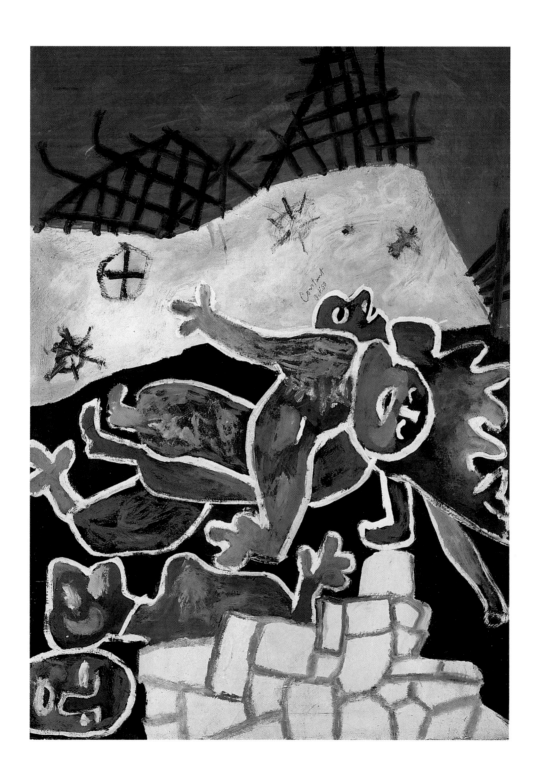

Constant
War, 1950
oil on canvas, 101x70 cm
Amsterdam
Stedelijk Museum
cat. 135

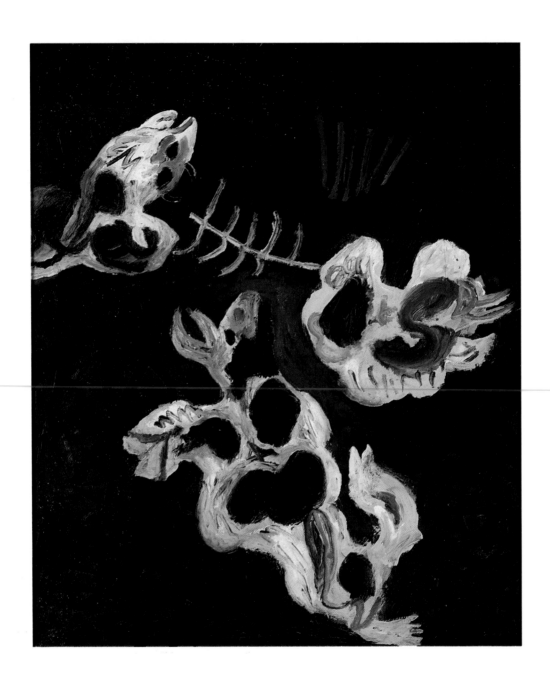

Constant
Corrida, 1951
oil on canvas, 81x64 cm
Amsterdam
Stedelijk Museum
cat. 136

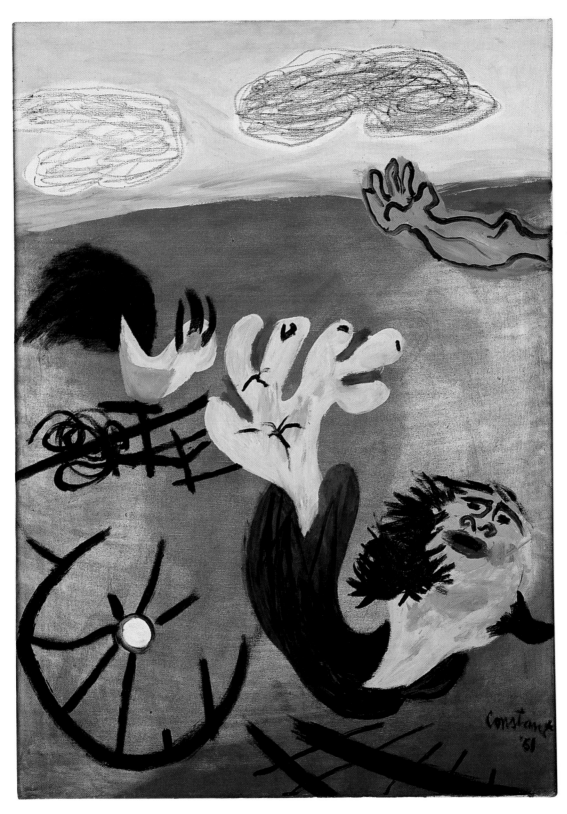

Constant
Scorched Earth II, 1951
oil on canvas, black chalk
100x70 cm
Amsterdam, Stedelijk Museum
cat. 137

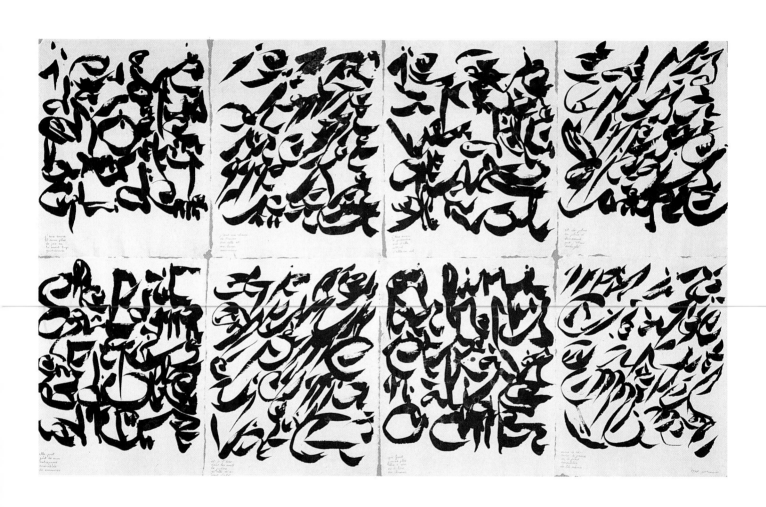

Christian Dotremont
Logograms, 1978
ink on paper
127x200 cm
Brussels, Musée d'Ixelles
cat. 138

242

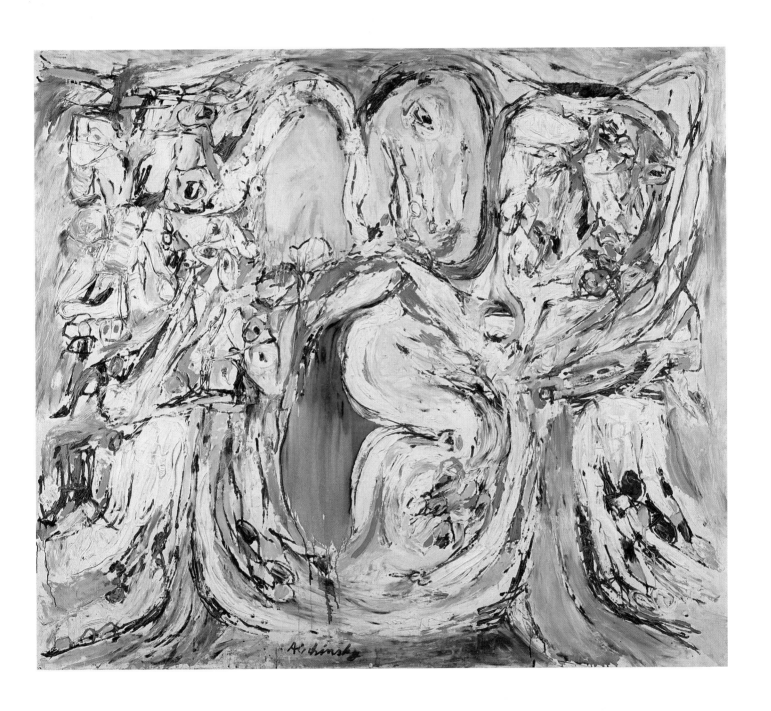

Pierre Alechinsky
Growing Grass, 1960
oil on canvas, 184x205 cm
Brussels, Musées royaux
des Beaux-Arts de Belgique
cat. 139

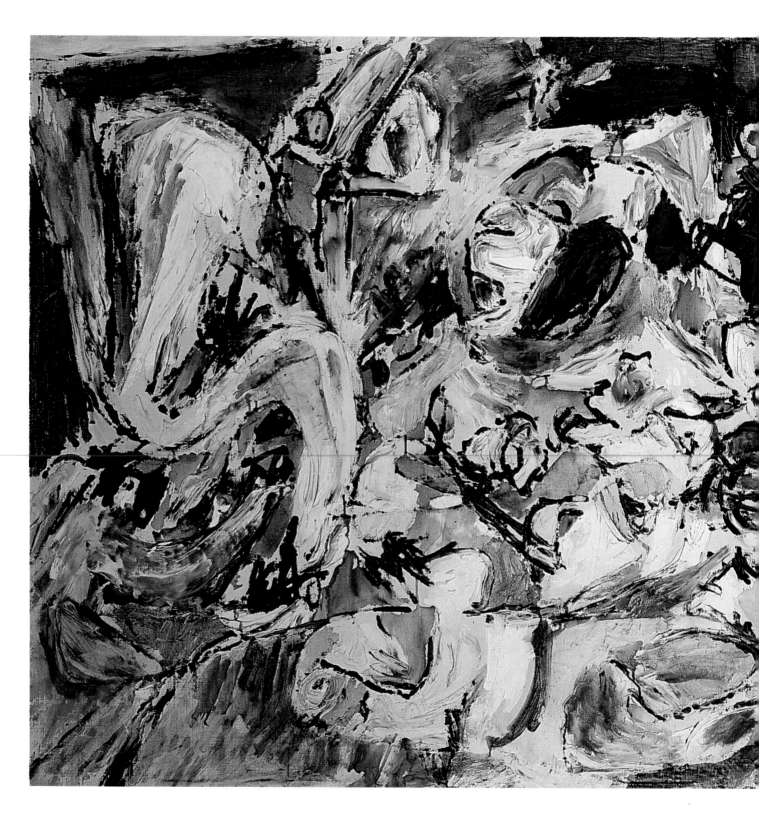

Pierre Alechinsky
Recently, 1958
oil on canvas, 99x195,5 cm
Amsterdam, Stedelijk Museum
gift Paolo Marinotti
cat. 140

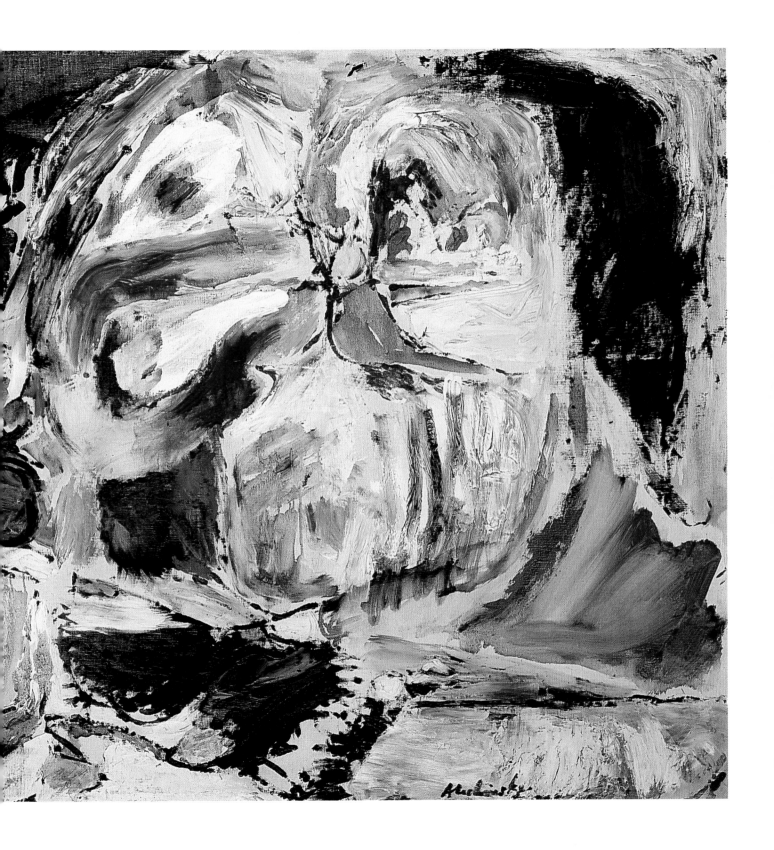

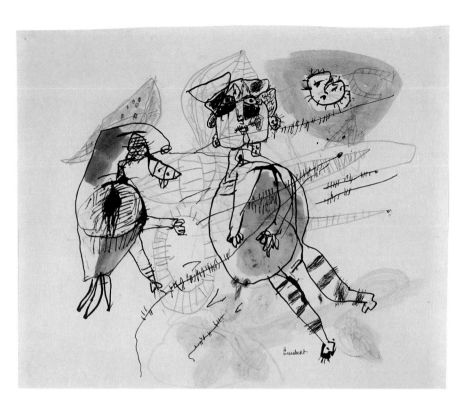

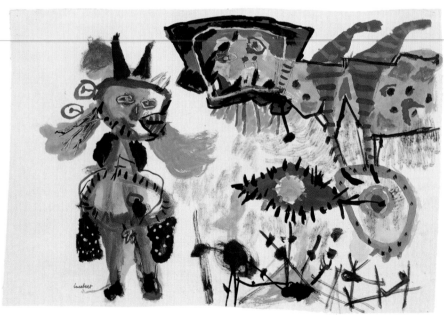

Lucebert
Farmer Floating in the Air, 1951-52
watercolour, Indian ink on paper
30,5x37 cm
Amsterdam, Stedelijk Museum
cat. 141

Lucebert
Burning Answer, 1951-52
gouache on paper
27x40 cm
Amsterdam, Stedelijk Museum
cat. 142

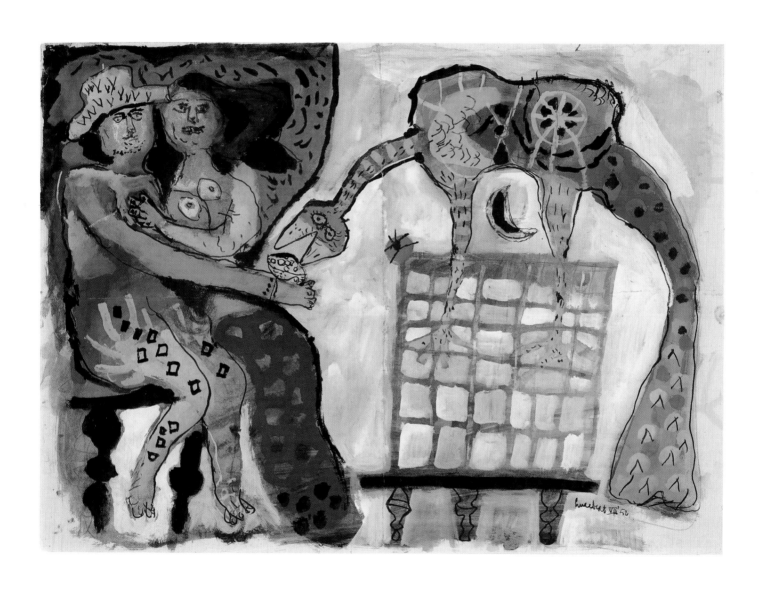

Lucebert
The Poet Feeds Poetry, 1952
watercolour, Indian ink on paper
42x56,5 cm
Amsterdam, Stedelijk Museum
cat. 143

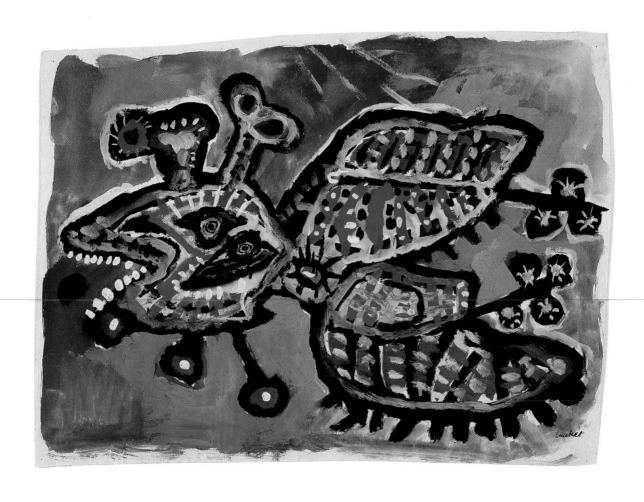

Lucebert
Easter Bird, 1951-52
gouache on paper
29x40 cm
Amsterdam, Stedelijk Museum
cat. 144

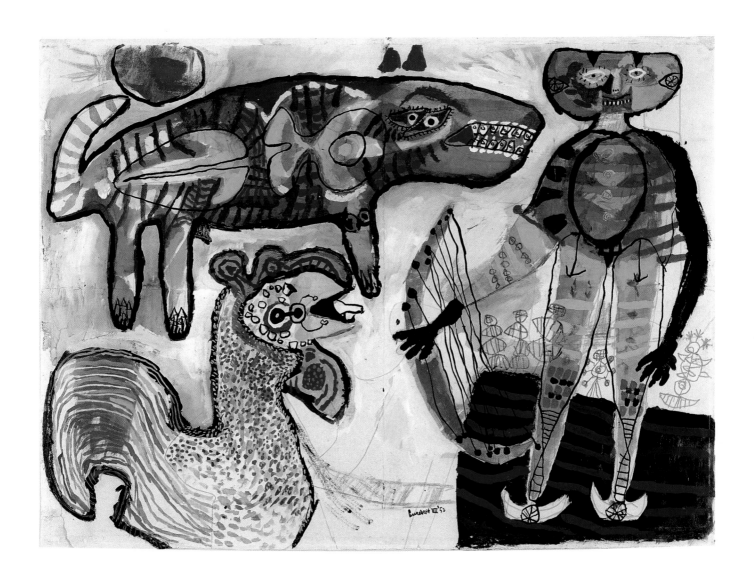

Lucebert
Orpheus and the Animals, 1952
gouache, coloured pencil on paper
42x56 cm
Amsterdam, Stedelijk Museum
cat. 145

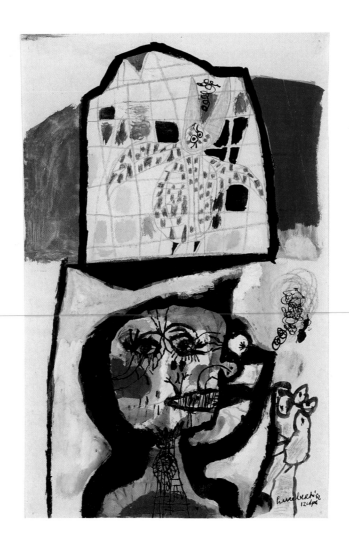

Lucebert
Yoker the Smoker with Yardbird, 1952
watercolour, crayon on paper
33,5x21,5 cm
Amsterdam, Stedelijk Museum
cat. 146

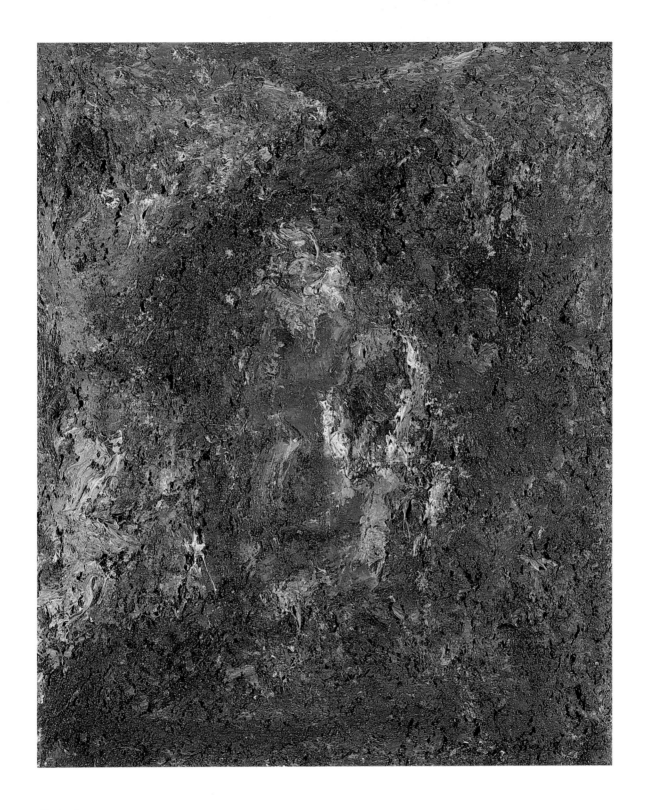

Eugène Leroy
Self-portrait, 1974-77
oil on canvas
81x65 cm
private collection
cat. 147

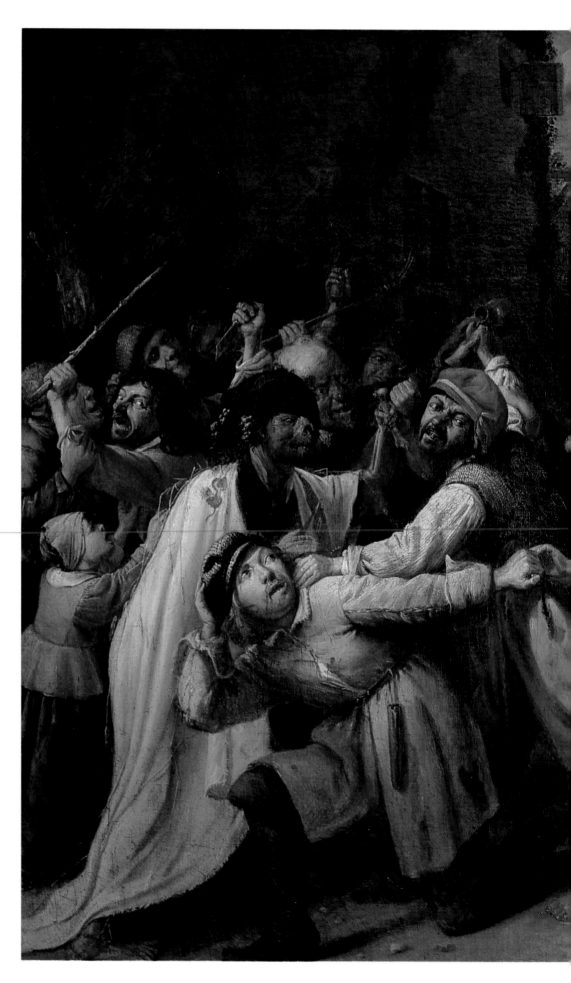

Joos van Craesbeeck
The Death is Fierce and Fast, undated
oil on panel, 73x103 cm
Antwerp, Koninklijk Museum
voor Schone Kunsten
cat. 148

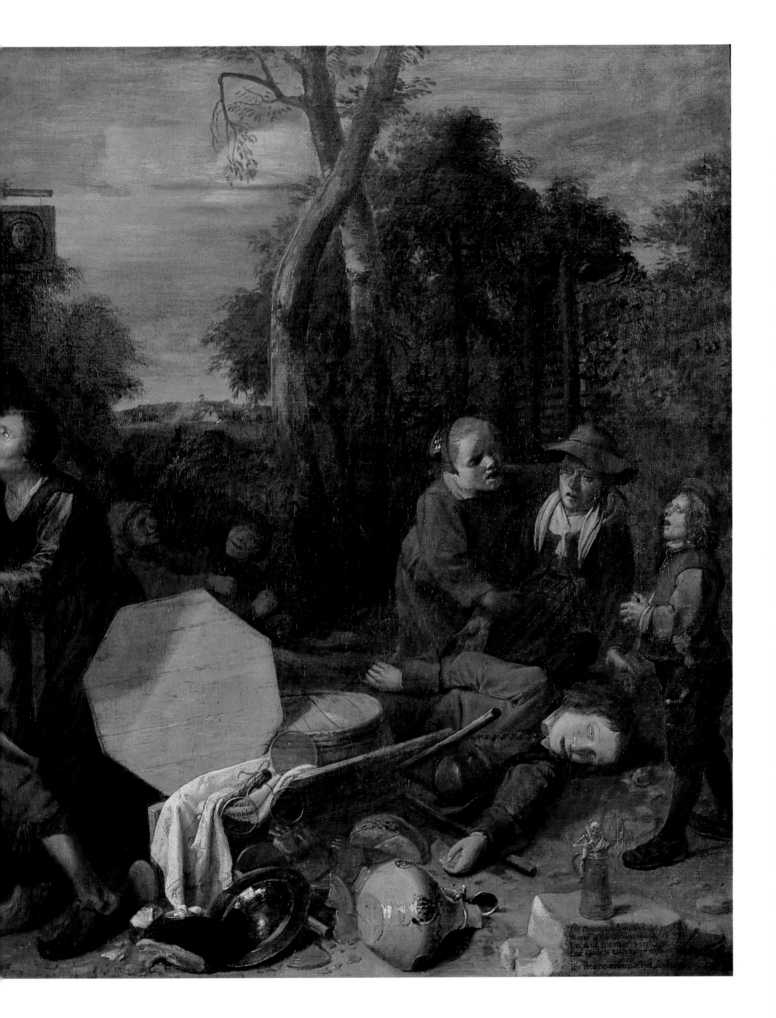

253

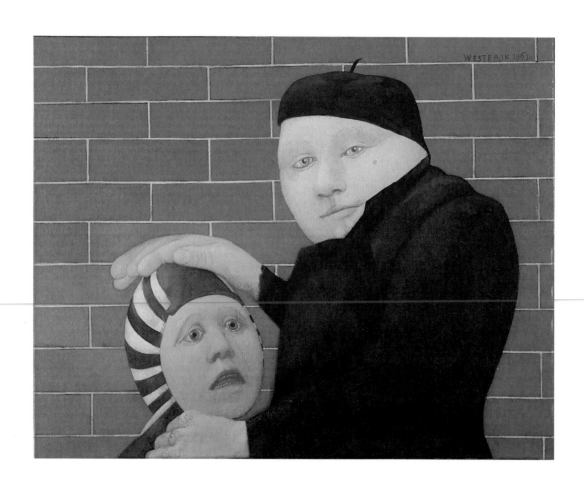

Co Westerik
Schoolmaster with Child, 1961
oil, tempera on board
58x74,5 cm
Naarden, Becht Collection
cat. 149

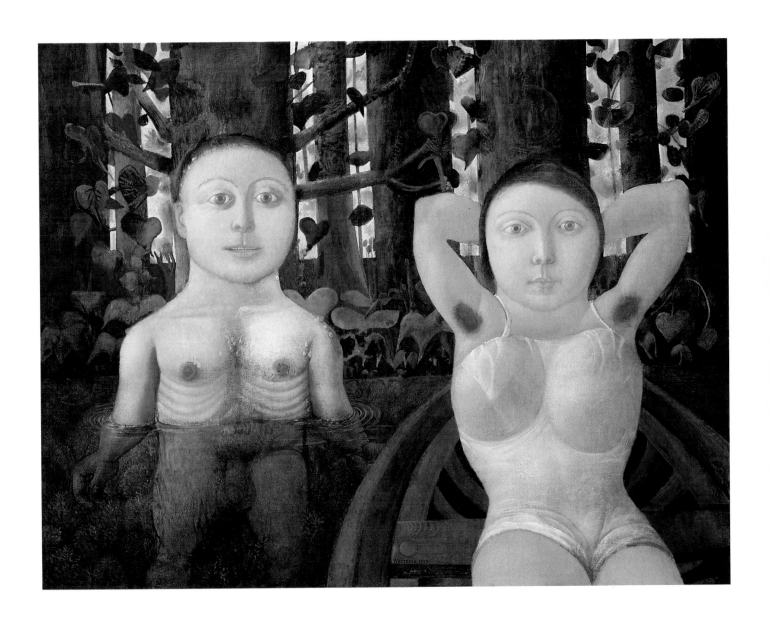

Co Westerik
Man in the Water, Woman in Boat, 1959
oil, tempera on canvas, 118x150 cm
The Hague
The Haags Gemeentemuseum
cat. 150

Co Westerik
Cut by a Grass Blade, 1966
oil distemper on board
60x75 cm
Amsterdam, Stedelijk Museum
cat. 151

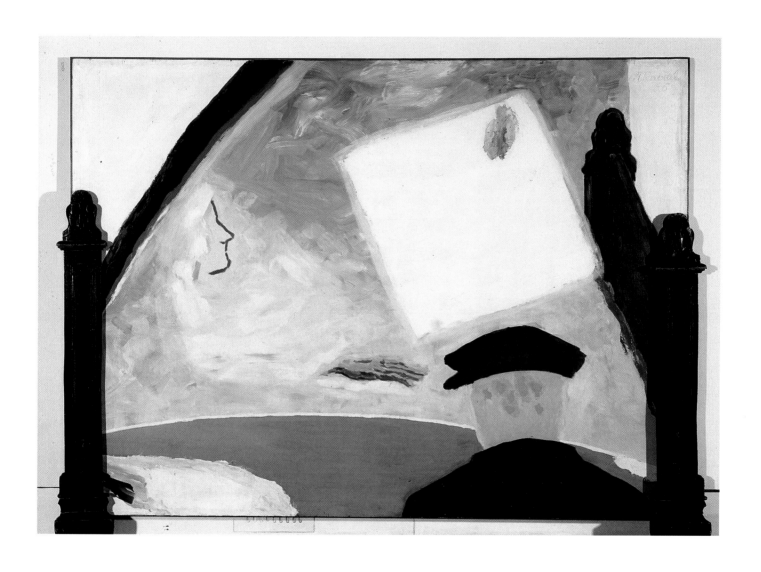

Roger Raveel
My Mother's Deathbed, 1965
oil on canvas, 161x212 cm
Ghent, Museum
van Hedendaagse Kunst
cat. 152

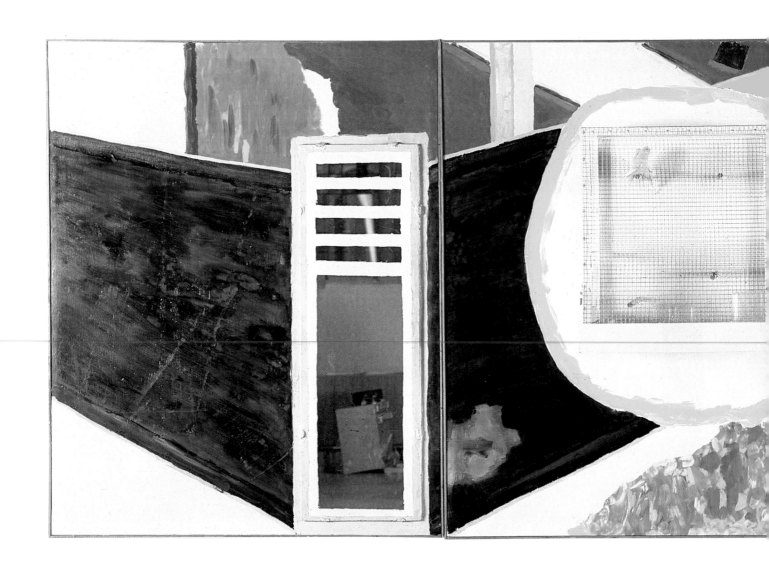

Roger Raveel
Tremendously Beautiful Life, 1965
triptych, oil on canvas, mixed media
150x120, 150x204, 150x120 cm
private collection
cat. 153

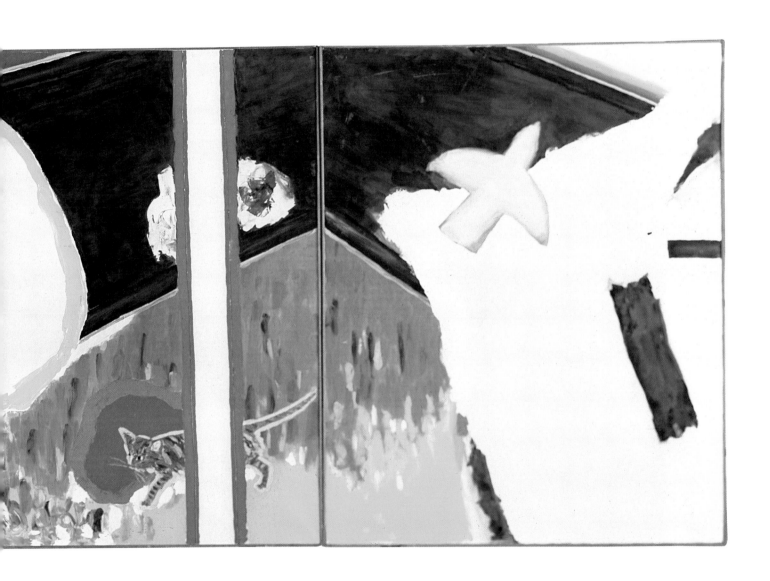

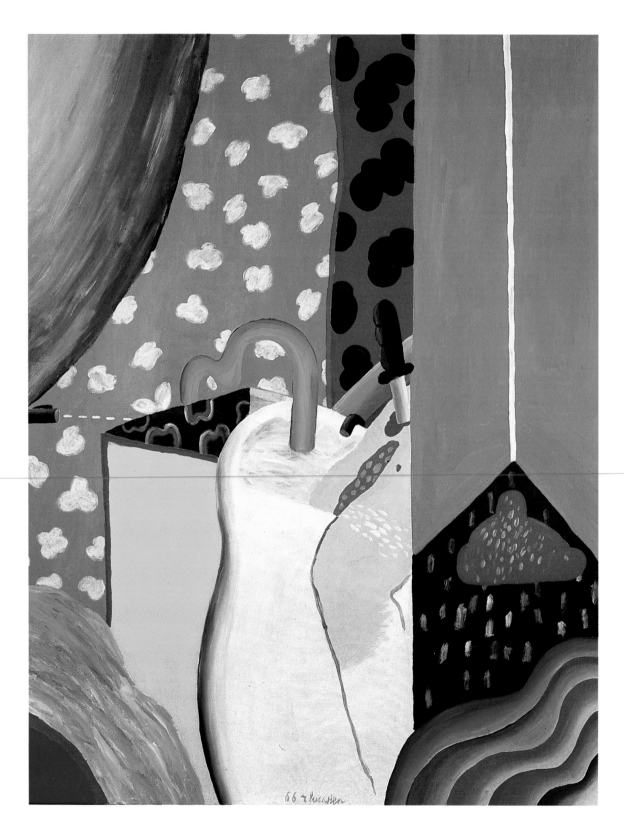

Reinier Lucassen
Long Live Marat, 1966
oil on canvas, 160x120 cm
Amsterdam, Stedelijk Museum
cat. 154

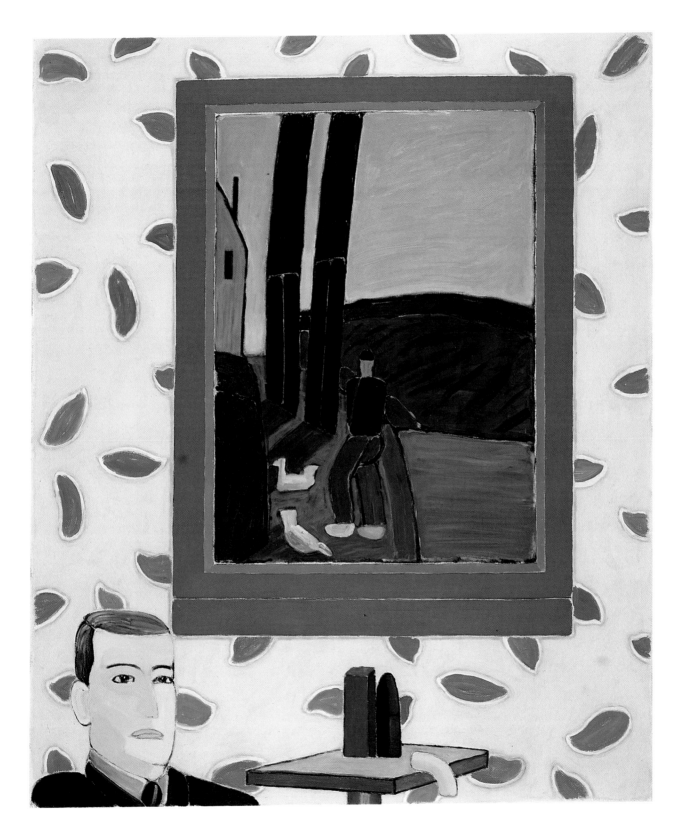

Reinier Lucassen
Portrait of Brusselmans, 1976
acrylic on canvas, 160x130 cm
K.C.M. Fauser Collection
cat. 155

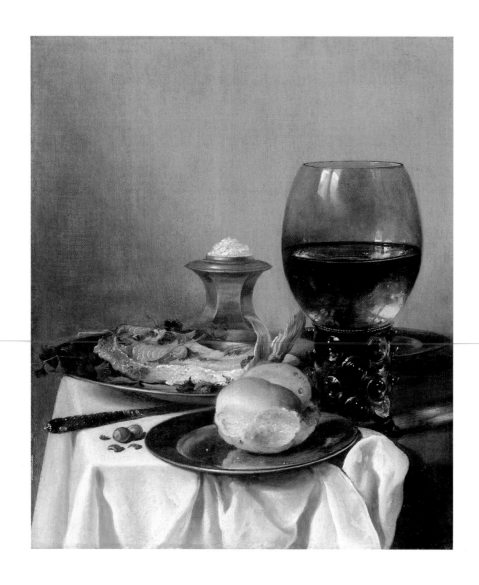

Pieter Claesz
Still Life, s.d.
panel, 52,8x44 cm
Amsterdam, Rijksmuseum
cat. 156

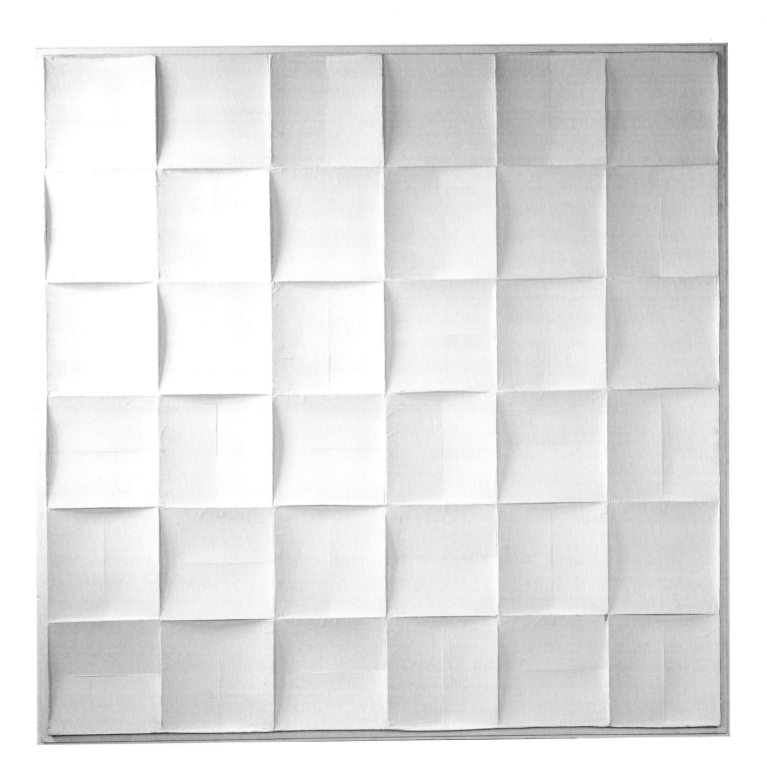

Jan Schoonhoven
R 71-10, 1971
relief, 156x156 cm
Otterlo, Kröller-Müller Museum
cat. 157

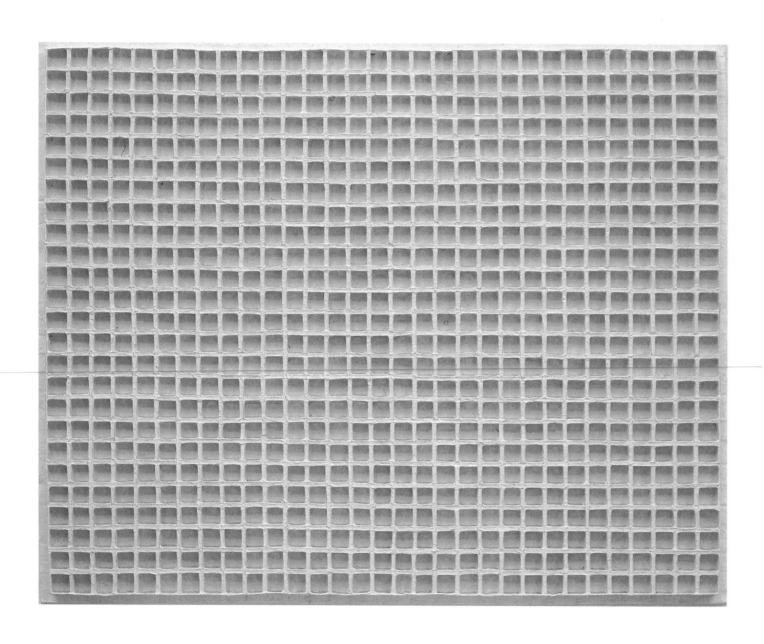

Jan Schoonhoven
Big Square Relief, 1964
painted papier-maché
107,5x131,5 cm
(with frame)
Eindhoven, Stedelijk
Van Abbemuseum
cat. 158

264

Ad Dekkers
1st Phase from Circle to Square
1968
polyester applied by hand
synthetic paint
diam. 180x2,5 cm
Amsterdam, Stedelijk Museum
cat. 159

Armando
12 Bolts (on Black), 1961
fibreboard, iron bolts, assemblage
44x80 cm
Amsterdam, Stedelijk Museum
cat. 160

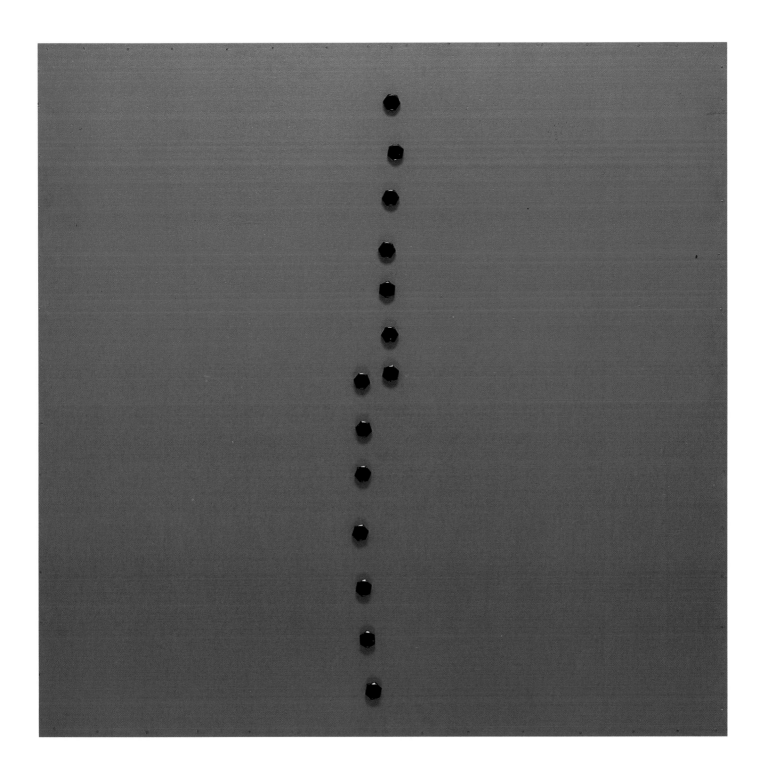

Armando
2x7 Bolts on Red, 1961
bolts, fibreboard, paint, collage
122,5x122,5 cm
Amsterdam, Stedelijk Museum
cat. 161

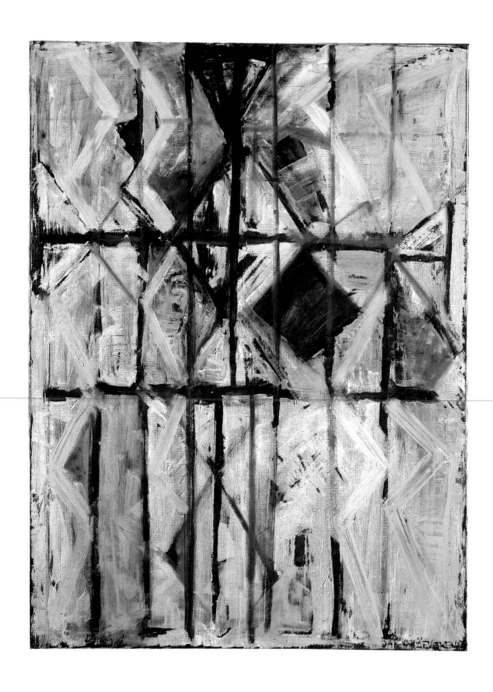

Dan van Severen
Untitled
1957
oil on canvas, 135x97x2 cm
Ghent, Dan van Severen
cat. 162

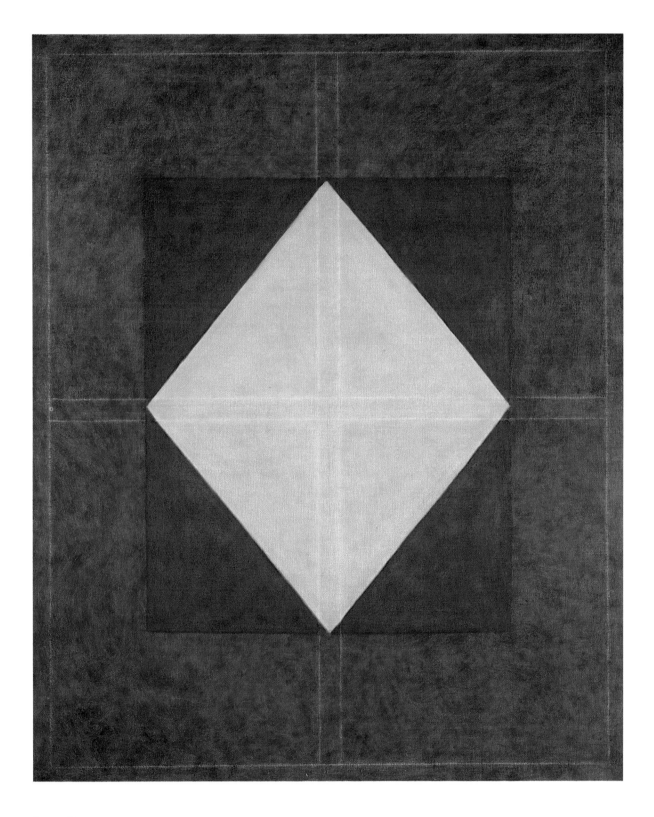

Dan van Severen
Blue Composition, 1969
oil on canvas, 162x130 cm
Ghent, Museum
van Hedendaagse Kunst
cat. 163

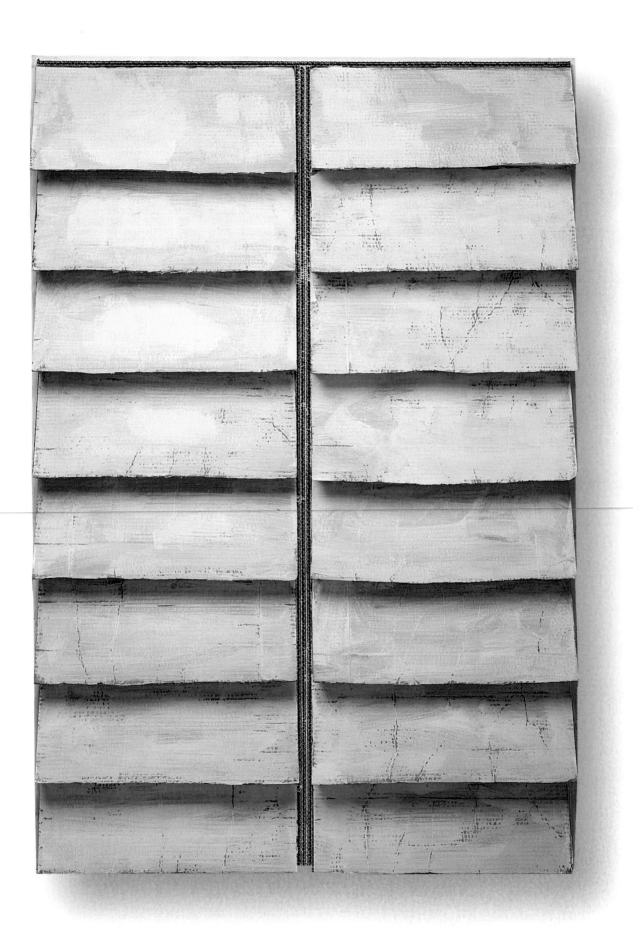

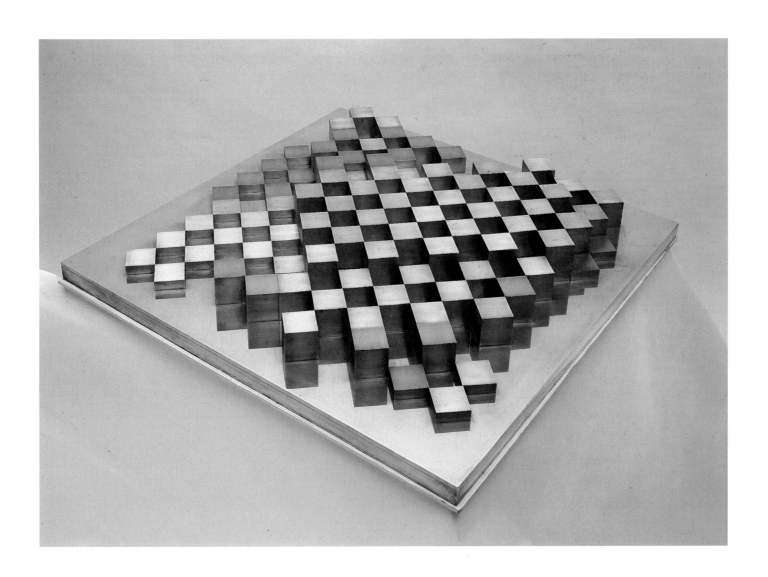

Jan Schoonhoven
R 83-2, 1983
slanting planes of cardboard, arranged
eight by two, 122x82x13,5 cm
Amsterdam, Stedelijk Museum
cat. 164

André Volten
Reclining Relief, 1973
copper
121,2x99x99 cm
Amsterdam, Stedelijk Museum
cat. 165

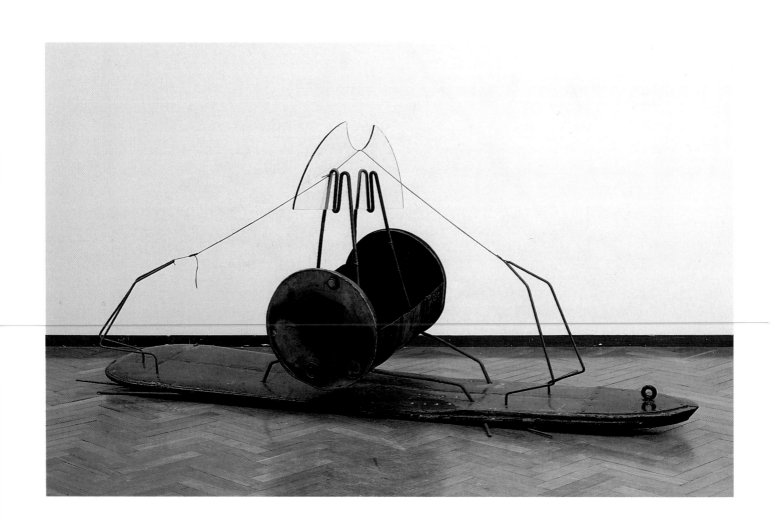

Carel Visser
Oil Ship, 1996
sheet iron, steel, glass, leather
152x125x319 cm
Amsterdam, Stedelijk Museum
cat. 166

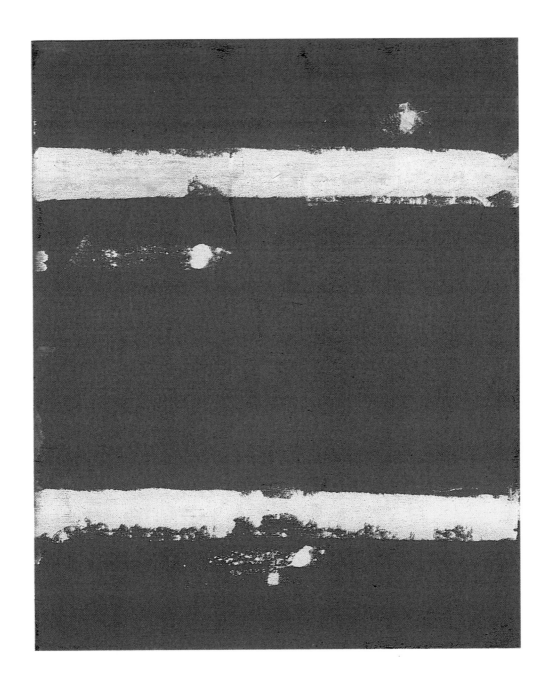

Raoul De Keyser
Hall (3), 1985
oil on canvas, 60x50 cm
Ghent, Vereniging voor het Museum
van Hedendaagse Kunst
cat. 167

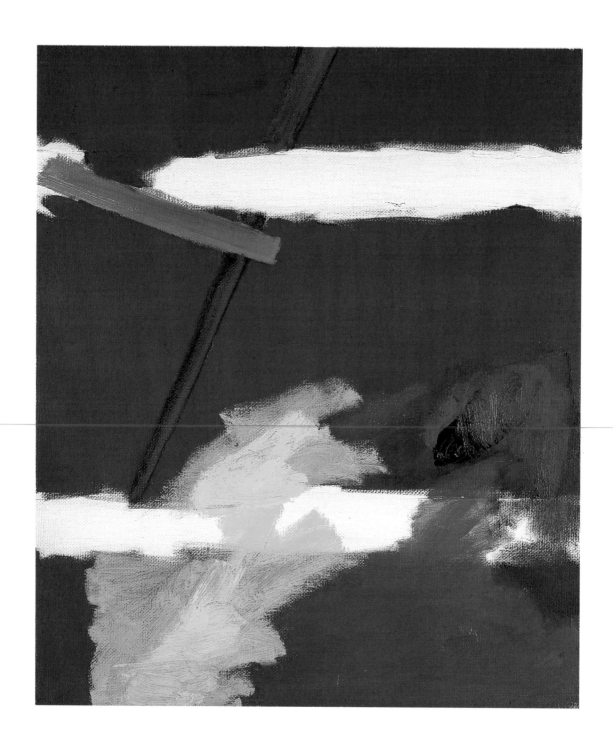

Raoul De Keyser
Gate of Hell, 1985
oil on canvas, 50x40 cm
Ghent, Museum
van Hedendaagse Kunst
cat. 168

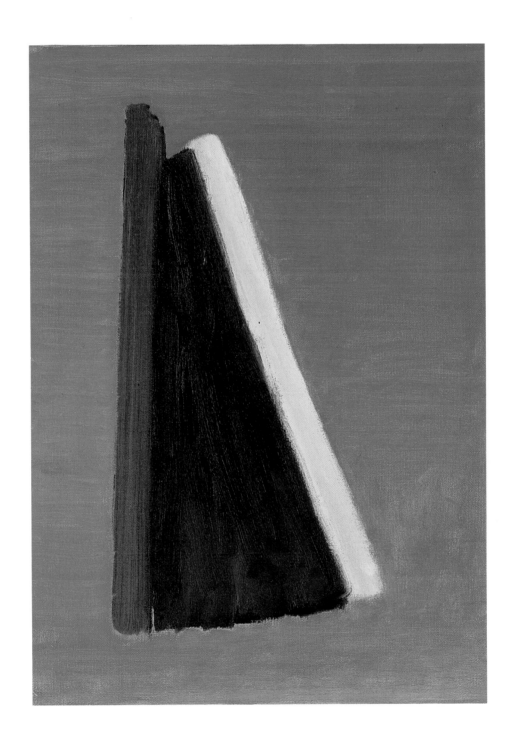

Raoul De Keyser
Untitled, 1988
oil on canvas, 50x70 cm
private collection
cat. 169

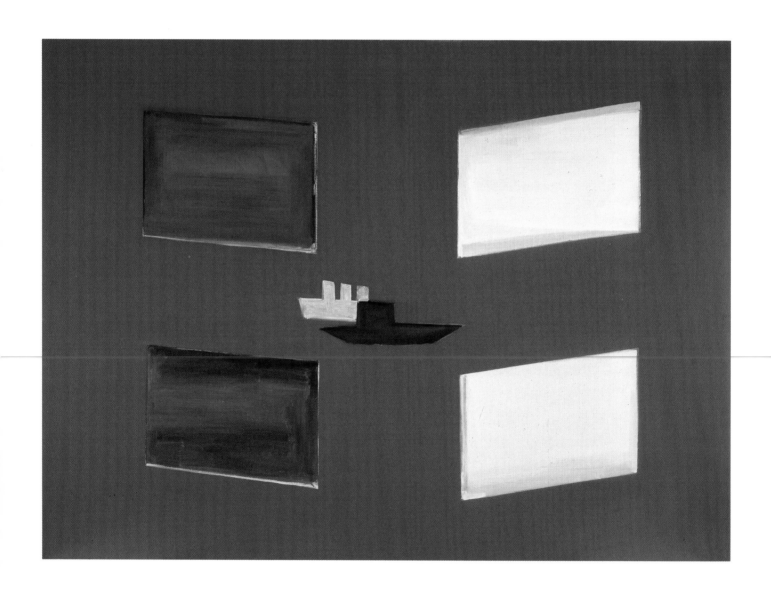

René Daniëls
Hot Day in the Lighthouse, 1984
oil on canvas, 150x200,5 cm
Eindhoven, Stedelijk
Van Abbemuseum
cat. 170

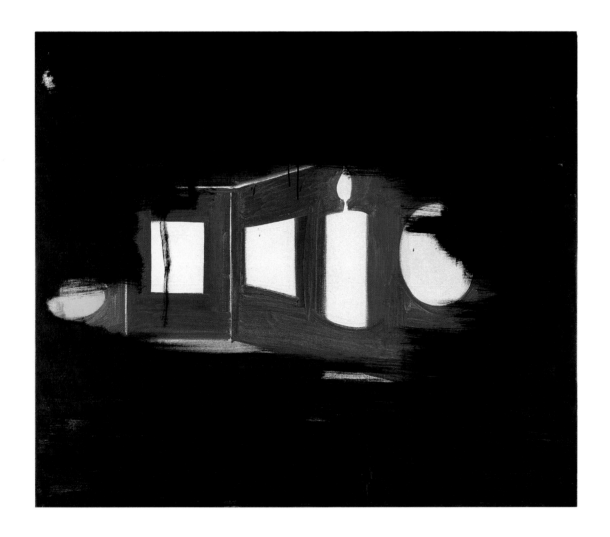

René Daniëls
Untitled, 1987
oil on canvas, 105x120 cm
Ghent, Museum
van Hedendaagse Kunst
cat. 171

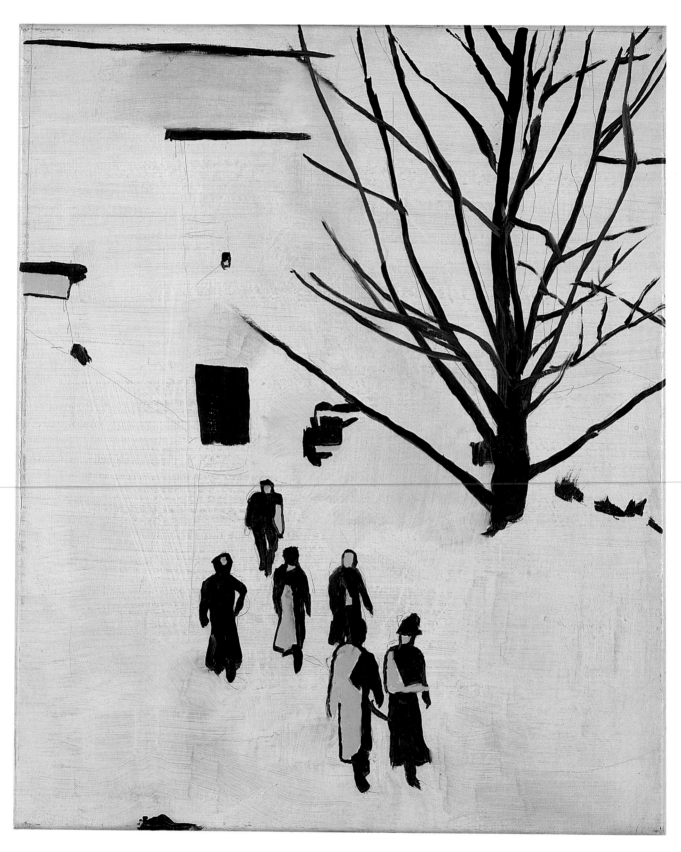

Luc Tuymans
The Walk, 1989
oil on canvas, 70x55 cm
private collection
cat. 172

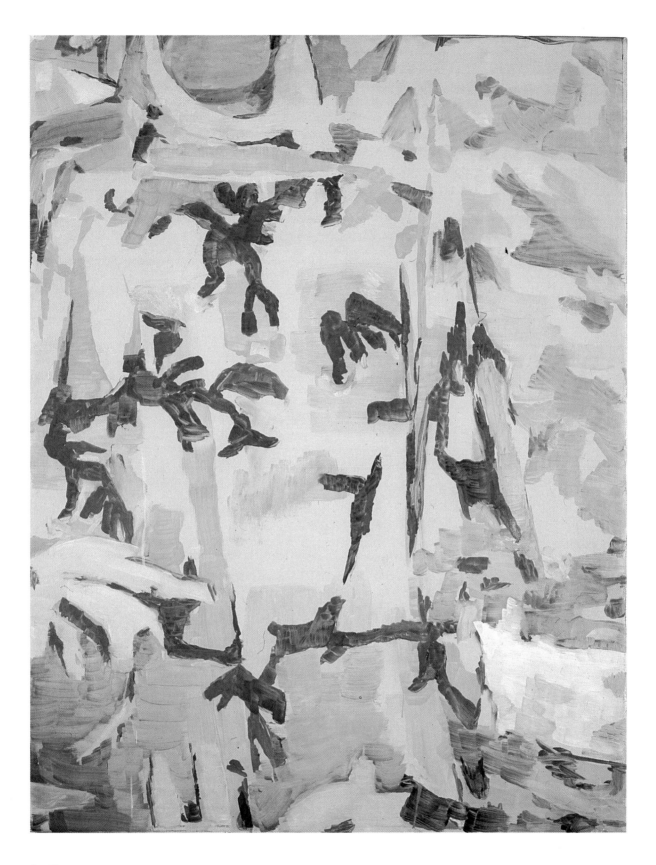

Luc Tuymans
Camouflage, 1993
oil on canvas, 77x58,5 cm
private collection
cat. 173

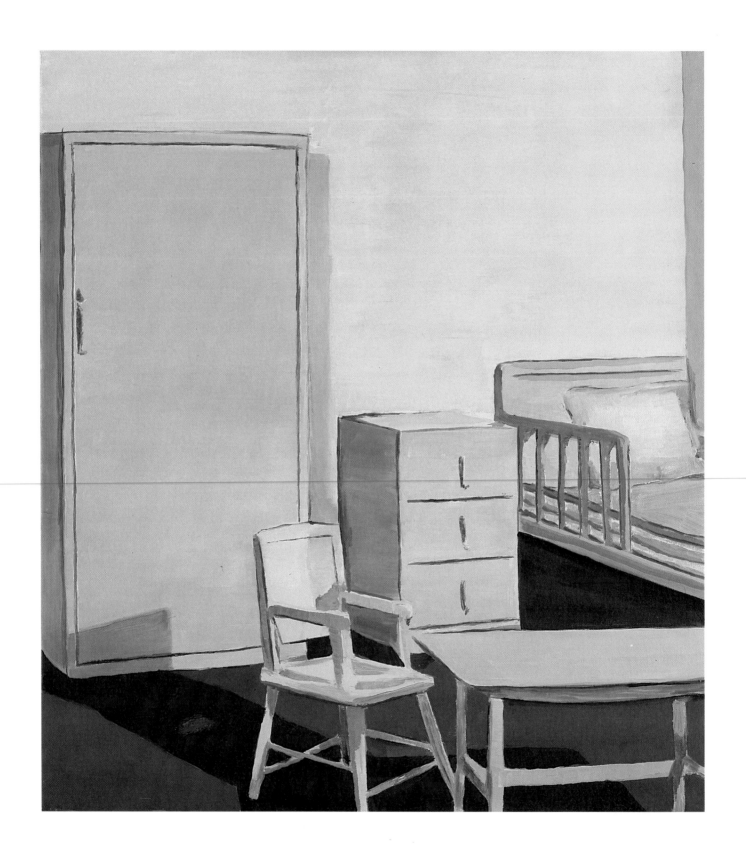

Luc Tuymans
Silent Music, 1993
oil on canvas, 85,5x73,5 cm
Amsterdam, Stedelijk Museum
cat. 174

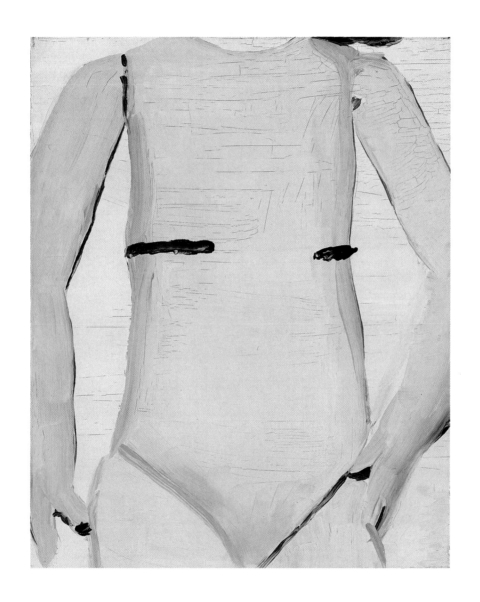

Luc Tuymans
Body, 1990
oil on canvas, 48x38 cm
private collection
cat. 175

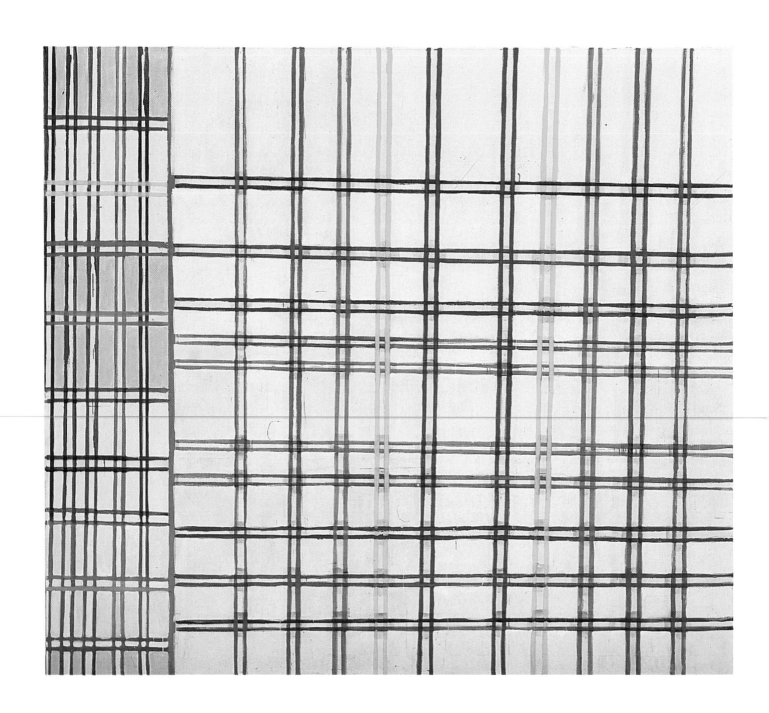

Rob Birza
*Strawberries, Pistache, Peach
and Banana*, 1990
egg-distemper on canvas, 250x275 cm
Amsterdam, Stedelijk Museum
cat. 176

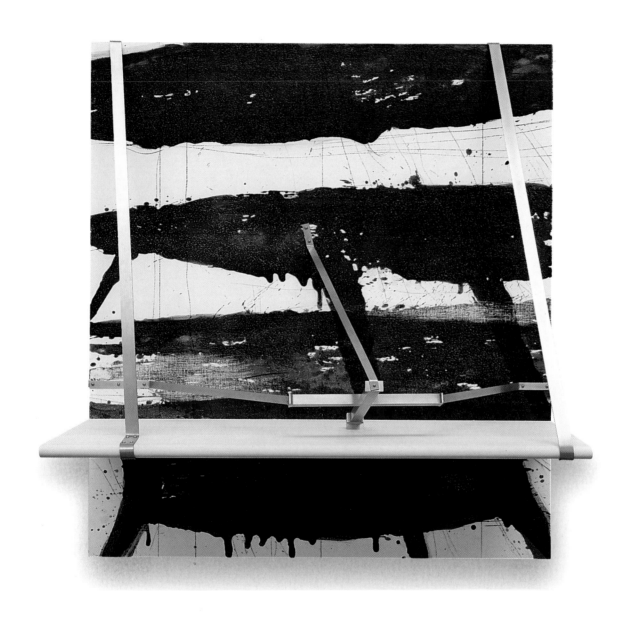

Marien Schouten
Untitled, 1995-96
mixed media, 175x158x79 cm
Ghent, Museum
van Hededaagse Kunst
cat. 177

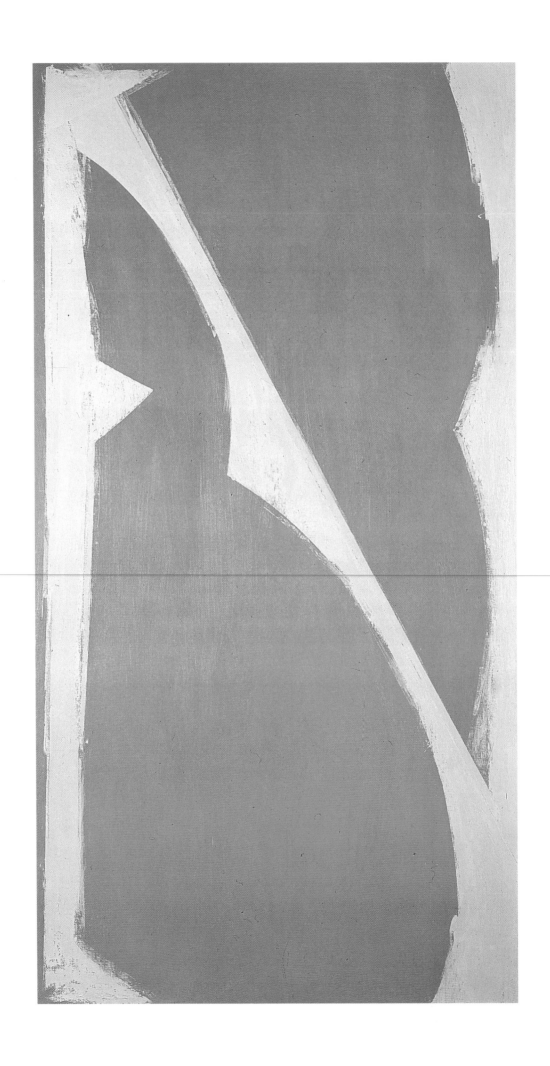

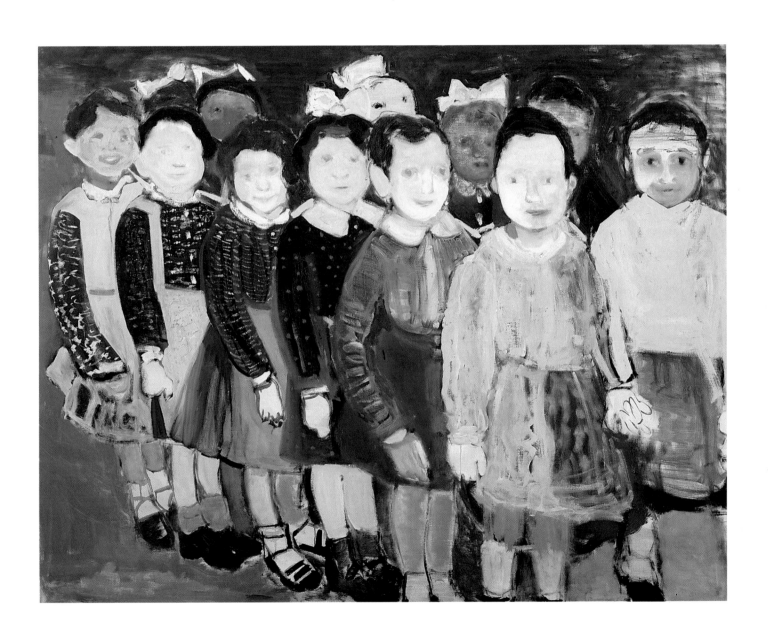

Toon Verhoef
Untitled, 1983
oil, alkyd on canvas, 290x150 cm
Amsterdam, Stedelijk Museum
cat. 178

Marlene Dumas
Turkish Schoolgirls, 1986
oil on canvas, 160x200 cm
Amsterdam, Stedelijk Museum
cat. 179

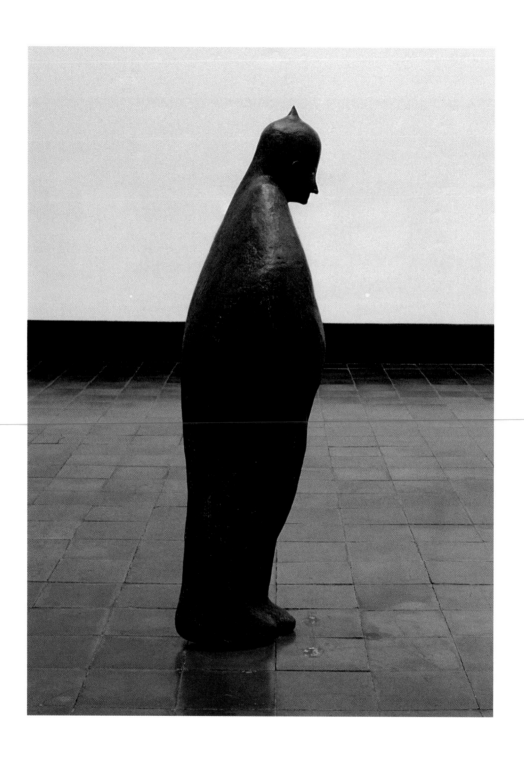

Henk Visch
Book, 1993
bronze, 105x45x29 cm
Brussels
Ministerie van de Vlaamse
Gemeenschap
cat. 180

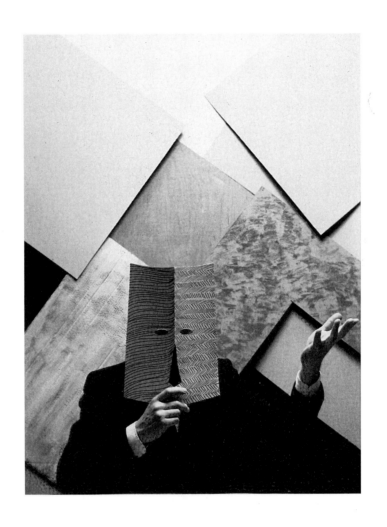

Jan Vercruysse
Portrait of the Artist
by Himself (XIII), 1984
photoprint, 70,5x52 cm
Ghent, Museum
van Hedendaagse Kunst
cat. 181

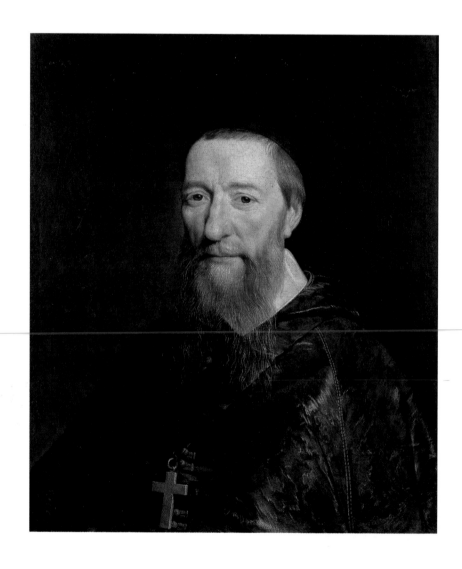

Philippe de Champaigne
Portrait of Jean-Pierre Camus
1643
oil on canvas, 73,2x59,4 cm
Ghent
Museum voor Schone Kunsten
cat. 182

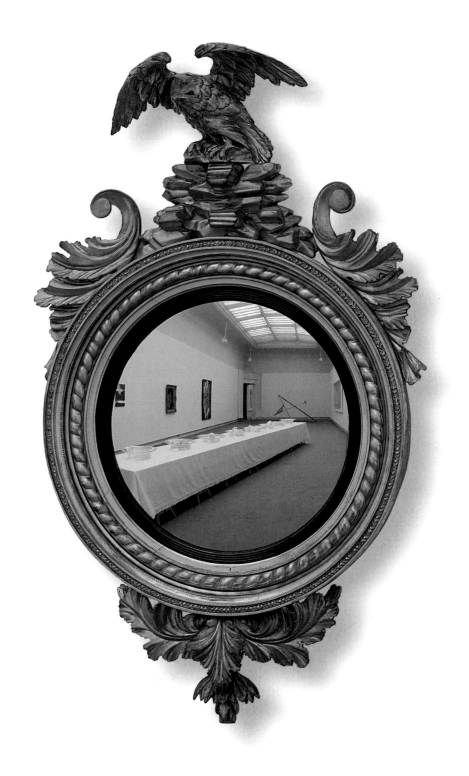

Marcel Broodthaers
Mirror Regency, 1973
mirror, gold paint on wood
142x77,3 cm, mirror diam. 52 cm
Ghent, Vereniging voor het Museum
van Hedendaagse Kunst
cat. 183

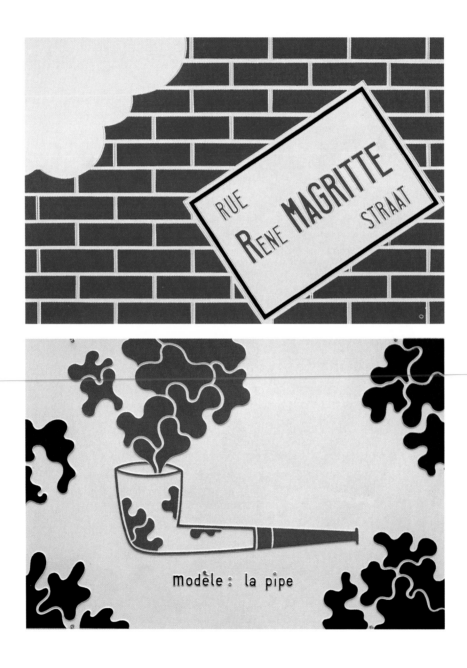

Marcel Broodthaers
Rue René Magritte
1968
plastic, 85x120 cm
private collection
cat. 184

Marcel Broodthaers
Modèle: la pipe (Model: the pipe)
1971-72
plastic, 85x120 cm
private collection
cat. 185

Marcel Broodthaers
Citron - Citroen, 1974
lithography on paper, 105x66 cm
Ghent, Museum
van Hedendaagse Kunst
cat. 186

Stanley Brouwn
Length 1 step on 14-10-87, 1987
paper behind perspex, ink, pencil
126x120 cm
Amsterdam, Stedelijk Museum
cat. 187b

Stanley Brouwn
a. 100 m, 1:100
b. 100 steps, 1:100, 1978
paper on pencil, 115x20 cm
Amsterdam, Stedelijk Museum
cat. 187a

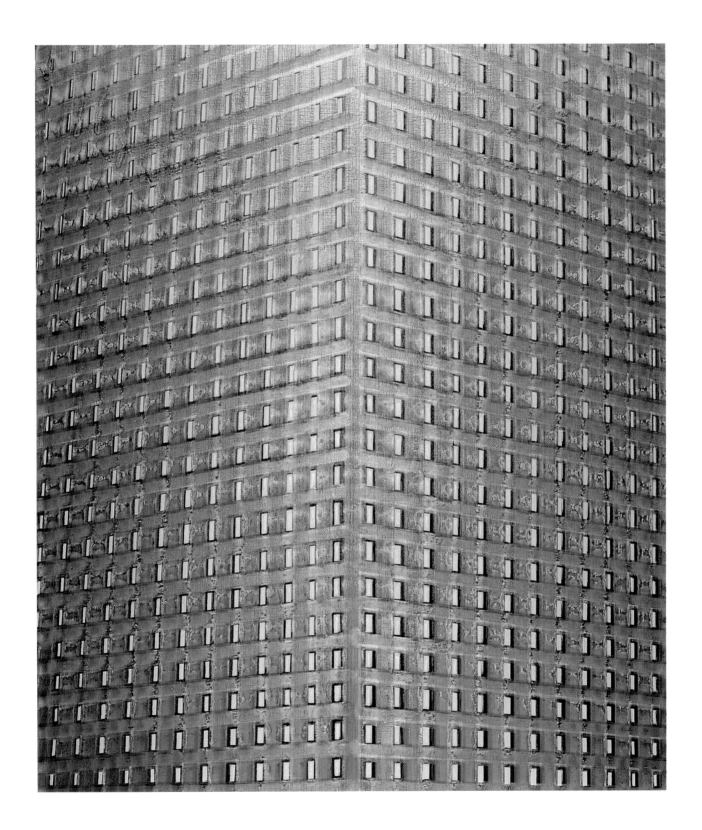

Jeroen Henneman
Facades D, 1996
acrylic on canvas, 165x140 cm
Amsterdam
Stedelijk Museum
cat. 188

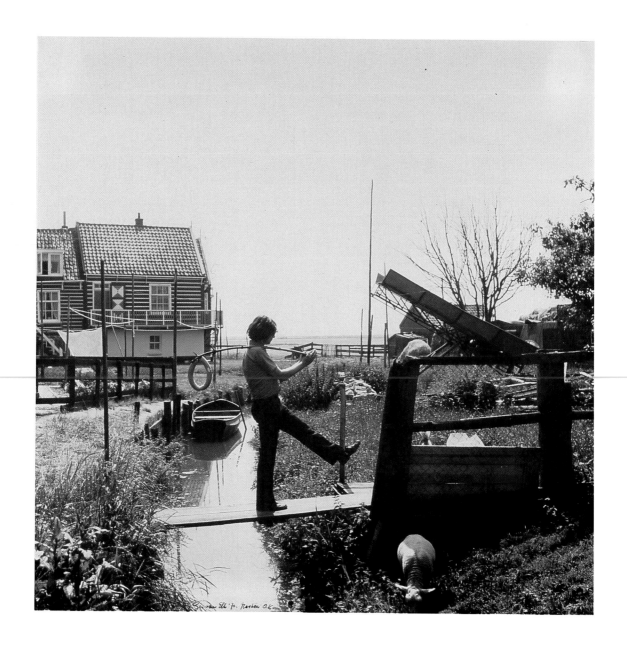

Ger van Elk
The Co-Founder of the Word O.K.
Marken, 1971
colour photography, 76x76x2 cm
Groningen
H. de Groot Family Collection
cat. 189

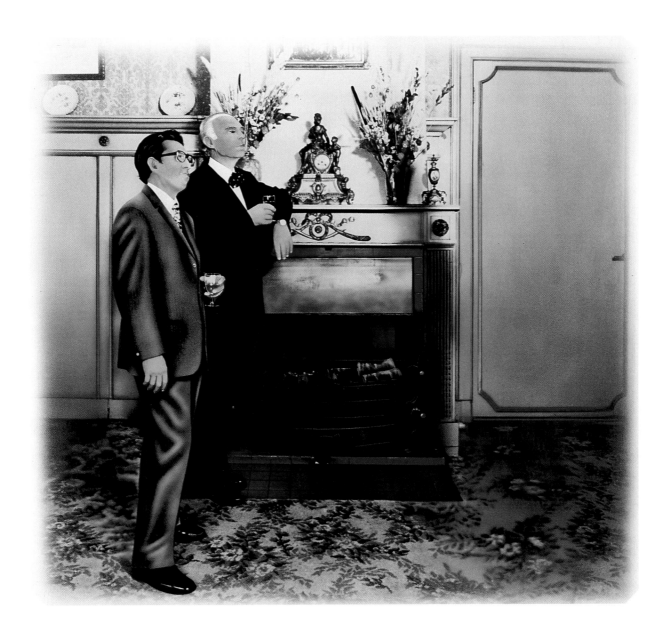

Ger van Elk
"Missing Persons" Mantelpiece
1976
photographic paper, retouched
photograph, frame, 93x99 cm
Amsterdam, Stedelijk Museum
cat. 190

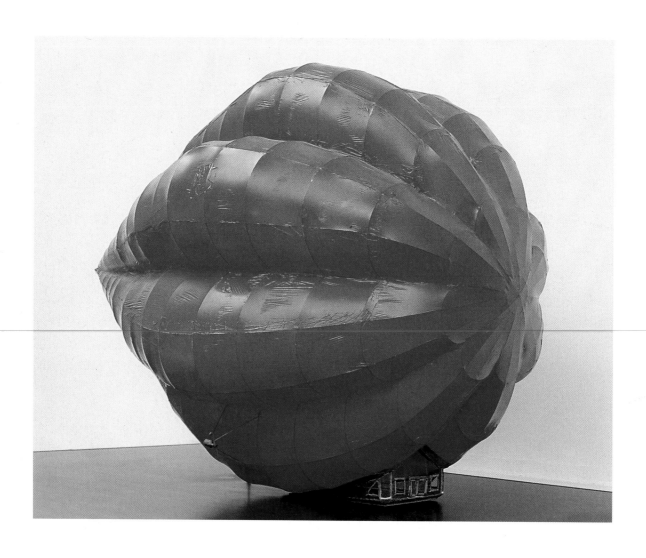

Panamarenko
Poppy, 1985
mixed media, 104x155x100 cm
private collection
cat. 191

Peter Struycken
Computerstructure IV A, 1969
perspex-enamel, 150x150 cm
Amsterdam, Stedelijk Museum
cat. 192

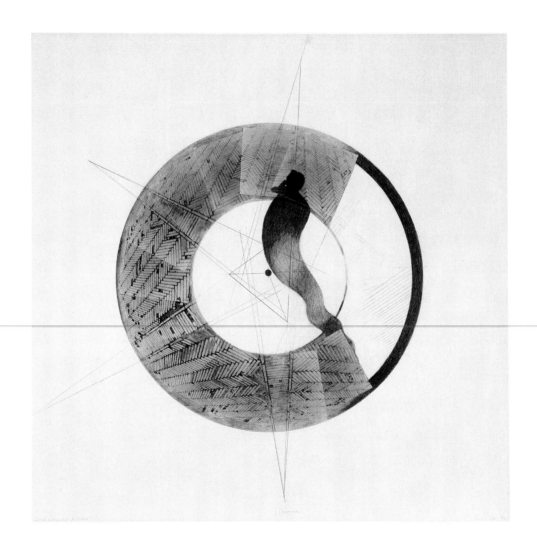

Jan Dibbets
Spoleto Self-portrait, 1980
photo, pencil, paper
two parts, 73x73 cm each
Amsterdam, Stedelijk Museum
cat. 193

298

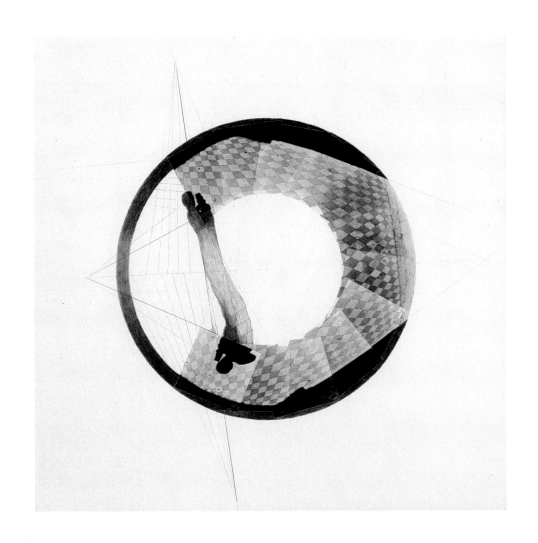

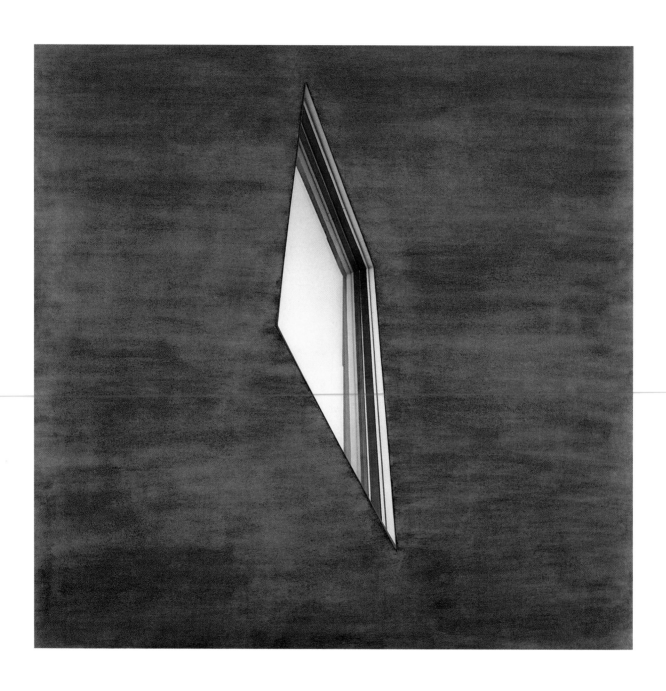

Jan Dibbets
Wayzata Window, 1989
mixed media
185x185 cm
Amsterdam, private collection
cat. 194

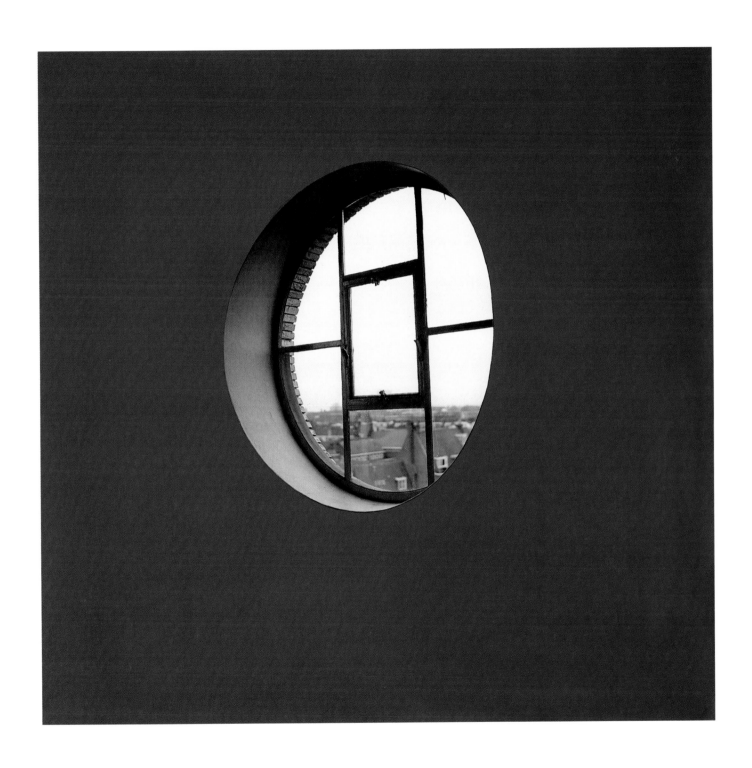

Jan Dibbets
SVB, Amsterdam, 1996
photograph, watercolour, paper
on panel, 225x225 cm
Paris, Courtesy Galerie Daniel Lelong
cat. 195

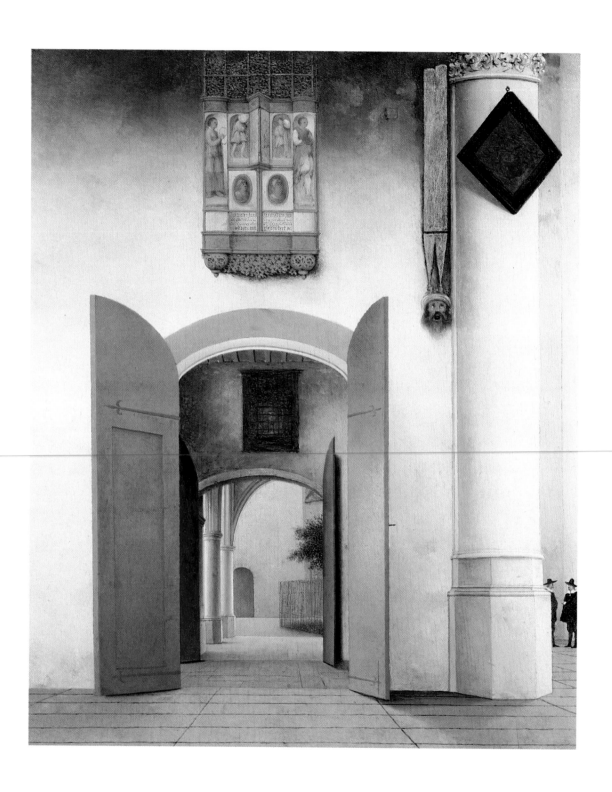

Pieter Saenredam
Interior of St. Laurence's Church
Alkmaar, 1661
panel, 54,5x43,5 cm
Rotterdam, Museum Boijmans
Van Beuningen
cat. 196

Appendix

In a certain way I am glad I have not *learned* how to paint, because then I might have *learned* how to pass by such effects as this. Now I say, No, this is just what I want – if it is impossible, it is impossible; I will try it, though I do not know how it ought to be done. *I do not know myself* how I paint it.

Letter to Theo, The Hague, September 3, 1882, in V.W. van Gogh (ed.), *The Complete Letters of Vincent van Gogh*, English translations by J. van Gogh-Bonger and C. de Dood, Greenwich (Connecticut), 1958

But I want to point out something which is perhaps worthwhile. All academic figures are put together in the same way and, let's say, *on ne peut mieux*. Irreproachable, *faultless*. You will guess what I am driving at, they do not reveal anything new.
This is not true of the figures of a Millet, a Lhermitte, a Régamey, a Daumier; they are also well put together, but after all in a different way than the academy teaches.
But I think that however correctly academic a figure may be, it will be superfluous in these days, though it were by Ingres himself... when it lacks the essential modern note, the intimate character, the real *action*.
Perhaps you will ask: When will a figure *not* be superfluous, though there may be faults, great faults in it in my opinion?
When the digger digs, when the peasant is a peasant and the peasant woman, a peasant woman.
Is this something new? – yes – even the figures by Ostade, Terborch, are not in action like those painted nowadays.
... It is not yet well expressed. Tell Serret that *I should be desperate if my figures were correct*, tell him that I do not want them to be academically correct, tell him that I mean: If one photographs a digger, *he certainly would not be digging then*. Tell him that I adore the fig-

ures by Michelangelo though the legs are undoubtedly too long, the hips and the backsides too large. Tell him that, for me, Millet and Lhermitte are the real artists for the very reason that they do not paint things as they are, traced in a dry analytical way, but as *they* – Millet, Lhermitte, Michelangelo – feel them. Tell him that my great longing is to learn to make those very incorrectnesses, those deviations, remodelings, changes in reality, so that they may become, yes, lies if you like – but truer than the literal truth ...
To draw *a peasant's figure in action*, I repeat, that's what an essentially modern figure is, the very core of modern art, which neither the Greeks nor the Renaissance nor the old Dutch school have done.

Letter to Theo, Nuenen, July 1885, in V.W. van Gogh (ed.), *The Complete Letters of Vincent van Gogh*, English translations by J. van Gogh-Bonger and C. de Dood, Greenwich (Connecticut), 1958

At the moment I am absorbed in the blooming fruit trees, pink peach trees, yellow-white pear trees. My brush stroke has no system at all. I hit the canvas with irregular touches of the brush, which I leave as they are. Patches of thickly laid-on colour, spots of canvas left uncovered, here and there portions that are left absolutely unfinished, repetitions, savageries; in short, I am inclined to think that the result is so disquieting and irritating as to be a godsend to those people who have fixed preconceived ideas about technique.

Letter to Emile Bernard, Arles, April 9, 1888, in V.W. van Gogh (ed.), *The Complete Letters of Vincent van Gogh*, English translations by J. van Gogh-Bonger and C. de Dood, Greenwich (Connecticut), 1958

I still have a cypress with a star[1] from down there [Saint-Rémy-de-Provence], a last attempt – a night sky with a moon without radiance, the slender crescent barely emerging from the opaque shadow cast by the earth – one star with an exaggerated brilliance, if you like, a soft brilliance of pink and green in the ultramarine sky, across which some clouds are hurrying. Below, a road bordered with tall yellow canes, behind these the blue *Basses Alpes*, an old inn with yellow lighted windows, and a very tall cypress, very straight, very sombre.
On the road, a yellow cart with a white horse in harness, and two late wayfarers. Very romantic, if you like, but also *Provence*, I think. I shall probably etch this and also other landscapes and subjects, memories of Provence, then I shall look forward to giving you one, a whole summary, rather deliberate and studied.
... Look, here's an idea which might suit you: I am trying to do some studies of wheat[2] like this, but I cannot draw it – nothing but ears of wheat with green-blue stalks, long leaves like ribbons of green shot with pink, ears that are just turning yellow, edged with the pale pink of the dusty bloom – a pink bindweed at the bottom twisted round a stem.
After this I would like to paint some portraits against a very vivid yet tranquil background. There are the greens of a different quality, but of the same value, so as to form a whole of green tones, which by its vibration will make you think of the gentle rustle of the ears swaying in the breeze: it is not at all easy as a colour scheme.

From an unfinished letter to Paul Gauguin, found among Vincent's papers, Auvers-sur-Oise, June 17 circa, 1890, in V.W. van Gogh (ed.), *The Complete Letters of Vincent van Gogh*, English translations by J. van Gogh-Bonger and C. de Dood, Greenwich (Connecticut), 1958
[1] *Road with Cypress and Star*, Otterlo, Rijksmuseum Kröller-Müller (cat. 29)

[2] *Ears of Wheat*, Amsterdam, Van Gogh Museum (cat. 24)

These days there are so many who believe they can produce art through the work of their hands alone that it is important to draw attention to someone, a stubborn and naïve person, who has accomplished nothing through the skill of his fingers but who, through a deeper, finer gift, showed in everything he did that there was something of the visionary within him.
Van Gogh, though in essence of an uncommonly pure nature, was not a man to work and polish purity with fine instruments. He worked in rebellious haste: there was so much, every day, and life lay revealed to him everywhere. But he also lived too much in revolt against appearances, he felt himself too much the inborn enemy of all that shines and charms, he was too firmly inclined to comprehend things to their very bowels with an almost barbaric grasp to have anything of the polisher about him.
Running throughout his hard life, throughout his work, there is a heavily driving force, a pulse of continually flaring broad, intense raptures, the raptures of a humble man. If what I have often thought is true, namely that the ability to attain any great expression in art is reserved for those who live in unending awe of the phenomena of the universe, then he met one of the principal criteria. He stood in awe of nature, beholding it with rare open-mindedness; he looked around him without despising anything that came his way, and worked with humble devotion through which he succeeded in making what was least significant important. This conferred greatness on almost everything he drew or painted, which, though often imperfect, was never small or weak.
... He worked as if carrying out a violent assault on things; he worked

with the energy of resignation, which is not far from despair. It was a fierce process of wrenching things from nature and tensely flinging them on to the patient canvas. With the violent insight, the surprising lucidity of great gentleness, he seeks the raw root of things and thus sees those truths which, in art too, often remain concealed from the wise and the clever, but are revealed by grace to children. The power of the child had stayed in him. At the bottom of his often bitter feelings lay an unspoilt serenity. A hard life of suffering had no power to damage such a man, and in his vision he seems to retain the reconciling quality of the first Christians.

From the same source as his respect for the phenomena of nature came his feeling for those ennobled by suffering; he was repelled by the refinements of the wealthy, and he believed in the purity of fishermen and tax gatherers and pariahs, for poverty, sin, and deprivation bring out the strongest centres of life in us...

Deeply averse to resorting to loose pictorial effects, seeking something wide and even, something eloquently decorative and definite, he remained, though he wrested what was seen with great conceptual ability into a feverishly well thought-out framework, an Impressionist in his way of working – in that he did not use his strong perceptions as the material for creating general images, but was able to give his immediate, intense impressions themselves a wider significance, through the abstract that was in him ...

Towards the end of his sadly short life, he boldly wanted to let go of reality, groping for images of the so-called supernatural, he came close to the abyss of impotence. The raw is no longer sublime; it has become almost vulgar.

Van Gogh had the advantage of never having studied at the inhibiting art schools. Isolated in the world, and isolated in his artistic

aims, he stubbornly searched for an instrument that would be suitable as the medium for what he intended. The fact that this laboriously self-developed instrument was simple in nature contributed to his being able to make expressive something so overwhelming in its effect. That it was so entirely different from the instruments with whose sounds the cultivated art lovers around him were familiar was the principal reason for so little being understood of his very simple words. Moreover, it seems that, let it be said to our shame, in this world glittering gifts are cherished and honoured, whereas he who has within him the weight of genius without the facility of talent is driven out like a leper ...

Jan Veth, "Studiën over moderne kunst: I. Tentoonstelling van werken door Vincent van Gogh in de Amsterdamsche Panoramazaal (1892)" (Studies in modern art: I. Exhibition of works by Vincent van Gogh at the Amsterdam Panoramazaal), in *De Nieuwe Gids*, 8, 1893, vol. I, 428-31

The degree to which Vincent's work is appreciated in our time is remarkable, and provides further evidence to support the argument I have put forward on several occasions, namely that the public is always some generations behind in its estimation of painting. Who cared thirty years ago about that desperate, solitary figure struggling with objects and light? Who saw anything else in that red-haired, ugly, angular and silent seeker but a *raté* (misfit)? No one, I believe, and those who did care about him regarded him – with the exception of his brother – with more pity than admiration. This is because madness is the ghost of genius; people sense the former and fail to recognize the latter. But after some years have passed the object of our pity suddenly turns out to have been a genius and his works attract old

and young maniacs as a sugar pot attracts flies. In my view this kind of admiration is always worthless. An understanding of art is shown not by admiring *Van Gogh now*, but by admiring the *Van Gogh of our time*.

What made Vincent an artist for every age, the eternally human, again flourishes in the art of our time, but in a different form. The eternally human, which is at the same time the eternally religious, recognisable in ever changing forms, is true understanding of art. With Van Gogh the eternally human – one cannot speak of him without touching on this – is closely connected to the objects he depicts. His objects are in turn closely connected to his colouring, and this results in an entity that is harmonious in itself.

His Brabant work is characterised by a very heavy tone. This dominates all the works from this period. It is the tone we also encounter in Dostoyevsky's books and in Beethoven's music, the tone of compassion. He was drawn to the tragic aspect of life, not as beauty but in the service of God. They served God who in another form showed their great love for mankind. The great artist sacrifices himself on the cross. His art becomes his cross, and as long as this is not the case, as long as your art does not become your cross, you can be sure that you are not a great artist. Bear that cross with all the strength that is in you and one day that cross will bear you.

Theo van Doesburg, "Vincent van Gogh", in *Eenheid*, 297, February 12th 1916, on the occasion of an exhibition of works by Van Gogh, particularly those from his Brabant period (1883-86)

He carried his life above the world. He found himself in Solitude. He showed himself then. Silence was happiness to him. Saying nothing was his revenge on

those who talked about him. He gave a throne for a little beauty in grey. He gave gold riches for a little freedom of thought. He was spiritually lawless. His spirit was tough, but not strong. Amid noise he was poverty-stricken. In quiet he was rich. Mist and haze were his domain. He was one with them. He became them. And gave himself. Sometimes. If necessary. He did not keep track of time. That's why he was not of his time. He was of the Middle Ages. He took no account of events. He knew reality. Fearsome. Hunger and standing on a wind-swept plain that was poor and barren, at night. He was no dreamer. He was a workman.

He practised a strange profession which no one understood.

When he came to himself, he worked through the reality of *empathy to abstraction* and came to understand that for the artist reality does not have the same meaning as for the barber or merchant.

Like Van Gogh, he was an end, not a beginning ...

Theo van Doesburg, "Thijs Maris (1839-1917)", in *Eenheid*, 380, September 15th 1917

When he painted a Pointillist portrait of me at Katwijk in 1906 or 1907... almost every Sunday morning as I posed and he was just about to start work ... to my irritation the door bell rang and we were disturbed by female visitors [Toorop's fans]. And what silly creatures some of them were! ...

At that time Toorop had completed a litho, *Verlangen en Bevrediging* (Longing and Fulfilment). On the left a young woman, apparently a virgin, with her arms and eyes raised to heaven; on the right a somewhat older, evidently married woman, quietly sitting with eyes cast down and contemplating her hands held together in her lap. Superbly drawn, of course, but with a symbolism as tangible as a three-

penny bit. The *cher Maître* strode about his studio and explained – without clarifying – the secrets of his symbolism to the flock of half a dozen ladies in rustling silk who arranged themselves before each painting three on his right and three on his left like the bottles in a cruet.

Jan continued to hold forth, but since he was not good at expressing himself he quickly got carried away and his exposition became so confused that he could not follow it himself. He said then that he could put it better in music and went to the piano, which stood ready and open, and improvised on very pleasing melodies and chords. The ladies were enraptured, particularly those closest to him, and listened with beatific if not imbecilic expressions, chorusing in threes when asked if he had made himself clear: "Oh yes, oh yes, oh yes, Mr. Toorop!" ...

Aegidius W. Timmerman, *Tim's herinneringen* (Tim's memories), Amsterdam, 1983 (first published 1938), 142-43

Let us turn our thoughts to Cézanne, devout, spiritual Cézanne, great Cézanne. He died some time ago and yet his soul lives among us in the works as we see them. Cézanne! May his works now finally be appreciated. There is not only a strong and fine element in Cézanne but without doubt a spiritual element too, a deeply spiritual element, a psyche, but you must understand this and apprehend it by viewing his works at length and, beyond the beauty of his painting, recognizing its spiritual beauty.

For it is not always necessary to compose a depiction or a representation of a deeply spiritual story in familiar or unfamiliar forms, lines or colours. No, the work must bear the psyche within it: it must radiate without a story accompanying it. That is true art. Such is architec-

ture in its beautiful and large proportions, in its very simple construction! But know first, be able first and then feel! And you artists, you are all often inspired to create, but know first and then be able: feel strongly but in the psyche. So let us aspire to the highest psyche, then our ability will also become stronger and more valuable through practice. Embody our work in a style, but highly simplified in straight or quietly moving vertical or horizontal lines. In a style in line with architecture! In triangles, in the young French artists' interesting pursuit in recent years of Cubism.

Let our work be steeped in the effects of contrast and complementary colours, make tone, seek architectural mass colour in large, flat relationships! Do all this and yet pursue the psyche. We must aspire to higher expression of the psyche – spiritualisation in healthy and strong forms. Away with that commercial business of small, sentimental Dutch interiors, that chickens and milk-pail stuff that cannot uplift us, however beautifully painted. For painting like this is nothing compared with a wonderful old Vermeer or Pieter de Hooch. You might as well give up. Take as your example the Egyptians, take the beautiful age of the Greeks, take Giotto ...

From an address by Jan Toorop delivered at the opening of the first exhibition by the Moderne Kunstkring at the Stedelijk Museum, Amsterdam, in *De Tijd*, October 7th 1911

The public thinks my work is rather vague: at best people say that it strongly reminds them of music. Well, I have nothing against that, provided that they do not go on to say that my work thus falls outside the category of visual art. For I construct lines and colour combinations on a flat surface with the aim of expressing

general beauty as deliberately as possible. Nature (or what I see) inspires me, gives me, like any other painter, the emotion which inspires the urge to make something, but I want to get as close as possible to the truth and therefore make everything abstract until I reach the foundation (though still an outward foundation!) of things. For me it is true that by saying *nothing specific* one says the most specific thing, the truth (which is all-embracing). In my view the architecture of the Ancients is the greatest art. I believe that it is possible by using horizontal and vertical lines, constructed *consciously* but not *calculatedly* and guided by high intuition, and brought to harmony and rhythm, I believe that with these basic forms of beauty – if necessary supplemented by lines in other directions or curves – it is possible to arrive at a work of art as strong as it is true.

So there is nothing vague here for those who see more deeply; it is only vague to a superficial viewer of nature. And *chance* must be as distant as *calculation*. And furthermore it seems to me necessary to break a horizontal or vertical line continually, for if these directions are not opposed by others, they will start to say something 'specific', something human, again. And I believe that in art one should not try to convey something human.

By not trying to say or tell anything human, by a complete negation of self, the work of art emerges that is a monument to Beauty, above all most human in its depth and universality! There is no doubt in my mind that this is an art for the future ...

Mondrian in a letter to H.P. Bremmer, January 29th 1914, quoted by J.M. Joosten in *Museumjournaal* 13/4, 1968, 209

The life of modern cultured man is gradually turning away from the

natural: life is becoming more and more *abstract*.

As the natural (the external) becomes more and more 'automatic', we see life's interest fixed more and more on the inward. The life of *truly modern* man is directed neither toward the material for its own sake nor toward the predominantly emotional: rather, it takes the form of the autonomous life of the human spirit becoming conscious.

Modern man – although a unity of body, soul, and mind – manifests a changed consciousness: all expressions of life assume a different appearance, a more *determinate abstract* appearance.

Art too, as the product of a new duality in man, is increasingly expressed as the product of cultivated outwardness and of deeper, more conscious inwardness. As pure creation of the human *spirit*, art is expressed as pure aesthetic creation manifested in abstract form.

The truly modern artist *consciously* perceives the abstractness of the emotion of beauty: he *consciously* recognizes aesthetic emotion as cosmic, universal. This conscious recognition results in an abstract plastic art – limits him to the purely universal. That is why the new art cannot be manifested as (naturalistic) concrete representation, which always directs attention more or less to particular form even when universal vision is present – or in any case conceals the universal within itself. The new plastic art cannot be cloaked in what is characteristic of the particular, natural form and colour, but must be expressed by the abstraction of form and colour – by means of the straight line and determinate primary colour.

These universal plastic means were discovered in modern painting by carrying through the process of consistent abstraction of form and colour: once these were discovered there emerged, almost of its own accord, *an exact plastic of pure relationship* – thus the essence of all emotion of plastic beauty ...

Harry Holtzmann and Martin S. James (eds. and trans.), *The New Art - The New Life: The Collected Writings of Piet Mondrian*, London, 1987, 28-29, originally published as "De Nieuwe Beelding in de schilderkunst" (The new plastic in painting), in *De Stijl*, I (1917), 2-3

Painting is: bringing colours together to form a unity. The means of expression of painting is colour and nothing else. This has always been more or less the case, but objects were used to give the colours definition, support, for the sake of the composition. But arms and legs, people, animals and plants are not essential means of expression for a painterly harmony. The *true* visual means, the means through which the painter actually achieves unity or harmony, *visualises* them, in colour. Everything else is forced on him.

In no other age has he been so aware of this as in our own.

Unity, harmony (not naturalistic, but aesthetic) is the subject of painting and of art in general. While working, the painter has come to realise that there is a difference between symbolising harmony by means of figures – the method of the so-called Symbolists – and visualising it, that is to say achieving harmony in painting through the relation of colour to colour.

Painting does not aim to make propaganda for a particular set of feelings or ideas such as religion, socialism, theosophy, etc. Nor does it aspire to imitate. Painting – and art in general – aims at that one fundamental feeling which encompasses all the categories of feeling: to visualise, that is realise, unity, harmony, using only the mean that is characteristic of it: colour ...

Theo van Doesburg, "Over het moderne schilderen" (On modern painting) in *De Stijl*, IV, 3, March 1921, 33-34

In the art of those who after Expressionism felt the influence of the Surrealists there is a remarkable contradiction or tension between the freedom with which motifs from the unconscious are let loose in the forbidden world of daylight and the frenetic efforts to achieve a smooth, exact, cool, workmanlike manner of painting, the more detailed as the actual content seems more mysterious, more uncertain. A dogged earnestness, a sombre and irritated or cynical turning to reality, led some to speak of "new objectivity", which superficially conveys something of this art, which incidentally was very far from objective under the surface. Later, people talked of "magic realism" ...

The year in which Hitler came to power, in which signs of crisis made almost the whole of life uneasy, created the psychological atmosphere in which the new came into being. It was typically Dutch that the younger painters [such as Willink and Pyke Koch] should have concentrated on a changed way of painting which again limited itself to detail. With this detail they brought the natural reality of things closer. And as a result our great seventeenth-century tradition of the still life almost automatically regained its power over painting. Art became more national, though this was accompanied by an increasing sense of anxiety. It was nationalism in desperation ... The craft of painting became a value in itself, and stood in the case of some in opposition to the modern aesthetic of the Ecole de Paris. With astonishing speed artists who had earlier been Impressionists, and sometimes Cubists afterwards, proved able to behave like modern seventeenth-century painters. They were again masters at rendering materials and the same *tours de force* performed in the past with insects, fruit, nails, and spots, for which the burgher was delighted to be able to use his magnifying glass, were now

done with dead birds, chains, pebbles, flowers, and so on. With the will to see more clearly and sharply came the will to find the technique which would achieve this. But not as a smiling pleasure, rather as a doggedly pursued duty. The oppressiveness of the times also had its effect. On the one hand, there was the increasing urge towards security in technique, something to hold on to, a basis, though this could not give real security. On the other, there was the growing sense of uneasiness with the culture, so that all delight in reality regained, every smile at the happiness of the pleasant detail of life, turned into deadly earnestness or irony, a rigidifying, a dulling ...

A.M. Hammacher, "De Schilderkunst in de jaren van oorlogsdreiging 1932-1940" (Painting in the years when war threatened 1932-1940), in *Stromingen en persoonlijkheden*, 1955, 36-37, 134-35

Western art, once the celebrator of emperors and popes, turned to serve the newly powerful bourgeoisie, becoming an instrument of the glorification of bourgeois ideals. Now that these ideals have become a fiction with the disappearance of their economic base, a new era is upon us, in which the whole matrix of cultural conventions loses its significance and a new freedom can be won from the most primary source of life. But, just as with a social revolution, this spiritual revolution cannot be enacted without conflict. Stubbornly the bourgeois mind clutches on to its aesthetic ideal and in a last, desperate effort employs all its wiles to convert the indifferent masses to the same belief ...

The general social impotence, the passivity of the masses, are an indication of the brakes that cultural norms apply to the natural expression of the forces of life. For the satisfaction of this primitive need for vital expression is the driving

force of life, the cure for every form of vital weakness. It transforms art into a power for spiritual health. As such, it is the property of all and for this reason every limitation that reduces art to the preserve of a small group of specialists, connoisseurs, and virtuosi must be removed.

But this people's art is not an art that necessarily conforms to the norms set by the people, for they expect what they were brought up with, unless they have had the opportunity to experience something different. In other words, unless the people themselves are actively involved in the making of art. A people's art is a form of expression nourished only by a natural and therefore general urge to expression. Instead of solving problems posed by some preconceived aesthetic ideal, this art recognizes only the norms of expressivity, spontaneously directed by its own intuition. The great value of a people's art is that, precisely because it is the form of expression of the untrained, the greatest possible latitude is given the unconscious, thereby opening up ever wider perspectives for the comprehension of the secret of life ...

In this period of change, the role of the creative artist can only be that of the revolutionary: it is his duty to destroy the last remnants of an empty, irksome aesthetic, arousing the creative instincts still slumbering unconscious in the human mind. The masses, brought up with aesthetic conventions imposed from without, are as yet unaware of their creative potential. This will be stimulated by an art which does not define but suggest, by the arousal of associations and the speculations which come forth from them, creating a new and fantastic way of seeing. The onlooker's creative ability (inherent to human nature) will bring this new way of seeing within everyone's reach once aesthetic conventions cease to hinder the working of the unconscious ...

Because we see the activation of the

urge to create as art's most important task, in the coming period we will strive for the greatest possible materialistic and therefore greatest possible suggestive effect. Viewed in this light, the creative act is more important than that which it creates, while the latter will gain in significance the more it reveals the work which brought it into being and the less it appears as a polished end-product ...

A living art makes no distinction between beautiful and ugly because it sets no aesthetic norms. The ugly which in the art of past centuries has come to supplement the beautiful is a permanent complaint against the unnatural class society and its aesthetic of virtuosity; it is a demonstration of the retarding and limiting influence of this aesthetic on the natural urge to create. If we observe forms of expression that include every stage of human life, for example that of a child (who has yet to be socially integrated), then we no longer find this distinction. The child knows of no law other than its spontaneous sensation of life and feels no need to express anything else. The same is true of primitive cultures, which is why they are so attractive to today's human beings, forced to live in a morbid atmosphere of unreality, lies, and infertility. A new freedom is coming into being which will enable human beings to express themselves in accordance with their instincts ...

The chalkings on pavements and walls clearly show that human beings were born to manifest themselves; now the struggle is in full swing against the power that would force them into the strait-jacket of clerk or commoner and deprive them of this first vital need. A painting is not a composition of colour and line but an animal, a night, a scream, a human being, or all of these things together. The objective, abstracting spirit of the bourgeois world has reduced the painting to the means which

brought it into being; the creative imagination, however, seeks to recognize every form and even in the sterile environment of the abstract it has created a new relationship with reality, turning on the suggestive power which every natural or artificial form possesses for the active onlooker. The suggestive power knows no limits and so one can say that after a period in which it meant *nothing*, art has now entered an era in which it means *everything* ...

Constant Nieuwenhuys, "Manifesto", in *Theories and Documents of Contemporary Art: A Sourcebook of Artists' Writings* (edited by Kristine Stiles and Peter Selz), Berkeley, 1996, 204-208; originally published in *Reflex*, Orgaan van de Experimentele Groep, I, 1, 1948

———

Zero does not aim at geometry. This may be self-evident, but is certainly clear from a comparison between zero products and truly geometric things. Naturally, geometry has a role in the art of zero, but not a dominant one. Zero does not wish to give a geometric construction, but uses geometry to explain a point of view. The geometric aspect of zero arises from the element of repetition, the placing in rows (*Reihungen*).

This arrangement stems from the need to avoid preference. The absence of a preference for certain places and points in the artwork is essential for zero and necessary for giving isolated reality. The geometric side of zero is thus attuned to extreme simplicity, an organisation of highly complicated forms, reality derived from truth.

Zero is in the first place a new view of reality in which the individual role of the artist is reduced to a minimum. The zero artist simply chooses, isolates, parts of reality (materials as well as ideas derived from reality) and shows them in the most neutral way possible. The avoidance of personal emotions is fundamental to zero. Things are ac-

cepted as they are and not changed for personal reasons; changes are made only when they are necessary to show reality in a more intensive way. Alterations serve only to isolate and concentrate parts of reality. Time and space are virtually synonymous. An accumulation through repetition of one motif, one thing, one object, one part of isolated reality implies, apart from rhythm and time, a suggestion of absence of time, of timelessness, because of the repetition. This antithesis as a result of the element of *Reihungen* embodies, despite the monotony, the greatest possible tension. Zero does not wish to draw attention to this in the first place, but accepts it as a fundamental element of reality.

Zero's principal task is to show the essence of reality, the true reality of materials, of localised things in isolated clarity. Zero's method is determined by its starting point. It is not zero's intention to create a new form. The form is already given by isolated reality. The aim is to found reality as art in an impersonal way.
Delft 1964

Jan J. Schoonhoven, "zero", in *De nieuwe stijl*, I, 1965, 118, 123

———

These are a few shameless confessions. Here is the first straight away: I believe in *l'art pour l'art*, art for art's sake. My second confession is that until recently I didn't know myself that I was an artist who made art for art's sake, but others have made this clear to me. At first, I was content with this knowledge, and didn't think much more about it, but recently, perhaps because it is characteristic of man to want to know what and who he is, I have looked at publications on the subject to see what it means to be an artist who makes art for art's sake. It is still not clear to me what and who I am, but I have learned that I am someone who is concerned with the individual artwork, also known

these days as the isolated artwork. These artworks are produced by rather unworldly romantics and eccentrics; they are totally outdated and on the whole nonsense, criminal or at least highly suspect. The modern description often applied to this type of artist is that he is on an ego trip, and not concerned with anything else.

Be this as it may, reading such articles made it clear to me that my products are not art as art should be. For art should have a message, should be committed and thus have a social function. Art should be a political pamphlet in the struggle against injustice and serve to promote social and who knows what other kinds of reforms. Stunned, baffled, and tormented by a deep sense of guilt, I have pondered all this for many hours, but now I've managed to recover to the extent that I dare to observe that in my view it is foolish and stupidly arrogant to imagine that through art one can make statements that will lead to social, political or any other reforms.

I also believe that the individual artwork can never be anything else than a statement about reality, however subjective – and it is precisely subjective, individual and less obvious thinking about reality and experience of it which results in infinitely more interesting and meaningful statements than the all too self-evident pronouncements of committed artists and theorists.

In itself what these artists and theorists put first – commitment – is not dangerous, in fact fairly harmless. What is less harmless is that many of them argue or demand that every artist should be concerned with this, supposedly on the grounds of his responsibility to the public, which boils down to the notion that the artist should be someone who sits up straight, minds his manners and says what everyone already knows but would love to hear one more time.

The artist and art must be the con-

science of the rest of mankind. But I say that the only responsibility an artist has is to himself, his art.

In all this I have still not given an answer as regards my view of the place of art and its function in society. My answer to this question is as follows, and this is what is unique about art: art has no function; that is the only way it functions in society. The function of art is not to function; to put it another way, perhaps more clearly, art is opposed to (and even hostile to) functioning, that is annexation, adaptation, and adoption. But above all art is about feeling and giving form to it.

Reinier Lucassen, "De kunstenaar heeft alleen verantwoording tegenover zichzelf" (The artist bears responsibility only to himself) (1976), in *Lucassen: schilderijen, tekeningen, assemblages 1960-1986*, Amsterdam, 1986, 62

When Jan Dibbets was ten years old, his father took him to the Rijksmuseum in Amsterdam to see the national art treasures, an obligatory visit for all good Dutch boys, sweetened after it by a boat trip around the city's canals. Dibbets remembers how his father explained Rembrandt's *Nachtwacht* (Nightwatch), telling him it was the greatest Dutch painting. It certainly was impressive to a small boy, but Jan preferred the cool, transparent church interiors of Pieter Jansz Saenredam. His father, as a father should do, was introducing him to Dutch culture; he, however, started to look at paintings, at *individual* paintings, as an artist does. Eight years later when he went to art school, by then convinced that Piet Mondrian was the greatest painter of the twentieth century, he was shocked to learn that in art school, his view was not generally held, and he was taught to draw in the traditional manner, after casts of antique sculpture. The daily practice of learning the skills of art, the orientation towards craft, made

him almost forget Mondrian. From the point of view of the crafts he was learning, other artists seemed more exciting, artists such as Francis Bacon, Max Beckmann, and Pablo Picasso, because they are, on the level of craft, more accessible and more useful than Mondrian. Beckmann or Picasso can teach you how to make an interesting painting; one can imitate them with slight variations. But to imitate Mondrian is ridiculous. Mondrian requires a different frame of mind. For Mondrian you must give up what you always thought was beautiful ...

R.H. Fuchs, "The Eye Framed and Unframed", in *Jan Dibbets*, Minneapolis, Walker Art Center, 1987, 47

... It seems as if every artist has the feeling that he must start by re-inventing art.

... For me it was a real discovery to find that in his church interiors Saenredam was actually a seventeenth-century Mondrian. That is a mentality, and hundreds of years later exactly the same thing happens again, so you can say that the invention is different each time, but it comes from the same source.

... Is Saenredam a conscious – it's difficult to phrase this – model, reference point...? ...

My reference is Saenredam. I want that to indicate something, to say on the one hand something about abstraction and on the other how that abstraction can be present in a figurative image; it doesn't have to look like a Mondrian. It's odd that these things were already present before I ever thought that could become a reference point, you see. They just re-emerge twenty years later ...

Rudi Fuchs in conversation with Jan Dibbets, Amsterdam, 1984 (from the booklet accompanying the videotape published by Openbaar Kunstbezit, 1985, 9)

Suppose we think about the famous contrast between Cézanne and Van Gogh. Can we say that, in general, there are two kinds of painters? One kind who make everything still, like Cézanne. And another kind who keep everything in constant movement, like Van Gogh and you – there is movement everywhere, in every detail, in the mixing of colours, the rhythm of the brushwork, the drawing.

Yes, you could say my work is more baroque. Equally, looking at Van Gogh, you say he's more baroque than Cézanne. If you look at Vermeer and Rembrandt, Rembrandt is more baroque than Vermeer. There are two sides: you have Cézanne and Van Gogh, Matisse and Picasso. These two sides are always present in painting. They are two ways of looking at things. I have both sides in me. I can use both the calm, reflective element and the baroque, expressionistic side.

My colour is always alive, because I'm always concerned with the light – something you achieve through mixing. I've always mixed, wherever you look, because of the light. So it's not the contrast of an aesthetic colour scheme that's important but the light. I mix my colours. I'm always painting the light. The mixing is the basis of the light and that is probably typically Dutch. You see it in De Kooning, in Rembrandt, in Van Gogh, in Mondrian, in Bram van Velde, and in me. The mixing of colour is used not just to revitalise the aesthetic oppositions or make them more beautiful, but because the light is more important. More important than the colours. We use colour to give shape to the light and materialise it. In fact I've never mixed a colour in order to say: that blue looks beautiful against that green. I've always done it because of the light.

Do you think it has to do with the Dutch landscape? What always strikes me is the difference between the Dutch landscape and for exam-

ple Tuscany, which always has a motionless quality. Here the wind is always blowing, the light moves, the water moves, the clouds move, everything is constantly on the move.

Yes, the clouds are always very mobile in Holland. You can see that in the cloud painters of the seventeenth century; the sky is forever changing. The rain is lashed along by the wind. Lashing rain is wonderful: it changes the rhythm, the colour, of the landscape. If you look in an abstract way, if you look across the land meditatively, you see that the rain is no longer rain but a rhythm that completely changes the colour and the landscape, just as clouds change the sky, something you see often in northern countries like Holland and England. There are clouds in the south, of course, but it's different there. The stillness of nature, the stillness of the mountains, the steel-blue sky, and the heat are the determining factors there.

Van Gogh was in the south but wanted to come back north at a certain point. He felt the need for grey – grey skies and grey weather.

Isn't that fantastic? He needed the south so much that it was down there that he painted until he dropped, he made a good job of that. If he had gone back with that experience of colour and rhythm and started painting the Brabant landscape again, you would really have seen something. That rhythm in grey and the brightness... But it was not to be. He did paint that landscape, but in the Dutch tradition of Breitner's brown colours. Whereas if he had painted it later, they might have been the finest Van Goghs ever. The very last works have something of that quality. The late work with the grey sky and the landscape a superb green – you see that a lot in Holland. In the late afternoon after a rainy day you suddenly see what Van Gogh painted, that light yellow-green landscape under a dark sky.

309

From "In Monaco, September 1990: Karel Appel in gesprek met R.H. Fuchs" (In Monaco, September 1990: Karel Appel in conversation with R.H. Fuchs), in *Karel Appel: ik wou dat ik een vogel was, berichten uit het atelier* (Karel Appel: I wish I were a bird, reports from the studio, edited by R.H. Fuchs), Haags Gemeentemuseum, 1990, 133-35

... In the 1960s, when I started, little thought was given to the fact that an artwork has not only a form but a content. Artists had forgotten that art is not about a Danish interior in which a Cobra painting must also hang. They had forgotten that art can also be a difficult object that you have to think about. In those days it was useful to point out that attention needed to be given to the content, the concept. By that time Abstract Expressionism had become completely aestheticised. To the level of attractive colours and forms then, to attractive ideas now. Conceptual art and its postmodern offspring seem to have become a new academicism.

... Making art means employing a language, just as with a text. As an artist you are aware of art history, you are aware that you are building on the basis of what already exists. You can still communicate with the past and with the present as long as people understand the language of art.

You use materials that are available and that everyone knows in order to convey something else with them. Whether you do that with paint or with theory as materials makes no difference. They are both forms. The story you tell may be of great importance but still produce a bad painting if its form is weak. Conversely, the story may be insignificant but its form more successful. These are great mysteries.

I spoke recently to a curator at a large museum of modern art in Amsterdam. He had just organised an exhibition of works by young artists. I told him that they looked identical to works done twenty years ago. Even the names were the same, only the surnames had changed. No, he said, they may look like earlier works, but they are different. What matters now is speed. To which I replied that with luck things would happen so fast that you wouldn't even see all that art!

This is typical of what is happening. Everything turns on speed, because the advantage of speed is that you don't have to think about anything. One thing is instantly followed by the next, so that you can never finish anything, you never have to pause to consider anything, you can never enjoy anything, because the next treat is waiting round the corner. An enormous lucky dip has come into existence full of things that seem to me worthless. Art of today is apparently often about exchanging information. I ask myself: What do you do with that information? But that is not important, it seems, just as long as information is given.

Art is complicated. Art is dangerous because it brings about isolation. The artist is alone and in his solitary state he produces the Great Secret which will radiate to the viewer. He too will feel alone in his viewing. He is thrown back on himself because he must make a judgement on his own ... An artwork is an invitation to form an individual judgement.

... Over the last twenty-five years, we West European artists have looked enviously at New York. We saw it as the Mecca of art and as artists we wanted to be as international as possible. In our yearning to be part of the big structures we lost sight of the art of proximity. For being part of a big structure is comfortable and agreeable. It gives you a sense of security if you act, smell, think, and talk like your neighbour. Group feeling is a safe feeling; it is recognition. But people also seek out the group because of fear of the individual.

And art is exactly the opposite of mass communication. The more the world becomes a global village, the more art moves in the opposite direction. This is why it is important for art to be about very personal things. Indeed, I would like to call for an art of intimacy, for sticking close to one's own soul. I will argue for an art of Big Words: intimacy, stillness, concentration, mystery.

I've always been jealous of the painter who went out of doors with his easel. I know that's not on any more, that it's become an untenable position, and I'm not calling for a return to it, but I've always missed that: the poetry of proximity. This, combined with my finding that there is no hierarchy of subject-matter, makes it clear that in art there is only one question: what do you do with a subject matters? And that's what it has always been about – someone expressing what he felt as an individual. Because he wants to share that experience, the artist must express himself in a way that others can recognize. This is why art is always about rearranging familiar things.

Ger van Elk, "Het is van God gegeven" (It is God-given), from Van Elk's acceptance speech after being awarded the 1996 J.C. van Lanschot prize for sculpture; printed in *Jong Holland*, 4, 1996, 50-53

For me painting was not a sudden trendy switch to another medium. I have always painted and drawn. And it was never so expressionistic as to be out of control. I don't think that is possible anyway. I always felt that I must keep it under control. I wouldn't be able to paint very expressionistically. But I have let the qualities of the paint express more ... I think a lot about form and content. That's why the appearance of my work sometimes varies a good deal. Form and content must be in balance. I see a lot of things which seem to me to have gone wrong, so that I think: This has been misconceived; it shouldn't have been done that way ...

I never just start painting. With drawing it's different, and I make use of what I draw, but I never just start painting.

In my work I always begin with an idea. I do it first on a small scale, because I think the idea must be perfect, as perfect as possible. In the past it often worked like this: I set to work with a certain idea in mind and that was then turned upside down by all kinds of things. Or by aesthetic considerations, because I thought one way looked better. Now I try to avoid that as much as possible. Even if I think something is not all that beautiful, I leave it as it is, because it has to be that way. Or more was added while I was working and then I couldn't sustain the idea, with the result that I had to stop and make a new plan. Sometimes it's nice to go back to old things you've abandoned. Then you get an unexpected confrontation.

The idea is what makes the work stand up and what makes it less non-committal than it would be if you sacrificed everything to the paint.

The images can arise in various ways: two pictures may be lying on top of each other in the studio, or something unusual may come to your mind. They arise through association, but are not neutral. They must have something that makes them stick in the mind. They must have a compelling quality.

René Daniels in conversation with Geurt Imanse and Mieke Rijnders, in *Over schilderkunst* (On painting), Amsterdam, 1983, 16, 19

At the beginning of the 1990s (or end of the twentieth century) it is evident that the workings of suggestive artworks need re-examination. It has become clear that all artworks that *suggest* narrative put the viewer on trial (or, 'on stage', if you prefer the terminology of the

theatre to that of the courtroom).
In literature, in theatre (Ionesco,
Beckett, Genet ...) and in film
(Resnais, Godard ...) this is old
news. (In certain recent advertising
there is an analogous develop-
ment.) They have dealt with am-
biguous images. Works that are
built to accommodate a multiplici-
ty of equally plausible interpreta-
tions. Yet works that do give the
outsider the feeling of: If-you-
don't-know-it's-no-use-me-telling-
you. (Wasn't that what Gary Coop-
er said to Grace Kelly in *High
Noon?*) Yet all of these media dealt
with a type of storytelling and an
unfolding of time from the start.
Painting, on the other hand, is on-
tologically of a different order and
by its character 'out' of time. So
even when you deal with paintings
that show affinities with these art
forms, you cannot ignore these im-
portant differences. While twenti-
eth-century art in general 'express-
es' rather than 'explains' and 'veils'
rather than 'exposes', "the privileg-
ing of reading over 'imagining' was
of central significance for concep-
tual art. (Linguistic theory has
taught us to read pictures, rather
than to imagine meaning.)"[3]
So here we are bending ourselves
over backwards to 'read out' and
'read in'. Fools rushing in "where
angels fear to tread" eager to enter
the work and possess the secret.

Marlene Dumas, *Miss Interpreted:
Marlene Dumas*, Stedelijk Van
Abbemuseum, Eindhoven, 1992,
26
[3] Nicolas de Ville on Gerard
Hemsworth, *Between Shopping and
Reification*, Self-Portraits Matt's
Gallery, London, 1978

Bruegel our god, Bruegel our father, beacon of joy forsaken by Baudelaire, beacon of marvels and delightful mirages.

Our companions, friends from France, are unaware of the colours of our pictures. One of them said to me: "Bruegel – a small master, an illustrator of Rabelais". Or again, "De Braekeleer – he's good; but we've got Bonvin – and he's better!". But a pleasant wind of change on this subject is rustling in France, launching our sensual painters in Paris. Yes, our gestures are pictorial, our inventiveness enormous, our thoughts tragicomical, our temptations ludicrous, our desires earthy, our paradise doughy and made of milk, and our hovels made of butter. The other day I was being a good Belgian in front of Edmond Jaloux, the most delicate of critics in France, when, carefully sponging a bit of my painting, I polished the precious enamel, the sonorous material of the colour of my home. Then, I dreamed of our blond serving-girls, chickens from the land of plenty, squatting beautifully, with ease, in the age-old way, washing, dusting, soaping floors, parquets and boards, porcelains, earthenware, brasses and vessels, with the great reinforcement of pure water and fresh soap.

James Ensor, "Discours prononcé à l'occasion de la commémoration Breughel à Bruxelles" (1924), in *Mes écrits*, 5ème éd., Liège, 1974, 85-86

———

Dear brothers-in-law of France, you will see the interior of my house more closely, my kitchen with curly cabbages, my bearded fish, striped, my modern goddesses, animalised, my friends with tight lips, reddened and simpering adorably, my rebellious angels glimpsed between the clouds, and I will be well represented.

All paintings come from I know not where, from the sea above all.

And my suffering masks, scandalised, insolent, cruel, wicked and, I was able to say and write, a long time ago, "tracked down by the followers I am joyously confined within the solitary habitat where sits enthroned the muzzled mask of violence and clamour".

And the mask shouts at me: freshness of tone, intense expression, sumptuous decor, large, unexpected gestures, disordered movements, exquisite turbulence.

Oh! the animal masks of the Ostend carnivals: faces of vicunas, birds imperfectly detailed with paradise tails, cranes with azure beaks clamouring half-witted lies, architects with clay feet, obtuse pedants with fusty skulls, filled with fireclay; vivisectionists without heart, singular insects, hard shells protecting soft creatures. Witness "the Entry of Christ into Brussels" swarming with all the hard and soft species vomited up by the sea. Won over by irony, touched by the splendours, my vision becomes more refined, I purify my colours, they are entire and personal.

James Ensor, "Discours à l'occasion de mon exposition au Jeu de Paume à Paris en 1932", in *Mes écrits*, 5ème éd., Liège, 1974, 163-64

———

One is quite surprised when one considers the dates of the first works produced by Ensor, and then one measures all the irrepressible resolve, all the spirit of naughtiness of his genius. In 1876, while Impressionism was coming into being, he was painting the sea, the dunes, maritime countryside in a black and desolate tone, with a lyricism that was completely his own. Then there were, five years later, his masterpieces of realism and intimacy. If his open air is heavy, no less heavy are his ceilings and drapes, all that domestic and bourgeois atmosphere where the smallest flower, the most inconsequential brass, the slightest presence are exalted with a mysterious plenitude. The unfettered fertility of the Belgian genius is found, is concentrated in this particular domain where he excelled – that of the interior and interior things. And that, with Ensor, with an extraordinary power, tragic and at the same time comical. And that marvellous pictorial science! What feeling for air, for shadow and matter! All the means proper to the art of the paintbrush are put to good use here to express suggestions which touch the soul and are the art of the poet. Then the palette is cleared at the same time as the imagination takes off on a new flight. From the sombre to the dazzling, Ensor follows the same curve as Van Gogh, his contemporary and brother in expressionism. It is also the curve of Redon. Colour washes the world of Ensor, is made meticulous, mottled, coruscating. The mystery, in these new clothes, is always just as intense. An insatiable appetite for poetry never ceases to animate this luxuriant production. The whole period of the time was given to poetry. Belgian Symbolism, developing side-by-side with French Symbolism, intermingling its own leaves and branches with it, claims Ensor as one of its most glorious poets. No, one could never say enough ... of the importance – in this exceptionally fertile climate which renewed human awareness – of Belgian Symbolism. The towns of Belgium, with all their flame confined by their past of art and fable, all their power of secrecy, of solitude, of dreams, of joviality and melancholy, have engendered then a lyricism that responds to the inventiveness of the illustrious precursors of French Symbolism and the whole flowering that followed it on the *rive gauche* of the Seine. Certainly, Ensor was famous in France at that time, as is witnessed – at the end of the Symbolist adventure in 1899 – by the edition of "La Plume" dedicated to his work as an engraver, work comparable to that of Rembrandt. It continues to be so when we link it to that period of communion between France and Belgium.

Jean Cassou, *Panorama des arts plastiques contemporains*, Paris, 1960, 541-42

———

At Ostend, a city where the weather is fickle, Ensor felt himself to be in his true, physical climate, in the natural environment where his roots could nourish themselves and the flowers of his imagination could thrive. Since his childhood his lungs, his nervous system and brain had been fanned by the winds and breezes of Ostend, a salty sea-air, sparkling with light, lashed by wind. The morals and habits of the town – varying from the conventional to the licentious, with folklore next to petite bourgeoisie, stylish next to garish exhibitionism, dress-coats, in fishermen's garb or bathing costumes – taught him to assess human passions. The spirit of art is embodied in flesh, and the flesh in Ensor's art is that of his city. In consequence, his affection for the city never ran dry. He sang its praises: "Ostend, sovereign fairy of the multicoloured heavens and waters / Ostend, bouquet of gladness, freshness, of health and powerful humanity / Ostend, strange city. Paradise of our painters. Goddess of blond light / Ostend, I have drunk of your pure and salty milk, the delicious milk of the sea...". Throughout his life, in every period of his work, in his letters, his conversations, and his articles, his love for Ostend asserts itself, bursting out again and again.

Ostend can make innumerable claims to the love of its painter: the fields that surround the town, vaulted and magnified by gigantic spaces with clouds and light, the dunes with their soft forms and crowned with sedges, the breezes with their fantastic capriciousness, the majestic presence of the sea, the Winter mists and the moans of the dark season, the Summer fanfares, the gay panoply of colours and

smells from the harbours and docks, the frank language of the people, the rural life touched by cosmopolitanism, the eccentricity and comedy of the bathing season, the carnival with joyful masks against a background of sorrow, the pathos of the storms, intertwined with moments of deep, silent rest. Each of these aspects finds a response in some aspect of Ensor's work.

Paul Haeserts, *James Ensor*, Bruxelles, 1958, 44

The dead towns of Belgian Symbolism were real, existing places which were in a state of decay, such as Bruges, Ghent, Veurne, Mechelen and others. Their decay inspired idealisation of the tangible and the interweaving of states of mind with the external environment. These towns were far away from the commercial metropolis and its fast pace of change. It was mainly the magical canal cities and towns which questioned the stability of existence, ambiguous Atlantises, drifting in an indefinite state, at once earthy and aqueous. In the canal city the Belgian Symbolists discovered an extremely suggestive landscape for their visionary experience. The watery depths and the blindly winding meanders provide a structural metaphor for the unconscious mind. A journey of initiation in a canal town means not only a farewell to the world, a symbolic disembodiment and descent into the underworld, but also an exploration of the shadowy depths of the unconscious. Geographical cities were transformed into literary towns of the soul and of "Other Worlds". This was achieved by means of figurative obfuscation (weather conditions such as incessant rain and fog cloud and blur reality and deny the nature of its substance) and by an ever-present metaphor for the attente, the expectancy of time that is still. Lethargic cities of still water were

used by the Symbolists as images for that still, inner space where the possibility of progress ceases to exist. Progress – the obsession of modern times – is contradicted by the frozen activity of a museum city in which the present is for ever being dissolved in favour of a legendary past or hurtling towards a situation of languishing decay.

Donald Friedman, "Het Belgisch symbolisme. Een poëzie van de ruimte" (Belgian Symbolism. Poetry of space), in *Les Vingt en de avant-garde in België. Prenten, tekeningen en boeken ca. 1890*, tent. cat., Gent, Museum voor Schone Kunsten, 1992, 103-104

When we come to the first group, which opted for Sint-Martens-Latem as a home in the years 1897-98, it would be just as difficult to speak of a school as such, were it not for the presence of a common spirit, which indeed lives on, albeit revealed in diverse shades, and owing little to the Latem landscape. This first group is devoid of all formulas; yet something like a spiritual discipline in which each member of that group had a share (one, incidentally, that each elaborated and still elaborates according to his own temperament) could serve, albeit loosely and freely, as the bond that unites the personalities into what I would now like to call a school ... The first Latem group consisted of Georges Minne, Valerius de Saedeleer, Julius de Praetere, and the brothers Van de Woestijne ...
The Latem school, it has been said, is a mystical school. Let me immediately add that this is something of an exaggeration, and that, if the school did express itself in mystical terms, this was anything but deliberate. What united these artists in that period was a longing for things spiritual. It was the time when a rather superficial, luminist Impressionism prevailed: the last group was to react against this of its own accord. The essentially religious Georges Minne, the neophyte Va-

lerius de Saedeleer, Julius de Praetere, who was first and foremost a decorative artist, devoting himself to book-printing and the company of literati; Gustave van de Woestijne, who at that time felt attracted mainly to the art of the Flemish Primitives and was in origin over-sensitively devout; they felt little sympathy for Impressionism, which was insensitive to all but bare sensation. The chance that had brought them together was to intensify that reactive aversion; they came together often at table: readings were given from Plato and Ruisbroeck; they acquired a thorough knowledge of Shakespeare; the latest works of Maeterlinck, such as "The Life of Bees" and of Ibsen, such as "When We Dead Awaken", were recited to them; the voluminous library of Hector van Houtte was always open to them: it even happened that poets such as René de Clercq, who at that time was studying in Ghent, came to read their own works to them; at Van Houtte's home there was music-making: all this was to contribute to the creation of the atmosphere of which I spoke earlier, and which indeed, on account of the nature of those artists who formed the group, might be called mystical.

Karel van de Woestijne, in *De Nieuwe Rotterdamse Courant*, 2nd of June 1924

It has to be said: at the time that the Great War broke out, we in Belgium were neither particularly 'European' nor particularly 'modern'. Whilst elsewhere enlightened researchers had already begun to overturn form and to renew the spirit of painting and sculpture, we were still hanging on with singular obstinacy, almost voluptuously, to Impressionism – or to be more exact, to our own local neo-Impressionism. This reigned over us tyrannically, obscuring all our other gifts and exalting only a few of our qualities, in the end the least essential of

them. It seems to have been like a euphoria for us artists, and one might believe that even the optimism of this spontaneous and superficial art, its facility, its charm, had penetrated the finest minds, in order to dull them. The cult of the rustic, outdoor life, and the atmospheric painting had been imposed on us all, conquering the *hoi polloi* as well as the elite. There was even a moment when our art presented that curious situation of no longer offering that distinction – in my opinion, supreme, indispensable to its existence – between the avant-garde which seeks, explores, experiments, far from the madding crowd, and the bulk of the army marching along recognised paths which have already been cleared, applauded by those whose instinct is to follow, not to lead. With us, more or less everyone was under the spell of a few virtuoso masters, at heart very conformist, without great originality, but who were nonetheless taken for pure artists, almost for innovators. I will not cast the first stone: we were all more or less contaminated, in our narrow province. So, in all corners of Belgium, we were painting, with the same spirit, a great many landscapes – uniformly bright among those of Flanders where a perpetual idyll blossomed along pseudo-Arcadian rivers, in luxuriantly blooming fields, darker and more mobile among those of Antwerp which described the impetuous Schelde river, the polders and the moors – a great many still lifes and numerous interiors. Man and his drama, his physics and his metaphysics were neglected.
I still do not know to what to attribute this indifference which swept over a country that was generally extremely curious for new ideas and new men. Our isolation was to blame to a large extent, a sort of regionalist sufficiency, too much confidence in ourselves, the lack of intellectual exchanges, the absence of severe criticism. Was it

also our love of painting, that innate affection for the pictorial, which all too often encourages one to neglect the content of the work in favour of its appearance, which made us take pleasure, in a serene beatitude, in those subtle games of nuances and shadows, those refinements of colour, those shifts of light on the sky, on the grass, on the fabric, on the skin?

Abroad however, around 1910, there was already an aesthetic which was more thoughtful, and the first researches of the new art were being sketched out. Not only were we not taking part, but we knew almost nothing about it ...

Everything changed with the war, and the turnaround was as complete as it was sudden. It was a revelation for many of our artists. It led many of them to leave their invaded country to live in exile in Holland, France, and England. Uprooted without wishing it, fatigued by their torpor, placed before the evidence of a new art which, even by then, had taken root in those countries in strength, finding themselves in the presence of foreign confrères who were more informed, exchanging opinions and ideas with them, initiated into new forms of life, our painters gained with this exodus a breadth of vision, an experience, a renewal of their interior being, a stimulus which it is perhaps difficult to define for each of them, but which brought about the most fertile reactions. The war taught everyone the pain and joy of Man, the value of life, the great role of art in a society which was materially impoverished. It plunged them into an atmosphere of tragedy, far different from that of their youth, which was so carefree, so joyous and at heart so spineless. It liberated them from that nonchalance of spirit, that tepidness of heart, that rejection of effort, of which they had been the victims. And the bitter search began for all those men whose disquiet had suddenly been aroused – Gustave

De Smet, Frits van den Berghe, Jozef Cantré were in Holland, Gustave van de Woestijne, Constant Permeke, Edgard Tytgat in England. They developed very quickly there, less under the influence of the new theories or at the sight of unexpected works than under that of their internal ferment, their humanity regenerated by their intellectual and emotional preoccupations, the pain that strengthens, the curiosity that stimulates.

André de Ridder, "L'école belge contemporaine", in *Cahiers de Belgique*, IV, 4-5, 1931, 177-84

It is in the nature of his generation to explore life to its very foundations: this most elementary deed, by which Permeke pushes at a precipice of vitality in ferment, forces him to express this dynamic charge in the most direct manner in the observable world, both through the nature of the subjects he treats and through his artistic language. In all the lustre of high, Flemish-Burgundian culture that we read in the work of Van Eyck, we still find above all a rough, manly permeation into reality: a middle-class positive, honest mind for truth. Bruegel plunges once more – at a time when the world was expanding immeasurably through the journeys of the explorers and the religious reformation was tearing the whole Western world apart – with fantastic obsession into the fermenting life of a cosmos in a state of continual rebirth, with the cycle of the seasons and with the farmer at one with the earth. He trumpets his experience to the world in colour that has the same richness of tone as in Van Eyck's work, and sometimes, as in his *Cattle Returning* and in his *Storm*, is reduced to a monochromatic drone, giving us a powerful view of dark, subterranean powers. In a unique unfolding of the power of seething life, which the seventeenth century makes into the apogee of painting

in the West, we see in the work of Rubens too both the experience of nature and the lustre of colour which he uses with the power of one reborn, which is the essential condition of the act of a genius. He, too, spreads a luxuriance of tone that presupposes a rare, rich culture, as in the time of Van Eyck; at the same time there is a kindred, all-embracing appetite for the fullness of what for him was a happy life. His female nudes are attractive not because of perfection of form according to southern perceptions, but through their exaggerated, blond blossoming, like the tastiest fruits of God's beautiful creation. Ensor did not depict his life experience, at least initially, in the fullness of the painter's language: he starts out from the subdued palette of Vogels and not from the sparkling and crafted harmoniousness of De Braekeleer, and only when he uses a bright palette consistently does the exultation of colour come through. Though his colour satiated it with the word made flesh and blood, it still does not demonstrate the sonorous harmony of the absolutely Flemish palette. His father was English: would this factor not partly explain his very peculiar nature? With Permeke everything is proclaimed, from top to bottom, in heavily resonant, very sombre colouring and, responding to the essence of his discovery: the dark, threatening, fermenting primitive matter, still in bass chords tending towards a monochromatic drone. Only the perfection of the craftsman's technique, such as that which appeared at last in the full lustre of De Braekeleer's work, eluded him.

Walther Vanbeselaere, *De Vlaamse schilderkunst van 1850 tot 1950, van Leys tot Permeke* (Flemish Painting from 1850 to 1950, from Leys to Permeke), Bruxelles, 1959, 280-82

The thing that distinguishes young Belgian painters, in the general cur-

rent they are following, is firstly the union of two opposite qualities, of the direct rapport with life and the sense of the fantastic – qualities both inherited from their predecessors. They thus achieve a deeper truth than reality. By the felicitous choice of their subjects and by the way they treat them, we feel that they are living in the middle of everything they are painting, things animate and inanimate, places, landscapes as well as human beings, animals, flower-pots or boats. They are carefree and pick up their forms with both hands, preserving their original side, their flavour and yet knowing how to imbue them with something of the visionary, which removes heaviness and vulgarity from them. This transcendental element is to be found to a great extent in the colours which include blues and greens that are singularly mystical and that, often sombre, go to the point of engulfing three-quarters of the forms, making them into a confusing play of shadows with a trace of light.

Moreover, I see the Belgian character in the pleasure in their work, the pleasure of using the paste, of filling surfaces with colours, widely, but carefully. They play with it, they apply themselves to it. This is being a good artisan. In addition, certain canvases by the moderns – especially the bright ones – remind us of fine peasant furniture painted by decorators from the past who were real artists, more so than our salon artists.

G. Barth, reply to *L'enquête sur l'état actuel de la peinture belge*, special edition of *La Nervie*, 1-4, 1926, 27

It has always been the case that it was the presence or absence of 'psychological values' which determined the greatness or the sterility of artistic output. New 'psychological values' provoke the formation of new formal frameworks. The harmonious dosage of these two values produces 'style'. The adop-

tion of a new form that is not based on an internal renewal ends up as what is generally called a 'school'. The artist who allows himself to be classed in this category is confined within a 'formula'.

Working according to a predetermined formula and school is necessarily to reduce oneself to an imitation – an imitation including, in the best cases, some variant in the work. In spite of infinite cross-breedings and in spite of all the individual differences, populations do appear to be governed by racial possibilities of a general kind. In art, these possibilities determine the orientation of what is commonly called 'tradition'. Apart from certain exceptions, our national art has, since the Renaissance, not manifested much interest in those possibilities appropriate to it. Some people are blinded by the purely external peculiarities of their predecessors. The great mass were content to intercept signals from Paris. The modernist movement which, for several years now, is to be found everywhere, must be envisaged in the first place in the form of a reaction against the preceding period. In each country this reaction is manifested in a manner which is different and quite unilateral.

To enumerate the various lacunae of Impressionism is to determine at the same time the different particular reactions of Modernism. Each ethnic group reacts in fact according to its basic nature. The French reacted through Cubism (construction) against Impressionism (dispersion). Most of them, during this revolution, confused the means with the end. The human element, which was almost entirely absent in the preceding period, is also missing in the current works. It is simply a matter of changing our attitude. The backbone is missing from this attitude; it is weakening and ends up dying in academic neo-Classicism. The original Cubism never had any real adepts with us. Our nature refuses to be-

come enthusiastic about a development which is purely formal. Neo-Classicism only influenced those elements endowed with the academic manner here. Neither neo-Classicism nor those elements which allowed themselves to be influenced by it are of sufficient importance to deserve being fought against.

As is the case everywhere else, living forces are rare in France; they remain isolated and give rise only to temporary disciplines. What is true for the authentic French is much more so for the foreign elements that French art has appropriated, such as Chagall, Picasso, Zadkine, etc. Psychological values do not allow themselves to be copied, only the external form supports approximation. As far as we are concerned, we have a spiritual and emotional universe all our own, strongly characterised, and in this respect we cannot therefore undergo education different from that which we provide for ourselves.

Frits van den Berghe, reply to the "Enquête sur la Jeune Peinture Française", in *Sélection*, v, 8, mai 1926, 229-30

Pure image and community art were the two most current expressions to describe geometric abstract art which came into being in Belgium around 1920 and which constituted the local variant of international constructivism. In 1920, Paul van Ostaijen, in working out his theory on "abstract vision" with which every modern artist had to be familiar, spoke of "emancipated Cubism: that constructive direction in the new art". Here he was referring to the historical process which had come about from "subjective Cubism". "Emancipated or evolved Cubism" was the result of the purification process that consisted of the exclusion of the anecdotal and the casual, both in the vision of the artist and in the construction laws of painting.

Jozef Peeters, the Antwerp protagonist of community art, spoke of a blending between Futurism, Cubism, Expressionism and "new results that continually arise through and alongside the three pioneering directions". Indeed, after the end of the war, the neo-Plasticism of De Stijl, the constructivist developments in Berlin, the Abstract Cubism in France – and after 1920 Purism too – had their influence on the evolution of art in Belgium. The originality of Belgian art production in the postwar years lay not in the application of new plastic models, but in the personal processing of the impulses, in the synthesis, in "unorthodox variations of the predominant styles".

This probably explains the importance attached to the emphasis on personal identity, or at least on being different. Thus Jozef Peeters accepted the neo-Plasticism of Piet Mondrian – which he called pure image – as only another art form in addition to his community art, but he found it too doctrinaire: "Pure imagery, like community art, is the only direction which, seen from the outside, can lead the observer to perceive plasticity ...

Yet when we consider the work of Mondrian as a whole and always discover the same imagery principle, supported on the horizontal and the vertical, to suggest the greatest possible calm, we must confess that such a working method becomes a system ... against this we juxtapose the use of any geometrical constructive principle whatever it may be". In consequence, he was of the opinion that "the Dutch were too hasty in coming to the conclusion ... that they found the style of our civilisation". Victor Servranckx too, whose work distinguished itself between 1922 and 1924 under the influence of De Stijl, found it necessary to distance himself from the Dutch movement, like Jozef Peeters, for fear of plastic impoverishment.

Eric Pil, "Verschuivingen binnen de avant-garde. Evoluties in de plastische kunsten in België, 1917-1929" (Shifts in the avant-garde. The development of plastic arts in Belgium, 1917-1929), in *Avant-garde in België, 1917-1929*, tent. cat, Bruxelles, Musée d'Art Moderne; Antwerpen, Koninklijk Museum voor Schone Kunsten, 1992, 59-60

For me, the creation of a picture is an idea about something or several things which can become visible through my painting.

Of course, not all ideas are designs for pictures. It should be clearly understood that an idea has to be sufficiently stimulating for me to apply myself faithfully to painting the thing or the things that gave me the idea in the first place.

The concept of a picture – that is, the idea – is not visible in the pictures: an idea could not be seen by the eyes.

What is represented in a picture is that which is visible to the eye – the thing or the things that constituted the idea.

Thus, what is represented in the picture entitled "The Empire of the Lights" are the things about which I had the idea – that is to say, in precise terms, a landscape by night and a sky such as we see in the middle of the day. The landscape evokes the night and the sky evokes the day.

This evocation of night and day seems to me endowed with the power to surprise and enchant us. I call this power: poetry.

If I believe this evocation has such a poetic power, it is, among other things, because I have always had the greatest interest in night and day, though without ever feeling a preference for one or the other.

This great personal interest for night and day is a feeling of admiration and astonishment.

René Magritte, *Ecrits complèts*, texte établi et annotée par André Blavier, Paris, 1979, 422

Cobra was created in 1948 out of an attempt to re-group the international Surrealist movement and to get it out from under the leaden wings of Breton. That attempt was a bit of a damp squib, but resulted nonetheless in the foundation of the group by the Danish, Dutch and Belgian participants at the congress of "surréalisme révolutionnaire". Unlike the Jeune Peinture Belge, Cobra did have a coherent programme. First of all, the Surrealist roots were clear: a left-socialist orientation, a rejection of Parisian formalism and a preference for externalising the psychological automatism – a sort of counterpart to Freudian free association – in their paintings. In addition, the Cobra artists – such as Jean Dubuffet in France – cultivated a lively interest in the art of amateurs (children's drawings, naïve art, the art of mental patients, folk art), for magic symbols and for the latent pictorial value of writing. In addition, they shared the same taste for experiment and the desire to express themselves completely spontaneously, unhindered by aesthetic conventions.

Stylistically speaking, their work is characterised by the autonomy of line and colour, which follow their own 'natural laws', and by a synthesis which is difficult to define between figuration and abstraction. The Belgian contribution to Cobra was initially mainly concentrated in the person of the poet Christian Dotremont, who was, together with Asger Jorn, the most important driving-force behind the movement. Apart from Alechinsky, the Belgian fraction included only literati. For the rest, Cobra tried to supplement its Belgian members with artists whom the group perceived to have similar intentions and who were to some extent in the ambience of the Jeune Peinture Belge: Louis van Lint, Jan Cox, Raoul Ubac, Pol Bury, Jean Raine, Reinhoud (d'Haese), Hugo Claus, etc. were invited to make contribu-

tions to the eponymous magazine or to take part in their activities. The presence of Jan Cox causes the most surprise in this respect. After all, he had no more than superficial affinities with the attitudes of Cobra: his work, it is true, bathed in a poetic and surrealist atmosphere, but it is much more literary in character and it also lacks the wantonly uncompromising attitude of Cobra. To a lesser degree this was also true of the others. The most authoritative and original Belgian contribution in the field of painting is without the slightest doubt that of Pierre Alechinsky, who joined the group immediately after his first exhibition. Apart from being an inspired artist, the young Alechinsky turned out to be an enthusiastic inspiration to the movement. In the years that followed, he developed his highly personal, flamboyantly gestural style into organic, trembling-wavering compositions of which the figuration of primeval vegetation spreads out like a population of micro-organisms over the entire surface of the picture. The Eastern calligraphy, of which he acquired an extensive knowledge on a trip to Japan in 1955, was never to leave him from then on.

In the integration of the verbal element into painting, Dotremont had already paved the way with his "Peintures-Mots" at the end of the 1940s. Ten years later (1959), Englebert van Anderlecht, Serge Vandercam and Jean Dypréau exhibited their "Peintures Partagées": a combination of extremely agitated, dripping plastic writing with graffiti-like phrases (by Dypréau). And before that, Henri Michaux had already explored the plastic possibilities and travelled the realms of the subconscious under the influence of mescaline. Quite different – even in outlook – are the monumental, tense compositions of Antoine Mortier. They look like greatly enlarged calligraphic characters done with broad, masterly black brush-

strokes, but the structures thus created betray an expressionistic point of departure whose roots actually lie with Permeke.

Paul Van Calster, "Abstracte kunst wordt respectabel" (Abstract Art becomes respectable), in *De fifties in België*, tent. cat., Bruxelles, 1988-89, 229-30

We don't 'consider' painting any more, we 'have' it. It is an autonomous world, a body, which we don't simply look at but which we penetrate. It exists in itself, free from clinging subjectivity, closed and multifarious. It lives with what Willy Roggeman, referring to modern poetry, calls its own, absolute thing-character.

It is what distinguishes the 'third' generation of abstracts from the 'second'. Though the second, which came into existence largely after 1945 with the Jeune Peinture Belge, had gradually freed itself from external reality and though its abstraction also maintained memories of things observed optically, which frequently remained its starting-point, the centre of gravity for the third lay elsewhere. The younger painters, who had grown up after the war, were able to pursue their researches with greater freedom, both in depth and in width. Their work presupposes non-figurative conquest but comes about, beyond a clear dividing-line between figurative and abstract, in fields where contradiction has lost its meaning and where other tensions are to be found.

While their indirect predecessors maintain certain affinities, according to their personal sensitivities, with post-Impressionism (Van Lint, Ann Bonnet), with post-Expressionism (Mortier), with neo-Plasticism (Bertrand), younger artists like Burssens, Mara, Vandercam and De Leeuw are striving towards a completely different concept of painting. Rather than interpretation or Symbolism – which al-

ways implies consciously ordered intervention and the subjective transposition of a reality external to the pictorial reality – painting itself is for them the battlefield where everything happens, beginning and end in itself, the means *and* the end. Battlefield, field of exploration, laboratory and fertile soil.

Nature, a time-limit pushed out by technoid plastic art, celebrates its return in surprising fashion in an intoxication of biological-organic powers. The bloody ectoplasms of Landuyt, the grandiose gestations of André Bogaert, the avalanches of Van Anderlecht, the geologies of Leblanc – all the animal, vegetable and mineral crawling and looking for form in the cosmos – demand their place in it, metamorphosing, threatening or dissolving. Strongly emotionally charged, the concretions of an intense-living time in which everything is a probe into the nucleus and the essence of things, in which frontiers are continually pushed back or ruptured, in which the fear of death is overturned into a spasming, brutal and all-embracing love for life.

Marc Callewaert, *Hedendaagse schilderkunst in België* (Contemporary painting in Belgium), in *De Kunst-meridiaan*, VI, 1-2, Bruxelles, 1959, 35-37

Abstract art, it is true, systematically pushed aside figuration after 1945 but the opposition to abstraction nevertheless did not abate. True, this opposition identifies itself mainly with the defence of epigonism with the great figurative trends in the modern art from Expressionism to Surrealism. Nothing is so reassuring or soporific as post-movements. There are illustrated guides to and grammars of the original "isms", so that the work of epigones makes few demands. People recognise what others did better for them and accept this as a reassuring criterion.

It is also typical of the criticism that

accuses the current situation of epigonism, that it never complains about this epigonism in "retro-arts". From this corner of opposition people have regularly proclaimed the prophecy of the return of figurative art since the 1950s.

In 1960 it came back, but it was not recognised. It was not traditional figuration that made its entrance but an image of reality that was being formed by younger generations in accordance with their contemporary, urbane world of experience. The image is modern, related to the style of publicity and mass-media, relational, iconoclastic, redolent with the attributes of the urbane consumer society. The images are painted bright and fresh, clearly formulated, direct, open-handed, disarming. The argument of the opposition is that this cannot be art and thus the wheels of misunderstanding and incomprehension grind on.

The new imagery is Anglo-Saxon, Pop, New Figuration. In addition, there is the fascination of Francis Bacon. This volte-face takes place in an established art world in which abstraction has been pushing out waves of renewal since 1910, but which for years has been showing signs of running out of steam, especially where art is the expression of an emotional, tempestuous attitude of mind. Passionate outpouring soon becomes empty bombast, purely stylised posturing, senseless repetition without excitement or meaning. At first sight, it is an intriguing question – why the return of figuration sits so uncomfortably in the ranks of the lyrical abstracts and not in those of the cold abstracts. But then this is not so strange. It is clear that the motifs of the latter are more spiritual than emotional and that a mental discipline is less likely to lead to exhaustion than to continual expressionistic frenzy. A considerable part of lyric abstraction dwells like every romantic self-expression on the frontier of the self-portrait and

there is no reason in principle why this self-portrait should remain hidden in the mists of abstract style-figures.

The same goes for the dialogue with reality. How many figurative motifs are not hidden under so-called abstract forms and structures? How many artists have longed to return from abstract signs back to concrete reality, or rather, quite simply to identify art with freedom? This longing on the part of his contemporaries is described by Roel D'Haese when he was exhibiting his *L'Enfant Prodigue* (1960) in the 1960 Salon de Mai, this little man wrought by the hand of God, with his long nose and a bucket over his head, who sits dismayed looking at all that fuss. "They are all waiting at the start-line to make a sprint towards figuration, but no-one dares to do it."

Thus we see at the beginning of the 1960s figurative buds suddenly bursting on much abstract vegetation as though aroused by an early, warm spring.

Karel J. Geirlandt, "Van objekt naar nieuwe figuratie" (From object to new figuration), in *De jaren '60, Kunst in België*, tent. cat., Gent, Centrum voor Kunst en Cultuur, 1979, 35-37

Here, in the silence, under beams the colour of a monk's habit, a kind of coenobite of painting applies himself slowly to his work. Work or prayer? On one of the walls hangs a small piece of paper with this inscription:

Voici la nudité,
le reste est vêtement.
Voici le vêtement,
tout le reste est parure.
Voici la pureté,
tout le reste est souillure.
Voici la pauvreté,
le reste est ornement.

[Behold nudity, / the rest is clothing. / Behold clothing, / all the rest

is decoration. / Behold purity, / all the rest is filth. / Behold poverty, / the rest is ornament, Charles Péguy, "La tapisserie de Notre-Dame", in *Oeuvres Poetiques Completes*, Paris, 1949, 683]

A text by Péguy that we could well take for one by Gezelle! But let us not be more nationalistic than the Fleming: this sentence fits in perfectly with the climate of the place and with the person of Van Severen. His paintings are mantras, slowly ripened meditations, spiritual exercises taken to the point of saturation where expression is resolved into silence. The image is a very simple geometry, without colour, almost always symmetrical. It hypnotises if it does not leave one indifferent. For me these rare works, as rare as those of Brancusi, are carved in granite. They must be taken away from their environment and a new environment must be constructed around each of them. The strange feeling of finding myself here! I am not accustomed to this climate. I am no longer. Paris, the commercialisation of art, the purchased glories, the game of advertising, the nauseating snobbery, of which I am clearly an accomplice ... something has been wounded in me. I suffer from it incessantly, so used to that pain that I no longer notice. But here I do notice. I spoke of Brancusi, and I could also speak of Mondrian. Since I saw the atelier in rue du Départ, in Montparnasse, around 1925, I have not known that effacement of the personality coupled with a work which is a river Somme of spirit and culture. Somme and summit. And which remains hidden. It is in those places, however, that the conscience of the world resides.

Van Severen can remain silent, I have no need of comment, since everything is familiar to me here. I breathe as I have not done for a long time, as no doubt I shall not do for a long time to come.

And I rediscover my concept of value: burgeoning art, the complete

denuding of the spirit, a rare calm which suffices unto itself, something which cannot be weighed or measured and which is protected from commerce and spectacle.

Michel Seuphor, *La peinture abstraite en Flandre*, Bruxelles, 1963, 95

In spite of its echoes in other quarters, English Pop art has still remained very insular in its effect and influence. On the other hand, American Pop art is having a marvellous effect on the new figurative art, partly because at the beginning and in the work of its predecessors (Robert Rauschenberg, Jasper Johns and Larry Rivers) it was influenced by movements and artists from Europe and it made references to Dadaism, Surrealism and even Expressionism.

Has this new figurative art anything to do with pop art, as the founder of the new realism maintains? That question we shall try to answer, even though in a regional context. We get the first information for producing the answer from 1961, 1962, 1963 in Ghent and from 1962 in Antwerp. A real competitive battle broke out between Antwerp, where Hessenhuis was going through its last flickerings, and Ghent, where a group of collectors, art critics and art lovers, centred around Karel Geirlandt, organised many confrontations between artists from our country and the most innovative artists from abroad in St. Peter's Abbey under the flag of Forum.

But the most significant event, which attracted attention in foreign capitals, was FIGURATIE EN DEFIGURATIE, held in 1964 in the museum of Ghent.

The whole plastic contribution, which was encountered through the ostracism of a certain avant-garde, suddenly came under the spotlights thanks to the masterly works of those who had dared to resist the siren seduction of ab-

317

straction. Pierre Restany justly wrote in one of the introductory contributions: *People are speaking everywhere of a crisis in abstract art and a return to figuration. But it is not so much the actual painting which has changed as our way of looking at it and our vision of things.* He thus showed his approval with the option that Karel Geirlandt ... had chosen in his introduction. *A declaration of painters' rights*, as it were, was initiated here; it was to result in a libertarian concept of the plastic arts, which brought about the explosion of the 1968 firework display.

Jean Dypréau, "1960-1970", in K.J. Geirlandt, Ph. Mertens, J. Dypréau, W. van Mulders, *Kunst in België na 1945*, Antwerpen, 1983, 106-107

Though the connection between art and life for Roger Raveel, between art and nature for Raoul De Keyser and between art and life-anecdotage for Pjeroo Roobjee was a strong one and sometimes emphasised rather oppressively, these artists have never been able completely to dissociate themselves from the individual involvement with canvases, paint, colour or form. The main preoccupation in the end was always of a pictorial nature; they remained 'atelier' painters without radical openings to the outside world. Such an artist was Raoul De Keyser, whose 'slices' behave as subjects and whose 'linen boxes' behave as though they were obtrusive objects. Such an artist was Roger Raveel who put real objects and mirrors into his paintings, thus breaking through the traditional flatness of the painting. It is impossible to individualise these objects or remove them from the context, however, without irreparably damaging the work as a pictorial whole. Yet the artistic climate in Belgium had developed to such a degree, through the interventions of the aforementioned artists and through

Forum artists like Gentils, Bury, Roel D'Haese that the borders between sculpture and painting, between abstract and figurative, between the theme and the fact of the picture, had been lifted for good. They smoothed the path and created a feeling for a belief in freedom. This climate of artistic permissiveness and lack of restriction is typical of the 1960s. It is here that we come across the first traces of a consciously professed ideal of freedom with the new generation. Artists like Panamarenko, Marcel Broodthaers, Jef Geys, Guy Mees, Hugo Heyrman, Jacques Charlier, Bernd Lohaus, Wout Vercammen were from now on to use this ideal of freedom as the slogan and motto of their art and their whole attitude. Just as music at the same time freed itself dogmatically from the written note in order to put the 'actions of musicians' first and foremost, so did the plastic artists withdraw from their isolation, seeking the points of contact with theatre, film, literature, philosophy and other disciplines which had become quite necessary.

Contact between art and life was no longer sought within the traditional imagery but in life activity itself. This new form of expression did not, however, come about from an anti-academic attitude or purely as a reaction against the traditional plastic media (a dove for Raveel always remains a plastic element, albeit new and stronger than before), but also from purely social motives. The artist wanted to be socio-critical in a positive manner. But not without irony. Sometimes with humour. With pure romanticism and a poetic sensitivity too. And often with cynicism and sharp objectivity. The backgrounds against which this 'new' mentality took shape are multifarious and diverse. For example, there were the Provo and hippie movements which tried to formulate their dissatisfaction in fairly playful and unusual ways, but which have never formed a real

threat to the social order. There were also the young university and academy students who, intuitively, sensed the limitations of the existing social structures and the cultural elitism that went with them. From this arose the 'student campaigns', the 'anti-university' movement in Berlin in 1967, immediately followed by the 'May Revolution' in Paris in 1968.

The artistic world was also involved in the climate of emancipation and dismantling of the traditional systems. Thus, in May 1968 too, the Palais des Beaux-Arts in Brussels was occupied by artists, actors, composers and writers. They considered this institution as the platform for bringing their ideas to the attention of the public. They were concerned, among other things, about the inertia of Belgian cultural policy which urgently needed reforming, especially in the field of modern art.

Jan Hoet, "Kunst en realiteit en leven" (Art, reality and life), in *De jaren '60, Kunst in België*, tent. cat. Gent, Centrum voor Kunst en Cultuur, 1979, 62-63

It is often said that this is the time in which values no longer exist, in which everything is relative – post-Modernism. When art is discussed, people also say that this is the time when the great, powerful trends of the 1960s and 1970s, Minimalism and Conceptualism, are working through.

One of the giants of that time is *Joseph Beuys*.

Someone who has not only produced a different kind of art, but also a new paradigm of the artist as a total being, interested in the world as a total given.

In Belgium, various people have given shape to that image, such as *Bernd Lohaus* with his sensitive approach to the relationship between the individual and his environment. Far and away the most powerful example, however, is the work

of *Panamarenko* who has chosen technology as a metaphor for human striving.

The creative impulse is being driven by continuous efforts to encapsulate the dream in constructions, drawings, maquettes, experiments and theories: flying on its own muscle-power, if not thinking-power. Because they arise from a commitment to the world, they become, in their growth process, models for thinking and acting. Mechanisms are interesting because they offer insight into reality; fascinating because they are conceivable instruments for reaching Utopia.

Communicativeness flows forth from the clarity and logic of the sculptures. These can go from a twenty metre-long zeppelin to a flying May-bug in a colourful box.

Just as for Beuys, art for Panamarenko has nothing to do with products in the first place, but with the full potential of the individual, with the actions that result from his attitude to life. An artist is someone who acts and reacts to his environment. Panamarenko looks for images in the margins of a fragmentary system of knowledge (technology) and in the margins of conventional aesthetic codes. His works grow as myths and heroic stories grow. As springboards to the stars from a desire for global order.

He found a form in which there is a place both for the attitude of happenings – art can exist in life *tout-court* – and for the sensitivity of the early objects that, with their simple themes, show how a work is founded on plastic qualities. In the 1980s, Panamarenko fell back more than ever to the field of technique as a place where he could maintain his individuality.

Bart De Baere, Ilse Kuijken, "Voedingsbodem" (Culture medium), in L. van den Abeele, B. De Baere, I. Kuijken, J. Braet, D. Pültau, 1990, *Fragmenten van kunst in België*, "Openbaar Kunstbezit in Vlaanderen", XXVIII, 3, 1990, 104

Between matter and mystery, painting and literature, scepticism and primitivism, irony and burlesque, dream and strict reality, Belgian artists delight in moving to the outer limits. Doubtlessly because the country in which they live is itself situated on the borders of different worlds and different languages.

Joris-Karl Huysmans put that tension and that paradox beautifully into words when discussing the work of Félicien Rops. According to him, painting is only capable of life when it is to be found "between the heaven and hell of art". While Memling or Van der Weyden were inspired by Purity, we have had to wait until our own time for an artist who willingly and knowingly allowed himself to be inspired by Lust. "Félicien Rops, the primitive with the *spirito di contraddizione*, went in quite the opposite direction to Memling: he is permeated with Satanism and summed it up in amazing prints that are really unique as discoveries, as symbols, as biting and pithy, cruel and offensive art."

Rops is the purest example of an artist who overturned the prevailing values in art and morality through bringing about a sort of distortion within the conventional language of form itself. In this respect he certainly crosses the path taken by Antoine Wiertz – of whom Jean Delville said that he was "an impulsive fantasist, in other words, according to pathological science, a madman" – and that goes further in the direction of James Ensor and, later, of Broodthaers and De Cordier.

As a citizen of the "lonely land of derision", Ensor dedicated most of his life to light and colour, and at the same time he satirised the baseness and narrow-mindedness of human nature. It is from this viewpoint that his masterpiece *The Entry of Christ into Brussels* must be read. This painting is a manifestation both of his skill as a painter and of his moral attitudes. Apart

from the fact that this work is on first interpretation an allegory of the difficulties an artist encounters in trying to become recognised, it is a critique of the (religious, political or aesthetic) doctrines and dogmas that try to rule the world, and it also gives expression, at the same time, to a gentle image the actors, play in the social tragi-comedy. The painting expresses very strongly the twofold longings of a man who indulges in the pleasures of the flesh in order to paint and his inner need to divest himself of human baseness. (Which can be seen explicitly in the series of studies for the picture, in particular *The Haloes of Christ or the Sensitivities of the Light.*)

Today, Thierry De Cordier – who, it is true, uses another language – represents a similar hiatus. It is indeed the inability to communicate in accordance with the prevailing criteria that lies at the heart of his work and inspires its painful creation. The man who decided "to change the world in silence" and "have his tongue cut out" has been leading a sort of reclusive existence at his country home in Flanders in the company of his wife and children. People will recognise in the extreme attitudes of this artist-poet-gardener, who introduces himself as "an earthworm", the same mixture of pride and humility with which his predecessor identified himself in the exile of his godless morality with Dionysus and the Crucified One ...

Bernard Marcadé, "De uitkijkpost" (Look-out post), in *Kunst in België na 1980*, tent. cat., Bruxelles, Musées Royaux des Beaux-Arts de Belgique, 1993, 13-14

It also seems as though Belgian art never ceases to organise encounters with death. Belgium dances with death. Belgium makes love with death. Belgium flirts with cadavers. Antoine Wiertz, Félicien Rops, James Ensor, Georges Ro-

denbach (in his beautiful novel *Bruges la morte*, 1892), Michel de Ghelderode, Paul Delvaux and many others never cease to show the moments of this perpetual flirting between the living and the dead, between young girls and skeletons. Death always starts again. Belgium of course is not the only country to have a relationship with the Grim Reaper. But, more than the art of other countries, Belgian art seems to be tireless in returning to the link between life and death, to the fascination that the dead exert on the living, to the nostalgia that drives the deceased and ghosts to return to the earth, in order to seduce the men and women who survive them. Couples are engaged in a *danse macabre*. Is it the dead who seduce, or are they seduced? We still do not know. Is it up to the living to face corruption or to conquer it, perhaps to avoid it by their charm?

Gilbert Lascault, "Portraits incomplets et déformés d'un pays proche", in *L'Art en Belgique. Flandre et Wallonie au XXème siècle, un point de vue*, tent. cat., Paris, Musée d'Art Moderne de la Ville de Paris, 1990-91, 118

If regional production does not contribute to international taste, it is almost doomed to exist unseen and insignificant. Internationalism behaves like an authoritarian father who binds his children to himself by obliging them to introject his image and in letting him punish them.

It is also important to realise that the term *internationalism* is intimately bound up with the term *avant-garde*. Both terms illustrate the longing of the art world to discern an essential dynamics in the history of art. This generates in everyone the feeling of rising above himself and of seeing himself confirmed by the negation of prior

stages (the avant-garde) and the renunciation of a local context (internationalism).

These problems will mainly crystallise in the works of Marcel Broodthaers who, through a mixture of regional narrow-mindedness and lucid, intellectualistic parody, has cast the insoluble contradictions of the Belgian artist in an almost archetypal form. It is also important to mention that this strategy of Broodthaers must have been felt as offensive and annoying, because it was only outside Belgium that Broodthaers enjoyed some credibility.

In consequence, the 1970s will clearly be distinguished from the 1960s by the artist's awareness of having to cope with a homogeneous internationalism. This displeasure did exist earlier of course, although it had never been focused on as clearly as in the 1970s.

Probably a great deal of the artistic output in the 1970s in Belgium can be explained from this permanent displeasure. The feelings of rebellion are so intense that they no longer appear sublimated in the formal types of expression but are given direct shape in a *remonstration* on the nature of art itself. The great concern of the artist will therefore lie in formulating as pregnantly as possible the limiting factors, the dominant ideology of the art business. Experimental methods and strategies will be devised to carry out this critical task as well as possible, because we have learned from recent art history that only the unusual and the unknown are in a position to break through prevailing mentalities. As a result, the most characteristic feature of the 1970s will be found in this concretion of attitudes and strategies.

Wim van Mulders, "1970-1980", in K.J. Geirlandt, Ph. Mertens, J. Dypréau, W. van Mulders, *Kunst in België na 1945*, Antwerpen, 1983, 152

It is difficult for the art of this country to come up for consideration beyond its borders. Is this only a consequence of deficient infrastructure or has it partly to do with the properties and characteristics of that art?
We should not underestimate the lack of a real infrastructure and financial possibilities. Because there is a danger that people will think this to be quite a normal situation through working for a long time in those critical circumstances. When considering the recognition of Belgian artists abroad, we should take into account that Belgian art, generally speaking, due to its complexity, lacks a certain formal definition. I am not in this respect suggesting in any way that complexity can be used as a measure of value. I am only stating that that complexity can explicitly be found in the work of very many artists from Belgium. But the works of someone like Beuys also has something which is not easy to categorise, something nostalgic and nocturnal. Foreign artworks frequently have something simple, something strict or something extreme and often give evidence of an effort at simplicity. The powerful radicality of Fontana, for example, is simply unthinkable in Belgium.
Hence your pronouncement "The Belgian artist is a thief"?
Indeed, because it is impossible for the Belgian artist to identify himself with either the Latin or the Germanic or the Anglo-Saxon cultural determinants because of his sociocultural reality (the geographical location, the historical past).
We like to see the totality and to bring partial aspects into a whole.
It is also typical that in Belgium no particular current or 'ism' has arisen. Besides, the fast and loose relationship of a number of prominent Belgian artists with regard to certain types of artistic expression seems to be a historical constant. We only have to think of the relationship of Magritte with Surrealism, Dotremont or Alechinsky with Co-bra, Peeters and Servranckx in comparison to De Stijl.
The bottom line is the expressed undogmatic attitude. We don't say: 'either this way or that way', but 'both this way and that way'. We are strong on dialogue. We directly hold the synthesis of the dialectical process to be central. We are critical and relational by nature. We have developed no taste for extreme consequences. This non-pamphleteering disposition leads to a certain ambiguity. Just think of Broodthaers, or even Van Severen and Raveel. Broodthaers is certainly the paradigm par excellence of clear formulation with ambiguous content.
What also strikes me is that Beuys, Fabro and Merz, for example, are able to operate in an uncomplicated way. Like children, stripped of ... and with directness. Belgian artists strive for nuances, and still work as adults.
Another manifestation, for example, that makes many things clear is the difference between the complexity of Ensor in comparison with the visual directness of Van Gogh. Even with someone like Ensor it was a long time (longer than for his contemporaries) before people became aware of his significance for the history of Western art.

Jan Hoet, interviewed by Bart Cassiman, May 1986, in *Initiatief 85*, tent. cat., Gent, Centrum voor Kunst en Cultuur, 1986, 4-5

Biographies of the Artists

The biographies of the Belgian artists were edited by Geurt Imanse and compiled by Anne Parez (AP).

The biographies of the Dutch artists were edited by Geurt Imanse and compiled by Paul Kempers (PK).

Pierre Alechinsky
Brussels 1927

When the young painter Alechinsky met Christian Dotremont in 1949 he severed his earlier connections and immediately committed himself to the artistic initiative which had just been formed under the name of Cobra (CoBrA = Copenhagen, Brussels, Amsterdam) with Dotremont as its leading light.

The short-lived, though especially important from the viewpoint of plastic arts, adventure of Cobra found in Alechinsky a perfect representative. He refused to choose between figurative or abstract art and pleaded for a highly spontaneous art: in order to rediscover the vital élan of primitive inspiration, intellect had to be avoided.

He produced works whose characters were reminiscent of Ensor, but in which nature still dominated, colour in itself, savagery, unbridled power, and restless energy.

After Cobra split up, Alechinsky went to Paris. With the engraver Stanley W. Hayter he sharpened his sensitivities to gesture and his love of drawing. In Japan he went on to study calligraphy. There he found a response to something that had been gestating in him for a long time: "painted writing" as a means of expression.

Alechinsky was still not forty years of age when his art reached full maturity.

He worked on yellow design paper which he laid on the floor in order to become fully involved with the work, a process to which fellow-artist Walasse Ting had introduced him. His works are a multicoloured labyrinth of people and animals, lines and signs, endlessly knotted together and disentangled once more.

In the middle of the 1960s he began 'painting-writing' with acrylics. He extended his paintings with a 'comic-strip story' – as it were, contemporary predellas, similar to what we find underneath Gothic panels. In these he gives a comment or explanation of the work, digresses or summarises.

Who Alechinsky would have become if he had not met Dotremont remains an open question. But it is a fact that it would have been difficult for him to achieve a more prominent position in the international art world than he now occupies.
AP

Karel Appel
Amsterdam 1921

The work of Karel Appel, son of an Amsterdam barber, caused quite a commotion in art circles of the 1940s and 1950s. His notorious credo, "I just mess about", was eagerly pounced on by the scandalized Dutch critics of the day and brandished as a weapon against modern art.

As a member of the Cobra group, Appel, a born individualist, paid scant attention to the theoretical writings and pamphlets of Constant and Dotremont. Expressing himself direclty in paint was more important to him than the Marxist analysis of Western culture advocated by Constant, the group's ideologist. Of all the group, it was Appel who reacted most expressively to the Cobra avowal of 1948: "A painting is no longer a construction of colours and lines, but an animal, a night, a scream, a human being, or all of them at once".

Even after Cobra disbanded, Appel, in Paris in the 1950s and New York from 1972 on, continued to address his subject-matter in an emotional vein. As he put it: "This is how it works.

I stand in front of the canvas. In my uplifted hands I hold my paint. My hand approaches the canvas; when I touch the canvas it starts to vibrate, to come alive. The flight begins: to unite canvas, eye, hand and form".

A survey of his recent work, staged in 1990 by Rudi Fuchs in the Gemeentemuseum, The Hague, showed how Appel, after nigh on half a century of painting and sculpting, had succeeded in developing his original principles even further.

In 1951 Appel painted a mural in the Appel bar of the Stedelijk Museum, and another in the cafeteria in 1996. His *Toscaanse landschappen* (Tuscan landscapes) of the 1990s were recently exhibited in the same museum (1996).
PK

Armando
Amsterdam 1929

Flags (*Fahnen*), wheels, edges of forests and ladders are frequent motifs in the paintings of artist, poet and writer Armando.

As a member of the Dutch Informal Group (1959-60) he caused a stir with his *Peintures criminelles*, a series of virtually monochrome, abstract oils. In Nul, the group founded by Jan Schoonhoven, Henk Peeters and Jan Henderikse (1960-1965), Armando proceeded to 'intensify' reality by isolating materials from everyday life.

His montages of rivets, bolts, barbed wire or car tyres on plates of monochrome black, red or white (*2x7 bolts on red*, 1961, Amsterdam, Stedelijk Museum) date from this period. In the 1970s he painted a series of *Schuldig landschap* (Guilty landscape), oppressive black-and-white canvases, offset with an occasional line of red.

Armando, who grew up in the period before World War Two, remains a romantic, fascinated by themes such as hate, guilt and transience. From Berlin, the erstwhile capital of Hitler's Third Reich, where he lived for some years from 1979 on, he sent articles to the leading Dutch daily *NRC-Handelsblad* on the phenomenon of "the enemy".

Since then he has regularly exhibited paintings, drawings and sculptures which bear poignant witness to his continuing obsession with war.
PK

Gerrit Benner

Leeuwarden 1897 - Nyermirdum 1981

Simplicity, a feeling for nature, chromatic expression. Akin to Cobra, the Expressionist vein of De Ploeg (The plough) and Der Blaue Reiter. Creature of paint. Soloist. All these labels have been applied to Gerrit Benner, the painter from Friesland whose robust style was reminiscent of Cobra but who never belonged to a particular group or movement.

His large paintings of meadows, skies, cows, horses, grass and water, executed in broad strokes and reduced to elementary shapes in pure colours, were an affirmation of his love for the Frisian landscape. The profundity of that love for the vast skies in the Netherlands' most northerly province is borne out by the fact that a large number of his pictures were painted in his Amsterdam studio, its windows covered to block out the view.

Most of those paintings were done from memory: "Oh, I have an idea of what I want, and sometimes I don't. I paint patches of, say, white or blue, and there is movement, which I arrest with calmness". After 1954, the year Benner moved to Amsterdam and had his first one-man show at the Stedelijk, his career gathered momentum with showings at the Biennials of São Paulo (1954) and Venice (1958). Towards the end of the 1960s his landscapes became more tranquil; whereas he had previously sometimes mixed his paint with sawdust and 'modelled' the resulting thick paste layer by layer on the canvas, he now worked with greater refinement, delicately applying thin layers of paint (*Voorjaar* [Spring], 1971, Amsterdam, Stedelijk Museum). In 1971 he returned to Friesland, dying there at the age of eighty-three.

PK

Gaston Bertrand

Wonck-aan-de-Jeker 1910 - Brussels 1994

Gaston Bertrand was one of the founders of the Jeune Peinture Belge movement in 1945 – a very heterogeneous association without a common style or theory, which wanted to promote young Belgian talent nationally and internationally. It was also the first movement in Belgium that broke with regionalism in favour of internationalism. Bertrand at that time was thirty-five and had already made a name for himself in artistic circles around the Salon Apport. He worked in a figurative style and knew Ensor, as can be seen from his *Rood interieur* (Red interior), 1942, and his *Geel interieur* (Yellow interior).

When Jeune Peinture Belge was disbanded in 1948, its driving forces had already found their own paths. Bertrand gradually evolved in the direction of abstract art, though he did not make a complete break with figurative art. For Bertrand, however, abstract art meant widening his artistic freedom without letting go of figurative themes, even though he sometimes balanced his work on the very edge of readability. He kept nature and the environment as a starting-point within abstraction and interwove this with his own inner life.

The sea and the shore, the classicism and the restraint of the architecture in Italy and Provence, the Paris metro… he represents it all as a memory, simplified, and interiorised. His themes came in series. In the abbey of Montmajour near Arles he made a series of ink drawings, watercolours and oil paintings which form a high point in his work. Some of his themes can suddenly appear again in another context – thus the nun's cap appears again in the metro series – and series can spill over into each other: his creative process followed no fixed course. He worked fastidiously when designing and creating; his orderly nature can easily be seen from the carefully studied arrangement of surfaces and lines into works that might sometimes come over as being precious.

AP

Rob Birza

Geldrop 1962

After completing his training with a stint at Ateliers '63 in Haarlem (1986-87), Rob Birza rapidly caused a furore on the Dutch art scene. The young painter's unconventional combination of medieval techniques (egg tempera) and the modern subject-matter of comic strips and TV series attracted considerable attention. His work, which displays great diversity, is hard to classify. However, its unexpected blend of banality and High Art and its frequent references to modern art (*Ceci n'est pas un Léger*, 1989; *Andy*, 1989) unmistakably link him with the idiom of the postmodern painting that made its appearance in the 1980s. In the 1990s Birza has exhibited installations of objects, sound and paint (*Buddha's Horizon / View of the Lights*, 1993). These staged, spatial paintings address the senses. In *Buddha's Horizon*, for instance, the song of two whales blared from the loudspeakers and a collection of lamps dating from the 1960s dazzled the beholder. In the "furniture paintings" he started to make in 1992 Birza attached fluffy toy animals, orange tub-chairs and cut-up bathmats to his canvas. He took a long trip to India (New Delhi) in 1995, painting, among other works, *Kill India Kiss India*. While the painting was on exhibition at the National Gallery of Delhi a fanatical Indian nationalist attacked it with a knife. This and other works done in New Delhi, where he lived for two months with Indian artists in the Sankriti Kendra studios, were later exhibited at the Stedelijk Bureau Amsterdam (*The Other Self*: watercolours, egg tempera abstracts and an installation). Last spring Birza, whose work is frequently to be seen in Dutch museums, exhibited fresh-tinted watercolours and drawings (1989-96) at the Stedelijk Museum. And in the summer of 1996 he and colleague Rob Scholte collaborated on a work in the Stadsgalerij, Heerlen, called *Attitudes II*, inspired by Edvard Munch's *Shriek*.

PK

Bram Bogart

Delft 1921

One really has to have an extremely strong artistic vision not to be swayed by the siren call of Cobra, particularly so if one has Karel Appel and Corneille as neighbours in the same building in Paris for years. Bram Bogart was successful in this respect and created an oeuvre that occupied an important place in 'addition' to Cobra.

Bogart did not feel at home with the aesthetic of Cobra, which was too impulsive for him and left too much to chance. He, on the contrary, wanted to dominate, to structure. After an initial Expressionist period, influenced by the work of Vincent van Gogh and Constant Permeke, and a sojourn in the south of France where he discovered the value of drawing and calligraphy, Bogart began to develop a very personal style of Abstract-Expressionism. The emancipation of the material and the artist's awareness of it are central to his thinking process.

He was to spread the paint – cement paint – in thick layers of crumbly paste on the canvas, almost like masonry. The canvas was laid on the floor: the paste was not allowed to lose its shape. Colour and material are one and become form, surface becomes relief and relief becomes object, an existential total-image.

Michel Seuphor, artist and eminent art critic, describes Bogart's work as a marriage between Expressionism and De Stijl. In the lyricism of the paste, in the thick layers like clay, in the relief that comes about from an

earth-bound élan, we still find Permeke. The structure of Bogart's works remind us of the work of his countryman Piet Mondrian. (Bram Bogart – actually, Abraham van den Boogaert – is Dutch by birth and Belgian by naturalisation.) Bogart was gradually to evolve to simpler forms and fewer colours. That reduction process was to lead him occasionally to monochrome works in which he, in his own words, enriched the colour on large, almost even surfaces. We could in consequence describe his work as pure imagery from colour.

AP

Eugène Brands
Amsterdam 1913

In 1946 Eugène Brands took part in the exhibition 10 Young Painters at the Stedelijk. Two years later, three of the other participants in that show, Karel Appel, Corneille and Anton Rooskens, invited him to join the Experimental Group (1948), which later that year merged with the international Cobra group. As well as the bold – almost primitive – coloured wooden reliefs he was producing at the time, Brands was painting in a lyrical-abstract style which was a far cry from the violent expressionism of the other Cobra members. Only when he left the movement at the end of 1949 did typical Cobra motifs begin to appear in his work: children with enormous heads, walking houses, fish and arcane magical signs.

With his large oils of the 1960s Brands reverted to the abstract vein of the late 1940s. Characteristic of this work are large, cloudy patches of soft, poetic colour. Much of Brands' oeuvre (paintings, gouaches, collages, drawings and assemblages) is in the G. Hofland Collection, which has exhibited at De Beyerd Museum in Breda in 1990.

PK

Marcel Broodthaers
Sint-Gillis 1924, - Cologne 1976

For Marcel Broodthaers life did not begin at forty, as the saying goes, but one year earlier. Broodthaers was a thirty-nine-old poet and journalist when he decided to become a plastic artist, a step that also took plastic form when he covered a bundle of poems with plaster and made it into a sculpture.

It was not his intention to produce a work of art: Broodthaers wanted to investigate and demystify the art process, and he could only do that by taking on the mantle of an artist. As with many conceptual artists, he starts out with objects, outer coverings which he piles up. His glass jars with empty mussel shells – a sarcastic reference to Belgian eating habits – his cupboard with eggshells, his pots with the smile of Marilyn Monroe, all these show us things in exactly the same way, according to him, as a museum, equally unusual and unreal, equally ordinary and real.

He had a fractious relationship with Belgian cultural politics and museums: in May 1968 he was one of the occupiers of the Palais des Beaux-Arts in Brussels. Disenchanted, he set up a fictional museum in the same year in his home which he ran as a professional curator, including loans (from the public too), museum bulletins and exhibitions (of postcards) and vernissages.

After this *Musée d'Art Moderne, Département des Aigles, Section XIXème siècle*, "a protest against the term *museum*" (M.B.), others followed, ending up at Documenta 5 in 1972 with the *Musée d'Art Ancien, Galerie du XXème siècle*.

Broodthaers continually plays with language, and his work is often a conceptual play on language: texts by Stéphane Mallarmé (1969) are plastically transformed, *Salle Blanche* (1975) is an interior whose walls are decked with words referring to the museum and the hierarchy; *Ensemble de neuf toiles sur un sujet littéraire* (1972) is an ironic description of the activities of the people involved. The intellectualist work of Marcel Broodthaers was at first mainly appreciated outside Belgium.

AP

Stanley Brouwn
Paramaribo 1935

Stanley Brouwn settled in Amsterdam in 1957. In the 1960s he took part in various international Fluxus events, but later dismissed these activities as being irrelevant. His early *this way brouwn* project (1961) attracted attention: he would ask random pedestrians how to get from A to B and request them to draw the route for him. Stamped *stanley brouwn*, these anonymous sketches were subsequently displayed as art. Drawings, photographs, card-index systems and texts are the tangible record of Brouwn's conceptual art, in which the concepts of space, distance and time are important parameters. This is illustrated by the counted and measured footsteps which Brouwn began to register in 1971. In 1976 he exhibited one kilometer in the form of ten books, each containing a hundred pages and registering ten 1000-millimeter sections. In later work, too, for istance *1m²-1stap²-1el²-1voet²* (1 m²-1 step²-1ell²-1foot²) (1989), Brouwn appears to retain the ratio of human size to the metric system as a constant. In 1982 he represented the Netherlands at the Venice Biennale, where bridging and measuring distances was the theme of all thirty-five exhibits. In 1987 he was awarded the Sandberg prize for his entire oeuvre.

PK

Jean Brusselmans
Brussels 1884 - Dilbeek 1953

Jean Brusselmans was born two years before Constant Permeke and died one year after him; he was an Expressionist and… had a dislike for Permeke's work!

While Permeke was enjoying an established reputation during his forties, with all the financial benefits it brought, Brusselmans at that time was absolutely nowhere on the scene. Fame for him came only when he was about sixty, after an isolated life, embittered by the lack of success and beset by material worries. Brusselmans' unpleasant character was to cause difficulties throughout his life, even in avant-garde circles where it easily happened that people took his side. He was rather harsh to things he did not like, and those were quite a few. Like the Latem school, for example, where Flemish Expressionism reached the absolute top. He distrusted the dynamic, the cosmic compassion, the compulsive power with which it held us in its grasp.

Brusselmans did not let himself be drawn along by the inner life, had a dislike for the passionate, sometimes dramatic resorting to intuition and instinct, and kept nature at a distance. He kept emotions reined in and only let them loose in a controlled form.

Nature is there to be ordered, simplified, stripped of details, schematised into a decorative game of colour and line done with tightly controlled brush-strokes.

His works exude peace and harmony, from which only his range of colour escapes occasionally. Then he pampers the observer with sparkling colours and a wealth of nuances. Brusselmans, however, came from Fauvism – albeit strongly purified in his hands – and was befriended by Rik Wouters for whom emotion could only be experienced in exuberant colours.

Thus Brusselmans developed a synthesism that appeared quite stiff owing to the artist's conscious order. This reasoning, considered art seemed to take a long time to grow up compared with the Expressionism by which "the outermost was turned inwards and the innermost outwards".

AP

Constant

Constant A. Nieuwenhuis, *Amsterdam 1920*

Along with Christian Dotremont, Constant was Cobra's chief ideologist. He wrote numerous manifestos and articles for the group, defining the social role of the artist and calling for the liberation of creativity so as to serve a constantly self-renewing culture. His encounter with Asger Jorn in 1946 had a marked effect on his work: fantastical creatures and aggressive, fearsome animal and human figures began to populate his canvases. In Paris (1951-52) he painted "war pictures" filled with the ruins of a destroyed world where helpless people lifted their hands to the skies. During the late 1950s Constant developed his conception of *Nieuw Babylon* (New Babylon), the ideal city where man would be freed of the necessity to work and as *homo ludens* could bring his creative powers to fruition. The constructions and models for New Babylon have frequently been exhibited. In the 1970s Constant returned to paintings, watercolours and drawings for which the work of old masters such as Velázquez yielded a rich source of inspiration. In late 1995 the Stedelijk staged a major Constant retrospective ("Paintings 1948-1995").

PK

Corneille

Corneille Guillaume van Beverloo, *Liège 1922*

Co-founder, with Appel and Constant, of the Nederlandse Experimentele Groep (Dutch Experimental Group, 1948) which later that year merged with Cobra. In 1950 Corneille, like Appel, moved to Paris, where his work was exhibited. A year later he journeyed to the Sahara. The profound impression of his first encounter with the desert is recorded in a series of paintings showing the earth as a "sun-scorched mass of sand and stone on which only a few animal and plant species thrive. Subsequent journeys took Corneille to South America, the United States and central Africa. In his paintings, often bird's-eye views of landscapes and cities, heightened colour contrasts and compact forms generate more movement. Since the late 1960s Corneille's paintings, gouaches and drawings, in which large planes of colour feature prominently, have assumed a more figurative character. In a lyrical style to which he has adhered ever since, the painter tells us what he has seen and experienced in visions of tropical landscapes and gardens inhabited by plants, animals and women.

PK

René Daniels

Eindhoven 1950

In 1987 Daniels suffered a cerebral haemorrhage with little chance of recovery. This abruptly curtailed a flourishing artistic career. Daniels was known chiefly as a neo-Fauvist, the generation of painters who rediscovered figuration towards the end of the 1970s. In his early work, and in an expressionistic vein, he painted motifs such as a gramophone record, a skateboard or a shoe; in 1980 the human figure made its appearance, first only an isolated eye, nose or mouth, followed a little later by faces in profile and entire figures (*Palais des beaux-aards*, 1983, Amsterdam, Stedelijk Museum). Daniels' work evolved into a surrealist play on words and image (*De revue passeren* [Passing the review], 1982, *Twee I's strijdend om een punt* [Two I's fighting for a dot], 1982) in which the beholder can relate title and picture in an associative game. In the series *Mooie tentoonstellingen* (Beautiful Exhibitions) of 1985-86 and *Lentebloesem* (Spring blossom) of 1987 (Amsterdam, Stedelijk Museum) Daniels went a step further. *Mooie tentoonstellingen* is a collection of painted exhibition galleries, each rendered in distorted perspective. This gives the two-dimensional forms an ambiguous character, so that they can also be seen as a bow-tie or a megaphone. In *Lentebloesem* Daniels bestowed equal status on images and words; the words, often titles of earlier works, are painted on the flowering branches as 'blossoms'. Daniels was represented at major exhibitions such as Zeitgeist (1982, Berlin), Documenta VII (1982) and the São Paulo Biennial (1983). The *Lentebloesem* series was exhibited at the Boijmans Van Beuningen Museum, Rotterdam, in 1990.

PK

Thierry de Cordier

Oudenaarde 1954

After completing his studies at the Ghent Academy for Fine Arts Thierry de Cordier returned to Ostend – to reflect. There he lived on the dike, "with his back to the others and his face to the sea".

He was to keep up that attitude; he could only function as an individual, and moreover not in the twentieth century, a century he had "absolutely nothing to do with".

This does not mean that we should dismiss his work as nostalgia or a rejection of modern society. De Cordier does not act from a romantic impulse. His work is not a *retour à la nature*, he is not a second Jean-Jacques Rousseau.

His organic forms and shapes do not symbolise what is past but what the future holds in store. His work is "a final explosion of the illusions we have about our blissful origins" (Stefan Hertmans).

That causes fear, sometimes expressed in tangible terms as in a little village in southern France where the inhabitants destroyed one of his works. Indeed, his work is not reassuring but in a certain sense is unbearable; disruptive too, because it is allegorical and thus goes beyond the boundaries of truth.

De Cordier does not ask the observer to try out seclusion as he was doing in his own home. In fact, he does not live in complete seclusion – if so, his work would not make much sense – but remains in contact with the outside world. His home is closed to the outside world but at the same time, it has spyholes. It is a place of protection, the place where thoughts about the world come into being.

De Cordier writes them down as they come to him, in no particular order, without beginning, without end. Differently from the philosophers then, although he himself is a philosopher, a philosopher who, like Diogenes in his barrel on the *agorà* cut himself off from men and yet remained in their midst (Stefan Hertmans).

AP

Raoul De Keyser

Deinze 1930

On the one hand it is the artist's privilege to collaborate with a teacher of the stature of Roger Raveel. On the other hand, it really is difficult to extricate himself from the teacher's influence and become himself, but Raoul De Keyser nevertheless succeeded in this respect. In 1966, together with Raveel, Etienne Elias and the Dutch Reinier Lucassen, he turned the cellars of the castle at Beervelde into a real environment in true Raveel style. Since that time Raoul De Keyser, who was closest to Raveel, has come a long way. Increasingly far-reaching conceptualising and ever more restrained expression were to bring him in the end face to face with the essence of a problem relating to content and the pictorial.

Raoul De Keyser demonstrated a lively interest in the third dimension in a painting as object. For this reason he drew the borders into the painting and at the beginning of the 1970s he created linen boxes in which you, as the observer, had to walk about and which he painted with acrylics so that, though objects, they still remained paintings. De Keyser draws on a simple vocabulary of everyday things like the chalk lines on a sports field and

tries to give them a value they don't have. This is the point he starts out from, even though his starting point could be completely abstract. As his work advances it becomes clear that he is not striving after a final result. He is a painter who distrusts and rejects the definitively painted image. A canvas by De Keyser, in the heavy colours that he takes over from Pop Art, is a story of possibilities and doubts, of corrections and overlaps. Mistakes and hesitations are not concealed and uncovered pieces of canvas remain white spots. His work is layered: what is visible is a separate story with something beneath.

A final phase in which the artist takes everything together in harmony is missing. A work by Raoul De Keyser can only be considered as a temporary solution.

AP

Ad Dekkers

Nieuwpoort 1938 - Gorkum 1974

His first abstract reliefs and spatial constructions date from 1962. Not long afterwards, he represented the Netherlands at the Biennial in São Paulo (1967) and the Documenta in Kassel (1968). Dekkers was always in search of the 'right' balance between form, colour and dimension, and continually sought ways of giving systematic shape to changes of form – the central theme of his work. Simple geometric shapes (circles, triangles, squares) were displaced, reduced or altered in various phases (*Circle developing towards square*, 1970). He deliberately left room for the view of the beholder: "I only indicate something, by putting the first phase towards a square inside a circle. The largest part of the process is left to the viewer's imagination, which produces a tension between what is present and what is absent". Mondrian was especially important in the development of his work and Dekkers was fascinated by him, "not so much by the use of primary colours or the utopian ide-

al of harmony as by his philosophy, which was aimed at making the purest possible use of the means of expression". Dekkers suffered several psychological crises and in 1974 he took his own life.

PK

Paul Delvaux

Antheit 1897 - Veurne 1994

Paul Delvaux was no longer a beginner when he got to know the work of Giorgio de Chirico. The first years after his training were a quest for a personal plastic language. He worked as a post-Impressionist and is connected with Expressionism, but he could not be himself in either; de Chirico's work showed him the way. Although he immediately fell under the spell of Surrealist mystery in de Chirico's work, it was still to be some years before Delvaux gave shape to his own Surrealistic dream world, and longer still before the international art world recognised him.

In the middle of the 1940s there was a retrospective in his own country, followed by the film *Le Monde de Paul Delvaux*. International recognition came with the World Expo in 1958 in Brussels, and from the 1960s onwards, the greatest museums have bought his works.

This artist did not make things easy for the art historians in their attempts to pigeon-hole him and explain his work in psychoanalytic terms. He did take part in Surrealist exhibitions but felt nothing for the label Surrealist or for André Breton, the man behind the Surrealist manifesto (1924). He rejected the so-called double meanings in his work: "The reality of the canvas has nothing to do with the reality outside it".

Each canvas shows a poetic dream world, peopled by skeletons, (mostly) naked women and men in city clothing, detained in an abandoned station or an anachronistic, antique decor. His colouring is cool, his drawing has classical puri-

ty, his composition is based on contrasts. A work by Delvaux breathes absence, the powerlessness to communicate, frozen erotica, mystery, silence. "Mister Paul fell very gently asleep", it read in July 1994.

By slipping away silently, mysteriously from life, Paul Delvaux remained true to his style until death.

AP

Gustave De Smet

Ghent 1877 - Deurle 1943

Gustave De Smet saw two world wars, two tragedies that he as a shy pacifist was no match for. He spent the First World War in Holland, where he became acquainted with German Expressionism. This must have been a revelation, for the artist changed direction completely and switched from Impressionism to Expressionism. De Smet settled in the Leie region. There he was to paint his strongest works between 1922 and 1930. He lived among the people and built up, over the years, a relationship of trust with the farmers and their environment, and this feeling imbued all his work. His subjects are limited. He continually depicted the Leie landscape and the people of Deurle showing them at work, at the funfair, at home in the intimacy of daily life. He is the least instinctive of the Expressionists and inclined slightly towards Cubism. There is a certain geometry in his work and his palette, too, is clearer, his composition better ordered. While Permeke transforms his figures purely instinctively, Gustave De Smet's characters are strongly diagrammatic – they are types, almost dolls, and not individuals. They appear somewhat childish and have been created out of his wonder at the daily life around him. While the powerful Permeke creates first and then thinks, the reverse happens with the shy De Smet: what he creates is the result of an idea, a style that he imposes on the subject.

In one of his last phases he relied more on reality, but this innovation

was not to be explored more deeply. He died quite unexpectedly, in 1943, and in his house – the present Gustave De Smet Museum – he left behind a treasure-trove of works which, in their modest, artless simplicity contrast strongly with the instinctive power of Permeke.

AP

Roel D'Haese

Geraardsbergen 1921 - Nieuwpoort 1996

Just as Vic Gentils, we can consider the sculptor Roel D'Haese, pupil of Oscar Jespers, as an artist who continues the work of Bosch, Bruegel and Ensor in his own highly personal language.

The idiom of Roel D'Haese is not so easily accessible, neither in its form nor in its content: he does not make it easy for the observer or himself. D'Haese worked with various materials like wood, stone, copper, iron, and gold.

He liked to use difficult technical processes with which he wrestled until he won control over them – forging iron, casting bronze, working with lost-wax techniques, welding bronze. D'Haese did it all, alone, driven, utterly determined.

He worked figuratively but subjected the material, kneaded it as it were, transformed it with satirical and socio-critical aims, creased it, stretched it out, tore it open until it responded in full to his temperament, until it embodied his expressive dynamism.

D'Haese provoked on occasion, drew on polemics, sarcasm, and went on to the attack. In his sarcastic universe he was not afraid of treading on people's toes; 'delicate' questions or politically-charged subjects were not skirted round. His works scored direct hits on more than one occasion, works that affect us when we would rather they didn't or when we consider ourselves invulnerable…

D'Haese is also the sculptor of the supernatural; with him each sculpture is the result of "a heroic strug-

gle with what does not exist and is unknown, and therefore inimical" (Jan Hoet).

With his capricious, baroque form language, his bizarre, fantastic iconography he confronts us with mankind, the protagonist in the human drama, who fills us with fear, with disbelief.

He presents us with myth and strengthens it further with the use of gold, the blinding light, the wonder, the mystery of eras long gone, reminiscent of lost civilisations…

D'Haese left us an extraordinarily fascinating oeuvre, fantastic, sarcastic, penetrating, with which he represented Belgium at events like the Venice Biennale and Documenta in Kassel.

AP

Jan Dibbets

Weert 1941

Dibbets' work is rooted in Concept Art, Land Art and Arte Povera, movements of the 1960s. He gained recognition with the series of *Perspectief correcties* (Perspective corrections) he started to make in 1967, photographing a trapezium placed in a landscape or his studio from a viewpoint that made it look square. In 1971 he made his first polaroids of arc-shaped panoramas of the flat Dutch countryside which he classifies as "hilly landscapes" and which alienate the beholder from the reality with which he is familiar. In the 1980s, after a period spent examining the colour and structure of water and grass (*Monet's Dream Study*, 1975, Amsterdam, Stedelijk Museum), he turned to photographing interiors and ceilings, arranging them in circular panoramas on a watercolour ground. His fascination in the seventeenth-century painter Pieter Saenredam then prompted him to photograph church interiors. In this exercise, more so than in his earlier work, the emphasis is on the aesthetic value of space and form. In 1993 Dibbets was commissioned by the French Minister of Culture, Jack Lang, to design thirty-one stained-glass windows for the Cathedral of St. Louis in Blois. A year ago, in 1995, he designed a memorial in Paris to the physicist François Arago (1786-1853) in the form of 135 round, bronze plaques placed on the corresponding number of spots in the paved street. The recipient of many international awards, Dibbets exhibited four 'windows' at the Stedelijk in the autumn of 1996.

PK

Christian Dotremont

Tervuren 1922 - Buizingen 1979

Like Pierre Alechinsky, Christian Dotremont is one of the most important Belgian Cobra artists, both the driving force and the writer of texts which more often than not caused scandal.

In April 1947, he founded the group Surréalisme révolutionnaire, whose members founded Cobra a year later (the name was devised by Dotremont). Cobra's manifesto was from his hand. In 1949, he wrote *Le grand Rendez-vous Naturel* about the first great Cobra exhibition in the Stedelijk Museum in Amsterdam and read out the second part of this text in the museum. There followed a scandal that was broadly publicised by the press and radio.

Dotremont henceforth stood on the black list as a subversive element. Anyone who thinks that he had his hands full with things to do would be wrong. In the Ateliers du Marais in Paris, the Belgian Cobra members met together to experiment in complete freedom with all sorts of techniques: painters wrote and poets painted and sculpted.

Together with the Danish artist Asger Jorn and Alechinsky, Dotremont had already made the first *peinture-mots* before 1950, word-paintings that combined text and image. In *Les Transformes* (1950) word and image undergo all sorts of mutations and in *Et de Linge* (1957) the text follows the rhythm of the drawing. After a sojourn in Lapland, where he was fascinated by tracks in the snow, he created his *logoneiges* and *logoglaces* – snow and ice writing – which can be seen as the predecessors of land-art.

In the 1960s he created his famous *logograms* in Indian ink on paper, that look like Chinese poetry. In these written images where words are images, Dotremont asks the viewer to recognize the drawings in the spontaneous writing and only then to discover the text.

By and large, Christian Dotremont is without doubt known for his *Sept Ecritures*, the panel that he designed with Alechinsky for the Anneessens metro station in Brussels (1976).

AP

Marlene Dumas

Capetown 1953

Fear, love, passion, eroticism and death. Humour, irony and despair. Terms with which Marlene Dumas, who completed her training at Ateliers 63 in Haarlem, is often associated. She attracted attention in the late 1970s with collage-like works incorporating newspaper cuttings, drawings, photographs and texts. In the 1980s she adopted an expressive style for her melancholy paintings of lovers, pregnant women, babies, children (*Turkse schoolmeisjes* [Turkish schoolgirls], 1987, Amsterdam, Stedelijk Museum) or more dramatic subjects such as war criminals sentenced to death (*The Nuremberg Trial*, 1990). She often starts from her own polaroids or from photographs gleaned from the media and stored in her own 'data bank'. Dumas, daughter of a South African parson, is fascinated not only by images but by words too. Her texts about art and the problem of interpreting art were collected in the catalogue to her exhibition Miss Interpreted (1992, Eindhoven, Van Abbemuseum): … People search for Meaning as if it is a Thing. As if a work of art is a girl who ought to take off her knickers, would like to take them off, if only the right interpreter came along. As if there were knickers we could take off".

More recently Dumas has not only painted large nudes (*Indifference*, 1994) but also made series of pen drawings such as the *Black Drawings* (1991-92), more than a hundred portraits of Black people. Dumas, who enjoys an international reputation, was represented at Documenta IX (1992) and the Venice Biennale (1995). In 1995 the Castello di Rivoli Museum of Modern Art staged a noteworthy Marlene Dumas - Francis Bacon double exhibition which had been organized by the Konsthall in Malmö earlier that year.

PK

James Ensor

Ostend 1860-1949

Who would not consider it a gift to reach eighty-nine in good health? James Ensor would on the contrary have considered it as a misfired joke played by Destiny: he had already been artistically dead as a door-nail for more than fifty years and he knew it.

Actually he was given a taste of his own medicine: no other artist apart from Hieronymus Bosch had represented life as a cynical joke. Ensor was nineteen when he created his first masterpieces in an initial creative phase extending to 1885. They were pictures of daily life, dark in colour and free in their brush-work.

In 1886 his light period began: the creative Ensor arose. Incredible masterpieces were created, including *The Entry of Christ into Brussels*, perhaps his best-known work, which established his reputation as the first "modern" painter. He attacked society with heavy colours and in an exuberantly Expressionistic style. Each work is a burlesque masquerade, an amazing ensemble of faces, masks – his most original creation – and skeletons. Ensor

opened wide the doors to the bizarre, complex world of demonic, macabre, and ironic phantasms. One thing is constant: the artist himself, who continually pops up in his work. Ensor knew he was a genius, suffered from a lack of appreciation, and did not hesitate to identify himself with Christ, an outcast as he was.

A few years before the end of the century, his creative powers dried up – suddenly and for ever.

The artist was dead, but the man had another half-century of useless life before him in which, ironically enough, that recognition came to him which had eluded him at the high-point of his art, a fact he had criticized in satirical pictures. He had no choice but to play the game until in 1949 he laid down the mask for good.

AP

Jan Fabre
Antwerp 1958

Jan Fabre is an energetic artist working in different fields, which is not an unqualified pleasure for everyone…

He is a playwright, director, choreographer, plastic artist, and writer. Among all these disciplines, however, he makes no distinction. He draws as part of his theatre-work, makes theatre as conceptual artwork and provides his drawings with texts. There is a thread that runs through all his various activities: his individual vocabulary.

He constantly addresses his collection of Fabre-motifs: ball-point blue, insects, animals, a twin… and they all make reference to his world. The twin motif harks back to a brother who died young; one of his opera characters reverts to a woman neighbour. His love of nature dates from his childhood, and anyone who thinks that his roots – Fabre comes from a countryside background of simple, almost illiterate people – or his scientific training have a role to play would be wrong. The artist explicitly

states that he pursues his goal under his own power – that is, to add a few pages to the history of insects. His artistic thinking is preoccupied with metamorphosis; for Fabre, creating also means transforming until an absolute work of art arises. About his theatre work he says: "My theatre scripts live according to their own rules of play and their own enigmas".

De macht der theaterlijke dwaasheden (The strength of theatrical madness, 1984), a theatre piece that grows out of the interaction between author, actors, and public, is one of his most fascinating creations. Fabre is not an easy artist: he is obstinate, keen on provocations with double meanings, refuses all compromise and thrashes out his conflicts with society by means of his use of language and the way he constructs his texts.

He is also vain; in his multi-media works he gives vent to his very pertinent ideas about art and the history of art, in which he is keen to carve out his own niche. The fact that this has meanwhile already occurred is an indication of the lively interest his work has arisen.

AP

Edgar Fernhout
Bergen N.H. 1912-1974

Fernhout's mother was the painter Charley Toorop; his grandfather was Jan Toorop. The boy grew up in the artistic milieu of Bergen. In this village near the coast in the province of Noord-Holland an artists' colony had formed around the art collector and patron Piet Boendermaker. Le Fauconnier and Leo Gestel were among the members of this Bergen School. Fernhout worked in Italy and France from 1936 to 1939, settling in Amsterdam on his return. He was only twenty when he had his first one-man show, but this success did little to allay his feelings of inferiority to his well-known mother. Only after her death in 1955 did he finally shake off her influence; the still

lifes, self-portraits and landscapes he had painted in her realistic style thus far were now replaced by abstract compositions built up in small dabs of blue, grey or greenish tones, inspired by his encounter with the work of Jean Bazaine and other painters of the Ecole de Paris. Paradoxically, Fernhout came to his most personal style after moving permanently to Bergen in 1956, the village which held such strong memories of his mother. Although the 'sea' and 'dune' paintings (1961-62) and the systematic abstracts of the 1970s (*Voorjaar* [Spring], 1974, *Herfst* [Autumn], 1973) are a far cry from his earlier work, all Fernhout's paintings are based on his observation of nature. Not until he abandoned figuration did Fernhout, under the influence of his admired Cézanne and Mondrian, learn to distill the essence of his subject with purely painterly means. His paintings, Fernhout was once moved to say in an interview, had to satisfy only one condition: they had to be "real". "A picture can be painted with a clog if necessary, as long as it has been experienced and does not lapse into personal aesthetic mannerism".

The Stedelijk Museum in Amsterdam presented a Fernhout retrospective in 1990.

PK

Vic Gentils
Ilfracombe, United Kingdom 1919-1997

The fact that in the Low Countries it is impossible to avoid the fantastic, the grotesque, the bitingly sneering can be seen in a masterly way in the works of Hieronymus Bosch, Antoine Wiertz, and James Ensor.

Vic Gentils takes this line further. He made his debut as a painter, but turned his back on real painting at the end of the 1950s, an approach that he had already announced when he began to integrate objects into his pictures.

He has chosen another language – sculpture – and – unusual material –

waste products from his immediate surroundings, which he processes into baroque works full of irony. Thus he laid the link with Anti-Peinture, which was to make its mark in the 1960s. Gentils feels strongly attracted to things of the past; he is afraid that the past will escape him and therefore constructs a present with elements from earlier times which he adapts. He mainly works with wood, the material that responds best to his Expressionist artistry. Table-pots, picture-frames, banisters, machineparts… all lose their original purpose; he processes them into grotesque and sometimes provocative constructions and assemblies. Gentils alternates between figurative works and abstract ones; sometimes they bear no resemblance to figures, other times they penetratingly bring us face to face with man. He broadened his artistic thinking under the influence of the G 58 group (Antwerp) and the Nieuwe Vlaamse School (New Flemish School) who were striving to push back frontiers and establish contacts with foreign trends in art. The work of Jean Tinguely and César and the reliefs of Zoltan Kemény are both a confirmation of and a stimulus for his art. Vic Gentils is undoubtedly one of the most important representatives of postwar Belgian sculpture in which the material plays a crucial role. Nor has that gone unnoticed abroad.

AP

Jeroen Henneman
(Haarlem 1942)

As a child, the Amsterdam-based artist Henneman wanted to be an engineer when he grew up. He still feels strongly attracted to buildings, bridges and curious constructions. He first attracted attention with fantastical drawings of a surrealist quality. His love of the 'impossible' and the game he plays with reality are always rendered in a sober, lucid style. *De kus* (The kiss), a sculpture in front of the head of-

fice of Koninklijke Bijenkorf Beheer in south-east Amsterdam, demonstrates how two pieces of steel section, placed opposite each other, can meet in a kiss. For this monumental piece of public art he was awarded the National Steel Prize in 1983 and the European Steel Prize in 1985. Henneman's objects, drawings and paintings have been exhibited at the Solomon R. Guggenheim Museum in New York (1972), and the Stedelijk Museum in Amsterdam (1989). He also designs theatre productions and is responsible for the interior (furniture, paintings, colour scheme) of the rooms where registry office marriages take place in Amsterdam's combined Town Hall-Opera House, completed in the 1980s. A survey of his work was shown in the Gasunie gallery, Groningen, in 1989.

PK

Willem Hussem
Rotterdam 1900 - The Hague 1974
In the 1940s Hussem joined Vrij Beelden (1947-1955), an artists' association which, like Cobra, did much to promote modern art in the Netherlands. In the 1950s, inspired by oriental calligraphic techniques, he painted monochrome *Tekens* (Signs), placed on the canvas in a spontaneous reflex action with rapid strokes of paint. Later, on a white and grey-white ground, he painted coloured shapes (circles, squares) and lines with a calligraphic quality, held captive in enigmatic tension. Hussem never adhered to one style; his large oeuvre reflects multifarious influences ranging from Cobra to the geometric abstraction of Mondrian, Malevich and the brightly coloured American hard-edged painting of the 1960s. A poet as well as an artist, he published several books of poems from 1940 on, influenced by the Japanese *haiku* and Chinese poetry: "Set the blue / of the sea / against the / blue of the / sky brush / with the white / of a sail / and see how / the wind rises" (*Steltlopen op*

zee [Stilt-walk on the sea], 1961). Hussem was awarded the prestigious Jacob Maris Prize in 1952 for the painting *Dans* (Dance) and again in 1955 for his abstract *Binding*. For many years his fame was confined to The Hague. Only after his participation in the 1960 Venice Biennale and his first one-man show at the Gemeentemuseum in The Hague (1960-61) did he become more widely known.

During that period he was seen as a kind of father-figure to the generation of artists that emerged in the 1950s, enthusiastically stimulating Jan Cremer, Peter Struycken and Henk Peeters (the latter a member of the Nul group, like Armando). The Stedelijk's recent acquisition of *Zonder titel* (Untitled), an oil of 1956, endorses former director Willem Sandberg's high opinion of Hussem in 1955, the year in which the museum took *Tekens* (1954) and *Binding* (1954) into the collection.

PK

Fernand Khnopff
(Grembergen 1858 - Brussels 1921)
Towards the end of the nineteenth century people became aware that science, progress, and the various discoveries had fulfilled few of man's high expectations. Unease and melancholy dominated the artist. This *fin-de-siècle* malaise was closely linked with Symbolism. Symbolism, characterised by a symbiosis between literature and plastic art, cut itself off from Realism and Impressionism and had its greatest flowering between 1885 and 1895. The Symbolists were interested in the irrational (feelings, moods, dreams) and expressed themselves in symbols and allusions. It was not by chance that Sigmund Freud was at work studying the subconscious and dreams. Symbolism included outstanding artists like Charles Baudelaire, Paul Verlaine, and Paul Gauguin. Fernand Khnopff is its most important Belgian representative. Brussels, in

particular, was a very important centre at the end of the nineteenth century as far as avant-garde and Symbolism were concerned. In 1883, Khnopff was a co-founder of Les Vingt, a group of progressive poets, composers, and painters who inspired each other. The aristocratic, anglophile Khnopff was an admirer of the French Symbolist Gustave Moreau, and of the English pre-Raphaelites. He counted a number of poets among his close friends, illustrated work by Georges Rodenbach (*Bruges la Morte*), and liked to take over motifs from the Symbolist literature of Maurice Maeterlinck and Emile Verhaeren. His favourite subjects were silence, loneliness, the abandoned city, the secretive, and women as enigmatic beings in the field of tension of innocence and unemotional erotica. In fact, the representation of women is a theme that flows through the work of the Symbolists: as sexual beings, alluring through their erotic refinement, dangerously seductive, naïve, unfathomable.

Soft colours – and therefore a preference for pastels – and a refined, idealised and somewhat reserved style of execution are typical of the art of Khnopff, whose quest was mainly for an unearthly beauty. In this respect a flicker of ambiguity was never far away.

AP

Pyke Koch
Beek 1901 - Wassenaar 1991
Koch was a self-taught painter who abandoned his law studies in 1927 in favour of art. His first paintings were influenced by Surrealism and German Neue Sachlichkeit (New Objectivity), movements which gained currency in the Netherlands in the late 1920s. It was some years before Koch opted for the precise, pristine technique that came to typify his work. His female portraits of the 1930s (*De Schiettent* [Shooting gallery], 1931, *Bertha van Antwerpen* [Bertha of Antwerp], 1931) and a series of self-portraits cast in

a heroic role *Zelfportret met Zwarte doek* (Self-portrait with black headband, 1937) classified him as an exponent of Magic Realism, a term he defined thus: "Magic Realism shows ordinary things which at the same time contain an element of improbability". His contemporaries Carel Willink and Raoul Hynckes worked in a similar vein. Apart from a stay in Florence (1938-39), where he studied the painters of the Renaissance, Koch spent his whole life in Utrecht. In 1995 the Boijmans Van Beuningen Museum in Rotterdam staged a major retrospective of his work.

PK

Herman Kruijder
Lage Vuursche 1881 - Amsterdam 1935
It was in about 1910 that the former house-painter Herman Kruijder decided to devote himself entirely to art, a decision which brought little joy to the Expressionist painter during his lifetime. Not until after World War Two did his visionary work gain wider recognition. At first he worked in a poetically impressionist style, but during a stay in the village of Bennebroek in the province of Noord-Holland (1923-27) he switched to garish colours in clashing contrasts. Well-known examples are *De brief* (The letter, 1923-25) and *De varkensdoder* (The pig killer, 1923-25), paintings whose ominous atmosphere might have been symptomatic of the artist's state of mind. Towards the end of 1926 Kruijder suffered a mental crisis which ultimately led to a suicide attempt. In Blaricum (1927-34) he painted more tranquil rural, motifs. The triptych *Pan* (1931) echoed the colours of his Bennebroek period. With vigorous brush-strokes he now layered his paint thickly in a violently Expressionistic style, as in *De haan* (The cock, 1931-32, Amsterdam, Stedelijk Museum), which is regarded as one of his finest paintings.

PK

Ger Lataster

Schaesberg 1920

The Limburg-born Ger Lataster is a prolific painter of large canvases. "Anything less than a square metre doesn't work for me", he once said, "I have no control over small things". Lataster, who trained at the Rijksakademie in Amsterdam and was given his first one-man show in 1960 by Stedelijk Museum director Sandberg, has always painted in an Abstract-Expressionist vein. Although he is usually classified among the painters linked with Cobra, Lataster does not work in a spontaneous manner. His "emotionally romantic orgies of paint" are the result of carefully considered notes and preliminary sketches. In the mid-1960s he incorporated recognizable figurative motifs such as sickles, hammers, cannons and hands in the abstract painted surface. He also experiments with placing material (plastic) just as it is on the canvas, and audaciously applies broad strokes of 'vulgar' colours like gold and silver. Lataster's unconventional and steady output has earned him a growing reputation since the 1960s: he is represented in leading galleries in Cologne, Milan and New York and features regularly at major exhibitions. In 1987 he was commissioned to paint a ceiling in the Mauritshuis at The Hague. To mark Lataster's seventy-fifth birthday, which took place in 1995, the Stedelijk Museum elected to stage an exhibition of his work this year in combination with that of the Abstract Expressionist Jef Diederen, who also recently celebrated his seventy-fifth birthday.

PK

Eugène Leroy

Tourcoing 1910

Eugène Leroy lost his father, also a painter, when he was only one year old. Yet he considers him as the man to whom he owes everything: "For me he was the very incarnation of painting. I owe him everything [...]". He was given his father's painting materials at an early age as a present and began a journey of discovery through the museums to study the great masters.

When, as a young man of seventeen, Leroy made a particularly successful self-portrait, his teacher advised him to sign it: the artist Eugène Leroy was born. Self-portrait was to remain a permanent theme in his art. When he was about 21, he no longer took traditional lessons at the Ecole des Beaux-Arts in Paris and Lille. A long period of study journeys and exhibitions lay before him; in 1937 he exhibited for the first time, in Lille, the city in which he was to settle some twenty years later.

His subjects – nudes, landscapes, and portraits – might well be called classical, though he could not be accused of insipid imitation; through searching and testing, he was to create an equivalent of his examples, which would at the same time be fed and tormented by a restlessness that his father never knew. The realism of his early watercolours was to be transformed into a passionate exchange of thoughts with painting and its great masters – Rembrandt for example – from whom he learned to direct all his artistic power towards something simple.

Under Leroy's sturdy workmanship lurks an almost religious approach to light and human value, while academic high-mindedness is not to be found.

In 1966, after a brief attempt in the direction of abstraction, there began a period of reflection about the art of painting. Leroy has been a drawer and a sculptor, has made engravings and painted in large formats with gouache, acrylics and oil paints especially.

In 1992 his career was crowned with an invitation to Documenta IX in Kassel.

AP

Reinier Lucassen

Amsterdam 1939

Lucassen, along with Pieter Holstein, Alphons Freymuth and Roger Raveel, gained recognition in the 1960s as an exponent of New Figuration, an art-historical term denoting a group of artists who as a matter of fact never exhibited under that title. What they did have in common was a Pop-Art-inspired penchant for quoting popular pictures from comic strips and magazines (*De eenzaamheid van Donald Duck* [The Loneliness of Donald Duck], 1964, Amsterdam, Stedelijk Museum), for references to art history (*Van Gogh, P.M. en Lucassen* [Van Gogh, P.M. and Lucassen], 1975) and for mixing different styles in one and the same painting (*My Hero-Portret van Jack the Ripper* [My hero-portrait of Jack the Ripper], 1967). Up to the beginning of the 1980s the work of Lucassen, a loner ("I don't trust anyone"), was often characterized as humorous and ironical, and as a precursor of the post-modern quotation art of the neo-Fauves. His frequent references to paintings by René Magritte and Francis Picabia probably reinforced that opinion. He himself has always opposed this one-sided interpretation: "If people laugh when they do understand the content of my work, it is not because what I am saying is funny. It's because they cannot cross the border between seriousness and humour, a border that does not exist for me". Lucassen himself crossed that border around 1980, when he developed an almost abstract idiom with an emotional content ("Art is about feeling and giving form to that feeling"). On a monochrome ground we see fragmentary figures and much-reduced realistic shapes, sober representations which are often akin to mysterious pictograms. In this arcane world of signs, numbers, dots and circles there are echoes of the late Picabia, to whom Lucassen has paid homage on more than one occasion, for instance in *Russische compositie naar Picabia of illusie van de werkelijkheid* (Russian composition after Picabia, or the illusion of reality, 1981, Amsterdam, Stedelijk Museum).

PK

Lucebert

Lubertus Jacobus Swaanswijk, *Amsterdam 1924 - Alkmaar 1994*

It was his experimental poems that first drew attention in the 1950s to the poet-painter Lucebert, who died on May 10, 1994.

Infected by Cobra's cry for freedom and originality, he jettisoned the rules of grammar and gave free rein to irrational streams of consciousness, sounds and associations. Although he only belonged to the group for one year (1949), he never abandoned Cobra's principles of improvisation, experiment and unbridled imagination.

Lucebert was a self-taught painter and draughtsman. At first he drew naïve, realistic scenes, later developing his characteristic handwriting: experimental forms combined with a pattern of nervously superimposed lines. In his paintings of the 1960s the vivid colours and bold outlines of the fanciful Cobra creatures gave way to portraits of hideous dictators and tyrants. Lucebert, who lived alternately in Bergen in the province of Noord-Holland and Spain, received several Dutch and international awards for his poetry and paintings, including the prestigious P.C. Hooft prize in 1967. It is hard to pigeonhole his work in a particular style or period in view of the fact that he reserved the right to work in any style or form he pleased. The subjects of his paintings, drawings and gouaches range between the two extremes of lighthearted fun and grim monstrosity. In 1986 Lucebert specialist Kees Groenendijk's collection was incorporated with that of the Stedelijk Museum. This 'merger' means that Amsterdam now boasts a unique body of the artist's

work. In 1996 these holdings were enriched by the addition of Groenendijk's literary Lucebert archive, part of which was exhibited in the Print Room of the Stedelijk last summer.

PK

René Magritte

Lessines 1898 - Brussels 1967

The work of Surrealist Giorgio de Chirico was a catalyst for René Magritte too.

After completing his studies at the Brussels Academy, Magritte worked in the neighbourhood of Victor Servranckx and created almost abstract works with references to the work of Fernand Léger. Then the work of de Chirico showed him the way and Magritte was already producing Surrealist work by 1926; Magic-Realistic to be precise, since he is not an orthodox Surrealist. The extraordinary, astonishing feeling with him was not caused by playing with elements from the subconscious; besides, there is little room for chance.

With *La trahison des images* (The treachery of images), *Ceci n'est pas une pipe* (This is not a pipe) (1928-29), it was clear what his intention was and what he expected of the observer. By placing a perfectly ordinary object in an unusual context, he deliberately conveys confusion. Thus he forces us, in a poetic manner, to question our relationship with reality, because things are not what they appear to be, everything is illusion.

He spent his first years as a Surrealist in Paris, but in 1930 he returned to Brussels for good.

From that time onwards his iconography was more or less established: his variations on his themes are extremely ingenious and sometimes highly amusing, even in a macabre manner.

During the Second World War he let off steam ironically through an excited Impressionism in the style of Auguste Renoir.

To this *période vache* belong the paintings he made for his first exhibition in Paris, meant to teach the public a lesson.

When he died in 1967 the government showed little interest in his work; his widow auctioned off a number of his paintings in London and gave only few of them to the State. This blunder has now been made good thanks to the recent, unusually fascinating bequest of the Scutenaire couple.

Brussels henceforth possesses the most important collection of Magrittes in the world.

AP

Constantin Meunier

Etterbeek 1831 - Elsene 1905

The tragic event of his father's death when he was still an infant played a decisive role in Meunier's life. His mother opened a guesthouse where artists lodged and thus her gifted youngest son came into contact with art.

When he was sixteen he studied sculpture at the Brussels Academy and developed a great admiration for Classical sculpture.

A number of years later he decided that painting came first and that was to be the case for thirty years. Meunier's work was Realistic in style and was inspired by religious and historical themes like *Het martelaarschap van de Heilige Stefanus* (The Martyrdom of St. Stephen) or *De brand van Turnhout* (The burning of Turnhout), until he chose daily life in his family as a subject – and that produced a much more spontaneous style. Just before he was fifty, he came into chance contact with the industrial area of Liège. It awakened in him the conviction that he had to dedicate himself to the working classes. This he did... as a sculptor, which was his real calling. Although he was deeply affected by the misery in which the proletariat was living, he did not fall into a boring Realism that might have been a predecessor of much twentieth-century east-bloc art. That is due to his venera-

tion for Greek sculpture: his sculptures entitled *De Buildrager* (The sack dragger) or *De Mijnwerkster* (The miner), for example are a mixture of his social commitment and classical ideal of beauty.

Meunier's art enjoyed wide success after some initial hesitation, abroad as well, to the genuine astonishment of the artist himself. He continued to work in all simplicity on busts, figurines, and monumental works such as his *Monument voor de Arbeid* (Monument to Labour), which was unveiled in 1930, and which he intended as the apotheosis of his whole life's work. A monument for Emile Zola, that remained unfinished, shows how much Meunier was aware of the ideological similarities between their work. His *Zaaier* (The seed-sower), *Scheepslosser* (Dockworker), *Smid* (Blacksmith) are the bronze comrades of Zola's Rougon-Macquart family.

AP

Georges Minne

Ghent 1866 - Sint-Martens Latem 1941

One of the eye-catchers in the Ghent art heritage is the *Fontein der Geknielden* (Fountain of the Kneelers) by Georges Minne, a work created at the end of the last century. It presents five naked young men with heads bowed in kneeling position.

It combines all the characteristics of Minne's Symbolist sculpture, and anyone who has seen only this work will have no difficulty recognising his other sculptures from the same period. Minne was twenty-four years old when he exhibited at Les Vingt in Brussels. Although he immediately drew attention and was confirmed in his talent by Rodin, he had doubts about himself and decided to take lessons in Brussels. It was around that time that his theme of the kneeling young man came into being, to which he gave shape in an ascetic language of form, slender and

drawn-out in body, composed, dreamy and still in concept. With a minimum of subjects – there is also a mother-and-child theme, the straddle-legged figure, the resurrection – Minne achieved a maximum of plastic intensity.

In 1907, he settled in Latem where Albijn van den Abeele and Valerius de Saedeleer were working. He slowly evolved towards the Naturalism of Constantin Meunier. He made studies from nature and studied anatomy at college so he could reproduce reality as objectively as possible. After the First World War, he returned to his composed style and produced a series of drawings that show less mutual similarity than his sculpture because it was a matter of "expressing an inexhaustible feeling" (Karel van de Woestijne).

After a break of ten years he once more put sculpture on exhibition in 1925. This late work was appreciated as being more mature and fuller, which writer-critic Karel van de Woestijne ascribed to the freer processing of the material and to a religiousness which (involuntarily) deepened after the war.

AP

Piet Mondrian

Amersfoort 1872 - New York 1944

With Bart van der Leck and Theo van Doesburg, Mondrian was a co-founder of *De Stijl* review (1917-31). Later acclaimed worldwide as an abstract artist, Mondrian's first paintings were still lifes and landscapes in the manner of The Hague and Amsterdam Impressionists. During his years in Amsterdam (1892-1911) and Paris (1912-14) he was exposed to the influences of Symbolism, Fauvism and Cubism. In 1908 he visited Domburg in the province of Zeeland, where his forms became more schematic and his colours brighter. *De rode boom* (The red tree), painted that year, clearly demonstrates the influence of Jan Sluijters' Fauvism and Jan Toorop's Pointillism. During his

Paris period Mondrian developed a personal variant of Cubism aimed at the increasing reduction and abstraction of his former figuration. He spent World War One back in the Netherlands, where he painted his first virtually abstract work in 1915: *Zee en pier (Compositie nr. 10)* (Pier and ocean [Composition no. 10]), a black and white painting consisting solely of separate lines. Under the influence of ideas which he developed further as a member of the Theosophical Association, he wrote theoretical treatises in *De Stijl* on the spiritual and universal power of the 'pure plasticism' that was the aim of neo-Plasticism: a totally abstract art based on geometrical forms, straight lines and primary colours. In 1940, by which time he had emigrated to New York, the balanced harmony of the pictures he had painted during his Paris period (1919-38) gave way to vibrant grids and planes of colour. His last paintings, *Broadway Boogie Woogie* (1943) and *Victory Boogie Woogie* (1944), capture the rhythm of the modern metropolis in an abstract idiom. 1994 was "Mondrian year", during which the Dutch painter's pioneer work was presented at the Gemeentemuseum in The Hague and New York's Museum of Modern Art. This auspicious event is documented by a two-volume catalogue raisonné compiled by Mondrian specialists Robert Welsh and Joop Joosten and scheduled for publication shortly.
PK

Antoine Mortier
Sint-Gillis 1908
It was quite a number of years before people in Belgium could accept that, in addition to Expressionism and Surrealism, another school of art existed – namely, abstract art.
The art world denied the abstraction of the 1920s and considered lyric abstractions as a development of Expressionism.
Only in the 1960s did Belgium

awake – albeit with aversion – when artist-critic Michel Seuphor called art-lovers to order with his book on Abstract art in Flanders. Antoine Mortier is an artist who undoubtedly could have made an interesting contribution about the art critics of those times.
After a figurative phase with clear reminiscences of Permeke, he was to be found – during and after the war – in the Apport and Jeune Peinture Belge circles.
However, he soon left both groups because in reality he is an *Einzelgänger* (loner), who wants to go his own way alone. And he has been alone all his life. He presented his art after the Second World War to a public who neither understood it nor wanted to.
The imposing power of conviction of his monumental signs, the inaccessible solidity of his structures, the beauty of his colours left the public completely unmoved. Mortier did not give in, but decided to dedicate himself completely to his art, tight-lipped, obstinate, against everyone. Every time, he was met with incomprehension or silence. Every time, he went on, hardening his attitude even more.
He confronted the art world with giant works, exuding a powerful plastic tension. Just as he refused any compromise, so he refused to choose for either abstraction or figuration. During the 1950s he produced a series of works which, although referring to daily life, are sublimated, grand, vital.
It was only after Seuphor's book came out that things began to change, albeit hesitantly: trust in Abstract art was slow in coming – writer Marnix Gijsen was still calling it "an experiment" in 1962. Antoine Mortier will be proved right.
AP

Panamarenko
Antwerp 1940
People have called him the illegitimate son of Leonardo da Vinci and Marcel Duchamp; he is an inge-

nious *bricoleur* who, with his fragile little aircraft, gives shape in a manner at once poetic and theoretically and ethically well-founded to one of man's age-old dreams: to be able to fly. During the 1960s the young artist Panamarenko was a welcome guest at happenings. He was in his element – a fish in water (though perhaps 'a bird in the air' would be a better simile) – in that typical atmosphere of freedom, contestation and lively protest.
Thus in 1966 he thought it was time for serious matters and... launched out with *Molly Peters*, a life-sized sex kitten in plastic; he created a roof gutter with drainpipe in which the water kept flowing, a bicycle with uneven wheels, etc. His interest in technique and cipher work was gradually awakening and he went on to invent all sorts of fantastic miniature aircraft which... did not fly: Panamarenko became the engineer of poetic nonsense.
The aircraft as a high point of human ingenuity was of no interest to him; what did fascinate him was freeing oneself from the earth, escaping gravity, flying under one's own power as insects do to perfection with their gossamer wings.
He was to base some of his model aircraft on this notion, the *Umbilly I* (1976) for example, an aesthetic construction with transparent wings like a dragon-fly.
Panamarenko works with light material like aluminium and polyester, and is always testing different propelling mechanisms for supplementing human energy.
His model planes are the result of a technology conceived by him, which is also understandable to the outsider. They form a useless pendant for the streamlined, highly-developed products of leading-edge technology. He offers us a carefully thought-out poetic alternative with which he calls into question the place of mankind in a hyper-mechanised society.
Panamarenko stands for playful fantasy, for the child who wants to

fly like a bird and he appeals to the inventor hidden in every human being. Recently (1996) he turned his attention to the phenomenon of the submarine with the same result: this artificial form too, a metaphor for a fish probably, cannot move under its own power.
AP

Constant Permeke
Antwerp 1886 - Ostend 1952
Permeke is without doubt one of Belgium's most important cultural ambassadors. He is the figurehead of Flemish Expressionism, the school of art that blossomed during the first decade of this century and which reproduces inner torment in dark colours and massive forms. Permeke made his debut with Luminist work deriving from Emile Claus and to which he soon bade farewell. Karel van de Woestijne thought him too powerful for this, and without disrespect to the sparkle of Luminism, it had to be admitted that it little suited an original force like Permeke. He was made for the Expressionism to which he was to give form in a masterly way.
After the First World War he settled in Ostend where he was to create his best work. He shared life with the fishermen, when he wasn't sitting in bars or being enticed into dance halls by noisy, cheap music.
He reproduced what was around him without falling into the picturesque. He only kept the essentials and depicted them with a rough, almost brutal magnitude. He created powerful, soft-coloured, conceptually synthetic, primitive archetypes, and sensitively rendered their authenticity, a quality he highly esteemed.
In 1925 he was living in Astene and painted landscapes of the river Leie, subdued in colour and slow in rhythm, the paint now and then applied thickly, or sometimes just to a minimum. After a sojourn in Antwerp he finally settled in Jabbeke and became the leading

figure of a successful art school. He was to create a number of sculptures which might be considered as three-dimensional versions of his paintings. Although Permeke did work to commissions occasionally and hence repeated himself, his work is unassailable and of an astonishing power, one of the high points in our art.

AP

Roger Raveel
Machelen aan de Leie 1921

Even those who are not involved in modern and contemporary art on a daily basis would recognise a work by Roger Raveel without problems as 'a Raveel'. This artist has indeed built up an oeuvre that is absolutely unique and yet continues to play with the same components. Roger Raveel soon dismisses critics who might accuse him of repetitiveness by writing "Raveel copies himself" and pointing out the difference between style and repetition.

Raveel made his debut with a figurative period in which he introduced the observer to the simple elements from his own surroundings that were to reappear continually: the little garden with fence, the cat, the man with the hat, the wheelbarrow. He does not build up any intimate evocation with them, but is instead searching for the relationship between things.

After an abstract period in which colour and light were of central importance, he caused a controversy with his *Neerhof* (Pigeon-house), a composition comprising a cage with a live pigeon. It was the solution to a problem that had preoccupied him for a long time: how painting and space influence each other. The American Pop artist Robert Rauschenberg pursued the same question with his *Combine Paintings* – canvases to which he attached objects – but Raveel's solution is different. He also introduces, in addition to objects, white-coloured areas, mirrors and shapes which have been cut out. The ob-

server is invited to participate in the work, blind spots refer to an absence into which people can project themselves. With mirrors he helps us to step into his world or he takes the world with him for a walk. Thus both the real and the imaginary spaces come together.

Roger Raveel's world, depicted in clear, bright colours, is not only a 'new vision' of reality, but also a plastic enlargement of it. Clear brush-strokes change place with plain fields of colour, contours around empty spaces.

Raveel's work, which has not undergone any real evolution over the last decade, stands for the synthesis between object-art and painting.

AP

Gerrit Rietveld
Utrecht 1888-1964

Furniture maker, designer and architect, Rietveld collaborated with Piet Mondrian, Bart van der Leck and Theo van Doesburg on the very first numbers of *De Stijl*, in which the principles of neo-Plasticism were expounded. He is best known for the *Red and Blue Chair* of 1918 and his design of 1924 for the Rietveld-Schröder house in Utrecht. In a letter to Van Doesburg, with Mondrian the leading theorist of De Stijl, Rietveld gave the following commentary on the underlying principles of the chair's design: "The construction enables the components to be connected without being mutilated, so that nothing dominates or subordinates, the chief idea being for the whole thing to stand freely and firmly in the room and for the form to prevail over the material". In his architectural designs, too, Rietveld adhered to the elementary principles of De Stijl: rectangular planes of primary colour which move freely in space. For a long time the Schröder house, completed in 1924, was a working monument to modern, functional architecture: open, flexibles spaces set in a visible steel frame with large windows

which create an impression of unbounded openness. Another well-known Rietveld design is the *Zigzag Chair* (1934, Amsterdam, Stedelijk Museum). After De Stijl disbanded in 1931, the internationally renowned designer received relatively few commissions. The predominantly reactionary architectural styles of the 1930s and 1940s cramped his style, and it was not until the 1950s, when the "light-air-space" philosophy of Modernism caught on, that important commissions came Rietveld's way again. One of them was the Dutch pavilion for the 1954 Venice Biennale; another was the sculpture pavilion for Sonsbeek, also in 1954, rebuilt at the Kröller-Müller Rijksmuseum in Otterlo in 1965. His last designs, for the Rietveld Academy of Art (1967) and the Vincent van Gogh Museum (1973), both in Amsterdam, were completed posthumously.

PK

Félicien Rops
Namur 1853 - Essonnes 1898

"A satanising gypsy", "a bastard", "a Belgian shanty-dweller", "a real artist" – these are some of the comments that show that Rops' work certainly did not go unnoticed. Almost a hundred years after his death, Félicien Rops is unanimously regarded as a great artist.

Although we know him mainly as a lithographer and etcher, Rops was also a painter of landscapes, perfectly reminiscent of Eugène Boudin, and Symbolist pictures. He also worked in the Realist and Impressionist styles, surpassing himself in *La Mort au Bal Masqué* (1865-75) in which he already prefigured Ensor.

Rops is nonetheless at his strongest and most individual in etching, a discipline which fits in seamlessly with his critical talent, his sharp eye and his astonishing drawing ability. He was soon making a name for himself as a caricaturist in the satirical journals *Le Crocodile* and *Uylenspiegel*, and went to Paris to

study engraving with Félix Bracquemond. In 1874 he settled there as an illustrator. He had only one objective: to be the illustrator of modern life and modern nakedness. A great lover of women, he created a highly individual type that became the subject of his art: not the wife or the mother, but the seducer, the ruler, against whom a man had to be on his guard, a vulgar saucy slut who made a man into a caricature and caused his ruin. He was also fascinated by all sorts of phantasms and by the supernatural: the devil, death, skeletons. A rather extreme (for that time) *piquanterie* and a certain degree of decadence lay at the heart of Rops' dubious reputation. But sadly, people have turned their attention too much on the pornographic Rops, thus missing his phenomenal talent. Even when he was working with black and white, he remained a rare colourist, and his drawing is astonishingly pure and expressive.

AP

Jules Schmalzigaug
Antwerp 1882 - The Hague 1917

It must have been a great shock to the solid liberal bourgeoisie from which Jules Schmalzigaug stemmed when it became clear to him in 1912 where his artistic destiny lay: in the avant-garde environment of Futurism. Until he left for Italy in 1912, Schmalzigaug was the product of his upbringing: an intelligent, sensitive, traditional young painter of great erudition. During his many journeys he lost his heart to Venice, as though he already felt that this was the place where his artistic future lay.

In 1911 he gave a glimpse of the Futurist-to-be when he expressed enthusiasm about aircraft at the Paris Salon de l'Aéronautique. One year later, at the Paris art shop of Bernheim-Jeune, his Futurist adventure began. In particular, he got to know the work of Umberto Boccioni and Gino Severini and immediately understood their signifi-

cance. He distanced himself from his earlier work and left for Venice. Futurism was not a trend in art towards which people in narrow bourgeois circles warmed easily. Its leading light, Marinetti, pleaded in the Futurist Manifesto (1909) for a break with the artistic past and for the destruction of museums and libraries. It was fanatical about war and anarchy, technology and speed and the whirling movements of dancing. This is what appealed to Schmalzigaug: the thrilling flight out of the system, the renewal.

Light, movement and colour became the components of his work. He divided his figures into fragments which were interspersed with other fragments.

When the First World War broke out, the highly promising Schmalzigaug had to leave Italy and this meant the end of his creative élan. Cut off from Futurism and absorbed into a narrow-minded environment that was not open to revolutionary trends, he felt isolated and artistically paralysed.

In 1917 Jules Schmalzigaug bade farewell to life, a life which should have just begun for him.

AP

Jan Schoonhoven
Delft 1914-1994

A post-office employee, Jan Schoonhoven was one of the founders of the Nul group (Armando, Henk Peeters, Jan Henderikse) in the 1960s. The group eschewed the personal handwriting of the Abstract Expressionists and the Informal painting of the 1950s, and opted for commonplace materials. Serialism, organization and monochromy were considered important factors. Schoonhoven, hailed by the press as "Holland's greatest minimal artist", was best known for his reliefs made of folded cardboard pasted with old newspapers and given a coat of paint. These three-dimensional artworks assume a different appearance with every change of the lighting.

Schoonhoven's reliefs look regular but are characterized by slight deviations: he varied the shape of the compartments, gave them slanting sides or incorporated overhanging horizontal strips of cardboard. In the 1970s he had the reliefs made by other people in order to eliminate his individual handwriting as far as possible. Giving his work neutral titles was another way of avoiding personal expression. Letters and numbers sufficed for Schoonhoven; *R 72-24*, for instance, indicates the type of work ("R" for relief, the year in which it was made and its ordinal number). Later, in 1978, Schoonhoven turned to drawing: 'lines', squiggles and signs with a calligraphic character, weblike grids and labyrinths. These works, which seem to hark back to the Abstract-Informal character of his work of the 1950s, are dominated by the expressive power of the pencil or Chinese brush. "Things got wilder. The hand was allowed to go its own way." Schoonhoven was awarded the David Röel prize for his oeuvre in 1984. His work has been exhibited on numerous occasions at home and abroad.

PK

Marien Schouten
Andel 1956

Schouten completed his training at Ateliers 63 in Haarlem. In 1985 he won the Prix de Rome for painting. In the work he has done since then, he explores the borderland between painting, sculpture and architecture. The organic, vegetational forms, lattices, wooden grids and motifs referring to architecture (planks, iron mounts) have developed since the late 1980s into characteristic 'installations' in which Schouten quite literally puts the painting 'in place' with the aid of railings, glass walls, lamps and plaster and bronze reliefs. Important factors in his game of spatial illusion and his investigation of the relationship between the flat canvas and the

surrounding space are, according to Schouten, the architect H.P. Berlage's ideas about ornament and space and the illusion-generating idiom of the Renaissance and Baroque. "Het vieze tafeltje" (The dirty table, 1996) at the Stedelijk was the first major retrospective of Schouten's work from 1984 to 1996 to be held in the Netherlands. The exhibits ranged from pure painting on canvas and walls to steel and glass constructions.

PK

Victor Servranckx
Diegem 1897 - Vilvoorde 1965

In 1909 the Futurist Manifesto appeared in *Le Figaro*. In it, the writer Filippo Tommaso Marinetti, ideologue of the Futurists, gave pride of place to machines and said he liked a racing car better than the *Nike* of Samothrace.

After that time, technology and machines became part of the themes of plastic artists – and not only of the Futurists. In France, for example, the Cubist Fernand Léger turned to twentieth-century technology as a subject for his art, and young Abstract artists also found in it a source of inspiration.

Michel Seuphor emphasized the relationship between the discovery of the aesthetics of the machine and the development of Abstract art: it was clear that the abstract geometrical language of form went quite naturally together with the interest in the beauty of the machine. Although Abstract art in Belgium did not provoke much excitement, a number of artist did nevertheless break free from figurative art. Victor Servranckx was one of them.

During the day he was an exemplary student at the Brussels Academy, but in the evenings the real Servranckx came to life, when he worked on his geometric-mechanical abstract canvases.

He put them on exhibition in 1917, and this was apparently the first time that the public had come face to face with Abstract work. His

works exude a quiet power and are images of modern times. With clear colours, wavy lines, stripes and geometric figures he celebrated machinery, without depicting machines themselves.

During the years of the Second World War Servranckx returned to a lyric palette and very spontaneous lines, perhaps shocked by the terrible events. He did not refuse a temporary experience in figurative art, in very sensual pictures, but towards the end of his life he was once more working in a geometric-abstract style. He did not always achieve the same level, but he had the additional merit of being a pioneer who helped to clear the way for Abstract art in Belgium.

AP

Jan Sluijters
's-Hertogenbosch 1881 - Amsterdam 1957

Sluijters, a draughtsman's son, studied at the Rijksakademie in Amsterdam. In 1906, back from his Prix de Rome journey, he went to Paris, the mecca of modern art in those days. It was there that he was first confronted with the 'wild' Fauvist palette. From 1911 he was influenced by Cubism and German Expressionism, movements represented in various exhibitions in the Netherlands at the time. In 1913 he exhibited at the first German autumn salon and, under the effect of Futurism, painted a few near-abstract works. Sluijters was best known for his figurative, moderately Expressionist work of the 1920s and 1930s – portraits – in which Van Dongen's influence is sometimes quite pronounced. A highly successful exhibition at the Stedelijk in 1927 ensured Sluijters a place in the history of Dutch art.

PK

Jacob Smits
Rotterdam 1855 - Mol 1928

"An artist must work in his studio; there he can concentrate best on the mystery of light": this is a saying

by Jacob Smits with which he defines himself as an anti-Impressionist. Smits was in his twenties when the Impressionist vision burst in on the art world. Although he was to handle the same theme – light – in his own art, there was an enormous gulf between him and the Impressionists, even as regards strokes and lines.

Smits saw the light as substance, not as a continual exchange of optical impressions, and he felt nothing for the virtuoso Impressionist touch either.

Smits, a Dutchman who became a naturalised Belgian, settled for good in Kempen after completing his studies. At that time, in 1889, this area was still very rural and that is precisely what attracted him to it: the rather poor landscape and meagre existence of hard-working farmers who still lived in accordance with the rhythm of the seasons. In his paintings he was to depict the things around him, without allowing himself to be diverted by the trivial or the transient. He depicted the essential in Man and Nature in an honest and uncomplicated manner.

At the beginning of his career, he worked with light and shadow effects; a work like *The Father of the Condemned* (1901) is strongly reminiscent of Rembrandt.

Before long, the poverty of rural life was to become the core of his work. Smits' viewpoint is both social and mystical: he integrates religious themes quite naturally into his work, and gives the Christ figure a wholly unassuming place among the farmers.

From a plastic art point of view, light is of central importance in his work, a light which he depicts by accumulating thick layers of paint. In this regard his art heralds Expressionism. Yet Smits was never to do violence to reality in order to increase expressive power. He did simplify and compose it in such a way as to internalise it.

AP

Leon Spilliaert
Ostend 1881 - Brussels 1946

Karel van de Woestijne said of Leon Spilliaert's work: "It leads me to self-consciousness", by which he meant that Spilliaert's art gave him a discomforting feeling. And so it is. Certainly in his best works, created between 1900 and 1912, the heavy atmosphere is reminiscent of the Norwegian Edvard Munch.

Spilliaert's youth coincided with the flourishing period of the sophisticated, elegant Ostend where the European aristocracy came for the frivolous pleasures of a seaside resort. However, this is not what fascinated Spilliaert, but the Ostend that existed after the season was over: the deserted Royal Galleries on the sea dike. He did not depict reality as it was, but greatly simplified and as he saw it in his nervous, over-sensitive imagination. In his self-portraits, which were also done during this period, we find the key: they are the imaginings of a sombre, tormented artist.

Where Munch expressed his mental battering with surging lines, Spilliaert gave shape to his inner disquiet with straight lines, a daring perspective and geometric forms.

His colours are sombre, the plastic materials meagre: no oil paint, but watercolours and pastels, pencil and ink, sometimes used together. His work was not liked by public or critics – Spilliaert remained misunderstood for a long time – and was recognised by only a handful of admirers. The Symbolist writer Emile Verhaeren, for example, felt sympathy with Spilliaert. Yet Spilliaert is not purely a Symbolist. Between Symbolism, Expressionism and Surrealism he sought a language of his own which was nothing but the highest personal expression of what moved him.

Around 1910 it seems that the tormented mind of Spilliaert had calmed down: his colour schemes became more lively, his touch broader and the atmosphere less melancholic.

Leon Spilliaert, self-taught and a loner, is recognised today as one of our most original talents.

AP

Peter Struycken
The Hague 1939

He created many artworks for public spaces in which he took as his starting point the 'physical experience' of the setting. This year he put the finishing touch to a fountain on the Spuiplein in The Hague. He sited two footpaths amid 196 computer-controlled jets of water forming various patterns. This makes it possible for the public to walk through the fountain, "like Moses crossing the Red Sea". Since as early as 1967 systematisation and arrangement and its variations have been constant features of Struycken's work, which includes videos, slide installations, paintings, sculpture and photographic works. The aim of his art based on computer calculations is to expose the structure of the world around us, a world which Struycken says should be thought of as "a space full of colours". He hopes to make visible the laws underlying the seemingly chaotic randomness of nature. In his penchant for the systematic ("a structure which adds up in every respect has for me a beauty that I experience in no other way"), Struycken belongs to the tradition of Dutch Constructivism and seems to relate to artists like Ad Dekkers and Martin Rous. His complex and variable images ("series of form and colour") have been embodied in several large-scale commissions such as the computer-controlled ceiling lighting for the Muziektheater in Amsterdam (1986), the metal terrain marking for the tax offices in Zwolle (1977) and a noise-reducing wall for a post-office railway yard in Utrecht (1984). On a smaller scale Struycken designed the *Koninginnezegel*, a postage stamp with a portrait of Queen Beatrix made up of dots. His work was seen at the São Paulo

Biennial (1967) and Documenta VII (Kassel 1982). In 1992 he was awarded the J.C. van Lanschot Prize for sculpture.

PK

Charley Toorop
Katwijk aan Zee 1891 - Bergen N.H. 1955

Charley was the daughter of the Symbolist painter Jan Toorop. She studied singing and violin before deciding to embark on a career as a painter in 1910. Her earliest work demonstrates the Expressionist influence of Der Blaue Reiter artist Kandinsky, whose work was first shown in the Netherlands in 1912, when she was painting landscapes, figures and self-portraits. In the early 1930s she finally opted for a style of expressive Realism and gradually acquired a reputation for her bold portraits of workers, peasants and ordinary people. Her house in Bergen was a meeting place for a circle of artists and writers (among them the poet A. Roland Holst and the painter Leo Gestel) who played a prominent part in the cultural scene of the 1930s. Life during the war, a time of oppression and resistance, was expressed in a series of poignant paintings such as *Clown in Front of the Ruins of Rotterdam* (1941) and *Arbeidersvrouw in ruïnes* (Working-class woman among the ruins, 1943). After the war she completed the large family portrait *Drie generaties* (Three generations, 1950), showing the death-mask of her father made by John Rädecker, accompanied by herself and her son, the painter Edgar Fernhout. Charley Toorop retrospectives were held in the 1980s in Stuttgart, Utrecht and Arnhem.

PK

Jan Toorop
Purworejo 1858 - The Hague 1928

Born on Java, Toorop came to the Netherlands when he was thirteen. In 1880 he enrolled at the Rijks-

akademie in Amsterdam. After working in both a Realistic and an Impressionist style for a while, Toorop became the leading Dutch representative of late nineteenth-century Symbolism. His decorative linear forms epitomize the poetic, melancholy mood of Art Nouveau and Jugendstil. Toorop was exposed to significant artistic influences during his Brussels period (1882-86), when he studied at the Académie des Beaux-Arts and became a member of Les Vingts, a group of Belgian artists. He exhibited with James Ensor, Henry van de Velde, Fernand Khnopff and Félicien Rops. Under the influence of Georges Seurat, whose work he had seen in Paris, Toorop, who ranks as a pioneer of Modernism in the Netherlands, adopted the Pointillist technique. In 1891, by which time he was back in the Netherlands (The Hague, Katwijk), his daughter Charley was born. A little later he painted his most important Symbolist works *Venus der zee* [Venus anadyomene], 1890, *De jonge generatie* [The young generation], 1891), heralded by *Oude eiken in Surrey* (Old oaks in Surrey). This establishes Toorop as one of the earliest Dutch Symbolists. After 1907 he attempted to capture the effect of light in broad strokes of colour in a style akin to the Luminism practised by Paul Signac and Henri-Edmond Cross. Toorop, Piet Mondrian and Jan Sluijters now constituted the vanguard of modern painting. In his later years Toorop, a Roman Catholic, painted boldly expressive portraits, some of them of clergymen, as well as producing drawings whose stylized figuration incorporates religious motifs popular in Catholic circles. He was also active in the applied arts, designing posters (his popular Art Nouveau placards for a salad oil factory in Delft earned Art Nouveau the nickname of "salad-oil style" in the Netherlands), did sketches for the decorative tiled panels in Berlage's Amsterdam Exchange building as well as designing stained-glass windows, murals and book-bindings.
PK

Luc Tuymans
Mortsel 1958

Luc Tuymans has the ability to be involved and detached at the same time. His *Gaskamer* (Gas-chamber, 1986) is not very different from a room in a house, his lamp made of human skin (*Recherches*, 1989) is almost an ordinary floor-lamp.
What drives Tuymans is the desire to analyse the world as 'matter of fact', without allowing himself to be led by emotions. For this reason a portrait of a terminal patient from the series *Diagnostische blik* (Diagnostic view, 1992) gives us no access to the man behind the patient. In the same series he also presents us with a leg or a breast: by isolating a small detail and enlarging it the world becomes more precise but also more difficult to identify. The knee in *Repulsion* (1991) is consequently hardly recognisable as a knee, but does have a power of suggestion that goes far beyond the edges of the canvas. Zooming in on a detail is a film procedure, and Tuymans feels a strong relationship with film, so strong in fact that he actually began to put a film drama together. In the end it did not come to fruition because Tuymans found the plastic arts more important, but *Antichambre* (1985), a canvas created fairly soon after the aborted film experiment, certainly built on it. Before Tuymans begins to paint he has the image, which is actually nothing more than a memory, already completed in thoughts. The painting is only its realisation in paints: a shadowy representation in subdued colours in a spatial context which cannot be defined more closely. The light in Tuymans' work is dusky and dim, which gives it an immanent character. His works come over anachronistically because he also gives his work the patina of archaic sculpture material from which he derived it, and places it in the past.
His art moves between two poles: poetry and objective depiction. It is expressed in the field of tension between each of these.
AP

Englebert van Anderlecht
Brussels 1918-1961

The painter Englebert van Anderlecht lived for only forty-three years. This unbearable reality – which was not hidden from him – was something which he was able to fashion into an extraordinarily creative élan. He left behind an extensive oeuvre, strongly charged with emotion, as witness of his inner tensions. Nothing would lead one to suspect that he was born an artist. He came from a large family of modest means and had already started his first job when he was only fourteen.
The artist in him soon became obvious. Van Anderlecht went to study at the academy, obtained diplomas and prizes which provided him with a bursary and supplemented his training further as a self-taught man.
His talent burst forth and in the middle of the 1950s – very early, therefore – he confronted the astonished art-world with an extensive collection of Abstract-Expressionistic works that evinced his violent temperament. With turbulent brushstrokes he unleashes a storm of colour on the canvas. His art gives off an almost frightening intensity: Van Anderlecht creates with a hellish speed, racing against time... *Je peins contre le temps* (I paint against time) is the title of the work that he exhibited in 1959 – two years before his death – together with critic Jean Dypréau. It is a composition of violence, leaking strokes of colour, combined with those macabre words, and it has to be seen in the light of a project called *Peinture partagée* (Shared painting) which was created with colleague Serge Vandercam.
It is an encounter between two actions, the pictorial and the written gesture, and at the same time the contrast between the two, the conflict. The work appears to try to provoke death and suffering. At the same time it is an act of rebellion against the approaching end, a rebellion to which Van Anderlecht had already given shape in *Couper la parole* (Cutting up words) by slashing and tearing the canvas.
Englebert van Anderlecht had to give up the struggle in 1961. He had given the world everything he had.
AP

Frits van den Berghe
Ghent 1883-1939

Perhaps it is true that everything has its good side. The enforced sojourn in painful circumstances in Holland of Frits van den Berghe and his colleague Gust De Smet during the First World War meant an artistic re-orientation for both artists which gave a new élan to their art.
Van den Berghe was in the United States when the war broke out. He came back, found his country occupied and went off to Holland where new trends like German Expressionism seemed to be in vogue. He dropped Impressionism and became an Expressionist.
In 1922 he returned to Belgium and settled down in the Leie region. He formed the second Latem school together with Constant Permeke and Gust De Smet. They created a synthetic and expressive style, each with his own palette, and movingly depicted men and the cosmos. Though the colour schemes of his earliest Expressionist works were still dark in tone, Van den Berghe's palette gradually became more lively. He is not such a great colourist as De Smet, but he still achieved monumental results, such as in his famous work *Sunday on the Leie* (1924). There is humour, even satire, in this canvas, such as we find in most of his work in fact.
Although he achieved an artistic

high-point with this excellent work, it would be a few years more before his Expressionism took on a more Surrealist hue. Van den Berghe came from an intellectual environment and this probably explains his interest in the fantastic and in the hidden corners of the human psyche. Under the spell of what he discovered under the microscope of a doctor friend, he created an astonishing world and it gave him pleasure to give shape to what lurked in the darkness of the human mind. Van den Berghe was unable to bring this new dimension in his art to full fruition: he died at the age of fifty-six.

AP

Bart van der Leck

Utrecht 1876 - Blaricum 1958

With Piet Mondrian and Theo van Doesburg, Van der Leck was a co-founder of *De Stijl* review in 1917. A year later, however, he refused to sign the group's first manifesto, being reluctant to commit himself whole-heartedly to the pure abstraction propagated by De Stijl. After breaking with Van Doesburg in 1920 he bid farewell to neo-Plasticism and reverted to his abstract reductions of reality. Van der Leck developed his distinctive style, which is characterized by simplified forms in primary colours, after being exposed to Symbolist and Fauvist influences. His theories regarding a synthesis of painting and architecture had a considerable effect on the ideas of Mondrian, whom he met in Laren in 1916. Van der Leck's reduction of the palette to the primary colours-red, yellow and blue – and the non-colours-white, black and grey – and his predilection for abstract, geometrical forms, contributed importantly to the development of the neo-Plasticism later promulgated by De Stijl. As well as a painter Van der Leck designed stained-glass windows and packing material. He also devised interior colour schemes.

PK

Gustave van de Woestijne

Ghent 1881 - Ukkel 1947

Happily, the religious vocation of Gustave van de Woestijne was a passing phase – he married in 1908 – otherwise the first Latem school would have lost a refined Symbolist and one of its central figures to the Benedictines in Louvain. Religion played an important part in Van de Woestijne's parental home; this explains his becoming a novice in 1905 and was also to have an influence on his art.

After his studies at the Ghent Academy he settled in Latem where eminent artists like Georges Minne and Valerius de Saedeleer were at work. The exhibition of Flemish Primitives in Bruges (1902) sharpened his religious sensitivity further and influenced his art considerably. His best works were created during the twelve years that followed, in which a number of influences from fifteen-century panel-painters can be detected: the meticulous depiction of reality, the sharp contours, and also a touch of religion, purity and simplicity. He mainly creates small, dreamy canvases, calm and composed, sometimes with a tinge of mysticism.

The gorgeous colours of the Flemish Primitives could not tempt him, but the muted colours of Italian frescoes did. He spent the First World War and a number of years after it in England where he met Permeke, and thereafter joined the Expressionists. This did not suit his shy, refined nature so well and the works he produced from then on did not always reach the same level. While his *Kindertafel* (Children's table, 1919) charms the eye through composed forms and soft colours, works like *Christus offert zijn bloed* (Christ offers his blood, 1925) give evidence of mystical exaggerations that are perhaps less appealing.

This tendency continued: the quality of his work declined, his drawing became sharper, the colours harder and the works sometimes surprising and frightened. A few years before his death in 1947, Van de Woestijne retreated from the world.

AP

Theo van Doesburg

Utrecht 1883 - Davos 1931

The most important theorist behind *De Stijl* review (1917-1922), Van Doesburg propagated the principles of neo-Plasticism in countless lectures and articles (see also Piet Mondrian and Bart van der Leck). An inspired and tireless organizer, he maintained extensive contacts with representatives of the avant-garde movements Dada, Constructivism and the Bauhaus. In 1920 he edited a few issues of the Dada periodical *Mécano*, whose contributors included Jean Arp, Tristan Tzara, Raoul Hausmann and Kurt Schwitters. Three years later he and Kurt Schwitters toured the Netherlands with an uproarious *Dada review*. In 1926 Van Doesburg published the manifesto *Painting and Plasticism* with a view to expanding the principles of neo-Plasticism. In this manifesto he expounded the fundamentals of Elementarism and advocated the introduction of the diagonal as a dynamic design element in the new art of colour, line and plane (*Contra-compositie V* [Counter-composition V], 1924, Amsterdam, Stedelijk Museum). Van Doesburg's proposed expansion of the artistic means (the introduction of the angle of 45°, 'floating' planes of colour suggesting depth) sparked off his disagreement with Mondrian, who took the manifesto as personal criticism. "Elementarism", wrote Van Doesburg, "was born partly as a reaction to an overly dogmatic and often shortsighted application of neo-Plasticism, partly as a consequence of this and finally and above all as a stringent correction of neo-Plastic ideas." Mondrian was particularly put out by Van Doesburg's demand that Elementarism should apply to the fourth dimension, the time-space domain. In the end the editors of *De Stijl* quarrelled. Van Doesburg co-founded the Abstraction-Création group in Paris in 1931. Earlier, in 1927, he had remodelled the interior of the Café Aubette in Strasbourg with Jean Arp and Sophie Täuber-Arp. He also designed a number of stained-glass windows. The Bauhaus architects and the artists of the Abstraction-Création group were much influenced by Van Doesburg's ideas.

PK

Kees van Dongen

Delfshaven 1877 - Monte Carlo 1968

After a brief career as a draughtsman for the *Rotterdams Nieuwsblad*, Kees van Dongen went to Paris in 1897, but by the end of the year was back in the Netherlands. During this period he painted landscapes and harbour views in the style of such Amsterdam Impressionists as Breitner. From 1899 on he spent lengthy periods in Paris, earning a living as a porter, a housepainter and an illustrator of satirical reviews like *L'assiette au beurre*, *Le Rire* and *Gil Blas*. At the end of 1905, by which time he had already exhibited at the famous Salon des Indépendants of 1904, his work was shown together with that of the Fauvists Henri Matisse, André Derain, Maurice de Vlaminck at the Salon d'Automne. In the ensuing turbulent years, during which he met Pablo Picasso and Max Jacob and was on contract to Daniel-Henri Kahnweiler, the well-known avant-garde art dealer, Van Dongen was influenced by the Fauvists and developed his own definitive style: plastic, dynamic forms in vivid contrasting colours. Seeking his themes in the exciting Parisian night-life of the time, in circuses, theatres and music-halls, he painted garishly coloured, erotic portraits of nude or scantily clad women. By 1914 his rapidly growing fame had earned him a reputation as a *beau monde* portraitist, and his work lost

its former 'wildness'. He stylized his figures into fairly realistic, modish apparitions and even countenanced the use of pastel shades. In great demand as a portrait painter, he revelled in being acclaimed "the most Parisian of artists". In the 1920s his sitters tended to be baronesses, bankers and other wealthy individuals who frequented the casinos and dance-halls. In 1926, three years before acquiring the French nationality, he became a Chevalier in the Légion d'Honneur. In 1990 the Musée d'Art Moderne de la Ville de Paris mounted a Van Dongen retrospective.
PK

Ger van Elk
Amsterdam 1941
He once clean-shaved a cactus with an electric razor (*Identifications, Part 6 [The Shaving of the Cactus]*, 1970, Amsterdam, Stedelijk Museum) and video-taped the operation. In the middle of the Atlantic ("the most dust-free spot in the world") he painted a block of wood white (his contribution to the exhibition Sonsbeek Off Limits, Arnhem 1971). But even before these actions his collaboration with Wim T. Schippers in the Adynamische Groep (Adynamic Group) had earned him his spurs. After the 1960s and 1970s, a period influenced by Fluxus and 'Nul' and in which the poetry of the small, conceptual gesture played an important part, Van Elk painted pictures based on photographs (*Russian Diplomacy*, 1974, Amsterdam, Stedelijk Museum), fashioned sculptures and manipulated photographs, or combined all three techniques. In the 1980s he produced a series of works whose theme was the famous Dutch art of the Golden Age; he splashed paint onto photographs of flower paintings, landscapes and still lifes, the spatters and stains contrasting with the realistic representation. Van Elk is fond of playing games with perspective distortions to which he

adapts the shape of the frame. With the series of *Sandwiches*, sculptures made in the 1990s and exhibited in the Boijmans Van Beuningen Museum in Rotterdam in 1993, the versatile Van Elk ("I am challenged by things I am not good at") presented a surprisingly aggressive series of objects incorporating framed photographs of various parts of the female body (*Kutwijf* [Bitch], 1992) or small painted portraits, sandwiched firmly together with large nuts and bolts. Van Elk is well known on the internationl scene (Documenta VI, 1977, Venice Biennale 1978, Documenta VII, 1982). He lives alternately in America and the Netherlands, and was awarded the J.C. van Lanschot prize for sculpture in 1996.
PK

Vincent van Gogh
Groot-Zundert 1853 - Auvers-sur-Oise 1890
Van Gogh was still working in the style of the Hague School when he went to Paris in 1886. Through his brother Theo, who worked for an art-dealer there, he encountered Impressionism and began using his colour in an entirely different way. In 1888 he left Paris for Arles in Provence, intending to set up an artist' co-operative there. Theo persuaded Gauguin to join Vincent, but living and working together caused problems between the two artists. Things came to a head when the distraught Van Gogh threatened Gauguin, famously cut off his own ear and a year later entered the asylum at St. Rémy. From an artistic point of view, however, his association with Gauguin was extremely fruitful: the latter's colourful flat forms and symbolism had a profound effect on Van Gogh's artistic development. In Provence he painted landscapes, flower still lifes and self-portraits (*Self-portrait with Bandaged Ear*, 1889) in glowing colours and jagged lines, and in total contrast to his earlier, sombre

works (*The Potato Eaters*, 1885). Van Gogh's unique innovative talent (he was later dubbed the "spiritual father" of French Fauvism and German Expressionism) went virtually unnoticed during his lifetime. After his discharge from the mental home in 1890, he moved to Auvers-sur-Oise where, after a last outburst of frenzied creativity (*Portrait of Doctor Gachet*, 1890), a self-inflicted revolver wound put an end to his life.
PK

Dan van Severen
Lokeren 1927
The geometric-abstract but nonetheless highly personal work of Dan van Severen could be described with the contemporary expression "Less is more". "Less" with regard to the form, because Van Severen tries to restrict himself to the absolute minimum of plastic art media, "more" with regard to the content, because he wants to bring out essential values with those media.
His work reflects a quest for an increasingly meagre expression of the overwhelmingly unutterable. With the passage of time Van Severen was to reduce his initially modest vocabulary even further: from canvas to paper, from oil paints to pencil, from colour to non-colour. During the 1950s and 1960s, he was still working with grey forms, which – supported by a blue or brown background – called up a highly personal, individual meditative tension. Van Severen allows circles, lozenges and rectangles to enter into dialogue with curved, vertical and horizontal lines.
Circles and curved lines gradually disappear to make way for (even) stricter compositions: lozenges and rectangles, sometimes hardly distinguishable from the medium on which they are drawn, tell their story in thin white and grey tint; Van Severen's art achieves something immaterial. His urge towards deeper purity finally brought him to the

bare pencil line, frail, drawn on paper, and to the ultimate simplicity of a cross. He is closely linked to the fundamental painting of the 1970s, but Van Severen has his own argument. His ascetic works try to turn the current "age of anxiety" towards contemplation, and thus help tormented mankind in its quest for balance and harmony. They are a metaphor for the longing for peace and detachment and exude their own mystique. Creating art means looking for ultimate reality which, according to Van Severen, can be most closely approached through abstraction. This partly explains why Van Severen chooses understated titles: *Composition, Untitled, Rectangular Composition*, and so on.
AP

Georges Vantongerloo
Antwerp 1886 - Paris 1965
Actually, the question of who the first Abstract artist in Belgium was – Servranckx or Vantongerloo – is irrelevant: both of them embarked on new paths, long before the public followed them. He started off as an artist during the First World War, when he met Theo van Doesburg in Holland, who was planning to set up an avant-garde journal. It appeared in 1917, was called *De Stijl*, and Vantongerloo was to continue working for it until 1922.
The art movement of the same name, with Mondrian as its leading representative, was to influence Vantongerloo's first Abstract works quite noticeably. The horizontal-vertical theme recurs in his paintings and as a sculptor he concentrated on space. His sculptures, open and closed spherical constructions, are based on spatial structures. After the war he returned to Belgium where it was a long time before this art was accepted. Vantongerloo found himself in an artistic isolation from which he forced a way out ten years later by settling in Paris, where Mondrian had also settled down.

In Paris things were not much better for Abstract art, but Vantongerloo committed himself with all the means at his disposal. He exhibited in 1930 with the Cercle et Carré group and one year later was the co-founder of the Abstraction-Création group, which was to promote Abstract art long into the 1930s. In the meantime his Abstract sculpture evolved from open, sometimes architectural constructions into works where he employed curved lines. Curves, but scientific curves – parabolas, therefore – since he was striving for a mathematical order in his work.

After 1945, he began to use unusual material, especially (coloured) Plexiglas, which he combined with shiny wires into luminous constructions. Vantongerloo died in 1965, the same year as Servranckx, who had also been a pioneer in Abstract art.

AP

Jan Vercruysse
Ostend 1948

The fact that Jan Vercruysse prefers to keep biographical information to himself is already a hint to anyone confronted with his intellectualist and extremely hermetic art. Hermeticism in particular is his defence against an intrusive art-world.

Vercruysse made his debut with visual poetry and followed on with photowork which to some extent was part of that because here too he combines image and language into enigmatic compositions.

He puts photos of himself or a woman together with reproductions of artworks and symbolic objects such as masks or clocks. Actually, they are not photos but single prints with which he makes a comment on the unique character of art and on the position of the artist, and investigates the nature of beauty. At the end of the 1970s, he was part of an international trend that aimed at integrating sculpture into the environment considered as a sculpturally binding element. His works are made of marginal elements – frames, pillars, plinths, panels – and so greatly reduced that they do not tell a story of their own. They do not allow themselves to be identified stylistically, they are not fixed in time and are not part of social reality. His four *Kamers* (Rooms), for example, are both content and wrapping, inner rooms of and for art, with a little mirror within for introspection. His *Atopies*, also created in the 1980s, are frontal compositions. They refer to the photowork and have the mirror in common with the *Kamers*. Changes in material, form or arrangement play no role because Vercruysse is investigating the possibilities and limitations of art in them. That also applies to his *Tombeaux*: their content is their form, they occupy their unique place and cover nothing that people would be able to call by name.

AP

Toon Verhoef
Voorburg 1946

In the mid-1970s Toon Verhoef succeeded in reviving interest in painting, which had taken a back seat for quite a time. Based on abstract signs, his works proved that the search for painterly means had not yet ended. Inspired by Clyfford Still and Ellsworth Kelly, Verhoef's canvases are often elongated, upright formats in which sections of circles, crossed bands and the mirrored letter "K" play an important role. The paint is applied in layers of contrasting colour and then scraped off, giving the works a wrought, structured look. In 1984 his formats became very large indeed; they are painted with elongated, more or less geometrical shapes from which a mysterious expressive power emanates. He was seeking to achieve the 'right' painting, a painting whose strength would derive from purely painterly parameters such as colour, (abstract) form and format. In 1995 Verhoef, winner of the Amsterdam Art Foundation Award in 1988, designed a stained-glass window for the Nieuwe Kerk in Amsterdam in memory of the victims of World War Two. He was represented at Documenta VII (Kassel, 1982) and has exhibited in various group and one-man shows.

PK

Henk Visch
Eindhoven 1950

Visch started off as graphic artist. In the early 1980s, like René Daniels and Peer Veneman, who come from the same region of the Netherlands (Brabant) as himself, he attracted attention with figurative sculptures which he described as "carpentry drawings". These introverted human figures teeter in precarious equilibrium; made of fragile material – weathered wood, wood chips, feathers and paper – they are often painted with curious signs or lines of colour.

Midway through the 1980s, back from a stay in New York, the human figures made way for sculptures which were no longer based on visible reality. The ensuing works express a "psychic reality", as Visch puts it, and are meant to trigger an "associative experience" in the beholder. This new approach has resulted in a highly varied oeuvre of sculptures, drawings and prints. Visch, who does not confine himself to specific materials or forms, works with aluminium, iron and polystyrene foam. He gives his works poetic, sometimes slightly ironic titles. For example, an iron wheel with a diameter of two-and-a-half metres, to which little lamps are attached, is called *Take me to the River* (1988).

He has also exhibited a human figure made of polystyrene foam, wrapped in a piece of cloth and sporting a humming-top on its head: "Idle Thoughts for Idle Men" (1991). Visch's work is regularly exhibited, and was shown at the 1988 Venice Biennale and at Documenta IX (1992).

PK

Carel Visser
Papendrecht 1928

One of the Netherland's leading sculptors, Carel Visser has received several prizes for his large oeuvre, including the 1971 State Prize for Art and Architecture and the J.C. van Lanschot prize for sculpture in 1994. He became known in the 1950s for his welded iron animal, sculptures.

A little later, adopting the principles of De Stijl, he produced sturdy geometrical-abstract compositions made of iron. These were followed towards the end of the 1970s by assemblages of found objects and materials – sheets of glass, feathers and eggs. Visser the sculptor has never stuck to one material or technique; besides sculptures he has made drawings, reliefs, woodcuts and collages.

Despite this variety, he has always focused on the fundamental problem of sculpture: how to establish a connection between the different parts of a sculpture and how to connect it with the ground on which it stands. He would 'destroy' a work's stability by using flaccid materials like sheet iron and leather (*Slappe kubus* [Limp cube], 1969, Amsterdam, Stedelijk Museum), and incorporated commonplace, ephemeral materials in collages of birds' feathers, small bones, eggshells and sea-shells. "I won't use a material if people can't grasp what it is", he once said. "The things must have a perfectly clear meaning and bring with them an atmosphere that everybody can recognize." *Wandelstok* (Walking-stick, 1978) was the first of a series of works in which objects are supported by goats' horns, ostrich eggs or swans' wings. In 1980 Visser started to pile up car tyres, olive cans, car windscreens and other 'found' materials. His assemblage method results in humorous, ambiguous sculptures which stimulate the beholder's imagination.

In 1994 the Gemeentemuseum in The Hague staged a Visser retro-

spective. That same year he represented the Netherlands at the São Paulo Biennial.

PK

André Volten
Andijk 1925

Volten was born into a family of Zuider Zee fishermen from the province of Noord Holland and began by painting and drawing Abstract-Impressionist works. After spending four years in Brussels, in 1950 he moved to a studio in the north of Amsterdam, in the heart of the docklands. There he worked voluntarily at a large shipyard and learnt how to weld and forge. In 1953 he produced his first abstract metal sculptures and reliefs of thin, vertically and horizontally linked lines. The rhythmic piling up of T- and H-shaped beams was followed by heavier constructions of cube-shaped and partly transparent elements. With his decision to give up pencil and brush in favour of a welding torch Volten took a remarkable step. His early use of such "unartistic" industrial materials as iron sections was also revolutionary for the Netherlands. He quickly won recognition for his geometric Constructivist work. In 1966 he had his first one-man show at the Stedelijk Museum in Amsterdam and this was followed by large solo exhibitions in Rotterdam (Museum Boijmans-van Beuningen, 1975) and Duisburg (Wilhelm Lehmbruck Museum, 1975, 1996). He became best known, however, for his monumental works in public spaces, for which he has received commissions almost every year from 1960.

Celebrated examples include the steel column on the Frederiksplein in Amsterdam (1967-70) and the ring of granite before the Amsterdam Town Hall/Music Theatre (1983-86). In 1996 Volten was awarded the Oeuvre Prize of the Foundation for the Visual Arts, Design and Architecture.

AP

Co Westerik
The Hague 1924

Westerik's tempera and tempera/oil paintings and drawings convey a tranquil yet strained image of people, animals or plants (*Tulp* [Tulip], 1990) embroiled in a dramatic situation. By painting his subjects (feet, fingers, hands, heads, veined skin) in exaggerated close-up or in spaces too small for them, Westerik gives reality an alienating twist. "It all comes from inner inspiration", he once remarked; "that inner world, between what the mind's eye sees and reality, yields a *geistliche Idee.*" The artist is best known for his knowledge of the painting techniques employed by the old masters (Jan van Eyck, Rogier van der Weyden) and for his painstaking method. Painting is a lengthy, unremitting process for Westerik, a struggle with the material, constantly raising doubts: "You have to do your job properly. The thing has to have clarity. It has to be painted carefully. And that calls for a craftsman's technique". *Vless* (Flesh, 1991), purchased by the Stedelijk Museum, demonstrates Westerik's fascination for the human skin, for flesh in all its nuances of pinks, browns and yellows; it also demonstrates his ability to give flesh a powerful erotic charge. He has received various awards (including the 1961 Jacob Maris prize for painting and drawing), took part in the 1982 Venice Biennale and exhibits regularly in Dutch museums. In 1991 the Stedelijk organized a major survey of his paintings, prints and drawings.

PK

Antoine Wiertz
Dinant 1806 - Brussels 1865

Antoine Wiertz was actually a little mad, which during the Romantic period was not very noticeable since everyone was so at that time. People were fanatical about the past and longed passionately for death. Love for one's country, heroism and mystery were the order of the day. It was a time of superlatives, the ideal framework for someone like Wiertz, who considered himself a genius. He created a highly implausible series of works that bulged with an intellectualism he did not possess.

Yet Antoine Wiertz did have talent: he was only fourteen when he went to study in Antwerp, studies that were paid for by patrons, because Wiertz came from a modest family. This perhaps lay at the basis of his megalomania. After his studies and a sojourn in Paris where the work of Géricault moved him greatly, he won the Prix de Rome. He set to work, as he modestly remarked, comparing himself with Michelangelo and Rubens and leaving all the Romantic painters far behind. He painted an enormous work that was received with great enthusiasm in his own country too. Wiertz felt he was the successor of Rubens and set about creating what he called "des tableaux pour la gloire". His passion for Rubens and his determination to equal the master can be seen in a number of works that measure for measure are pastiches of Rubens. On several occasions he held exhibitions in which he tried to confront his work with that of Rubens, but that was too much even for the official authorities whom he had excited so much.

Wiertz did, however, leave behind a number of good works – solidly constructed, perfectly finished and painted with consummate skill. They stand in remarkable contrast to the rest of his bombastic, pretentious works. The State gave him a museum with a studio where he worked until his death. He portrayed himself in caricatural tones.

AP

Carel Willink
Amsterdam 1900-1983

After studying architecture at the Delft Polytechnic, Willink went to Berlin in 1920, where he became a member of the avant-garde November Gruppe. Through this group he was introduced to the newest art movements – Expressionism, Constructivism, Dada – and took part in exhibitions in Berlin and Belgrade. In 1924, by which time he was back in Amsterdam, he had his first one-man show. Under the influence of de Chirico's Pittura Metafisica and his writer-friend Eddy du Perron, whose work he often illustrated, Willink returned to figuration. In 1930 he began to develop the realistic precision that was to become his trademark. He painted gardens (Bomarzo), landscapes, houses and people in a neo-Classic style with an alienating and ominous effect (*De laatste bezoekers aan Pompei* [The last visitors to Pompeii], 1931). Willink, who with Raoul Hynckes and Pyke Koch is classified as an exponent of Magic Realism, always opposed theoretical interpretations of his oeuvre. Continuing to paint portraits of the *beau monde*, Willink and his designer-dressed wife Mathilde lived in a handsome house opposite the Rijksmuseum in Amsterdam until his death.

PK

Rik Wouters
Mechelen 1882 - Amsterdam 1916

Rik Wouters loved life so much that he preferred to express himself more as a painter than as a sculptor: sculpture hemmed in too much his effervescent urge to express himself. He was unable directly to give shape to what welled up inside him and he wanted to be able to translate what he so eagerly observed – an unending stream of happy impressions – into an exhuberant display of colour. Yet nothing seems less true if we look at his *Zotte geweld* (Mad violence, 1912), a memorial to Isadora Duncan, a sculpture that he created while fully under the spell of her ecstatic dance art.

It is a burst of laughter turned into a sculpture, an explosion of the joy

of life. Rik Wouters was a Sunday child who enjoyed life from moment to moment like a many-coloured kaleidoscope, a procession of sunny trifles which he immediately conjured up on his canvas. He found a wealth of colours in the simplest little things of daily life and, in his wife Nel, a continual source of inspiration. She was at the source of his oeuvre.

Seeing his wife as she moved around him, looking at what she was doing gave him happiness and he expressed it on his canvases over and over again.

He found happiness mostly at home, in the intimacy of a very successful marriage, although nature too was one great allure for his artistic soul, which saw nothing but exuberant colours.

He drew and painted the life around him; the subject-matter was not important for him.

Rik Wouters' work therefore demands no intellectual effort on the part of the observer. There is nothing more than what you see. What he observes with his artistic sensitivity, he reproduces with broad, easy strokes, in vivid colours placed next to each other, without much attention for perspective or contours. His works have no ideological or psychological depths, no hidden symbolism.

AP

General Bibliography

The *General Bibliography* of this catalogue includes both the entries on Belgium and those on the Low Countries. The former were edited by Norbert De Dauw and Patrick van Rossum; the latter were edited by Geurt Imanse.

La Belgique, société et culture depuis 150 ans, Bruxelles, 1980

Les grands événements du XXe siècle en Belgique, Bruxelles, 1987

BANEKE, J. (ed.), *Dutch art and character. Psychoanalytic perspectives on Bosch, Bruegel, Rembrandt, Van Gogh, Mondrian, Willink, Queen Wilhelmina*, Swets & Zeitlinger, Amsterdam-Lisse, 1993

BARTIER, J. et al., *Histoire de la Belgique contemporaine 1914-1970*, Bruxelles, 1975

BEKKERS, L.; STEGEMAN, E., *Hedendaagse schilders in Nederland en Vlaanderen*, "Stichting Ons Erfdeel", Rekkem, 1995

BIRON, M., *La modernité belge: littérature et société*, Bruxelles-Montreal, 1994

BITSCH, M.-T., *Histoire de la Belgique*, Paris, 1992

BLOK, C. (red.), *Nederlandse kunst vanaf 1900*, Teleac, Utrecht, 1994

BLOTKAMP, C., *Keuzen. Beschouwingen over hedendaagse Nederlandse kunstenaars*, Reflex, Utrecht, 1985

DUMONT, G.-H., *La Belgique*, Paris, 1991

FUCHS, R.H., *Dutch Painting*, London, 1978

GENICOT, L. (dir.), *Histoire de la Wallonie*, Toulouse, 1973

HAMMACHER, A.M., *Stromingen en persoonlijkheden. Een halve eeuw schilderkunst in Nederland*, Nijmegen, 1955

IMANSE, G. (red.), *De Nederlandse identiteit in de kunst na 1945*, Uniepers, Abcoude, 1995

IMANSE, G. (Red.), *Van Gogh bis Cobra. Holländische Malerei 1880-1950*, Verlag Gerd Hatje, Stuttgart, 1980; *Van Gogh tot Cobra, Nederlandse schilderkunst 1880-1950*, Meulenhoff-Landshoff, Amsterdam, 1981

JAFFÉ, H.L.C., *De Stijl 1917-1931. The Dutch contribution to modern art*, Amsterdam, 1956

KOSSMANN, E.H., *The Low Countries*, Oxford, 1978

LOOSJES-TERPSTRA, A.B., *Moderne kunst in Nederland 1900-1914*, Utrecht, 1959

MABILLE, X., *Histoire politique de la Belgique*, Bruxelles, 1986

MEKKINK, M. et al. (red.), *Kunst van Nu. Encyclopedisch overzicht vanaf 1970*, Primavera Pers, Leiden, 1995

MORELLI, A. (ed.), *Les grands mythes de l'histoire de Belgique, de Flandre et de Wallonie*, Bruxelles, 1995

PIRENNE, H., *Histoire de Belgique des origines à nos jours*, Bruxelles, 1975

READ, H. (Red.), *Du Mont's Künstler-Lexikon*, DuMont Buchverlag, Köln, 1991

SPAANSTRA-POLAK, B., *Symbolism. Translated from the Dutch by L. Scott*, Meulenhoff Amsterdam, 1967

STENGERS, J. (dir.), *Bruxelles, croissance d'une capitale*, Antwerpen, 1979

STENGERS, J., *Congo, mythes et réalités: 100 ans d'histoire*, Paris, 1989

STENGERS, J., "La déconstruction de l'état-nation: le cas belge", *Vingtième Siècle*, 50, 1996, 36-54

STOKVIS, W., *Cobra: an international movement in art after the second World War*, Barcelona, 1987

STOKVIS, W. (red.), *De doorbraak van de moderne kunst in Nederland. De jaren 1945-1951*, Meulenhoff Amsterdam, 1984

STOKVIS, W. (red.), *Vrij Spel. Nederlandse kunst 1970-1990*, Meulenhoff, Amsterdam, 1993

WENTINCK, CH., *De Nederlandse schilderkunst sinds van Gogh*, Nijmegen, 1959

WITTE, E. (dir.), *Histoire de Flandre des origines à nos jours*, Bruxelles, 1982

WITTE, E.; CRAEYBECKX, J., *La Belgique politique de 1830 à nos jours*, Bruxelles, 1987

1880-1914

ARON, P., *Les écrivains belges et le socialisme, 1880-1913: l'expérience de l'art social, d'Edmond Picard à Emile Verhaeren*, Bruxelles, 1985

BITSCH, M.-T., *La Belgique entre la France et l'Allemagne*, Paris, 1994

CHARRIAUT, H., *La Belgique moderne, terre d'expériences*, Paris, 1910

ELIAS, H., *Geschiedenis van de Vlaamse gedachte 1780-1914, vierde deel: Taalbeweging en cultuurflamingantisme. De groei van het Vlaamse bewustzijn 1883-1914* (tweede druk), Antwerpen, 1971

GODDARD, S.H. (ed.), *Les XX and the Belgian Avant-garde. Prints, drawings and books circa 1890*, Kansas City, 1992

LEMONNIER, C., *La vie belge*, Paris, 1905

LIEBMAN, M., *Les socialistes belges, 1885-1914: la révolte et l'organisation*, Bruxelles, 1979

LILAR, S., *Une enfance gantoise*, Paris, 1976

PIRENNE, H., *Histoire de Belgique*, deel VII: *De la Révolution de 1830 à la guerre de 1914*, Bruxelles, 1948

ZOLBERG, A., "The Making of Flemings and Walloons: Belgium, 1830-1914", *Journal of Interdisciplinary History*, 5, 1974, 179-235

ZWEIG, S., *Emile Verhaeren, sa vie, son oeuvre*

1914-19

CHRISTENS, R.; DE CLERCQ, K., *Frontleven 14/18. Het dagelijks leven van de Belgische soldaat aan de Iijzer*, Tielt, 1987

DEFLO, F., *De literaire oorlog. De Vlaamse prozaliteratuur over de Eerste Wereldoorlog*, Aartrijke, 1991

DE SCHAEPDRIJVER, S., *De Grote Oorlog, België 1914-1918*, Amsterdam, 1997

PIRENNE, H., *La Belgique et la guerre mondiale*, Paris-New Haven, 1928

STENGERS, J., "Belgium", in WILSON, K. (ed.), *Decisions for War 1914*, New York, 1995, 151-74

VANACKER, D., *Het aktivistisch avontuur*, Gent, 1991

WHITLOCK, B., *Belgium: a Personal Narrative*, New York, 1919

1920-40

De dolle jaren in België 1920-1930, Bruxelles, 1981

Les années trente en Belgique: la séduction des masses, Bruxelles, 1994

HOOZEE, R. (red.), *Moderne kunst in België 1900-1945*, Antwerpen, 1992

STÉPHANY, P., *Les années 20-30: la Belgique entre les deux guerres*, Bruxelles, 1983, 2 delen

VAN KALKEN, F., *Entre deux guerres: esquisse de la vie politique en Belgique entre 1918 et 1940*, Bruxelles, 1945

1945-50

BERNARD, H., *La Résistance 1940-1945*, Bruxelles, 1968

CONWAY, M., *Collaboratie in België. Léon Degrelle en het Rexisme, 1940-44*, Bruxelles, 1994; Yale University Press, Yale, 1993

DE WEVER, B., *Greep naar de macht. Vlaams-nationalisme en Nieuwe Orde: het VNV 1933-1945*, Tielt, 1994

GÉRARD-LIBOIS, J.; GOTOVITCH, J., *L'an 40: la Belgique occupée*, Bruxelles, 1971

HUYSE, L.; DHONDT, S., *Onverwerkt verleden. Collaboratie en repressie in België, 1942-1952*, Leuven, 1991

KLARSFELD, S., *Mémorial de la déportation des Juifs de Belgique*, Bruxelles-New York, 1982

STEINBERG, M., *L'étoile et le fusil, I. La question juive 1940-1942*, Bruxelles, 1983; *II. 1942. Les cent jours de la déportation des juifs de Belgique*, Bruxelles, 1984; *III. La traque des juifs 1942-1944*, Bruxelles, 1986, 2 delen

STRUYE, P., *L'évolution du sentiment public en Belgique sous l'occupation allemande*, Bruxelles, 1945

VERHOEYEN, E., *België bezet 1940-1944*, Bruxelles, 1993

1950-96

BLOMMAERT, J.; VERSCHUEREN, J.; *Het Belgische migrantendebat: de pragmatiek van de abnormalisering*, Antwerpen, 1992

CEULEERS, J.; VANHAECKE, F., *De stoute jaren '58-'68*, Leuven, 1988

CLEMENT, J. et al., *Het Sint-Michielsakkoord en zijn achtergronden*, Antwerpen, 1993

COPPIETERS, M.; DE BATSELIER, N., *Het sienjaal. Radicaal-democratisch project*, Antwerpen, 1996

FOX, R.C., *In the Belgian Château: the spirit and culture of a European society in an age of change*, Chicago, 1994

MORELLI, A. (red.), *Histoire des étrangers et de l'immigration en Belgique de la préhistoire à nos jours*, Bruxelles, 1992

REYNEBEAU, M., *Het klauwen van de leeuw. De Vlaamse identiteit van de 12de tot de 21ste eeuw*, Leuven, 1995

Catalogues

Actie, werkelijkheid en fictie in de kunst van de jaren '60 in Nederland, Museum Boymans-van Beuningen, Rotterdam, 1979-80

Art Pays-Bas XXe siècle - Du concept à l'image, ARC - Musée d'Art Moderne de la Ville de Paris, Paris, 1994

Beeldende Kunst in Nederland tussen 1945-1965. Een overzicht, Museum Van Bommel-Van Dam, Venlo, 1982

België Nederland. Knooppunten en parallellen in de kunst na 1945, Palais des Beaux-Arts, Bruxelles; Museum Boymans-van Beuningen, Rotterdam, 1980

Contemporary Art from the Netherlands, Museum of Contemporary Art, Chicago, 1982

Een nieuwe synthese. Geometrisch-abstracte Kunst in Nederland 1945-1960, Rijksmuseum Twenthe, Enschede; Gemeentelijk Museum "Het Princessehof", Leeuwarden; Stedelijk Museum "De Lakenhal", Leiden, 1988

Gesignaleerd. Neue Kunst aus den Niederlanden, Kunsthalle zu Kiel, Kiel, 1983

Het nieuwe wereldbeeld: Het begin van de abstracte kunst in Nederland 1920-1925, Centraal Museum, Utrecht, 1972

La Beauté Exacte: de Van Gogh à Mondrian, Art Pays Bas XXe siècle, Musée d'Art Moderne de la Ville de Paris, Paris, 1994

Moderne Nederlandse schilderkunst / Modern Dutch painting, Stedelijk Museum, Amsterdam, 1983

PIERRE ALECHINSKY
Centres et Marges, Entretien de P. Alechinsky avec M. Gibson et un poème d'O. Paz, un poème d'H. Claus, 1988
Extraits pour traits, Petite anthologie des préfaces sur l'artiste réunies et présentées par Michel Sicard, Paris, 1989
Travaux d'impression, Dialogue de M. Butor et M. Sicard. Préface d'A. Coron, Paris, 1992
BOSQUET, A., *Pierre Alechinsky*, Paris, 1971
RIVIERE, Y., *Pierre Alechinsky. Les Estampes de 1946 à 1972*, Paris, 1973
SELLO, K., *Pierre Alechinsky: Margin and Center*, Kat., Kunstverein Hannover, Hannover, 1988

KAREL APPEL
FUCHS, R.H. (samenstell.), *Ik wou dat ik een vogel was. Berichten uit het atelier*, Haags Gemeentemuseum, Meulenhoff Amsterdam, 1990
KUSPIT, D., *Karel Appel. Sculpture. A catalogue raisonné*, Abrams, New York, 1994
RAGON, M., *Karel Appel. Peinture 1937-1957*, Éditions Galilée, Paris, 1988

ARMANDO
Armando, Stedelijk Van Abbemuseum, Eindhoven; Stedelijk Museum, Amsterdam, 1981 (cat.)
Armando: Bilder, Skulpturen, Zeichnungen, Neuer Berliner Kunstverein, Berlin, 1994 (cat.)
DAMSCH-WIEHAGER, R., *Nul, die Wirklichkeit als Kunst fundieren: die Niederländische Gruppe Nul 1960-1965 und heute*, Cantz, Stuttgart, 1993

GERRIT BENNER
Benner, Stedelijk Museum, Amsterdam, 1959 (cat.)
Gerrit Benner, Galerie Tegenbosch, Eindhoven, 1986 (cat.)
In de ban van Benner, Singer Museum, Laren, 1989 (cat.)

GASTON BERTRAND
GOYENS DE HEUSCH, S., *Gaston Bertrand. Une poétique de la distance*, Louvain-La-Neuve, 1985
LEGRAND, F.C., *Gaston Bertrand*, Bruxelles, 1972
MEURIS, J., *Profiel van Gaston Bertrand*, Gent, 1970

ROB BIRZA
Nine Contemporary artists: philip akkerman, rob birza, paul cox, guido geelen, joep van lieshout, willem oorebeek, charly van rest, han schuil, roos theeuws, Witte de With, Rotterdam, 1991 (cat.)
Rob Birza, Galerie Van Krimpen, Amsterdam, 1989
Rob Birza, Voorwoord Wim Beeren, tekst door Toine Ooms, Marjolijn Schaap, Stedelijk Museum, Amsterdam, 1991 (cat.)

BRAM BOGART
BONITO OLIVA, A., *Bram Bogart. Ora la luce è finalmente matura*, Galleria San Carlo, Milano, 1991
MEURIS, J., *Bram Bogart ou l'expressionnisme en ses suprèmes retranchements, Rétrospective*, Le Botanique, Bruxelles, 1992
VAN DEN BUSSCHE, W., *Bram Bogart Retrospectief*, Provinciaal Museum voor Moderne Kunst, Oostende, 1995

EUGÈNE BRANDS
Eugène Brands, Galerie Nouvelles Images, 's-Gravenhage, 1980; Stedelijk Museum, Schiedam, 1981 (cat.)
Eugène Brands. Collectie G. Hofland, De Beyerd Centrum voor Beeldende Kunst, Breda, 1990 (cat.)
WINGEN, E., *Eugène Brands*, SDU Uitgeverij, 's-Gravenhage, 1988

MARCEL BROODTHAERS
BORGEMEISTER, R.; CLADDERS, J.; COMPTON, M. et al., *Marcel Broodthaers. L'oeuvre Graphique, Essais*, Centre Genevois de Gravure Contemporaine, Genève, 1991
DAVID, C.; DABIN, V., *Marcel Broodthaers*, Galerie du Jeu de Paume, Paris, 1991
GOLDWATER, M.; COMPTON, M.; CRIMP, D. et al., *Marcel Broodthaers*, cat., Walker Art Center in Minneapolis, Minneapolis, 1989
NUYENS, M.C., *Marcel Broodthaers; het volledig grafisch werk en de boeken*, Galerie Jos Jamar, Knokke-Duinbergen, 1989

STANLEY BROUWN
Stanley Brouwn, Villa Arson, Nice, 1995 (cat.)
This way Brouwn, Art & Project, Amsterdam, 1969 (cat.)
GOLDSTEIN, A. et al., *Reconsidering the object of art: 1965-1975*, Museum of Contemporary Art, Los Angeles, 1995

JEAN BRUSSELMANS
Jean Brusselmans, retrospectieve tentoonstelling, Groeningenmuseum, Brugge, 1980
Jean Brusselmans. Werken en dagen. Werken op papier, Eigenbrakel, 1989
Vlaams expressionisme in Europese context, 1900-1930, Museum voor Schone Kunsten, Gent, 10/03/1990-10/06/1990
DELEVOY, R.L., *Jean Brusselmans*, Bruxelles, 1972
DE DAUW, N.; DE VOS, D.; DELEVOY, R.L.; MERTENS, PH., *Retrospective Jean Brusselmans*, tent. cat., Groeningenmuseum, Brugge, 1980

CONSTANT
Constant 1945-1983, Rheinisches Landesmuseum, Bonn, 1986 (cat.)
Constant: paintings 1948-1995, tekst door Marcel Hummelink, Stedelijk Museum, Amsterdam, 1995 (cat.)
LOCHER, J.L.; JITTA, J., *Constant. Schilderijen 1940-1980*, Staatsuitgeverij, Haags Gemeentemuseum, 's-Gravenhage, 1980

CORNEILLE
BAJ, E. et al., *Corneille. Het Complete Grafische Werk 1948-1975*, Meulenhoff Amsterdam, 1992
CLUNY, C.M., *Corneille*, Editions de la Différence, Paris, 1992
FLOMENHAFT, E., *The Roots and Development of Cobra Art*, Fine Arts Museum of Long Island, Hempstead, NY, 1985

RENÉ DANIËLS
René Daniëls, text von Els Hoek, Raum Aktueller Kunst, Wien, 1993 (cat.)
René Daniëls. Le van Abbemuseum Eindhoven à l'Institut Neérlandais Paris, tekst: Paul Groot, Arno Vriends, Stedelijk Van Abbemuseum, Eindhoven, 1994 (cat.)
René Daniëls. Schilderijen en tekeningen / Paintings and Drawings 1976-1986, tekst door Jan Debbaut, Stedelijk Van Abbemuseum, Eindhoven, 1986 (cat.)

THIERRY DE CORDIER
CASSIMAN, B., "Propos sur le maître de Schorisse", in *L'art en Belgique, Flandre et Wallonie au XXième siècle*, Paris, 1991
DE BAERE, B., "Thierry De Cordier, Wereldverbeteraar", *Metropolis*, 1, 1989
VANROBAEYS, B., "Thierry De Cordier, Emigratie naar het innerlijke. Over de nietigheid van de mens in het universum en over de zinloosheid van het zijn", *Arte Factum*, 12/1990-01/1991

RAOUL DE KEYSER
Raoul De Keyser, Kunsthalle Bern, Bern, 08/05/1991-23/06/1991
DE VOS, D., *R. De Keyser, Malmédy Series 1981-1983. Een keuze voor het Groeningemuseum*, Astene, 1989
JOORIS, R., *R. De Keyser*, Museum Deinze en Leiestreek, 1990
LOOK, U.; BUCHLMANN, R., *Raoul De Keyser*, tent. cat., Kunsthalle Bern, Bern, 1991

AD DEKKERS
Ad Dekkers, Stedelijk Museum, Amsterdam, 1981; Staatliche Kunsthalle, Baden-Baden, 1982
Ad Dekkers, tent. cat., Stedelijk Van Abbemuseum, Eindhoven, 1974
BLOTKAMP, C., *Ad Dekkers*, Staatsuitgeverij, 's-Gravenhage, 1981

PAUL DELVAUX
DEBRA, M., *Wandelingen en gesprekken met Delvaux*, Tielt, 1991
EMERSON, B., *Delvaux*, Antwerpen, 1985
SABATINI, L., "Le musée de l'art Wallon, Liège", *Musea Nostra*, 7, 1988
VAN DEUN, CH.; HAMMACHER, A.M.; LANGUI, E. et al., *Paul Delvaux*, Kat., Kunsthalle der Hypo-Kulturstiftung, München, 1989

GUSTAVE DE SMET
Lineart Gent, Internationale kunstbeurs, Gent, 21/10/1989-29/10/1989
Vlaams Expressionisme in Europese context 1900-1930, Museum voor Schone Kunsten, Gent, 10/03/1990-10/06/1990
BOYENS, P., *Gust De Smet*, Antwerpen, 1989
BOYENS, P., *Retrospective Gust. De Smet*, tent. cat., Provinciaal Museum voor Moderne Kunst, Oostende, 1989
VAN PUYVELDE, L., *Gustave De Smet, (Monographiën over Belgische Kunst)*, Antwerpen, 1949
VERMEULEN, A., *De Leie. Natuur en Cultuur*, Tielt, 1988

ROEL D'HAESE
Roel D'Haese, Etsen, Sculptuur, Palais des Beaux-Arts, Bruxelles, 23/04/1986-08/06/1986
GEIRLANDT, K.J., *Roel D'Haese, Etsen/Sculptuur*, tent. cat., Palais des Beaux-Arts, Bruxelles, 1986
GEIRLANDT, K.J. et al., *Kunst in België na 45*, Antwerpen, 1983
POPELIER, B., *Roel D'Haese: Drie gesprekken*, Gent, 1987

JAN DIBBETS
Jan Dibbets, Solomon R. Guggenheim Museum, New York, 1987; Walker Art Center, Minneapolis, 1988; The Detroit Institute of Arts, Detroit, 1988; Norton Gallery and School of Art, West Palm Beach, 1988; Stedelijk Van Abbemuseum, Eindhoven, 1988-89 (cat.)
Jan Dibbets, Stedelijk Van Abbemuseum, Eindhoven; Kunsthalle

Bern, Bern; ARC - Musée de l'Art Moderne de la Ville de Paris, Paris; Bonnefantenmuseum, Maastricht, 1980 (cat.)
FUCHS, R.H.; MOURE, G., *Jan Dibbets. Interior Light. Works on Architecture 1969-1990*, B & P, Groningen, 1991

CHRISTIAN DOTREMONT
CALONNE, J., *Facéties et compagnie de Christian Dotremont*, Bruxelles, 1991
DOTREMONT, C.; DENISSEN, F., *De steen en het oorkussen* (C. Dotremont, vert. F. Denissen), Antwerpen, 1987
DOTREMONT, C.; JORN, A., *Le grand rendez-vous naturel* (C. Dotremont, dessins d'A. Jorn), Caen, 1988
LOREAU, M., *Dotremont - Logogrammes*, Paris, 1975
NOIRET, J., *Logogrammes*, Argile, XXIII-XXIV, 1981

MARLENE DUMAS
Marlene Dumas, Bonner Kunsteverein, Bonn, 1993; Institut of Contemporary Arts, London, 1993 (cat.)
Marlene Dumas, Francis Bacon, Castello di Rivoli, Malmö Konsthall, Malmö, 1995 (cat.)
Miss Interpreted, Stedelijk Van Abbemuseum, Eindhoven, 1992 (cat.)

JAMES ENSOR
HOOZEE, R.; BROWN-TAEVERNIER, S., *James Ensor*, Gent, 1987
LEGRAND, F.-C., *Ensor, naargeestig en charmant. Een andere Ensor*, Antwerpen, 1993
LESKO, D., *James Ensor, The Creative Years*, Princeton, New Jersey, 1985
POPELIER, B., *Ensor op hoge poten*, Kredietbank, Bruxelles, 1994
TAEVERNIER, A., *James Ensor, Geillustreerde catalogus van de gravures*, Gent, 1973
TRICOT, X., *James Ensor, Catalogue raisonné des peintures*, Antwerpen, 1992

JAN FABRE
De mestkever van de verbeelding, De Bezige Bij, Amsterdam, 1994

Jan Fabre, Texte zum Werk, Kunstverein Hannover, Hannover, 1992
Jan Fabre, Texts on his theaterwork, Kaaitheater, Theater am Turm, Bruxelles, Frankfurt, 1993
BOUSSET, S.; TILROE, A.; HERTMANS, S. et al., *Mestkever van de verbeelding. Over Jan Fabre*, Amsterdam, 1994
FABRE, J.; SCHNEIDER, E., *Jan Fabre*, Kat., Kunstverein Hannover, Hannover, 1992
FABRE, J.; ZELLER, U.; VISSER, T., *Jan Fabre Der Leimrutenman/The Lime Twig Man*, Kat., Galerie der Stadt Stuttgart, Stuttgart, 1995

EDGAR FERNHOUT
Edgar Fernhout, tekst Rudi Fuchs et al., Stedelijk Van Abbemuseum, Eindhoven, 1976 (cat.)
Werken van Edgar Fernhout, tekst A.M. Hammacher, Stedelijk Van Abbemuseum, Eindhoven, 1954 (cat.)
VAN DEN BERK, A.; MOERBEEK, J., *Fernhout. Schilder / Painter*, SDU Uitgeverij; Openbaar Kunstbezit, 's-Gravenhage, 1990

VIC GENTILS
Hedendaagse Monumentale Vlaamse Beeldhouwkunst Helan Arts Foundation, Bornem, 1989
Le noir dans le sculptural, Atelier 340 Jette, 1993
111 Hedendaagse kunstenaars, België en Luxemburg, Confrontaties, Tielt, 1993
CARDYN-OOMEN, D.; FONCE, J.; FONTIER, J., *Vic Gentils, overzichtstentoonstelling 1941-1990*, tent. cat., Koninklijk Museum voor Schone Kunsten, Antwerpen, 1983
GEIRLANDT, K.J.; FONCE, J.; GENTILS, A., *Vic Gentils*, Tielt, 1994

JEROEN HENNEMAN
Jeroen Henneman. Buildings, Amsterdam, 1991
Jeroen Henneman. Een Overzicht, Gasunie Galerie, Groningen, 1989 (cat.)
POOT, J. (red.), *Drawings since 1960: a selection of the collection of drawings of the Stedelijk Museum*,

texts door Ad Petersen en Jurrie Poot, Stedelijk Museum, Amsterdam, 1989

WILLEM HUSSEM
Gross Bild. Overeenkomsten en verschillen in hedendaagse westerse en niet-westerse kunst, Gemeentelijk Museum Jan Cunen, Oss; Galerie van Esch, Eindhoven, 1992 (cat.)
Willem Hussem. De kracht van de penseelstreek, schilderijen en tekeningen 1945-1974, Centraal Museum, Utrecht; Vishal, Haarlem, 1984 (cat.)
STEENBRUGGEN, H., *Willem Hussem: tussen schrift en leegte*, Stichting Plint, Eindhoven, 1994

FERNAND KHNOPFF
DELEVOY, R.L.; DE CROES, C. et al., *Fernand Khnopff*, Bruxelles, 1987
DRAGUET, M., *Khnopff ou l'ambigu poétique*, Bruxelles, 1995
DRAGUET, M., *Khnopff 1858-1921*, Bruxelles, 1995
GIBSON, M., *Symbolisme*, Köln, 1996
PUDLES, L., "Fernand Khnopff, Georges Rodenbach and Bruges, the Dead City", *The Art Bulletin*, LXXIV, 4, 1992

PYKE KOCH
Magisch Realisme in Nederland. Raoul Hynckes, Pyke Koch, Carel Willink, Koninklijk Museum voor Schone Kunsten, Antwerpen, 1971 (cat.)
Pyke Koch. Réalisme magique aux Pays-Bas, texte par John Steen et al., Musée des Beaux-Arts, Lausanne, 1995 (cat.)
Pyke Koch. Schilderijen en tekeningen / Paintings and Drawings, tekst door Carel Blotkamp et al., Museum Boijmans Van Beuningen, Rotterdam, 1995 (cat.)

HERMAN KRUIJDER
Herman Kruijder, Singer Museum, Laren, 1980; Gemeentemuseum De Wieger, Deurne, 1980 (cat.)
Herman Kruijder, Stedelijk Museum, Amsterdam, 1953 (cat.)
ROODENBURG-SCHADD, C., *Goed*

Modern Werk. De Collectie Regnault in Het Stedelijk, Waanders Uitgevers, Zwolle, 1995

GER LATASTER
Ger Lataster, tent. cat., Stedelijk Van Abbemuseum, Eindhoven, 1985
Lataster. Schilderijen en tekeningen 1952-1993, tent. cat., tekst door Mariette Dölle, Dordrechts Museum, Dordrecht, 1994
Lataster 1982-1988, tent. cat., tekst door Daniel Lataster, Museum Van Bommel-Van Dam, Venlo, 1989

EUGÈNE LEROY
FOURNET, C.L.; PLEYNET, M.; STALTER, M.-A. et al., *Eugène Leroy*, tent. cat., Musée d'Art Moderne et d'Art Contemporaine, Nice, 1993
KIRILI, A., "Direct Contact. A conversation with Eugène Leroy", *Arts Magazine*, 66, 8, 1992
LEROY, E.; DEVOLDER, E., *Eugène Leroy, conversation avec Eddy Devolder*, Gerpinnes, 1993
OBALK, H., *Eugène Leroy: oil Paintings, Collection Art Random*, Kyoto, 1990
SCOTT, S., "Eugène Leroy-Michael Werner-Edward Thorp", *Artnews*, 91, 10, december 1992
SMITH, R., "Looking beneath the Surfaces of Eugène Leroy", *The New York Times*, 18 september 1992

REINIER LUCASSEN
Lucassen, Stedelijk Museum, Amsterdam, 1979 (cat.)
Reinier Lucassen, Stedelijk Van Abbemuseum, Eindhoven; Stedelijk Museum, Amsterdam, 1976 (cat.)
LASSE, N.; SIZOO, H.; TILROE, A.; *Lucassen. Schilderijen, tekeningen, assemblages 1960-1986*, Art Book, Amsterdam, 1986

LUCEBERT
Der Junge Lucebert; Gemälde, Gouachen, Aquarellen, Zeichnungen, Radierungen 1947-1965, Kunsthalle zu Kiel, Kiel; Museum Bochum, Bochum, 1989 (cat.)
Lucebert; schilder-dichter, tekst

door Willemijn Stokvis et al., Frans Halsmuseum, Haarlem, 1991 (cat.)
PETERSEN, A., *Lucebert in het Stedelijk. Catalogus van alle schilderijen, tekeningen, gouaches, aquarellen en prenten in de verzameling*, Stedelijk Museum, Amsterdam, 1987

RENÉ MAGRITTE
René Magritte, Catalogue raisonné, 5 delen, Mercatorfonds, Menil Foundation, 1992-93
René Magritte, Lettres à A. Bosmans, Bruxelles, 1990
SYLVESTER, D., *René Magritte, catalogue raisonné* (5dln.), Antwerpen, 1992
TORCZNYZER, H.; BESSARD, B., *Magritte: Ideas and Images*, New York, 1977
WHITFIELD, S., *Magritte*, tent. cat., Hayward Gallery, London; The Metropolitan Museum of Modern Art, New York; The Menil Collection, Houston; The Art Institute of Chicago, Chicago, 1992-93

CONSTANTIN MEUNIER
De 19de-eeuwse Belgische beeldhouwkunst, Bruxelles, 1990
Moderne Kunst in België 1900-1945, Antwerpen, 1992
Vlaams expressionisme in Europese context 1900-1930, Museum voor Schone Kunsten, Gent, 10/03/1990-10/06/1990
HANOTELLE, M., *Paris-Bruxelles. Rodin et Meunier*, Paris, 1982
ROBERT-JONES, PH., *Constantin Meunier, Georges Minne. Tekeningen en Beeldhouwwerken*, Bruxelles, 1969

GEORGES MINNE
ALHADEFF, A., *Minne and Gauguin in Brussels; An unexplored encounter, Studies in Western Art, Acts of the XXIInd International Congress of the History of Art*, 1982, 164-74
ALHADEFF, A., "The great awakening: le milieu belge", *Arts Magazine*, 55, 4, 1980
BAUDSON, P., "Georges Minne", in *Het symbolisme in de Belgische tekening*, 1979
HOOZEER, R.; ALHADEFF, A. et al.,

Georges Minne en de kunst rond 1900, tent. cat., Museum voor Schone Kunsten, Gent, 1982
LEHMBRUCK, W., *Georges Minne, J. Beuys*, Museum voor Schone Kunsten, Gent, 1991

PIET MONDRIAN
Mondrian. Tekeningen, Aquarellen, New Yorkse Schilderijen / Zeichnungen, Aquarelle, New Yorker Bilder / Drawings, Water Colours, New York Paintings, Haags Gemeentemuseum, 's-Gravenhage; Staatsgalerie, Stuttgart; The Baltimore Museum of Art, Baltimore, 1981 (cat.)
Piet Mondriaan: 1872-1944, tekst door Yves-Alain Bois, Joop Joosten et al., Haags Gemeentemuseum, 's-Gravenhage, 1994; National Gallery of Art, Washington; Museum of Modern Art, New York, 1995-96 (cat.)
MILNER, J., *Mondrian*, London, 1994

ANTOINE MORTIER
Antoine Mortier, tekeningen, Palais des Beaux-Arts, Bruxelles, 23/04/1986 - 08/06/1986
GEIRLANDT, K.; HOET, J.; LEGRAND, F.C. et al., *Antoine Mortier*, Tielt, 1989
OLLINGER-ZINQUE, G. (red.), *Antoine Mortier, tekeningen*, tent. cat., Palais des Beaux-Arts, Bruxelles, 1986
PAM, R., *Antoine Mortier*, En marge, coll. La petite pierre, Bruxelles, 1988

PANAMARENKO
HENNEBERT, D.; BLONDET-BISCH, TH.; DELAUNAY, D. et al., *Les Construction du Ciel 1900-1959 & Panamarenko*, tent. cat., Fondation pour l'Architecture, Bruxelles, 1995
SACK, J., "De piloot", in *Panamarenko. Pastilles*, Antwerpen, 1989
THEYS, H., *Panamarenko. A Book by Hans Theys, Frank Van Hoecke en Isy Brachot*, Bruxelles, 1992
VAN MULDERS, W., "De weemoed van de fysica", *Kunst en Cultuur*, 05/1989

VAN MULDERS, W., "On the earth and in the air. Panamarenko", *Artforum*, 15, 8, april 1987

CONSTANT PERMEKE
Constant Permeke Retrospectieve, Provinciaal Museum voor Moderne Kunst, Oostende, 1986-87
D'HAESE, J., *Constant Permeke*, Beauvoorde, 1985
STORCK, H.; CONRAD, P., *Permeke*, Iblisfilms, Bruxelles, 1985
VAN DEN BUSSCHE, W., *Permeke*, Antwerpen, 1986
VAN DEN BUSSCHE, W., *Permeke*, tent. cat., Provinciaal Museum voor Moderne Kunst, Oostende, 1986-87, Antwerpen, 1986

ROGER RAVEEL
Roger Raveel, Le sens du non-sense, Bruxelles, 10/05/1990 (cat.)
Roger Raveel '70, Provinciaal Museum voor Moderne Kunst, Oostende, 1991-92
HOET, J., *Omtrent Roger Raveel. Herinnering aan het doodsbed van mijn moeder*, tent. cat., Museum van Hedendaagse Kunst, Gent, 1981
JOORIS, R., *Roger Raveel*, Antwerpen, 1988
JOORIS, R., *Roger Raveel Tekenschrift, Revolver*, 1/2, 1988
JOORIS, R.; SCHEIRE, O., *Roger Raveel ziet ... zien*, tent. cat., Stedelijke Musea, Sint-Niklaas, 1981

GERRIT RIETVELD
Gerrit Rietveld, Bonnefantenmuseum, Maastricht, 1977 (cat.)
Gerrit Th. Rietveld. Het volledige werk, tekst Marijke Küper, Ida van Zijl, Centraal Museum, Utrecht, 1992; Centre national d'art et de culture Georges Pompidou, Paris, 1993 (cat.)
VÖGE, P., *The complete Rietveld furniture*, Uitgeverij 010, Rotterdam, 1993

FÉLICIEN ROPS
Félicien Rops, Koninklijke Bibliotheek, Bruxelles, 12/10/1991-16/11/1991
CUVELIER, G., *Félicien Rops (1853-*

1889), *L'oeuvre peint*, Bruxelles, 1987

MAKEIN, S., *Die Gestalt der Dämonischen frau im werk von Félicien Rops*, Westfälische Wilhelms-Universität (fac. Filos.), Münster, 1990

QUOITIN, V., *De verzoeking van Sint-Antonius: een studie van de decadentie bij vier kunstenaars: Flaubert, Rops, Khnopff, Ensor*, K.U. Leuven (fac. Letteren en Wijsbegeerte), 1989

ROUIR, E., *Félicien Rops, Catalogue Raisonné de l'œuvre gravé et lithographie*, Bruxelles, 1993

VAN MARIS, L., *Félicien Rops, over kunst, melancholie en perversiteit*, Amsterdam, 1982

JULES SCHMALZIGAUG
LISTA, G., *Futurisme. Abstraction et Modernité*, Paris, 1982

MERTENS, PH., *Jules Schmalzigaug 1882-1917*, tent. cat., Musée Royaux des Beaux-Arts de Belgique, Musée d'Art Moderne, Bruxelles, 1984

ROTHUIZEN, W., "De herontdekking van een futurist", *De Haagse Post*, 27/11/1982

JAN SCHOONHOVEN
Jan Schoonhoven (Retrospectief. Tekeningen en reliefs), Haags Gemeentemuseum, 's-Gravenhage, 1984; Kunsthalle, Nürnberg, 1984; Badischer Kunstverein, Karlsruhe, 1985 (cat.)

Nul, die Wirklichkeit als Kunst fundieren: die Niederländische Gruppe Nul 1960-1965 und heute / Nul, de werkelijkheid als kunst funderen: De Nederlandse groep Nul 1960-1965 en heden, Galerie der Stadt Esslingen, Villa Merkel; Van Reekum Museum, Apeldoorn, 1993 (cat.)

WESSELING, J., *Jan Schoonhoven: beeldend kunstenaar - visual artist*, SDU-'s-Gravenhage, Openbaar Kunstbezit, Amsterdam, 1990

MARIEN SCHOUTEN
Marien Schouten, Kunsthalle Bern, Bern, 1992 (cat.)

Marien Schouten. 'Het vieze tafeltje' Werken 1984-1996 / 'The Dirty Table' Works 1984-1996, Stedelijk Museum, Amsterdam, 1996 (cat.)

Marien Schouten (Tekeningen en Schilderijen 1985-1989), Museum Boymans-van Beuningen, Rotterdam, 1989 (cat.)

VICTOR SERVRANCKX
Victor Servranckx 1897-1965 en de abstracte kunst, Palais des Beaux-Arts, Musée d'Art Moderne, Bruxelles, 26/05/1989 - 16/07/1989

Vlaams expressionisme in Europese context 1900-1930, Museum voor Schone Kunsten, Gent, 10/03/1990 - 10/06/1990

HOET, J., *Retrospectieve tentoonstelling Victor Servranckx 1897-1965*, tent. cat., Provinciaal Begijnhof, Hasselt, 1970

RICHTER, H., "Geist der Poesie, Victor Servranckx, ein Konstruktivist", *Der Kunst*, 9, 09/1988

JAN SLUIJTERS
JUFFERMANS, J., *Jan Sluijters. Schilder*, Tableau, Mijdrecht, 1981

ROODENBURG-SCHADD, C., *Goed Modern Werk. De Collectie Regnault in Het Stedelijk*, Waanders Uitgevers, Zwolle, 1995

VAN WESSEM, J.N., *Art and Architecture in the Netherlands: Jan Sluijters*, translated from the Dutch by Roy Edwards, Meulenhoff Amsterdam, 1966

JACOB SMITS
Moderne kunst in België 1900-1945, Antwerpen, 1992

Vlaams expressionisme in Europese context, 1900-1930, Museum voor Schone Kunsten, Gent, 10/03/1990 - 10/06/1990

VANBESELAERE, W., *Jacob Smits*, Kasterlee, 1975

VAN GOMPEL, F.; NUYTS, B.; VERHEYEN, I., *Jacob Smits, een portret*, Mol, 1988

LEON SPILLIAERT
ADRIAENS-PANNIER, A.; N. HOSTYN, *Spilliaert*, tent. cat., Museum voor Schone Kunsten, Oostende; Museum het Palais te Den Haag, 1996

LEGRAND, F.C., *Leon Spilliaert in zijn tijd*, Tielt, 1981

TRICOT, X., *Leon Spilliaert, Prenten en illustraties*, Antwerpen, 1994

CHARLEY TOOROP
Charley Toorop. Schilderijen, Gemeentemuseum Arnhem, Arnhem, 1988 (cat.)

Charley Toorop 1891-1955, Centraal Museum, Utrecht, 1982; Württembergischer Kunstverein, Stuttgart, 1982 (cat.)

BREMER, J., *Charley Toorop. Werken in de verzameling van het Kröller-Müller Museum*, Kröller-Müller Museum, Otterlo, 1995

JAN TOOROP
Jan Toorop, Haags Gemeentemuseum, 's-Gravenhage, 1989 (cat.)

Jan Toorop, Institut Néerlandais, Paris, 1977 (cat.)

Jan Toorop. De jaren 1885-1910, Rijksmuseum Kröller-Müller, Otterlo, 1978-79 (cat.)

LUC TUYMANS
Het sublieme gemis. Over het geheugen van de verbeelding, Koninklijk Museum voor Schone Kunsten, Antwerpen, 1993

Indelible Evidence, Gallerie Erika und Otto Friedrich, Bern, 1994

LOOCK, U.; ALIAGA, J.V.; SPECTOR, N., *Luc Tuymans*, London, 1996

PAS, J., "Luc Tuymans, Disenchantment, Ontgoocheling", *Artefactum*, 42, 1992

VAN RUYSSEVELT, R., *Luc Tuymans*, tent. cat., Provinciaal Museum voor Moderne Kunst, Oostende, 1990

YOOD, J., *Luc Tuymans. Renaissance Society*, Artforum, 23, 8, april 1995

ENGLEBERT VAN ANDERLECHT
Englebert Van Anderlecht, Museum van Elsene, 1968

Englebert Van Anderlecht, Palais des Beaux-Arts, Bruxelles, 12/01/1963 - 27/01/1963

DYPREAU, J., *Van Anderlecht*, tent. cat., Palais des Beaux-Arts, Bruxelles, 1959

GEIRLANDT, K.J. et al., *Kunst in België na 45*, Antwerpen, 1983

FRITS VAN DEN BERGHE
Frits Van den Berghe, Museum voor Schone Kunsten, Gent, 10/12/1983 - 04/04/1984

Vlaams Expressionisme in Europese context 1900-1930, Museum voor Schone Kunsten, Gent, 10/03/1990 - 10/06/1990

HAESAERTS, P., *Sint-Martens-Latem, gezegend oord van de Vlaamse kunst*, Antwerpen, 1982

HOOZEE, R.; TAHON-VANROOSE, M. et al., *Frits Van den Berghe*, tent. cat., Museum voor Schone Kunsten, Gent, 1983-84

BART VAN DER LECK
Bart van der Leck, Rijksmuseum Kröller-Müller, Otterlo; Stedelijk Museum, Amsterdam, 1976 (cat.)

Bart van der Leck: een 'toepassend kunstenaar', Kröller-Müller Museum, Otterlo; Kunstmuseum Wolfsburg, Wolfsburg, 1994-95 (cat.)

Bart van der Leck 1876-1958. A la recherche de l'image des temps modernes, Institut Néerlandais, Paris, 1980 (cat.)

GUSTAVE VAN DE WOESTIJNE
Gustave Van de Woestijne Retrospectieve, Museum voor Schone Kunsten, Antwerpen, 1981

Vlaams expressionisme in Europese context 1900-1930, Museum voor Schone Kunsten, Gent, 10/03/1990 - 10/06/1990

BOYENS, P., *L'art flamand. Du symbolisme à l'expressionisme*, Tielt, 1992

BOYENS, P., *Sint Martens Latem*, Tielt, 1992

GEPTS, G., *Gustave Van de Woestijne 1881-1947*, tent. cat., Koninklijk Museum voor Schone Kunsten, Antwerpen, 1981

THEO VAN DOESBURG
Theo van Doesburg. Aspects méconnus de l'Aubette, Palais Rohan-Galerie Alsacienne, Strasbourg, 1989 (cat.)

JAFFÉ, H.L.C., *Theo van Doesburg*, Meulenhoff Amsterdam, 1983

VAN STRAATEN, E., *Theo van Doesburg, painter and architect*, SDU Publishers, The Hague, 1989

KEES VAN DONGEN
Kees van Dongen, Museum Boijmans-van Beuningen, Rotterdam, 1989-90 (cat.)
Van Dongen, Le Peintre 1877-1968, Musée d'Art Moderne de la Ville de Paris, Paris, 1990 (cat.)
CHAUMEIL, L., *Van Dongen. L'homme et l'artiste - La vie et l'oeuvre*, Genève, 1967

GER VAN ELK
Ger van Elk, Kusthalle, Basel, 1980; Musée d'Art Moderne de la Ville de Paris, Paris, 1980; Museum Boymans-van Beuningen, Rotterdam, 1981 (cat.)
Ger van Elk. De la nature des genres / Von der Natur des Genres, Centre National d'Art Contemporain de Grenoble, Grenoble, 1988 (cat.)
Ger van Elk "Sandwiches": persen, drukken en trekken, Museum Boijmans Van Beuningen, Rotterdam, 1993 (cat.)

VINCENT VAN GOGH
Vincent van Gogh. Schilderijen, Rijksmuseum Vincent van Gogh, Amsterdam, 1990 (cat.)
FAILLE, J.B., *The Works of Vincent van Gogh, his paintings and drawings*, New York, 1970
HULSKER, J., *The Complete van Gogh: Paintings, Drawings, Sketches*, Oxford-New York, 1980

DAN VAN SEVEREN
Dan Van Severen, Museum J. Dhondt-Dhaenens, Deurle, 1992
Kruisweg-Alfabet, Gent, 1981
GEVAERTS, Y.; VAN SEVEREN, D., *Dan Van Severen 1959-1974*, tent. cat., Palais des Beaux-Arts, Bruxelles, 1974
VAN DAMME, L., *Visions*, Gent, 1982

GEORGES VANTONGERLOO
Abstracte Schilderkunst in België 1920-1970, Bruxelles, 1996
Georges Vantongerloo, A traveling Retrospective Exhibition, USA 1980
CEULEERS, J., *Georges Vantongerloo 1886-1965*, tent. cat., Galerij Ronny Van De Velde, Antwerpen, 1996

GEIRLANDT, K.J. et al., *Kunst in België na 45*, Antwerpen, 1983
MARZIO, P.C.; MERTENS, PH.; THOMAS-JANKOWSKI, A., *Georges Vantongerloo*, cat., Corcoran Gallery of Art, Washington; Dallas Museum of Art, Dallas; Los Angeles County Museum of Art, Los Angeles, 1980

JAN VERCRUYSSE
CASSIMAN, B., *Ivam centre del carme, Espacio mental, R. Daniels, T. de Cordier, I. Genzken, C. Iglesias, T. Scutte, J. Vercruysse*, Generalitat Valenciana, Valencia, 1991
CUEFF, A.; ZACHAROPOULOS, D., *Jan Vercruysse*, tent. cat., Stedelijk Van Abbemuseum, Eindhoven, 1990
DREHER, TH., "Das Sublime, zum Schönen erstartt", *Artefactum*, 18, 1990
GEIRLANDT, K.J. et al., *Kunst in België na '45*, Mercatorfonds, Antwerpen, 1983
VERCRUYSSE, J., *Jan Vercruysse*, cat., La Biennale di Venezia, Padiglione del Belgio, Venezia, 1993

TOON VERHOEF
Toon Verhoef, Halle für Neue Kunst, Schaffhausen, 1991 (cat.)
Toon Verhoef. Schilderijen en Tekeningen 1968-1986, Stedelijk Van Abbemuseum, Eindhoven, 1987 (cat.)
Toon Verhoef. Schilderijen en Tekeningen 1975-1983, Stedelijk Museum, Amsterdam, 1983 (cat.)

HENK VISCH
Henk Visch, Kunstverein Hannover, Hannover, 1990 (cat.)
Henk Visch. I see I understand I know I remember I do, The Institute for Contemporary Art, P.S.1 Museum, New York, 1992
Henk Visch. Skulpturen 1980-1986, Städtische Galerie, Nordhorn, 1986-87 (cat.)

CAREL VISSER
Carel Visser, text von Dieter Elmer und Rudi Fuchs, Sprengel-Museum Hannover, Hannover; Forum des Landesmuseum, 1990 (cat.)

Carel Visser. Nieuw werk / New work, tekst door J.L. Locher, Haags Gemeentemuseum, 's-Gravenhage, 1994 (cat.)
BLOTKAMP, C., *Carel Visser*, Veen-Reflex, Utrecht-Antwerpen, 1989

ANDRÉ VOLTEN
André Volten. Konstruktion und Struktur. Messingskulpturen 1965-1995, Wilhelm Lehmbruch Museum der Stadt Duisburg, Duisburg, 1996 (cat.)
BEEREN, W.; HAMMACHER, A.M., *André Volten, Oeuvreprijs 1996 Stichting Fonds voor Beeldende Kunsten, Vormgeving en Bouwkunst* (Jüryrapport), Amsterdam, 1996
HARTSUYKER, E., *André Volten* (translated from the Dutch by Max Schuchart), Meulenhoff Amsterdam, 1966

CO WESTERIK
Co Westerik, tekst door W.A.L. Beeren, Dorine Mignot, en Charlotte Wiethoff, Stedelijk Museum, Amsterdam, 1991-92 (cat.)
Co Westerik, tekst von J.L. Locher und M. Eberle, Staatliche Kunsthalle Berlin, Berlin, 1983; Saarland-Museum in der Stiftung Saarländischer Kulturbesitz, Saarbrücken; Haags Gemeentemuseum, 's-Gravenhage, 1984 (cat.)
BEEREN, W.A.L., *Co Westerik, schilder, peintre, maler, painter*, Uitgeverij Van Spijk, Venlo, 1981

ANTOINE WIERTZ
MOERMAN, A., *A. Wiertz 1806-1865*, Bruxelles, 1974
WIERTZ, A., *Gevaarlijke liefdes*, Antwerpen, 1990

CAREL WILLINK
Carel Willink, samenstell. Walter Kramer, Museum Boymans-van Beuningen, Rotterdam, 1973-74 (cat.)
De onbekende Willink: het vroege werk 1920-1930, tekst Marja Bosma, Centraal Museum, Utrecht, 1992
JAFFÉ, H.L.C., *Willink*, Meulenhoff-Landshoff (derde druk), Amsterdam, 1986

RIK WOUTERS
Rik Wouters, De Zonnehof, Amersfoort, 15/11/1988-08/01/1989
Vlaams expressionisme in Europese context 1900-1930, Museum voor Schone Kunsten, Gent, 10/03/1990-10/06/1990
AVERMAETE, R., *Rik Wouters*, Bruxelles, 1986
BERTRAND, O., *Rik Wouters (1882-1916)*, tent. cat., Museum voor Moderne Kunst, Oostende; Museum Van Bommel-Van Dam, Venlo, 1994-95
RANSON, J., "Expo Rik Wouters", *Vooruit*, 27/05/1982
SCHOONBAERT, L.M.A.; MARECHAL, E. et al., *Rik Wouters als schilder belicht*, tent. cat. *Rik Wouters*, De Zonnehof, Amersfoort, 1988-89

Index of Names

Aachen 70
Aarschot 69
Abramovič, Marina 27
Abstract Art 20, 333
Abstraction-Création 336, 338
Académie Française, Paris 68
Académie des Beaux-Arts 335
Achinese, people 33
Adynamische Groep (Adynamic group) 337
Adamo, Salvatore 91
Agalev (acronym of Anders Gann Leven), Live in a different Way, political party 95
Agir, political party 96
Africa 58, 59, 63, 89, 90, 324
Afsluitdyk (Enclosing Dyke) 43
Ajax (football team), Amsterdam 41
Albert I, King of the Belgians 69, 72, 80, 82
Alechinsky, Pierre 28, 94, 103, *243, 244, 245*, 316, 320, 321, 326, 343
Alfrink, Cardinal 39
Algemen Nederlandsch Werklieden Verbond, General Dutch Union of Workers 44
Algeria 89, 90
Allebé, August 38
Allies
Almere 50, 51
Alps 99
America 58, 64, 323, 337
Amsterdam 28, 30, 34, 36, 39, 41, 42, 44, 45, 47, 49, 50, 51, 52, 55, 57, 58, 59, 94, 321, 322, 323, 327, 328, 330, 331, 339
Amsterdam Art Foundation Award 338
Amsterdam Town All Music Theatre 339
Amsterdam's Concertgebouw Orchestra 37
Anatolia 90
Anneessens metro station in Brussels 326
Anti-Peinture 327
Anti-Revolutionary movement 35, 44, 59
Anti-Revolutionary Party (ARP) 34
Antwerp 17, 19, 25, 43, 63, 64, 69, 77, 84, 85, 86, 87, 89, 92, 96, 103, 313, 315, 317, 332, 339
Appel, Karel 23, 24, 28, 37, 103, *230, 231, 232*, 310, 321, 322, 323, 324, 343

Appel Bar (Stedelijk Museum) 321
Arab Oil 49
Arago, François 326
Arbeitseinsatz 73, 84, 86
Arbeitseinsatzbefehl 85
Ardennes 81, 87
Argan, Carlo Giulio 22
Arles, Provence 337
Armando *266, 267*, 321, 328, 333, 343
Arnhem 50, 335
Arp, Jean 336
Arntz, Gerd 47
Art Historical Institute, Groningen 100
Arte Povera 326
Art Nouveau 18, 21, 92, 335
Asia 40, 58
Asselbergs, W.J.M.A. *see* Van Duinkerken, Anton
Astene 332
Astrid, Queen of the Belgians 87
Atelier '63, Haarlem 322, 326, 333
Atelier du Marais, Paris 326
Atomium, Brussels 90
Australia 39
Austria 38, 63, 87
Austrian Southern Netherlands (Belgium today) 38
Auverse-sur-Oise 337
Avenue Louise, Brussels 86

Bacon, Francis 309, 317, 326
Baels, Liliane 87
Bakema, Jacob 50
Baroque 18, 24, 100, 333
Barth, G. 314
Batavia 39
Battle of Britain 84
Battle of Leuven 93
Baudelaire, Charles 312, 328
Baudouin I, King of the Belgians 88, 89, 97
Bauhaus 336
Bazaine, Jean 327
Bayer, multinational 92
BBC 40
Beatles, 28
Beatrix of Orange, Queen of Netherland 41, 52, 334
Beckett, Samuel 311
Beckmann, Max 309
Beervelde, castle of 324
Beethoven, Ludwig van 305
Belgian Association of Jews (Belgische Jodenvereniging) 85, 87

Belgian Worker's Party 65, 66, 76, 78
Belgische Socialistische Party, Belgian Socialist Party 92, 95
Belgium, 22, 24, 28, 39, 44, 54, 63, 64, 65, 66, 67, 68, 69, 70, 71, 72, 73, 74, 75, 76, 77, 78, 79, 80, 81, 82, 83, 84, 85, 86, 87, 88, 89, 90, 91, 92, 93, 94, 95, 96, 97, 98, 312, 313, 315, 319, 320, 322, 323, 326, 331, 333, 336, 338
Belgrade 339
Belle epoque 63, 68, 76, 91
Benelux 41
Bennebroek 328, 329
Benner, Gerrit *228, 229*, 322, 343
Berchem, Nicolas 99
Berenson, Bernard 99
Berchtesgaden 82
Bergamo 99
Bergen 42, 327, 330, 335
Bergen School 327
Berlage's Amsterdam Exchange building 335
Berlage, Hendrik Petrus 50, 55, 333
Berlaymont, Brussels 92
Berlin 32, 73, 76, 81, 83, 318, 321, 339
Bernard, Emile 304
Bernheim-Jeune, Paris 333
Bertrand, Gaston *224, 225*, 316, 322, 343
Beuys, Joseph 28, 318, 320
Biennale of Venice 322, 323, 326, 328, 332, 337, 338, 339
Biennial of São Paulo 322, 324, 325, 334, 339
Biesheuvel, J.M.A. 55
Bijlmermeer, Amsterdam 50, 51
Binnenhof The Hague 36
Birmingham 101
Birza, Rob 23, *282*, 322, 343
Blankers-Koen, Fanny 41
Blaricum 329
Blitzkrieg 69
Blommaert, Jan 98
Blut und Boden 96
Boccioni, Umberto 333
Bogart, Bram *223*, 322, 323, 343
Bogaert, André 316
Boendermaker, Piet 327
Boijmans van Beuningen Museum, Rotterdam 324, 328, 337, 339
Bomarzo (Gardens) 340
Bonaparte, Louis 31

Bonvin, François 312
Bonnet, Ann 316
Boon, Louis-Paul 94
Borinage 65, 78, 91
Bosch, Hieronymus 17, 102, 103, 104, 325, 326, 327
Both, Jan 99, 101
Boudin, Eugène 332
Brabant 43, 64, 93, 305, 309, 338
Bracquemond, Felix, 332
Brancusi, Constantin 317
Brando, Marlon 58
Brands, Eugène *236, 237*, 323, 343
Braque, Georges 20
Brel, Jacques 94
Breton, André 316, 325
Briel, Den 38
Brinkman, Johannes Andreas 50
Broadcasting Act 52
Broodthaers, Marcel 20, 23, 28, *289, 290, 291*, 318, 319, 320, 323, 343
Brotherhood 104
Brouwn, Stanley 23, 24, *292*, 323, 343
Bruckner, Anton 37
Bruegel, Pieter the Elder, 24, 102, 103, *150, 151*, 312, 314, 325
Brueghel *see* Bruegel
Bruges 30, 74, 313, 336
Brun, Frans 33
Brussels 25, 28, 30, 63, 64, 65, 66, 68, 70, 72, 74, 76, 78, 80, 83, 84, 85, 87, 88, 89, 92, 93, 94, 95, 96, 97, 98, 321, 328, 330, 335, 339
Brussels Academy 330, 333
Brusselmans, Jean 22, 24, 25, 28, *136, 137*, 343
Budapest 64
Buenos Aires 70
Burckhardt, Jacob 100
Burgundian State 84
Burssens 316
Bury, Pol 316, 318
Buysse, Cyriel 67

Café Aubette, Strasbourg 336
Cairo 63
Callewaert, Marc 316
Calvinist Reformed Church 57
Cantré, Jozef 314
Caravaggio 100, 104
Caribbean 40
Carmiggelt, Simon 59
Carlos (Juan) de Bourbon 39
Cassiman, Bart 320

Cassou, Jean 312
Castello di Rivoli 326
Catalonia 65
Cathedral of S. Louis, Blois 326
Catholic Action (Katholike Actie) 78
Catholic Boerenbond (Farmers' League) 91
Catholic Church 33, 38, 39, 57, 91
Catholic Party 64, 81
Catholic University of Leuven 93
Catholic Working-Class Women, guild of the 79
Catholic Youth Guard see Jeune Garde Catholique
Cats, J. 31
Celtic, Glasgow 41
Cercle et Carré, group 338
Cercle Léon XIII 65
César 327
Cézanne, Paul 20, 306, 309, 327
Chagall, Marc 315
Charleroi, 86, 89, 97
Charles, J.B. (pseudonym of Nagel, W.H.) 48
Charlier, Jacques 318
Charriaut, Henri 68
Christene Volkpartij, Christian People's Party 93
Christus Rex, Brussels 80
Churchill, Winston 68
Citroen, Paul 55
City Hall - Opera House 328
Claes, Ernest 75
Claesz, Pieter 24, 262
Claus, Emile 331
Claus, Hugo 94, 316
Cobra, international group 37, 94, 103, 310, 316, 320, 321, 322, 323, 324, 326, 328, 329
Codde, Pieter 99
Colijn, H. 47
Cologne 31, 329
Commission for the Relief in Belgium 70
Communist Partisans 86
Communist Party 75
Community Question 92, 95
Compulsory Education Act 46
Concept Art 326
Conceptualism 318
Conscience africaine, periodical 89
Congo 63, 89
Constant (Nieuwenhuis, Constant A.) 37, 240, 241, 308, 321, 324, 328, 329, 343

Constructivism 334, 336, 339
Cooper, Gary 311
Copenhagen 94, 321
Corneille (Van Beverloo, Corneille Guillaume) 233, 234, 235, 322, 323, 324, 343
Cox, Jan 316
Cremer, Jan 328
Cross, Henri-Edmond 335
Cruijff, Johan 42
Cubism 19, 20, 21, 22, 24, 306, 315, 325, 331, 334
Cuypers, Petrus Josephus Hubertus 55

Daalder, H. 52
Dada, movement 20, 37, 336, 339
Dada, review 336
Dadaism, 317
Daniëls, René 276, 277, 311, 324, 338, 343
Daumier, Honoré 100, 304
David, star of 85
David Röel prize 333
Dawes Plan 76
Dawn of the Golden Age 100
Dean, James 58
De Baere, Bart 319
De Benedetti, Carlo 96
De Beyerd Museum, Breda 323
De Braekeleer 312, 314
De Champaigne, Philippe 288
De Chirico, Giorgio 102, 103, 325, 330, 339, 340
De Clerq, René 313
De Clerq, Staf 81, 87
De Cordier, Thierry 27, 28, 215, 319, 343
De Gemeenschap 55
De Ghelderode, Michel 319
Degrelle, Léon 80, 83, 84, 86, 87
De Groote, Keyser 52
De Guevara, Felipe 102
De Hoock, Pieter 306
De Keyser Raoul 273, 274, 275, 318, 325, 343
Dekkers, Ad 265, 325, 334, 343
De Kooning, Willem 309
De Kuip, Rotterdam
De Leeuw 316
Delft Polytechnic 339
Delft School 55
Delta Plan 43
Delvaux, Paul 24, 103, 190, 191, 319, 325, 344
Delville, Jean 319

De Man, Hendrick 63, 78, 80, 87
De Nieuwe Gids (The New Guide), periodical 37
Den Uijl, Joop M. 53
Départ, rue de 317
De Ploeg 322
De Praetere, Julius 313
Derain, André 337
De Ridder, André 314
Der Blaue Reiter 322, 334
De Saedeleer, Valerius 313, 330, 336
De Smet, Gustave 22, 24, 154, 155, 314, 325, 336, 344
De Standard 34
De Stijl, movement 18, 22, 23, 55, 315, 320, 322, 331, 332, 339
De Stijl, review 331, 332, 336, 338
Destrée 67
De Telegraaf, daily 49
De Tribune, periodical 45
Deutch-Vlämische Arbeitsgemeinschaft, movement see De Vlag
Devisenschutzkommando 86
De Vlaamsche Leeuw (The Flemish Lion) 71
De Vlaeminck, Maurice 337
De Vlag, movement 84, 86
De Vries Lyckle 100
De Vrijschutter, newspaper 84
D'Haese, Roel 226, 317, 318, 325, 326, 344
Dibbets, Jan 23, 24, 28, 298, 299, 300, 301, 309, 326, 344
Diederen, Jef 329
Diepenbrock, Alphons 37
Dietsland 80, 84
Diksmuide 74, 76
Dilbeek 25
Dinant 69
Diogenes 324
Dionysus 319
Documenta, Kassel 99, 323, 324, 325, 326, 329, 334, 337, 338
Domburg 42, 331
Domela Nieuwenhuis, Ferdinand 44, 45, 71
Doornik (Tournai) 71
Dostoyevsky, Fëdor Michajlovic 305
Dotremont, Christian 242, 316, 320, 321, 324, 326, 344
Douard, Cecile 64
Dowes Dekker, Eduard see Multatuli
Drachten 37
Drees, Willem 48

Droogsloot 99
Dubuffet, Jean 316
Duchamp, Marcel 20, 21, 331
Dudok, Willem Marinus 43
Duiker, Johannes 47, 50
Dumas, Marlene 27, 285, 311, 326, 344
Duncan, Isadora 340
Du Perron, Eddy 340
Dürer, Albrecht 19, 104
Dutch Association of Trade Unions (NVV) 47
Dutch Communist Party 45
Dutch East Indies 32, 39, 40, 48, 89
Dutch Informal Group 321
Dutch Movement for Unity trough Democracy 40
Dutch Reformed (Nederlandse Hervormde Kerk) Church 34, 35, 57
Dutch, Revolt 33
Dypréau, Jean 316, 318, 335

Eben-Emael 81
Ecole de Paris 21, 307, 327
Ecole des Beaux-Arts, Lille 329
Ecole des Beaux-Arts, Paris 329
Ecolo, political party 95, 96
Eighty Year's War 30, 33, 39
Einstein, Albert 81
Elementarism 336
Elias, Etienne 87, 324
Elisabeth, Queen of the Belgians 72, 85
Emerald Girdle, archipelago 41
Empain, holding 63
Engels, Friederich 32, 37, 44
England 30, 31, 32, 36, 38, 40, 44, 54, 68, 75, 81, 309, 314, 336
Ensor, James 18, 20, 22, 23, 24, 27, 28, 103, 104, 105, 110, 111, 164, 165, 166, 167, 168, 169, 170, 171, 172, 173, 174, 175, 176, 177, 178, 179, 180, 181, 312, 313, 314, 319, 320, 321, 322, 325, 326, 327, 332, 335, 344
Equality Act see Gelijkheidswet
Erasmus 38, 104
Ethos 103
Ermitage, St. Petersbourg 100
Europe 17, 19, 24, 28, 31, 32, 33, 36, 37, 41, 42, 44, 48, 59, 63, 65, 68, 69, 75, 78, 80, 81, 91, 96, 98, 100, 317
European Coal and Steel Community 41

European Cup 41

European Economic Community 41

European Steel Prize 328

Experimental Group 323

EXPO, Brussels 90, 92, 325

Expressionism 19, 20, 21, 22, 27, 104, 307, 310, 315, 316, 317, 322, 323, 325, 331, 332, 334, 336, 337, 339

Fabre, Jan 24, 27, 28, *214*, 327, 344

Fabriano, Gentile da 17

Fabro 320

Factory Act 46

Farmers' Union 65

Fauvism 19, 21, 22, 323, 331, 337

Fazio, Bartolomeo 17

Feyenoord, Rotterdam 41

Fernhout, Edgar *220*, *221*, 327, 335, 344

Fifties, group 37

Flamenpolitik (Deusch-Vlämische Arbeitsgemeinschaft) 71, 73, 83

Flanders 17, 20, 22, 23, 24, 28, 30, 63, 64, 65, 66, 67, 69, 73, 75, 80, 81, 83, 87, 88, 90, 91, 92, 93, 94, 96, 97, 98, 313, 319, 331

Flaubert, Gustave 103

Flemish Liberal Party 96

Flemish Movement 39, 67, 71, 73, 76, 87, 94, 97

Flemish Primitives 313, 336

Flemish State 73

Florence 328

Fluxus 323, 337

Fontainbleau 19

Fontana, Lucio 320

Ford, multinational 92, 94

Fort Breendonk, Antwerp 86

Forum, Liège 77

Forum, movement 317, 318

Forum, review 55

France 19, 31, 32, 36, 37, 38, 63, 64, 68, 69, 70, 74, 81, 82, 90, 97, 100, 312, 314, 315, 316, 322, 327, 333

Franco, Francisco Bahamonte 87

Francqui, Emile 70, 76

Frank, Anne 40

Frederiksplein, Amsterdam 339

Free University 34, 35

French Empire 31

French Limousin 65

French Revolution 31, 34

Freud, Sigmund 328

Freymuth, Alphons 329

Friedman, Donald 313

Friesland 45, 322

Frontbeweging (Front Movement) 72, 75, 76

Front Démocratique des Francophones (FDP), political party 93

Front Movement *see* Frontbeweging

Front Party 75, 76, 80

Fuchs, Rudi 27, 99, 101, 309, 321

Führer *see* Hitler

Futurism 315, 333, 334

G 58 group, Antwerp 327

Gasunie Gallery, Groningen 328

Gauguin, Paul 20, 304, 328, 337

Geheim Leger, Secret Army 86

Geirlandt, Karel J. 317, 318

Gelijkheidswet 66

Gemeentemuseum, The Hague 321, 328, 331, 339

Gemeentelijke Universiteit, Amsterdam 34

Genet, Jean 311

Gentils, Vic *227*, 318, 325, 327, 344

Gereformeerde Church 33, 34

Géricault, Jean-Louis-Théodore 339

German diocesan State 31

Germany 21, 36, 37, 40, 47, 63, 68, 70, 71, 73, 74, 80, 81, 82, 83, 84, 85, 87

Gerson, Horst 99, 100

Gestapo 85, 86

Gestel, Leo 327, 335

Gezelle, Guido 317

Geys, Jef 318

Ghent 30, 63, 64, 65, 67, 71, 89, 92, 313, 317, 318, 330

Ghent Academy for Fine Arts 324, 336

Ghent University 67, 71, 73, 77, 91

G. Hofland Collection 323

Gijsen, Marnix 331

Gil Blas, review 337

Giotto 306

Glorious Revolution 31

GNP 92, 96

Godard, Jean-Luc 311

Goethe, Johan Wolfgang 28

Golden Age 337

Gold Standard 47, 76

Goltzius, Hendrick 100

Gomorrah 17

Gorbachev, Mikhail 59

Gorter, Herman 46, 54

Grand Pensionary 31

Grampré Molière, M.J. 50, 51, 55

Great Britain *see* England

Great Powers 68

Groen van Prinsteren, Guillaume 34

Groningen 50, 51

Grootveld, Robert Jasper 58

Grossaktion 86

Groupe Général de Sabotage (v; Sabotage)

Guillemins (railway station), Liège 89

Guldensporenslag 69

Gullit, Ruud 42

Gustave De Smet Museum, Deurle 325

Haarlem 10, 18, 19, 50

Haeserts, Paul 313

Hals, Franz 18, 38

Hamilton, George 22

Hammacher, A.M. 307

Hampton, Lionel 57

Happart, José 95

Hapsbourg Empire 32, 68

Haro!, newspaper 75

Hausmann, Raoul 336

Haverman, H.J. 34

Gayter, Stanley W. 321

Heliopolis 63

Henderikse, Jan 32, 333

Henneman, Jeroen *293*, 328, 344

Hercules 100

Hermans, Willem Frederik 37, 39

Hermeticism 338

Hertsman, Stefan 324

Hessenhuis 317

Heyrman, Hugo 318

Heysel (park) Brussels 90

Hilverdink, Eduard Alexander 45

Himmler, Heinrich 84, 85, 86

Hitler, Adolph 82, 83, 84, 87, 88, 307

Hitler's Third Reich *see* Reich

Hockney, David 28

Hoenzollern Empire 68

Hoet, Jan 24, 318, 320, 326

Holst, Henriëtte Roland 46, 55, 335

Holstein, Pieter 329

Holtzmann, Harry 307

Hoover, Herbert 70

Housing Act 49

Huizinga, Johan 55

Hussem, Willem *218*, 328, 344

Huysmans, Joris-Karel 319

Hynckes, Raoul 328, 340

Ibsen, Henrik 313

Ijsselmer, lake 43, 50, 57

Ijzerbedevaart (Yser Pilgrimage) 76, 77, 81

Ijzerslag (Battle of Yser) 69, 71

Imanse, Geurt 321

Impressionism 20, 22, 23, 315, 325, 328, 336, 337

India 322

Indonesia, Republic of 32, 40, 41

Industrial Accident Act 46

Ingres, Jean-Auguste-Dominique

Internationalism 319

Jonesco, Eugène 311

Irene of Orange, Princess of Netherlands 39, 41

Israel 49

Italian Fascism 40

Italy 18, 19, 20, 21, 36, 63, 80, 99, 101, 322, 333

Jabbeke 332

Jacob Maris Prize 328, 339

Jacob, Max 337

Jaloux, Edmond 312

James, Martin 307

Japan 316, 321

Java 335

J.C. van Lanschot Prize 334, 337, 338

Jeune Garde Catholique (Catholic Youth Guard) 65

Jeune Peinture Belge 316, 322, 331

Jesper, Oscar 325

Jewish Defence Committe (Joods Verdedigingscomité) 86

Johns, Jasper 317

Jong Vlaanderem, group 71

Jong Vlamingen (Young Flemings) 76

Joosten, Jop 331

Jordaan, Amsterdam 47

Jorn, Asger, 316, 324, 326

Jugendstil 335

Juliana of Orange, Queen of Netherlands 41, 53

Kahnweiler, Daniel Henri 337

Kaiser Wilhelm 69

Kandinsky, Vasilij 21, 334

Karel, King of the Belgians 87

Katanga 89

Katholieke Actie *see* Catholic Action

Katholieke Arbeidersvrouwen *see* Catholic Working-Class Women

Kautsky, Karl 45
Katwijk 305, 335
Kees Groenendijk's collection 330
Kelly, Ellsworth 338
Kelly, Grace 311
Keynes, Milton 51
Kemény Zoltan 327
Kempen 76, 334
Kempers, Paul 321
Khnopff, Fernand *121*, 328, 335, 344
Kingdom of the Netherlands 32, 38, 40
Kinshasa 89
Kirchner, Ernest Ludwig 20
Kloek, Wouter 101
Kloos, Willem 37
Koch, Pyke *210*, *211*, 307, 328, 340, 344
Koniklijke-Haagsche Plateelfabriek Rozenburg N.V. (Royal Rozenburg Earthenware and Porcelain Factory, The Hague) *146*, *147*
KoninklijkeBijenkort Bheer, Amsterdam 328
Konsthall, Malmö 326
Kröller-Müller Rijksmuseum, Otterlo 332
Krupp, german cannons 69
Kruijder, Herman 22, 24, *157*, *158*, 328, 329, 344
Kuijken, Ilse 319
Kupper, CEM *see* Van Doesburg, Theo
Kuyper, Abraham 34, 35, 46, 47

Labour exchange 65
Labour Plan 78
Lagrou 87
Lahaut, Julien 88
Laken Palace, Brussels 83, 87, 88
La Libre Belgique (Free Belgium) 71, 84
Land Art 326
Landuyt 316
Lang, Jack 326
Lapland 326
La Plume, review 312
Laren 336
Lascault, Gilbert 319
L'assiette au beurre, review 337
Lataster, Ger 219, 329, 345
Latem 313, 330, 336
Latem school 313, 323, 336
League of Nations, Geneva 74
Leblanc 316

Le Fauconnier, Henri 327
Le Figaro 333
Léger, Fernand 330, 333
Légion d'Honneur 337
Leiden 50
Leie, region 325, 332, 336
Lely, Cornelis 42, 43
Lelystad 50, 51
Leonardo (da Vinci) 331
Leopold II, King of the Belgians 63, 68
Leopold III, King of the Belgians 80, 82, 83, 87, 88
Leopold's Congo Free State 63
Léopoldville 89
Lepland 326
Le Rire, review 337
Leroy, Eugène 28, *251*, 329, 345
Le Vingts, Brussels 328, 330, 335
Leuven 69, 93, 95, 336
Lhermitte 304
Liberal Education Act 44
Liège 65, 69, 77, 84, 88, 89, 93, 95, 300
Liga voor Publieke Moraal Zedenadel 79
Lijphart, A. 52, 53
Lilar, Suzanne 69
Limburg 44, 86, 89, 95, 329
Lodewijk 39
Lohaus, Bernd 318
London 30, 39, 40, 41, 64, 68, 69, 70, 82, 86, 330
London's National Gallery 101
Lorrain, Claude 99
Louvain *see* Leuven
Louvain-la-Neuve 93
Low Countries *see* Netherlands
Lucassen, Reinier *260*, *261*, 309, 324, 329, 345
Lucebert (Swaanswijk, Lubertus Jacobus) *246*, *247*, *248*, *249*, *250*, 329, 330, 345
Luminism 331, 335
Lumumba, Patrice 89
Luxemburg 88

Maas, river 42, 43, 86, 89
Madrid 70
Maeterlinck, Maurice 67, 313, 328
Maghreb 90, 96
Magic Palace, Antwerp 77
Magic Réalism 307, 328, 340
Magritte, René, 20, 22, 23, 25, 28, 29, 102, 105, *182*, *183*, *184*, *185*, *186*, 316, 320, 329, 330, 345

Mahler, Gustave 37
Malevich, Casimir 21, 328
Mallarmé, Stéphane 323
Manet, Edouard 99
Mannerism 19, 20
Marcadé, Bernard 319
Marcinelle 89, 90
Marinetti, Filippo Tommaso 333
Maris, Matthijs *117*
Marshall Aid 48, 58
Marx, Karl 32, 37, 44
Masaccio 102
Matisse, Henri 20, 21, 309, 337
Maurithuis 101, 329
May Revolution 318
Max, Adolphe 70, 75
Mecano, Dada periodical 336
Mechelen 85, 86, 313
Mees, Guy 318
Memling 319
Mendes da Costa, Joseph *148*
Mendini, Alessandro 51
Mercier, Cardinal 70, 75
Mertz 320
Metsys, Quentin 103
Meunier, Constantin *124*, 330, 345
Meuse, river *see* Maas
Michaux, Henri 316
Michelangelo 20, 100, 104, 304, 339
Middelburg 50
Middle Ages 19, 36, 305
Milan (football team) 41, 329
Milan 41
Military Government (Militärverwaltung) 83, 84, 85, 86
Military Security Service 72, 86
Millet, Jean-François 304
Minimalism 318
Minne, Georges 28, *124*, 313, 330, 336, 345
Miró, Joan 28
Miss interpreted, exibition 326
Modernism 21, 22, 315, 332, 335
Moluccas 41
Mondrian, Piet 18, 20, 21, 22, 23, 24, 28, 37, 42, 55, 104, 105, *144*, *145*, *194*, *195*, *196*, *197*, *198*, *199*, *200*, 306, 309, 315, 317, 323, 325, 327, 328, 331, 332, 335, 336, 338, 345
Monet, Claude 20
Monroe, Marilyn 323
Montmajour (Arles), abbey of 322
Montparnasse, Paris 317
Moreau Gustave 328

Morelli, Anne 98
Morocco 90
Mortier, Antoine *222*, 316, 331, 345
Motril, Spain 97
Multatuli (pseudonym of Douwes Dekker, Eduard) 37
Munch, Edvard 322, 334
Munich 42
Münster, bishop of 31
Musée d'Art Modern de la Ville de Paris 337
Museum of Fine Arts, Boston 100
Museum van Hedendagse (Museum of Contemporary Art), Ghent 27
Mussolini, Benito 80
Muziektheater, Amsterdam 334

Nagel, W.H. *see* Charles, J.B. 48
Nagele 50
Namur 73, 95
Naples 17
Napoleon 31, 36, 68
National Committee for Aid and Food Supplies 70, 74
National Gallery of Delhi (New Dehli) 322
National Socialism 39, 40
National Socialistische Beweging (NSB) 39, 40
National Steel Prize 328
NATO 41, 59, 93, 94
Naturalism 37, 102, 330
Nauman, Bruce 27
Nederlandse-Experimentele Groep (Dutch Experimental Group) 324
Neo-Classicism 315
Neo-Impressionism 313
Neo-Plasticism 315, 316, 331, 332, 336
Netherlands 17, 18, 20, 21, 22, 23, 28, 30, 31, 32, 33, 34, 35, 36, 37, 38, 39, 40, 41, 42, 43, 44, 46, 47, 48, 49, 50, 51, 52, 53, 55, 56, 58, 59, 60, 63, 64, 67, 70, 74, 76, 80, 82, 94, 95, 97, 99, 100, 104, 105, 309, 310, 314, 322, 323, 325, 327, 328, 331, 333, 334, 335, 336, 337, 338, 339
Netherlandsche Unie (Netherlands Union), movement 40
Neue Sachlichkeit (New Objectivity) 55, 328
New Delhi 322
New Figuration 329
New Order, political party 80, 81, 83, 84

New York 37, 63, 70, 310, 321, 329, 331, 338
New York Museum of Modern Art 331
New York School 21
Nieuwe Kerk, Amsterdam 338
Nieuwenhuis, Constant A. *see* Constant
Nieuwe Vlaamse School (New Flemish School) 327
Nijmegen 50
Nobel prize 67
November Gruppe 339
NRC - Handelsblad 321
Nul, Group 321, 328, 333, 337
Nuremberg 19

Oeuvre Prize of the Foundation for The Visual Art, Design and Architecture 339
Offensief, organization 79
Olympic Games 39, 41
Olitsky 99
Onze Lieve Heer op zolder (Our Lord in the Attic), Amsterdam 33
Opwaartsche Wegen, review 55
Orange (dynasty), Royal House of 30, 31, 32, 36, 38, 39, 40, 41, 60
Orange (football team) 41, 42
Orange Party 31
Ostend 103, 312, 324, 332, 334
Oud, Jacobus Johannes

Painting and Plasticism 336
Palais des Beaux-Arts, Brussels 318, 323
Palazzo Grassi, Venice 27, 28
Paleizenplein, Brussels 97
Panamarenko 25, 27, 28, *296*, 318, 319, 331, 345
Paola, Queen of the Belgians 91
Parez, Anna 321
Paris 19, 21, 22, 24, 28, 30, 37, 63, 64, 69, 70, 312, 315, 317, 318, 321, 322, 324, 330, 331, 333, 334, 335, 336, 337, 338, 339
Patinir, Joachim 17, 18, 20, 22, 24, 28, 103, *109*
P.C. Hoolf prize 330
Peers 95
Peeters, Henk 321, 328
Peeters, Jowef 315, 320, 333
Péguy, Charles 317
Peinture Partagée (Shared painting) 335

Permeke, Constant 22, 27, 28, 29, 104, *152*, *153*, 314, 316, 322, 323, 325, 331, 332, 336, 345
Petit, Gabrielle 71
Philip II of Spain 30
Philips, multinational 52, 92, 95
Picabia, Francis 329
Picart, Bernard 37
Picasso, Pablo 20, 21, 23, 104, 309, 315, 337
Pierlot, gouvernement of 81
Pil, Eric 315
Pirenne, Henri 67, 71
Pius XI, Pope 78
Plato 313
Pointillism 331
Polak, Henri 47
Poland 85
Pompei 340
Poor Law 46
Pop Art 325, 329
Post-Expressionism 316
Post-Impressionism 316
Post-Modernism 318
Po Walley 65
POW 83
Prado (Museum), Madrid 103
Prague 19, 48
Praz, Mario 103
Pre-Raphaelites 328
Prink Room of the Stedelijk Museum, Amsterdam 330
Prix de Rome 333, 334, 339
Provence 304, 322, 337
Provincial States 32
Provo, movement 41, 58, 318
Prussia 38

Quist, W. 51

Raad van Vlaanderen 73
Rabelais, François 312
Rädecker, John 335
Radio Luxemburg 58
Radio Orange 40
RAF 84
Raine, Jean 316
Ranstad (Ring City) 50
Raphael 17
Rassemblement Wallon, political party 93
Rauschenberg, Robert 317, 332
Raveel, Roger 24, 28, *257*, *258*, *259*, 318, 320, 329, 332, 345
Realism 102, 328, 330, 335
Reaper, Grim 319

Reclus, Elisée 68
Rect voor Allen (Justice for all), newspaper 45
Red Devils (national team of the Belgium) 41
Redon, Odilon 312
Régamey 304
Register of Jews 85
Reich 71, 73, 74, 81, 82, 84, 85, 321
Reihungen 308
Reinhoud (d'Haese) 316
Rembrandt 18, 23, 38, 99, 100, 105, 309, 312, 329, 334
Renaissance 17, 18, 30, 102, 304, 328, 333
Renan, Ernest 63, 67
Renoir, Auguste 330
Republic of the Seven United Netherlands 30
Resnais, Alain 311
Restany, Pierre 318
Rex, political party 80, 81, 83, 84, 86
Rexist Wallon Guard 86
Reynebeau, Marc 98
Rhine, river 42, 43, 86
Ridderzaal, The Hague 36
Rietveld Academy of Art 332
Rietveld, Gerrit Thomas 55, *202*, *203*, *204*, *205*, 332, 345
Rietveld-Schröder House, Utrecht 332
Rijksakademie, Amsterdam 329, 334, 335
Rijksmuseum, Amsterdam 55, 99, 101, 309, 340
Rivers, Larry 317
Rodenback, Georges 319, 328
Rodenko, Paul 37
Rodin, Auguste 330
Roggerman, Willy 316
Roghman, R. 31
Romanticism 55
Rome 18, 19, 20, 24, 33, 39, 78
Romein, Jan 55
Roncquières, Hainaut 90
Roobjee, Pjeroo 318
Rooskens, Anton 323
Rops, Félicien 103, *115*, 319, 332, 335, 345
Rotterdam 43, 47, 48, 50, 51
Roubaix 64
Rougon-Macquart Family 330
Rous, Martin 334
Rousseau, Jean-Jacques 324
Royal Dutch Airways 39

Royal Dutch Oil Company 32
Royal Galleries, Ostend 334
Royal Question 80, 88, 92, 93
Rubens, Pieter Paul 18, 19, 20, 22, 23, 24, 28, 103, 303, 314, 339
Ruisbroeck 313
Ruskin, John 100
Russia, 38, 63, 68, 85
Russian Revolution 45

Sabotage, group 86
Saenredam, Pieter Jansz 18, *302*, 309, 326
Sahara 324
Saint-Martens 313
Saint Peter's, abbey 317
Saint-Rémy, Provence 304, 337
Saint-Sauver, Brussels 77
Salon Apport 322
Salon d'Automne 337
Salon de L'Aeronautique 333
Salon de May 317
Salon des Indépendants 337
Sambre, river 89
Sandberg Prize 323
Sandberg 328, 329
Sankriti Kendra 322
Sarajevo 68
Sassetta 99
Sonsbeek Off Limits 337
Sauvy 92
Schaarbeek, National Shooting Range of 71
Sauvy 92
Schaepman, Herman J.A.M. 35
Schelde, river 42, 43, 313
Scheldt, river *see* Schelde
Schenk, Jan 30
Schippers, Wim T. 337
Schmalzigaug, Jules *139*, 333, 346
Scholte, Rob 52, 322
Schoonhoven, Jan J. 23, 24, 28, *263*, *264*, *270*, 308, 321, 333, 346
Schoterhand, district 45
Schouten, Marien 23, 27, 28, *283*, 333, 346
Schutzstaat (protectorate) 82
Schwitters, Kurt 38, 336
Scotland 33
Scriptores Catholici 79
Seine, river 23, 312
Servranckx, Victor 23, 76, *187*, *188*, 315, 320, 330, 333, 338, 346
Seuphor, Michel 317, 322, 331, 333
Seurat, Georges 20, 335
Severini, Gino 333

Shakespeare, William 313
Shell 32
Sicherheitspolizei *see* Military Security Service
Siemens 92
Signac, Paul 335
Sluijters, Jan *163*, 331, 334, 335, 346
Smith, Jacob *122*, *123*, 334, 346
Social Democratic Labour Party 48
Social Democratic Union (SDB) 44, 45
Social Democratic Workers' Party (SDAP) 45, 48
Socialist General Union of Dutch Diamond-Workers 46
Socialist Wallonia from the Belgian State 92
Socialist Workers' Youth Centre 58
Social Security Act 49, 88
Societé Générale 96
Sodom 17
Solomon R. Guggenheim Museum, New York, 328
Sombart, Werner 65
Sorbonne, Paris 63
Soviet Union 59
Spain 38, 63, 87, 330
Spilliaert, Leon 23, *114*, *125*, 334, 346
Spuilplein, The Hague 334
SS (Schutzstaffel) 85
SS Vlaanderen 84, 85, 87
Stadsgalerij, Heerlen 322
States General 30, 31, 32, 36
State of the Netherlands 35, 60
State Prize for Art and Architecture 338
State University of Groningen 34
State University of Leiden 34
State University of Utrecht 34
Stedelijk Bureau, Amsterdam 322
Stedelijk Museum, Amsterdam 28, 37, 321, 322, 323, 324, 326, 327, 328, 329, 330, 333, 334, 339
Steen, Jan 100, 101, 103
Stevenage 51
Still, Clyfford 338
Stock Exchange 55
Struycken, Peter *297*, 328, 334
Stuart, Mary 34
Stuttgart 335
Sukarno 40
Sumatra, Island of 32
Suriname 50
Surréalism 19, 22, 29, 102, 103, 316, 317, 320, 328, 331, 334

Surréalism révolutionaire 316, 326
Swaanstwijk, Lubertus Jacobus *see* Lucebert
Switzerland 63, 68
Symbolism 312, 313, 316, 328, 331, 334, 335

Tachtig (Eighty), movement 37
Tamines 69
Tarde, Gabriel 63
Tauber-Arp, Sophie 336
Terborch 304
Teer Braak, Menno 55
't Hart, Maarten 55
The Hague 36, 39, 50, 59, 70, 328, 329, 331, 335
The Hague School 337
Theosophical Association 331
Third World 58
Thijs, Philippe 68
Thomas à Kempis 104
Thorbecke, Jan Rudolf 32, 33
Thoré-Bürger 99
Timmermann, Aegidius W. 306
Tinguely, Jean 327
Toorop, Charley 22, 23, 102, *140*, *141*, 327, 334, 335, 346
Toorop, Jan 21, 23, 54, *118*, *119*, *120*, 305, 306, 327, 331
Turcoing 64
Tour de France 68
Troelstra, Pieter Jelles 45, 46, 53
Tunisia 90
Turkey 90
Tuymans, Luc 27, 28, *278*, *279*, *280*, *281*, 335, 346
Tzara, Tristan 336
Twenthe 44
Tytgat, Edgard 314

Ubac, Raoul 316
Uliver, cargo plan 39
United States of America 40, 48, 70, 324, 336
Unity Law 89
Université Libre de Bruxelles 86
Utrecht 33, 50, 99, 328, 334, 335

Van Abbemuseum, Eindhoven 326
Van Anderlecht, Englebert *217*, 316, 335, 346
Vanbeselaere, Walter 314
Van Beverloo, Corneille Guillaume *see* Corneille
Van Calster, Paul 316
Van Craesbeek, Joos *252*

Van Delen, Dirck 36
Van den Abeele, Albijn 330
Van den Berghe, Frits 80, *159*, *160*, 314, 315, 336, 346
Van den Boogaert, Abraham *see* Bogart, Bram
Van den Vondel, Joost 37
Van der Broek, Johannes Hendrik 50
Vandercam, Serge 316, 335
Van der Hoef, Chris *149*
Van der Leck, Bart *138*, *207*, 331, 332, 336, 346
Van der Vlugt, Ger 51
Van der Vlugt, L.C. 50
Van der Weyden, Rogier 17, 319, 338
Van de Velde, Henry 335
Van de Woestijne, Gustave *156*, 313, 314, 336, 346
Van de Woestijne, Karel 313, 330, 331, 334
Van Doesburg, Theo 18, 55, *189*, *208*, *209*, 305, 307, 331, 332, 336, 338, 346
Van Dongen, Kees, *162*, 334, 337, 347
Van Dujn, Roel 58
Van Duinkerken, Anton (pseudonym of W.J.M.A. Asselbergs) 55
Van Dyck, Anthonie 18, 22
Van Eeden, Frederik 37, 54
Van Eesteren, Cornelis
Van Elk, Ger 100, *294*, *295*, 310, 337, 347
Van Eyck, Jan 17, 18, 29, 102, 314, 339
Van Gogh, Theo 304, 337
Van Gogh, Vincent 18, 20, 22, 23, 24, 28, 29, 37, 43, 44, 102, 104, 105, *112*, *113*, *126*, *127*, *128*, *129*, *130*, *131*, *132*, *133*, *134*, *135*, 304, 305, 309, 310, 312, 320, 322, 332, 337, 347
Van Haarlem, Cornelis 100
Van Heemskeerck, Jacoba 142, 143
Van het Reve, Geerard Kornelis 37, 55, 59
Van Houten, Sam 44, 46
Van Houtte, Hector 313
Van Lint, Louis 316
Van Mander, Karel 18, 20
Van Mulders, Wim 320
Van Nelle, factory 50
Van Ostade, Adriaen 103
Van Ostaijen, Paul 76, 315

Van Paridon, Louis 158
Van Ruysdael, Jacob 18, 28, *192*, *193*
Van Scorel, Jan 17, 18, 19, 20, 22, *108*
Van Severen, Dan 23, *268*, *269*, 317, 320, 337, 338, 347
Vantongerloo, Georges 23, *201*, *206*, 338, 347
Van Velde, Bram 309
Van Waldeck-Pyrmont, Emma 38
Vasari, Giorgio 18, 20, 102
Veiligheidscorps 86
Velázquez, Diego Rodriguez 324
Veneman, Peer 338
Venice 19, 28, 333
Vercammen, Wout 318
Vercruysse, Jan 25, *287*, 338, 347
Verhaeren, Emile 66, 67, 68, 94, 328, 334
Verhoef, Toon *284*, 338, 347
Verlaine, Paul 328
Vermeer, Jan 18, 20, 38, 306, 309
Verschueren, Jef 98
Verwey, Albert 37
Veth, Jan 37, 305
Veurne 313
Vietnam War 42, 57, 58, 94
Vienna 21, 24, 64
Visch, Henk *286*, 338, 347
Visser, Karel *272*, 338, 339, 347
Viti, Paolo 24
Vlaams Blok 96
Vlaamsch National Verbond 80, 81, 83, 86, 87
Vlaamse Beweging 66
Voeren area (Voer) 95
Vogels 314
Volk en Staat paper 84, 85
Volkshuizen 65
Volksunie 93, 96
Volksverwering 85
Voltaire 28, 37
Volten, André *271*, 339, 347
Von Amsberg, Claus 41, 52
Von Bissing, Freiherr 71
Von Bissing University, Ghent 71, 73
Von Falkenhausen, Alexander 83
Vrij Beelden, association 328
Vrij België, newspaper 84
Vrij Vlaanderen, newspaper 75

Walasse Ting 321
Wallonia 64, 73, 77, 87, 88, 89, 90, 92, 95, 96, 97, 98

Wall Street 47

Warhol, Andy 27

War of the Austrian Succession 31

War of the Spanish Succession 30, 31

Weissenbruch, Jan Hendrick 101

Welsh, Robert 331

Werbestelle, Employment Agency 84

Werkliedenpartij 92

Westerik, Co 102, *254, 255, 256,* 339, 347

Wiertz, Antoine Joseph *116,* 319, 339, 347

Wilhelm Lehmbruch Museum, Duisburg 339

Wilhelmina of Orange, Queen of Netherlands 38, 41, 53

Wilhelmina of Prussia 31

Willem I Orange, Stadholder 34, 38

Willem II Orange Stadholder 31, 32, 33

Willem III Orange Stadholder 31, 32, 35, 38, 45

Willem IV Orange Stadholder 31

Willem V Orange Stadholder 31

Willink, Carel *212, 213,* 307, 328, 339, 340, 347

Wlaamse Beweging *see* Flemish Movement

Woeste, Charles 75

Wolkers, Jan 55

Wouters, Rik *161,* 323, 340, 347

Yser, river 69, 70, 71, 72, 73, 75, 76, 77, 81

Zadkine, Ossip 315

Zaire 89

Zeeland 30, 42, 43, 331

Zivilverwaltung 83

Zivilfahndungsdienst 84, 85

Zola, Emile 330

Zonnestraal, sanatorium 47

Zuyder Zee (North Sea), inner sea 42, 43, 60, 339

Zuyder Zee Association 42

Zweig, Stefan 68

Index of the Artists and Works

Alechinsky, Pierre
Growing Grass — 243
Recently — 244, 245

Allebé, August
Eduard Douwes Dekker
(pseudonym Multatuli) — 38

Appel, Karel
Machteld — 230
Nude No. 1 — 231
Savage Nude — 232
Toscaanse landschappen (Tuscan Landscapes) — 321

Armando
2x7 Bolts on Red — 267, 321
12 Bolts (on Black) — 266
Fahnen (Flags) — 321
Peintures criminelles — 321
Schuldig landschap (Guilty Landscape) — 321

Arntz, Gerd
Unemployed People — 47

Benner, Gerrit
Frisian Landscape — 228
Voorjaar (Spring) — 229, 322

Bertrand, Gaston
Cathedral — 224
Composition — 225
Geel-interieur (Yellow interior) — 322
Rood-interieur (Red interior) — 322

Birza, Rob
Andy — 322
Attitudes II — 322
Buddha's Horizon / View of the Lights — 322
Ceci n'est pas un Legér — 322
Kill India Kiss India — 322
Strawberries, Pistach, Peach and Banana — 282
The Other Self — 322

Bogart, Bram
Urge — 223

Bosch, Hieronymus
The Path of Life, The Haywain — 102
The Temptations of St. Anthony — 103

Both, Jan
Italian Landscape with Draughtsman — 99

Brands, Eugène
Sign in Orion — 237
Summer — 236

Broodthaers, Marcel
Citron - Citroen — 291
Ensemble de neuf toiles sur un sujet littéraire — 323
Mirroir Regency — 289
Modèle: la pipe (Model: the pipe) — 290
Musée d'Art Ancien
Galerie du XXème Siècle — 323
Musée d'Art Moderne, Département
des Aigles, Section XIXème Siècle — 323
Rue René Magritte — 290
Salle Blanche — 323

Brouwn, Stanley
1 m²-1 stap² -1 el² -1 voet²
(1 m², 1 step², 1 ell², 1 foot²) — 323
a. 100 m, 1:100 b. 100 steps, 1:100 — 292
Lenght 1 step on 14-10-87 — 292
this way brouwn — 323

Bruegel, Jan the Elder
Fighting Farmers — 150, 151

Bruegel, Pieter the Elder
Cattle Returning — 314
Storm — 314

Brun, Frans
Building a moderate Protestant conventicle
behind merchants' houses on Keisersgracht
Amsterdam, in 1630 — 33

Brusselmans, Jean
Spring, View of Dilbeek — 136
Woman in a Kitchen — 137

Cats, J.
French soldiers entering Amsterdam
on January 19 1795 — 31

Citroen, Paul
Menno ter Braak — 55

Claesz, Pieter
Still Life — 262

Constant
Corrida — 240
Nieuw Babylon (New Babylon) — 324
Reclining Figure — 238
Scorched Earth II — 241
War — 239

Corneille
Man looking for Mushrooms — 234
Summer-day — 235
The Gay Rythm of the City — 233

Daniëls, René
De revue passeren (Passing the review) — 324
Hot Day in the Lighthouse — 276
Lentebloesem (Spring blossom) — 324
Mooie tentoonstellingen
(Beautiful Exhibitions) — 324
Palais des beaux-aards — 324
Twee I's strijdend om een punt
(Two I's fighting for a dot) — 324
Untitled — 277

De Champaigne, Philippe
Portrait of Jean-Pierre Camus — 288

De Cordier, Thierry
Je n'ai rien à voir avec le XXème siècle
(I have nothing to do with the 20th century) — 215

De Keyser, Raoul
Gate of Hell — 274
Hall (3) — 273
Untitled — 275

Dekkers, Ad
Circle developing towards square — 325
1st Phase from Circle to Square — 265

Delvaux, Paul
Au bord de la Mer (At the Seaside) — 191
La Vénus endormie — 103
The Storm — 190

De Smet, Gustave
The Pigeon House — 154
Village Fair — 155

D'Haese, Roel
Bist du der Römer? — 226
L'Enfant Prodigue — 317

Dibbets, Jan
Monet's Dream Study — 326
Perspectief correcties
(Perspective corrections) — 326
Spoleto Self-portrait — 298, 299
SVB, Amsterdam — 301
Wayzata Window — 300

Dotremont, Christian
Et de Linge — 326
Les Transformes — 326
Logoglaces — 326
Logograms — 242, 326
Logoneiges — 326
Peintures-Mots — 326
Sept Ecritures — 326

Douard, Cecile
Hiercheuse poussant son wagonnet: Cuesmes 64

Dumas, Marlene
Black Drawings 326
Indifference 326
The Nuremberg Trial 326
Turkse schoolmeisjes
(Turkish Schoolgirls) 285, 326

Dypréau Jean
Peintures Partagées 316

Ensor, James
Adoration of the Shepherds 175
Baths at Ostend 171
Breakwater 174
Carnival in Flanders 170
Christ and The Beggars 178
Christ Calms Down the Storm 167
Christ Descending to Hell 178
Christ Mocked 104, 179
Forest at Groenendael 176
Large Marine: Sunset 166
Le Rameur (The Rower) 22, 111
Menu for Charles Vos 180
Old Lady with Masks 165
Penitent Mercenaries in a Cathedral 173
Rue du Bon Secours a Bruxelles 175
Self-portrait 103
Self-portrait at the Ease 28
Self-portrait with Flower Hat 110
Still Life 168
The Calvary 172
The Deadly Sins Dominated by Death 180
*The Entry of Christ
into Brussels* 104, 312, 319, 326
The Gamblers 177
*The Haloes of Christ
and the Sensitivities of Light* 319
The Mask Theatre 164
The Red Judge 169
The Thunderstorm 177
Warmth-seeking Skeletons 27
Warmth-seeking Skeletons, etching 181

Fabre, Jan
De macht der theaterlijke dwaasheden
(The strenght of theatrical madness) 327
The Bee-keeper 214

Fernhout, Edgar
By the Sea 221
Herfst (Autumn) 327
In Autumn 220
Voorjaar (Spring) 327

Gentils, Vic
Hommage à Permeke 227

Goltzius, Hendrick
Hercules and Cacus 100

Haverman, H.J.
Abraham Kuyper in 1897 34

Henneman, Jeroen
De kus (The kiss) 327
Facades D 293

Hilverdink, Eduard Alexander
Amsterdam's poor Jewish district in 1889 44

Hussem, Willem
Binding 328
Dans (Dance) 328
Steltlopen op zee
(Stilt-walk on the sea) 328
Tekens (Signs) 328
Untitled 218
Zonder titel (Untitled) 328

Khnopff, Fernand
Brown Eyes and a Blue Flower 121

Koch, Pyke
Bertha van Antwerpen 328
De Schiettent (Shooting gallery) 328
The Big Contorsionist (Cirque Parade) 211
Women in a Street 210
Zelfportret met zwarte doek
(Self-portrait with black headband) 328

Koninklijke Haagsche Plateelfabriek
Rozenburg N.V. (Royal Rozenburg
Earthenware and Porcelaine Factory
The Hague)
Bonbonnières 147
Vases 146, 147

Kruijder, Herman
De brief (The letter) 328
De haan (The cock) 328
De varkensdoder (The pig killer) 328
Pan 328
Pig Farmer 158
Pig Killer 157

Lataster, Ger
Spain 219

Leroy, Eugène
Self-portrait 251

Lucassen, Reinier
De eenzamheid van Donald Duck
(The loneliness of Donald Duck) 329
Long Live Marat 260
My Hero-Portret van Jack the Ripper
(My Hero-portrait of Jack the Ripper) 329
Portrait of Brusselmans 261
*Russische compositie naar Picabia
of illusie van de werkelijkheid*
(Russian composition after Picabia
or the illusion of reality) 329
Van Gogh, P.M. en Lucassen 329

Lucebert
Burning Answer 246
Easter Bird 248
Farmer Floating in the Air 246
Orpheus and the Animals 249
The Poet Feeds Poetry 247
Yoker the Smoker with Yardbird 250

Magritte, René
Bel Canto 183
Ceci n'est pas une pipe 330
La Plaine de l'air 28
La trahison des images 330
L'Empire des Lumières 28, 315
Les amants 102
Natural Encounters 185
Person Meditating on Madness 184
Perspective (Manet's Balcon) II 182
The Mountaineer 186

Maris, Matthijs
Young Bride 117

Masaccio
Adoration of the Magi 102

Mendes da Costa, Joseph
Plate 148

Meunier, Constantin
De brand van Turnhout
(The burning of Turnhout) 330
De Buildrager
(The sack dragger) 330
De Mijnwerkster (The miner) 330
Het martelaarschap van de Heilige Stefanus
(The Martyrdom of St. Stephen) 330
Monument voor de Arbeid
(Monument to Labour) 330
Scheepslosser (Dockworker) 330
Smid (Blacksmith) 330
Working-class Woman 124
Zaaier (The seedsower) 330

Minne, Georges
Fontein der Geknielden
(Fountain of the Kneelers) 330
Little Boy Kneeled 124
Man Crying over his Dead Dear 124

Mondrian, Piet
Arum Lilies 145
Broadway Boogie Woogie 331
Composition No. XIV 196
Composition with Red 104
Composition with Red, Yellow and Blue 199
Composition I with Red, Yellow and Blue 200
Composition with Red, Yellow
Blue and Black 197
Composition with Yellow and Blue 198
De rode boom
(The red tree) 330
Sunflower I 144
Tableau III (Oval Composition) 194
Tableau No. 3 (Oval conposition)
(Trees) 195
Victory Boogie Woogie 331
Zee en pier (Compositie nr. 10)
(Pier and ocean – Composition No. 10) 331

Mortier, Antoine
Reminiscence 222

Munch, Edvard
Shriek 322

Nauman, Bruce
Green Light Corridor 27

Panamarenko
Molly Peters 331
Poppy 296
Umbilly I 331

Patinir, Joachim
Sodoma and Gomora on Fire 17, 109

Permeke, Constant
The Cabriolet 153
The Weeder 152

Picart, Bernard
Synagogue in Amsterdam during a service 37

Raveel, Roger
Combine paintings 332
My Mother's Deathbed 257
Neerhof
(Pigeon-house) 332
Tremendously Beautiful Life 258, 259

Rembrandt
Abraham's Sacrifice 100
Artist in His Studio 100
Nachtwacht (Nightwatch) 309

Rietveld, Gerrit
Armchair (Berlin Chair) 204
Cart 202
Chair 205
Low Arm Chair 203
Red and Blue Chair 332
Small Low Table from the 'Military' Series 202
Zigzag Chair 332

Roghman, R.
The horribly mutilated corpses of Pensionary
Johan de Witt and his brother 31

Rops, Félicien
La Mort au Bal Masqué 332
La mort qui danse 103
Pornokratès 103
Quarrel 115
Tentation 103

Saenredam, Pieter
Interior of St. Laurence Church, Alkmaar 302

Schenk, Jan
The Corn Exchange built in 1617
in Amsterdam, the centre of the grain trade 30

Schmalzigaug, Jules
Space and Light (The Sun moves
through the Church of the Salute-Venice) 139

Schoonhoven, Jan
Big Square Relief 264
R 71-10 263
R 72-24 333
R 83-2 270

Schouten, Marien
Untitled 283

Servranckx, Victor
Opus 2, Port 187
Red Rotative 188

Sluijters, Jan
Bal Tabarin 163

Smits, Jacob
Pond in a Park at Brussels 122
Sunrise in the Kemp - Brabant 123
The Father of the Condemned 334

Spilliaert, Leon
Eve and the Serpent 125
Kursaal and Dike at Ostend 114

Steen, Jan
Ahasuerus 101
As the Old Sing, So Pipe the Young 101
Skittle Players Outside an Inn 101

Struycken, Peter
Computerstructure IV A 297
Koninginnezegel 334

Toorop, Charley
Arbeidersvrouw in ruïnes
(Working-class Woman among the ruins) 334
Clown 334
Drie generaties
(Three generations) 334
Three Generations 141
Women 140

Toorop Jan
De Jonge Generatie
(The young generation) 335
Desiderio e appagamento 305
Oude eiken in Surrey
(Old oaks in Surrey) 335, 118
Tramps 120
The Three Girls of Volker van Waverveen 119
Venus der zee (Venus anadyomene) 334

Tuymans, Luc
Antichambre 335
Body 281
Camouflage 279
Diagnostische blik (Diagnostic view) 335
Gaskamer (Gas-chamber) 335
Recherches 335
Repulsion 335
Silent Music 280
The Walk 278

Van Anderlecht, Englebert
Composition No. 3 217
Couper la parole 335
Je peins contre le temps 335
Peinture partagée 316, 335

Van Craesbeeck, Joos
The Death is Fierce and Fast 252, 253

Van Delen, Dirck
The Great Hall of the Binnenhof
at The Hague during the Assembly
of the General States 36

Van den Berghe, Frits
Neptune — 160
Sunday on the Leie — 335
The Sunken Road — 159

Vandercam, Serge
Peintures Partagées — 316

Van der Hoef, Chris
Dish — 149
Bowl — 149

Van der Leck, Bart
Composition — 207
The Storm — 138

Van de Woestijne, Gustave
Christus offert zijn bloed
(Christ offers his blood) — 336
Kindertafel
(Children's table) — 336
Liquer Drinkers — 156

Van Doesburg, Theo
Composition XXII — 189
Contra-compositie V — 336
Contra-composition V — 208
Contra-composition XV — 209

Van Dongen, Kees
Josephine Baker at a Blacks' Ball — 162

Van Elk, Ger
Identifications, Part 6
(The Shaving of the Cactus) — 336
Kutwijf (Bitch) — 337
"Missing Persons" Mantlepiece — 295
Russian Diplomacy — 337
The Co-Founder of the Word OK Marken — 294

Van Eyck, Jan
Hermits and Pilgrims
Adoration of the Holy Lamb — 29
Judges and Knights
Adoration of the Holy Lamb — 102

Van Gogh, Vincent
Cedar Walk with Figure — 133
Ears of Wheat — 23, 129, 135, 304
Field with Poppies — 130, 131
Fir Trees at Sunset — 134
Pietà (after Délacroix) — 104
Portrait of Doctor Gachet — 337
Road with Cypress and Star — 22, 135, 304
Self-portrait — 28
Self-portrait — 112

Self-portrait with Bandaged Ear — 337
*Still Life: One-eared Vase
with Asters and Phlox* — 126
Still Life: Vase with Carnations — 127
Still Life with Lemons and Bottle — 132
Sunset — 22
The Potato Eaters — 44, 337
Undergrowth — 128
Weaver
(Seen frontally at his loom) — 22, 113

Van Haarlem, Cornelis
Titans — 100

Van Heemskerck, Jacoba
Composition No. 93 — 142, 143

Van Ruysdael, Jacob Jsaacsz
Cornfield — 192, 193

Van Scorel, Jan
Portrait of a Young Scolar — 17, 108

Van Severen, Dan
Blue Composition — 269
Composition — 337
Rectangular Composition — 337
Untitled — 268
Untitled — 337

Vantongerloo, Georges
Composition from the Ovoid — 201
Space Segment — 206
Study — 201

Vercruysse, Jan
Atopies — 338
Kamers (Rooms) — 338
Portrait of the Artist by Himself (XIII) — 287
Tombeaux — 338

Verhoef, Toon
Untitled — 284

Veth, Jan
Portrait of Albert Verwey — 37

Visch, Henk
Book — 286
Idle Thoughts for Idle Men — 338
Take Me to the River — 338

Visser, Carel
Oil Ship — 272
Slappe kubus (Limp cube) — 338
Wandelstok (Walking-stick) — 338

Volten, André
Reclining Relief — 271

Weissenbruch, Jan Hendrick
View at Geestbrug — 101

Westerik, Co
Cut by a Grass Blade — 256
Man in the Water, Woman in the Boat — 255
Schoolmaster with Child — 254
Tulp (Tulip) — 339
Vlees (Flesh) — 339

Wiertz, Antoine Joseph
A coquettish Woman Undressed — 116

Willink, Carel
De laatste bezoekers aan Pompei
(The last visitors to Pompeii) — 339
Girl with a Ball — 213
Portrait of Miesje — 212

Wouters, Rik
The Crazy Dancer — 161
Zotte geweld (Mad violence) — 339

Photos Credits

RCS Libri & Grandi Opere Archive, Milan 27, 28, 29, 102 (above and bottom), 103, 104, 108

D&H Fotografie, Foto Dikken & Hulsinga, Leeuwarden 212

Fabrice Gibert, Paris 301

FLP, The Hague 199

Fodialle Publiciteitsfotograaf © Guy van Belleghem, Ostenda 153

Fotografie Dirk Pauwels, Ghent 137, 174, 175, 176, 177, 178, 179, 180, 181, 182, 215, 217, 226, 232, 279, 281, 289, 290, 291, 296

Fotografie Ditmar Bollaert & Karel Moortgat, Ghent 124

Fotografie Gert Jan van Rooij, Amsterdam 283

Fotografie Rob Kollaend, The Hague 255

Fotografie Tom Haartsen, Ouderkerk a/d Amstel 100, 192, 193, 293

Foto Peter Lorré, Ghent 124

Fotowerken Frans Claes, Antwerp 191

Hugo Maertens Fotograaf, Bruges 136, 139

John Stoel, Haren 122, 228, 294

Jörg P. Anders, Berlin 102 (second from above)

Kunstfoto Speltdoorn en Zoon, Brussels 114, 116, 150, 151, 159, 183, 184, 185

Oronoz, Madrid 102 (second from bottom)

Pelegrie N.V., Antwerp 109

Photo Cussac, Brussels 243

Piotr Tomczyk, Łodz 209

P. Ysalrie, Ghent 222

Stichting Beeldrecht, Amstelveen 142, 143, 144, 145, 200

This catalogue has been published with the support of Cartiere Burgo
and it is printed on R4 New Matt Satin 130 g/m² paper manifactured by Cartiere Burgo

Fotocomposizione Grande - Monza (Milan)

Printed in March 1997
by New Interlitho-Italia - Caleppio di Settala (Milan)